böhlau

GIOTTO THE PAINTER

Volume 2: Works

by Michael Viktor Schwarz

GIOTTO THE PAINTER

VOLUME 2: WORKS

by Michael Viktor Schwarz

Böhlau Verlag Wien Köln

Bibliografische Information der Deutschen Nationalbibliothek:
Die Deutsche Nationalbibliothek verzeichnet diese Publikation in der
Deutschen Nationalbibliografie; detaillierte bibliografische Daten
sind im Internet über https://dnb.de abrufbar.

© 2023 Böhlau Verlag, Zeltgasse 1, A-1080 Wien, ein Imprint der Brill-Gruppe
(Koninklijke Brill NV, Leiden, Niederlande; Brill USA Inc., Boston MA, USA; Brill Asia Pte Ltd,
Singapore; Brill Deutschland GmbH, Paderborn, Deutschland; Brill Österreich GmbH, Wien,
Österreich)
Koninklijke Brill NV umfasst die Imprints Brill, Brill Nijhoff, Brill Hotei, Brill Schöningh, Brill Fink,
Brill mentis, Vandenhoeck & Ruprecht, Böhlau und V&R unipress.

Alle Rechte vorbehalten. Das Werk und seine Teile sind urheberrechtlich geschützt.
Jede Verwertung in anderen als den gesetzlich zugelassenen Fällen bedarf der vorherigen schriftlichen
Einwilligung des Verlages.
Umschlagabbildung: Staatliche Museen zu Berlin, Preußischer Kulturbesitz: Gemäldegalerie
Umschlaggestaltung: Michael Haderer, Wien
Satz: Bettina Waringer
Druck und Bindung: Hubert & Co., Göttingen
Printed in the EU.
Vandenhoeck & Ruprecht Verlage | www.vandenhoeck-ruprecht-verlage.com

ISBN: 978-3-205-21696-4

TABLE OF CONTENTS

INTRODUCTION 25

SPEECH WHICH SPEAKS TO THE EYE:
THE ARENA CHAPEL 33

Annunciation Day in Padua 34 • Enrico Scrovegni's Foundation 39 • Three Portraits 48 • The Last Judgement 53 • The Triumphal Arch 68 • The Lives of Mary and Jesus 75 • Judas 85 • The Palace Chapel 93 • Giotto's Christmas 95 • The Inverted Passe-Partout and the Objects / The Rejection of Joachim 107 • Dynamics of Pictorial Invention 112 • The Painter Shows Houses, Courtyards, and Halls 117 • Narration through Figures and Movements 122 • Emotional Energy 130 • Christ's Gazes 137 • Eloquent Hands 140 • The Paduan Bottega: Picture Fields 145 • The Paduan Bottega: the Framing System 149 • Songs and Images: the Allegories 152 • Giotto in Padua 181

GIOTTO AVANT GIOTTO: WORKS BEFORE AND AROUND 1300 189

The Isaac Pictures in the Upper Church of Assisi 190 • Roman Painting in the Last Decade of the Thirteenth Century 201 • The Isaac Master Ensemble 208 • The Navicella: Vestiges 225 • The Navicella: Stefaneschi's Donation 239 • The Navicella: Giotto's Narration 243 • How the Navicella Works Allegorically 250 • The Cross of Santa Maria Novella: Prerequisites 252 • The Cross of Santa Maria Novella: a New Image for the Florentines 259 • The Madonna of San Giorgio alla Costa 270 • Summary: From Presence to Image 277 • Outlook: the Crosses in Rimini and Padua 289

ASSISI 1308 AND OTHER ST. FRANCIS-PROBLEMS 297

Use and Conversion of the Double Church 297 • Palmerino di Guido and other Painters on Site 299 • Giottesque Painting in Assisi: the Legend of St. Francis 302 • Giottesque Painting in Assisi: the Chapel of St. Nicholas 315 • Giottesque Painting in

6 Table of Contents

Assisi: the Crossing and North Transept of the Lower Church 326 • The Mary Magdalene Chapel 334 • Soulful Looks 340 • On the Connection and Sequence of the Murals 353 • Giotto's St. Francis Panel (Louvre) and the Legend of St. Francis in Assisi 359 • An Image of St. Francis for the Pisans 372

GIOTTO AUTONOMOUS: THE BARDI CHAPEL
AND THE WORKS OF THE SECOND DECADE 379

Sanctitatis nova signa 384 • The St. Francis Chapel of the Bardi 388 • Giotto's St. Francis Cycle 396 • The Bardi Style 403 • Cairo in Florence 407 • Rome: the Capella in St. Peter's (1312/13) 413 • The Choir Chapel of the Badia 416 • El comune come era rubato (Florence, Bargello) 422 • Ognissanti: the Madonna 428 • Ave Virgo Virginum 433 • Ognissanti: the Cross 437 • Ognissanti: the (so-called) Death of the Virgin 439 • Giotto autonomous 447

GIOTTO PLURALISTIC: THE PERUZZI CHAPEL IN
FLORENCE AND THE LATE WORKS 449

The Murals of the Capella Magna in Naples 451 • The Baroncelli Retable 453 • The Architectural Polyptychs: Giotto's Gothic 467 • The Stefaneschi Altarpiece: Dating and Placement 473 • The Stefaneschi Altarpiece: Peter and Paul and the Holiness of Rome 480 • The Stefaneschi-Altarpiece: Peter and Peter and the Curia at Avignon 488 • The Badia Altarpiece: Predella, Patronage, Dating 495 • The Badia Altarpiece: Strategy of Representation 501 • The Bologna Altarpiece 503 • The Sts. Johns' Chapel of the Peruzzi 510 • Two Lives in Six Pictures 517 • The Peruzzi Style 527 • Ephesus in Florence or a Window to the World 532 • Variety 540

GIOTTO'S PAINTING AND THE VISUAL CULTURE
OF HIS TIME . 543

Florence before 1300 544 • Giotto's Rome 549 • The Visual Medium Finds Itself 553 • The Portrait: A Roman Medium Renovated 555 • Dialectic of Success 561 • Giotto and the Sienese or the Triumph of the Real 566

Table of Contents

THE CAMPANILE: SURVIVAL UNDER CONSTRUCTION 571

The Building 573 • The Siena Parchment: Giotto's Gothic once again 576 • The Shepherd's Tower 584

PHOTO CREDITS . 593

ABBREVIATIONS

ASF – Archivio di Stato di Firenze
ASP – Archivio di Stato di Padova
ASV – Archivio di Stato di Venezia
BAV – Biblioteca Apostolica Vaticana
BCP – Biblioteca Civica di Padova
BNCF – Biblioteca Nazionale Centrale di Firenze
BNF – Bibliothéque Nationale de France, Paris
DizBI – Dizionario Biografico degli Italiani, vol. 1 et seqq., Rome 1960 et seqq. (http://www.treccani.it/biografico/)
EncDantesca – Enciclopedia Dantesca, ed. U. Bosco, 6 vols., Rome 1970–1975 (http://www.treccani.it/enciclopedia/elenco-opere/Enciclopedia_Dantesca)
NA – Notarile Antecosimiano

TRANSLATIONS

The Bible. Authorized King James Version. With an introduction and notes by R. Caroll and St. Prickett, Oxford 1998
Giorgio Vasari, Lives of the Most Eminent Painters Sculptors & Architects, trans. G. du C. de Vere, 10 vols., London 1912–14

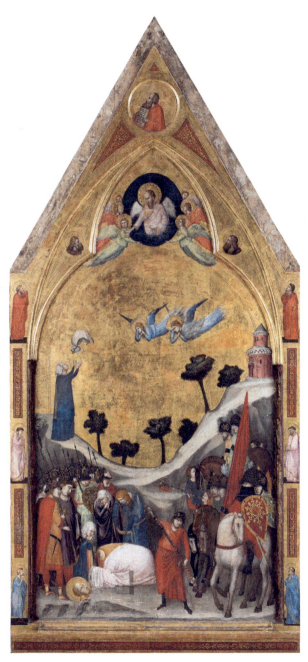

Pl. XVIII: Rome, Pinacoteca Vaticana: Stefaneschi Altarpiece, The Beheading of St. Paul

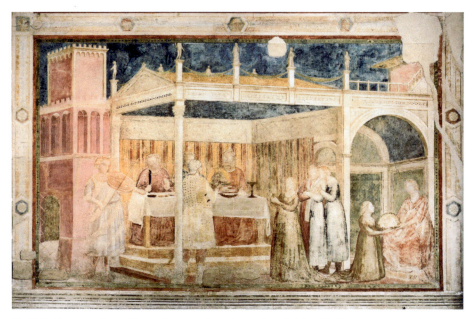

Pl. XIX: Florence, Santa Croce, Peruzzi Chapel, north wall: Herod's Feast

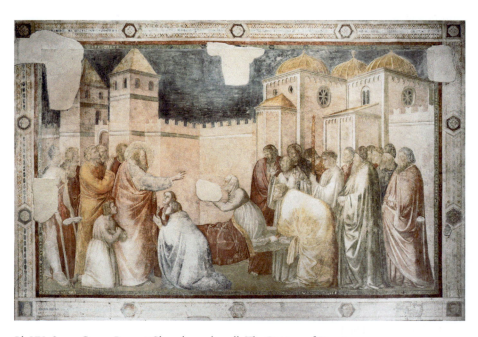

Pl. XX: Santa Croce, Peruzzi Chapel, south wall: The Raising of Drusiana

INTRODUCTION

This study of Giotto's works is based on the volume concerning Giotto's life and the sources from the late 13th to the mid-16th century compiled therein. It covers what is mentioned in these documents and texts as his work or what may be credibly identified as his through a critical reading of these sources. Likewise, a chronological framework is developed from these sources (supplemented by other sources from the historical context of individual works). For the Giotto problems in the actual sense, the chronological ceiling of the texts "until Vasari" is crucial. It captures the state of what was known before a dramatic increase in fictitious knowledge about the painter set in, driven mainly by Vasari, covering up the *curriculum vitae* and catalogue of works of the historical Giotto, the "Giotto of the past" (see vol. 1 p. 36), with thick layers of crust. If monographs on Giotto usually rely on Vasari, the opposite is the case here, and for good reason. However, Vasari will play an important role in the third volume, which deals with Giotto's afterlife.

Attributions, de-attributions, and datings based only on visual evidence are neither made, nor accepted, nor extensively reported on here.[1] On the one hand, it is the case that the details of documented Giotto works (facial forms, eye forms, drapery forms, contours, etc.) often differ considerably. This has led critics to dismember the oeuvre against the testimony of written sources, no matter how reliable they are – and despite the widely available experience that creativity is inconceivable without experimentation and change. (I refer again to Richard Offner's essay *Giotto, non-Giotto* which is built upon a monolithic Giotto image and is still authoritative for many students, see vol. 1, p. 10.) On the other hand, certain Giotto characteristics, including the oval faces with almond eyes that are frequently encountered in the Arena and Bardi chapels, are widespread far beyond the circle of plausible Giotto works. In fact, it is such details that are most easily learned and passed on and are therefore probably useful as evidence of the artist's influence but not of his authorship. Wanting to determine authorship and dating primarily by the comparison of details, as is often done in Giotto research and in research on Trecento painting in general, is therefore a problematic approach – even if such a form of connoisseurship represents a mainstream of art research.[2]

1 For complete information on the history of fluctuating datings and attributions, see R. Salvini, *Tutta la pittura di Giotto*, Milan 1962, G. Vigorelli and E. Baccheschi, *L'opera completa di Giotto*, Milan 1977, and G. Previtali, *Giotto e la sua bottega*, Milan (3) 1993 as well as *Giotto: Bilancio critico di sessant'anni di studi e ricerche*. Exh. cat. ed. A. Tartuferi, Florence 2000 and *La basilica di San Francesco in Assisi*, ed. G. Bonsanti (Mirabilia Italiae 3), Modena 2002.

2 G. Bickendorf, Die Tradition der Kennerschaft von Lanzi über Rumohr und Waagen zu Morelli, in: *Giovanni Morelli e la cultura dei conoscitori: Atti del convegno internazionale*

The person who transferred the critical examination of "handwriting" from the study of old manuscripts to the problem of attributing and dating valuable paintings seems to have been Giulio Mancini (1559–1639), whom readers of the first volume encountered in a very different role: we owe to him the transmission of an early written source on Giotto's Navicella (2.2.5).[3] It was the physician, politician, art lover, and art dealer Giovanni Morelli (1816–1891) who launched the method into the arsenal of early academic art history. However, it is also known that Morelli preferred to ground his opinions on a broader evidential basis.[4] His legendary attribution of the Dresden Venus to Giorgione, published in 1880 under the pseudonym Lermolieff and still valid today, was founded only in the first step on the examination of the handwriting details that pointed to Giorgione's "hand and genius".[5] Morelli also relied on a written source that provided the painter's name and, above all, on the history of nude painting in Venice, placing the picture at the beginning of this tradition. This could hardly depart more completely from what Bernard Berenson and others propagated in the 20th century as the Morelli method. If connoisseurship leads to lasting results, then it does so as a complement to source studies and research in media history: this is what Morelli demonstrated in his discussion of the Dresden Venus.

Based on the works secured for Giotto by early sources, one aim of the following is to examine the painter's contribution to the visual culture of his time. For what purposes was his painting used and what were its effects there? Which tried and tested and which newly created tools did Giotto use for which task? This media-critical approach requires a comprehensive historical contextualisation of his works; the study of patronage and audience sometimes reveals quite different circumstances from those that have become conventional in the course of time, whether through the formation of legends or through wishful thinking.

Bergamo, 4–7 giugno 1987, ed. G. Agosti et al., Bergamo 1993, pp. 25–47 and id., *Die Historisierung der italienischen Kunstbetrachtung im 17. und 18. Jahrhundert*, Berlin 1998.

3 Giulio Mancini, *Considerazioni sulla pittura*, ed. A. Marucchi, 2 vols., Rome 1956–1957. English translation: T.B. Butler, *Giulio Mancini's Considerations on Painting*, Ph. D. Case Western Ohio Reserve University, 1972.

4 R. Wollheim, Giovanni Morelli and the Origins of Scientific Connoisseurship, in: id., *On Art and Mind: Essays and Lectures*, London 1973, pp. 177–201, esp. 184. J. Vakkari, Giovanni Morelli's "Scientific" Method of attribution and its reinterpretation from the 1960's until the 1990's, *Konsthistorik Tidskrift* 70, 2001, pp. 46–54. U. Pfisterer, Giovanni Morelli (1816–1891), in: *Klassiker der Kunstgeschichte 1: Von Winckelmann bis Warburg*, ed. id., Munich 2007, pp. 92–109.

5 I. Lermolieff, *Die Werke italienischer Meister in den Galerien von München, Dresden und Berlin*, Leipzig 1880, pp. 193–194. Translation after: G. Morelli, *Italian Masters in German Collections: A Critical Essay on the Italian Pictures in the Galleries of Munich – Dresden – Berlin*, trans. L.M. Richter, London 1883, p. 164–165.

The other aim is to explore his representational technique. Studying such technique often requires the eye of the connoisseur, but not focussing on the details, rather focussing on the architecture of the images. This may be reflected in details, but is not identical. Here, the reader's willingness to engage in formalistic arguments is required. Giotto's images may seem pleasing and simple, but they are artificial products and the circumstances of their invention are often complex. However, anyone who wants to understand Giotto's representational technique and its development in historical perspective must first gain an idea of what the state of representational technique was in the second half of the 13th century when he was beginning to paint, and that means above all understanding how very different that time's idea of the image was from today's. Art history has hardly dealt with this problem yet, so I can only give a sketch here:[6] An open question was the relationship between the surface on which the painters painted and the subject of the representation: did contemporaries imagine what was represented as being in front of or behind this surface, or – that is what we take for granted – as being completely independant from the surface? As a rule, one encounters indications of oscillation: sometimes it can be observed in the same painting that in one spot figures intersect with frames and in an other spot that frames intersect with figures. For the artists and from the painting process, the idea that the representation was situated in front of the surface was more natural and this is often illustrated by a special treatment of the surface (in this context, I will suggest the term "inverted passe-partout").

Furthermore, there was no standard as to what exactly was the object of the picture. The only thing that was not open for debate was the presentation of the main character(s) in a recognisable form – but what else was to be depicted? What details, props, backdrops, supporting characters, extras and accessories were to be added? This includes the fact that the time horizon of what was to be presented was also not fixed.[7] How much of the before and after of the event was to be portrayed? Quite obviously, the selection was not guided by the idea that all the elements potentially visible to an eyewitness at a given moment in the narrated event should be depicted (i.e. that which a photograph of the situation would show), but was made according to other criteria – format-related, economic, decorative, content-related. It is not correct to say that there was a dichotomy between the narrative picture and the representational picture (between "historia" and "imago"), rather the precarious balance between the image's narrative mission and its mission to give presence to its subject that existed in most of the pictures was important for

6 Cf. M.V. Schwarz, Goldgrund im Mittelalter: "Don't ask for meaning, ask for the use!" in: *Gold*. Exh. cat. ed. Th. Zaunschirm, Munich 2012, pp. 29–37.

7 Put differently, this question is one of the central issues of art historical narratology. Cf. U. Rehm, Wieviel Zeit haben die Bilder?, *Wiener Jahrbuch für Kunstgeschichte* 53, 2004, pp. 161–189.

the question of which elements should be represented.[8] To make the problem more vivid: Modern painters "leave out" and thus create concise compositions, medieval painters had to decide what to include in a picture and how rich it should become. This also means that the question of how much of the surface was to be covered by representations of objects was open.

And finally, it does not seem to have been established what contribution was expected of the artist beyond mastering the technical and achieving a certain perfection. Famous and highly paid painters reproduced tried and tested compositions without explicit alteration. An interesting phenomenon is the transverse rectangular picture field, in which the heads of the figures are lined up on a strip above or slightly below the middle: It dominated European painting from the 10th century and was still the rule in the 14th century (Giotto's work included). At the same time, erratic and even bizarre solutions are frequently found, which did not escape the attention of contemporaries. "Painters and poets have always been free to dare to do anything they felt like," noted the liturgical theorist William Durand, referring back to a formulation in Horace's *Poetics*.[9]

Giotto navigated this field of possibilities throughout his work. In doing so, he established many tendencies that were pioneering and pointed in the direction of the modern image. This is a theme of the third volume. However, he did not establish a set of rules to which he then adhered. The treatise of Cennino Cennini, which codifies traditions from Giotto's workshop, contains many teachings on painting technique but virtually nothing on representation – everything concerning the representational techniques was, in Giotto's time as well as three generations later, still either tradition-based consensus or the subject of experimentation and in flux. This is also something I will come back to in the third volume.

This hypothesis, which will be unfolded in the following, is opposed by an idea about Giotto that also needs to be discussed here: that he was the pioneer of the study of nature in painting. This is the almost hegemonic understanding of his work and his contribution to the history of visual media. The sentences that created the basis for this are found in two of Boccaccio's works (2.4.2, 3). But even during Giotto's lifetime, it was heard in Florence that his paintings appeared as if they were "not painted with artistry, but created by nature and lack only movement and a perceptible breath" (2.3.3). And immediately after his death, it was said that he had portrayed every figure and action "in a natural way" (2.1.1). Ghiberti summarised the discourse that developed from these texts in the

8 Cf. M.B. Hauknes, Emblematic Narratives in the Sancta Sanctorum, *Studies in Iconography* 34, 2013, pp. 1–46. Basically, the article refutes the thesis stated at the beginning.

9 ",,, nam pictoribus atque poetis quelibet audendi semper fuit equa potestas." Guilelmus Durantis, *Rationale Divinorum Officiorum* I–VI, ed. A. Davril and T.M. Thibodeau, Turnhout 1995, p. 42.

Introduction

statement that Giotto had "introduced" "natural art" (2.1.4): "Arecò l'arte naturale." In retrospect, this reads as if Giotto was the trigger for a movement that is considered typical for the history of the visual in "Western" culture since the 15th century and that can also be understood as a history of technology, as the history of optical media. Milestones are the study of nature by Renaissance artists and the realism of the Flemish Primitives, then the invention of perspective, the camera obscura and finally photography and its subsequent media. It is a history that seems to be heading towards the kind of image that appears to us as a duplicate of reality.

Unfortunately, this model is intellectually misleading. Just as it is obvious that photography was developed on the basis of older techniques of image making, so too it is obvious that it has given a radically new face to expectations on the image; few of today's habits of thought about images go back before the mid-19th century – before Daguerre and Talbot. The most striking standard is that a picture (except of course the picture as a work of Modern Art) is expected to correspond to an experience that can be produced by optical means. The most popular criterion among amateurs is the "correct" perspective. What is decisive, however, for the modern idea of the image is not the visual but the physical evidence: the mechanical image has only one referent, namely the prototype. And the connection between the image and the prototype can be described physically, namely through light waves and chemical reactions. Therefore, this image is even able to prove the existence of its archetype: no effect without a cause.[10]

There is no reason to assume, that the Europeans of Giotto's time thought similarly about the images they used, nor that it was this form of image that Giotto aimed for. It is true that conceptions that can be addressed as proto-photographic existed in the field of sacred images. Through the work of Hans Belting and his students, these images have received much attention from art historians in recent decades. One can think of the belief that the Veronica was an imprint of Christ's face on a cloth: a mechanical reproduction in the narrowest sense. Relevant in a broader sense are the images allegedly painted by Luke and Nicodemus, which supposedly reproduced Mary or Christ as these holy eyewitnesses had seen them.[11] The perception of such products as images *and* relics and the frequent attribution of an origin from the East, however, make it clear that their status was not something normal, but rather that of a marvellous "other". Giotto dealt with this "other"

10 As is well known, this was particularly emphasized by Roland Barthes (*La chambre claire*, Paris 1980).

11 H. Belting, Die Reaktion der Kunst des 13. Jahrhunderts auf den Import von Reliquien und Ikonen, in: *Il medio oriente e l'occidente nell'arte del XIII secolo (Atti del Congresso Internazionale di Storia dell'Arte 24)*, ed. id., Bologna 1982, pp. 35–53. Id., *Bild und Kult. Eine Geschichte des Bildes vor dem Zeitalter der Kunst*, Munich 1990. *Il volto di Cristo*. Exh. cat. Rome, ed. G. Morello and G. Wolf, Milan 2000.

occasionally; it occurs in his work as a means of setting apart cult images from "normal" images and as a concept in the specific task of portraiture, but it was of no significance for the development of his representational technique as a whole.

Besides, it is questionable whether Boccaccio really meant with his remarks about imitating nature what we understand when we unsophisticatedly read them. It is worth looking at a later and very different book by Boccaccio, the *Genealogia Deorum Gentilium* (XIV, 7): there, it is the poets whom he calls imitators ("symiae", i.e. apes) of nature: contrary to what the uneducated believe, their words do not portray abstract ideas, but rather reality in its beautiful and terrible manifestations. According to Boccaccio, the poets' texts are structures that refer to "what nature accomplishes in her power" ("quod agit natura potentia"). Poets imitate nature by narrating the workings of nature.[12] In this, nature is not seen as a given, but as an actor. Certainly Boccaccio was aware of the use of apes as a metaphor in the sequel to the *Roman de la Rose*, where this is even clearer. Jean le Meun uses the metaphor to describe how Lady Ars proceeds (V 16029–31):[13]

Si garde coment Nature euvre,	*She observes how Nature works,*
Car mout voudrait faire autel euvre	*For what she wants to create is an equal work,*
E la contrefais come singes.	*And imitates her as the apes do.*

And here follows the passage in the *Decameron* in a translation that allows Boccaccio's "natura" to be understood as an agent, if not as a creating deity, that is also inherent in her creations:

> *[Giotto] was gifted with such excellent talents, that there was nothing pertaining to Natura (mother of all things and bringer of the continuous circling of the heavens), which he would not have been able to imitate with his pencil or brush so well, and draw it so like her, as to deceive people's sense of sight by making them imagine that to be Natura herself which was only the painting.*

12 Giovanni Boccaccio, *Genealogie Deorum Gentilium Libri*, ed. V. Romano, 2 vols. Bari 1951, vol.2 p. 731. R. Stillers, Mit einem Füllhorn voller Erfindungen geht die Dichtung stets einher: Anthropologische Poetik und Bildlichkeit bei Boccaccio, in: *Mimesis – Repräsentation – Imagination: Literaturtheoretische Positionen von Aristoteles bis zum Ende des 18. Jahrhunderts*, ed. J. Schönert and U. Zeuch, Berlin and New York 2004, pp. 131–150.

13 Guillaume de Lorris and Jean de Meun, *Der Rosenroman*, ed. K.A. Ott, 3 vols., Munich 1976–1979, vol. 3 p. 866. On the ape metaphor: H. W. Janson, *Apes and Ape Lore in the Middle Ages and the Renaissance*, London 1952, pp. 287–325. E. Weslau, Der Affe als Nachahmer und Dieb, *Neophilologus* 64, 1980, pp. 161–170.

Boccaccio's words seem to characterise a practice that points ahead to photography – provided we understand by nature what we usually understand by nature: *natura naturata*, created or given nature. If we think of nature as active (*natura naturans*), then imitation (μίμησις) means something other than "making a copy". In Aristotle, imitation describes that human creativity (*ars, τέχνη*) which proceeds analogously to Natura's creativity and whose results remain within the framework of Natura's laws: "Ars imitatur naturam" – and what does not imitate nature is not *ars*, not productive activity.[14] So Boccaccio is not saying that Giotto visually duplicated natural things, but he is saying that Giotto had the ability to paint things in such a way that they corresponded structurally and qualitatively to things generated by nature. For this reason, and not because they are copies, they can appear as real.

Boccaccio's context also includes the anecdotes on artists handed down by Pliny the Elder in the 35th book of his *Naturalis Historia*: for Pliny, the fact that natural and artificial things, such as real and painted grapes, might be confused characterises the work of the great painters of antiquity. The ability to create things in exactly the same form as nature is the setting for their competitions and then for their praise, which shaped the *topoi* of post-antique laudatory writing about artists.[15] All in all, Boccaccio's sentences about Giotto do not speak of an artistic revolution, but they make it clear that the painter's practice is a perfect and exemplary form of art.

Seen in this light, the concept of a discovery of nature by Giotto is neither obvious nor without alternative. Art historians such as Heinrich Wölfflin, Friedrich Rintelen, Theodor Hetzer, Max Imdahl, and Norman Bryson have also seen this. Wölfflin seems to have been the first to pose the question of whether Giotto's painting actually anticipated the later constitution of the picture as a reproduction of reality, which he saw as beginning

14 A. Cerbo, Le arti figurative nel Boccaccio latino, in: *La letteratura italiana e le arti.* Atti del XX Congresso dell'Associazione degli Italianisti (2016), ed. L. Battistini, V. Caputo, M. De Blasi, et al., Rome 2018 (http.//www.italianisti.i//AttidiCongresso?pg=cms&ext=p&cms_codsec=14&cms_codcms=1039). A. Schmitt, Mimesis bei Aristoteles und in den Poetikkommentaren der Renaissance: Zum Wandel des Gedankens von der Nachahmung der Natur in der frühen Neuzeit, in: *Mimesis und Simulation*, ed. A. Kablitz and G. Neumann, Freiburg 1998, pp. 17–53. U. Eco, *Il problema estitico in Tommaso d'Aquino*, Milan 1982, pp. 198–200. K. Flasch, Ars imitatur naturam: Platonischer Naturbegriff und mittelalterliche Philosophie der Kunst, in: *Parusia: Studien zur Philosophie Platons und zur Problemgeschichte des Platonismus.* Festschrift J. Hirschberger, Frankfurt 1965, pp. 265–306. H. Blumenberg, "Nachahmung der Natur". Zur Vorgeschichte der Idee des schöpferischen Menschen, *Studium Generale* 10, 1957, pp. 266–283.

15 Pliny, *Natural History*, ed. H. Rackham, vol. 9, London 1952, passim. E. Kris and O. Kurz, *Legend, myth, and magic in the image of the artist: a historical experiment*, New Haven 1979, pp. 61–70.

with Masaccio.[16] Rintelen, Hetzer and Imdahl then described Giotto's imagery in a way that is radically opposed to the notion of the nature-duplicating Giotto: as networks of relationships realised within the picture-plane that produce content.[17] But whether they did them justice is a question that arises when one reads remarks like these: Giotto's pictures are a world "incomparable to our own." "The quiet attractions of abstract representations" made them stand out, according to Rintelen.[18] This may be the view of those who start from the naturalistic painting of the 19th century or again from photography and look back comparatively. However, anyone who delves into the production of Giotto's predecessors and contemporaries will not see the typical traits of his paintings in the boldness of abstraction and the meaningful ordering of their objects. One would rather agree with Norman Bryson, who emphasised surplus information and the arbitrary features in Giotto's pictorial systems.[19] What most clearly distinguishes Giotto's imagery from that of most of his contemporaries is not its stringency, but the fact that he chose to represent much that was secondary. But of course this has to be examined on a case-by-case basis.

16 H. Wölfflin, *Die klassische Kunst: Eine Einführung in die italienische Renaissance*, Munich (3) 1904, pp. 8–9. The remark was censored in an important anthology of Giotto contributions; there, the panegyric first half of Wölfflin's Giotto text was translated and printed, but not the question that followed: *Giotto in Perspective*, ed. L. Schneider, Englewood Cliffs 1974, pp. 70–71.

17 F. Rintelen, *Giotto und die Giotto-Apokryphen*, Basel 1911. I used the second edition from 1923. Th. Hetzer, *Giotto. Seine Stellung in der europäischen Kunst,* Frankfurt 1940. I used the edition in: Th. Hetzer, *Giotto. Grundlegung der europäischen Kunst* (Schriften Theodor Hetzers 1), ed. G. Berthold, Stuttgart 1981, pp. 13–204. M. Imdahl, *Giotto Arenafresken. Ikonographie, Ikonologie, Ikonik*, Munich 1980.

18 Rintelen, *Giotto und die Giotto-Apokryphen*, p. 13.

19 N. Bryson, *Vision and Painting: The Logic of the Gaze*, Houndmills and London 1983, pp. 56–66.

SPEECH WHICH SPEAKS TO THE EYE:

THE ARENA CHAPEL

Dominated by powdered lapis lazuli, which covers the vault and the backgrounds of the 40 vibrantly coloured pictures, and littered with countless golden halos detached from the walls, the interior of the Arena Chapel overwhelms its visitors by its sheer splendour. That it was Giotto who was entrusted with the creation of this in every respect extraordinary space is well documented by narrative sources (tradition) from his lifetime. They also provide a *terminus ante quem*: it was in 1313 when the chronicler Riccobaldo Ferrarese wrote that Giotto had painted "in ecclesia Arene Padue" (2.2.1)[20]; and around 1314 the poet Francesco da Barberino mentioned Giotto's allegory of envy there (2.4.1). From his biography it can be added that the painter was predominantly in Florence and for some months probably in Rome in the years 1311 to 1313 (1.1.9–11). Before that, however, the chronology of his life is not as transparent. The evidence that he stayed in Assisi shortly before 1309 (1.1.8) can suggest a dating of the Arena Chapel frescoes to either before 1308/09, or between about 1309 and 1311. Regarding the date of the decoration, it could only be said to be "certainly before 1313, probably before 1311" if there were no primary sources (remnants) in Padua (as well as in Venice and Udine: A 2–14).[21] These sources concern the Arena Chapel only as a building and institution and say nothing about the paintings and their creator. However, they provide a *terminus post quem* of 1300 for the architecture of the church. The dating of the murals can be plausibly narrowed down even further: on the one side to the period after 1303 since this year is mentioned in the surviving text of an inscription that can only have been the founding inscription of the chapel (A 3). On the other side to the time before 1307 since in the summer of that year the bishop entrusted the chapel, consecrated in 1305 (A 6), with the pastoral care of the inhabitants of its surroundings (A 7, 8) – a pointless measure if the space was not furnished and usable at that time.[22] In addition, it should be noted that Giotto was also

20 Signatures in three Arabic numerals refer to the apparatus of vol. 1.

21 Signatures beginning with the capital letter A refer to the appendix of vol. 1.

22 The *terminus ante quem* 1306 has become obsolete. It is true that certain miniatures in the volumes A 15, A 16, and B 16 of the antiphonary of the Cathedral of Padua (Biblioteca Capitolare) echo Giotto's frescoes (see C. Bellinati, La Cappella di Giotto all'Arena e le miniature dell'Antifonario "Giottesco" della Cattedrale (1306), in: *Da Giotto al Mantega*. Exh. cat. ed. L. Grossato, Padua 1974, pp. 23–30), but it can no longer be argued that these volumes were completed in 1306: *I manoscritti miniati della Biblioteca Capitolare di Padova*, ed. G. Mariani Canova, M. Minazzato, and F. Toniolo, Padua 2014, vol. 1 pp. 187–218, esp. 191. The same applies to the *terminus ante quem* 1305: the consecration crosses discov-

Speech which Speaks to the Eye: The Arena Chapel

painting in the Palazzo della Ragione of Padua in 1307 or somewhat later (2.7.1), and, finally, that he was in Assisi before (but not long before) 1309 (1.1.8). This makes the Arena Chapel not only the most extensive surviving work by Giotto, but also a very reliably dated one – probably the only one whose time frame cannot be seriously questioned: the frescoes were almost certainly painted between 1303 and 1307. It is befitting that Giotto's house in Florence is mentioned as rented out in 1305 and 1307 (1.3.2, 3). Whoever wants to gain clarity about the chronology and development of Giotto's oeuvre can only begin here, in the Arena Chapel, and then must navigate forward and backward.

ANNUNCIATION DAY IN PADUA

For the glory of Almighty God, the Most Holy Virgin Mary and all the saints, and so that the city of Padua may be maintained in lasting peace and in a good and serene state, we prescribe and order: every year in March, on the day of the Annunciation to the Blessed Virgin Mary, or on another day pleasing to the Reverend Bishop of Padua, a representation of the angelic salutation shall be made in the following manner: in the chapel of the Paduan Palatium Juris [Palazzo della Ragione] in the middle of the Terce hour [about half past seven in the morning] two boys are to be dressed, one like an angel with wings and lily, the other in a feminine and virginal manner in the costume of the Virgin Mary, so that one represents the Angel Gabriel and the other the Virgin Mary. And the Reverend Bishop or his vicar must go to the Cathedral of Padua together with the [Cathedral] Chapter, the Paduan clergy and all the Paduan convents and their crosses and then come in procession to the Palatium Juris of the Commune of Padua. And there the Lord Podestà of Padua must have gathered with all the judges of his curia and with all the judges and officials of the commune of Padua and with all the knights, doctors and honourable citizens of Padua. And when all have assembled, they must place the said angel on one throne and Mary on another honourable throne prepared for her. And on the said thrones, according to tradition, they must be carried from the said palace to the Arena, in a procession, with the communal trumpeters and the Paduan clergy in front, followed by the Lord Podestà with all the citizens and with the governors of the artisan and merchant

ered in 1967, whose colour substance overlays Giotto's frescoes, need not belong to the consecration act of that year, as Claudio Bellinati postulated: C. Bellinati, *La Cappella di Giotto all'Arena (1300–1306): Studio storico-cronologico su nuovi documenti*, Padua 1967, p. 9. There is no doubt that there was also a consecration ceremony when the high altar was rebuilt after the addition of the apse, and this was hardly the last.

guilds. And there in the court of the Arena, on the prepared and customary places, the angel greets Mary with the angelic salutation. And Mary and the angel also do the other things which were part of such a representation of the Annunciation and which they usually do. And this feast is to be cherished and carried out, without any cost to the commune and the religious institutes. Excluded are the communal trumpeters, who are paid by the audience to blow the trumpets at this feast and, while playing, must accompany the angel and Mary from the palace into the Arena, without any [further] fee or reward. And the Lord Podestà must order his knights to take care, as must the city soldiers, that no trouble arises from the gathering of the people.

This is how the people of Padua spent the morning of the Feast of the Annunciation, honouring Mary as the patron saint of their city. The earliest evidence of this custom is the text presented here from the year 1278, whose wording refers to a tradition that already existed at that time (A 1). It was not the only para-liturgical event that was celebrated on 25 March in Padua. A 14th century script of a second Annunciation play is handed down. It began at noon, when the other celebration had probably just finished, and used the sacristy, the baptistery, the nave and the canon choir of the Cathedral as locations.[23] Whether the *sacra rappresentazione* in the Arena was an offshoot of that in the cathedral or vice versa remains unclear. However, it can be understood that the performance in the church was dedicated to Mary more in her capacity as the patron of the cathedral and diocese, while the play under the open sky of the Arena paid tribute to her role in the world of the citizens.

For many years the processional route resulted in the Paduans leaving the safety of the walled city. The cathedral and the Palazzo della Ragione, the spiritual and political centre of the commune, where the clergy and the laity gathered, were located within the ring of walls built around 1200, while the ruins of the Roman amphitheatre, known as the Arena, lay beyond it to the northeast. This area was not to receive protection until the middle of the 14th century. Furthermore, the procession meant moving from public land to private land. After the Arena (like the whole city of Padua) had been confirmed as an episcopal property by Henry IV in 1090, it was handed over to the noble Dalesmanini family probably as a fiefdom in the 12th century.

In 1300, when the Dalesmanini sold the estate, the contract describes the Arena as being surrounded on three sides by a wall (A 2). The border was only open to its largest neighbour, the monastery of the Eremitani, whose stately church, begun in 1256 and not

23 K. Young, *The Drama of the Medieval Church*, Oxford 1962, vol. 2 pp. 248–250. English translation: L. Jacobus, *Giotto and the Arena Chapel: Art, Architecture and Experience*, Turnhout 2008, pp. 374–376. A dating is only possible based on the sole known manuscript (Padua, Biblioteca Capititolare, ms. C. 56, fol. 35v–38r), which seems to originate from the 14th century.

completed for a long time, guarded the entrance to the Arena. The wall described was not identical with the outer shell of the amphitheatre, but was situated in front of it. The openness towards the Hermits indicates an understanding between the Dalesmanini and the friars. Presumably, the monastery stood wholly or partly on land donated by the Dalesmanini and separated from the Arena area. It is known that the family co-financed the construction of the church.[24] The most important building on the grounds of the Arena was a several-storey house with loggia and hall, which according to the purchase contract was surrounded by a separate wall. Towers and service buildings were included. This is where the procession of the Paduans headed.

And if, as required by the statute, all the honourable citizens of Padua took part in the procession, the Dalesmanini would walk behind the two thrones and arrive, as it were, like pilgrims to their own property. As *homines religiosi* they would have experienced how the actions of the two boys transformed their estate into the holy ground of Palestine and their everyday life into biblical times. Given that in medieval Padua the type of the *homo politicus* had already split off from the *homo religiosus*, they could also see how their fellow citizens, under their spiritual and secular heads, acted as a community, and that their land provided the setting for this.

According to the statutes, the spectacle was not allowed to cost either the citizens or the churches and monasteries anything; it was therefore dependent on donations. The owner of the Arena who succeeded the Dalesmanini felt obliged to contribute and took over about half of the expenses. This is verified for 1309 (A 10). It is recorded in his widow's will that she reached into her jewel case and clothes chest and lent her *corona* and other jewellery along with robes for the performance[25] – presumably to equip the boy who played Mary. It is quite probable that the couple was continuing a practice that the Dalesmanini had begun and which was obviously part of their responsibilities. It would have been difficult for a respected family simply to experience the ritual sanctification of their own land without contributing.

The new owner, who had purchased the property on 6 February 1300 and who hosted the performance only a few weeks later, was Enrico Scrovegni. At first little changed:

24 *Padova. Basiliche e chiese*, ed. C. Bellinati and L. Puppi, Vicenza 1975, vol. 1 p. 218 (P. Carpeggiani).

25 ASV, Archivi notarili, Notai di Venezia, Testamenti rogati da Giovanni De Caresinis 1358–79, busta 1023: "Item volo et ordino quod corona mea cum lapidibus in ea fixis et omnibus suis ornamentis et omnis vestis meis, et generaliter omnia alia mea ornamenta, que et quas dare et concedere solita sum pro festo Marie et Angeli de la Rena, quando dictum festum celebratur de mense marcii, pro representacione salutacionis virginis semper sint et eas et ea esse volo donec durare poterunt dicto reverendo consueti deputata." A summary of the passage at: I. Hueck, Zu Enrico Scrovegnis Veränderungen der Arenakapelle, *Mitteilungen des kunsthistorischen Institutes in Florenz* 17, 1973, pp. 277–294, esp. 282 note 22.

Like the Dalesmanini, the Scrovegni had lived from land ownership and banking for generations. Both families belonged to the ruling elite in Padua and the Veneto.[26] What was different was the resonance of the names. In the form of archival documents and scattered references, the members of the Dalesmanini family would be known only to those who are specifically interested in medieval Padua. In contrast, Enrico Scrovegni had become famous through his patronage of Giotto, while Dante made his father Reginaldo infamous as a sinner in the *Divine Comedy* (*Inferno* XVII 43–78). We do not know how the then long-dead man (he had died before 15 September 1289)[27] became the poet's target. Was he really so ruthless in financial matters that everyone wished he would burn in the deepest hell with the worst usurers, or did Dante again need a convenient mouth to speak his words? Reginaldo's statement that his neighbour Vitaliano will soon be frying alongside him comes into question. Vitaliano del Dente was an important figure in Padua in the first decade of the 14th century. Unlike Reginaldo, he had the opportunity to upset the poet.[28] In any case, both immortalities taken together – the immortality of the son through frescoes and that of the father in verse – mean that the profiles of the Scrovegni fluctuate in the gaze of (art) history to a degree more dramatic than reasonable.

Enrico not only supported the annual procession to the Arena financially, but also gave it a new architectural and liturgical destination by building a church on the spot.[29] Both the laying of the foundation stone in 1303 and the final consecration in 1305 obviously took place on the occasion of the procession (A 3, 6). 150 years later it looked as if it were the chapel that made the Arena the destination of the procession and the scene of the *sacra rappresentazione* (2.7.3): "The noble house of Scrovegni, however, claimed this privilege by building such a sumptuous chapel in honour of the glorious Virgin." As is well known, this

26 J.K. Hyde, *Padua in the Age of Dante*, Manchester and New York 1966, pp. 85–87 and passim. G. Rippe, *Padoue et son contado (Xe – XIIIe siècle): société et pouvoirs*, Rome 2003, pp. 843–868. S. Collodo, Origini e fortuna della famiglia Scrovegni, in: *Il secolo di Giotto nel Veneto*, ed. G. Valenzano and F. Toniolo, Venice 2007, pp. 47–80, esp. 56–62.

27 C. Bellinati, *Giotto: Padua felix – atlante iconografico della Cappella di Giotto (1300–1305)*, Treviso 1996, p. 155 refers to a document with this date which mentions Reginaldo as deceased.

28 Franz Xaver Kraus prudently reviewed the evidence of Dante's stay in Padua: F.X. Kraus, *Dante. Sein Leben und sein Werk, sein Verhältnis zur Kunst und zur Politik*, Berlin 1897, pp. 60–61. On Vitaliano: EncDanteca s.v. Dente, Vitaliano del (V. Presta). It is interesting that Vitaliano was the father-in-law of Dante's Veronese host Bartolomeo della Scala: H.M. Thomas, Contributi alla storia della Cappella degli Scrovegni a Padova, *Nuova Rivista Storica* 57, 1973, pp. 111–128, esp. 114. After leaving Verona, the poet may have hoped for Vitaliano's support.

29 M.V. Schwarz, Padua, its Arena, and the Arena-Chapel: a liturgical ensemble, *Journal of the Warburg and Courtauld Institutes* 73, 2010, pp. 39–64.

is not true, but the idea shows how closely the chapel was linked to the event. There is no doubt that the chapel was also part of an extension project for the palace, but it seems to have been given priority over the residential building. Moreover, the palace seems to never have been Enrico's main domicile, either because the work dragged on until after his escape from Padua (1318), or because he did not want to exchange his accommodation in the city centre, in the "contrata Strate maioris",[30] for one outside the walls, or, most probably, because he had thought of the Arena as a *villa suburbana* rather than a residence.

Enrico's petition to be permitted to build a chapel in the old amphitheatre must have reached the bishop's office by the end of March or by early April 1302, because Ottobono dei Razzi, to whom Scrovegni turned, was no longer acting as bishop of Padua starting in April, but as Patriarch of Aquileia (A 5). Thus, the processions of the years 1300 to 1302 can be considered as inspiration for the decision and the petition to build. The start of the work was then not far off: The hexameters of a lost inscription, which could be seen in the 16th century near Scrovegni's tomb in the apse of the chapel, and in the 17th century at its portal (A 3), refer to the Feast of the Annunciation in the following year 1303, albeit in a complicated way:

This place, once called the Arena,
Becomes for God a noble altar full of majesty.
Thus God's eternal power transforms the vices,
So that places full of evil turn into something honourable.
Behold, it was a very great house of the heathen, which
When it was exterminated, was rebuilt by many, and miraculously sold.
Those who in happy times strove for the luxury of life,
Become nameless and forgotten as soon as their power ceases.
But the knight Henricus Scrovegni saves his honourable soul
And makes a venerable feast here,
For he ordered the temple to be solemnly dedicated to the Mother of God,
That he may be blessed with eternal reward.
Divine virtue followed earthly vices,
After earthly followed heavenly joys, exceeding the vain ones.
When this place was solemnly dedicated to God,
The Lord's years have been counted thus:
In the year 1303, March united the feast of the benevolent
Virgin with Palm Sunday in the same ordo.

30 As in a document from 1314: Bellinati, *Giotto: Padua felix*, p. 162. It is known that the Scrovegni palace there was destroyed by fire in 1290, but rebuilt in the following decade: Jacobus, *Giotto and the Arena Chapel*, p. 13.

The last sentence is not easy to understand. It does not say that in 1303 the Feast of the Annunciation ("the feast of the benevolent Virgin") fell on Palm Sunday, which varied according to the date of Easter. In 1303, it was celebrated six days before Palm Sunday and thus on the Monday after Passion Sunday. It is true that Palm Sunday was in March (31 March). But this is not uncommon and the mention of the month can hardly be the central point of the sentence. As Claudio Bellinati suggested, it is about the *ordo*. "In the same *ordo*" can mean Lent with its specific liturgy (*ordo quadragesimalis*).[31] Lent had begun with the veiling of the crosses and other images on Ash Wednesday, more than three weeks before the procession, only to approach its climax six days after the Feast of the Annunciation, on Palm Sunday with another grand procession, this one in remembrance of Christ's triumphal entry into Jerusalem which was, not only in Padua, a highlight of the liturgical year. The end of the inscription thus probably emphasized that the "feast of worship" made possible by Scrovegni took place on a day which was not only a joyful one because of the commemoration of the Incarnation of the Lord, the procession, and the spectacle, but also a serious one because it recalled Christ's Passion.

Other passages of the inscription are less arcane: There is the invocation of a sinister *genius loci* of the Arena ("house of the heathen"), which makes the procession, the play, and the chapel foundation almost look like necessary acts of exorcism. There is also an unambiguous explanation of Scrovegni's final motivation, namely that he hopes to save his soul as a reward for his foundation. Likewise, it is clear what it was that was consecrated in the spring of 1303, namely the foundation stone. The final consecration of the finished church is not an option, since there is a document which refers to 1305 as the scheduled date for it (A 6). And the charter of endowment issued in 1317 testifies that a proper cornerstone ceremony had taken place (A 13).

On the other hand, there is the question of what kind of church was envisaged by those who performed the act of consecration in 1303: a house chapel as suggested by Scrovegni's petition, a chapel open to the public that could be used in connection with the Annunciation play, or the church of a small clerical convent, of the kind soon to be realized in the Arena?

ENRICO SCROVEGNI'S FOUNDATION

On 9 January 1305, represented by Johannes a Soleis, the convent of the Eremitani lodged a complaint against Scrovegni with the bishop – not for the first time, as the document states (A 5). Johannes referred to Scrovegni's building application, for which Johannes demanded access despite his seemingly exact knowledge of its contents. According to

31 Bellinati, *La Cappella di Giotto all'Arena*, pp. 14–15.

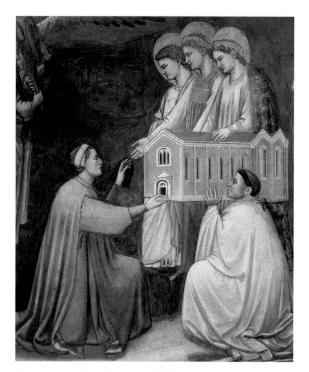

Fig. 1: Arena Chapel, west wall: The Last Judgement, foundation scene

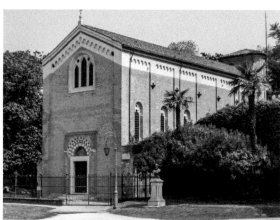

Fig. 2: Arena Chapel

Johannes, the request was for a "small church in the form of an oratory for him [Enrico Scrovegni], his wife, his mother, and his family". Johannes added that this meant a church intended for the visit of family members only and not for other people. This remark makes apparent what was behind the complaint and in general behind the fight of the Eremitani against Scrovegni's foundation: they wanted to protect themselves from competition. The undertaking *in* the Arena threatened to deprive their church outside the Arena of visitors and thus also of the donations and endowments on which the Augustinian friars, living under the poverty rule, were existentially dependent.

In reality, there are two Arena chapels today, and neither is credibly a family oratory (fig. 1, 2). One chapel is built, the other is that which depicted by Giotto in the form of a model that Enrico Scrovegni, assisted by a cleric, is handing over to the Blessed Mother and two saints. Those who want to gain insight in the history of the foundation, construction, and decoration should start with a comparison between three chapels: the one applied for, the one depicted and the one built.

Contrary to what would have been appropriate for the non-public chapel Scrovegni had applied for, both the depicted and the built chapel have a large door in the western façade that opens invitingly into the Arena's oval

manège. The door of the depicted chapel is indeed open and Scrovegni's thumb, as painted by Giotto, points this out to the spectators (fig. 3). The depicted and the built architecture are similar in other respects as well: both are halls erected of brick and a few stone blocks, with six narrow windows in the right wall and a wide three-bay opening above the door. In addition, details such as the lesenes and the arched friezes are identical. One would call the painted chapel a faithful portrait of the built one, if it were not for discrepancies concerning the sanctuary: where the built chapel has a narrowed choir, the depicted one has a sprawling transept with high, two-part windows and gables, the interior of which, in contrast to the barrel-vaulted nave, can only be imagined with a cross-ribbed vault. This raises the question whether the

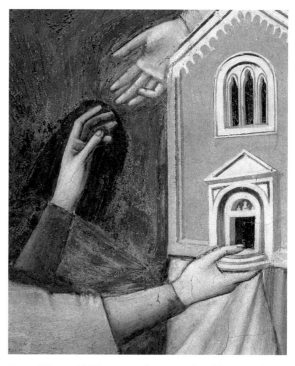

Fig. 3: West wall: The Last Judgement, detail from the foundation scene

built chapel is in a kind of unfinished state or a reduced version of the painted chapel. In other words: was the project to build a transept in the future or in the past when Giotto painted the model? Everything speaks for the second possibility: the existing choir could not have been extended to form a transept.[32] The eastern parts would had to have had been demolished. This includes the triumphal arch, whose pictures, painted by Giotto, occupy a key part of the overall programme. Only if Giotto had painted the model in a space still under construction in its eastern parts and if the image of the Last Judgement had preceded all the other frescoes, would it be possible for the painted chapel to visualise

32 As proof, compare an attempt to "reconcile" the triumphal arch with the transept: D. Gioseffi, *Giotto architetto*, Milan 1963, fig. 29 A. The visual counterargument also concerns the building history proposed by Laura Jacobus. In this case, too, the triumphal arch and its fresco programme were to coexist with the transept, which would have led to a dysfunctional and otherwise unknown spatial disposition. Cf. Jacobus, *Giotto and the Arena Chapel*, pp. 37–83. See also my review of this book: *Bollettino d'arte*, ser. 7, 94, 2009 (2010), pp. 169–172.

a project valid at the time and thus a future expected for the building. And this is contradicted, among other things, by the technical findings that were made during the most recent restoration of the murals: like the east wall, the west wall was painted after the side walls and thus belongs to the last parts of the decoration to be executed.[33] It should also be considered that it is the depicted church and not the built one that has a prototype in Paduan architectural history: The same disposition of a hall nave with a transept could be found in the hospital church of Ognissanti.[34] The depicted church picks up on this, and the one that was built can easily be understood as an improvised reduction of this type.

Three versions of the building concept can be distinguished as follows: The first version, to which Scrovegni perhaps never intended to give architectural form, was the house chapel. The second version is represented by the model reproduced in the image of the Last Judgement: a hall with a door to the Arena and a stately transept. It is an edifice that nobody would call a house chapel. Rather, it is a veritable church. Ongoing construction work in the Arena was under constant observation by the Eremitani, who were within a stone's throw of the site and who were also building their own church. Accordingly, the complaint of January 1305 was not their first action against Scrovegni's building and foundation concept; nor was it the last (see A 11, 12). The third version with the small choir, as it was then realized, is probably a result of this critique: a change of plan in the course of construction, which reduced the dimensions, but left the public character of the space unchanged. Or is it? The change of the choir section was not only a question of cost and floor space, but also of function. The sanctuary is the clergy's sphere of action. If the sanctuary was reduced in size, this may mean that something had also changed in the staffing of the foundation. And the reduction of the sanctuary was not the only plan change. Probably hand in hand with this, a marble-framed door, which should have led to the nave from the south, was walled up (and soon covered by Giotto's frescoes inside). It would have made the church accessible from a plot of land for which, according to his will of 1336, Scrovegni had plans: here convent buildings were to be erected for the Augustinian canons, to whom he had entrusted the Arena Chapel in 1317 (A 17).[35]

The abandoned door indicates that this plan for the use of the ground dates back to the time when the chapel was built, but had been suspended in the meantime. When con-

33 F. Capanna und A. Guglielmi, Osservazioni relative alle tecniche di esecuzione dei dipinti murali nella cappella, effettuate durante il cantiere di restauro, in: *Giotto nella Cappella Scrovegni: Materiali per la tecnica pittorica: Studi e ricerche dell'Istituto Centrale per il Restauro*, ed. G. Basile (Bollettino d'arte, vol. speciale 2005), Rome 2005, pp. 47–72, esp. 48.

34 M.C. Forato, *La chiesa di Ognissanti in Padova*, Padua 1991. L. Morello, Chiesa e xenodochio degli Ognissanti di Padova in età medievale: Indagine storico-archeologico-artistica dopo i recenti restauri, *Bollettino del Museo Civico di Padova* 81, 1992, pp. 51–98.

35 Hueck, Zu Enrico Scrovegnis Veränderungen der Arena-Kapelle, p. 279.

sidered together with the abandoned transept, the following picture results: In the second phase (documented by Giotto's painted model) a medium sized convent church was projected with cloister buildings at the spot where, in the image of the Last Judgment, the head and left hand of the cleric are located. If this is correct, then the Eremitani were not simply threatened by a church in the territory of their pastoral care, but by a kind of rival community. Where the old owner of the Arena, the Dalesmanini family, had promoted them, the new owner acted against their interests.

Scrovegni's memory is burdened by a story related to events in the early days of the foundation, perhaps reflecting a crisis in its execution. It may be relevant here. Giovanni da Nono reports the following in his book about the Paduan families (A 15):

> *After the death of his first wife, Henricus Scrovegni married Johanna, the daughter of the noble Franciscus, Margrave of Este, and also had the church of Santa Maria de Caritate built on the site of the Arena, which he bought from Manfredus, the natural son of the noble knight Guecillus Dalesmanini. For this he used money from the assets of the noble knight Bardellone Bonacolsi, the former lord of Mantua, who had been expelled by his brother Bottesella because he wanted to have Margrave Obizzone poisoned in Mantua. When he came to Venice thereafter and was struck by a deadly disease, he appointed Henricus Scrovegni as his executor. Henricus also dedicated himself to the Order of the Friars of Santa Maria de Caritate in the Arena, called the Order of the Fratres Gaudentes, which he left after about a year had passed. Here he made himself a hypocrite. As many as he could, he tried to deceive, and he also tried to deceive Pope Benedict of Treviso by assuring him that he had built the said church with money from his own fortune.*

This is only one shot from a volley of accusations fired by the author in the Scrovegni chapter of his book. The text was obviously written after Enrico's involuntary departure from Padua (1318). Its aim is defamation. Other nastiness includes that Enrico's father was only able to conceive a son using potency-boosting drugs and that he, who was a nobody by birth, acquired his fortune overnight through excessive usury, an assertion for which Giovanni da Nono probably relied on Dante's *Divine Comedy*. That the chronicler was not thoroughly informed becomes clear when he applies the wrong name to Enrico's second wife, who came from the princely family of Este: she was not called Johanna, but Jacobina. However, some of the facts he gives in connection with the chapel are verifiable; it is not possible to dismiss the narrative completely. First, it is true that Bardellone Bonacolsi was expelled from Mantua in 1299 – although Azzo VIII d'Este, Lord of Ferrara, had supported his rule. He did not die in Venice the following year, but in Este Ferrara.[36]

36 DizBI s.v. Bonacolsi, Bardellone (I. Walter).

The claim that parts of his fortune went to the son-in-law of Azzos's brother, Francesco and that Enrico used these funds to buy the Arena in Padua and build the chapel, may be a malevolent allegation, but it is not absurd; we do not know when Enrico and Jacobina d'Este were married, but given what we know about the life dates of Jacobina's father and her children, there is no reason to doubt that she was of marriageable age or close to it around 1300.[37] In this context, a formulation in Enrico's will from 1336 (A 17) attracts attention: the testator notes that he had built the chapel entirely from his own pocket, and thus seems either to deny Giovanni da Nono's text – or unwillingly to support it. Secondly, Scrovegni was acquainted, if not friends, with Benedict XI (1303–04), aka Nicolò Boccasino from Treviso. For Benedict he was "familiaris noster"[38] and accordingly the Pope supported his foundation. On 1 March 1304 he issued a letter of indulgence for the chapel, which became effective for the first time three weeks later in connection with the procession and the play: remission of punishment for sins of one year and 40 days is granted to those who visit the church devoutly on the following holidays: Nativity of Mary, Annunciation, Candlemas, and Assumption. 100 days of indulgences are also granted to those who visit the church in the week following these feasts (A 4). Thus, the Pope had integrated the probably still unfinished sanctuary into the religious life of Padua in a better way than any Scrovegni could have wished for himself. And thirdly, the passage about the Cavalieri Gaudenti did not materialize out of thin air – though some scholars overestimate the quality of the source material.[39]

37 DizBI s.v. Este, Francesco d' (G. Battioni). Jacobina made her will in 1365 (see note 25) Her sons were not yet twenty in 1336 (A 17)

38 C. Grandjean, *Le registre du Benoit XI: recueil des bulles de ce pape*, Paris 1905, p. 126 No. 155. Cf. E. Napione and D. Gallo, Benedetto e la cappella degli Scrovegni, in: *Benedetto XI frate Predicatore e papa*, ed. M. Benedetti, Milan 2007, pp. 95–212.

39 The pieces of evidence presented by Rough (and others after him) in his highly regarded article are without exception ambiguous or misleading: R.H. Rough, Enrico Scrovegni, the Cavalieri Gaudenti, and the Arena Chapel in Padua, *The Art Bullettin* 62, 1980, pp. 24–35. One example might be the tomb inscription cited by Rough p. 24: "Sepulcrum Congregationis Fratrum Sant. Mar. de Arena". Neither did the inscription mark a tomb of the *Cavalieri Gaudenti*, nor was it situated in the Arena Chapel. In reality, the words were to commemorate the members of a brotherhood founded in 1325 and dedicated to the organisation of the Annunciation play; and the plate was set into the floor of the Oratorio dell'Annunziata outside the Arena. J. Salomonio, *Urbis Patavinae Inscriptiones*, Padua 1701, p. 258. Cf. also H.M. Thomas, Giotto corretto: le bandiere delle schiere angeliche nella Cappella degli Scrovegni, *Bollettino del Museo Civico di Padova* 83, 1984, pp. 43–58: That the banner of the angels, which appears on the far right of Giotto's image of the Last Judgment, alludes to the coat of arms of the Cavalieri Gaudenti is anything but compelling. A reference to the coat of arms of Padua, which also shows a red cross on a white background, is much closer.

In fact, the report on Scrovegni's liaison with the Cavalieri Gaudenti may reflect the failure of the project in its second phase: this would mean that the order to which Scrovegni wanted to entrust the church with transept (the depicted project) can be identified. The historical evaluation of the congregation suffers from two conditions: first, its activities found an unfavourable reporter in Salimbene de Adam, whom a modern historian described as a "shameless gossip";[40] secondly, centuries after its abolition, it fell into the hands of a completely unqualified historiographer in Domenico Maria Federici of Treviso. His *Istoria de' Cavalieri Gaudenti* (1787) is a concoction.[41] One reason for this is that the author limited his research to the traditions and archival holdings in his native region (Treviso and Padua). Starting from Giovanni da Nono's remarks on the Arena Chapel and supported by Dante's lines on Reginaldo Scrovegni, Enrico thus became a central character in the history of the order, although he had been a marginal figure at best.[42]

Keeping to the facts, the following can be reported about the Cavalieri Gaudenti: the order was founded in 1261 by a group of Bolognese nobles supported by a Franciscan friar. Urban IV awarded it the Augustinian Rule.[43] It had a male and female lay branch (knights and knightesses) and a clergy branch.[44] At the centre of its spirituality was the veneration of the Virgin Mary. The popular name of the "Rejoicing Knights" derives from the hymns they sang in praise of the Mother of God. The brothers called themselves "Militia Beatae Mariae Virginis". According to their Mendicant background, the clerics were committed to poverty. However, the sources do not reveal that the suppression of usury was one of the explicit aims of the Order, as is often claimed with reference to Federici.[45] Regarding

40 Salimbene de Adam, *Chronica*, ed. F. Bernini, Bari 1942, vol. 2 pp. 149–152. "Shameless gossip" after: D. Abulafia, *Frederick II: a medieval emperor*, London 1988, pp. 251, 260.

41 D.M. Federici, *Istoria de' Cavalieri Gaudenti*, 2 vols., Venice 1787.

42 It should be noted that the *Catalogo de'Cavalieri Gaudenti*, which Federici presents (ibid, vol. 1 pp. 370–384), is a compilation by the author. The fact that Scrovegni figures there with the addition "Fu Priore" (p. 379) merely reflects Federici's idea of Enrico's importance. It is unlikely that he had any proof.

43 Salimbene de Adam, *Cronica*, vol. 2 pp. 149–150. H. Hefele, *Die Bettelorden und das religiöse Volksleben Ober- und Mittelitaliens im XIII. Jahrhundert*, Leipzig and Berlin 1910, pp. 74–75. A. De Stefano, Le origini dei Frati Gaudenti, *Bilychnis: Rivista mensile illustrata di studi religiosi* 4, 1915, pp. 374–397. The rule: G.G. Meersssemann, *Dossier de l'ordre de la pénitence au XIIIe siècle*, Fribourg 1961, pp. 295–307.

44 The Cavalieri were not an exclusive lay order, as can be read occasionally in Giotto literature. Cf. U. Schlegel, Zum Bildprogramm der Arena Kapelle, *Zeitschrift für Kunstgeschichte* 20, 1957, pp. 125–146.

45 Cf. Federici, *Istoria de' Cavalieri Gaudenti*, vol. 1 pp. 61–68. Some of the cited documents date back to the time before the foundation of the order, others are interpreted in a manipulative way against the background of the Dante passage on Reginaldo.

the activities in Padua, testaments found by Federici indicate that starting from 1277 the friars planned the construction of a church and religious house there and raised funds.[46] In 1284 a pious man bequeathed them not money but bricks and declared that the Order was planning to build a Marian church ("duo miliaria lapid. de fornace in aedificari Ecclesiae S. Mariae Fratr. Gaudentium de Pad.").[47]

Another relevant document dates from 7 April 1300: Beatrix, widow of Garzilione de Vigontia, a Cavaliere Gaudente, bequeaths 25 lire to the order for the construction of a church, provided that work will begin within seven years of her death.[48] It is not difficult to connect the document with the Arena Chapel: the date is just eight weeks after Scrovegni's purchase of the estate. Thus one would have to imagine that he provided the building site and acted as a main sponsor (whether from his own resources or from the Bonacolsi fortune). Another testament bears the date of 25 October 1302, i.e. it was drawn up five months before the consecration of the chapel's foundation stone. The *cavalieressa* Giuditta de'Forzatè bequeathed 25 lire to the Cavalieri for the purchase of vestments and a chalice "provided they make the church".[49] Although these testaments, or at least the last two, might be aimed for the church in the Arena, the establishment of the Cavalieri Gaudenti there still failed. The reason may thus have been less Scrovegni's perfidy than the antagonism of the Eremitani. Least surprising would be that the struggle for survival between mendicants lives on in the infamy of a rich man whose father, according to Dante, burned in hell.

Whether the Cavalieri Gaudenti were involved or not, the transition from the second phase of the project to the third did not simply mean a downsizing of the church, but a departure from the concept of a convent church with a corresponding institute. The aim was now no longer to establish a community of monks, friars or canons, who prayed for the Scrovegni family and the Paduans. Nonetheless, according to the evidence of the west portal, the building in its third phase was still planned as a publicly accessible one. Since the only remaining door other than the west portal goes from the eastern section of the nave to the north, namely towards the palace, it suggests that the intention was that the chapel should be cared for by the clergy living in the palace. This is the compromise church decorated by Giotto, which was probably consecrated on 25 March 1305 on the Feast of the Annunciation.

46 Ibid. vol. 2 doc. LXXXVII and XCI. Cf. *Padova: Basiliche e chiese*, vol. 1 p. 24.

47 Federici, *Istoria de' Cavalieri Gaudenti*, vol. 2 doc. XCI.

48 Ibid. vol. 2 doc. CVII: "Item relinquo Fratribus Gaudentibus de Padua pro adjutorio unius Ecclesiae faciendae libr. viginti quinque denariorum par., si tamen dicti Fratres inceperint facere dictam Ecclesiam usque ad septem annos post obitum meum." A certain Antonius is named as notary.

49 Ibid. vol. 2 doc. CVIII: "Item reliquit Fratribus Gaudentibus de Padua lib. viginti quinique parvorum pro apparamentis vel calice, quando, et quomodo videbitur Commissario suo, vel suis, si Ecclesiam fecerint."

Enrico Scrovegni's Foundation

Three months earlier, the Eremitani had launched a new protest to the bishop with the letter quoted above. Presumably they had already been working against Scrovegni's plans since the project's most powerful supporter, Benedict XI, had died in the summer of 1304. Specifically, the letter of January 1305 was about church bells and a "campanile" (A 5). This argument again shows that the model in Giotto's Last Judgment does not reflect a project that was current at the time. If a belfry had really been part of the plan, it would certainly not have been omitted. On the other hand, it is clear that the built chapel was to have a bell frame. In the attic above the vault of the square ante-choir, a diaphragm arch has been preserved, which could not have been intended for anything other than to support a turret together with the east gable of the nave.[50] A similar belfry was only erected in the 15th century above the polygonal apse, which is younger than what then became the ante-choir.

The protest against the Campanile was a protest against the public character of the church and foundation. That the Eremitani (again, I believe) were able to prevail on this matter deprived Scrovegni's chapel of its voice among the bells of the Paduan churches. The liturgy celebrated there, to which no bell called, was a private matter of the founder. If one of the aims of the foundation in the Arena had been to combine Scrovegni's spiritual intentions with those of his Paduan fellow citizens, the building, consecrated in 1305, had only succeeded in a rudimentary form. Things would probably have been different without the early death of Pope Benedict. Some sources from the following years, which have not yet been thoroughly considered, give an idea of the institution, how it existed when Giotto painted and how it developed in the years immediately thereafter:

According to episcopal documents from the years 1307 to 1309, the Arena Chapel was presided over by a *praepositus* and was thus staffed with more than one priest. In 1309 he is mentioned by name: "dominus presbyterus Thomasius prepositus ecclesie sancte Marie in arena de Padua". In 1307 and again in 1308 he was entrusted with caring for "the souls of those who dwell within the walls of the Arena and in its immediate vicinity" and also for the soul of the noble Lord Henricus Scrovegni (A 7, 8). This group of people was separated from the parish of San Tomìo, a church located between the city walls and the Arena, which had previously been responsible for them. It was demolished in the 19th century. The document of 1309 shows Scrovegni, supported by Prior Thomasius, concerned with further upgrading the canonical and economic position of his foundation (A 9): through a complicated swap of patronage rights, involving a monastery from the surrounding area, and the addition of a considerable sum of money, the parish church of San Tomìo was itself tied to the Arena Chapel. Whoever exercised the patronage right

50 C. Bertelli, La voce dell'angelo nella Cappella degli Scrovegni, in: *Lezioni di metodo: Studi in onore di Lionello Puppi,* ed. L. Olivato and G. Barbieri, Vicenza 2002, pp. 159–165, esp. 162.

over San Tomìo had considerable scope for the symbolic design of the wider surroundings of the Arena. For example, it was largely up to the patron to decide whether San Tomìo or the Arena Chapel formed the centre of this religious territory.[51] Finally, a document from 1310 explicitly states that the church in the Arena is subordinate to the bishop (A 11): it is a proper member of the Paduan church family, which is to be respected by the Eremitani, just as its patron and clergy must respect them.

Accordingly, it was not simply a house chaplain of the Scrovegni family who looked after the church in the first years of its existence and who would have been there even without a representative building. But it cannot have been an institute of the size established and financed in 1317 either (A 13): a prior plus three other clerics plus four servants. For it was expressly stated on this occasion that the church built by Scrovegni was not yet adequately endowed. At the time when Giotto's frescoes were painted, the Arena Chapel must have been a small parochial-type institution, closely linked to the Scrovegni family and their suburban manor house, and barely visible. But it is important to consider the papal indulgence, which might have lured some pious Paduans past the portal of the church of the Eremitani, provisionally arranged for the cult, into the Arena and might have prevented others from leaving the Arena immediately after the Annunciation play and visiting the church of the Eremintani on this occasion (A 4). Thus, on the Marian Holidays, there was a guaranteed influx of people – and donations (A 13).

THREE PORTRAITS

According to the painted dedication scene, Scrovegni was not on his own when he conceived his foundation. It shows not one but two donors in addition to the detailed portrait of the chapel. It is Scrovegni who presents the model but it is a cleric who carries the model on both hands and on his right shoulder. His face is no less elaborate than Scrovegni's, and it also appears in a strict profile (fig. 4, 5). Like Scrovegni's head, Giotto painted this one on a separate *giornata*; both were thus given undivided care. The only other head to receive this treatment in the Last Judgment picture is that of Christ.

Whether the two heads should be understood as portraits and thus as the founding works of post-antique portraiture is a question that has been discussed time and again and with varying results.[52] The difference between the two profiles, staged by the juxta-

51 Bellinati, La cappella di Giotto all'Arena e le miniature dell'Antifonario, p. 25. *Padova: Basiliche e chiese*, vol. 1 pp. 42–43. G. Toffanin, *Cento chiese padovane scomparse*, Padua 1988, pp. 176–177.

52 K. Bauch, Giotto und die Porträtkunst, in: *Giotto e il suo tempo. Atti del congresso inter-*

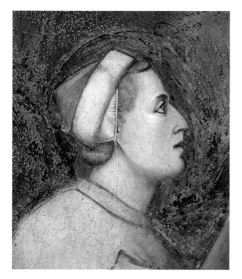 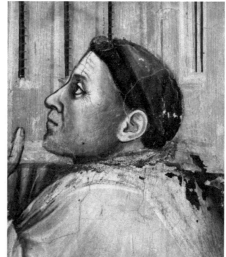

Fig. 4: Foundation scene, Enrico Scrovegni Fig. 5: Foundation scene, the prelate

position, played a major role here: Scrovegni's sharp face, with its prominent nose, small eyes and mouth, opened in "breathless fearful tension" (if Peter Cornelius Claussen has understood the painter's intention correctly)[53], is contrasted with the priest's rather short face with deep-set wrinkled eyes. Wolfram Prinz wanted to read this face as that of a "man of simple standing",[54] a thought that the other head would hardly suggest. It was also once claimed that Scrovegni was "made up to a youthful nobleman".[55] That sounds reflective and yet is just as unfounded. The staging of the physiognomic differences is probably correctly understood if one reads it as an instruction from the painter to the viewers to give in to their fantasies about the two personalities – which, unlike Giotto's contemporaries, art historians should not of course spontaneously do.

nazionale *(Assisi – Padova – Firenze, 1967)*, Rome, 1971, pp. 299–309. P. Seiler, Giotto als Erfinder des Porträts, in: *Das Porträt vor der Erfindung des Porträts*, ed. M. Büchsel, Mainz 2003, pp. 153–172.

53 P.C. Claussen, Enrico Scrovegni, der exemplarische Fall: Zur Stiftung der Arenakapelle in Padua, in: *Für irdischen Ruhm und himmlischen Lohn: Stifter und Auftraggeber in der mittelalterlichen Kunst*, ed. H-R. Meier, C. Jäggi, and Ph. Büttner, Berlin 1995, pp. 227–246, esp. 230.

54 W. Prinz, Ritratto istoriato oder das Bildnis in der Bilderzählung: Ein frühes Beispiel von Giotto in der Bardi-Kapelle, *Mitteilungen des Kunsthistorischen Institutes in Florenz* 30, 1986, pp. 577–580.

55 Seiler, Giotto als Erfinder des Porträts, p. 169.

Equally fundamental and still little considered is the fact that both heads appear in profile and could have developed from shadows. "What is less the image of a living man than a shade? Yet how full of speech! Little gold, but the purest" – this is what Johann Caspar Lavater wrote half a millennium after Giotto but still half a century before the invention of photography.[56] What he meant is that the silhouette provides an image of the sitter that is limited in information, but objective, today one would say biometric, and, on top of that easy to obtain. It cannot be proven that Giotto based both heads on traced shadows. However, it should be noted that the use of the profile in representations of donors was a novelty and that the differences between the two Paduan heads are mainly due to the different profiles. The appearance of stereotypical elements in the two faces (the shape of the eyes, for example, can also be found on other figures in the Arena frescoes) does not speak against a silhouette as a starting point, but only shows how the faces were put together from elements of different origins. The idea may be helpful that these are portraits not in the sense of photographs, but in the sense of photofits, which, unlike the police photofits, contain one real element, namely the profile line.[57] There is more on this important subject at the end of the book and in the third volume.

A passage from the *Expositio in Problematibus Aristotleis* by Pietro d'Abano shows that in Giotto's and Scrovegni's Padua the idea was alive of a kind of image which tells something intimate about a person and at the same time aims at the physical resemblance with this person, thus making recognition possible. Aristotle, according to Pietro, raised the problem of why there are pictures that depict human faces (2.3.1, trans. Johannes Thomann):

> *He gives two solutions saying first: the reason is that by means of images of the face is represented the kind of constitutional arrangement of that person, whose image it is, and most of all, when it is painted by a painter capable of producing a likeness in all respects, for example by Giotto, so that we reach by means of this [i.e. the image] the knowledge of him [i.e. of whom the image is made] in such a way that if he met [us] he would be recognized through it [i.e. the painted image].*

Since the scholar mentions Giotto by name, one might assume that the two donor figures of the Arena Chapel were before his eyes and mind while he was reflecting on the answers given by Aristotle.

56 Johann Caspar Lavater, *Essays on Physiognomy; Designed to Promote the Knowledge and the Love of Mankind*, London (3) 1840, p. 188.

57 Cf. V. Kockel, Typus und Individuum: Zur Interpretation des "Realismus" im Porträt der Späten Republik, in: *Realität und Projektion: Wirklichkeitsnahe Darstellung in Antike und Mittelalter*, ed. M. Büchsel and P. Schmidt, Berlin 2005, pp. 73–85.

Three Portraits

If one wants to add a text to the performance of the two kneelers, another pair of donors, inspired by Giotto's in the Arena Chapel, will help. The two figures on the triumphal arch of the Franciscan church of San Fermo Maggiore in Verona were accompanied by inscriptions (no longer legible today but handed down in copies). To the figure of the clergyman, representing Daniele Gusmerino, the prior of the monastery, the words were assigned: "Stained glass windows, paintings, nave, choir, and much more is offered to you, Christ, by that poor Friar Minor, Daniel." And to the lay donor, Guglielmo Castelbarco, who holds the model of the church, belonged the text: "Receive, holy God, the gifts from my, Gulielmus', property, which my father [the Prior Daniel] hands over to you."[58] The unwritten Paduan text, from which the Veronese text was developed, may accentuate the role of the lay founder somewhat more confidently, but here too it can be assumed that the clergyman was meant to be important – not a servant, but a trustee.

The second portrait, that of the cleric, may thus refer to a personality who was in some way in a position equal to Scrovegni. There are a number of suggestions in the research to date: Scrovegni's advisor could be a Cistercian monk of the monastery of Sant'Orsola founded by Scrovegni prior to the Arena Chapel;[59] he could also be an Augustinian Hermit, either one of the neighbours (who may not have been consistently unfavourable) or a friar from the Veronese Eremitani community, with whom the Scrovegni family was on good terms;[60] he could be a Cavaliere Gaudente, and thus perhaps the (designated) prior of the (at most) planned house;[61] or he could be an Augustinian Canon, which would mean that the community in the Arena should have been one of the Augustinian Canons from the beginning and Giovanni da Nono's story was truly nothing but gossip.[62] He could also be Thomasius, who is mentioned in 1309 as the *praepositus* of the chapel (A 9). The white robe is consistent with all these possibilities.

Finally, there is one observation that leads to a sound proposal: The white garment is complemented by a blue or grey-blue cowl (*almutium*, almuce), which was applied *al secco* and has largely peeled off. Clerics wearing grey-blue cowls over a white surplice have attracted Irene Hueck's attention in the miniature of the consecration rite in an Antiphonary from Padua Cathedral (Biblioteca Capitolare B 16, fol. 206r). Only Paduan

58 "Vitras, picturam, navem, corum et alia plura ofert tibi, Christe, Daniel pauperculus iste." "Suscipe, sancte Deus, munuscula que pater meus de mei fisco Gulielmi dat tibi, Christus." Cit. after: E. Cozzi, Verona, in: *La pittura nel Veneto*, ed. C. Pirovano, Milan 1992, pp. 303–379, esp. 316.

59 Bellinati, La cappella di Giotto all'Arena, p. 20.

60 R. Simon, Giotto and after: altars and alterations at the Arena Chapel, Padua, *Apollo* 1995, pp. 24–36, esp. 36.

61 P. Selvatico, L'oratorio dell'Annunziata nell'Arena di Padova, in: id., *Scritti d'arte*, Florence 1859, pp. 215–287, esp. 257.

62 Hueck, Zu Enrico Scrovegnis Veränderungen, p. 108.

Fig. 6: Statute book of the Paduan Cathedral Chapter, initial page

cathedral canons can be indicated there.[63] Claudio Bellinati then referred to the opening miniature in the statutes of the Paduan Cathedral Chapter from 1401 (Bibliotheca Capitolare, D. 66, Fol. 1r).[64] Here are explicitly Paduan cathedral canons kneeling in white surplices with either purple or grey-blue to blue *almutia*, probably according to rank, at the side of the Mother of God and Patroness of the Cathedral (fig. 6).

The Scrovegni were connected with the Paduan Cathedral Chapter: Pietro Scrovegni, probably a brother of Enrico's father Reginaldo (his fortune fell to Reginaldo and later to his children) is documented as a member of the Canonica between 1256 and 1276. A Guglielmo Scrovegni was also a canon from 1260 to probably 1263.[65] Obviously not one of these two is represented, otherwise Giotto would have combined the physiognomic differences with a marked difference in age. But it is clear that the circles of the Cathedral Chapter were socially open to the founder of the Arena Chapel. There he could easily find a competent advisor to assist him in the planning of a Marian church and thus a kind of complement to the Paduan Cathedral.

Claudio Bellinati thought especially of Altegrado de'Cattanei, who came from a Veronese family. He was initially a Professor of Theology in Padua, became a member of the Cathedral Chapter in 1296, its archpriest in 1301 and was soon afterwards (1303) elected Bishop of Vicenza. His paths crossed with Scrovegni's both before and after this career jump. Altegrado appears as a witness in the foundation letter of the monastery of Sant'Orsola (1294). And when the Vicentines expelled him, he found refuge "in domo

63 Hueck, Zu Enrico Scrovegnis Veränderungen, note 15 on p. 108.
64 C. Bellinati, *Nuovi studi sulla Cappella di Giotto all'Arena di Padova (25 marzo 1303 – 2003)*, Padua 2003, fig. p. 22. *I manoscritti miniati della Biblioteca Capitolare di Padova*, vol. 1 pp. 329–332.
65 F.S. Dondi dall'Orologio, *Serie cronologico-istorica dei canonici di Padova*, Padua 1805, pp. 192–194. Bellinati, La cappella di Giotto all'Arena, S. 23. Collodo, Origini e fortuna della famiglia Scrovegni, p. 50.

domini Henrici Scrovigni" in Padua (1310).[66] However, Altegrado should have been depicted in episcopal vestments from 1303 or, at the latest, from 1304. Another candidate is Pandolfo di Lusia. A member of the Chapter since at least 1301, he succeeded Altegrando as its archpriest in 1304.[67] In 1306 he became Bishop of Treviso and – this is the link with Scrovegni – soon afterwards had allegories painted in the Bishop's Palace there, which were evidently conceived by the poet Francesco da Barberino on the model of the allegories in the Arena Chapel (see vol. 3 p. 79). Altegrado and Pandulfo are possible models for the kneeling cleric, but the probability of identification with one or the other cannot be judged from an academic perspective. Scrovegni may have known other canons as well. The decisive point is that Altegrado and Pandulfo correspond to the type that Giotto's figure most probably represents: the kneeling man, looking at the founder, is a distinguished prelate with whom Scrovegni has friendly or family ties and who, because of these bonds, supports the founder fraternally in his spiritual self-realization and in his provision for the afterlife.

THE LAST JUDGEMENT

"Ecclesia beatae Mariae virginis de caritate de Arena" is the name of the chapel in the letter of indulgence issued by Benedict XI (A 4). The consecration to Maria "de caritate" is not unique, but had a certain topicality the Veneto in the high Middle ages. The church that preceded the existing Eremitani Church had also been consecrated with this title, and in Scrovegni's time there was still a chapel within the monastery with this dedication,[68] facts that did not help to defuse the competition between the new foundation and the monastery. Apart from this, it was Mary's popular quality of *caritas* that Scrovegni and his spiritual advisor were counting on. *Caritas* in the Christian (Pauline) sense means selfless love, a feeling which, when a holy person directs it towards mortal and sinful men, is best described with the term *mercy*.[69] And never is this form of Our Lady's compassionate love

66 Bellinati, *Giotto: Padua felix*, p. 141, 158 and Bellinati, *Nuovi studi sulla Cappella di Giotto*, pp. 19–42. On Altegrado see also: DizBI s.v. Cattano (Cattanei), Altigrado ((F. Ciapparoni) and G. Mantovani, *Il formulario Vicentino-Padovano di lettere vescovili (sec. XIV)*, Padua 1988, pp. xix-xxv. The identification is supported: B.G. Kohl, Giotto and his lay patrons, in: *The Cambridge Companion to Giotto*, ed. A. Derbes and M. Sandona, Cambridge 2004, pp. 176–196, esp. 186–187.

67 Dondi dall'Orologio, *Serie cronologico-istorica dei canonici di Padova*, p. 107.

68 Bellinati, *Giotto: Padua felix*, p. 155. A. Derbes and M. Sandona, Ave charitate plena: Variations on the Theme of Charity in the Arena Chapel, *Speculum* 76, 2001, pp. 599–637, esp. 600–601.

69 Derbes and Sandona, Ave charitate plena, esp. 605. To clarify the meaning of the

so valuable as on the Day of Judgement, when Christians may expect Mary to appeal mercifully to the mercy of her Son. From this point of view, it seems logical to equip a church dedicated to Our Lady of Charity with a prominent image of the Last Judgement; about 10 metres high, it covers the entrance wall. One of the rules of medieval images of the Last Judgment is that Mary stands or kneels at the throne of the Judge as intercessor together with John the Baptist. Not so in the Judgment of the Arena Chapel (fig. 7): Here Mary appears twice and both times without the assistance of the Baptist, i.e. as sovereign.[70]

At one of her appearances, when she is pictured with the group of donors, Mary keeps away from the main event and turns exclusively to Scrovegni, to whom she looks and for whose hand she mercifully reaches out. Her entourage also seems to be related to the donor and the model of the donated church and not to the scene of the Last Judgement: the disciple John on her right and Catherine, crowned martyr, on her left are the patrons of the side altars.[71] The way Catherine touches the roof of the model chapel as if she wanted to respond to the prelate and his gesture of support tangibly connects the trio of saints with the depicted church building. The positioning of the three saints follows the orientation of the transept and thus responds to the positioning of the three altars as it must have been intended there: Mary in the centre, John in the Gospel-side transept arm, Catherine in the Epistle-side transept arm. Today the altars of St. John and St. Catherine stand in front of the ambo and the pulpit of the small church, as if they had been stowed there. So the depicted model does not simply keep alive a memory of what was projected; in combination with the saints, the representation points out that what was projected but not realized is part of the spiritual value of the foundation: Scrovegni wanted to offer the trio a more magnificent place of worship than he had been granted. The prelate's robe, which falls over the door frame, links the painted existence of the donor group and the real existence of the visitors to the church space that Scrovegni donated. All in all,

term *caritas* in medieval theology, the authors refer to the *Meditationes Vitae Christi*, where Christ describes the motivation for his self-sacrifice with the words "ex caritate". *Meditaciones vite Christi*, by Johannes de Caulibus, ed. M. Stallings-Taney (Corpus Christianorum Continuatio Mediaevalis 53), Turnholt 1997, p. 13.

70 D.C. Shorr, The Role of the Virgin in Giotto's Last Judgement, *The Art Bulletin* 38, 1956, pp. 207–214. J. Baschet, *Les justices de l'au-delà: Les représentations de l'enfer en France et en Italie (XIIe-XVe siècle)*, Rome 1993, p. 623.

71 *Padova: Basiliche e chiese*, vol. 1 p. 247. The office of "chaplain to the altar of St John the Evangelist" at the Arena Chapel is documented in 1523: ASV, Archivio Gradenigo di Rio Marin, busta 269: F. Sardi and E.P. Zanon, Censimenti dell'Archivio Gradenigo di Rio Marin, in: *Il restauro della Cappella degli Scrovegni: Indagini, progetto, risultati*, ed. G. Basile, Milan 2003, pp. 295–300, esp. 299. For alternative identifications of the three figures see: E. Borsook, *The Mural Painters of Tucany from Cimabue to Andrea del Sarto*, Oxford (2) 1980, p. 13 note. 37.

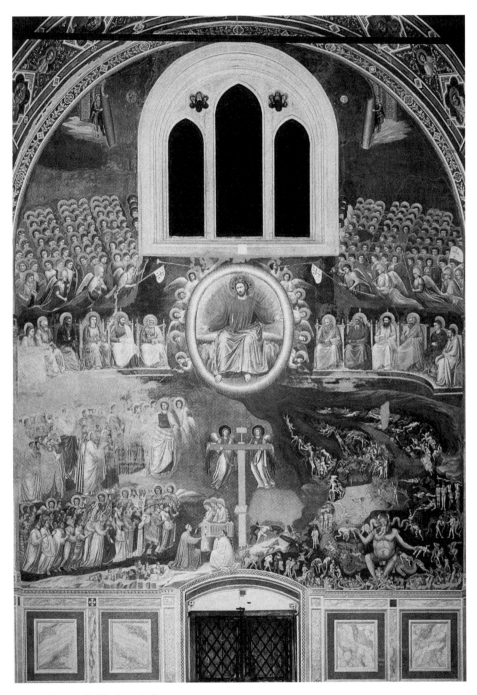

Fig. 7: West wall: The Last Judgement

the appearance of the Madonna della Carità proves to be a graphic explanation of the foundation and its spiritual function for Scrovegni and the Paduans, while the rest of the painting on the west wall gives an outlook into the future.

This is the setting of the second Mary of Mercy (pl. I). Slightly below the judge's throne she is presented as the leader of the saints. The textual basis for this appearance was probably the Vision of the Verger of St. Peter's, recounted in the *Legenda Aurea* in the context of the feast of All Saints: the pious sacristan had fallen asleep at the main altar of St. Peter's Church in Rome after devoutly doing his work.[72]

> *There he was rapt in ecstasy. In a vision he saw the King of kings seated on a high throne, surrounded by all the angels. Then the Virgin of virgins came forward wearing a gleaming diadem and followed by an innumerable multitude of virgins and continent. [...] Then came a man clad in camel skins, whom a large number of ancients followed, and after them another man wearing pontifical vestments and accompanied by a chorus of men similarly attired.*

More people in groups follow. An angel informs the visionary that he has seen Mary, John the Baptist, Peter and all the saints: they always appear before Christ on All Saints' Day to thank him for the institution of this feast and to beg for the redemption of mankind.

In the picture, Mary is assimilated to Christ by her size and by a golden aureole, held by angels and surrounding her whole body. If the area on the left with the first choirs of saints had not been lessened in its compositional weight due to its poor state of preservation and if Mary herself had not lost her right arm, she would be perceived as the most important figure in the scene after Christ. She would also emerge more clearly as a figure that demands our affection. If Giotto's Madonna in the Aureole embodies what should be understood by a Madonna de Caritate, then the merciful attention that the faithful ask of her is practically identical with the mercy she herself asks of her Son, the Judge: in terms of composition and content, the figure forms a counterpart to the stream of fire that pours from Christ's aureole into hell and represents his wrath. On the basis of this observation, the turn of the Judge's body to the side of grace can be read not only symbolically, but also

72 „Extra se rapitur et ecce, vidit regem regum in sublimi solio consistentem et omnes angelos in eius circuitu commorantes. Tunc virgo virginum in dyademate praefulgenti abvenit, quam innumerabilis multitudo virginum et continentium sequebatur. ... Post hoc advenit quidam vestitus de pilis camelorum, quem sequebatur mulitudo venerabilium seniorum. Deinde abvenit et alius pontificali habitu decoratus quem aliquorum chorus in habitu consimili sequebatur.", *Legenda Aurea*, by Iacopo da Varazze, ed. G.P. Maggioni, Florence 1998, pp. 1111–1112. English text after: *The Golden Legend: Readings on the Saints*, by Jacobus de Voragine, trans. W.G. Ryan, Princeton 1993, vol. 2 p. 279.

Fig. 8: Florence, Baptistery, dome mosaic: The Last Judgment

concretely as a narrative: he turns to his Mother and in this gesture grants her what she and, guided by her, the community of saints asks of Him, thus responding to what the visitors to the chapel have asked of the Saints and, above all, of the Blessed Mother.

Giotto's fiction of the Last Day, which forms the plot for this Maria della Carità, is a montage of at least three pictorial sources: firstly, the painter used the Last Judgment mosaic in the dome of the Florentine Baptistery, which can be dated around 1240 (fig. 8). From this grandiose picture in his hometown come several motifs: the Judge's figure, depicted as enlarged if not to the colossal scale used in the mosaic, as well as His aureole, which is striking for its colourfulness, and the hell made of red, i.e. glowing rock. However, now the rocks do not form a mountainous area, but an immensely wide cave. There are also individual motifs that have been adopted. Among them is the figure of Satan, who devours souls and sits on a throne of serpents. In terms of scale, he is the most important figure after Christ and Mary. Perhaps the benches of the Apostles, curved forward at the sides, can also be counted among the borrowings from the Florentine image, because this spatial trick could be inspired by the real spatiality of the mosaics. There the lateral parts of the dome, where the Apostles sit, "embrace" the upwardly gazing visitor.[73]

73 E.F. Rothschild and E.H. Wilkins, Hell in the Florentine Baptistery mosaic and in Giotto's

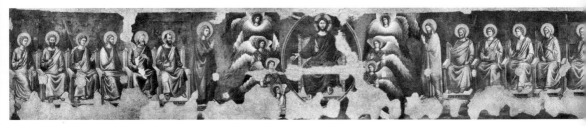

Fig. 9: Rome, Santa Cecilia in Trastevere, west wall: The Last Judgement (Pietro Cavallini)

The second and perhaps most important visual source was the Last Judgement on the west wall of Santa Cecilia in Trastevere, Rome, created by Pietro Cavallini. Although it is difficult to date more precisely than "before or around 1300",[74] it was in any case relevant. Its popularity in the visual culture of Rome around 1300 is evidenced by the painting of a simplified version on the west wall of the church of Santa Maria in Vescovio (Lazio).[75] This reproduction also contributes to a better understanding of Cavallini's scene as a whole. Only a wide strip with the Judge, the intercessors Mary and John and the Apostles is preserved in Trastevere (fig. 9), as well as a narrow strip below with the heads of saints and damned souls. Giotto clearly adopted the Judge's sliced tunic and the angels' gathering around his aureole from Cavallini. His model may also have been helpful in mastering the shape of the wall in Padua. The west wall of Santa Cecilia, like that of the Arena Chapel, was pierced by a large window, in this case an oculus, which was located at a lower level in the wall than was convenient for the composition of a Last Judgement. A conflict between the window and the position of Christ was inescapable. In Giotto's work it can be discerned in the strangely egg-shaped mandorla that avoids the frame of the window; in Cavallini's work it can be seen in the awkward overlapping of the painted border around the rose window by the mandorla. Equally precarious was the filling of the zones to the sides of the window. What Giotto presents here, the flying formations of the armies of angels and the rolling-up of the canopy of heaven, is breath-taking from a

Paduan fresco, *Art Studies* 6, 1928, pp. 30–35. M.V. Schwarz, *Die Mosaiken des Baptisteriums in Florenz: Drei Studien zur Florentiner Kunstgeschichte*, Cologne 1997, pp. 19–44. The latest book published on the Florentine mosaics does not represent the current state of research: M. Boskovits, *The Mosaics of the Baptistery of Florence* (A Critical and Historical Corpus of Florentine Painting, sec. 1, vol. 2), Florence 2007.

74 M. Schmitz, *Pietro Cavallini in Santa Cecilia in Trastevere: Ein Beitrag zu römischen Malerei des Due- und Trecento*, Munich 2013, pp. 172–182.

75 A. Tomei, Il ciclo vetero e neotestamentario di S. Maria in Vescovio, in: *Roma Anno 1300: Atti della IV settimana di studi di storia dell'arte medievale dell'Università di Roma La Sapienza (19–24 maggio 1980)*, ed. A.M. Romanini, Rome 1983, pp. 355–366.

The Last Judgement

59

narrative point of view, but was certainly developed in light of Cavallini's solution, which is lost.

The important motif of a procession of saints moving towards the centre is also taken from Cavallini. In Santa Cecilia it appears on the lower preserved strip on the left. Giotto doubled it, situating the saints on two levels, one above the other (fig. 10). The saints taking part in these two parades are divided into separate choirs, which are formed and directed by angels acting as heralds or masters of ceremonies. This is also adopted from Cavallini. Initially Giotto wanted to have the first herald angel in the lower procession indicate the Judge with a gesture – just as he had seen it in Cavallini's mural[76] (fig. 11). Wilhelm Paeseler thought that Giotto's depiction of the groups was a step backwards in comparison with Cavallini, for it did not convey their timidity in approaching the Judge.[77] But perhaps it would be better to comment on the subtle differences between the representations in order to suggest why the change was made: Giotto wants to show us saints who are sure of their job.

If the choirs are formally derived from Cavallini, the result is nevertheless structured according to the All Saints chapter of the *Legenda Aurea*. It has already been said that the appearance of the second Mary goes back to the vision of the sacristan of St. Peter's and thus to the final section of this chapter (pl. I). The groups following behind Mary in the upper row are badly preserved, so that it is hardly possible to determine how exactly they are attuned to the vision. At any rate, "a large number of ancients" can be seen. The vision and likewise the picture probably suggest patriarchs and other Old Testament saints including John the Baptist. If the old woman who is led by Mary's hand really represents Eve (as Margrit Lisner suggested)[78] this would be an elegant adaptation of the vision to a church dedicated to Mary (thus, a church of the New Eve).

The lower procession essentially follows the main part of the chapter, where the different types or orders of saints are presented: the front choir, as indicated by the palm branches, are the martyrs (this corresponds to the second *differentia* according to the *Legenda Aurea*). One of them, a deacon, perhaps Stephen, has momentarily turned his gaze away from Christ and is watching the act of donation that Scrovegni and his spiritual

76 The overpainted hand was discovered by Hans Michael Thomas: H.M. Thomas, Gedanken zu Bildkonzeption, Ikonographie und künstlerischer Darlegung Giottos in Padua, *Bollettino del Museo Civico di Padova* 74, 1985, pp. 53–66.

77 W. Paeseler, Die römische Weltgerichtstafel im Vatikan: Ihre Stellung in der Geschichte des Weltgerichtsbildes und in der römischen Malerei des 13. Jahrhunderts, *Kunstgeschichtliches Jahrbuch der Bibliotheca Hertziana* 2, 1938, pp. 311–394, esp. 372.

78 M. Lisner, Farbgebung und Farbikonographie in Giottos Arenafresken: Figurenfarbe und Bildgedanke, *Mitteilungen des kunsthistorischen Institutes in Florenz* 29, 1985, pp. 1–78.

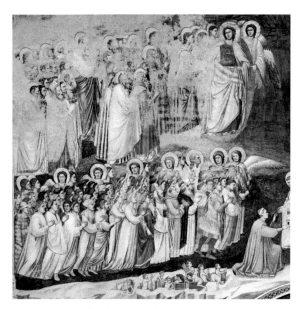

Fig. 10: West wall: The Last Judgement, intercessors

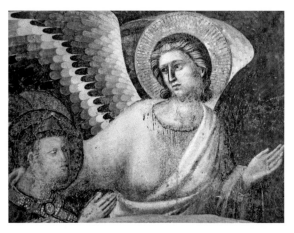

Fig. 11: Rome, Santa Cecilia in Trastevere: The Last Judgement, detail (Pietro Cavallini)

friend are carrying out. This clarifies the functional connection between foundation and intercession. Behind the martyrs follow the confessors (according to the *Legenda Aurea* the third *differentia*). Dominic, Francis and Bernard of Clairvaux or Benedict of Nursia stand in the first row. The gold trimming on their robes is striking – even the habit of St. Francis shows gilding. This proves that we are not dealing with earthly persons who have become history, but with transcended ones who are eternally present in heaven. The confessors are followed by the virgins. They are the fourth and last *differentia* of the saints according to the *Legenda Aurea*.

The parade of the patrons and patronesses should have ended with this choir, because the female saints represent the end of the hierarchy not only in the *Legenda aurea*, but also in the images of the Last Judgement with intercessory choirs, including that of Pietro Cavallini in Santa Cecilia in Trastevere. The exception is the knot of intercessors in the dome mosaic of the Florentine Baptistery. Behind the female intercessors and in connection with the resurrected men, depicted as children, hurrying to paradise, there appear some youthful heads. Most of them turn to the judge like intercessors, but one turns to the door of paradise like a resurrected man (fig. 12). What is meant by this is unclear.

It is therefore a problem that in Padua the holy virgins are followed by a mass of other people, which for its part seems to be divided into three choirs or cohorts. First there are three rows of male laymen in rich dress with contemporary elements. They are succeeded

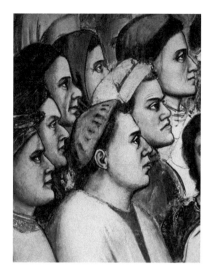

Fig. 12: Florence, Baptistery, dome mosaic: The Last Judgement, detail

Fig. 13: West wall: The Last Judgement, redeemed believers

by two rows of men, whose costumes correspond to those of the upper classes of the early 14th century and are complemented by highly distinctive headgear in different, but always muted colours; they are all beardless and middle-aged, yet look persuasively individual (fig. 13). Among these men are the most distinctly characterised faces in Giotto's oeuvre. They can compete in terms of individuality with those of Scrovegni, the prelate, and the other donors whom our painter portrayed in Rome and Assisi. The corpulent gentleman with the soft cap is particularly memorable. His features recur in later Paduan Trecento painting, most clearly in Altichiero (vol. 3 p. 171), which makes it all the more painful that it is obscure whom – in the sense of a social type – Giotto wanted to represent.

Finally, the last two rows consist of roughly equal numbers of women and men (fig. 10). The figure standing furthest back is the only one whose costume is supposed to be conspicuous: a youngster with a coat woven from straw, a wide-brimmed hat, and a cane. In this case a proposal for identification is available. Supposedly, he is Blessed Antonio Pellegrino: a Paduan who left a wealthy family home as a child and made a pilgrimage across the world to Rome, Santiago and Cologne. After returning home to Padua in 1267, he died around his fifteenth year, poor and abandoned by everyone. Miracles soon occurred at his grave and a veneration that lasted until recent times began. Another characteristic of his biography is that a proper canonization was never achieved and the veneration remained local. The Paduans had to be content with one Saint Anthony (the Franciscan buried in the Santo), as an unnamed pope put it in the *vita* of the young pil-

Fig. 14: Torcello, Cathedral, west wall: The Last Judgement

grim, written about 1270.[79] And perhaps it is precisely this difficult fact for the admirers of Blessed Antonio that is addressed by the figure's position at the edge of the picture.

Who are the persons who trail behind the choirs of the saints? Who are the youths in the same place in the mosaic in Florence? A look into the *Legenda aurea* may help here.[80] In the text on All Souls' Day, which immediately follows the chapter on All Saints' Day, the "faithful souls" ("fideles defuncti") are divided into three orders analogous to the four orders of saints, although somewhat artificially. The first group consists of those who have repented but have not had the opportunity of making penance. The second group are those who have atoned, but have not atoned enough because of pastoral malpractice. The third group is made up of those who have loved earthly goods unduly, but not more than God. All are certain of a favourable judgment on the Last Day, because as virtuous and believing Christians they share in the treasury of merit of the Church. It should be noted that for the author and readers of the *Legenda aurea*, these persons are not saints and cannot be intercessors; on the other hand, at the Last Judgment, they may have an advantage over those who have died less certain of their faith.

If this correctly identifies the persons whom Giotto painted here, then the image indicates, in the form of the three choirs, the desired position of the viewers on Judgment Day. In this case, the portrait mode chosen for the middle cohort, combined with the discreetly elegant clothing, has the job of enabling Scrovegni and his fellow citizens to identify with the group of characters depicted here (fig. 13). In this context, it seems that Antonio Pellegrino was expressly not included in the picture as a saint, but as someone who will find salvation through his life of commitment, and whose existence thus provides an attainable model, while at the same time setting an immensely high standard. In this way he once again bears the motif of contrition that runs through the pictorial decoration of the chapel (see below).

79 A. Rigon, Pellegrino sulla terra: Un santo per la città, in: *Incontrarsi a Emmaus*. Exh. cat. ed. G. Mariani Canova and A.M. Spiazzi, Padua 1997, pp. 94–97.

80 *Legenda Aurea*, ed. Maggioni, pp. 1113–1129.

Finally, Giotto used a Byzantine or Byzantinizing image as a third model, alongside the Last Judgments in Florence and Rome. The descriptive motif of the stream of fire that connects the judge's aureole with hell comes from the Greek iconography of the Last Day. It can be found not far from Padua in the Last Judgement mosaic on the west wall of the Cathedral of Torcello (fig. 14) and was probably also part of the Last Judgement on the west wall of San Marco in Venice.[81] The adoption of the motif most likely had to do with the patron and the audience of the painting. While we do not know of any links between the painter and Venice, good contacts between the patron and the Lagoon are documented. It should be remembered that Scrovegni borrowed textiles from Venice for the consecration of the chapel in 1305 (A 6) and that

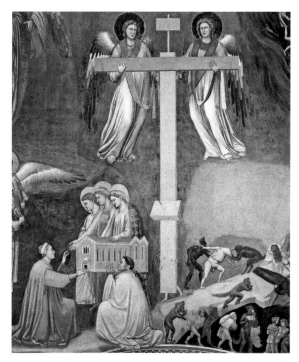

Fig. 15: West wall: The Last Judgement, foundation scene, apparition of the cross, reprobates

he later lived in Venice in exile. Furthermore, the pictorial language of the Lagoon was probably more familiar to the Paduans than anything that Giotto designed. *En passant*, it should be noted that Enrico's uncle Pietro, in his capacity as archpriest of the Paduan Cathedral Chapter, was a co-commissioner of the *Epistolario* of Giovanni Gaibana and thus of a major work of Byzantinizing book illumination in Italy.[82] Greek motifs in the Arena Chapel may also have had the function of making Giotto's pictures familiar and easy to understand in Padua.

A completely new motif, on the other hand, is the cross held out to viewers by a pair of angels (fig. 15). In both Latin and Greek iconography of the Last Judgement, the instru-

81 *Alfa e Omega. Il giudizio universale tra oriente e occidente*, ed. V. Pace, Castel Bolognese 2006, pp. 53–60 (M. Angheben). O. Demus, *The Mosaics of San Marco in Venice*, Chicago and London 1984, vol. 1 (1), pp. 9, 18.
82 *I manoscritti miniati della Biblioteca Capitolare di Padova*, vol. 1 pp. 121–142, esp. 122. F.L. Bassetto, *Il maestro del Gaibana: un miniatore del Duecento fra Padova, Venezia e l'Europa*, Milan 2015.

ments of the Passion are presented because they are arguments of grace. Accordingly, they usually lie ready, be it on an altar or on the empty throne awaiting the Second Coming of the Lord. In contrast, in Giotto's painting, the cross is literally carried along by angels. Only visible at a second glance is the depiction of a soul clinging to its vertical beam in such a way that one can hardly see more than the legs. Doomed to hell, the soul uses the cross as a means of rescue. The argument of the *Arma Christi* becomes a narrative about the possibility of obtaining grace. It complements the narrative of Christ's turning to the Maria della Carità. In addition, the cross is important for the integration of the parts of the picture: It provides the only clear link between the scene of the Last Judgement and the group of founders. Once viewers have discovered the soul seeking refuge at the cross, they can no longer exclude the motif from the context of Scrovegni's appearance before the Madonna. There, the scene brings to mind something of the urgency, the trust and also the calculation behind the founding of the chapel. Finally, in the conception of the inclusion of the cross it may have been important to give the painted events an external reference that reaches into the world of the visitors and viewers.

A *croce dipinta* that was originally in the chapel is now in the Paduan Museo Civico (fig. 160). Based on its size and decorated backside it is a *crux triumphalis*, which was regularly placed in the middle of the church (*in medio ecclesiae*). It was certainly created by Giotto, but there is stylistic evidence that it precedes his other works for the chapel.[83] The piece will be discussed in this volume in connection with the formal links between the "Giotto *avant* Giotto" and the Giotto of the Arena Chapel (pp. 289–295). Possibly made for the planned church with transept, it could have been Giotto's ticket to Padua. In this case, the cross would probably have been one of several furnishings that had been created for the larger projected church and had to be accommodated in the reduced building. The statues of the Madonna and two angels by Giovanni Pisano certainly belong to the church with transept. They were probably intended to be placed on the high altar; in 1317 or later they were integrated into Scrovegni's tomb in the apse and today they stand on the present high altar, which is what remains from its baroque predecessor.[84] There is also the statue of Enrico Scrovegni in the sacristy, which has probably been there since its construction around or after 1317, and which can only be the rest of a monumental tomb pro-

83 The similarity of the faces on the back of the cross with the Madonna of San Giorgio alla Costa in Florence (see pp. 270–276), as pointed out by Francesca Flores d'Arcais, fits with a dating in the early period of Giotto's Paduan activity: F. d'Arcais, La croce giottesca del Museo Civico di Padova, *Bollettino del Museo Civico di Padova* 73, 1984, pp. 65–82, esp. 80. In contrast, Cesare Gnudi suggests a date of 1317/18: C. Gnudi, *Giotto*, Milan 1959, p. 199. It is in turn based on a late dating of the cross in Rimini.

84 *Giotto e il suo tempo.* Exh. cat. Padua, ed. V. Sgarbi, Milan 2000, pp. 378–381 (G. Tigler).

The Last Judgement

ject for the planned church with transept.[85] And there is (more correctly: was) the stone plate with the founding inscription, which in early modern times wandered around in the church, only to eventually be lost (A 3). All these objects should be dated, in my opinion, to 1303 rather than to 1304/05. One may call them flotsam of the painted (model) project and the grand foundation concept for the Arena Chapel, whose realization failed because the Eremitani did not want to accept their demotion in the sacred topography of Padua.

A triumphal cross was probably also erected to suit the conditions of the reduced project. Four and a half metres above floor level, the last restoration revealed traces in the choir arch that most likely came from a crossbeam, which was intended to have carried the triumphal rood. According to the technical findings, the beam must have been added after Giotto had finished painting the nave of the chapel, but before, or at the latest in the course of, the (re) painting of the choir, which was carried out by another artist several years later (probably in connection with the construction of the apse and Scrovegni's tomb monument). If one simulates an installation of Giotto's cross on the beam, the result appears aesthetically satisfactory.[86] Whether it was this cross or another that was erected there, visitors to the church could now connect the cross painted in the image of the Last Judgement to the material one in the triumphal arch and draw a spiritual benefit from this – a situation that probably existed until the construction of the high altar in the baroque period.

How can one read the colossal fresco of the Last Judgement as a whole? There is no doubt that there are passages that function well narratively, even movingly. I have already gone into most of them: The group of the founders and saints, the "cross with legs" (as described by Peter Cornelius Claussen)[87], Christ's turning to the Madonna della Carità; then there are the resurrected men climbing out of the graves; and above all, hell is teeming with many individual, often gruesome and always gripping incidents. On the other hand, however, the overlapping of visual and literary sources has not led to a coherent narrative. One-sidedly, but not entirely incorrectly, Johan Jakob Tikkanen stated that the "colossal painting" was an "actionless symbolisation" ("handlungsloses Repräsentationbild").[88] The nine choirs of angels fly in and yet appear to stand still. We also see how the

85 Ibid. pp. 382–385 (Tigler). Cf. R. Simon, "The monument constructed for me": Evidence for the first tomb monument of Enrico Scrovegni in the Arena Chapel, Padua, in: *Venice and the Veneto during the Renaissance. The Legacy of Benjamin G. Kohl*, ed. M. Knapton, J.E. Law, and A.A. Smith, Florence 2014, pp. 385–404. Note that Simon assumes a different course of the chapel's construction history.

86 F. Capanna and A. Guglielmi, Osservazioni su due stuccature simmetriche scoperte nell'arco trionfale, in: *Il restauro della Cappella degli Scrovegni: indagini, progetto, risultati*, ed. G. Basile, Geneva 2004, pp. 251–254, fig. 189–193.

87 Claussen, Enrico Scrovegni, der exemplarische Fall, p. 232.

88 J.J. Tikkanen, *Der malerische Styl Giotto's: Versuch einer Charakteristik desselben*, Helsinki 1884, p. 15.

choirs of the saints, divided into two processions, are moving to the right – but where to? The stationary intercessory choirs in Florence and Torcello are comparatively easier to understand. All in all, Giotto's conception can be used as a diagram that illustrates the disparate prophecies of the Last Day and puts them into context, but no one will view it as a conclusive pictorial narrative. This corresponds to the distinction between the two levels (namely personal hope attached to the founding versus a generally hoped-for future), for which the two figures of Mary are included: the one to whose Caritas the founder appeals directly with the handing over of the foundation, and the one whose Caritas will shape the Last Day for mankind. All this is closer to constituting eschatological didactics than to the illusion of an event.[89]

On the other hand, Giotto has provided his painting with an architectural frame, at least partially designed to be perceived as an opening in the wall (rather than as a ledge around a picture). A pedestal zone of faked marble slabs, modelled on the incrustation style of Florentine 12th-century architecture, terminates with a cornice above which (as in a picture frame) the rocky floor becomes visible, from which, on one side, the resurrected climb from graves while in a gigantic cave on the other the damned are roasted (fig. 7). In the centre, above the door which is cut into the marble incrustation, the separation into architectural frame on the one hand and image on the other is then ostentatiously violated in the production of an illusionistic unity, not only by the cleric's robe, but also by the damned and devils that use the cornice above the door as a walkway (fig. 15).[90] One could ignore this and classify the ambivalence of the frame as typical of the indeterminacy of the medieval picture – painted frames that are intersected by pictorial objects occur frequently in High Medieval painting – if Giotto had not scrupulously avoided such overlaps in the other paintings in the chapel. As an example, we need only to refer to the capped floor slab in the scene with the Rejection of Joachim in the Temple, where the painter almost sacrifices the plausibility of the depicted architecture to the integrity of the frame (pl. IV). Moreover, the lateral pillars on the west wall look even more ambiguous. Do these pictorial elements of architecture stand in front of a blue-ground picture field or does a blue space open up behind them? "Consolidated blue", "hermetic blue", "massive blue", this is how Wilhelm Hausenstein describes Giotto's Paduan pictorial grounds and yet does not say explicitly whether something opens up in this blue or not.[91] The only thing that is unambiguous is the arch that the pillars bear: it simulates a relief applied to the wall and not an open arcade; otherwise we would have to see the splay of the arch

89 It is therefore problematic to characterize the pictorial effect as "radical illusionism": V. Herzner, Giottos Grabmal für Enrico Scrovegni, *Münchner Jahrbuch der bildenden Kunst* 33, 1982, pp. 33–66, esp. 56.

90 A. Volpe, *Intorno alle cornici di Giotto*, Rome 2021, p. 84.

91 W. Hausenstein, *Giotto*, Berlin 1923, pp. 261–262.

just as we see the splays of the pillars. It is therefore part of a picture frame and not a window frame (fig.16).

All in all, Giotto's painting on the west wall, although it appears as a coherent structure, does not constitute a continuous whole. There are areas that Giotto rendered as reality, continuing the image's material surroundings into the painting, and which are immediately before the viewer: the group of founders by the architecture of the frame and the smaller people balancing on the lower cornice. Then there are areas that appear embedded in the pictorial environment and at a distance from the real world, but which are directly relevant to the viewer and require participation or give instructions for action; these include the "cross with legs" and the dialogue between the judge and the hovering Mary. And then there is a lot of material that is impressive, even moving, but unclear in its syntactic coherence with other parts of the image and its relation to the viewer, and which one could also describe as a collection of illustrations of passages from eschatological texts.

Fig. 16: West wall: The Last Judgement, rolling in of the firmament

It is characteristic how the report of the sexton of St. Peter is used: It does not enter into the picture as a vision, but rather was used to provide a list of persons and protocols for the saints' appearance. Characteristic too is the image taken from a passage from Isaiah (34, 4), where the canopy of heaven is compared to a book *rotulus* (fig. 16): "And the heaven shall be rolled together as a scroll." The event is realised much more impressively by Giotto than in the Byzantine images of the Last Judgement, from where it was taken over by Giotto together with the stream of fire; in these cases, a single angel handles a *rotulus* which is actually only book size. Giotto, however, includes a solemn pair of angels, the motif of the celestial city becoming visible, and depicts, in particular, the scroll on an imposing scale. But what is decisive is that the blue-grey material with a red back, that is being rolled up in Padua is not identical to the blue background of the painted wall. This blue, then, is not the sky, and no blue sky unifies Giotto's scene in time and place. What the painter shows us against a magnificent background of lapis lazuli is essentially an ar-

rangement of motifs from various accounts on the end of the world – which includes the sky depicted as an oversized scroll.

THE TRIUMPHAL ARCH

The triumphal arch could easily open up wider and higher (pl. II). The low hanging apex in front of the cross-ribbed vault over the square bay of the choir is particularly disconcerting. The potential for a considerably higher arch and better integration of the nave and choir was proven by the unknown architect who later – probably in 1317 in connection with the establishment of the Augustinian canonry – added the polygonal apse to the square of the choir.

This suggests the idea that the wall of the triumphal arch – the result of the omitted transept – was designed in this form to provide a carrier for Giotto's frescoes. Along with this, it was important to render the façade as a counterpart to the west wall and the image of the Last Judgement planned there. The architectural elements are particularly important in this context: like the arrangement on the entrance wall, that on the triumphal arch consists of a marble-panelled pedestal zone with pilasters resting on it, placed in front of the red-coloured "actual" wall, which is visible in a narrow strip in the corners of the room. (On the side walls, the system is slightly different and not consistently architectural; I will come back to this.) The proportions and the sculptural details also underscore the connection between the entrance wall and the triumphal arch: not only the painted, but also the sculpted pilaster capitals of the triumphal arch are at the same height as the painted pilaster capitals on either side of the Last Judgement. Their relatively low position is dictated by the composition of the picture and especially by the appearance of the Judge below the window. Were the capitals set higher, they would have reduced the importance of the main figure.

The surfaces created and organised in this way on the triumphal arch corresponded to its function as a carrier of images. They made it possible to arrange the representations over four levels and to run the narration of the pictures on the lateral walls across the east wall. Thus the arch not only appeared as an echo of the west wall, but could also be integrated into the pictorial decoration of the side walls.

Unlike that of the west wall, Giotto specified the representational status of the pictorial fields on the choir arch quite clearly, although not all four registers are defined identically.[92] This begins at the top in the lunette, where he visualized the Dispatching of Gabriel with a remarkably loosely composed scene, which in many ways is close to and

92 The differences have already been pointed out: Lisner, Farbgebung und Farbikonographie in Giottos Arenafresken, p. 17

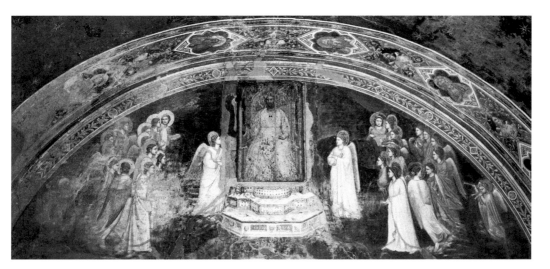

Fig. 17: Choir arch: the Dispatching of Gabriel

reflects the image of the Last Judgment (fig. 17, 7). Frank Jewett Mather has pointed out that the scene, based on Luke 1: 26–27. is given additional importance by connecting it to the *Meditationes Vitae Christi* (I–II): there, the sending of the archangel is preceded by the intercession of the angels for mankind. Thus the command to Gabriel becomes a command to save mankind from damnation.[93] The picture is also, in terms of its content, a real counterpart to the Last Judgment: the act of salvation initiated here is completed there.

The scattered figures on little clouds merge even less clearly into a pictorial unity than the judgment scene.[94] Simultaneously, Giotto makes explicit here the effect of an opening into another world, which is hinted at in the Last Judgement but not consistently performed. The fact that the main figure is painted on a wooden panel and inserted into the mural as a lid or shutter over an opening has caused some speculation (see also fig. 271): Laura Jacobus argued that this was a secondary solution, and originally the figure of God should have appeared illuminated in a stained glass window.[95] However, it is difficult to imagine a state of planning or construction of the chapel that would have included an

93 F.J. Mather, Jr., Giotto's First Biblical Subject in the Arena Chapel, *American Journal of Archaeology* 17, 1913, pp. 201–205.

94 Tomei's suggestion the composition can be traced back to Byzantine models is not convincing because of the lack of similarities: A. Tomei, Giotto's Annunciation to the Virgin in Arena Chapel in Padua between East and West, *Ikon* 10, 2017, pp. 73–82.

95 L. Jacobus, Giotto's design of the Arena Chapel, Padua, *Apollo* 1995, pp. 37–42.

Fig. 18: Choir arch: The Annunciation, Gabriel

external window in this position.[96] In contrast, Herbert Kessler thought that Giotto had chosen the pictorial form of an icon in order to create distance.[97] The alleged icon, however, has neither gold ground nor frame, as would be expected, but has hinges on the left side. The panel is thus the door of a hatch through which one could reach the roof truss above the choir with the help of a ladder. Until the sacristy with its upper floor was added, which only happened years after Giotto's activity in Padua, this was the only access to this space. If the bell frame had been built and put into operation, which was prevented by the complaint of the Hermits (A 5), the hatch would have been used for the maintenance of the bells. But even without bells the roof had to be accessible.

The remains of *sinopia* on the stone frame of the opening show that God was not originally intended to sit on a throne, but rather to appear in an aureole like Christ on the entrance wall, so that he would have inevitably been perceived as the counterpart of the Judge. The reason for the introduction of the throne was probably that this motif works better with the panel form, because this way the borderlines between the fresco and tempera surfaces disappear in the structure of the representation. As long as the painting was in perfect condition both on the wall and on the panel, God did not appear in a mode that evoked distance. If the difference between fresco and tempera was perceived at all in the twilight under the vaulting, then it might have been that the divine protagonist, despite being painted in the same warm, thoroughly fresco-like tones, gained an even greater intensity and thus probably the highest sense of presence among the painted

96 There is no visible evidence of a subsequent heightening of the choir square (a thesis first presented by Irene Hueck: Zu Enrico Scrovegnis Veränderungen an der Arenakapelle, p. 112 footnote 24). An architectural historian could point to the short columns under the vaulting, which are placed on consoles high up on the wall, but in fact this is a motif that can be found elsewhere in Padua, for example in the Eremitani Church. Any evidence from the rectangular opening itself was rendered unrecognizable by the construction work carried out at this spot in 1963, so that no arguments can be won here: *La Cappella degli Scrovegni a Padova*, ed. D. Banzato et al. (Mirabilia Italiae 13), Modena 2005, pp. 188–189 (A. Verdi).

97 H.L. Kessler, *Spiritual Seeing: Picturing God's Invisibility in Medieval Art*, Philadelphia 2000, p. 19.

figures in the chapel. In the context of the illusive quality of the lunette as a whole, the figure of God must have become palpably real.

Two symmetrically projected structures are pushed from below into the blue ground of the Dispatching scene (fig. 18, 19). They are the architectural setting for the Annunciation. On the one hand Giotto provides two spatial boxes for Mary and the angel; on the other he has a total of four Gothic oriels projecting into the space of the viewer (pl. II). Although the two outer ones are intersected by the frame band and are tamed in their spatial unfolding, a visually arresting illusionistic effect remains for the inner ones that are at the same time reminiscent of highly elaborate sculptured consoles. If one can experience the scene of Gabriel's Sending within an opening of the wall into the beyond, then the architectural features of the Annunciation scene are a form of intervention into the real space. Therefore, the nature of the surface of the painted wall is questionable in both the Dispatching and the Annunciation scene. This, together with their positioning in the chapel, gives the two representations – Sending and Annunciation – a special status in the programme as a whole: they do not belong to an independent pictorial world and thus to a parallel reality, but are attached to the reality of the viewer, live on it, "parasitize" on it (as Wilhelm Vöge put it when he described the illusionistic effect of a Late Gothic sculpture).[98]

Fig. 19: Choir arch: The Annunciation, Mary

Beneath this, to the left and right of the opening, the wall plane is treated differently. It is neither open to the front nor to the back, but is divided into two layers lying closely one behind the other and is, so to speak, doubled: The front layer is marked by a total of four pilasters, which are closely linked to the actual wall plane by the real sculpted capitals of the pilasters on both sides of the opening. Set back by about half the width of a pilaster (and thus also behind the real surface of the painted plaster), there is the fictive wall plane in front of which the pilasters were supposedly placed. In the upper register, between the pilasters, there is one picture to each side, which belongs to the cycles of the lateral walls and continues them onto the choir wall; one could also say that the two images guide the chapel's picture cycle as a whole across the choir wall in two places that occupy key positions

98 W. Vöge, *Niclas Hagnower, der Meister des Isenheimer Hochaltars und seine Frühwerke*, Freiburg 1931, p. 63.

Fig. 20: Choir arch: tomb niche on the right

Fig. 21: Florence, Baptistery: Monument to Bishop Ranieri

both architecturally and – as will be shown – in terms of the medium. A red-green framing strip isolates the picture field from the simulated architecture and links it with the identically framed picture fields along the side walls. But that is only one of the roles that the images play. Additionally, they are assigned to the two illusionistic phenomena directly below. As a continuation of the wall-structuring simulated architecture, cross-ribbed vaulted chambers, each with a tracery window and a multipart oil lamp, open up behind white imitation marble slabs (fig. 20). The projection of both interiors is aligned to the central axis of the nave of the chapel. However, certain peculiarities of the depiction of the space – including, for example, the improvised perspective on the side walls – give an impression of how heavily Giotto was reliant on a mixture of common sense and empiricism for this task (see vol. 3, pp. 202–204). The chambers would probably be considerably less convincing if it were not for the oil lamp frames with their three rings and very cleverly distributed burning bowls.

It is possible to see the two chambers as the painted replacement for the unbuilt transept or side chapels.[99] In this case, however, we would be dealing with a lamentably weak attempt at architectural illusion. In contrast, Ursula Schle-

99 Transept: Gioseffi, *Giotto architetto*, p. 53. Side chapels: R. Longhi, Giotto spazioso, *Paragone arte* 3, 1952, 31, pp. 18–24, J. White, *The Birth and Rebirth of Pictorial Space*, London 1957, p. 60, and M. Kohnen, Die Coretti der Arena-Kapelle zu Padua und die ornamentale Wanddekoration um 1300, *Mitteilungen des kunsthistorischen Institutes in Florenz* 48, 2004, pp. 417–423.

gel identified them as *arcosolia*, i.e. tomb niches.[100] The white slab is then to be read as a sarcophagus front. In order to support this thesis, reference can be made to the sarcophagus of Bishop Ranieri in the Florentine Baptistery, which has a front incrusted with marble and may have been the direct model for the slabs portrayed by Giotto (fig. 21). The oil lamps could then be interpreted as cemetery lamps. The "apparent" ground plan of the chambers may count against this argument: in photographs taken frontally the chambers appear square. But one must take into account what Ursula Schlegel has observed and what can easily be verified in the chapel: If one looks up along the short distance from the middle of the space to the niches, they appear rectangular and correspond to the *arcosolium* form. Giotto's penetrating empirical work is also evident here.

For Ursula Schlegel, the niches "mean" funerary monuments and define the room as a mausoleum. Yet the question arises whether the niches really "are" tomb monuments. Today Enrico Scrovegni and his wife rest in the polygonal apse, which was added later. When Giotto decorated the triumphal arch, this could not have been planned. The originally foreseen place of burial had probably been the sanctuary. After the abandonment of plans to build this part of the church, the most likely place for burial was the so-called crypt. It extends under the entire nave, has a vault painted with stars and is accessible from the side of the palace by a staircase.

It is a space that owed its existence primarily to the need to raise the floor level of the chapel to the level of what had been the arena ("sand") of the amphitheatre and was now the court of the palace complex – or, to be more precise, to the height of the top of the three dignified steps that rose above this level, and which are shown on the church model in the foundation scene (and which, albeit a 19th century replica, also exist in front of the chapel itself, see fig. 2, 3). Since the foundation stones of the Roman tribune had been extracted and reused in the early Middle Ages, the level of the former tribune was lower than that of the former arena. This difference could most easily be compensated by building a cellar or crypt. At the palace, the architect probably did the same. It was equally logical that the space created as a substructure would then be given functions, and in fact several different ones. It can be archaeologically proven that is was used as a well house: on the narrow side towards the *manège*, i.e. below the main portal of the chapel, there was a wall-mounted fountain connected to a fountain on the former playing field. Whether it ever worked is unclear.[101] According to the model plan, water was to be led

100 Schlegel, Zum Bildprogramm der Arena Kapelle.

101 G. Zampieri, *La Cappella degli Scrovegni in Padova: il sito e l'area archeologica*, Milan 2004, pp. 65–80. For a detailed description of this little-noticed space, see also: S. Borsella, L'architettura, le trasformazioni e i restauri dalle origini alle soglie del XXI secolo, in: *Il restauro della Cappella degli Scrovegni: indagini, progetto, risultati*, ed. G. Basile, Geneva 2004, pp. 171–182, esp.173–174. A function as a dining hall or chapter house, as was propagated early on, is out of the question. See: Federici, *Istoria de'Cavalieri Gaudenti*, vol. 1 p. 363

into the enclosure of the planned monastery through the basement of the church. At that time, access must have been planned not from the side of the palace but from the other side. In the framework of the reduced plan, it became an obvious step to use the site as a mausoleum, whether to house floor or wall tombs.[102]

In this case the two painted cenotaphs would have functioned as a visual link between the church and the graves themselves and would have been a central element for the liturgical commemoration of the founder and his wife. One could possibly have been intended as the monument to Enrico and the other as that to his wife Jacobina d'Este. In this case, the large central fields of the sarcophagus fronts were left blank for inscriptions; the monument to Bishop Ranieri shows an epigraph in this place (fig. 21). And just like the niches and slabs, the pictures above should be read as counterparts. This is shown – as Theodor Hetzer and Mikhail Alpatov have pointed out – by the mirror-image yellow-red colour scheme alone.[103] The right hand structure, i.e. the niche on the Epistle side of the church with the representation of the Visitation of Mary by Elizabeth – a theme that brings together ideas of motherhood and redemption – would be assigned to the wife and (future) mother. The left hand niche, i.e. the one on the more distinguished Gospel side of the church, which is combined with a strictly male theme, would thus have been intended as the tomb of Scrovegni himself. We will come back to the fact, that this male theme is the Hiring of Judas, and that where on the female side the fertile body of Mary appears, on the male side the bag with the blood money is visible.[104] It will only be said here that for Ursula Schlegel in her 1957 article, which shaped research on the Arena Chapel more than any other, the Judas image on the triumphal arch is the key to the interpretation of the entire picture programme of the church. Just as Judas betrayed Christ for money, so the usurer betrays his neighbour. According to Schlegel the programme of the decoration as a whole is permeated by the young Scrovegni's remorse about the usurious sins of his father for which Dante made the old man immortal.[105]

In any case, the idea that the triumphal arch is the place where the meaning of the picture cycles and their relation to reality are produced is convincing. *Meaning*, since placing the Annunciation at the centre, explicates what the *raison d'être* of the foundation is, namely

102 As examples of lower churches or large crypts that served as burial places in the decades around 1300, the complexes in the Franciscan churches of Santa Croce in Florence and San Fermo Maggiore in Verona can be mentioned.

103 Th. Hetzer, *Giotto – seine Stellung in der europäischen Kunst*, Frankfurt 1941, pp. 158–159. M. Alpatoff, The Parallelism of Giotto's Paduan Frescoes, *The Art Bulletin* 29, 1947, pp. 149–154.

104 Cf. A. Derbes and M. Sandona, Barren Metal and the Fruitful Womb: The Program of Giotto's Arena Chapel in Padua, *The Art Bulletin* 80, 1988, pp. 274–291.

105 Schlegel, Zum Bildprogramm der Arena Kapelle. English translation: U. Schlegel, On the Picture Program of the Arena Chapel, in: J.H. Stubblebine, *Giotto: The Arena Chapel Frescoes*, New York and London 1969, pp. 182–202.

the feast of the Annunciation. And this pictorial theme is joined to others that have to do with the founder, his life, and his grave. *Relation to reality*, in that the painter makes possible complementary forms of experience using different modes of representation, which certainly became even more gripping through the liturgy: on Marian feasts, and especially on Annunciation Day, visitors had the opportunity to see the Sending of Gabriel as if it were happening in that moment. And they were able to witness the Annunciation taking place in the chapel, not as a play depicted in painting, as was claimed,[106] but as an artificial reality.

THE LIVES OF MARY AND JESUS

The pictorial decoration in the nave of the Arena Chapel is so familiar to art lovers that it is difficult for them to notice its peculiarity (fig. 22, 23). The fact is, however, that there is no other sequence of New Testament pictures which, in more than 30 episodes, recounts the events from the prehistory of Mary's birth to the event of Pentecost – and so one wonders whether it is not superficial to treat them as a single continuous cycle following the first impression of the decoration. In contrast, Giuseppe Basile, for example, proposed a division into four sections: The story of Joachim and Anna (six pictures from the Rejection of Joachim's Offerings to the Meeting at the Golden Gate, i.e. the top row on the right, the Eremitani-side wall), the Life of the Virgin (eight pictures from the Birth of Mary to the Annunciation, i.e. the upper row on the left, the palace side wall, and ending in the upper zone of the triumphal arch), the Life of Christ (twelve images from the Visitation to the Expulsion of the Traders from the Temple, i.e. starting with the right hand image in the middle zone of the triumphal arch plus the middle row on both walls), the Passion (twelve images from the Hiring of Judas to the Pentecost image, i.e. starting with the left image of the middle zone of the triumphal arch plus the lower row on both walls).[107] This seems plausible but is nevertheless arbitrary in terms of content and reading. For example, a Joachim and Anna cycle would be relevant only if understood as part (let us say as the first chapter) of a Life of the Virgin. And the Annunciation can be understood more easily as the first climax of a biographical narrative about Mary than – according to Basile – as its ending. Her (re)active role in Giotto's fresco fits in well with the former reading; she has knelt down and in this way gives her consent to continue the story: "Behold the handmaid of the Lord; be it unto me according to thy word" (Luke 1: 38).[108] Likewise, it could unsettle the pious users of the picture cycle if Giotto had opened

106 L. Jacobus, Giotto's Annunciation in the Arena Chapel, Padua, *The Art Bulletin* 81, 1999, pp. 93–107. J. Tripps, *Das handelnde Bildwerk in der Gotik*, Berlin (2) 2000, p. 92.

107 G. Basile, *Giotto: The Arena Chapel Frescoes*, London and New York 1993.

108 R. van Marle, *Recherches sur l'Iconographie du Giotto et du Duccio*, Strasbourg 1920, pp. 55–

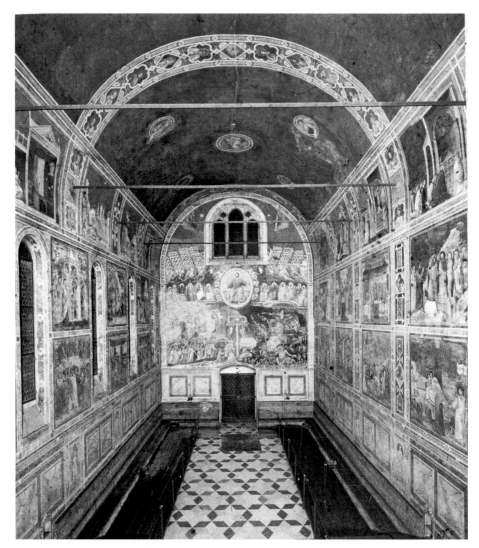

Fig. 22: Arena Chapel to the west (palace side on the right, Eremitani side on the left)

the important section of the Passion with the Hiring of Judas, which is not well established as a pictorial theme. One can compare the Arena Chapel frescoes with the similarly

60. O. Pächt, Künstlerische Originalität und ikonographische Erneuerung, in: id., *Methodisches zur kunsthistorischen Praxis: Ausgewählte Schriften*, Munich 1986, pp. 153–164.

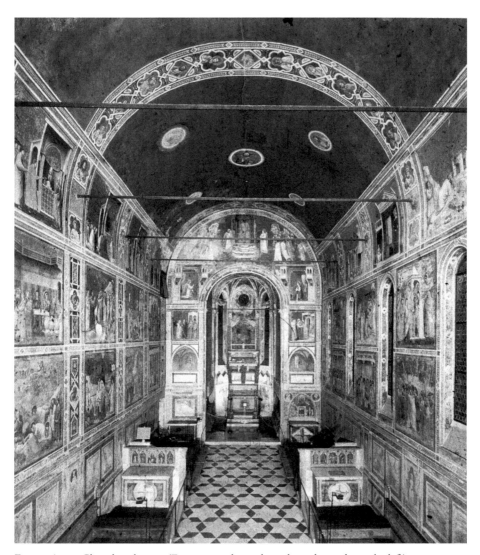

Fig. 23: Arena Chapel to the east (Eremitani side on the right, palace side on the left)

extensive inventory of painted scenes in Duccio's Maestà for Siena Cathedral. The specific organisation of this polyptych (front, back, predella, crowning) ensures easier legibility. Here the Passion (back of the main panel) begins with the Entry into Jerusalem, while the Life of Mary (front of the predella) ends with the episode of Christ Disputing with

the Doctors.[109] With regard to the Arena Chapel, however, it should be noted that those responsible could not leave it to chance which scenes appeared at the triumphal arch and thus at the most visible position in the space.

Giotto's sequence of paintings is probably best understood by starting from a concept with two main parts, analogous to the vaulting decoration, which is separated into a Marian bay in the west and a Christ bay in the east, thus dividing the space between the two main figures not only within the cycles but also within the conceptualisation of piety behind them. The first and more extensive section is the Life of Mary with 21 fields: It begins with the Expulsion of Joachim from the Temple and ends with the scene showing Christ Disputing with the Doctors, i.e. it includes the top row on both walls, plus three of the four scenes on the triumphal arch, plus the middle row on the Eremitani side wall, plus the first image of the middle row on the palace side wall. Mary's childhood and thus the role of her parents was given so much weight for two reasons. First, in a Marian Church, it is natural to provide a Life of the Virgin that drew on all the traditions regarding her (which at that time meant all knowledge about the Virgin) and in this way could compete with narratives about Christ. The standard of comprehensiveness to which such narratives in the medium of mural painting would be held was the New Testament cycles of the great Roman basilicas. The cycle in Old Saint Peter's had, for example, 43 pictures.[110] Secondly, it was essential to have the Annunciation, the event that represented both the spiritual use made of the Arena by the Paduans and the central event of Mary's life, appear on the triumphal arch. This meant that the prelude to the Annunciation had to fill the complete upper register on both walls of the nave, and comprise a total of twelve images. There is ample evidence that the painter had to protract the beginning of the Marian cycle: He dedicated an entire picture to a short sentence from the Pseudo-Matthew Gospel (ii, i), which tells of Joachim's unspectacular activity immediately after his expulsion from the temple: "And did not return to his house, but went to his flocks" (fig. 59). One also wonders whether the story with the rods that Mary finally brings into Joseph's care could not have been told in fewer than three pictures (fig. 352). Giotto's pupil Taddeo Gaddi later showed in the Baroncelli Chapel of Santa Croce in Florence how it was possible to narrate the story using only one image.

The picture of Mary's Return to her Parental Home follows this somewhat redundant triad and helps to integrate the Annunciation into the cycle without diminishing its prominent position in the overall programme. The procession of the temple virgins moves towards a building decorated with a palm leaf, in front of which musicians have

109 These considerations are based on John White's reconstruction of the Maestà: J. White, *Duccio: Tuscan Art and the medieval workshop*, London and New York 1979, pp. 80–134.

110 J. Garber, *Wirkungen der frühchristlichen Gemäldezyklen der alten Peters- und Pauls-Basiliken in Rom*, Berlin and Vienna 1918.

The Lives of Mary and Jesus 79

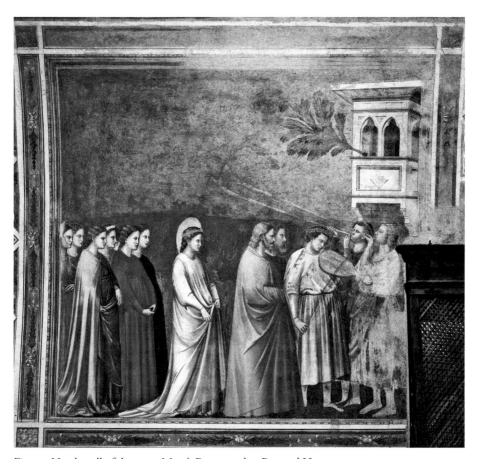

Fig. 24: North wall of the nave: Mary's Return to her Parental Home

lined up. It is represented by only one motif, a Gothic oriel, which with its consoles and tracery windows exactly resembles the four Gothic oriels in the architectural setting of the Annunciation scene (fig. 24, 18, 19). This defines the parental home as the same building in which Gabriel will appear, speak the words of the Annunciation to which Mary will consent, and binds the triumphal arch scene into the cycle despite its divergent status.

That the images following the Annunciation are to be read not so much from the point of view of an infancy narrative of Christ as from that of a life of the Virgin is evident in the last two of them: The female protagonist in the Massacre of the Innocents is a mother in a coat originally of the same blue that Mary regularly wears (fig. 25). Giotto makes her clutch her child to herself, just as Mary clutches Christ to herself in the preceding picture

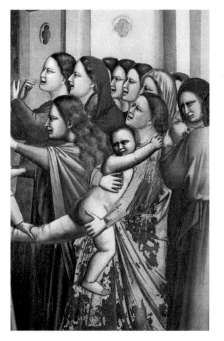 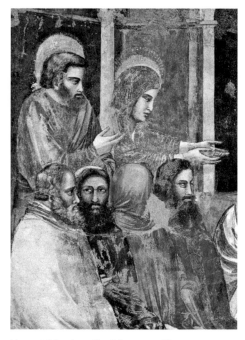

Fig. 25: South wall of the nave: The Massacre of the Innocents, detail

Fig. 26: North wall of the nave: Christ among the Doctors, detail

of the Flight into Egypt. The woman also suggests a comparison with the Blessed Mother in terms of content. For if the children of Bethlehem were the first martyrs who preceded Christ in his Passion (this has been the view since early Christian times), it was the mothers of Bethlehem who anticipated Mary's distress.

Likewise, when reading the following picture that shows Christ Disputing with the Doctors, one should be aware where the accent is placed. Although Christ is enthroned in the centre, it is Mary, with her arms outstretched, who captivates the eye (fig. 26). The textual basis for this is probably not the passage in Luke (2: 45–50) but the narration in the fourteenth chapter of the *Meditationes Vitae Christi* with the longer dialogue between Mother and Son. It ends with Christ's joyful agreement to return to Nazareth.[111] There he will finish his youth and only as an adult, after his baptism by John, will he appear in public again. The scene is quite a natural conclusion to a cycle of the life of Mary.

The other basic component of Giotto's pictorial narration is the Passion cycle of thirteen episodes. As with Duccio's Maestà, it begins with the image showing the Entry into Jerusalem (cf. fig. 75). It comprises the last two pictures of the middle row on the pal-

111 *Meditaciones vite Christi*, p. 63.

The Lives of Mary and Jesus

ace-side wall, plus one picture on the triumphal arch, plus the two lower rows on both walls. That it begins with the Entry into Jerusalem is also suggested by the liturgy: Palm Sunday, on which Christ's entry is remembered with a procession, opens Holy Week and signals the last phase of Lent. In addition, Palm Sunday seems to have had a special meaning for the founder of the Arena Chapel. As is known, the inscription from 1303 records that Palm Sunday and the Annunciation of Mary were both celebrated in March that year and that the Annunciation of Mary had thus taken place during Lent (A 3). Strictly speaking, the Annunciation was commemorated on a Monday with the procession into the Arena and the *sacra rappresentazione* there, while *Dominica in Palmis* was celebrated the following Sunday with another procession that was at least as solemn. Under these circumstances, the liturgical memory of the 33 years of Christ's carnal existence was condensed to one week, plus another week for the Passion and Resurrection. The situation was even more dramatic in 1301, when the Feast of the Annunciation and Palm Sunday fell on two consecutive days. An inversion occurred in 1304, however, when the Feast of the Annunciation was celebrated on Wednesday during Holy Week and thus three days after Palm Sunday. In this case, the Incarnation was remembered after the commemoration of Christ's Passion had already entered its most intense phase. Therefore Giotto's picture showing the entry into Jerusalem is not only a fitting beginning of a Passion Cycle, but also gives an idea of what might have been the motivation for the introduction of such a detailed and thoroughly integrated Passion Cycle in a Church dedicated to Mary: the intertwining liturgical commemoration of the Incarnation of Christ on the one hand and his Passion on the other, alongside which one could expect a deeper insight into the connection between both events given the overlapping of the liturgical calendar.

Seen in this light, the Passion cycle does not begin, as Basile suggests, at the triumphal arch with the Hiring of Judas, but two images before. However, this made it possible to place the Hiring of Judas at the arch, below the Annunciation angel and above the Gospel-side cenotaph, and to create the extraordinarily intriguing constellation of images to which we will return.

Before this, however, it must be admitted that the separation of the programme into a Life of Mary ending with the representation of Christ Disputing with the Doctors and a Passion cycle beginning with the Entry into Jerusalem makes three scenes outliers. The Baptism of Christ, the Marriage in Cana and the Raising of Lazarus have remained unconsidered. One could explain them as a short report about the public activity of Christ, as it existed in, indeed, nine pictures also at the Maestà (on the frontside of the *predella*). But perhaps one should read the three pictures in Padua more in the sense of a transposition. In this case it is about the transformation of a Marian sequence, which also has capacity for a Christological reading (from the Annunciation up to the scene of Christ Disputing with the Doctors), into a Christological sequence, the Passion, which also has capacity for a Marian reading in the sense of *compassio* (in the Bearing the cross, Cruci-

fixion, Lamentation scenes). Accordingly, I would like to interpret the three scenes in such a way that they are neither an independent cycle nor belong to one of the two major cycles. The reason for the choice of each of the three pictures was different. Only Christ's Baptism is obvious; it is an event that cannot be missing even in the narrowest selection of scenes from the life of Christ outside his infancy and the Passion. The Marriage in Cana, on the other hand, was the occasion on which, according to the *Meditationes Vitae Christi*, John was called to be an apostle: Together with Catherine, John is co-patron saint of the chapel. Mary's prominent role at the banquet table, described in the Bible, explained and embellished in the *Meditations* and emphasised by Giotto (fig. 47), may also have been important: it is at Mary's request that Christ works the miracle. Finally, the third scene, the Raising of Lazarus, is a theme that fits particularly well into a burial church, since the hope of resurrection and of Christ's intervention is concretized in the event.

From a historical point of view, however, the triad probably has a uniform origin: Christ's Baptism, the Marriage at Cana and the Raising of Lazarus also appear in the clerestory of the upper church of San Francesco in Assisi and represent there, within a relatively short Christological cycle, the public ministry of Jesus between infancy and the Passion.[112] Since the young Giotto had probably been involved in this painting campaign (p. 208–225), and since the artist was therefore more closely associated with the model than the client, the introduction of the three pictures can also be read as a reference to Giotto's collaboration in the conception of the Arena Chapel programme.

Considering the presence of the picture triad against this background, one might again speak of *one* cycle covering the walls of the chapel, but one that undergoes a profound shift of focus in the three pictures: from the Marian to the Christological, from the theme of the Incarnation to that of the Passion, from a celebration of the patron saint of the Church to the fundamental act of redemption, which is the prerequisite for the hope manifested in the image of the Universal Judgment.

However, this cycle is still not Marian enough for a Marian church. And that is what we must discuss, before turning to the details in the pictures. What is missing is the visual display of the death and glorification of the Mother of God, which literally crowned Duccio's Maestà. On its front above the main picture there were six panels with the events of Mary's last days on earth, while the lost central structure probably showed her ascension and coronation. In Padua one can now refer to the frescoes on the walls of the square bay of the choir, which, although not Giotto's works, are dedicated to precisely these themes.[113] On the left (palace side) wall we see (from top to bottom): the Annunciation of

112 G. Ruf, *Die Fresken der Oberkirche von San Francesco in Assisi: Ikonographie und Theologie*, Munich 2004, p. 172.

113 S. Knudsen, *An Investigation of the Program of the Arena Chapel: Mariological Considerations*, Ph. D. The University of Texas at Austin 1986, pp. 171–219. The author emphasizes the overall Marian character of the programme and treats the choir frescoes in detail.

Fig. 27: Arena Chapel, north wall of the choir Fig. 28: Arena Chapel, south wall of the choir

the Death of the Virgin, the Gathering of the Apostles and the Death of Mary (fig. 27). On the right (Eremitani side) wall, in contrast, we see (from bottom to top): the Burial of Mary, her Assumption, and her Coronation (fig. 28). These scenes, which illustrate the extraordinary status of the church's patron amongst women and saints, belong to a decoration campaign which only took place after Giotto's departure from Padua. They are the work of a painter who endeavoured to realise some of Giotto's ideas and who also had many Giottesque models at his disposal – and not only from the nave of the Arena Chapel – but who did not succeed in creating cohesive pictorial systems in Giotto's spirit. For the dating, it should be noted that Scrovegni's tomb, together with the choir polygon into which it is integrated, is part of a further redesign of the chapel, which was probably made in response to the foundation of the Augustinian Priory in 1317 (A 13).

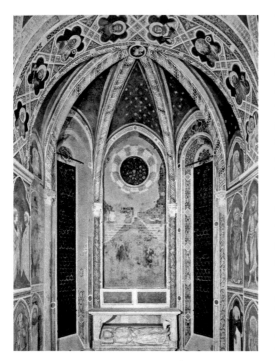

Fig. 29: Apse with Enrico Scrovegni's tomb monument

The lower walls of the square bay and the polygonal apse are furnished with blind arcades, which provided for the installation of choir stalls. Thus, the setting was created for a tomb, the liturgical care of which was entirely in the hands of clergymen celebrating services in the choir. As the ornamental parts of the frescoes show, the painted decoration of the square bay and apse is a unity that is based on the existence of the tomb (fig. 29). However, the monument can only be dated very roughly. If it was not erected together with the polygon, i.e. around 1317, then any date up to 1336 is possible: the wording of the testament drawn up in that year by Scrovegni in Venice implies the existence of a tomb in the chapel ready to receive a body (A 17). The fact that the founder lived in exile from 1318 does not necessarily mean that nothing happened in the chapel during the twenties and thirties. Documents show that Scrovegni kept in touch with Padua and his relatives there through the clerics active in and around the Arena, namely through Raynerius, Prior of the Augustinian Canons, and through Angelinus, priest of San Tomìo, and that money flowed along these means (A 16). If the Arena Chapel was originally intended to improve Enrico's post-mortem existence, then after 1318 the institution was engaged in improving the family's economic flexibility under the conditions of exile. In this situation, the possibility cannot be excluded that Scrovegni acted as commissioner in his foundation through intermediaries such as the two clerics.[114]

The addition of the polygonal apse was accompanied by the demolition of the original

[114] For the dating of the tomb: W. Wolters, *La scultura Veneziana gotica (1300–1460)*, 2 vols., Venice 1976, Cat. 29: According to Wolters, the architecture of the tomb was created before 1320, but the reclining figure, as it shows the patron deceased, only after 1336. As little as the first assumption, the second seems to me to be compelling. For the dating of the frescoes cf. *Padova: Basiliche e chiese*, vol. 1 p. 262: Claudio Bellinati dates the frescoes according to the canonization of Thomas Aquinas (1323), who is represented in the polygon. As is well known, however, such dates do not provide a reliable *terminus post quem*.

east wall of the choir. If frescoes from the Giotto campaign had been there, they fell victim to this measure. Hand in hand with the choir polygon was the sacristy built with an oratory above. Its window, with a view to the main altar, pierced the previously closed north wall (fig. 27) and damaged any paintings in the upper zone. All this would have affected the fresco programme of the choir to such an extent that a new version on two instead of three walls was inevitable. It can therefore be assumed that Giotto's painting of the Arena Chapel included a Marian finale in the choir. Several years after the completion of the decoration as a whole, in 1317 or later, Enrico Scrovegni sacrificed Giotto's version of this finale to the restructuring of the institution, the choir architecture, and the founder's tomb.[115] Perhaps immediately afterwards, perhaps a few years later, he had the new paintings in the choir made and removed what might have been left of the Giotto images on the side walls. The Giottesque motifs in the existing frescoes are possibly reflections of these original paintings.

JUDAS

When the feast of the Annunciation falls in the Lenten season, as in 1304, when it was celebrated on the Wednesday before Good Friday, two texts from the Gospels are read during Mass, instead of one; this is liturgical rule today and was also so in medieval Padua. One of them relates to the Annunciation and is the regular reading on 25 March (Luke 1:26–38): "And in the sixth month the angel Gabriel was sent from God unto a city of Galilee, named Nazareth, to a virgin ..." This corresponds to the representation on the triumphal arch at the top (pl. II, fig. 17): We see there not only the Annunciation, but also the sending of Gabriel. In 1304, however, the first reading had been Luke 22:1-71 as the pericope for Lent:[116]

> *Now the feast of the unleavened bread drew nigh, which is called the Passover. And the chief priests and scribes sought how they might kill him; for they feared the people. Then entered Satan into Judas surnamed Iscariot, being of the number of the twelve. And he went his way, and communed with the chief priests and captains, how he might betray him unto them. And they were glad, and covenanted to give him money. And he promised, and sought opportunity to betray him unto them in the absence of the multitude ...*

115 This is also how Irene Hueck argues: Hueck, Zu Enrico Scrovegnis Veränderungen der Arenakapelle, pp. 284–285.

116 The practice can be found in the pre-Tridentine liturgy of Padua: *Missale Pataviense cum additionibus benedictionum cereorum, cinerum etc.*, Venice 1522.

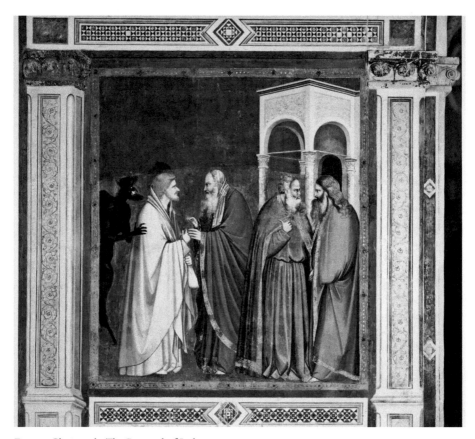

Fig. 30: Choir arch: The Betrayal of Judas

The text of the pericope continues until the burial of Christ. But here the beginning is particularly important, the report on Judas. This narration is likewise depicted on the choir arch, and follows exactly – as can be seen from Satan's appearance – the version of Luke that is read on the Wednesday of Holy Week (fig. 30).

Did the readings of 25 March 1304 generate the programme of the triumphal arch and ultimately the overall programme in its existing form? This question cannot probably be answered definitively. But it can be pointed out that the year that followed 25 March 1303, the date to which the first consecration inscription refers, is the most likely period for the introduction of the reduced plan and hence for the conception of the decoration. Giotto's activity was thus indeed marked by the expected (or freshly remembered) Annunciation Day of 1304.

But the constellation of images can also be experienced as meaningful independently from the two texts: it brings the remembrance of the Incarnation on the one hand and the

suffering of the incarnate one on the other to an overlap that is relevant to the founder's grave site. For Judas can be understood as a graphic antithesis to what a founder is: the one proves to be the worst possible merchant (*mercator pessimus*, as Judas is called in a responsorial sung in the Holy Thursday Mass),[117] because he sells the incarnate God for money, the other makes the best possible trade (as Chiara Frugoni put it)[118] by exchanging money, always potentially sinful, for good works. One despairs of his sin and, when he commits suicide, commits an even greater one, while the other, through his good works, expresses confidence in the grace of God. By associating himself at the site of his tomb with Judas, but simultaneously offering to Mary and the Paduans a church endowed with indulgences, Scrovegni shows that he is as contrite as he is hopeful and thus optimally qualified for redemption. Where the author of the *Legenda Aurea* explains that hope is a crucial condition for salvation, he states: "for although Judas confessed his sin, he did not hope for pardon and therefore did not obtain mercy"[119] – a view that can be traced back to the church fathers.[120] In contrast, Scrovegni showed with how much confidence he looked forward to his salvation – not only through the act of founding the church, but also by having it recorded by Giotto with the foundation scene in the context of the image of the Last Judgement.

That for Scrovegni (and Giotto) the figure of Judas was a natural alternative to the founder's existence and not a bleak image of horror is made clear by the form of Judas' depiction on the triumphal arch. The painter presents a very individual and lively physiognomy in profile (fig. 31). The features are just as far or even further removed from the normal type of Giotto's faces as are the portraits of Scrovegni and the cleric on the west wall. Whether the stereotype of the Jew as it occurs in Spain, France and Germany in the 13th and 14th centuries is meant here, is difficult to say.[121] In any case, it is not a grimace, and Judas has nothing truly repulsive about him. This becomes especially clear in the juxtaposition with the maliciously frowning priest. If Judas and Jew are merged together, then it is not in the sense of a renounced co-humanity. Judas only appears truly evil and thus humiliated when he performs the act of betrayal with pointed lips in the image of Christ's Arrest, but there it is more about narrative drama than a programmatic claim (fig. 62).

117 M. Collins, Mercator Pessimus? The Medieval Judas, *Papers of the Liverpool Latin Seminar* 3, 1983, pp. 197–213.

118 Ch. Frugoni, *L'affare migliore di Enrico: Giotto e la cappella Scrovegni*, Turin 2008.

119 "… nam etsi Iudas peccatum suum confessus fuerit, tamen non in spe venie et ideo non est misericordiam consecutus." *Legenda Aurea*, ed. Maggioni, p. 128

120 P. Dinzelbacher, *Judastraditionen*, Vienna 1977, p. 66.

121 Cf. M. Barash, *Giotto and the Language of Gesture*, Cambridge 1987, pp. 159–162, M. Shapiro, Frontal and Profile as Symbolic Forms, in: id., *Words, Script, and Pictures: Semantics of Visual Language*, New York 1996, pp. 69–112 and B. Blumenkranz, *Le juif médiéval au miroir de l'art chrétien*, Paris 1966.

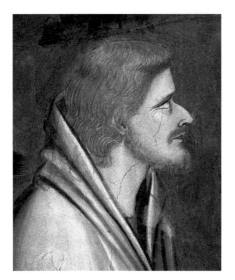

Fig. 31: The Betrayal of Judas, detail

Fig. 32: West wall: The Last Judgment, detail from the hell scene with Judas

In contrast, Judas' presence in the image of the Last Judgment in hell is undoubtedly programmatic (fig. 32). It seems questionable, however, whether this is seamlessly integrated in the same programme as the Judas scene on the triumphal arch and whether the depictions there will only become precisely legible when the hell scene is properly understood (as Ursula Schlegel believed).

Judas dangles at the left of the entrance of the great black cave, where the damned arrive. According to Matthew (27: 3–10) he is a hanged man who has judged himself; but following the Acts of the Apostles (1: 15–26) the body is additionally torn open and the intestines spill out, which happened by an accident that shows how the traitor was judged by God. The blending of the two types of death is frequent in Judas iconography and serves to increase the horror.[122] Next to Judas, three other men hang, about whom it is clear that they are not suicides. They were hung by devils on the strings of their moneybags. In Giotto's hell, the moneybag is a common prop. In this and in Judas' appearance both on the west wall and on the triumphal arch, Schlegel has found confirmation of the idea, emerging in the mid-14th century and popularized in the 16th century (see commentary to A 15), that Enrico Scrovegni was focused on the evil deeds of his father Reginaldo when building and endowing the chapel.[123]

122 *Lexikon der christlichen Ikonographie*, ed. E. Kirschbaum et al., Freiburg 1970, vol. 2 pp. 446–447.
123 Schlegel, Zum Bildprogramm der Arena Kapelle, pp. 128–129.

Judas

That one of the motivations of Scrovegni's foundation was to "pay" for the wealth his family had acquired over generations in various circumstances is clear from his testament and will not be disputed. It reads (A 17):

> *I command, desire, and order that all my unjustly acquired property – if such is found and has not already been returned – and all the unjustly acquired property of my grandfather, the late* dominus *Ugolinus, and my father, the late* dominus *Raynaldus Scrovegni, and also the unjustly acquired property of my brother, the late* dominus *Manfredus Scrovegni, and his son Manfredus the younger to that third which I have inherited, and that absolutely everything which has been unjustly acquired* [maleablata] *and which I am obliged to reimburse according to the law shall be returned and repaid, with all expenses incurred thereby, and to all those who demand it, without legal action, dispute, and without legal proceedings, without conditions or contract.*

However, such a safety clause ordering the return of the *mala ablata* was in line with the conventions of testaments at the time.[124] What the passage shows in addition to this is that Enrico's ideas about sin were not fixated on Reginaldo, as one would expect if one follows Dante and his Paduan readers.

It should also be pointed out that it was not Giotto in Padua who introduced Judas and the subject of venality and betrayal into the iconography of the Last Judgement. The figure was taken from the mosaic in the Florentine Baptistery, which was the authoritative model for the entire hell scene. And Judas' Paduan appearance is more restrained compared to the Florentine: in the mosaic the hanged man is positioned more conspicuously (fig. 33); he is also the only one among the hell dwellers to be honoured by an inscription there.

Besides the obsession with the purse, there is another fixation in the Paduan hell: the one with the penis.[125] Numerous male genitals are presented in large size and are maltreated

124 Frugoni, *L'affare migliore di Enrico*, pp. 426–429 (A. Bartoli Langeli). See also: L. Maino, *50 testamenti medioevali nell'Archivio Capitolare di Trento (secoli XII–XV)*, Ferrara 1999, p. 24 with examples from 1348 and 1398; G. Ceccarelli, L'usura nella trattatistica teologica sulle restituzioni dei male ablata (XIII–XIV secolo), in: *Credito e usura fra teologia, diritto e amministrazione: Linguaggi a confronto (sec. XII–XVI)*, ed. D. Quaglioni, G. Todeschini, and G.M. Varinanini, Rome 2005, pp. 3–23. Fundamental: K. Weinzierl, *Die Restitutionslehre der Frühscholastik*, Munich 1936.

125 G. Lorenzoni, Su alcuni aspetti iconografici dell'Inferno di Giotto nella Cappella Scrovegni di Padova, *Hortus Artium Medievalium* 4, 1998, pp. 155–159. Cf. also G. Lorenzoni, I circoncisi nell'Inferno della Cappella degli Scrovegni di Padova: una curiosità iconografica, *Atti e memorie dell'Accademia Patavina di Scienze, Lettere ed Arti* 108, 1995/96, III pp. 207–216.

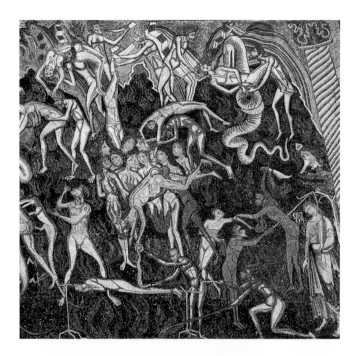

Fig. 33: Florence Baptistery: The Last Judgement, right section of the hell scene

Fig. 34: Hell scene, detail

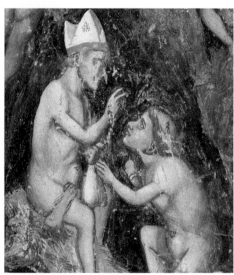

Fig. 35: Hell scene, detail

(fig. 34). To the same degree and with the same radicalism with which it treats usury, the scene denounces unchastity and exposes the appropriate sinners to ridicule.[126] The cruel punishment of sexual misconduct was also observed by most travellers to hell in the early and high Middle Ages. It is, in other words, commonplace in descriptions of the otherworld.[127] If, in the post-Franciscan times, this was accompanied by the punishment of economic misconduct, a biographical explanation is not necessarily required. The Paduan hell does not specifically reflect the feeling of guilt of being the son and heir of a Reginaldo, but certainly suggests Christ's words about the rich man, the camel, and the eye of the needle. In addition, the most clearly formulated financial sin in Padua, is that of simony: on a devil in the middle of hell a bishop sits naked except for the mitre; he has received money from a naked priest and in return gives him the blessing or grants absolution (fig. 35). The scene is certainly not to be understood in an anticlerical sense and aims rather to teach that pastoral activity in general and especially the pardoning of sins cannot be bought, and whoever tries to buy such services or gets paid for them commits a mortal sin.

It is therefore assumed that the image of Judas at the triumphal arch of the Arena Chapel referred to Enrico himself, to his sin and to his activity as a founder. If it had a matter of concern for him to also show his father, who had been dead for fifteen or more years, in the role of as a second Judas, then an image at the place of Reginaldo's tomb would have been the appropriate medium. In all probability Reginaldo's tomb was in or near the cathedral; he had donated a chapel and an annual celebration *pro defunctis* there and had already made provisions for his postmortem well-being. [128]

Peter Cornelius Claussen asked whether Scrovegni appeared to his contemporaries as an eccentric.[129] Self-incrimination as Judas is apt to support this view. It is true that the Judas theme also dominates the Passion cycle at the rood screen to the west choir at Naumburg, where the statues of the founders are placed, but the founders did not portray themselves as Judas. Instead, the Naumburg Cathedral clergy showed benefactors of the Cathedral who had been dead for 150 years or more and were to be brought back to living memory with a dramatic gesture.[130] The use of the Judas figure as a self-image is far outside the norm.

126 B. Cassidy, Laughing with Giotto at Sinners in Hell, *Viator: Medieval and Renaissance Studies* 35, 2004, pp. 355–386.

127 *Visions of Heaven and Hell Before Dante*, ed. E. Gardiner, New York 1989, p. XVII. The thesis that the erotic scenes in the Paduan Last Judgement are metaphors for the punishment of usury is therefore hardly convincing: Derbes und Sandona, Barren Metal and the Fruitful Womb, p. 277.

128 Bellinati, *Nuovi studi sulla Cappella di Giotto all'Arena di Padova*, p. 20.

129 Claussen, Enrico Scrovegni: Der exemplarische Fall, p. 235.

130 M.V. Schwarz, Retelling the Passion at Naumburg: The West Screen and Its Audience, *Artibus et Historiae* 51, 2005, pp. 59–72.

Fig. 36: North wall of the nave, decoration of the door from the palace, detail

Moreover, Giotto's Hiring of Judas not only refers to Scrovegni's painted cenotaph, which was unmarked during the founder's lifetime (and would remain so), but also functions as the interface between the chapel and the palace. One entered the chapel from the palace through a door in the corner below the picture (it is reopened today and accessible to visitors by entering through a climate lock); in the corner above there is a window, now bricked up, which would have allowed a view into the chapel from a room above the door, i.e. from a kind of private oratory. This means that Judas appears precisely where the pride of the founder and the tact of the painter or, let us say, the cleverness of both should have prevented him from appearing.

"The virtues of society are vices of the saint". Pride and tact are values of society: according to Ralph Waldo Emerson's principle they can thus easily be vices in the ethical system of religion. The spiritual revaluation of values is also a theme of the New Testament. According to Paul (1 Corinthians 3: 19) "the wisdom of the world" ("sapientia saeculi") is nothing but "foolishness with God". Indeed, a fool and (probably) a personification of *sapientia saeculi* are depicted in two medallions on the inner lintel above the same door from the palace[131] (fig. 36). Placed immediately next to the door is the allegory of folly (*stultitia*, fig. 91). It is part of the famous cycle of virtues and vices that decorates the pedestal zone of the side walls.

What really matters is true *sapientia*, wisdom that is focused on things in the hereafter. A personification of this idea appears on the wall opposite the door and is thus seen by those entering from the palace as the first image of the cycle of virtues and vices, and as

131 G. Schüßler, Giottos visuelle Definition der "Sapientia Saeculi" in der Cappella Scrovegni zu Padua, in: *Opere e giorni. Studi su mille anni di arte europea dedicati a Max Seidel*, ed. K. Bergdolt and G. Bonsanti, Venice 2001, pp. 111–122. Cf. the interpretation, similar in tendency, in A. Ladis, The Legend of Giotto's Wit, *The Art Bulletin* 69, 1986, pp. 581–596. Cf. also S.G. Mieth, Per i due tondi soprastanti l'antico accesso alla Cappella degli Scrovegni, *Bollettino del Museo Civico di Padova* 78, 1989, pp. 15–20. The positive reading suggested there takes too little account of the fool's appearance. Finally, and based on Mieth's thesis the equally positive interpretation of the medallion as an allegory of *circumspectio*: E. Frojmović, Giotto's Circumspection, *The Art Bulletin* 89, 2007, pp. 195–210. The fact that Francesco da Barberino adopted the figure does not say that he used it with the same meaning.

the first image in the chapel in general (fig. 79). The picture will be discussed in detail later, but here it may be pointed out how this personification recoils from what she sees in her mirror. This fright is a motif that admonishes the palace dwellers and users of the chapel to face unpleasant truths such as a possible future in hell because of their own similarity to Judas, their own *stultitia*, and their own inadequate, since merely secular, *sapientia*. Pious self-criticism and even inner self-chastisement is necessary if the foundation is to be counted as a good work in heaven.

THE PALACE CHAPEL

The link between palace and chapel is charged with signs of humility and contrition. This is evidence of the opposite of the Eremitani accusations regarding Enrico in their complaint of January 1305: that it had been vanity that had created the church in the Arena and made it the jewel that it is (A 5). Indeed, if the building is not only a gift to the Paduans and the good work of a man whose soul is burdened with power and wealth, but also a part of his palace (as it is indeed), then it suggests that the reproach of the friars is in the air and the founder does well to confront it before God and the community.

Little is known about the Arena Palace. When Albertino Mussato, chronicler and contemporary, recounts Enrico's escape, he describes the residence he left behind as a towering and spacious *palatium*, highlighting the splendour of the floors. However, he may have meant the residence in the city.[132] By contrast, Michele Savonarola in the mid-15th century is clearly describing the buildings in the Arena: in addition to the large chapel, which was, as he knows, donated by Scrovegni and painted by Giotto, he also mentions a residential edifice with many rooms and halls, in front of which there is a "round courtyard". This is the manège where, as Savonarola also knows, the Paduans gather on the day of the Annunciation to attend the "representatio Annuntiationis" (2.7.3). A large residential building has been visually documented there, starting in the late 16th century.[133] It occupied the northern curve of the Arena and formed the centre of a complex whose left wing was the chapel. This building probably really did go back to Scrovegni's time, perhaps even to that of the Dalesmanini, and may have been an extended version of the

132 Albertino Mussato, *De Gestis Italicorum post Henricum VII. Sette libri inediti*, ed. L. Padrin, Venice 1903, XII, 89. A. Mendin, Maddalena degli Scrovegni e le discordie tra i Carraresi e gli Scrovegni, *Atti e memorie della R. Accademia di Scienze*, CCXCVII, N.S. XII, 1895/96, pp. 243–272, esp. 251.

133 The oldest document showing the palace with sufficient clarity seems to be Giuseppe Viola Zanini's Padua Plan of 1599, conceived as a bird's eye view: S. Ghironi, *Padova – Piante e vedute (1449–1865)*, Padua (2) 1988, no. 13.

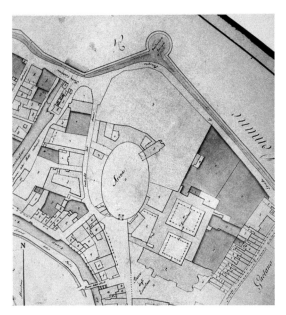

Fig. 37: Land Register Map (1811): Arena, Scrovegni Palace and Chapel, Eremitani Monastery

house mentioned in the 1300 contract of sale.[134] Little modified, it survived the centuries until it was demolished in 1827.

The cadastral plan of 1810/11 shows that the yard between palace and chapel was bridged by a hook-shaped walkway (fig. 37). This feature corresponds to damages and defects in the masonry on the northern wall of the chapel.[135] How old one considers the walkway to be depends on how reliable one considers the della Valle city map from the 18th century to be. It shows, instead of the hook-shaped bridge, a much simpler structure, which could have been a gate placed between the rear façades of the palace and the chapel. However, this plan is generally less detailed, and, unlike in the case of the authors of the cadastral plans, the owner of the palace did not need to grant access to its author. It can therefore be assumed that the situation recorded in the "Napoleonic" cadastral plan goes back to before the 18th century and, in fact, to the Scorvegni era. The walkway depicted there would have made it possible to reach the northern door to the chapel and the entry to the crypt from the palace. If the corridor was of two-stories, which is to be assumed, it also gave access to the lodge window above the door. Today this window is walled up, but it still has a wooden shutter, which appears in the fresco programme of the chapel as a disruption between the picture showing Mary's Return to her Parental House and the triumphal arch, i.e. the Annunciation scene (pl. II, fig. 24). The entrance to the upper floor of the sacristy, still visible on the exterior, was also reached via the upper floor of the corridor. The door, now walled up, led into a room that was probably created in the second decade of the 14th century and modernised in the 16th century; it has a second window to the chapel, which has already been mentioned and which provides a view not into the nave but into the choir[136] (fig. 27).

134 Cf. Zampieri, *La Cappella degli Scrovegni in Padova*.
135 *Carte Forcari sull'Arena di Padova: La "Casa Grande" e la Cappella degli Scrovegni*, ed. E. Bordignon Favero, Venice 1988, p. 25, *I catasti storici di Padova. XIX–XX secolo*, ed. I. Pavanello, Cittadella 2003, pp. 57–58. See: V. dal Piaz, La storia e l'architettura della Cappella, in: *La Cappella degli Scrovegni a Padova* (Mirabilia Italiae 13), Saggi, pp. 19–44.
136 *La Cappella degli Scrovegni a Padova* (Mirabilia Italiae 13), no. 345–349.

Whether the palace was completed in Enrico's time or later, it becomes clear how the residential and the cultic space were meant to interact in the Arena. First, direct access to the chapel from the palace was made possible so that the residents could attend the service in front of all the visitors to the church. Secondly, it was intended that they could follow the service unseen from a lofty oratory, which was also easily accessible from the palace. Probably the first option was made especially for male members of the household, while the second was intended for female members.

This situation is also revealing for the history of the building and the foundation. It is noticeable that from the box window into the nave there is no view of the high altar where it stands today. And the altar would also remain invisible from the window, if it were located to the west in the choir. Thus it is likely that the position of this oratory and the preserved opening still follow the disposition of the model plan, i.e. belong to the church with transept, as originally planned and presented in the picture of the Last Judgment. In this case, the window above the door was certainly not the only one that was to open into the church from the oratory. The space behind the window would have occupied the angle between the nave and the northern transept arm. From this room one would not only have been able to look into the nave, but also – through another opening in the western transept wall facing east – to see the altars in the sanctuary. From there the Scrovegni would have been able to observe every liturgical action in the chapel and thus would have been fully involved in the service of the friars or canons.

GIOTTO'S CHRISTMAS

How did Giotto conceptualize the more than thirty pictures on the long walls, which measure around 2 by 1.85 meters? And what were his intentions? Was it a matter of intervening in the visitor's reality, as can be observed at the top of the choir arch and in parts of the Last Judgement? One could also speak here of an extended reality. Was it about creating a visually simulated second reality, which appears as a documentation or imitation of the first – as in a photo or a landscape painting? Or was it about a visualization of the stories in order to promote their understanding – as in a picture book or a comic? These are relevant questions, because no agreement about the nature of what we call a picture was in existence at the time.

The most immediately recognizable representation in the cycle, which all modern viewers probably accept as a kind of testimony to a past reality, is the Christmas scene (pl. III). However, it may be that Giotto's contemporaries were less inclined to accept it as such. Perhaps there were visually educated people who found the concept speculative and unrealistic. What may have struck them most is the set of motifs that members of contemporary Western culture take for granted: the stable placed in a landscape. That Christ

was born in a stable and that an ox and donkey, which one likes to imagine as its original residents, were present, is at the heart of the popular Christmas stories and songs and forms the backdrop of the domestic or public manger scenes. One can also say: it belongs indispensably to what today (with a wink) is considered to be the "reality" of Christmas.

In Giotto's time, however, people either believed that Christ was born in a cave or within the city of Bethlehem and, to be precise, not in an inn there, "because there was no room for them in the inn" (Luke 2: 7). The former option is given by the apocryphal Gospels of Jacob (XVIII–XX) and Pseudo-Matthew (XIII–XV),[137] which did not lag behind the canonical Gospels in popularity and contributed no less than these to the canon of what was believed at the time (as is well known, the Apocrypha only became "apocryphal" during the Reformation and the Counterreformation).[138] Neither these two authors nor Luke and the other evangelists speak of a stable as the place of birth; Luke mentions a manger, i.e. a feeding trough, in which the new born child was put. It will soon be seen that a manger does in no way imply a stable. None of the authors mention the animals.

Instead, both ox and donkey belong to the characters of the Christmas account in the *Meditationes Vitae Christi* and thus to a then brand-new text.[139] Composed more or less simultaneously in Latin and *Volgare* in the Franciscan milieu of Tuscany, its utilization by Giotto in the Arena Chapel is among the earliest testaments to the existence of this book. Following Frank Jewett Mather, Max Imdahl and others have shown how Giotto continually used it in Padua.[140] However, the *Meditations* do not introduce a stable for an ox and

137 *Evangelia apocrypha*, ed. K. von Tischendorf, Leipzig 1876, pp. 1–50 (Jacobus) and 51–112 (Pseudo-Matthew). *Evangelia infantiae apocrypha / Apokryphe Kindheitsevangelien*, ed. G. Schneider, Freiburg 1995, pp. 125–135 (Jacobus) and 221–231 (Pseudo-Matthew).

138 D.R. Cartlidge and J.K. Elliott, *Art and the Christian Apocrypha*, London 2001, pp. 16, 18.

139 After the text had long been regarded as a product of the mid-13th century, conclusive arguments were found for its creation after 1298/99: E. Colledge, "Dominus cuidam devotae suae": a source for Pseudo-Bonaventura, *Franciscan Studies* 36, 1976, pp. 105–107. Since 1990 the possibility has been discussed that the work was only created in the mid-14th century: S. McNamer, Further evidence for the date of the Pseudo-Bonaventuran Meditationes Vitae Christi, *Franciscan Studies* 50, 1990, pp. 235–261. However, these arguments have proved to be unsustainable, so that a dating of the text in the years around 1300 remains probable: D. Falvay, St. Elizabeth of Hungary in Italian Vernacular Literature: Vitae, Miracles, Revelations, and Meditations on the Life of Christ, in: *Promoting the Saints: Cults and their Contexts from Late Antiquity until the Early Modern Period. (CEU Medievalia)*, ed. O. Gecser et al., Budapest 2011, pp. 137–150; P. Tóth, The Earliest Reference to the Meditationes Vitae Christi: New Evidence for its Date, Authorship, and Language, in: *The Meditationes Vitae Christi Reconsidered. New Perspectives on Text and Image*, ed. H. Flora and P. Tóth, Turnhout 2021, pp. 43–74.

140 M. Imdahl, *Giotto Arenafresken: Ikonographie, Ikonologie, Ikonik*, Munich 1980, pp. 52, 85–

donkey. The animals are the property of Mary and Joseph, who had travelled with them to Bethlehem "like poor merchants of beasts".[141] Giotto's picture presents ox and donkey not in the stable, but in front of it. Anyone who assumes that the painter was striving for a coherent pictorial narrative must either suppose that the ox and donkey have vacated the space for mother and child, or – as described in the *Meditations* – that it is simply not their home. The *Meditationes* then report how the two animals behaved wisely and helpfully after the birth of the child:[142]

> The ox and the ass knelt with their mouths above the manger and breathed on the Infant as though they possessed reason and knew that the Child was so poorly wrapped that He needed to be warmed, in that cold season.

In Giotto's fresco, it looks as if the animals are waiting until Christ is laid in the manger so that they can start their heating task. The one eye of the ox that is visible to us watches over the child as intensely as Mary's eye.

As far as the location of the event is concerned, the different editions of the *Meditationes* give varying details. If the Latin version had been used in Padua, one would have come across the following sentences about Mary's trouble in Bethlehem: "They all sent her and her companion away, and so they were forced to move to a covered alley where people usually took shelter when it rained."[143] Who would have also had a look into the *Legenda Aurea*, a book several decades older and long since popular, would have learned about the alley:[144]

86 and passim. H. Ronan, Meditations on a Chapel, *The Burlington Magazine* 122, 1980, pp. 118–121. Mather, Giotto's First Biblical Subject in the Arena Chapel. The exceptional importance of the text for the iconography of Christian art since around 1300 was probably discovered by Emile Mâle: E. Mâle, *L'art religieux de la fin du Moyen Age en France*, Paris 1922, pp. 27–34.

141 «... et vadunt sicut pauperes mercatores bestiarum.» *Meditaciones vite Christi*, p. 30. English translation (after the Italian version): *Meditations on the Life of Christ: an Illustrated Manuscript of the Fourteenth Century*, ed. I. Ragusa and R. Green, Princeton 1961, p. 31.

142 "Tunc bos et asinus flexis genibus poserunt ora super prasepium, flantes per nares ac si racione utentes cognoscerent quod puer sic pauperrime contectus, calefaccionem tempore tanti frigoris indigeret." *Meditaciones vite Christi*, p. 31. English: *Meditations on the Life of Christ*, p. 33.

143 «Omnes licenciebant eam et socium, et sic conguntur divertere ad quandam viam coopertam, ubi homines tempore plure divertebant.» *Meditaciones vite Christi*, p. 31.

144 "... operimentum habens, qui de versorium dicitur, sub quo cives ad colloquendum vel ad convescendum in diebus ottii vel pro aeris intemperie devertebant. Ubi forte Joseph praesepe bovi et asino fecerat vel sucundum quosdam rustici, cum ad forum veniebant,

> *It provided some overhead covering and served as a meeting place for townspeople who came to talk or eat together in their free time, or when the weather was bad. Perhaps Joseph set up a manger for his ox and his ass, or, as some think, peasants coming in to market were used to tying up their animals there and the crib was ready at hand.*

According to this version of the story, the feeding trough mentioned in Luke is therefore either Joseph's product or it belongs to the facilities of a kind of service station for pack animals and mounts.

In contrast, the Italian version of the *Meditationes* tells us that the following happened after Mary and Joseph had been rejected everywhere: "When they saw an empty cave that men used when it rained, they entered to lodge themselves."[145] Here the term cave refers back to the narration of the Apocrypha. In the concluding remarks about the place of birth, the two versions of the *Meditationes* agree again: "And Joseph, who was a master carpenter, possibly … it in some way."[146] The verb *claudere* resp. *chiudere* used here literally means to seal or close, but can also be read in the sense of covering or roofing.

This leads to the question whether Giotto really meant to represent a stable with the wooden structure that he depicted as housing Mary. Strictly speaking, there is nothing more to be seen than a kind of protective roof for a reclining person. Additionally, the shaded area behind the shelter is striking. Most likely it is a shallow cave or dent in the rock face. What at first glance appears to be a stable can also be read as an improvised porch or veranda in front of an insufficiently deep cave: a product made by Joseph. Simple but perfectly executed, the construction may suggest what a master carpenter can achieve in a hurry. Perhaps we should also think of the obviously new and beautifully crafted crib as Joseph's work. And perhaps Giotto's Joseph sleeps not only because pictorial tradition requires this (see below), but also because he had performed his professional tasks with so much diligence before the birth of the child.

Stable or self-built shelter? – It is hard to decide based on the mural and the text of the *Meditationes*. Cave or shadow? – There are further arguments for this beyond the evidence in Giotto's picture and the report of the *Meditationes*. Firstly, there are other texts

animalia sua ibidem ligabant, et ideo praesepe ibi constructam erat." *Legenda aurea*, ed. Maggioni, p. 65.

145 "Et quelli vedendo una grotta che niuno vera intrato et allora elli vedendo volta vintrono entro ed albergare. Chi qui ne tornavano homini quando pioveva." BNF, ms. Ital. 115, fol. 18 v. English: *Meditations on the Life of Christ*, p. 32.

146 «Et ibidem Joseph, qui erat magister lignanus, forte aliqualites se clausit.» *Meditaciones vite Christi*, p 31. "Et in quello luogo iosep lo quale era maestro di legname forsi che vi chiuse in alcun modo." BNF, ms. Ital. 115, fol. 18 v.

that testify to the tradition and popularity of the idea of a cave as the place of delivery. Some of them have already been mentioned. Secondly, there is the actual cave under the Church of the Nativity in Bethlehem, which had been shown to pilgrims as the birthplace of Christ since at least the fourth century.[147] And thirdly, there is a long iconographic tradition. Against the background of this tradition, not only can the question be decided whether the shadow really suggests a cave, but further insights into Giotto's pictorial invention can be gained.

Just as there are two different textual traditions about the place of birth, so too are there two different visual lines of transmission. Unlike the texts, these flourished largely independently of each other in the Middle Ages. Images produced in the Latin west show Mary and the child either in front of an architectural backdrop representing Bethlehem or in a void furnished with a crib and occasionally a mattress. An example of the first, which our painter certainly knew, can be found in the church of San Miniato al Monte above Florence. The late 13th century mural shows Mary, Joseph and the Child under a masonry arch.[148] Contrary to this, in the Greek east (and in the western enclaves of its visual culture) the birthplace is always depicted as a rocky landscape (fig. 38): slightly to the left of centre in the pictures (exactly where Giotto painted the shadow!), a cave opens up in a mountain. Often the mountain looks like a burst bubble and reveals how the landscape is conceived in its entirety around the cave motif. The following details also belong to the Byzantine image of Christ's birth: angels arranged along the curved ridge above the cave, shepherds in the right hand corner of the picture, to whom one of the angels speaks, and Joseph crouching in the foreground.[149] With small deviations most of them can be found in Giotto's painting, along with, in the guise of the shadow probably also the cave. As for the arc of angels, in Giotto's image it does not curve over the mountain, but in front of the rock face over the roof of the shelter. Beyond such motifs it is clear that both Giotto's fresco and the Byzantine representations bring together two events that are neatly separated and never intertwined in any of the texts, namely the birth of Christ and its proclamation to the shepherds. The Byzantine type was once called a "Sammelbild" (collecting picture)[150] – a picture that assembles various representations from the narra-

147 W. Harvey, W.R. Lethaby, O.M. Dalton et al., *The Church of the Nativity at Bethlehem*, London 1910, pp. 51–73 and B. Bagatti, *Gli antichi edifici di Betlemme*, Jerusalem 1952, pp. 114–156.

148 A. Tartuferi, *La pittura a Firenze nel Duecento*, Florence 1990, pl. 166.

149 G. Millet, *Recherches sur l'iconographie de l'évangile aux XIVe, XVe et XVIe siècles d'après les monuments des Mistra, de la Macèdonie et du Mont-Athos*, Paris (2) 1960, S. 93–169. J. Lafontaine-Dosogne, Les représentations de la nativité du Christ dans l'art de l'orient chrétien, in: *Miscellanea Codocologica F. Masai dedicata MCMLXXIX*, vol. 1, 1979, pp. 11–21.

150 *Lexikon der christlichen Ikonographie*, vol. 2, p. 101 (P. Wilhelm)

Fig. 38: Daphni Monastery, catholicon: The Nativity

tive environment of the birth of Christ. This also applies to Giotto's version. But what is different in the end is the stable; a stable never appears in the Byzantine images.

Giotto was not the first Italian to adapt the Byzantine nativity scene. In Rome at the end of the 13th century, Jacopo Torriti and Pietro Cavallini used this model in their mosaic cycles at the two most important Marian shrines in the city, Santa Maria Maggiore on the Esquiline hill and Santa Maria in Trastevere. Adapting the Byzantine nativity scene within the framework of large cycles of mosaics was apparently an aspect of the competition between famous artists, powerful families and holy places that took place in Rome and which will be discussed in the chapters dealing with pre-Paduan Giotto. There is some evidence that Giotto was involved in this competition even before he worked in Padua. His Navicella mosaic in the atrium of St. Peter's was commissioned by Cardinal Jacopo Stefaneschi, brother of the same Bertoldo Stefaneschi who had financed Cavallini's mosaics in Santa Maria in Trastevere.[151] Both brothers belonged to the circle of the Orsini family and were thus among the opponents of the Colonna family, which had co-financed Torriti's mosaics in Santa Maria Maggiore. Thus, we can be reasonably sure that Giotto was familiar with the Byzantine images of the Nativity in Rome. But we cannot be sure whether he was aware of using a type of image from the east in Padua. For him, it may have been a model exclusively associated with the great masters and achievements of Roman art around 1300.

When Cavallini adapted the composition for the apse wall of Santa Maria in Trastevere, he modified one detail and added another (fig. 39). He transformed one of the two shepherds into a squatting figure playing the flute. In this way an antique motif was forged, such as was particularly popular in Rome around 1300. The artist thus took

[151] G. Ragionieri, Cronologia e commitenza: Pietro Cavallini e gli Stefaneschi di Trastevere, *Annali della Scuola Normale Superiore di Pisa, Classe di lettere e filosofia* 3, 1981, pp. 447–467. W. Tronzo, Apse Decoration, the Liturgy, and the Perception of Art in Medieval Rome: S. Maria in Trastevere and S. Maria Maggiore, in: *Italian Church Decoration of the Middle Ages and Early Renaissance: Functions, Forms, and Regional Traditions*, ed. W. Tronzo, Bologna 1989, pp. 167–193.

the foreign feature out of the picture and adapted it to the Roman culture. The detail he added is the toy-sized building in the foreground, which bears the inscription "Taberna Meritoria". This name refers to a tradition that first appeared in the work of the early Christian historian Eusebius: on the site of Trastevere there had allegedly been a home for invalids (a home for soldiers with "merits"). On the day of Christ's birth an oil well had risen from there and flowed into the Tiber. In the mosaic the oil is depicted as a brown trickle connecting the little house with the river in the foreground.[152] Complementing the miracle in Bethlehem with the representation of a miracle that took place simultaneously in Trastevere naturally means that the picture also received a local accent in terms of narration.

Fig. 39: Rome, Santa Maria in Trastevere, apse: The Nativity (Pietro Cavallini)

Changes were introduced by Torriti as well when he used the Byzantine composition in Santa Maria Maggiore (fig. 40). He added a structure that would be considered a stable if it were not so small. It also looks as if it was built of stone or marble. One may well call the building next to the cave a *tempietto*. It is clear that the features of the little temple are intended to be perceived

Fig. 40: Rome, Santa Maria Maggiore, apse: The Nativity (Jacopo Torriti)

as antique and to resemble in this respect Cavallini's flute player. It is also clear, however, that the meaning of Torriti's *tempietto* cannot be restricted to a reference to antiquity.

Not far from the mosaic, a small chapel was attached to the church. The mosaic is positioned in the apse in such a way that it could be seen by those who entered the church from the chapel. The building was called Praesepe (literally "crib" or "feeding trough").[153]

152 P. Hetherington, *Pietro Cavallini: A Study in the Art of the Late Medieval Rome*, London 1979, p. 17.
153 *Santa Maria Maggiore e Roma*, ed. R. Luciani, Rome 1996, p 78 (V. Saxer) and 138–142

An English pilgrim of the 16th century wrote about the chapel:[154]

> *The Praesepe or the place where our saviour was borne in Bethelehem ... The monument itself, as the devotion at it is now in Rome ... and upon Christmas Day especially here is the Station, that is, the pilgrimage and devotion of al the Citie, making a joyful memorie of the birth of our Saviour.*

The chapel must have been erected in or before the seventh century as a kind of double of the holy site in Bethlehem. No one knows when the idea developed that the Roman chapel was the real birthplace. (Nor is it clear from when the Romans believed that it was part of a cave, an opinion that resulted in the building being lowered under the floor of the Sistine Chapel of Santa Maria Maggiore in 1587 with great technical effort.) Around 1291, not long before Torriti created the cycle of mosaics in the apse, the chapel was richly decorated. Arnolfo di Cambio adorned the façade and made for the interior half-life-size figures of Mary, Joseph, the child, the ox and donkey and the Magi, most of which have been preserved. The donor was Panulpho de Postrennio, canon of Santa Maria Maggiore.[155] Whether he and Arnolfo thereby really succeeded in inventing the Christmas crib is an old question that need not be discussed here. In any case, the Praesepe Chapel is the most plausible choice as a model for Torriti's little temple. If this is true, the *tempietto* anchors the mosaic in its site, which was an important pilgrimage destination.

Against this background Giotto's painting in Padua looks less astonishing. Not unlike his Roman colleagues, he used the Byzantine image type as a basis and adapted it to the needs of the users by changing details. But if in Rome – in Trastevere and on the Esquiline Hill – it was a matter of adapting to the local cult situations, then Giotto was more concerned with adjusting to a recent text: Like the motif of the attentive animals, the shelter might illustrate the *Meditationes* and visualize the story, told there with a "possibly", that Joseph used his professional skills to make the cave habitable. On the other hand, the representation of a largely free-standing construction remains difficult to account for. This motif compels us to look again.

Freestanding buildings of this kind are to be found in early Christian imagery. Although there are only a few examples and they are scattered over the period between the third and sixth centuries, this is clearly a distinct type. Most interesting are six sarcoph-

 (D.P. Sperduti). S.F. Ostrow, *Art and Spirituality in Counter-Reformation Rome*, Cambridge, Ma. 1996, pp. 23–62.

154 G. Martin, *Roma Sancta (1581)*, ed. G.B. Parks, Rome 1969, pp. 40–41.

155 So say the 16th century sources: Ostrow, *Art and Spirituality*, note 84 on p. 294. On the figures last: *Arnolfo alle origini del rinascimento Fiorentino*. Exh. cat. ed. E. Neri Lusanna, Florence 2005, pp. 190–192 (G. Kreytenberg).

Fig. 41: Rome, Campo Santo Teutonico: lid of a sarcophagus

agus lids – two intact and four preserved as fragments – which show the Christ Child in a basket-like manger under a protective roof, accompanied by an ox and donkey.[156] The construction represented consists of a tiled roof supported by two posts (fig. 41). It should be noted that the reliefs present the child, the manger, the animals and the shelter as a pictorial unit that can also exist separately – a prefabricated module that was ready for reuse. In a later discussion of Giotto's Roman background, this volume will draw attention to the contexts in which the painter was interested in ancient models. The situation is evident in the present case: what Giotto gained by including the shelter was a narrative element. The subtle deviations from the visual model can also be explained easily using the text of the *Meditationes*: Giotto's shelter does not have a tiled roof, because it is the work of a carpenter who could not use the help of a brick maker and roofer; and the shelter protects Mary instead of the manger and the animals, because it was built especially for Mary before the child was born.

But how do the animals come into the Early Christian representations? The question stands to reason: on the one hand, the ox and donkey, together with the Christ Child and the manger, belong to the central and oldest features of Christmas scenes. On the other hand, when the image was invented, there was no text that described theses standard aspects of what we now tell children when they see the animals standing by the manger. In

156 G. Bovini, *Rom und Ostia* (Repertorium der christlich-antiken Sarkophage 1), Wiesbaden 1967, no. 11 (Vatican City, Museo Pio Cristiano, intact), no. 28 (Museo Pio Cristiano, fragment), no. 135 (Museo Pio Cristiano, fragment), no. 170 (Museo Pio Cristiano, fragment). J. Dresken-Weiland, *Italien mit einem Nachtrag Rom und Ostia, Dalmatien, Museen der Welt* (Repertorium der christlich-antiken Sarkophage 2), Mainz 1998, no. 20 (Syracuse, Museo Archeologico Regionale P. Orsi, intact). G. Egger, *Frühchristliche und koptische Kunst*, Exh. cat., Vienna 1964, no. 34 (Rome, Campo Santo Teutonico, fragment).

Early Christian times, the ox and donkey were not elements of a narrative, but allegorical figures that illustrated the well-known passage in Isaiah (1: 3): "The ox knoweth his owner, and the ass his master's crib: but Israel doth not know, my people doth not consider." In addition, they suggest a prophecy in Habakkuk (3: 2). In the Septuagint, the Greek translation of the Old Testament, it does not read "O Lord, revive thy work in the midst of the years, in the midst of the years make known" (King James Bible, translated from the Hebrew), but: "Between two beasts you will be recognized."[157] This version was widely spread in the form of the Latin translation in the Pseudo-Matthew Gospel: "In medio duorum animalium innotesceris."[158]

What seems in the reliefs to be a touching insight into a, one might say, bucolic childhood, is thus actually visualized theology. But a narrative reading of the representation was already being given in Late Antiquity. As already noted, Pseudo-Matthew, who probably wrote in the fifth century, recounts that Christ was born in a cave.[159] He goes on to report that three days later the holy family moved to a stable ("stabulum") where Mary "placed the boy in a manger and an ox and a donkey adored him."[160] Then the author refers to the prophecies of Isaiah and Habakkuk, which were thereby fulfilled. After another three days, according to Pseudo-Matthew, the family continued their journey to Bethlehem. The question is how the stable-episode came about, since it was inserted between the events in the birth cave and the stay in the City of David and thus ultimately led to a hardly acceptable conflict with the report in Luke. Two circumstances must be taken into account here: on the one hand, the allegorical function of the animals and, on the other, the pictorial formula of ox and donkey, as they are presented under one roof together with the child lying in the crib – a pictorial coinage that was probably still popular at the time when Pseudo-Matthew lived and wrote.

After the end of the Roman world, the stable disappeared from both the visual arts and the written word. Even authors who carried on with the story of Pseudo-Matthew, such as the priest Wernher, did not mention a "stable".[161] But the ox and donkey survived and were able to expand their role. One of the first people to associate the animals directly with the birth event was the 12th century poetess Lady Ava. For her, the donkey belonged to Mary and Joseph, while they found the ox standing at the manger.[162] Another narrative

157 *Lexikon der christlichen Ikonographie*, vol. 2, p. 89 (P. Wilhelm)

158 *Evangelia apocrypha*, p. 80.

159 M. Berthold, Zur Datierung des Pseudo-Matthäus-Evangeliums, *Wiener Studien: Zeitschrift für klassische Philologie* 102, 1989, pp. 247–249

160 «... et ingessa est stabulum et posuit puerum in praesepio, et bos et asinus adoraverunt eum.» *Evangelia apocrypha*, p. 80.

161 Cf. A. Masser, *Bibel, Apokryphen und Legenden: Geburt und Kindheit Jesu in der religiösen Epik des Mittelalters*, Berlin 1969, pp. 176–185.

162 *Die Dichtungen der Frau Ava*, ed. F. Mauerer, Tübingen 1966, p. 13. Masser, *Bibel, Apokryphen und Legenden*, p. 190.

version that has been developed to achieve a high degree of consistency and connectivity is that of the *Meditationes*. It reconciles the distant memory of an Early Christian visual allegory with the various accounts in the canonical and apocryphal gospels and with other texts.

The medieval readers of and listeners to the *Meditationes* certainly did not absorb the information contained there in isolation, but in the context of its textual sources (the Bible, Apocrypha, pilgrim reports, etc.), which were typically understood in the sense of a *collectio* of memories and thus as mutually enlarging, supplementing, and affirming statements.[163] This may also have been the case for Giotto's patron and his advisors. At least the artist had at his disposal, in addition to the texts, the Byzantine pictorial scheme of the Nativity, including its Roman variations, as well as an Early Christian pictorial formulation, which he probably encountered on a sarcophagus lid. Following the Byzantine model and the Apocryphal Gospels and/or the Italian version of the *Meditationes*, he chose a cave embedded in a rocky landscape instead of an urban setting. And, following Torriti, he added a built structure to the cave. However, Giotto did not make it a temple in Padua, but rather a kind of shelter, as he tried to bring it into line with the early Christian images. At the same time, he related the building that he came upon as a separate motif – as the scenery of the manifestation of the Christ Child and the allegorical animals – to the narrative of the *Meditationes*. Thus, the sloppily built pasture shelter of a Roman estate, as portrayed on late antique sarcophagus lids, became a new and flawless carpenter's work. If the *Meditationes* offered the most complete synthesis of the facts handed down in textual form, then Giotto's picture is not only a visual interpretation of the *Meditationes*, but also the most complete synthesis of the textual *and* visual tradition.

This can be considered a curiosity. But for Giotto and his contemporaries, the range of sources that were being compiled was perhaps an important quality in itself. It was what set the picture apart from previous depictions of the birth of Christ: a comprehensive visualization of the event was achieved. Such density could not be realized in all the pictures in the chapel, but a modern interpreter would be well advised to imagine that this, and not the illustration of a single particularly esteemed text or the modification of a particularly successful representation, was intended.

Giotto's Christmas synthesis also draws on one – instructive – element that was not used in the attempt Duccio made a little later in Siena (fig. 42). The Christmas scene from the Maestà, the high altar retable of the cathedral, again varies the Byzantine image of the Nativity and also contains a wooden construction reminiscent of a stable, in which Mary rests. This is why James H. Stubblebine assumed that the panel was inspired by Giotto's Paduan paint-

163 M. Carruthers, *The Book of Memory: a Study of Memory in Medieval Culture*, Cambridge 1990, p. 246 and passim.

Fig. 42: Washington, National Gallery: The Nativity, panel from the Maestà (Duccio)

ing (which may still be correct despite several differences).[164] However, this time the wooden construction is not a protective roof, but has closed walls, and is not set in front of, but inside the cave. Viewers who are not fixated on the identification of the structure as a stable see it as a kind of panelling of the cave. As in Padua, it is probably the work of Joseph, who, in accordance with the *Meditationes*, made an inhospitable place inhabitable using his craftsmanship. But unlike Giotto, Duccio did not take into account the late antique motif of the roof over the manger and therefore understood *claudere* or *chiudere* in the sense of sealing. The wood-panelled cave is the straightforward combination of the Byzantine nativity cave with the narration in the *Meditationes* – without the use of visual material from Rome. Giotto was therefore not the only artist to strive for completeness in the visualization of the events of the nativity (and probably other Biblical episodes as well), but he was particularly creative in the exploration of the source materials.

Undoubtedly, behind this collecting activity was the hope of capturing the historical reality. But we should not believe that this reality appeared to the painter as a coherent image before his inner eye (to speak with Hans Belting: as an "inner image" that the artist only had to transform into a material one).[165] Rather, he was dealing with a conglomerate of information, the elements of which had to be explored, interpreted, and combined into a representation. The result is addressed to users who know the traditions and will therefore recognize them. In fact, it can be said that Giotto's fresco does not reproduce, but rather produces a readable form. This can be shown in particular by the wooden canopy, in which we want to see the depiction of a stable, but which in fact itself gave birth to our idea of the nativity stable and thus our own interpretative expectations. The stable *topos*, so familiar from the Christmas story, in fact, originated on the basis of copies and variations based on the Paduan fresco and displaced the cave and the city as the scene of Christ's birth.[166]

164 J.H. Stubblebine, *Duccio di Buoninsegna and his school*, Princeton 1979, vol. 1 p. 55.
165 H. Belting, *Bild-Anthropologie: Entwürfe für eine Bildwissenschaft*, Munich 2001, pp. 13–14 and passim.
166 M.V. Schwarz, Giottos Weihnachten: Eine transkulturelle und intermediale Bilderfindung

THE INVERTED PASSE-PARTOUT AND THE OBJECTS / THE REJECTION OF JOACHIM

What makes the scene so appealing – apart from common knowledge about Christmas – is the coherence of the pictorial fabric. It is true that the landscape, which has no vegetation, is more reminiscent of the concrete rocks in zoological gardens than of what we understand by landscape today. But it fills the entire width of the picture field and is given a sense of depth on the right hand side by the hill allocated to the shepherds (an impression that is not quite controllable, however). In addition, the persons and animals are numerous and arranged in such a way that the baldness of the formation itself does not become obvious. On both sides the edge of the picture crosses over important motifs: we see half of the shepherd and half of the donkey and little more than the heads of the ox and of the woman assisting Mary (an appearance probably referring to one of the two midwives summoned by Joseph in order to testify to Mary's virginity, according to Jacobus, Pseudo-Matthew and the *Legenda aurea*[167] – one more indication of Giotto's striving for the complete implementation of the tradition.) As for the other shepherd, we see him from behind. The way he turns his back to us while an angel speaks to him has a demonstrative quality, suggesting that Giotto has not built the scene simply for the viewer, since there is at least one person in the picture who is having his own perception of the scene that we do not share. By overlapping people and animals and with the figure seen from behind, the depiction appears not to be arranged for the viewer; rather, it seems to be a section from a larger whole that exists independently of the perception of the user of the picture. Like the uniform density of the fabric of the depicted, this awareness corresponds to our – modern – expectations of a picture.

Some of the typical features of the Nativity scene may have less to do with Giotto's authorship and invention than with the Byzantine model, which both demands and offers a landscape in the motifs of the cave and the shepherds. Other features are independent of the model and can only be understood if other pictorial inventions of the painter are considered: in pictorial narratives for which there was less visual and textual material available – and this applies to almost every one in the Arena Chapel – the question of whether and how Giotto produced a dense representational fabric apparently not limited to the picture field arises in a fundamentally different way. And a specific problem was posed, where the pictures could not legitimately be based on a landscape, but the texts demanded a built environment as the setting. Hence the opening picture of the cycle, which was probably

mit Folgen, in: *Kanon Kunstgeschichte: Einführung in Werke, Methoden und Epochen. I: Mittelalter*, ed. K. Marek and M. Schulz, Paderborn 2015, pp. 256–276.

167 *Legenda aurea*, ed. Maggioni, p. 66. *Lexikon der christlichen Ikonographie*, vol. 2 p. 96 (Wilhelm).

also the first in the chapel that Giotto painted after the medallions on the vault, looks completely different from the Christmas scene and also seems to have been conceived differently (pl. IV). If we start from this picture, it can be shown on what basis the painter gradually developed the pictorial fabrics and strategies typical of the Arena Chapel, which then also benefited the Nativity scene.

However, it must first be clarified why not only the narrative begins with this scene, but why we may also assume that Giotto started to decorate the walls at this very spot. Before the *giornate* (the patches of plaster painted "per day") and their sequence were systematically studied during the last restoration, there was a lot of room for reflection on the timeline of the work in the chapel. For Fritz Baumgart, the upper row of pictures was the most recent and actually added later,[168] so that the opening picture would be among Giotto's later works. Creighton Gilbert, on the other hand, had assumed that the decoration was done picture bay by picture bay, beginning at the triumphal arch:[169] In this case, the opening picture would be among the first, but together with the Nativity, the Lord's Supper, Mary's Return to her Parental Home, the Expulsion of the Traders, and the Pentecost event – scenes which, in my view, reflect insights that Giotto only gradually gained when he executed the cycle. The joints of the *giornate* with their slight overlaps, which are discernible on close examination and reveal which patch came first and which was added later, suggest that the pictures were created in horizontal rows that followed each other from top to bottom. The single rows of pictures were executed largely from left to right, i.e. on the Eremitani-side wall from east to west and on the palace-side wall from west to east. However, since Giotto and his collaborators sometimes painted the components of the frame system and parts of an image before work on the preceding one was completed, long series of overlaps of plaster patches running in the same direction are rare. Nonetheless, the numerical ratios are suggestive: in the upper row of the palace-side wall, approximately thirty-four overlaps that indicate work proceeded from left to right contrast with approximately twenty-four overlaps that would fit a sequence from right to left. In the upper row opposite, the ratio is even clearer, at ca. twenty-nine to ca. fourteen.[170]

168 F. Baumgart, Die Fresken Giottos in der Arenakapelle zu Padua, *Zeitschrift für Kunstgeschichte* 6, 1937, pp. 1–31.

169 C. Gilbert, The Sequence of Execution in the Arena-Chapel, in: *Essays in Honor of Walter Friedländer*, ed. W. Cahn and M. Franciscono, New York 1965, pp. 80–86.

170 *Giotto: The Frescoes of the Scrovegni Chapel in Padua*, ed. G. Basile, Milan 2002, pp. 24–29. Giuseppe Basile interprets the findings somewhat differently than I do: pp. 38–39. F. Capanna and A. Guglielmi, Osservazioni relative alle tecniche di esecuzione dei dipinti murali nella cappella, effetuate durante il cantiere di restauro, in: *Giotto nella Cappella Scrovegni: Materiali per la tecnica pittorica: Studi e ricerche dell'Istituto Centrale per il Restauro*, ed. G. Basile (Bollettino d'arte, Volume speziale 2005), Rome 2005, pp. 47–72.

So it is quite certain that the opening picture is the earliest one on the side facing the Hermits. Moreover, according to the technical findings, it is possible that Giotto painted the pictures over long groups in the sequence of the narrative. This facilitated conceptual coherence, and was therefore an attractive option as well as not being difficult to realise in a relatively small space. The examination of the single frescoes will later reveal that the pictorial inventions also suggests many arguments in favour of this sequence and thus for the fact that the upper row on the palace-side wall was executed after the upper row on the wall towards the Eremitani. This means that the opening picture, showing how Joachim, later to become Mary's father, is rejected in the temple, really seems to be the first of the images on the two, and indeed of all four, walls (since the west and east walls, the Last Judgment and triumphal arch scenes, were painted after the side walls, a fact that was also discovered during the last restoration).

In terms of form, the picture is not a coherent fabric, but is comprised of two clearly different parts: One part consists of the pictorial objects. These are four people and a large piece of marble furniture placed at an angle. According to the text it refers to the temple in Jerusalem. In fact, we are dealing with a *schola cantorum*, the liturgical equipment that was required in Roman churches for the papal mass.[171] The fact that furniture and equipment represent a sacred space in the *pars pro toto* procedure has occurred before – for example in Byzantine miniatures depicting the same scene.[172] What is special in Giotto is the conclusiveness of the structure: the square box for the singers, the altar ciborium and the epistle pulpit can be easily identified as composite solids in space and as functional objects. They are presented partly from above and partly slightly from below in such a way that the viewer can understand them comprehensively and is fully informed about what he is dealing with. The painter left out the ambo for the reading of the Gospel, first, probably in order to keep the spatial situation manageable, and, secondly, because the story takes place under the law of the Old Testament and there is no liturgical need for a Gospel pulpit yet. Giotto has pushed a platform under the entire structure. This also provides a defined location for the people standing outside the barriers, who are the actual protagonists. Without the platform they would be in a non-place.

The other element of which the picture consists, and which demands an explanation, is the surface that surrounds the figures and objects and consists of a brown stripe at the

171 John Ruskin associated Byzantine furnishing: J. Ruskin, *Giotto and his works in Padua*, London 1853. I used the English-Italian edition: *Giotto e le sue opere a Padova*, Padua 2001, p. 181. John White recognized a Schola Cantorum: J. White, Giotto's use of architecture in The Expulsion of Joachim and The Entry into Jerusalem at Padua, *Burlington Magazine* 115, 1973, pp. 439–447.

172 D. Giunta, Appunti sull'iconografia delle storie della vergine nella Cappella degli Scrovegni, *Rivista dell'Istituto Nazionale d'Archeologia e Storia dell'Arte*, n.s. 21–22, 1974–75, pp. 79–139.

bottom and a blue field above it. Remarkably, we read the strip as the ground, although it is not marked as such by any shading or texture. The blue above it we tend to read as sky. It has already become clear from looking at the image of the Last Judgement that there is little reason for this beyond the suggestion of colour. This brown-blue surface lies under what is depicted, just as a passe-partout would lie on top of it. One might speak of a mounting surface or an inverted passe-partout.

Taking up a concept of Jacques Lacan, Friedrich Kittler called the element of the photographic image, that does not contribute to a meaning of what is represented, the real ("das Reelle", "le réell").[173] One can also say that the real is the part of the picture that does not represent anything, but only exists as something that has unintentionally been reproduced: the little stain on the tie of the sitter or the contrail in the blue sky of the holiday picture are elements of the real. In fact, however, the real constitutes the major part of what is visible in a photograph, and the question is how anything can be made to appear at all if it is not embedded in the real. The real as the meaningless has no syntax, and so it is obvious if one calls the photo as a whole an image without syntax. In Giotto's painting, on the other hand, every motif is directed towards the comprehensible and meaningful representation of an event. But, where the representation of the event ends and where the wide field of the real would open up in the photograph, the brown-blue inverted passe-partout appears. It is the image's non-representational basis, without which the pictorial objects presented by the painter would not have a place or be able to become a representation. The difference between the equally lively and unpredictable, even anarchic real in the photograph on the one hand and the lifeless mounting surface on the other helps to mark the difference between a modern idea of imagery and that of Giotto and his contemporaries: Their picture is not a reduction or a coping with contingency (this is how Max Imdahl tried to understand Giotto's Arena murals),[174] but it is first of all the absence of contingency: total representation.

The rule is strange to us, but in European painting it prevailed until the 15th century: Unless pictorial narratives take place evidently outdoors and the environment is meaningful ("desert", "mountains", "with the shepherds" etc.), they consist on the one hand of the pictorial objects and on the other hand of an inverted passe-partout. The objects are comprised of figures and scenery elements, whereby the figures take up about half the height of the picture field and the scenery elements (usually architectures) just under the full height. The inverted passe-partout is made up of one to three dark stripes at the bottom, which together account for about ten percent of the picture height, and a light blue

173 F. Kittler, Die Welt des Symbolischen – eine Welt der Maschine, in: F. Kittler, *Draculas Vermächtnis: Technische Schriften*, Leipzig 1993, pp. 58–80. F. Kittler, *Optische Medien: Berliner Vorlesung 1999*, Berlin 2002, pp. 37–38.

174 Imdahl, *Giotto Arenafresken*, p. 17.

or gold area above, which fills the rest if the image format. Giotto found this rule confirmed in the great Florentine picture project of his childhood and youth, namely the mosaics of the five eastern dome sections of the Florentine Baptistery, created in the last two decades of the 13th century. Cimabue, Giotto's mythical teacher, was almost certainly involved in this venture.[175] In the dome pictures, the ground strip is usually a double one, a darker one at the bottom and a lighter one on top; the rest of the surface is not filled with lapis lazuli blue as in Giotto's work, but with a surface of golden cubes. In front of it, overlapping both the golden surface and the floor strips, the figures and the furniture-like, three-dimensionally projected architecture are mounted (fig. 43).

Fig. 43: Florence, Baptistery, dome mosaic: Joseph's Appointment (Corso di Buono)

In the Rejection of Joachim, Giotto does not provide significantly more information on the context of the objects that are depicted than the mosaicists do: are the scenes taking place in an interior or outdoors? Should we imagine the events surrounded by landscape or buildings? Are there witnesses beyond the persons depicted or is what we see happening in secret? The fact that the marble enclosure in Padua is a piece of real architecture does not make these questions less relevant, rather it renders them even more urgent.

But there are also enough differences: the cohesion of persons and dead objects is intensified in Giotto's work, for example through the use of the platform, which lies under the architecture in the same way as it does under the persons, and through the conical shape of the figures with their robes, which seem to grow out of the platform. In addition, the projection of the architecture is from the top in its lower parts, but from the bottom in its upper parts, which corresponds to our habits of perception and acts also to combine together the pictorial objects more clearly. In contrast to the Florentine mosaics, the picture does not simply arrange pictorial objects in a field but presents them explicitly as a configured unit. Both measures – the platform and the coordinated projection – make Giotto's representation decidedly easier to read, and it will be necessary to investigate how he arrived at these solutions.

175 Schwarz, *Die Mosaiken des Baptisteriums in Florenz*, pp. 95–141.

112 Speech which Speaks to the Eye: The Arena Chapel

DYNAMICS OF PICTORIAL INVENTION

In the upper row of frescoes, and thus among the older pictures, there is a second *schola cantorum* as a pictorial object and placeholder for the temple in Jerusalem. It helps to narrate the Presentation of Mary and is more impressive than the first one (fig. 44). This insight provides an opportunity to enquire into the reasons and the means for the increase: Why and in what way did the painter further develop what he had already worked out?

The imposing appearance of the marble furniture is enhanced by the fact that Giotto raises the screen like a wall against the movement of the figures with which he illustrates the story. In this case he did not follow the commands of readability – in fact the conglomeration of objects is not comprehensible at first glance – but sought instead to produce an exciting dramaturgy. And the narrative is also the reason for the view from below which dominates this picture: the three-year-old Mary had to climb fifteen steps (Pseudo-Matthew IV–VI). The painter cannot accommodate more than ten in his composition; nevertheless, there is something dizzying about the height difference, and the fact that it was overcome by the girl justifies Anna's sense of triumph, as described by Pseudo-Matthew and recounted in the picture: Foes ("inimici") could not prevent her from making her daughter a gift to God.[176] The dynamic projection contributes much to this experience of the beholder. While the view from below in the upper part of the picture corresponds approximately to what we know from the Rejection of Joachim, in the lower parts the viewing eye seems to be positioned approximately at the height of the third step of the stairway. In addition to a kind of normal perspective that creates readability and unity, there is a very subjective frog's eye view that reacts to aspects of the narrative. The difference with Dugento compositions such as the Florentine Mosaics (fig. 43) is again profound. The projection becomes part of the narrative.

At the same time, however, what is happening is somewhat pushed away from the viewer. This is because of the three figures who are seen from behind. The servant on the left, who carries Mary's dowry, is almost denied human form by the basket that appears in the place of his head. It is hardly possible to mark an outside view of an event more sharply than by this misshapen figure turned away from the viewer. Then there are the two men on the right who discuss the incident with each other. If Imdahl is right, they represent the "inimici" that Anna knows to already be overcome. Their mental distance to what is going on is obvious. The spatial distance is also revealing, and both forms of distancing are also imposed on the viewer, who cannot watch the process other than over

176 *Evangelia Apocrypha*, ed. Tischendorf, p. 62: "Ecce potero offerre munera domino, et non poterunt a me prohibere inimici mei." M. Imdahl, Ergänzende Bemerkungen zum Verhältnis zwischen Giottos Zyklus des Marienlebens und dem Pseudo-Matthäus-Evangelium, *Giessener Beiträge zur Kunstgeschichte* 2, 1973, pp. 1–6.

Fig. 44: North wall of the nave: The Presentation of the Virgin

the shoulders of the "inimici" and the being with the basket. Functionally, these figures represent the opposite of the figures in rear view that Leon Battista Alberti would describe a century and a half later in his painting treatise as links between the events in the picture and the attention of the viewer, as figures that invite "to cry or laugh along"[177] – but Giotto's figures are precedents for them in a different pictorial system. Hand in hand with the distancing of the viewer, however, the situation depicted in the picture field gains in plausibility: in contrast to Joachim's Rejection, it does not appear as if what happens is staged only for the viewer and would have no reason to exist without his gaze. To the extent that the narrated events move away from us and become credible as part of a larger visual fabric, the pictorial world becomes apparently independent, thus making a claim to

177 Leon Battista Alberti, *Della Pittura. Über die Malkunst*, ed. O. Bätschmann, trans. S. Gianfreda, Darmstadt 2002, pp. 132–133: "… a piangere con loro insieme o a ridere."

be real. What is going on here – and the impression is different than in the first picture – is not performed, but actually happens.

Finally, it is noticeable that the inverted passe-partout does not really appear to stand out; only the lower strip is visible as a brown area. Here the painter does not indicate where the brown meets the blue background, and thus the brown zone is not recognizable as part of an underlying field, unlike in the picture of the Rejection of Joachim.

Typical for the invention of the Presentation of the Virgin is, firstly, the new role of the viewer, whose position and gaze are integrated in the figures' arrangement but who nevertheless seems to be dispensable as a participating person, and, secondly, the discreetness, almost invisibility, of the inverted passepartout, effectively silencing the question of the conditions under which the pictorial objects appear. The problem is what this conception, significantly different from that of the Rejection of Joachim, is based on. In explaining this, it is possible to connect it to a working experience that the artist had. The last picture in the upper row on the Eremitani side shows the Encounter at the Golden Gate thus requiring an imposing city gate (fig. 45). Given the consistent size of pictorial objects and the same picture format throughout the cycle, it was not easy to make a particular architectural object appear distinctly impressive and not just as a *topos* or as one motif among many. The rocky base of the right-hand tower, the inward-sloping substructure and the rustica are all features taken from real structures that point in the direction of monumental building. What was decisive, however, were interventions in the projection – and he could then reuse them in a modified form in the Presentation of the Virgin: the diagonal positioning of the building with the right corner protruding towards the picture plane, the view from below already being used at the end of the rustication and the reduction in size of the forms towards the top (the merlons and roofs), which enhances the effect of the view from below. For the painter, scaling down was probably an authentic method of representing height.

The overlapped, not to say cut-through figure at the left edge of the picture also contributes an important effect. It is a shepherd, a companion of Joachim, who not only speaks of the patriarch's journey, but also raises the problem of the borders or edges of the picture.[178] If one understands his role in terms of space, one can say that he creates a kind of invisible outside of the picture, which acts to extend the distance between the viewer and the city gate. Joachim's back needs this extra layer. Without the shepherd, the figure would stand outside the pictorial space and virtually enter the space of the viewer. The shepherd is the first figure in the Arena Chapel overlaid by the edge of the picture, just as

178 The narrative function of the truncated figures has often been described, including by M.J. Zucker, Figure and Frame in the Paintings of Giotto, *Source* 1, 1982, 4, pp. 1–5. On their function in the spatial structure: D. Frey, Giotto und die maniera greca: Bildgesetzlichkeit und psychologische Deutung, *Wallraf-Richartz-Jahrbuch* 14, 1952, pp. 73–98.

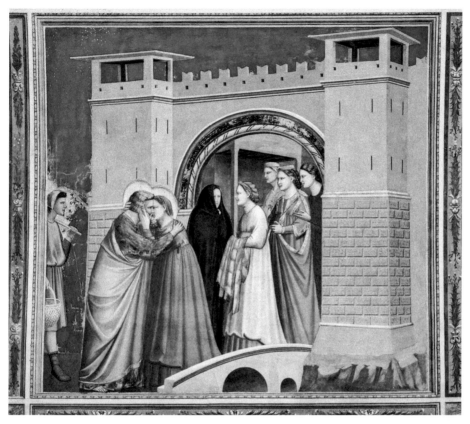

Fig. 45: South wall of the nave: Joachim and Anna Meeting at the Golden Gate

the two anonymous "inimici" in the Presentation are the first figures seen from behind. A look at the Nativity scene, for example, makes clear how much the upper row of pictures was a field of experimentation that shaped the appearance of the following frescos.

These experiments also questioned to some extent the dichotomy between the pictorial objects on the one hand and the inverted passe-partout that enables them to appear on the other. Anyone trying to understand the left margin and the constellation of the (half) shepherd, the edge of the tower and Joachim's back in the picture of the Encounter at the Golden Gate will wonder: is the gate standing on rock or – like the *schola cantorum* in the first picture – on the brown ground strip? And if the buildings of the city of Jerusalem can be seen in the archway, then why are neither walls nor houses visible behind the left corner of the left tower, but only the blue ground above the brown strip, i.e. the inverted passe-partout? Ultimately, the entire complex of gate, view into the city, figures, rock and bridge is again only a composite object placed in front of the blank form. But it looks

surprisingly impressive. This is because it is largely consistently projected, because the problem of a potential outside of the pictorial space has been dealt with, and because the mounting surface is barely visible. It was suppressed both from the inside, i.e. from the city gate, which was painted on a large scale in the picture, and from the outside, i.e. by the shepherd moving into the brown-blue field.

The fact that the visibility of the inverted passe-partout is minimized applies even more so to the image of the Presentation of the Virgin. Here, the representation covers the entire seam between the ground strip and the blue surface, thus making the mount completely unrecognizable. And this is certainly no coincidence. At least on the left, the picture field is systematically blocked by people and any opening in the row of figures, such as takes place in the Porta Aurea scene, is avoided. Nevertheless, it remains as improbable as in the first picture with the *schola cantorum* that for Giotto the brown surface at the bottom was a representation of the earth of Jerusalem and the blue surface accordingly represented the sky over Jerusalem.

In the depiction of Mary's Presentation it is easy to see a progression and improvement of the image of the Rejection of Joachim. The difference can be described according to four criteria: First, the position of the viewer is not only reflected, but changed in such a way that an effect is created that contributes to the narration of the image. Secondly, the pictorial objects are no longer primarily arranged for readability, but are now staged to emphasize the drama of the scene. Thirdly, the pictorial space is represented as a subspace of the world. And fourthly, the visibility of the mount is suppressed as much as possible. The last observation perhaps says most about the painter's approach: What is decisive is not that Giotto adds a surplus of reality to the picture (this surplus is not very extensive), but that he displaces the traditional forms of the motifs' presentation and replaces them with ones that are better oriented towards the viewer. In this way he reduces the visible presence of the means of representation and thus the experience of unreality.

As the painting of the chapel progresses, the inverted passe-partout will sometimes even disappear completely. It is clearly recognizable in the Betrothal of Mary and the Presentation of Christ in the Temple, as well as in the Hiring of Judas at the triumphal arch, an image that belongs to the later ones in the decoration. But in the lower and most recent row of pictures along the side walls it is nowhere explicitly found. However, nothing irreversible had happened. In the fresco cycles of Santa Croce, Florence, Giotto would return to the use of the brown-blue inverted passe-partout. Apparently, he himself did not classify the tendency discernible in the Arena Chapel, which from a long-term perspective can be read as a tendency towards depicting reality, to be epoch-making.

THE PAINTER SHOWS HOUSES, COURTYARDS, AND HALLS

Giotto's interiors can also be understood to a certain extent from the conflicts between the mounting surface and the pictorial objects, between the suggestion of proximity and the suggestion of distance of what is represented. The house of Mary's mother, which appears twice, in an identical form, in the upper row of pictures and thus almost like a person or a meaningful prop in the sequence of narrative pictures (in reference to the terminology of formalist literary criticism, Wolfgang Kemp speaks of a *chronotopos*)[179], is also placed in front of the familiar brown-blue passe-partout (pl. V, VI). In contrast to the *schola cantorum* in the opening scene, the architecture is parallel to the picture plane and moved to the lower edge of the picture (with a significant deviation in the second scene, where the washing tub – or rather washing goblet – is placed in a quasi gap between the viewer's space and the picture space; I will come back to this detail later). As a result, the brown strip thus appears in the form of two separate pieces on the left and right.

Both the shape and the projection of the house and its repetition within the cycle have an instructive pre-history before the painting of the Arena Chapel. These peculiarities will have to be revisited in the context of Giotto's works before and around 1300. Only the following should be noted here. Firstly, Anna's home is more of an architectural model composed of prestigious motifs than something that can easily be understood as the representation of a house. Secondly, although in both cases the visual narrative of events taking place inside the house is being shown, the share of the overall picture field given over to the interior is not high; a considerable part of the area is devoted to the representation of exterior components of the building (roof, loggia, balustrade of the balcony), and a likewise significant part is filled by the inverted passe-partout.

It can be said that the clear presence of the picture mount and the extensive depiction of external elements contribute considerably to making the building appear as a depicted object and not just as a spatial preparation of the image field. At the same time, the passe-partout distances the viewer from what can be seen in the house. Despite, or even precisely because of, the lack of a wall, the viewer does not participate, but becomes a *voyeur*: a viewer of events that take place without his intervention and without his participation being expected.[180]

Apparently, the painter was not satisfied in the long run with representing a space of action that is shown more or less equally from inside and outside. In the second row of pictures, there is no longer a "house"; instead, it can be shown how Giotto worked on replacing it.

179 W. Kemp, *Die Räume der Maler: Zur Bilderzählung seit Giotto*, Munich 1996.

180 A. Pinkus, Voyeuristic Stimuli: Seeing and Hearing in the Arena Chapel, *Wiener Jahrbuch für Kunstgeschichte* 59, 2010, pp. 7–26.

Fig. 46: North wall of the nave: Christ among the Doctors

This begins with the first picture on the palace side (the last of the Life of the Virgin), which is unfortunately badly preserved; in order to understand its characteristics one must look carefully (fig. 46): Twelve-year-old Jesus also sits enthroned and teaches in a sort of architectural box, which is surrounded by features of the exterior of the building and a section of the passe-partout, and yet the space is presented differently from the earlier images. Now both side walls are turned inwards and visible. This contributes to a significantly higher share of the interior being depicted in the picture field, bringing the viewer closer to the narrated event. The exterior is reduced to a decorated marble strip with a profile at the top, while a lower strip (the threshold) is missing. Added to this are the exterior views of two apses on the left and right, whose connection to the apses in the interior (or their identity with two of them) is not convincing, but they still play an important role: they disappear on both sides behind the painted frame of the picture, hiding the seam line of the passe-partout. As little as in the earlier Presentation of the Virgin (and

Fig. 47: North wall of the nave: The Wedding at Cana

in a form that is certainly prepared by this picture) Giotto shows how the brown ground strip touches the blue foil. The mount has withdrawn even further. What remains is nothing more than a thin blue clip that embraces the upper part of the architecture. However, the vast neglect of the exterior also means that the scenery that is depicted here is little defined. If the gables and loggia referred to the "house" of Anne, only the following abstract description for the place where the twelve-year-old Jesus preaches coul be given: "a box with apses".

This paved the way for a number of other solutions, which are encountered in the following pictures, i.e. the three transitional images and the Passion. What they have in common is that the architectural parts on the left and right reach to the picture frames and thus do not allow the inverted passe-partout to be seen as a connected whole. The Wedding at Cana (fig. 47) shows an asymmetrically opened stage without ceiling but terminated at the top by a kind of walkway with balustrade – a dining hall or courtyard? The

Fig. 48: South wall of the nave: The Last Supper

virtual disappearance of the exterior structure entails that the specification of the represented object also vanishes. In the Last Supper (fig. 48) and the Washing of the Feet the painter uses an architecture that is contradictory in itself, which he places in the picture at an almost imperceptible angle: to the back and left it appears to be a house with windows and shutters, but to the front and right it is a delicate arbour with fine marble ornaments.

In Christ before Caiaphas a new quality is achieved (pl. VII): we see a wide stage-like hall with round-arched windows closed off by shutters and a heavy beamed ceiling; this is seemingly very much a scene visualised according to modern ideas of dramaturgy. However, it should also be pointed out that the whole structure opens towards the viewer with an ornamented marble frame, which has no relation to the depicted location and action, but simply stands for architecture and makes ostentatiously visible what is happening in the picture. Mockery of Christ (fig. 49) takes places in an impressive prison courtyard

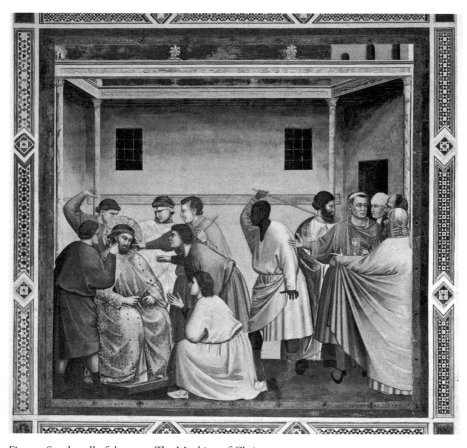

Fig. 49: South wall of the nave: The Mocking of Christ

with barred windows, but there is also a graceful arbour architecture, which is structurally integrated into the courtyard, although aesthetically it does not match the ambience of a prison at all. The construction can be described as an intra-image frame. Attention should be paid to the figures on the left and right, the henchman and the Pharisee. They both are shown diagonally from behind and are overlapped by the edge of the picture (but not by the arbour). Here an attempt is made to give the image-filling box for figures an exterior that does not depend on the passe-partout. In Pentecost, finally, Giotto uses an explicitly Gothic marble structure: it is a tracery case with a gabled roof, placed at an angle in the picture (fig. 50). What these buildings have in common is that they are perfectly adapted to the composition of the figures and their perception. Either they open up towards the viewer and make the protagonists completely visible, or they dissect the figure composition so that it appears in meaningfully separate portions.

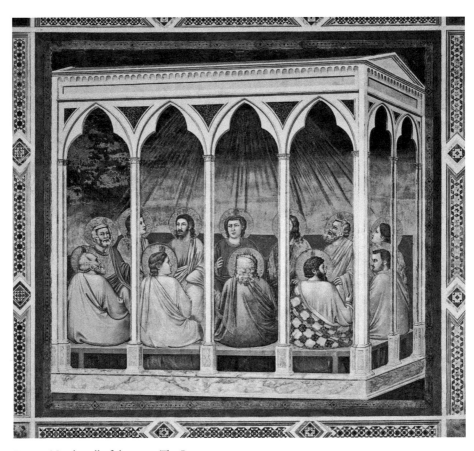

Fig. 50: North wall of the nave: The Pentecost

Overall, the architectural enclosures fulfil two functions: firstly, they make the inverted passe-partout largely (but never completely) disappear and secondly, they replace it with a continuous system of pictorial objects that reacts to the composition of the figures. What seems to be at issue is a form of presentation that allows the viewer to get close to the settings – but without letting him or her enter. The viewers is shown something, that they are meant to assume would happen in the same way even without a witness.

NARRATION THROUGH FIGURES AND MOVEMENTS

"Giotto sought and found everywhere, with previously unknown zeal and genius, the *one*, the 'interesting' moment," says theatre scholar Ivan Nagel about the pictorial narratives of

the Arena Chapel. According to Nagel, they anticipate the teachings of Diderot and Lessing on history painting.[181] Nothing could be less true. It hardly needs a second glance to realise that most of the pictures bring together motifs from several neighbouring time layers of the narrated events. In this they are nothing special, but correspond to the tradition of visual narration that dates back to antiquity (see also vol. 3 pp. 94–95, 231). If one wants to understand the special features of Giotto's pictorial narratives, it is advisable to look at the elements from which he assembled them. We have already dealt with the settings and now turn to the figures.

Giotto recounts events with and in fabricated excerpts of illusory worlds, developed on the basis of texts and older images – not least his own. Both text and visual skills are essential for the audience. Visual competency is not limited to the experience of paintings or artefacts in general, rather the artist expects the viewer to engage with the real world as well. Yet nowhere does the demand for visual knowledge of the world go so far that viewers should consider the painted world and the real world to be interchangeable. Giotto's pictorial worlds are left with their artificial quality. This is due not only to the use of unreal motifs such as open walls or interior frames (as added in the otherwise utterly realistic sceneries in the hall of Caiaphas and in the *praetorium*), but also to the marked economy and stringency of the pictorial narratives. If there is a kind of imitation or simulation of the random structure or non-structure of *le réell*, then it is above all in certain figures – and especially in their unpredictable mobility and emotionality, or, to be precise, in the emotions they waken in us.

In what way do Giotto's figures and their motions differ from those of painters of previous generations? Otto von Simson 1970 and William Tronzo 2004 addressed this question and found similar answers. The difference to older experimentations is, they argued, that the movements and projections were developed in a fundamentally changed way from the patterns and models used: "freely" and in such a way that they are completely absorbed in the new pictorial structure, says von Simson; "critically" and in a way that goes beyond the mere adaptation of the pattern to its narrative use, says Tronzo.[182] The latter based his reflections on observations by Alastair Smart, which showed that Giotto (and painters trained by him) repeatedly followed antique models, an insight that triggered a hunt for antique Giotto sources.[183] It led to a number of plausible results; one may think for example of the observation that the Roman horse tamers (*Dioscuri*) of the

181 I. Nagel, *Gemälde und Drama: Giotto Masaccio Leonardo*, Frankfurt 2009, p. 39: "Sonst suchte und fand Giotto überall, mit davor unbekanntem Eifer und Genie, den *einen*, den ,interessanten' Augenblick."

182 O. von Simson, Über Giottos Einzelgestalten, in: *Giotto di Bondone,* Constance 1970, pp. 229–241. W. Tronzo, Giotto's Figures, in: *Medioevo: Arte lombarda*, ed. A.C. Quintavalle, Milan 2004, pp. 287–297.

183 A. Smart, *The Assisi Problem and the Art of Giotto*, Oxford 1971, pp. 88–92.

Fig. 51: South wall of the nave: The Adoration of the Magi, detail

Quirinal are behind Giotto's camel tamer in the Adoration of the Magi[184] (fig. 51). In addition to the antique patterns, Otto von Simson also considered Byzantine and French material and the medieval model book system, which was a centuries-long living culture of varying and reusing figures. There was a notable burst of creativity that took place within the framework of a visual language widespread in Central Europe and Italy during the 13th century called the zigzag style (Zackenstil) by art historians. The hell scene in the dome mosaic of the Florentine baptistery, depicting masses of panic-stricken figures throwing themselves back and forth, whereby no two patterns of motion are quite the same, is one example of this style (fig. 52). And yet these figures are all ultimately variants of models from the same Middle Byzantine corpus.[185] If there was a single image from which Giotto could have learned a particularly free or critical approach to pre-existing models, then it would be this mosaic in the baptistery of his hometown. A figure like the dreaming Joachim in the fifth picture of the Arena cycle shows the relevance of such considerations (fig. 53). The squatting man is a pasticcio entirely in the spirit of the zigzag style – but more sovereign: The combination of the one kneeling with the one bent leg is taken from a figure of the disciple James in a Middle Byzantine representation of the Transfiguration (like the one in Sopoćani), and the resting position of the upper body is taken from a Middle Byzantine Agony in the Garden picture (like the one in the Church of St. Clement, Ohrid).

184 M.D. Edwards, The Impact of Rome on Giotto, *Bollettino del Museo Civico di Padova* 79, 1990, pp. 135–154, esp. 138–139. On the reception history of the horse tamers: V. Wiegartz, *Antike Bildwerke im Urteil mittelalterlicher Zeitgenossen*, Weimar 2004, pp. 121–127.

185 Schwarz, *Die Mosaiken des Baptisteriums in Florenz*, pp. 41–45. M.V. Schwarz, Zackenstil des Südens: Zur Höllenlandschaft im Florentiner Baptisterium, ihren Voraussetzungen und Wirkungen, in: *Europäische Bild- und Buchkultur im 13. Jahrhundert*, ed. Chr. Beier and M. Schuller-Juckes, Vienna 2020, pp. 33–50.

Fig. 52: Florence, Baptistery, dome mosaic: hell scene

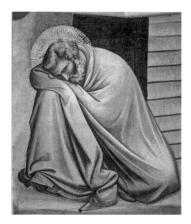

Fig. 53: South wall of the nave: Joachim's Dream

Still, the answer given by Simson and Tronzo is not entirely satisfactory. Both authors start from the assumption that medieval artists, including Giotto, always and on every occasion used painted or drawn exemplars. But this does not explain the appearance of specific figures that are neither a visual success in themselves nor able to fulfil their narrative function. And yet they do exist. I am thinking, for example, of the first scene of the St. Francis cycle in the lower church of S. Francesco in Assisi, which may have been created after the middle of the 13th century.[186] As far as is known, the cluster that includes Francis and the bishop standing behind him and wrapping him in his cloak was realized here for the first time (fig. 54 – in the 14th century it would become a topos in Franciscan iconography, which Giotto also made use of). In the case of the figure of Francis, it is evident that the painter known as the Franciscan Master did not use any known model, and certainly not an antique, Byzantine or Gothic one: the motions are not integrated; the legs in particular do not fit together. The elegantly twisted right leg may have been taken from somewhere (the hell scene of

186 S. Esser, *Die Ausmalung der Unterkirche von S. Francesco in Assisi durch den Franziskusmeister*, Ph. D. Bonn 1983.

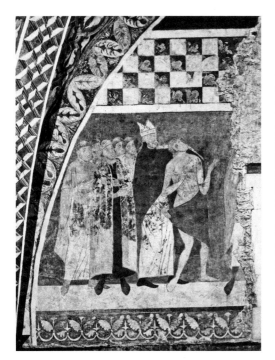

Fig. 54: Assisi, San Francesco, Lower Church: St. Francis' Renunciation of Worldly Goods

Fig. 55: South wall of the nave: The Massacre of the Innocents, detail

the Florentine baptistery comes into question),[187] but the left leg is a pure improvisation. The gestures of the arms demonstrate helplessness – not the helplessness of Saint Francis towards his angry father (who was in the lost right hand third of the picture) but the helplessness of the painter in developing a decipherable body language. What should have been made clear is that Francis turns to God while addressing his father with the words (Bonaventura, *Legenda Maior*, II, 4):[188] "Until today I called you my father on earth, but now I can speak with confidence: Our Father in heaven!" The failed figure shows that visual narrative could hardly succeed without models but that there were nevertheless cases (especially with new pictorial subjects) in which the painters tried to develop figures themselves. Thus, not only does the question arise of how Giotto used models, but also of where and how he worked without them.

187 On the relevant figure in Florence and its Middle Byzantine background: Schwarz, *Die Mosaiken des Baptisteriums in Florenz*, pp. 44–45.

188 "Usque nunc vocavi te patrem in terris, amodo autem secure dicere possum: Pater noster, qui es in caelis." *Fontes Franciscani*, ed. E. Menestò and St. Brufani, Assisi 1995, p. 790.

In the centre of the picture, which shows the Massacre of the Innocents, Giotto uses a classical model book figure (fig. 55). As Otto von Simson showed, the henchman in a grey garment, whose movement as he stabs elegantly like a torero, can be traced via Giovanni Pisano to transalpine Gothic painting. In addition, the child at whom the henchman's sword is aimed may also be based on a form discovered in a model book: if you rotate the figure in the plane, it is easy to imagine that the design was originally a Christ child in the arms of his mother, or possibly an angel or cupid from a decorative context. We will encounter such figures in Assisi, and perhaps Giotto adapted the child from there (p. 211). For the henchman with the hood, who stands diagonally behind the man in the grey dress, such possibilities can not apply, however.[189] His angular motion pattern is neither Gothic or Byzantine nor antique, but improvised like that of the figure of St. Francis in Assisi. In contrast, however, his depiction is functional, credible and in its additive design impressive in a sinister way. This henchman embodies the arbitrariness of violence better than his colleague from the model book, who is violent in a carefully choreographed way.

The model book material also plays a limited role in the picture with the Arrest of Christ (fig. 56). The fanatical priest in the pale purple robe on the right, whose gesture of speech runs through the whole body, may be a beautiful and, in the conventional sense, eloquent figure: it has its prototypes in the Italian reception of Gothic art. In quite the same role, namely as the Pharisee who leads the command at the Arrest of Christ, it appears on Giovanni Pisano's Pisan Cathedral pulpit, which according to the inscription was begun in 1302 and completed in 1311.[190] In this instance, the hand of the outstretched arm touches the shoulder of Christ, thus marking him as the one to whom the operation is addressed. Giotto transformed the position of the arm into a domineering gesture. The truly frightening embodiment of evil in Giotto's painting is yet another figure placed in front of the Peter and Malchus scene: the grey-veiled man with his too-short left arm stretched out at a right angle, whom one sees from behind and thus in a way that makes any identification impossible. What is depicted – but it is not easy to recognize – is Mark 14: 51–52: One of those who accompanied Christ is grabbed by the robe; he lets the robe go, "and fled from them naked." We see the purple cloth in the hand of the man in grey, the naked man is (for reasons of decency) outside the frame.[191] The decisive contribution

189 The following contribution therefore appears to be erroneous: Chr. Lloyd, Giotto and the Calydonian Boar Hunt: a Possible Antique Source?, *Source* 3, 1983, 3, pp. 8–11.

190 *Il Duomo di Pisa*, ed. A. Peroni (Mirabilia Italiae), 3 vols., Modena 1995, vol. 1 p. 227 (R.P. Novello).

191 V.L. Stoichita, Sens de lecture et structure de l'image: Quelques considérations sur l'art narratif de Giotto, *Art et fact: Revue des historiens d'art, des archéologues, des musicologues et des orientalistes de l'Université de l'Etat à Liège* 18, 1999, pp. 188–195, esp. 194.

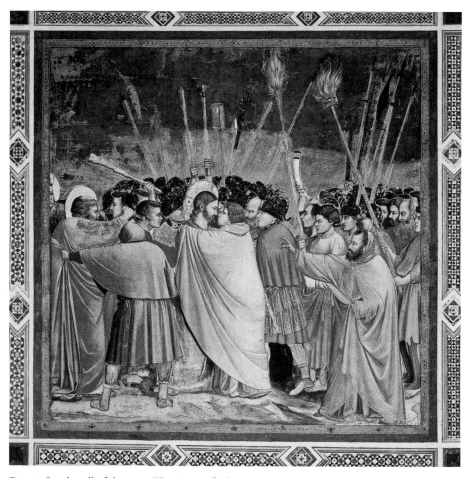

Fig. 56: South wall of the nave: The Arrest of Christ

to the effect of the picture, however, is the clumsy improvised posture and the aggressively protruding arm, which is made conspicuous by a kind of garment shield.

Likewise, the figure of Peter is not a creation based on models. The hand holding the knife has already amputated the ear but without the victim having become aware of it. The fact that Peter's upper arm half hides his face and that the violent movement of the arm is barely visible in Peter's body can be understood as an imperfection of the design and suggests the idea that we are indeed not dealing with a tried and tested figure, but with a figure invented *ad hoc*. Despite this, or perhaps because of it, the narrative effect is very powerful. And in the interplay with the gesture of the grey figure, seen from behind, and the club swung in the air, a zone of uncontrolled jerky movements is created, which

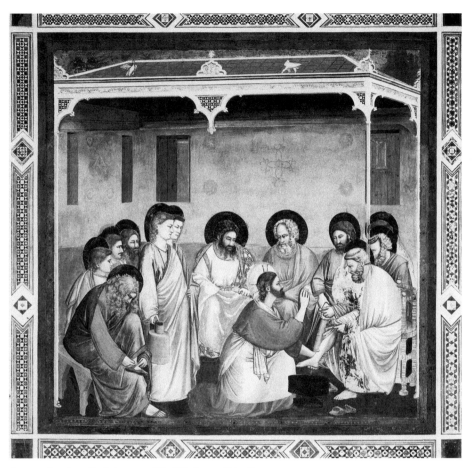

Fig. 57: South wall of the nave: The Washing of the Feet

contributes considerably to the drama of the picture. But even in cases where more or less suitable figures already existed, Giotto sometimes varied them so much that his creations seemed more like alternatives than derivations and it is difficult to recognize the source. It is worth mentioning the Virgin Mary in the Nativity (pl. III): the visual tradition and the material Giotto used for the invention of the image suggest a reclining figure leaning on her arm. At Santa Maria Maggiore, Torriti showed that such a figure allows the description of an intimate mother-child relationship (fig. 40). Giotto, however, abandoned the raised posture of the upper body and instead introduced a twisting of the entire body. Note the position of the left leg! The painter even accepts the visible buttocks. The torsion not only enables a more intense eye contact between mother and child, but also defines the figure of Mary completely by her relationship with Christ. With the rotation of the

diagonally lying body, the focus of our attention also veers to the left edge of the picture. Mary loses some of the dignity of her appearance; one can also criticise how her posture is not entirely physically plausible. But the body of the virgin is now an instrument of narration from head to toe.

Similar observations can be made with the image of the Washing of Feet: Peter and two other apostles present their feet in such a way that one may think that Giotto must have used the Roman *spinario* (fig. 57). The figure in question, portraying a boy pulling a thorn from the sole of his foot, was no doubt familiar to the artist as it belonged to the Lateran bronzes, a group of sculptures that were quasi profane cult objects in medieval Rome. It was actually claimed that the painter had adapted this figure for the painting.[192] However, on closer inspection none of the apostles follows the pattern of movement given there. Obviously, Giotto either did not see the possibility of resorting to the *spinario*, or he felt that his concept of the Washing of the Feet, which elaborates on a Byzantine or Veneto-Byzantine composition of great narrative power (a corresponding mosaic exists, for example, in San Marco in Venice), was not compatible with the Lateran boy and his self-absorbed posture.

It is true that Giotto worked on the models he used more carefully than most previous painters, but the antique and model book figures do not dominate the scenes, and it is the other figures that are more important for the appearance of the pictures and their narrative. When a reused figure occupies the centre of a picture, as in the Massacre of the Innocents, this is the exception. At least as frequently found are the improvised figures. Giotto did not only use them in special cases. As a result, the repertoire of bodily movements in the pictures seems unlimited: anything that is narratively desirable is feasible. Moreover, the painter knew how to transform the imperfection of these figures – imperfection measured by the standards handed down from antiquity – into intensified expression. Just as important as the potential for expression, however, is the unpredictable and irregular nature of the movements. This becomes particularly clear in the image of the Arrest: Giotto shows more and often choreographs differently than the combination of the text and the image tradition would suggest.

EMOTIONAL ENERGY

But on the feast day Joachim stood among those who brought burnt offerings to the Lord and prepared his gifts in the presence of the Lord. And there came to him a certain priest from the temple, Reuben by name, saying: It is not lawful for thee

192 Edwards, The Impact of Rome on Giotto, pp. 140–143. On the *spinario* and his reception history: U. Rehm, *Klassische Mythologie im Mittelalter: Antikenrezeption in der bildenden Kunst*, Vienna 2019, pp 189–194.

to stand with them who are doing sacrifice to God, for God has not blessed thee, neither has he given thee seed in Israel. Being therefore disgraced before all the people, Joachim went out of the temple and wept.

This is the textual basis for the first scene of Mary's life according to Pseudo-Matthew (II, i).[193] Almost word for word the same passage is found in the *Legenda Aurea*. While Giotto, as already mentioned, made the scenery of the temple plausible with the help of the marble furniture of papal basilicas, he did not rely on quotations – either from reality or from the pictorial tradition[194] – for the appearance of the characters, but speculated on the viewers' feelings (fig. 58). On the one hand, he probably assumed that the audience would be more outraged if not only a dignified old man was treated badly but at the same time a young man was treated well. It is thanks to one of the rare *pentimenti* in the frescoes that we can recognize the latter man's face within the marble barriers as beardless and youthful. Originally, only the upper half of the face would have been visible and only the colour of the hair alone would have allowed conclusions to be drawn about the age. On the other hand, the painter appeals to our pity for Joachim, which is not only stimulated by his painful and yet traditional facial features. More effective is his strangely tender gesture. Whoever does not know the story may believe that Joachim is not expelled from the temple in Jerusalem but from an animal hospital, so desperately caring is the way in which he presses the lamb to himself and so fragile and in need of help is the animal's appearance.[195]

The continuation of the story in the second picture is also a speculation on our compassion: According to the *Legenda Aurea*, based on pseudo-Matthew, Joachim "set out and went to his shepherds".[196] There, he who was rejected in the temple is obviously not welcome

193 "Factum est autem in diebus festis inter eos qui offerebant incensum domino staret Joachim, parans munera sua in conspectu domini. Et accedens ad eum scriba templi nomine Ruben ait: Non tibi licet inter sacrificia die agentes consistere, quia non te benedixit deus ut daret tibi germen in Israel. Passus itaque verecundium in conspectu populi abscessit de templo domini plorans, et non est reversus in domum suam ...» *Evangelia Apocrypha*, ed. Tischendorf, p. 55.

194 Cf. Giunta, Appunti sull'iconografia delle storie della vergine nella Cappella degli Scrovegni.

195 Cf. W. Prinz, *Die Storia oder die Kunst des Erzählens in der italienischen Malerei und Plastik des späten Mittelalters und der Frührenaissance 1260–1460*, 2 vols., Mainz 2000, vol. 1 pp. 78–79.

196 "Secedens ergo ad pastores suos ..." *Legenda aurea*, ed. Maggioni, p. 904. The passage reads in Pseudo-Matthew: "... et non est reversus in domam suam, sed abiit ad pecora sua, et duxit secum pastores inter montes in longinquam terram." *Evangelia Apocrypha*, ed. Tischendorf, p. 55. The fact that Giotto's shepherds come to meet Joachim shows that the text of the *Legenda Aurea* was used at this point.

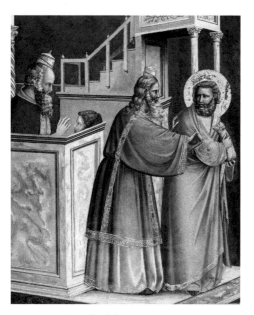

Fig. 58: South wall of the nave: Joachim's Expulsion from the Temple, detail

Fig. 59 South wall of the nave: Joachim among the Shepherds, detail

either, for Giotto's shepherds do not look at him, but have a meaningful look at each other "uncertain what to do and how to receive their master" (this is how Ruskin interpreted their conduct[197] – fig. 59). It may well be that the painter imagines them knowing about Joachim's problem. Not only is the rejection repeated, but also his attachment to an animal as a humiliating replacement. A white dog dances its welcoming ballet in front of Joachim, and he observes this joyful performance as seriously as if it were really about reflecting on the value of canine compared to human affection. Instead of being with his shepherds in a refuge, we see the patriarch at his lowest point. The continuation of the story is made all the more glorious with the apparitions of the angels in the following two pictures.

It is therefore not just the depiction of strong, unmistakeable feelings, anchored in the respective text, that captivates the viewers of Giotto's pictorial narratives: the jubilant joy of a young man attending the Betrothal of the Virgin, the screams and tears of the mothers of Bethlehem, the amazement of the relatives in the Raising of Lazarus. The transparency with which these emotions are presented is indeed new and important for reading the pictures. But at least as important are the small impulses, nuances, ambiguities and what the audience itself, encouraged by the painter, can contribute. This gives the pictures credibility and an additional emotional life. The whole range of these possibilities unfolds

197 Ruskin, Giotto e le sue opera a Padova, p. 182.

in the Crucifixion, a particularly calm, almost schematic and in any case traditionally composed picture, which must be experienced through the extraordinarily well thought-out and elaborate details (pl. VIII).

The viewer is addressed most directly by the figure of Mary Magdalene: she kneels at the foot of the cross. Although the idea that she played a special role in the crucifixion became increasingly clear among authors writing since the middle of the 13th century,[198] there is no real textual basis for her appearance here. There are a scattered few visual examples from the 13th century, and there is a strong pictorial tradition placing St. Francis at the foot of the cross.[199] Giotto's idea was not isolated, but still unusual. The visitor to the chapel would likely have been transfixed not only by the extreme emotionality of the figure, but also by a certain sense of surprise.

Giotto's Mary Magdalene is unaware of what is going on around her. The painter conveys this by depicting her clothes slipped off her shoulder. She concentrates completely on anointing the feet of the crucified Christ with her hair. This motif refers to passages in Luke (7: 37–38, banquet in the house of the Pharisee) and John (12: 1–8, banquet in the house of Lazarus). This means that her activity does not really belong in the context of the Passion but in the context of Christ's public ministry. Her behaviour, as conceived by Giotto, comes across as especially shocking because it is literally misplaced. The face of the saint appears distorted by pain in profile (fig. 60). Read together with the action fixed on Christ's feet, the expression gains a deeply disconnected quality.

Fig. 60: North wall of the nave: The Crucifixion, detail

A Good Friday *lauda* from around 1300, which was passed on in Assisi and Gubbio and which Giotto may or may not have known (just as it is unclear whether or not its anonymous author knew the Arena fresco or a variant of it – the question of pre-

198 S. Haskins, *Mary Magdalen: Myth and Metaphor*, London 1993, pp. 200–202.
199 D. Bohde, Mary Magdalene at the Foot of the Cross: Iconography and the Semantics of Place, *Mitteilungen des kunsthistorischen Institutes in Florenz* 61, 2019, pp. 12–42. The Crucifixion miniature of the Exultet roll of Salerno should be added to the collection of pictorial examples (G. Cavallo, *L'Exultet di Salerno*, Rome 1993). It should also be noted that the painted cross from Varlungo may be later than Giotto's fresco; at least it is later than the cross of Santa Maria Novella (1300–1301); the representation of the Golgotha hill points to this (*Dal Duecento a Giovanni da Milano. Cataloghi della Galleria dell'Accademia di Firenze: Dipinti I*, ed. M. Boskovits and A. Tartuferi, Florence 2003, Nr. 42).

cedence cannot really be clarified), could be added to Giotto's figure as text. It encourages the pious singers to identify with the Magdalene and to support her in her actions:[200]

E io, Madalena trista	*And I, the sinful Magdalene*
me gettai su ne' suoi piedi	*threw me at his feet,*
a' quali feci grande acquista	*at which I won a lot,*
che purgò i peccati mei:	*for I diminished my sins.*
Se en issi me chiodate	*Nail me firmly at his feet*
e giammaio non men levate.	*and do not let me rise.*

It is therefore Mary Magdalene in her role as a repentant sinner who is expected to have a special reverence for the sin-redeeming effect of Christ's sacrifice and whose self-sacrifice invites us to identify with her.

To the left of the cross, the mourning grimace of a woman dressed in yellow attracts the attention of the audience, although she is positioned at the edge of the picture. Her gaze on Mary, who is in danger of losing consciousness, is best understood from the fifth and sixth verses of the *Stabat Mater*. It is a text perhaps from as early as the 12th century, which became extremely popular in the 13th century:

Quis est homo, qui non fleret,	*Is there one who would not weep,*
Matrem Christi si vederet	*Whelmed in miseries so deep*
In tanto supplicio?	*Christ's dear mother to behold?*
Quis non posset contristari,	*Can the human heart refrain*
Christi Matrem contemplari	*From partaking in her pain*
Dolentem cum filio?	*In that mother's pain untold?*

The picture calls us to empathise with the woman, who apparently feels a raging pain of pity at the sight of Mary, who for her part has already been overwhelmed with grief for her Son. With this, Giotto has set a different accent from that which characterizes the *Stabat mater* hymn as a whole and which was described in this way: "The speaker of the Stabat mater seeks his salvation by entering into the communion of love and suffering of Mary and Christ. In the process of becoming one with Mary, he or she wants to be led into a perfect perception, understanding, and awareness of the redeeming act of Christ."[201] In

200 *Laude drammatiche e rappresentazioni sacre*, ed. V. de Bartholomaeis, Florence 1943, vol. 1 pp. 321–333, esp. 325.

201 A. Kraß, *Stabat mater dolorosa: lateinische Überlieferung und volkssprachliche Übertragungen im deutschen Mittelalter*, Munich 1998, p. 73.

addition, Giotto opens up a strongly mediated relationship between the viewer and Mary. It is not determined by putting dampers on emotion; on the contrary: just as Mary seems to suffer worse than Christ himself, the woman dressed in yellow seems to suffer more violently than Mary. By looking at both Mary and the weeping woman, who in turn looks at Mary, the viewer becomes both an inner participant and a helpless observer of the Passion.

To the right of the cross, the less sensational feelings prevail, allowing the viewer to retreat to a position of pure observation. At the same time this results in a captivating narrative web that brings the viewer close to one of the protagonists (fig. 61). Two motifs from the gospels were adapted: the first is the story of the good Centurion who, after the death of Christ, realises and proclaims that he was the Son of God. The Centurion is the only bearer of a nimbus in the group. The other motif is the story about Christ's robe according to John (19: 23–24):

> Then the soldiers, when they had crucified Jesus, took his garments, and made four parts, to every soldier a part; and also his coat: now the coat was without seam, woven from the top throughout. They said therefore among themselves, Let us not rend it, but cast lots for it, whose it shall be: that the scripture might be fulfilled, which saith, They parted my raiment among them, and for my vesture they did cast lots. These things therefore the soldiers did.

In order to visualize the action, Giotto transformed "They said therefore among themselves" into a loud argument. It unfolds in a group open to the spectators, whereby the painter reduced the number of soldiers to three, thus leaving out, so to speak, the person in front, who would have obstructed our view. On the right stands a young soldier whose friendly face, in its smoothness and openness, seems above all naïve, and who, almost naturally, already wields a knife to cut the robe. An elderly man holds back his hand and glares angrily at him. But the viewers will not take his side, because he behaves just as brutishly and, from the point of view of Christian ethics, just as inappropriately as his naïve companion. We take the side of the person on the right whose profile reflects and transcends the profile of the naïve. One might not call him a soldier in light of his golden armour; rather one thinks of a young officer, say a decurion. With a contemplative look and a gesture of speech, he got the attention of the naïve one and will be more effective than the angry one in stopping his destructive action. His eloquent hand is juxtaposed with the mechanical hands of the angry man.

Framed by the angry soldier and the decurion, who are moved far apart, the view opens to the second motif, the speech of the good Centurion. By arranging the scenes one behind the other instead of side by side, as would have been the obvious choice, the painter entwines the different actions and likewise our perception of the protagonists' different emotions. He gave the Centurion, in the form of the bearded pharisee, a partner

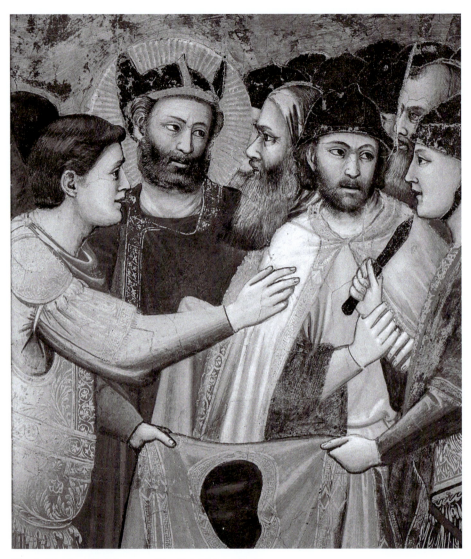

Fig. 61: North wall of the nave: The Crucifixion, detail

to whom he can direct his well-known phrase (Mark 15: 39: "Truly this man was the son of God") and through whom his gesture of pointing to Christ, long established in iconography, receives its motivation. The profile of the pharisee echoes the profile of the naïve young man. This correspondence raises doubts as to whether the speech of the Centurion will impress the pharisee in the same way as the words of the decurion impressed the

naïve young man. The tilted semi-profile of the Centurion, on the other hand, replicates the semi-profile of the angry man, and his distinctly different facial expression marks the distance between the emotions of higher comprehension and short-sighted advantage. However, most poignant is how the decurion and the Centurion are associated with each other, for the former participates in the nimbus of the latter: So it is not only that the impeccable behaviour, the sympathetic look, the splendid armour and the absence of the helmet win us over for this person, but the participation in the nimbus of the Centurion gives our inclination an objective confirmation and signals that he shares in the insight that, according to the biblical text, is due to the Centurion alone.

Giotto did not only create a sympathetic figure from a textual nothing, but almost a new saint, a holy decurion, who walks alongside the holy Centurion. A theological background cannot be excluded: since patristic times the seamless and undivided garment has been interpreted as a sign of unity, be it for the unity of the Trinity or for the unity of the Church.[202] Our decurion would thus be the saviour of an object of importance on the symbolic level. In addition, the Passion account of the *Legenda aurea* contains the story that the robe was later owned by Pontius Pilate, who, when he fell from grace, used the miraculous relic to appease the angry emperor.[203] Giotto may have known this story, as he used the *Legenda aurea* several times. In this case the decurion would be the intermediate owner, not mentioned in the text, but beneficial for the credibility of the Pilate legend and thus legitimately interpolated. Nevertheless, it is not said that Giotto's invention is influenced by such ideas related to the robe and can only be understood once corroborated by them. On the other hand, its function in the story is evident: with the decurion a character was created that makes the plot richer and draws the viewer into the narrative.

CHRIST'S GAZES

The scene of the Arrest of Christ is a real battlefield (fig. 56). Dynamics of resistance are already included in its basic concept: Giotto reverses the reading direction of the event so that Judas comes from the right instead of from the left, as is usual and would correspond with the sequence of scenes in the Arena Chapel.[204] With this the traitor turns not only against Christ, but also against the beholders of the scene. Equally effective are certain dramatically portrayed events, which follow a completely disparate choreography, such as the figures fleeing from the frame. In addition, there are weapons swinging through

202 Prinz, *Die Storia oder die Kunst des Erzählens*, p. 91. Ch. Frugoni, *Gli affreschi della Cappella Scrovegni a Padova*, Turin 2005, p. 184.

203 *Legenda aurea*, ed. Maggioni, p. 351.

204 Stoichita, Sens de lecture et structure de l'image, p. 194.

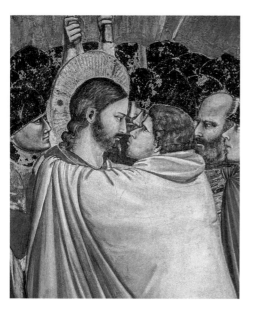

Fig. 62: South wall of the nave: The Arrest of Christ, detail

the air and rapid chaotic movements: a structure in which much seems random, much also seems redundant, and where a surplus of information constitutes a space of the real – this is how Norman Bryson reads the picture.[205] But at the centre, in the eye of the storm, is a non-event, namely the fact that the traitor has either already kissed the betrayed or has not yet kissed him (fig. 62). Even more so than through the calculated unfolding of unpredictability and chaos, Giotto deviates from the usual mode of representing the Arrest by allowing the action to stand still at this critical point.

The moment immediately after the kiss is intended, says Bruce Cole.[206] In this case, Christ's clearly open lips would form the words, "Friend, wherefore art thou come?" (Matt. 26: 50). It is true that according to the biblical account, Christ only speaks after the kiss, not before. In contrast, Max Imdahl says that our painter depicted the moment before the kiss, and points to the traitor's pursed lips. He proceeds to say: "In Giotto's painting, the momentary standstill in Judas' action caused by Jesus' gaze is the dramatic essence of the scene."[207] It is difficult to decide whose lips, the open or the pointed ones, are decisive in determining the narrative moment. It is also anything but certain that Giotto was concerned with the portrayal of a precise point in time. Rather, he showed a combined and complementary appearance of the kissing and the speaking mouth and thus a representation of betrayal and its unmasking in the same scene (as in this and in many other pictures of the Arena Chapel several layers of time are present anyway).[208] Nevertheless, Imdahl judged the situation plausibly when he said that Christ's gaze replaces the action. Or rather, it is this gaze that transforms physical into psychical action. The power of the gaze is underlined by the disappearance of Christ's body in Judas' coat and by his lowered head in profile, which resists the traitor's pressing

205 Cf. Bryson, *Vision and Painting*, pp. 56–66.
206 B. Cole, Another Look at Giotto's Stigmatization of St. Francis, *The Connoisseur*, 1972, 727, pp. 48–53.
207 Imdahl, *Giotto Arenafresken*, p. 94.
208 Some authors see it differently, for example: P. Toesca, *Giotto*, Turin 1941, p. 32 and Nagel, *Gemälde und Drama*, p. 39.

body. Victor Stoichita noticed an innovation in the iconography of the Arrest in the use of the profile for Christ, and thus also in the gaze fixed on Judas.[209] The power of this gaze is most clearly demonstrated, however, by the many powerless gazes that flock in a circle around the pair of betrayer and traitor.

The scene that immediately follows is similarly dramatic in its depiction of Christ before Annas and Caiaphas (pl. VII). The tearing of the robe and the hand of a young officer raised to strike Christ in the face, combined with numerous aggressive movements and hostile gestures, form the noisy background of the event. Nothing from the repertoire of motifs is fundamentally new. These elements have been part of the treatment of the scene in Tuscan painting for half a century; some of them even go back to Byzantine models and are suggested by the biblical text.[210] What is new is the feature we look at first, despite all the turbulence: Christ's face turned frontally out of the picture with oversized eyes (fig. 63). Christ is "practically never" depicted frontally in Padua, says Stoichita.[211] One exception is here. Equally striking and difficult to interpret is how he looks over his shoulder. The words related to his appearance here trigger the storm of indignation and cause Caiaphas to tear his robe. For when he asked Christ whether he was the Son of God, he received the answer: "Thou hast said: nevertheless I say to you, Hereafter shall ye see the Son of man sitting on the right hand of power, and coming in the clouds of heaven." (Matt. 26: 64). The sentence can be understood as an announcement of the Second Coming on Judgment Day. Giotto probably imagines Christ's gaze being directed towards the picture on the west wall and the representation of the Redeemer arriving in the clouds (fig. 7). The image of the Last Judgement seems to have been given the role of visualizing the speech of Christ, a connection, however, that not everybody may have understood. More important for our experience of the scene is the contrast between the confident calm of Christ, which appears, through the turning of his head, as the main motif of the picture, and the aggressive background noise. It is also important to realize that this face, whose gaze captivates us and from which we do not want to turn away our attention, will immediately be struck by the young officer's blow.

In the Arena Chapel there are gazes that help constitute the action, and gazes that captivate viewers,[212] but only Christ has a powerful gaze that transcends the action. Giotto allows this phenomenon to begin with Christ's birth, and so he first attributes it to a being who, in our understanding, is not yet able to master a focused gaze. In the image of

209 Stoichita, Sens de lecture et structure de l'image, p. 194.

210 A. Derbes, *Picturing the Passion in Late Medieval Italy: Narrative Painting, Franciscan Ideology, and the Levant*, Cambridge 1996, pp. 72–80.

211 Stoichita, Sens de lecture et structure de l'image, p. 194.

212 V.I. Stoichita, Giotto – the eye and the gaze, in: *The Right Moment. Essays offered to Barbara Baert*, Paris 2021, pp. 147–180.

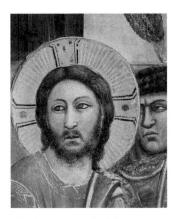 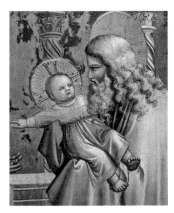

Fig. 63: South wall of the nave: Christ before Caiaphas, detail

Fig. 64: South wall of the nave: The Nativity of Christ, detail

Fig. 65: South wall of the nave: The Presentation in the Temple, detail

the Nativity, Mary looks at the child with concentration and care, as do the ox and the midwife; but Christ, both of whose eyes are visible, detaches himself from in this worldly benevolence through his active gaze and, although swaddled like a mummy, presents himself as a benevolent, caring and loving Lord (fig. 64). The same applies to the following two scenes, in which the *Meditationes Vitae Christi* in the Presentation literally demanded an action from the child. While in the text Christ reveals his will through gestures in a childlike manner ("Then the boy stretched His arms toward His mother and returned to her")[213], in Giotto's depiction, however, it is primarily the gaze that functions as a medium of his will (fig. 65).

Within the framework of Giotto's pictorial concept, the gazes of Christ play two roles: they preserve the narrative's meanings against the excess of redundancies and contingencies accumulated by Giotto and used to authenticate what is depicted and to reduce the perception of its artificiality. And they increase the contingency by presenting variants of the narrated events that would have been unforeseeable for the beholders even with exact knowledge of the visual and textual sources.

ELOQUENT HANDS

The role of gestures is similarly ambivalent. They contribute both to the stringency and the contingency of the narrative. This can readily be understood by looking at the hands

213 "Deinde puer Iesus extendens brachia versus matrem ad eam rediit." *Meditaciones vite Christi*, p. 46. Imdahl, *Giotto Arenafresken*, pp. 52–53.

Fig. 66: South wall of the nave: The Flight into Egypt, detail

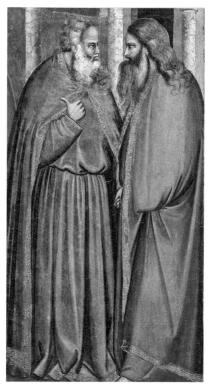

Fig. 67: Choir arch: The Betrayal of Judas, detail

of Enrico Scrovegni and Mary in the Foundation scene in the Last Judgment, which have almost, but not yet completely found each other and with which the meaning of the picture – the giving of a church building in exchange for intercession – is both explained and kept vague (fig. 1).

Another good example is the right hand of the green-clad boy in the picture of the Flight to Egypt (fig. 66, cf. fig. 193): the index and middle fingers imitate the donkey's trot.[214] It seems clear what those who walk behind the donkey are talking about: they are talking about walking behind the donkey. Or perhaps those who flee speak of fleeing. In any case, the gesture is redundant in the narrative context. On the one hand, it underlines the subject of the picture and makes the scene more stringent; on the other hand, the young people's babbling represented by the gesture does not do justice to the seriousness of the situation and so creates contingency.

In the Judas' Betrayal at the choir arch (fig. 30) the most conspicuous hand we see is that of the green-clad Pharisee on the right (fig. 67). With his thumb he indicates to his interlocutor the act of betrayal that is taking place. The gesture is considered coarse today; no educated person would use it. A fresco altarpiece by Pietro Lorenzetti in the Lower Church of San Francesco in Assisi, on the other hand, makes it clear that in Giotto's time,

214 Moshe Barash interprets the pose of the hand completely differently: according to him it is a horizontal variant of the *benedictio latina*. However, the author does not explain the function of such a gesture: Barash, *Giotto and the Language of Gesture*, pp. 35–37.

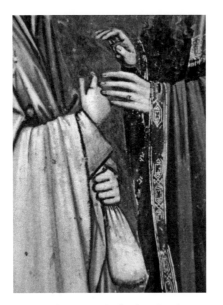 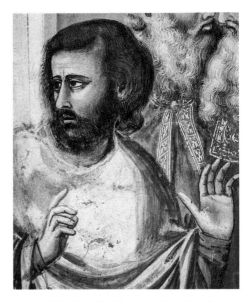

Fig. 68: The Betrayal of Judas, detail

Fig. 69: North wall of the nave: The Expulsion of the Merchants, detail

social leaders were free to use this gesture to point to social subordinates without violating the dictates of decency. There Mary points out her child to St. Francis in the same way as the Pharisee indicates his colleague to Judas. In the St. Francis cycle of the Upper Church, Francis, known for his modesty, refers to himself with this gesture (Sermon to Honorius III). Also John the Baptist, penitent and model of St. Francis, sometimes says "I" in this decidedly austere way.[215] Read analogously, Giotto's gesture in the Judas picture is the mark of social (and probably also mental) condescension.

The pair of pharisees seems to be derived from the "inimici" in the Presentation of Mary, but here the figures are turned towards the viewer. They do not reject the audience, which brings them closer to what Alberti wrote about such figures in his painting treatise a century and a half later:[216]

215 I owe this collection of material to Alexander Perrig (*Frankfurter Allgemeine Zeitung* 3 march 2006, p. 38).

216 Alberti, *Della Pittura. Über die Malkunst*, ed. Bätschmann and Gianfreda, pp. 132–133: „E piacemi sia nella storia chi ammonisca e insegni a noi quello che ivi si facci, o chiami con la mano a vedere, o con viso cruccioso e con gli occhi turbati minacci che niuno verso loro vada, o dimostri qualche pericolo o cosa ivi maravigliosa, o te inviti a piagnere con loro insieme o a ridere." Translation after John R. Spencer: Leon Battista Alberti, *On Painting*, ed. and trans. J.R. Spencer, New Haven and London 1966, p. 78.

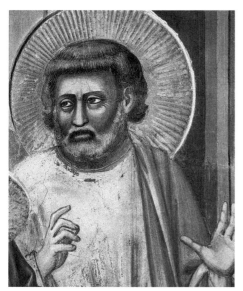

Fig. 70: The Expulsion of the Merchants, detail Fig. 71: The Expulsion of the Merchants, detail

> *In an istoria I like to see someone who admonishes and points out to us what is happening there; or beckons with his hand to see; or menaces with an angry face and with flashing eyes, so that no one should come near; or shows some danger or marvellous thing there; or invites us to weep or laugh together with them.*

To be more precise: the gesture and behaviour of the two men determines the perception of the scene behind them or at least places it in a specific context. Giotto's contemporaries must have been as surprised as they were satisfied to note that Judas' acting was no more justified from the point of view of the pharisees than from a Christian perspective.

The other prominent hands are those of a third pharisee (fig. 68). He speaks to Judas and fixes his eyes on him with a look whose power rivals that of Christ. This is complemented by his expressive hands. Precisely because the gesture is not clearly intelligible, it seems compelling. It is obviously repetitive and has both a calming and evocative effect. The longer one watches these hands, the more Judas' guilt evaporates and passes over to the speaker – and to the devil, who stands behind Judas and holds him. He does this so that Judas is exposed to the words of the Pharisee. With the help of the Pharisee's hands, Judas is de-demonized and made plausible as a potential alter ego for Scrovegni, without trivializing Judas' guilt.

The hands of the merchants in the temple are also eloquent, almost too eloquent for people who are being chased away by force. Especially the raised right hand of the per-

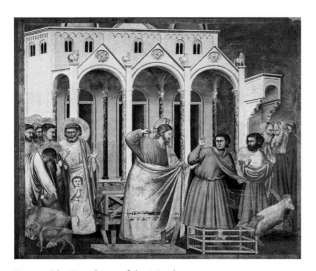

Fig. 72: The Expulsion of the Merchants

son on the left shows an almost gentle yielding, which, when read together with his gaze, allows only two interpretations (fig. 69): either Christ is not being taken seriously in his furore, or the man was already half converted before he was truly frightened. The second reading may be surprising, but it fits the account of Luke's Gospel, which says that Christ taught daily in the temple after the expulsion of the traders and the people listened to him (19: 45–48). And among the people – one might add – were those who had previously been profiteers. Such an interpretation of the picture scene, using Luke is supported on the one hand by the absence of the moneychangers, whom the other Gospels mention as the fellow-sufferers of the merchants, and on the other hand by the fact that the gesture of the merchant corresponds almost exactly to that of Peter, who is about to explain Christ's deed to the other disciples (fig. 70). The message that Peter conveys is already understood by the merchant: this is what Giotto seems to say with the parallel gesture. But the painter does not let the terror that spreads following Christ's attack in the temple disappear in this consensus. This is ensured by the representation of the animals fleeing to the left and right from the picture field. Note also the children who seek protection from the apostles. A scene on the left edge of the picture is particularly moving: John, who himself is hiding his face in fear, presses a boy against himself with his hand, while the boy in turn reaches for the disciple's robe (fig. 71): The hand on a shoulder, the little clasping hand and a quarter of a child's face give us the clearest testimony of Christ's wrath in the picture. This testimony reaches the audience relatively late (if at all): the picture as a whole is too spectacular (fig. 72). It touches the viewers all the more deeply when they discover this detail. The fact that certain gestures and other motifs are only gradually revealed is also among specific features of Giotto's paintings. Here complexity turns into an experience of reality.

THE PADUAN *BOTTEGA:* PICTURE FIELDS

As far as we know and can assume, there was no visual culture in Padua, when Giotto began his work for Scrovegni, that was in any way connected to his painting or to Roman or Florentine painting around 1300.[217] The audience and especially the patron had to be convinced of a pictorial language that was completely new to them. Perhaps Enrico Scrovegni came into contact with Giotto's art during a visit to central Italy. Indeed, if not, there would have been no arguments for awarding the contract to the Florentine, apart from reports about successfully completed commissions for sophisticated patrons in prestigious locations (including St. Peter's in Rome) and the inspection of sketches and drafts.

The insight into the foreignness of Giotto's visual language is also important when thinking about how he managed the assignment in terms of workload. It will probably never be clear how many assistants he employed who were merely helping and how many were standing and painting together with him on the scaffolding. What is certain is that he did not carry out the work alone, as some clashing details show (see below). On the other hand, the dominant impression that the decoration gives is its consistency. This corresponds with Giovanni Previtali's idea (*Giotto e la sua bottega*) that the master in Padua developed a particularly efficient style, which enabled him largely to manage without the supporting hands of other painters.[218]

The ideal-typical *bottega* (literally workshop, shop) is arguably a community whose members are, if not exclusively, then at least formatively trained by the master and can act as his doubles (or, at best, whose contribution is not visible at all). The Arena Chapel was probably the first large fresco decoration that Giotto created independently. There was certainly no well-rehearsed team that the master could transfer from Florence to Padua. The Paduan commission was therefore the necessary occasion for the founding of a bottega for Giotto and brought with it specific conditions: In this foreign environment an artistic community could be constituted as if under quarantine and quickly grow together.

How did the division of labour between Giotto and his assistants operate? Robert Oertel said:[219] "We have to imagine that everything accessory – architectural elements, ornaments, foliage, landscape – was carried out by specialized members of the workshop." Apparently Oertel is not only referring to the visual findings in the Arena Chapel, but also to the paradigmatic Rubens atelier in baroque Antwerp, with its specialization attested

217 The little that is known is presented in the following entry: F. d'Arcais, Pittura del Duecento e Trecento a Padova e nel territorio, in: *La pittura in Italia: Il Duecento e il Trecento,* Milan 1986, vol. 1 pp. 150–171, esp. 150–151.

218 Previtali, *Giotto e la sua bottega,* p. 87.

219 R. Oertel, *Die Frühzeit der italienischen Malerei,* Stuttgart 1966, p. 86.

to by tradition: Synders for animals, Wildens for landscapes, Jan Bruegel for flowers.[220] Laura Jacobus' comments, in contrast, are empirically based and schooled on the technical investigations of Bruno Zanardi in Assisi.[221] However, the numerous interesting observations she made are not easy to evaluate: are differences in painting technique evidence that different painters were at work, or of experimentation by the master, who was undoubtedly keen to find new approaches in other fields as well? Are heads and hands that recur more or less identically in several pictures evidence that there were assistants who were dependent on templates, or evidence that Giotto managed the extensive commission by streamlining his own methods (as Previtali would have argued)? Another thoughtful attempt to gain insight into the structure of the bottega is based on two observations: the first is, that the inscriptions in the chapel, some of which are short and found in the pictures and some of which are long and belong to the fourteen allegories of the pedestal zone, were probably written by four to six different hands. The second observation is, that in places where colours applied al secco have flaked off, preliminary drawings have been revealed and can be examined technically and stylistically. With a lot of good will they can be classified into a similar number of groups.[222] But can conclusions really be drawn from this about the number of painters and how they collaborated? Was there even a well-established procedure in Giotto's Paduan workshop? After all, the fresco technique in the form used in Padua was still young – not of ancient origin, as is often said, but probably no older than Giotto's work experience[223] – and a standard practice could hardly have developed yet.

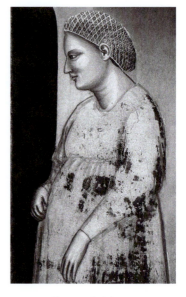

Fig. 73: Choir arch: The Visitation, detail

Quality differences are most easy to be defined and interpreted: one may mention the woman located on the right in the Visitation, a meticulously executed, but completely lifeless figure that stands out from its setting (fig. 73). A similar case can be found with the

220 Summarized presentation of the records: M.-L. Hairs, *Dans la sillage de Rubens: Les peintres d'histoire Anversois au XVIIe siècle*, Liège 1977, pp. 13–33.
221 Jacobus, *Giotto and the Arena Chapel*, pp. 133–152.
222 F. Capanna, Sotto il blu dell'Alemagna: nuovi studi sull'organizzazione del cantiere giottesco della Cappella degli Scrovegni, *Bollettino ICR*, n.s. 35, 2017 (2020), pp. 5–18.
223 Sh. Tsuji, The Origins of buon fresco, *Zeitschrift für Kunstgeschichte* 46, 1983, pp. 215–222.

midwife sitting on the right in the Birth of the Virgin. Such incidents are not frequent, but it is evident that Giotto sometimes – within the framework of his design, of course – delegated complete (secondary) figures.

There is also a picture that as a whole is strikingly weak: the Sacrifice of Joachim (fig. 74). The shortcomings can already be seen in the detail of the jumping ram in the foreground. Its model was one of a pair of animals running against each other, a motif that is common in ancient art.[224] However, the artist neither wanted to use a pair of rams in the painting, nor was he able to provide a suit-

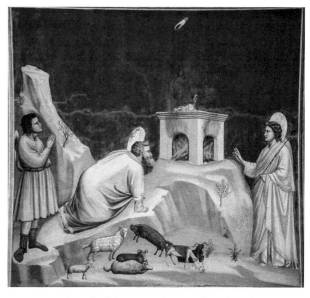

Fig. 74: South wall of the nave: The Sacrifice of Joachim

able counterpart for the animal he had borrowed. But the problems with the picture are not limited to details, and nor do they correspond to Oertel's paradigm of specialization nor to Jacobus' assumption that Giotto himself sketched all the pictures as sinopias on the wall: none of the three characters play their narrative roles sovereignly, and they hardly interact at all. The greeting angel seems to have been borrowed from a conventional Annunciation picture; the elegantly positioned shepherd is a Giotto figure, but seems to be developed for a different narrative context. It remains unclear what the sack-shaped figure of Joachim is directed towards, whether the angel, the offering or the fire. Unlike in other pictures, the main features of the story (Pseudo-Matthew III, i-iii) are not easily understood.[225] The sloping rock platform on which Joachim kneels is also revealing: its outline is so visibly attuned to the requirements of its user, including a spur tailored especially to his right hand, in a way that cannot otherwise be observed in the sequence of pictures. On the other hand, nothing in the painting really stands out from Giotto's Paduan style. The modelling of the robes and rocks is perfectly done. And there is even a painterly masterpiece: the fire that consumes the wood in the altar and flares out of its openings does not

224 J. Tripps, *Giotto malt ein lachendes Kamel: Zur Rolle des Tieres in der toskanischen Malerei des Trecento*, Freiburg 2003, pp. 27–29.
225 J. Lafontaine-Dosogne, *Iconographie de l'Enfance de la Vierge dans L'Empire Byzantine et en Occident*, 2 vols., Brussels 1964 and 1965, vol. 2 p. 73. Imdahl, *Giotto Arenafresken*, pp. 31–32.

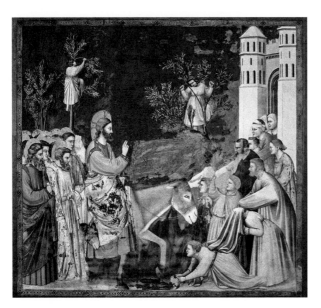

Fig. 75: North wall of the nave: The Entry into Jerusalem

compare with any depiction from this or earlier times. Either the painterly simulation of fire was one of the specialties of the collaborator to whom the picture was entrusted, or it was Giotto himself who intervened at this particularly difficult point.

Interestingly, the debacle of this painting, which is the fourth – apart from the medallions in the vaulting – executed in the chapel, was not repeated as work progressed. This can mean that the painter gained in competence through more practice and then could really work as a double of the master. It can also mean that Giotto divided the work better and avoided excessive demands on his collaborators. One place that suggests arguments for and against these statements is the picture that shows the Entry of Christ into Jerusalem (fig. 75): the invention is a great success; Max Imdahl's analysis has made this clear.[226] Here the idea is instantly convincing that a detailed preliminary drawing by Giotto exists, hidden under the final layer of plaster. But as far as the execution is concerned, the weaknesses are striking; they are condensed in the group on the right, whose painter was completely absorbed by the depiction of folds in the garments and the positioning of the bodies. The modelling of bodies revolving in space through the use of light that succeeded so naturally in all other scenes was not achieved here.[227] The most expressive face in the picture is that of the donkey, which is a replica of the animal in the Flight into Egypt. In contrast to the Joachim picture, it appears that only the execution was delegated. Since this is noticeable to such a high degree, it is probably due to the fact that the master, unlike in other pictures, did not contribute to the execution of this one at all.

All in all, the Paduan Bottega worked well, but was not hitch-free. Just as Giotto experimented with forms of representation, it is likely that he also experimented in the organisation of the division of labour. In any case, the nearly seamless integration of the assistants' contributions was an organizational and didactic achievement that stands

226 Ibid. pp. 61–64.
227 Cf. P. Hills, *The Light of Early Italian Painting*, New Haven and London 1987, pp. 41–63.

alongside Giotto's more strictly artistic accomplishments. It is possible that Taddeo Gaddi's artistry was one of the results: reportedly he worked for Giotto for 24 years (2.3.6). The time they spent together most likely ended with Giotto's move to Naples in 1328, as Taddeo's painting of the Baroncelli Chapel in Florence falls in the years after that (see pp. 454, 461). If this was the case, he received the initial and formative part of his training in the Arena Chapel and this would fit in well with the style he cultivated over the decades to come. In several aspects, Taddeo's formal language stays closer to the Arena frescoes than Giotto's own work.

THE PADUAN *BOTTEGA:* THE FRAMING SYSTEM

One area in which collaborators could be efficiently utilized to relieve the workshop head of his tasks (one can agree with Oertel here) was the framing system with which Giotto linked the images on the walls to each other, to the architecture, and to images on the inner façade and on the choir arch. This system includes imitation marble slabs, imitation architectural elements, Cosmatesque work, and vegetal ornaments – motifs that were repeated and mastered by the painters to perfection. Inserted in this system are also many figurative parts, especially on the upper walls and on the palace side wall. (On the south wall the decoration is reduced in favour of the windows). There are busts of saints, including the apostles and other biblical figures, but also non-biblical female martyrs and virgins. Most of the approximately 30 busts are shown rigidly from the front and are obviously serial products. In the corners of the room, the four Fathers of the Church stand out in a lower zone and the four Evangelists above them. The latter authenticate the stories told, while the former underline the coherence of the belief system into which the paintings are offering insight. This role of the Fathers of the Church corresponds to a then current theological discourse; this is something we will have to return to in connection with Giotto's activity in Assisi (p. 210). These eight differ from the other busts by the liveliness of the design, and among them are two that also stand out in execution: These are the Church Father Jerome and the Evangelist John (fig. 76). Both appear above the entrance from the palace, one on top of the other – a place that is additionally distinguished from that of the other authors and may have demanded Giotto's special commitment. At the same time, these two medallions were certainly specimen to which the assistants were to adhere.

Among the other images, the bust of the Magdalene is qualitatively out of the ordinary (fig. 77). The penitent saint adorns the ornamental strip next to the hell scene of the Last Judgment. Here, the mission of the representation probably went far beyond the decorative and was intended to serve as a catalyst for prayers in connection with the Last Judgement (and the unusual appearance of Mary Magdalene in the Crucifixion scene).

Fig. 76: North wall of the nave: St. John the Evangelist

Fig. 77: North wall of the nave: St. Mary Magdalene

Fig. 78: South wall of the nave: St. Augustine

Her look from the corner of her eye makes a lasting impression.

The busts of authors placed on the opposite (Paradise) side really do contain prayers. The parchment on which the Evangelist writes allows us to read the first words of the Ave Maria, a text that identifies him as Luke (and at the same time reminds us of the Annunciation play). Below him appears the bust of the Church Father Augustine (fig. 78), and here the book facing the viewer offers us several lines of text, although what is written does not fit the depicted author:[228]

> Ave Maria gratia plena, dominus tecum. Beneditta tu in mulieribus e benedittus fruttus ventris tui. Sca Maria ora per me. Beneditta sia la vergene Maria. Egredietur virga de radice Gesse, flos de radice eius ascendit. Beneditta sia la vergene Maria e laudato deo e tutti

It is an attempt at an improvisation on the Ave Maria using Isaiah (1:18). Hand in hand, the writer takes the prayer into his personal service: instead of "Pray for us sinners", the text now reads "Pray for *me*". He must have been a layman, otherwise he would hardly have fallen from Latin into the vernacular. The painter was probably also the author and scribe of the text. On occasion "Giotto's Ave Maria" is referenced,[229] but in fact the bust of

228 Claudio Bellinati's transcription: Frugoni, *Gli affreschi della Cappella Scrovegni a Padova*, p. 202.
229 *La cappella degli Scrovegni a Padova*, ed. Banzato et al., p. 235. Cf. A. Derbes and M. Sandona, Reading the Arena Chapel, in: *The Cambridge Companion to Giotto*, pp. 197–220, esp. 216: The text is assigned to Scrovegni as role text.

the Church Father is among the weaker works. Aside from the clumsy details it also trivializes Giotto's Jerome. Whereas Giotto's half-figure captivates us with the saint's concentrated gaze on a text that we do not see, here the text is thrust upon us. The language of the prayer corresponds more to Venetian than to Tuscan as was noticed. This means that the painter was a collaborator, who Giotto had recruited in Padua. The third volume will introduce a Giotto pupil named Gerarducius, who was working in Padua. He was not only an illuminator but also a scribe and as such may have been trained in the surroundings of the University of Padua. Whether he is the painter of Augustine's bust (and perhaps also the creator of Joachim's Sacrifice) cannot be proven, but the profiles of the assistant fresco painter and the illuminator fit together remarkably well.

The most interesting parts of the framing system, as far as iconography is concerned, are the ten typological medallions between the scenes from the life of Christ on the south wall.[230] Their quality is consistently high and the activity of assistants is therefore no more probable than in most of the history painting. A representation of the circumcision of Ishmael by Abraham – the first circumcision recorded in the Bible – announces the image of the Baptism in the Jordan; Moses, who strikes water from the rock, foreshadows the wine miracle at the Wedding of Cana; the Creation or Animation of Adam leads to the Revival of Lazarus; Zacharias preaches and prophesies the Entry of Christ into Jerusalem; Michael's victory over Lucifer prefigures the Expulsion of the Merchants from the Temple – so far the middle row of pictures. The lower row includes the Adoration of the Iron Serpent that announces the Crucifixion; Jonah, whom the whale swallows, represents Christ, who is mourned and who will then be laid in the tomb (pl. IX). This picture is followed by the only non-biblical typology in the chapel: the lioness, awakening her stillborn cubs by roaring (according to the *Bestiary*), introduces the Noli me tangere scene and distinguishes this scene as the representation of Christ's resurrection. The last two medallions show: the Ascension of Elijah (as a prediction of the Ascension of Christ) and Moses Receiving the Tablets of the Law (as an archetype for the miracle of Pentecost). Typology was a favourite form of theological speculation, but – according to Heather L. Sale – none of the innumerable known texts can account for the Paduan pairings in their entirety, most pairs can only be found in this one instance.[231] Here more clearly than elsewhere theological competence becomes apparent.

230 A. Bertini, Per la conoscenza dei medaglioni che accompagnano le storie della vita di Gesù nella Cappella degli Scrovegni, in: *Giotto e il suo tempo: Atti del congresso internazionale (1967)*, Rome 1971, pp. 143–147. H.L. Sale, Ten overlooked quatrefoils from the Arena Chapel, *Gazette des Beaux-Arts* 134, 1999, no. 1570, pp. 179–200. I. Hueck, Il programma iconografico dei dipinti, in: *La cappella degli Scrovegni a Padova*, ed. D. Banzato et al. (Mirabilia Italiae 13), Modena 2005, pp. 81–96, esp. 90.

231 Sale, Ten overlooked quatrefoils from the Arena Chapel, pp. 183–193.

152 Speech which Speaks to the Eye: The Arena Chapel

The most striking – and the most refined – among the medallions is the image of Jonah, which draws on a parallel made by Christ between the prophet and himself (Matt. 12:40). In this highly dramatic composition, the fish, an evil-eyed animal, emerges vertically from the depths and only the prophet's legs remain visible; but to the same extent the picture is also emblematic and decorative (pl. IX): the figures fit into the quatrefoil too well, the tip of Jonas' robe flutters too ornamentally, and the undulating water surface halves the picture format too exactly for the representation to be read naively as a narrative. At the same time, the quality is captivating: Noah's feet appear more substantial in their spatial position and corporeality than many a saint's face. The picture visualises an event that seems particularly significant because – according to the message conveyed by its unreal aspects – it is clearly more than meets the eye. In few other places can one study so well how Giotto creates meaning through the sophisticated use of his tools.

The allegories also belong to the cycle's framing system and here too, additional meaning is created by the interaction of different levels of reality. Overall, the frame system is an area where reality is uncertain: should the short garlands on the ledges of the upper zone be imagined as being made of real plants and placed there by the sacristan on the occasion of a feast day (perhaps for the 25th March), or are they coloured sculptures? If we are to believe that the Cosmatesque ornaments are inlays of stone and glass, would it not be necessary to indicate the materiality more clearly? The Paduan ornamentation has preliminary stages in Rome and Assisi, but the puzzling quality is enhanced in Padua.[232] Giotto's rectangular pieces of reality with their captivating narratives are inserted into a system that refuses to confirm its representational status.

SONGS AND IMAGES: THE ALLEGORIES

The programme of the two times seven allegories is based – as Selma Pfeiffenberger has already noted in her dissertation – on the virtue doctrine of Thomas Aquinas and thus on a text that was not yet a classic at the beginning of the 14th century. In the *Summa Theologiae* (II, 2, *proemium*) Thomas identified as the cardinal virtues (*virtutes cardinales*): the four main virtues, which had been handed down from Greek-Roman to Christian philosophy by Augustine (*Prudentia, Iustitia, Fortitudo,* and *Temperantia*), plus the three "theological" virtues which Paul had named in the First Letter to the Corinthians (*Fides, Spes,* and

232 Cf. R. Meoli Toulmin, L'ornamento nella pittura di Giotto con particolare riferimento alla Cappella degli Scrovegni, in: *Giotto e il suo tempo. Atti del congresso internazionale per la celebrazione del VII centenario della nascita di Giotto (Assisi – Padova – Firenze 1967)*, Rome 1971, pp. 177–189.

Songs and Images: The Allegories

Caritas).[233] Whoever referred to this canon had freedom in two respects. First, since the order was not fixed: the sequence given in the Arena Chapel, with *Iustitia* in the middle position, *Prudentia* on the altar side and *Spes* on the entrance or Last Judgement side of the room, must be understood as one that somebody has chosen in order to communicate something to the visitors of the church.[234] Secondly, since the canon could be varied in the choice of counterparts: there was no established series of "cardinal vices". The reference to the series of the seven deadly sins created by Gregory the Great was obvious, but by no means mandatory. If *Prudentia* is answered by *Stultitia*, *Iustitia* by *Iniustitia* and *Spes* by *Desperatio* (to address only the key positions for the time being), this was also a decision that was made in Scrovegni's circle.[235]

There was also no canonical form for the visualization of these moral ideas, except to make them appear as women, i.e. as female personifications. "The virtues are painted in the shape of women because they soothe and nourish," as William Durand says in his liturgical handbook from the late 13th century.[236] The women who embody the virtues and vices could be shown fighting duels or as one personification triumphing over another (both possibilities based on the *Psychomachia* of Prudentius).[237] It was also possible to have the individual personifications standing or enthroned with suitable attributes.[238] The most important cycle of virtues on the Paduans' horizon was probably the one executed in mosaic in the main dome of San Marco in Venice from the late 12th century. A total of sixteen personifications are gathered here, some of which show or handle attributes, but in many cases only present scrolls with biblical passages that characterize their nature.[239]

233 S. Pfeiffenberger, *The Iconology of Giotto's Virtues and Vices at Padua*. Ph.D. Bryn Mawr 1966, p. I:2.

234 This statement also applies if, like Irene Hueck, one assumes that the order Prudentia, Fortitudo, Temperantia, Justitia goes back to Augustine, *De libero arbitrio*, I, xiii, 27 (*Patrologia Latina* 32, cols. 1235–1236), because one *need* not have followed this text: I. Hueck, Il programma iconografico dei dipinti, p. 91.

235 Cf. C. Bellinati, L'estetica teologica nel ciclo di affreschi della Cappella di Giotto all'Arena di Padova, in: *Giotto e il suo tempo*. Exh. cat. Padua, ed. V. Sgarbi, Milan 2000, pp. 87–92, esp. 91–92.

236 "Virtutes in mulieris specie depinguntur, quia mulcent et nutriunt." Guilelmus Durantis, *Rationale Divinorum Officiorum* I–VI, ed. A. Davril and T.M. Thibodeau (Corpus Christianorum, Continuatio Mediaevalis CXL), Turnhout 1995, p. 41.

237 H. Woodruff, *The Illustrated Manuscripts of Prudentius*, Cambridge, Ma. 1930. J.S. Norman, *Metamorphosis of an Allegory: The Iconography of the Psychomachia in Medieval Art*, New York 1988.

238 A. Katzenellenbogen, *Allegories of the virtues and vices in mediaeval art: From Early Christian times to the thirteenth century*, London 1939.

239 O. Demus, *The Mosaics of San Marco in Venice*, Chicago and London 1984, vol. 1, 1, pp. 186–192.

Giotto's transformation of the personifications into one-person dramas, in which each figure speaks about itself in a vivid manner and, like a character in a narrative picture, "even appeals to the emotions of the viewer" (Hans Belting)[240], had no direct model. The Paduan figures also stood out from personifications in medieval literature. Allegories were constituted there as gatherings of personifications that were, in themselves, largely without fate or face. An example that may have been known to Giotto is the *Tesoretto* written in *volgare* by Brunetto Latini, brother of Giotto's Florentine neighbour, the notary Latino Latini (1.1.6). The first-person narrator sees the cardinal virtues and other concepts in the form of royal ladies, princesses, and countesses in palaces bearing their names. They teach him the lessons to be expected of them and demand allegiance.[241] Brunetto's model was the *Roman de la rose* by Guillaume de Lorris from the mid-13th century, probably the most influential allegorical text. Numerous abstract concepts appear as persons and partly support the actions of the narrator (this applies to *Amors, Bel-Acueil, Richete, Beauté* etc.) and partly hinder them (*Jalousie, Malebouche, Paour, Honte, Dangier* etc.). What constitutes these beings beyond their words, and how their character could become visible, is hardly reflected upon[242] (apart from one very special passage at the beginning, which I will come back to at the end of the chapter).

At least one intellectual among Giotto's contemporaries found the Paduan virtues and vices remarkable: "Who is envious is burned with envy inside and outside (Invidiosus invidia comburitur intus et extra) – this is how Giotto excellently painted it in Padua in the Arena", wrote Francesco da Barberino in his *Documenti d'Amore* a few years after the completion of the decoration (2.4.1). To support a statement, he quoted the painter Giotto as if he were the author of a treatise. In reality, however, Francesco's sentence neither formulates an original idea nor is it based on Giotto. It is, in fact, a traditional aphorism: the phrase "Invidus invidia comburitur intus et extra" is found in the collection of the *Carmina Burana* (CB 13), probably compiled by the Benedictine monks of Seckau.[243] Giotto's image certainly depicts how someone burns (or will burn) "externally", but a painting can hardly show that the same happens to this person "internally" (fig. 87). All the other motifs of Giotto's figure remain unmentioned: the giant ears, the grabbing hand and the

240 H. Belting, Das Bild als Text: Wandmalerei und Literatur im Zeitalter Dantes, in: *Malerei und Stadtkultur in der Dantezeit: Die Argumentation der Bilder*, ed. H. Belting and D. Blume, Munich 1989, pp. 23–63, esp. 34.

241 Brunetto Latini, *Il Tesoretto (The Little Treasure)*, ed. and trans. J. B. Holloway, New York and London 1981.

242 H.R. Jauss, Form und Auffassung der Allegorie in der Tradition der Psychomachia (von Prudentius zum ersten Roman de la Rose), in: *Medium Aevum Vivum. Festschrift für Walther Bulst*, ed. H.R. Jauss and D. Schaller, Heidelberg 1960, pp. 179–206.

243 *Carmina Burana: Die Lieder der Benediktbeurer Handschrift*, ed. B. Bischoff et al., Munich 1979, p. 34.

Songs and Images: The Allegories

satanic attribute of the slanderous serpent's tongue.[244] The latter turns against its hostess and illustrates the self-destructive nature of envy at least as precisely as the idea of inner burning. Francesco seems to have been unable to cope with the complexity of Giotto's picture-text and underestimated it as the illustration of a commonplace when thinking back on it years later. Interestingly enough, Francesco himself experimented with, created, and used pictorial allegories. This will be discussed later.

The fourteen allegories in the Arena Chapel are the most important decorations on the architectural pedestal painted on the walls. It consists of white, rose and grey veined square marble slabs, perfectly imitated in their precious materiality, framed by strips of greenish stone.[245] This structure closely follows the marble incrustation of the Florentine Baptistery from the 12th century; through Arnolfo di Cambio's planning for the new Cathedral it had regained its relevance and had become something like a patriotic form of the Florentines in the final years of the 13th century. The entire painted framing system of the chapel is based on the system of this pedestal. It is therefore likely that the pedestal – although executed last – was conceived during an early phase. What remains unknown, is if the intention was to refer to Florentine customs from the start. The upper parts of the framing system use many motifs from the painting of the Upper Church of San Francesco in Assisi or from Roman painting of the late 13th century (which makes no great difference, see below).[246] Essentially, it is surprising that none of this recurs in the pedestal – not even the patterns that imitate the *opus sectile* of the Cosmati workshops, which could have been easily combined with an marble incrustation. Instead of Cosmatesque work and ornamental relief sculpture, there is figurative sculpture, namely the cycle of allegories. These are fields of about 120 centimetres in height and 50 or (for the two in the middle of the wall) 60 centimetres in width (pl. X, figs. 79–91). They interrupt the pattern of the marble slabs according to the rhythm of the palace-side picture wall and continue in its framework. As a programme element they are at least as unusual as the Florentine marble incrustation and like this, they were not necessarily planned from the beginning.

Sometimes the allegories are described as grisailles. But this completely ignores their fictional materiality. Giotto does not depict something that is coloured in nature as colourless. What he depicts are sculptural works, objects that could very well be inserted into a marble incrustation. What is intended are reliefs in shallow recesses and not, as one

244 J.M. Gellrich, The Art of the Tongue: Illuminating Speech and Writing in Later Medieval Manuscripts, in: *Virtue and Vice: The Personifications in the Index of Christian Art*, ed. C. Hourihane, Princeton 2000, pp. 93–119.

245 Cf. Ph. Cordez, Giotto's marbles: Astrology and naturalism in the Scrovegni Chapel, *Mitteilungen des kunsthistorischen Institutes in Florenz* 55, 2013, pp. 1–25.

246 R. Meoli Toulmin, L'ornamento nella pittura di Giotto.

sometimes reads, statues in niches.[247] These sculptures are largely unpainted and as a result appear predominantly grey or white-grey. This applies in particular to the personifications themselves. Other parts of the relief fields seem to consist of coloured types of stone, including the back panels, individual frame strips, and certain motifs – such as the flames that will burn Invidia "externally". They are not painted in an unrealistic manner, but a realistic reproduction of flames sculpted from red stone and inserted into the relief. If one wanted to characterize this technique with a handy term, one would have to speak of marble relief intarsia or *pietra dura* relief. There are similar works in reality. Sarcophagus fronts from Tino da Camaino's workshop in Naples come to mind, where white-marble relief figurines are embedded in a mosaic ground or mounted in front of a coloured stone panel. However, Giotto's painted sculptures precede these; thus Giotto seems to have invented a hitherto unknown, extremely demanding sculptural technique in the medium of painting. And the representation in painting was just as demanding: the picture fields show reliefs that Giotto painted in (empiric) perspective, whereby one has to imagine that these reliefs themselves are executed in the flat perspective typical of bas-reliefs.

Such findings are often interpreted in the sense of a competition between painting and sculpture; behind this, something like a painted theory of art is hypothesised, an anticipation of the written art theory of the sixteenth century, which would deal with these problems.[248] In contrast, a more media-conscious and historically informed approach raises the question of how Giotto's modes of representation could serve the early fourteenth-century image user. The answer is that it was a matter of differentiating between the status of allegorical and narrative images. One form of representation recalls the reality of the past, the other makes present what in one sense was never real and in another sense is reality *par excellence*, namely exemplars from the realm of ideas. To be precise, the simulated sculptures give the concepts they denote a mediated presence: the painter does not visualise the ideas as such, but rather pretends to reproduce how a sculptor illustrated them. And Giotto not only reproduces, what the sculptor visualized, but also depicts in detail the marbles, granites, and the craftsmanship that the sculptor employed in order to realise these representations. In this way, the contents that are represented become numinous to the same extent as the reliefs become real and physical.

247 B. Cole, Virtues and Vices in Giotto's Arena Chapel Frescoes, in: id., *Studies in the History of Italian Art*, 1250–1550, London 1996, pp. 337–363.

248 R. Steiner, Paradoxien der Nachahmung bei Giotto: die Grisaillen der Arenakapelle zu Padua, in: *Die Trauben des Zeuxis: Formen künstlerischer Wirklichkeitsaneignung*, ed. H. Körner et al., Hildesheim 1990, pp. 61–81. This idea was taken up again by: S. Romano, Giotto e la nuova pittura: Immagine, parola e tecnica nel primo Trecento Italiano, in: *Il secolo di Giotto nel Veneto*, ed. G. Valenzano and F. Toniolo, Venice 2007, pp. 7–43 esp. 23–24.

The allegories are also distinguished from the narrative pictures in the chapel by being accompanied by inscriptions in majuscules, whose letters one must think of as niello-like inlay: there are name inscriptions within the respective relief field and longer texts that appear on the fake stone slabs below the fake reliefs. The existence of the slabs proves that such tituli were intended for the pictures from the beginning.[249] Since they were applied *al secco*, many of them are barely legible and have not been adequately considered by Giotto research for a long time. Recently it has been possible to make thirteen of the fourteen tituli almost completely legible. Since 2017 they have been available in print, edited by Giulia Ammannati.[250] Now the dual task of the poems is clear: the inscriptions provide visitors to the chapel with explanations of Giotto's figures, whereas the underlying texts were intended as models for them. This becomes apparent where paintings and texts diverge from each other. In some cases the songs, which are of varying lengths and metres, are explicitly formulated as descriptions of pictures; in others they give a poetic characterisation of the respective virtue or vice, leaving it up to the reader to read the text as a description of something visible or not. A precise comparison between what the text contains and what Giotto paints provides important insights into his creative approach. It quickly becomes clear that many of the particularly captivating motifs are not contained in the poems but rather developed by the painter.

Below PRUDENTIA, which is the first relief seen when entering from the palace (fig. 79), are the following verses (according to Ammannati's edition):

Res et tempus summa cura	*Facts and time with great care*
agit[a]t Prudentia,	*are considered by Prudence*
spec[u]let ur [ut] futu[ra]	*who scrutinizes the future*
[su]a providentia.	*with her foresight.*

249 Some scholars consider the inscriptions to be not part of the concept and to be added afterwards. These include: Pfeiffenberger, *The Iconology of Giotto's Virtues and Vices at Padua*, p. II:2:1, and Jacobus, *Giotto and the Arena Chapel*, p. 360.

250 *Pinxit industria docte mentis: Le iscrizioni delle allegorie di Virtù e Vizi dipinte da Giotto nella Cappella degli Scrovegni*, ed. G. Ammannati, Pisa 2017. See also: G. Ammannati, Virtù e Vizi nella Cappella degli Scrovegni: nuovi tituli recuperati, *Annali della Scuola Normale Superiore di Pisa. Classe di Lettere e Filosofia*, s. V, 772, 2015, pp. 445–471. Earlier attempts of transcriptions, which were based on a better state of preservation of the inscriptions, but followed mere appearance: B. de Selincourt, *Giotto*, London 1905, p. 162, A. Moschetti, *The Scrovegni Chapel and the Frescoes Painted by Giotto Therein*, Florence 1912, p. 123, and I.B. Supino, *Giotto*, Florence 1920, pp. 141–143, 148. Further text versions (based thereon, partly supplemented): *Padova. Basiliche e chiese*, vol. 1 pp. 259–262 (Bellinati), Borsook, *The Mural Painters of Tuscany*, pp. 13–14, *La cappella degli Scrovegni in Padova*, ed. Banzato et. al., pp. 216–226 (I. Hueck), Frugoni, *Gli affreschi della Capelle Scrovegni a Padova*, pp. 190–197, and Jacobus, *Giotto and the Arena Chapel*, pp. 360–364.

Memoratur iam elapsa,
 o[rd]inat pres[en]tia;
mens ruinam non est [p]assa,
 hac do[n]ata gratia.

Sextu[s] [circu]mgi[r]at p[er]gens;
 sc[it] t[u]turum spe[c]ulum
et antiqua vultus [v]ergens
 [qu]o transiit [s]e[c]ulum.

She remembers things already past
 and orders those present;
the mind does not suffer ruin,
 if it is granted this grace.

The compass turns in a circle,
 the mirror knows the future,
and the past things are known by the face
 turned to where time has passed.

Fig. 79: South wall of the nave: Prudentia

The text did not prescribe that Wisdom appears in the form of a scholar, but by Giotto's time this depiction was conventional. On the other hand, a look into a mirror was suggested, if not required, by the text. Combined with the motif of the scholar, the gesture became standard – beginning with Andrea Pisano's relief at the Florentine Campanile.[251] What is particularly impressive in Giotto's visualization, however, is the scholars suggestive flinching from the mirror image. In the context of a sacred space, this can be read as a dismayed insight into the danger faced by the soul and is the central motif with which the picture goes beyond a mere personification. Here one should remember Marcel Proust's clairvoyant remarks about the Paduan allegories (*À la recherche du temps perdu*). What Proust calls *symbole*, art historians call attribute:[252]

I came to understand that the arresting strangeness, the special beauty of these frescoes derived from the great part played in them by symbolism, and the fact that this was represented not as a symbol (for the thought symbolized was nowhere expressed) but as a reality, actually felt or materially handled, added something more precise and more literal to the meaning of the work, something more concrete and more striking to the lesson it imparted.

251 Pfeiffenberger, *The Iconology of Giotto's Virtues and Vices at Padua*, p. V:2.

252 Marcel Proust, *In Search of Lost Time*, trans. C.K. Scott Moncrieff and Terence Kilmartin revised by D.J. Enright, New York 1992, p. 112.

Incidentally, it was not clear until now whether the back of the head should be interpreted as a hairstyle or as a face – some even say it is Socrates' face.[253] Knowing the text, it is now clear that it is the profile of an old man, which Giotto has depicted discreetly, probably so as not to impair the narrative function of his figure.

The illusion that it is a relief is less convincing than in the other allegories. This has to do with the enormous lectern and the difficulty, perhaps even – in this case – the practical impossibility, of a representation using double perspective: the special (sculptural) perspective in which the subject of the relief is shown would have to be convincingly reproduced within the perspective of the painting that purports to portrays the relief. Yet Giotto seems to have seen the problem and attempted its solution.

FORTITUDO appears as a woman equipped for martial arts (fig. 80). The gaze is directed towards an enemy that is not visible to us. She weighs the metal club in her right hand, ready to strike; her heavy shield is studded with spearheads broken off their staves. She has fended off an initial attack – and turned her conventional attributes into tools of action. Thus, the personification has become a protagonist of a dramatic event, which adds a narrative to the allegorical discourse and makes concrete what strength means.

The inscription reads:

Cuncta sternit Fortitudo	*Fortitude defeats everything*
pugna[n]do viril[iter],	*by fighting manly,*
s[i]c[ut es]t similitude	*according to this representation*
depicta subtiliter.	*subtly painted.*
Cu[m] leone s[utum] [fe]rens,	*Carrying a lion shield,*
sic adve[r]sa repri[mit];	*she represses misfortune,*
et armata clavam gerens,	*and holding, armed, a club,*
prava q[ue]que deprimit.	*she crushes all perversity.*
En occidi vi leonem,	*Look, she has forcibly killed a lion*
eius pelle tegitur;	*and clothed herself with his skin,*
omnem superat agonem	*she overcomes every fight,*
et in nullo frangitur.	*and in no one is defeated.*

253 A.W.C. Lindsay, *Sketches of the History of Christian Art*, London 1847, vol. 2 p. 197. H. Thode, *Giotto*, Bielefeld and Leipzig 1899, p. 123.

Fig. 80: South wall of the nave: Fortitudo

In the motifs of the lion shield, club, and lion skin, the text and Giotto's picture coincide exactly and the text easily lives up to its explicitly stated claim to give a description of the picture. The club and lion skin in the text can be understood as an allusion to Hercules. And Herculean allegories of Fortitudo had already appeared before elsewhere: the figure on the main dome of San Marco in Venice fights a lion with her bare hands; Nicola Pisano's Fortitudo has also defeated a lion with her bare hands on the pulpit of Siena Cathedral.[254] The mosaic in Venice is a possible starting point for the text. In the Arena Chapel, however, the club is not like that used by Hercules, i.e. a wooden one, but a mace, of the kind that was used as a weapon in the Middle Ages. But the crucial step beyond the text is that, for Giotto's Fortitudo, the fight against the lion is in the distant past, while her present is dominated by her defence against a military enemy, of whom one can form a concrete idea from the traces they have left on the shield.

In TENP[er]ANTIA (fig. 81), the beginnings of lines are missing from the inscription due to damage to the plaster; accordingly, the edition given here is limited by considerable uncertainties.

[Hac virt]ute prediti	*They who are gifted with this virtue*
temperati moris	*of temperate demeanour*
[eius legi] subditi	*are subject to her law*
sun[t] in cuncta horis.	*in every single hour.*
[Semper lin]gue, gustui	*On their tongue, their throat,*
frenum sic imp[o]nunt;	*they always put a rein;*
[parcunt p]ravo actui,	*they refrain from evil deeds*
manum tfnc [c]o[m]p[om]unt.	*and control their hands.*

254 *La cappella degli Scrovegni a Padova*, ed. Banzato et. al., p. 220 (Hueck).

Songs and Images: The Allegories 161

Fig. 81: South wall of the nave: Temperantia

It was no small feat on Giotto's part that he was able to extract a narrative scene from these words and from their subject matter, the essence of moderation. With the motif of the reins, the author of the song took up a conventional image: In *De quattuor virtutibus cardinalibus*, a text by Martin of Braga, ascribed to Seneca in the Middle Ages, and thus to an author who almost had the reputation of a church father, it says: "Apply reins (frenum) to your emotions and resist all temptations that are inflicted on your soul by secret desires."[255] The painter illustrated this with the motif of the curb bit. Beyond that, he introduced a second motif, namely, the sword. The idea may have had its roots in Prudentius and the theme of the battle of virtues and vices.[256] Giotto's sword, however, stands for the opposite of battle: While Strength weighs the mace and signals readiness, Temperance keeps the sword ostentatiously unready. And this is also where the narrative action of the scene is located: Temperance makes using the weapon as difficult as possible by wrapping the belt tighter and tighter around the sword and scabbard.

With the following allegory, IUSTICIA, we have arrived in the middle of the room (fig. 82). This position is accentuated by the use of a wide picture field in which Justice appears not standing but in the form of a magnificent enthroned figure. This personification is accompanied by a painted relief showing a narrative commentary. This is reminiscent of the cycle of virtues and vices on the pedestal of the Last Judgement portal of Notre-Dame Cathedral in Paris from the early thirteenth century: there, each of the twelve enthroned personifications of virtues is shown alongside a narrative about a vice, inviting commentary on the moral idea that connects them.[257] At the top, for example, Strength is enthroned, armed and holding a lion's shield, while at the bottom there is

255 "Impone concupiscentiae frenum omniaque blandimenta quae occulta voluptate animum trahunt reice." *Martini Episcopi Bracarensis Opera Omnia*, ed. C.W. Barlow, New Haven 1950, p. 242. Pfeiffenberger, *The Iconology of Giotto's Virtues and Vices at Padua*, p. V:15–16.
256 Pfeiffenberger, *The Iconology of Giotto's Virtues and Vices at Padua*, p. V:16.
257 Katzenellenbogen, *Allegories of the virtues and vices in mediaeval art*, pp. 75–81. W. Sauerländer, *Gotische Skulptur in Frankreich 1140–1270*, Munich 1970, p. 135.

Fig. 82: South wall of the nave: Justitia

a man throwing away his sword and fleeing from a hare. This combination of, say, *Majestas Virtutis* and *Exemplum Vitii* seems to be behind Giotto's Justitia and her counterpart, the Injustitia on the palace-side wall, except that our painter has connected the *Majestas Virtutis* with an *Exemplum* or *Exempla Virtutis* and the *Exemplum* or *Exempla Vitii* with a *Majestas Vitii*. In general, however, the combination of personification and narration (example) given in Paris (and similarly in Chartres and Amiens) could have been significant for Giotto's conceptualisation of the Paduan virtues and vices. As a rule, Giotto's allegories are personifications that illustrate their contents by giving their own actions as an example. But in the case of Justice and Injustice the examples (more precisely, further examples) are narrated in separate images, thus recalling their French precursors.

The inscription under the picture is clearly legible except for the end:

Equa lance concta librat perfecta Iusticia coronando bonos, vibrat ensem contra vicia.	*With equivalent scales,* *perfect Justice weighs everyone:* *while crowning the good, she waves* *her sword against the vices.*
Cuncta gaudent libertate ipsa si regnaverit; agit cum iocunditate quisque quod voluerit.	*All enjoy freedom* *when she rules.* *Everyone carries out with joy* *the activity he prefers.*
Milles probus tunc venatur, cantatur et luditur; mercatori via da[tu]r: p[re]do [t]u[n]c a[bs]c[on]ditur.	*The good soldier goes hunting;* *people sing and have fun;* *the merchant has free way:* *for the marauder it is time to hide.*

The first stanza describes the activity of a personification of justice, the last addresses those effects of justice that the pedestal relief visualizes by depicting soldiers hunting (instead of fighting), girls making music and dancing, and merchants traveling. The text is thus conceived as providing material for a particularly elaborate representation, composed of a personification and examples, and this speaks for a close collaboration between the poet and the painter. Still, text and image are not congruent: in Giotto's depiction, it is not Justice herself who performs the coronation and carries out the punishment, but two little *genii* standing on the weighing scales: one turns to a goldsmith (?) holding a crown or a diadem, the other is about to behead a bound man. (The righteous man was accidentally, but the unjust man intentionally, damaged.)

Giotto worked on the subject of weighing in more detail than the text would suggest. The reading of the picture must start from Justice's slightly cross-eyed gaze that appears to fixate on something very close by, but which was painted al secco and has disappeared, namely the tongue of the scale, the device that allows the equilibrium to be precisely measured. Unlike in older depictions of *Justitia* – for example in San Marco, Venice[258] – Giotto's personification does not hold the scales as an attribute in her hand. The instrument was attached to a metal rod; a piece of it painted on the blue back wall is still visible. This rod is a part of the architecture. What we see as a throne is a monumental frame for the scale. This large and correspondingly precise apparatus is the professional tool of Giotto's Justice. Reward and punishment depend upon its correct operation, which requires the utmost concentration. The connections made in the picture are not only more complicated than in the poem, one may say that they make the theory and practice of justice real.

Justice is followed by FIDES, the first of the theological virtues, to which perhaps the centre of the wall would have been given if a cleric had acted as patron instead of a layman (fig. 83). The inscription, again explicitly phrased as a description of a picture, reads:[259]

Fig. 83: South wall of the nave: Fides

258 Pfeiffenberger, *The Iconology of Giotto's Virtues and Vices at Padua*, pp. V:24–27.
259 Cf. G. Schüßler, Fides II: Theologische Tugend, in: *Reallexikon zur deutschen Kunstgeschichte*, vol. 8, Munich 1987, cols. 773–830, esp. 782, 799, and 813.

Figurata	*The depicted*
Fide rata	*firm Faith*
Presentatur homini	*shows to the man*
Quod conscissa	*that, despite her wounds,*
Manet fixa,	*she remains fixed*
Christi [fide]s nomini.	*in her trust in the name of Christ.*
[Sanctam] Crucem	*The Holy Cross*
Christi ducem	*of Christ as guide,*
amplectando sequitur;	*she follows embracing it.*
cuius actus	*His deeds*
– va[l]e tactus –	*– farewell, tactus –*
approbando loquitur.	*she proclaims and confirms.*
Conculcavit,	*She has repressed,*
subiugavit	*subjugated*
ydola viriliter;	*the idols manly;*
coronatur et fundatur	*she is crowned and founded*
supra petram firmiter.	*on the rock firmly.*
Angelorum	*The angels,*
Supernorum	*the supreme ones,*
Confortata nu[min]e,	*comfort her with their power.*
manet recta	*She remains upright*
et perfecta	*and perfect*
pro tanto solamine.	*Because she has so much support.*

Also in this case, the picture follows the text. Both the painter and the poet had the figure of Ecclesia in mind.[260] But there are also motifs in the picture that are not given in the text: the parchments covered with secret signs at the feet of the figure, which probably refer to the writings of the heretics, and the banderole in her left hand with the beginning of the Credo. Her triumphant behaviour appears superficial until one notices that the figure also tells a story. There are a few small slits in the otherwise flawless robe. Surely they do not speak of poverty, as was argued.[261] If that were the case, then the garment would have been worn out and the hems damaged. Rather, the injuries speak – again in

260 Pfeiffenberger, *The Iconology of Giotto's Virtues and Vices at Padua*, pp. V:38–39.
261 H.M. Thomas, *Franziskanische Geschichtsvision und europäische Bildentfaltung*, Wiesbaden 1989, p. 20.

Songs and Images: The Allegories

the tradition of Prudentius – of combat, and here of the fight against the idolaters and false teachers, whose equipment is left behind at the feet of Fides. This corresponds with the part of the inscription that says that Fides stands there "conscissa", but unshaken, a statement that could be straightforwardly transformed into narrative. Connected with this is a shift in content, with an emphasis on an anti-heretic militancy.

KARITAS (written with kappa as at the main dome in Venice) would be expected to play a special role in the overall programme, since the term refers to a characteristic of Mary's which appears in the church's consecration title (fig. 84). The inscription is largely legible:

Hec figura Karitatis	*This figure of Charity*
sue sic proprietatis	*has its characteristics'*
gerit formam.	*appearance.*
Cor, quod latet in secreto,	*The heart, hidden in the depths,*
Christo dat. Hanc pro decreto	*she gives to Christ: as a law,*
servat normam.	*this norm shall be observed.*
Set terrene facultatis	*Earthly treasures,*
est contempt[r]ix, vanitatis	*she despises; vanity's*
color arde.	*colour withers.*
Cuncta cunctis liberali	*Everything to everyone,*
offert manu, spetiali	*she offers with a liberal hand*
zelo care.	*and has no special predilections.*

This inscription is phrased unmistakeably as a description of an image, and indeed, image and text come very close to each other here: The figure in relief literally gives a heart to a half figure of God. It is an anatomically modelled organ that has been torn or cut from a chest. If it did not appear in the form of painted sculpture, viewers would find this detail shocking. With her other hand, Caritas presents a bowl of flowers and fruit in a manner so realistic that visitors would certainly feel they could help themselves from the bowl if its contents were not also painted marble.[262] The motif of offering corresponds with the phrase "everything to everyone" in the last stanza of the titulus. And the "earthly treasures" mentioned in the third stanza are the moneybags on which the figure is standing.

262 For an identification of the flowers and fruit varieties: L. Pigozzo, Le piante in Giotto a Padova: Elementi per possibili letture iconografiche, *Bollettino del Museo Civico di Padova* 82, 1993, pp. 111–130, esp. 125–126.

Fig. 84: South wall of the nave: Caritas

Fig. 85: South wall of the nave: Spes

Unlike the inscription, however, the picture deals with the simultaneity of giving: what Caritas gives to God and to man, she gives to both at the same instant. The unusual posture of the figure emphasizes the simultaneity. According to Augustine, Hugo of St. Victor, Thomas Aquinas and others, this simultaneity is a characteristic of Caritas in the theological sense.[263] In this respect one can say that the image goes beyond the song.

The final virtue is SPES (fig. 85). The inscription reads:

Spes depicta sub figura	Hope, painted as figure,
hoc signatur, quod mens pura	means this: that the pure mind,
spe fulcita non clausura	if sustained by hope, does not remain closed
terrenorum clauditur;	in the prison of earthly things,

263 Pfeiffenberger, *The Iconology of Giotto's Virtues and Vices at Padua*, pp. V:53–54.

set a Cristo coronanda	*but, to be crowned by Christ,*
sursum volat: sic beanda	*she flies up: in this way, to be beatified*
et in celis sublimanda	*and elevated in heaven,*
fore firma redditur.	*is made sure.*

There are a number of new things in the song: neither the flying nor the coronation were previously established linguistic images connected to Spes. Giotto's figure, using motifs from an image of Nike, relies entirely on the miracle of flying. Yet it seems to be less the wings that cause movement than her gaze, directed at Christ and the crown. These motifs seem less elaborated compared to the other allegories. But the personification has a powerful visual context: the picture of the Last Judgement. In her diagonal flying movement, Giotto took up the postures of the resurrected and saints, which appear on the entrance wall, not far from Spes in the lower left hand corner of the picture. One could even say that the momentum that begins with the flight of Spes continues into the intercessory Mary in the aureole (fig. 7, pl. I). It is as if Hope floats into the picture, undergoes various metamorphoses and finally, in the form of the Madonna della Caritá, prepares to leave the pictorial space in the direction of the real space.

This raises the question of why it was not Caritas that was given the location next to the west wall: Just like Spes, and with equally good reason, the poet and the painter could have given her a pair of wings. Caritá would have flown around the corner into the scene of the Last Judgement and then would have approached the viewer as Madonna della Caritá. Moreover, this placement would have corresponded to the authoritative phrasing in Paul: "And now abideth faith, hope, charity, these three; but the greatest of these is charity" (1 Corinthians, 13: 13). For this reason, Caritas is also called *Mater Virtutum* at the main dome of San Marco in Venice.[264] The programme of the Arena Chapel, however, does not follow Paul, but places Hope in the key position. In doing so the cycle of allegories takes up the theme of contrition, from which the programme of the triumphal arch wall was developed, that is, where the founder had let himself be described as a second Judas. In light of this idea, there can only be one thing that distinguishes him from the first Judas and thus from somebody beyond redemption: hope. Where Judas surrendered to the mortal sin of despair, Scrovegni relies on the cardinal virtue of hope.

In fact, Spes, the virtue of the founders and donors, is answered on the palace-side wall by the vice of Judas: DESPERATIO (fig. 86). Just like its counterpart, this figure is visually linked with the Last Judgment, namely with those who are hanged in hell and especially with the hanged Judas. Both allegories tie the series of fictitious reliefs to the image of the Judgment. Of the few monumental cycles of virtues and vices that

264 Demus, *The Mosaics of San Marco in Venice*, vol. 1, 1, p. 186.

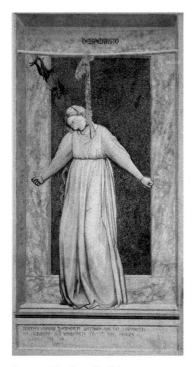

Fig. 86: North wall of the nave: Desperatio

are known, several are related to representations of the Last Judgement, including that of Notre-Dame in Paris: the theme of virtue and vice is an obvious complement to such an image. The representation of virtues and vices directs the meaning of a Last Judgement to a didactic and pastoral field. Peter Cornelius Claussen wrote that the path through the Arena Chapel resembles dancing on a rope stretched between virtues and vices.[265] In order to feel the right pedagogical effect, one must imagine this rope fastened between Prudentia and Stultitia and leading from there to the Last Judgement. The acrobat's gaze, when not directed towards Christ and the Madonna della Caritá, moves back and forth between heaven and hell, and between Spes as the central qualification for redemption and Desperatio as the definitive cause of damnation.

The inscription under Despair returns to the theme of hope, proving once more how central this virtue is to the chapel's programme. The personification of this vice, or, more precisely, of a woman who has abandoned herself to this vice, is the theme only of the first stanza:

Instar cordis desparati	*Symbol of a desperate heart,*
Sathan ductu suffocati	*suffocated by Satan's grip*
et Gehenne sic dampnati	*and damned so to Gehenna:*
tenet hec figura	*This is what this figure represents.*

[In adv]ersis spe firmetur	*In adversity, with hope let us make strong*
mens alata, n[e] dampnetur,	*the winged spirit, so that it will not be damned.*
non d[es]peret: nam tolletur,	*Do not despair: it will be lifted,*
spe sic [conc]essur[a].	*for hope will allow it.*

The painter makes Satan emerge in a way that feeds doubt as to whether he belongs to the reality level of the relief sculpture, of Giotto's painting – or even of the world of the viewers themselves. Satan's trademark is to question the order of the levels of reality. He

265 Claussen, Enrico Scrovegni, der exemplarische Fall?, p. 234.

Songs and Images: The Allegories

touches the white figure with a kind of riding crop, a gesture that can probably be read as an equivalent of "ductu". The woman is also worth a second look: unlike Judas and the other hanged men in the hell scene, she has ground under her feet. Together with the clenched fists, it becomes clear what Giotto, or rather the fictitious sculptor he interposed, intended: the woman has not hung herself; she is furiously strangling herself. This shocking insight once again indicates to the viewer what Satan's influence is capable of.

How Giotto's idea pierced the hearts of the churchgoers of earlier times is shown by the wilful damage visible in the picture: Satan is partly scratched away, as is the cloth that the woman uses instead of a rope (an improvisation that underlines the spontaneity of her doing). The eyes of the woman were scratched out. Spes on the other hand has provoked friendly reactions. Carved in the painted granite plate in front of which she appears are several coats-of-arms and two *fuit hic* graffiti.

Until recently there was little to discern from the inscription of INVIDIA (opposite Caritas), but now it is almost completely known. It is also now certain that Francesco da Barberino makes no reference to the text in his use of the figure (fig. 87):

[P]atet hic Invidi[a], *Behold here is Invidia,*
sua ferens propria, *with her attributes,*
quam pixit industria *painted by the craftsmanship*
 docte mentis. *of a learned mind.*

Bona terit cornibus, *with horns she scratches,*
sere[n]tin[i]s moribus] *with snakebites she bites,*
m[o]rdet, rapit minibus *with her hands she plunders*
 pie g[en]tis. *the belongings of upright people.*

Aure cuncta sciscitans, *Investigating everything with her ear,*
[sem]p[er] ardet inhians: *she always burns greedily staring.*
non impletur, obvians *She is never satiated, turning against herself*
 i[n] eventis. *as a result.*

It is a difficult script for a painter, because the figure cannot carry out simultaneously all the different actions mentioned by the poet. In one instance, however, a synthesis was achieved: Giotto found a way of combining the motif of snake bites with the statement that the behaviour of Invidia is ultimately directed against herself. In the snake coming out of her mouth and then turning back her face, the allegory becomes a narrative.

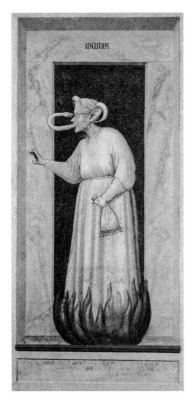

Fig. 87: North wall of the nave: Invidia

The praise of the artist in the first verse poses a particular problem. It seems natural to read it as the earliest literary reference to Giotto.[266] However, artist commendations are a topos that belong to the genre of literary descriptions of pictures. In cases where the pictures exist only as texts, in particular, praise certifies their existence. One could even say that the praise of artists and their pictures replaces their material existence. I will come back to an earlier example from the *Roman de la rose*. A more or less contemporary example can be found in Dante's *Divine Comedy*: where the poet describes three stone reliefs at the entrance to purgatory, which narrate examples of humble conduct, he praises them as extremely vivid representations that outshine even the works of the great ancient sculptor Polykleitos (Purg. X, 28–99). Those interested in Giotto encounter another case in Boccaccio's *Amorosa Visione*: the author praises murals in an invented palace and says that only an artist such as Giotto could accomplish such perfect works (2.4.2). What is unusual in the Invidia poem is not the praise of the artist per se, but that a text praising a painter has been realized in painting. Seen in this light, "painted by the craftsmanship of a learned mind" refers to the fictional quality of the image created in the song and in all likelihood not to the painter of the reproduction on the wall.

This is followed by the tragic-looking figure of INFIDELITAS – or more correctly of the *infidelis* with (probably) the small Infidelitas in his hand (fig. 88). The inscription reads:

Infidelis claudicat,	*The unfaithful limps,*
ydolo se dedicat,	*he dedicates himself to an idol,*
spernit qui se predicat	*disdains, what he is taught,*
clauso visu.	*his eyes closed.*

266 D. Giorgi, L'esordio della celebrazione di Giotto, *Annali della Scuola Normale Superiore di Pisa. Classe di Lettere e Filosofia*, s. V, 9/1, 2017, pp. 209–218.

Trahit Ydolotria	*Idolatry drags him*
hunc ignis ad atria,	*into the flames of hell,*
p[u]ls[u]m celi patria	*thrown out of the heavenly homeland,*
Christi nisu.	*created by the work of Christ.*
[C]a[p]ut tectum [g]a[l]ea	*The head covered by a helmet,*
gerit mens errorea,	*he has an erroneous mind,*
sperans so[l]a terrea,	*because he hopes only for earthly things,*
digna [ris]u.	*worthy of laughter.*

Again, as in the case of the allegory of Desperatio, we are not really faced with a personification. According to the text, a man appears as the protagonist in an activity that exemplifies the vice. Giotto's transformation of the allegorical text into a pictorial narrative functions as follows: he places something in the nonbeliever's hand, which can be read as the idol mentioned in the text or as the actual personification of disbelief (or, most likely, as both at the same time). This statuette, wavering uncertainly, draws the nonbeliever – or, more correctly, the nonbeliever draws himself with its help – into the hellfire. This is breathtakingly complex in its conceptualisation and seems psychological in a modern sense. Between this idea and what the text proposes, there is the unresolved contradiction that the limping of the nonbeliever slows him down on his way to hell. Above all, however, Giotto's depiction of the trailing leg establishes additional pathos.[267]

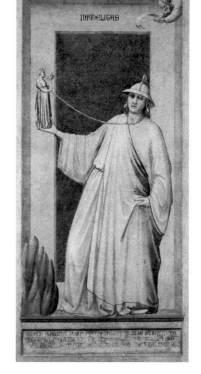

Fig. 88: North wall of the nave: Infidelitas

267 Cf. R. Schumacher-Wolfgarten, „Infidelitas" in der Arenakapelle, in: *Martin Gosebruch zu Ehren*, ed. F.N. Steigerwald, Munich 1984, pp. 113–120: According to the author, the figure is derived from a personification of the synagogue; the statuette, which is held by the figure in the hand, is not an idol, but a representation of Mary. The reading suffers, among other things, from the fact that the context of the allegory and the inscription, which was always legible in important parts, are ignored.

INIUSTITIA is clearly a counterpart to the opposing personification of Justice, not only in format but also in structure (pl. X). The text also aligns itself with the Justice text by describing how those who suffer under the rule of Justice flourish under the regime of Injustice. Although the song calls for the reverse in the first stanza, Injustice is not the main figure in Giotto's relief. Instead, the protagonist depicted is the tyrant mentioned at the end of the text.

Iniustitia	*Injustice!*
que fiducia	*What confidence*
malis datu[r]!	*she gives to the wicked!*
Cre[scunt] nemora;	*The woods grow,*
iuris anchora,	*the peace, still law,*
pax fugatur.	*is driven out.*
F[ig]u[n]t spolia	*They display the signs of triumph:*
ho[micid]ia,	*murder,*
fraus [et] dolus;	*fraud and malice.*
in itinere	*In the streets,*
vadit libere	*freely and undisturbed,*
predo solus.	*the marauder roams.*
I, [Iu]stitia!	*Go away, Justice!*
Gaude[n]t vitia,	*The vices are happy,*
sta[t] [t]yramn[u]s:	*the tyrant rises;*
rapit manibus,	*he grabs with his hands,*
rodit dentibus:	*he gnaws with his teeth:*
est u[t] [r]a[m]n[u]s.	*he is like a thorny bramble.*

The tyrant's actions given in the third stanza are omitted in the image; instead, he appears fearfully armed and is placed in a ruin instead of on a throne. Giotto gives an elaborate narrative form to the events described in the second stanza as the consequences of unjust rule. While on the other wall of the chapel, recreation and commerce are portrayed as *exempla* of just government, terrible things happen to the people here: the painter does not shy away even from depicting a rape.[268] The dramatic scenes are not presented in

268 P. Bokody, Justice, Love and Rape: Giotto's Allegories of Justice and Injustice in the Arena Chapel, Padua, in: *The Iconology of Law and Order (Legal and Cosmic)*, ed. A. Kérchy, G.E. Szönyi, and A. Kiss, Szeged 2012, pp. 50–61, esp. 57. It seems to me that the love theme is overemphasized in this interpretation.

relief, like the cheerful scenes opposite, but take place somehow at the feet of the tyrant. Also sprouting from this zone are young trees, which stand for uncultivated land and will eventually obscure the main character and the representation in general. Chaotic states are not merely reproduced; they govern the medium. What we see transcends the limits of what can be done in relief sculpture. The painter certainly does not contemplate these limits in the sense of a competition between disciplines, but rather problematizes the medium of relief in terms of appropriateness and order – concepts that are related to the idea of justice. If there is something self-reflexive about the picture, it does not concern discourses about art but rather moral discourses about virtues and vices.

IRA, the counterpart of Temperantia, is, like Spes, a figure in which Giotto depicts a single gesture that dominates her entire body (fig. 89). The inscription, written in the form of an description of the image, is not completely legible, but it allows us to understand the invention of the picture:

Clari[t]ate ration[is]	*The light of reason*
Ira privat hominem	*Wrath deprives man of*
[…]ctionis	*…*
modum fere neminem.	*… nearly boundless.*
Vestis [a]ct[us] hic [sc]issure	*The act of tearing the robe*
signant hoc et facies	*denotes this and that the figure's face*
Sol[em] [con]tra sic figure,	*turns so against the Sun,*
fert quem visus acties.	*that its gaze resists the sun.*

The motif of tearing a robe is biblical and was already visually present in the chapel in Giotto's scene showing Christ before Annas and Caiaphas. According to Giulia Ammannati, the motif of the gaze resisting the sun can probably be traced back to Augustine and can be understood from his text:[269] "Just as when a blind man is placed in the sun, the sun is present to him, but he is absent to the sun, so every slow-witted person, every evil person, every ungodly person is blind in his heart." Giotto's combination of the two motifs resulted in a figure that was both simple and complex: simple and easy to grasp because only a single movement was represented; complex and emotive because the figure is developed spatially and her head, thrown back with a shortened, yet expressive, face, was new and a

269 Augustinus, *In Iohannis euangelium tractatus CXXIV*, ed. R. Willems (Corpus Christianorum Series Latina 36), Turnhout 1954, I, 19: "Quomodo homo positus in sole caecus, praesens est illi sol, sed ipse soli absens est; sic omnis stultus, omnis iniquus, omnis impius, caecus est corde." Translation: St. Augustine, *Tractates on the Gospel of John 1–10*, trans. J.W. Rettig, Washington, DC, 1988, p. 58.

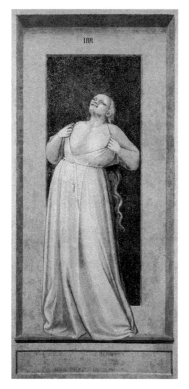

Fig. 89: North wall of the nave: Ira Fig. 90: North wall of the nave: Inconstantia

great technical risk. Until then Giotto had only experimented with shortened faces in secondary figures; as, for example, for the camel tamer (fig. 51). The question remains whether the personification is oriented towards Christ in the Last Judgement, and if this figure is the sun, which Ira does not see. Regardless of this, the pathos of the figure is effective.

INCONSTANTIA appears opposite Fortitudo. Her inscription has completely disappeared (fig. 90). A colourful glittering marble triangle represents an inclined plane, and she races down it in a lady's seat on a kind of discus. With outstretched arms she tries to keep her balance, a behaviour that accelerates the down-hill slide. The high speed can be read from the fabric fluttering behind her, whose schematic folding at the same time proves that the viewer is dealing with a relief and not a real textile.[270]

270 On a possible antique model for the figure: M. Gaggiotti, Un'insospettabile fonte d'ispirazione per Giotto: nota sul fregio della Basilica Aemilia. in: *Scritti di archeologia e storia dell'arte in onore di Carlo Pietrangeli*, ed. V. Casale et al., Rome 1996, pp. 11–21.

Songs and Images: The Allegories

Finally we arrive at STULTITIA, which is not exactly opposite Prudentia (fig. 91). In this place is the door to the palace, with the Sapientia Saeculi as decoration above. The painted relief is slightly offset towards the entrance wall. According to the incomplete inscription, Stultitia is not herself featured, but again a protagonist enacting this vice:

Hic signatur homo stultus,	*Here represented is the foolish man:*
al[vu]m gerens, pennis fultus	*with his belly, strong with his feathers,*
ore hians, risu [.]ult[us],	*open-mouthed, he laughs(?)/is laughed at (?)*
[...] lignum arens.	*... a dry wood*
[... este]	*...*
[... este]	*...*
[t]a[nt]o pilo, tali veste	*A mace and this type of robe,*
gaudet, sensu carens.	*he enjoys them so much, senselessly*

The motifs called for in the text can be found in the picture: feathers, thick belly, the open mouth, the club. It is noticeable that the "foolish man" turns to the left. According to Selma Pfeiffenberger, he either commands the other vices, or he turns against the Last Judgment and thus against Christ, the judge. The latter thought touches on a claim by Gosbert Schüßler, who used French illustrations to Psalm 52 as a comparison.[271] In a manuscript that may have been in Padua as early as the beginning of the 14th century, the figure of a fool is found in the initial D of the verse "Dixit insipiens in corde suo: Non est deus" (Biblioteca del Seminario, ms. 353, fol. 71v). The man, scantily clad like Giotto's *stultus*, bites into a loaf of bread and waves a wooden club. If this fool says to himself that there is no God, then one can also expect Giotto's equivalent to shout in the direction of Christ's appearance in the picture on the entrance wall: "There is no God". It is fitting that his gaze is raised and mouth open. Perhaps where the paint was scratched off, his tongue was visible. The little hill on which the fool has set himself is also an indication that he is challenging Christ.

By explicitly or implicitly drafting descriptions of pictures, the author of the poems had tried to anticipate the different structure of allegorical speech on the one hand and allegorical imagery on the other, and to produce texts that could be readily translated into images. Yet the painter did more than just visually spell out the texts. He took the provided material and imaginatively processed it into short narratives which, similarly to his history paintings, aroused the viewer's emotions. Nevertheless, it can be said that poet and painter were working on a joint project. That is yet another reason why one

271　Schüßler, Giottos visuelle Definition der "Sapientia Saeculi" in der Cappella Scrovegni zu Padua, p. 115.

Fig. 91: North wall of the nave: Stultitia

would like to know more about the author of the songs. Was it Scrovegni himself, who as a "knight" was potentially also a "singer"? If that were the case one would expect verses in French (*langue d'oïl*) or Franco-Italian, the literary language common in Veneto in the decades around 1300.[272] Was the author Scrovegni's spiritual guide, the canon, who appears as a co-founder in the image of the Last Judgment? In general, the members of the cathedral chapter and persons from its periphery are candidates for authorship. In the literature on the Arena Chapel there is often mention of a "theological adviser". Indeed, in the typological cycle on the palace-side wall, real theological competence is apparent. However, "theological adviser" is just a clumsy term for describing which theological texts may have been relevant in the context of the conception of the church's programme.[273] It tells us more about the author of the texts about the virtues and vices that, in addition to theological knowledge and a good command of Latin, he must have had access to secular poetry. Without paying attention to the songs, Hans Belting and Johannes Tripps have suggested a passage in the *Roman de la Rose* by Guillaume de Lorris as a possible model for Giotto's cycle of fourteen reliefs.[274] The book was popular in Italy in the decades before and around 1300, as evidenced not only by its influence on Brunetto Latini's *Tesoretto* but also by

272 M.G. Capusso, La produzione franco-italiana dei secoli XIII e XIV: convergenze letterarie e linguistiche, in *Plurilinguismo letterario*, ed. R. Oniga and S. Vatteroni, Rubbettino 2007, pp. 159–204.

273 Cf. H.M. Thomas, Die Frage nach Giottos Berater in Padua, *Bollettino del Museo Civico di Padova* 63, 1974, pp. 61–101. Thomas gives the name of Ubertino da Casale. Other names mentioned with not better arguments are that of the Augustinian hermit Alberto da Padova and the musician Marchetto da Padova.

274 Belting, Das Bild als Text, p. 34. Belting's statement that the relevant passage belongs to Jean de Meun's continuation of the novel is incorrect. J. Tripps, Giotto an der Mauer des Paradieses: Ein Interpretationsvorschlag zum Tugenden- und Lasterzyklus der Arena-Kapelle zu Padua, *Pantheon* 51, 1993, pp. 188–196.

Songs and Images: The Allegories

the writing of a shortened translation, which some consider an early work by Dante.[275] Hardly belonging to the educational world of a cleric, it can be assumed that a Scrovegni had read it (or had had it recited).

In the *Romance of the Rose* the knightly culture of north-eastern France shows its sophisticated and agnostic side. Georges Duby pointed out the absence of Christian ideas and values: its focus is on (courtly) love.[276] The plot follows a dream of the first-person narrator, in which he wakes up early in the morning and leaves his house and the city in a joyful mood:[277]

> *When I had gone a little further,*
> *I saw a large and wide garden,*
> *completely enclosed by a high, crenellated wall,*
> *decorated on the outside with pictures, and carved*
> *with many precious inscriptions.*
> *At the pictures and paintings*
> *on the wall, I looked with pleasure.*

The garden turns out to be the paradise of love, and the images that the narrator describes over hundreds of verses are the representations of eleven vices – if you want to call them vices. They are those qualities and phenomena that prevent entry into the garden and a life filled with love: Hate, Malice, Avarice, Greed, Stinginess, Envy, Sadness, Old Age, Time, Hypocrisy, and Poverty. What is said about the paintings in detail is a mixture of a characterization of what the term stands for and information about the appearance of the personifications painted on the wall. Clothing, physiognomy, and constitution are discussed. Often the abstract and the concrete overlap, for example in Haine (Hate). And at these points the text unfolds in a disturbing gloss (which necessarily becomes dull in translation):[278]

275 *The Fiore and the Detto d'Amore: a Late 13th-Century Italian Translation of the Roman de la rose.* A translation with introduction and notes by S. Casciani and Chr. Kleinhenz, Notre Dame, Ind. 2000. L. Vanossi, Dante e il "Roman de la Rose": Saggio sul "Fiore", Florence 1979.

276 G. Duby, Der Rosenroman: Sozialgeschichtliche Hintergründe eines höfischen Traums, in: G. Duby, *Wirklichkeit und höfischer Traum: Zur Kultur des Mittelalters*, Berlin 1986, pp. 65–102, esp. 80.

277 "Quant j'oi un poi avant alé / Si vi un vergier grant e lé / Tot clos de haut mur bataillié / Portraits dehorse e entraillié / A maintes riches escritures / Les images e les pointures / Dou mur vonlentiers remirai / Si vos conterai e dirai / De ces images la semblance / Si com moi vient en remenbrance," Guillaume de Lorris and Jean de Meun, *Der Rosenroman*, ed. K.A. Ott, Munich 1976, vol. 1 p. 84.

278 "Enz en milieu vi Haine / Qui de corroz e d'ataine / Sembla bien estre moverresse; / Cor-

178 Speech which Speaks to the Eye: The Arena Chapel

> *In the middle, I saw Hate,*
> *who of anger and strife*
> *seems to be the causer;*
> *angry and quarrelsome*
> *and full of great malice*
> *was the appearance of this picture;*
> *not well dressed either,*
> *but rather looking as if wild with fury.*
> *Grumpy and frightened*
> *was her face with a pug nose;*
> *she was ugly and filthy;*
> *and in an ugly way,*
> *she was wrapped in rags.*

In Vilanie (Malice) the poet considers the skills of the painter and opens up further levels of reflection about the reality and the artificiality of the images:[279]

> *He could paint and draw very well,*
> *who knew how to make this picture,*
> *cause it seemed a most villainous thing.*

In Avarice, the poet speculates about the age of the mended dress and imagines how much effort Lady Avarice might have put into looking after it so that she would not need a new one. In such phrases, Guillaume de Lorris makes the reader uncertain as to whether he is talking about a picture or a living person. Here, one feels reminded that it is similar uncertainties that make Giotto's allegories so fascinating, but that some of this is inherent in the Latin poems.

The reason why Guillaume de Lorris devotes so much wit and attention to the appearance and interpretation of these images is firstly because they only exist in verbal form and the authentication of their material existence must be poetically established. Secondly, it should be noted that this is a key passage in the text: the wall with the pictures marks the border between the natural and the ideal world. Beyond these verses and this wall there is no more reality, no more accident, and no more meaningless areas. Above all, there are

 roceuse e tençonerresse, / E pleine de grant cuvertage / Estoit par semblant cele image; / Si n'estoit pas bien atornee, / Ainz sembloit fame forsenee. / Rechignié avoit e froncié / Le vis, e le nés secorcié; / Hisdeuse estoit e roilliee / Hisdosement d'une toaille." Ibid.

279 "Mout sot bien poindre e bien portraire / Ci qui sot tel image faire, / Qu'el sembloit bien chose vilaine." Ibid. p. 86.

no human beings apart from the narrator, only personifications whose outposts in the real world are the painted pictures.[280] It corresponds to this liminal function when the reflection on the nature of certain vices becomes an attempt at both virtualization and concretization.

The texts that Guillaume creates for this purpose resemble in some ways the tituli of the Arena Chapel. There is the complicated relationship to the respective pictures which are virtual in one case, and lie in the future in the other (that is, they are to be painted by Giotto). Then there is the attempt to find vivid equivalents to abstract qualities, which do not only concern simply the appearance, but also the behaviour, indeed the thinking of the personifications. With the tituli, more emphasis is placed on doing or suffering: flying, limping, giving away the heart, being strangled, etc. This greater concreteness may also have to do with the fact that for the Paduan poet the visual realization of his designs was within reach. All in all, one can hardly avoid finding in the descriptions in the *Roman de la Rose* an important stimulus for the texts of the Paduan tituli. And they are also a kind of preliminary stage with regard to the complex mediality of the versions painted above the tituli by Giotto. Just as Guillaume de Lorris uses the literary fiction of painting to make the eleven vices very prominent on the one hand and to take them out of the action on the other, so too in Padua is an intense form of presence combined with a no less intense form of absence by means of the painted fiction of relief.

Just as Guillaume's poem seems to have been a source of inspiration for the author of the inscriptions, it was probably also important for the conception of the mediated form of imagery appearance and thus as a stimulus for the solution found by the artist. This leads to the question of how one should imagine the inscriptions and pictures being developed in the discourse between patron, poet and painter. A dynamic interaction between poetry and painting would not be unique in the early 14th century. Hans Belting has pointed to a case in the environment of Giotto and his Paduan activities,[281] namely, Francesco da Barberino a poet who created interacting combinations of allegorical images and texts. Like Giotto, he was Florentine and about the same age, and like Dante, he was exiled from Florence and for a long time had to lead a wandering life. His book entitled *Documenti d'Amore* contains the first mention of Giotto's Invidia (2.4.1). If the reference of this passage to both the titulus and motifs of the picture were not so fragile, Francesco would be the most obvious choice as author of the texts and confidant of Giotto and Scrovegni.[282]

280 Jauss, Form und Auffassung der Allegorie in der Tradition der Psychomachia, p. 179.

281 Belting, Das Bild als Text, pp. 34–35.

282 Cf. A. Lermer, Giotto's Virtues and Vices in the Arena Chapel: The Iconography and the Possible Mastermind behind it, in: *Out of the stream,* ed. L.U. Afonso and V. Serrao, Newcastle 2007, pp. 291–317.

180 Speech which Speaks to the Eye: The Arena Chapel

In the glosses of the *Documenti*, Francesco states that he designed three allegories of specific virtues for the Episcopal Palace of Treviso.[283] He certainly provided texts, but he may also have made visual models hand in hand with them; elsewhere he said that he had to become a "desingator" himself because he had not found an artist suitable to illustrate his works.[284] The designs for Treviso must have been made shortly before 1309, and the patron was probably Pandolfo di Lusia, former Paduan Canon of the Cathedral and from 1306 bishop of Treviso.[285] The connection with the allegories of the Arena Chapel was therefore close at various levels. Also relevant are the miniatures designed by Francesco for the *Documenti*; their execution in painting dates from the following decade. They are obviously inspired by Giotto: there is an Industria that embroiders instead of simply sitting enthroned, a Patientia that suffers blows, a Justitia that operates a scale, a Constantia that cannot be influenced by threats or gifts of money, nor by pleading or musical performances, etc.[286] These miniatures are not strictly illustrations, but ostensibly have "the purpose of inducing the author to give a description of the picture and this in turn serves as a verbal glossary (*expositione lictere*) of the literary theme" (Belting).[287] Verbal and visual poetry are intertwined not only in terms of content but also in terms of their creation. One may again refer to the *Roman de la Rose*. But that doesn't explain everything, because the fact is that this author, unlike Guillaume de Lorris, makes the pictures become real – and this probably has to do with the Arena Chapel.[288] Francesco da Barberino's verbal and

283 Francesco da Barberino, *I Documenti d'Amore di Francesco da Barberino secondo i manoscritti originali*, ed. F. Egidi, 4 vols., Rome 1905–22, vol. 3, p. 287.

284 "[...] sic dicas quod etsi non pictorem designatorem tamen figurarum ipsarum e fecit necessitas amoris gratia informante, cum nemo pictorum illarum partium ubi extitit liber fundatus me intelligeret iusto modo." Francesco da Barberino, *I Documenti d'Amore*, ed. Egidi, vol. 3 p. 351.

285 F.S. Dondi dall'Orologio, *Serie Cronologico-istorica dei Canonici di Padova*, Padua 1805, p. 107 and homepage of the Diocesi di Treviso.

286 F. Egidi, Le miniature dei Codici barberiani dei Documenti d'amore, *L'Arte* 5, 1902, pp. 1–20 and 78–95. D. Goldini, Testo e immagini nei Documenti d'Amore di Francesco da Barberino, *Quaderni di Italianistica* 1, 1980, pp. 125–138. V. Nardi, Le illustrazioni dei Documenti d'Amore di Francesco da Barberino, *Ricerche di Storia dell'Arte* 49, 1993 (Studi di miniatura, ed. A.R. Calderon Masetti), pp. 75–91. Sh. J. MacLaren, *Or guarda tu ... desta donna la forma: Francesco da Barberino's Poetic and Pictorial Invention*, Ph.D. Emory University 2007.

287 Belting, Das Bild als Text, p. 34.

288 The fact that Guillaume did not allow his pictures to become real is shown by the variety of illustrations for the *Romance of the Rose*, behind which there is obviously no author-assisted editing of an illustrated text: A. Kuhn, Die Illustrationen des Rosenromans, in: *Jahrbuch der kunsthistorischen Sammlungen des allerhöchsten Kaiserhauses in Wien* 31, 1913, pp. 1–66.

Giotto in Padua 181

visual poetry is hardly conceivable without, on the one hand, Guillaume de Lorris and, on the other, the verbal and visual allegories of Scrovegni, while Francesco probably owed more to Giotto than to the unknown author of the Paduan texts.

GIOTTO IN PADUA

Around 1300, the monastery at the tomb of St. Anthony of Padua, known as the Santo among Paduans, was one of the great pilgrimage destinations in northern Italy and, after Assisi, the most important holy site of the Franciscan Order. According to Riccobaldo Ferrarese (2.2.1) Giotto also painted here. Further details were given in the middle of the 15th century. Michele Savonarola wrote that Giotto was active in the chapter house ("capitulum") of the Santo (2.7.3). The question is, however, whether this statement is well founded, or whether the author simply connected something he had read (the phrase in Riccobaldo's chronicle) with something he had seen and which had impressed him as a particularly splendid ensemble of wall paintings.

A row of saints and prophets is preserved on the side walls of the hall; the figures are inserted into a painted blind arcade. Some of the motifs of this architecture are taken from the frame and pedestal structures of the Arena Chapel; however, the overall system here is different.[289] Comparisons in the Arena Chapel can also be found for the faces, but the figures in their entirety are far removed from Giotto's in their looming monumentality. The artist sought inspiration in the Arena Chapel, starting however from models that were deeply rooted in 13th century Venetian-Byzantine art. On the back wall of the hall, there are fragments of a multi-figured crucifixion with horsemen, flanked by a Franciscan martyrdom and a representation of the Stigmatisation of St. Francis. These pictures are close to Giotto's style, but are unattractive in detail and were painted long after the Arena frescoes: They are in some respects connected to the Giottesque frescoes in the transept of the Lower Church of San Francesco in Assisi – probably works of Giotto's pupil, Stefano – and can thus be dated to the time around and after 1320.[290]

289 Volpe, *Intorno alle cornici di Giotto*, pp. 63–66.

290 Cf. M. Lisner, Giotto und die Aufträge des Kardinals Jacopo Stefaneschi für Alt-St. Peter, II: Der Stefaneschi-Altar – Giotto und seine Werkstatt in Rom. Das Altarwerk und der verlorene Christuszyklus in der Petersapsis, *Römisches Jahrbuch der Bibliotheca Hertziana* 30, 1995, pp. 59–133, esp. 112–115. Margrit Lisner has observed that figures and groups of the Crucifixion in the chapter house (Padua) and of the Crucifixion in the north transept (Assisi) are connected. The riders are taken from Pietro Lorenzetti's crucifixion in the south transept in Assisi. See also: M. Seidel, Die Fresken des Ambrogio Lorenzetti in S. Agostino, *Mitteilungen des kunsthistorischen Institutes in Florenz* 22, 1978, pp. 185–252, esp. 233–239, F. Flores d'Arcais, La presenza di Giotto al Santo, in: *Le pitture del Santo in Padua*, ed. C.

Not a single source refers to the Chapel of Saint Catherine of the Santo. In 1984 Francesca Flores d'Arcais identified the busts in the entrance arch as Giotto's works and pointed out that the chapel was under the patronage of the Scrovegni family.[291] In fact, even more than in the chapter house, the painted ornamentation in this chapel is based on the Arena Chapel.[292] The half-figures framed by quatrefoils follow the corresponding pictures in the Arena Chapel almost exactly and are executed in an extremely appealing way. However, the soft modelling differs from Giotto's Arena style and makes a dating around or after the middle of the 14th century seem plausible. Whether the Scrovegni family's commitment to the chapel is older may be doubted. It could have been Enrico's son Ugolino who commissioned the altogether rather modest decoration; he had returned to Padua after the death of his father in Venetian exile (1336). Whether Giotto's works for the Santo were frescoes or one or more panel paintings remains unclear – nothing seems to have survived.

Did the work in the Santo precede the painting of the Arena Chapel? Like others before her, Francesca Flores d'Arcais wondered whether the painter's path to Padua was Franciscan, leading "from convent to convent": from San Francesco in Assisi via San Francesco in Rimini to San Antonio in Padua.[293] In this case one would have to assume that the Arena Chapel was a follow-up to the activity in the Santo. But the road to Padua may also have been paved by Scrovegni's connections. We owe Hans Belting the hint that Enrico's wife Jacobina d'Este on her mother's side was an Orsini.[294] Her mother Osina Orsini was a great-niece of Pope Nicholas III and a niece of Cardinal Matteo Rosso Orsini, who, as protector of the Franciscan Order, was responsible for furnishing the Upper Church of San Francesco in Assisi as a papal basilica. She was also a niece of Perna Orsini, the mother of Cardinal Jacopo Stefaneschi, who had commissioned the Navicella from Giotto in 1298.[295] Finally, it should be noted that Enrico Scrovegni and Cardinal Stefaneschi had a mutual acquaintance, if not a friend: This was Nicolò Boccasini of Treviso, who frequently stayed in Padua before and after his promotion to Cardinal in 1298, and

Semenzato, Vicenza 1984, pp. 3–13, and L. Bourda, *The Franciscans and Art Patronage in Late Medieval Italy*, Cambridge 2004, pp. 97–98.

291 Flores d'Arcais, La presenza di Giotto al Santo, pp. 10–12. G. Guazzini, A New Cycle by Giotto for the Scrovegni. The Chapel of Saint Catherine in the Basilica of Sant'Antonio in Padua, *Mitteilungen des Kunsthistorischen Institutes in Florenz* 61, 2019, pp. 169–201.

292 Volpe, *Intorno alle cornici di Giotto*, pp. 66–69.

293 Flores d'Arcais, *Giotto*, p. 128.

294 Belting, *Die Oberkirche von S. Francesco in Assisi: Ihre Dekoration als Aufgabe und die Genese einer neuen Wandmalerei*, Berlin 1977, p. 235.

295 S. Carocci, *Baroni di Roma: Dominazioni signorili e lignaggi aristocratici nel duecento e nel primo trecento*, Rome 1993, pp. 426–429.

had ties with both the Cathedral Chapter and the Scrovegni family.[296] In October 1303 he was elected Pope Benedict XI with Stefaneschi's vote. As mentioned above, the new Pontifex saw in Enrico Scrovegni a member of his *familia* and privileged the Arena Chapel with rich indulgences, while Stefaneschi was one of his closest confidants and stood by his deathbed in Perugia in July 1304.[297] It is therefore very plausible that Giotto's way to Padua did not lead from mendicant church to mendicant church, but from palace to palace, navigating a network of Roman nobility and curial connections.

The commission in the Santo was probably a consequence of and not the prerequisite for the commission in the Arena. The same definitely applies to the paintings in the Palazzo della Ragione, which Riccobaldo Ferrarese also mentions: "pinxit palacio comunis padue" (2.2.1).[298] In this case, there is reliable evidence from the early 14th century which provides information on the dating, materiality and subject of the pictures (2.7.1). In his *Visio Egidij* Giovanni da Nono describes the wooden vault erected in 1306/07 over the main hall of the Palazzo della Ragione or Salone, which occupied the entire upper floor. It was later destroyed in a large fire. According to Giovanni, the original construction – like its reconstruction, which stands on the original stone walls – was a colossal carpenter's work, resembling the inverted hull of a ship. Coloured windows with the Paduan coat of arms were inserted. At the end the author says (in the future tense, because the text is written as a vision of times to come):

> On this ceiling, admirably worked by the supreme painter Giotto, the twelve celestial signs and seven planets will shine with their respective properties/qualities, and further inside, other golden constellations with mirrors and other figurations will shine.

These sentences can only be understood to mean that Giotto's pictures were not frescos but tempera paintings decorating the wooden vault.[299] Thus, the date of construction of

296 E. Napione and D. Gallo, Benedetto e la cappella degli Scrovegni, in: *Benedetto XI frate Predicatore e papa*, ed. M. Benedetti, Milan 2007, pp. 95–212.

297 I. Hösl, *Kardinal Jacopo Stefaneschi. Ein Beitrag zur Literatur- und Kirchengeschichte des beginnenden vierzehnten Jahrhunderts*, Berlin 1908, p. 21.

298 Essential reading: G.F. Hartlaub, Giottos zweites Hauptwerk in Padua, *Zeitschrift für Kunstwissenschaft* 4, 1950, pp. 19–34. See also: D. Gunzburg, Giotto's Sky: the Fresco Paintings of the First Floor Salone of the Palazzo della Ragione, Padua, Italy, *Journal for the Study of Religion, Nature and Culture* 7, 4, 2013, pp. 407–433 and C. Bellinati, Giotto dipinse nel Palazzo della Ragione a Padova? in: *Il Palazzo della Ragione a Padova: La storia, l'architettura, il restauro*, ed. E. Vio, Padua 2008, pp. 327–331.

299 Graziella Federici Vescovini, Eva Frojmovič, and Dieter Blume (among others) do not read the text literally; they assume that Giotto's pictures were frescoes and covered the wall zone

184 Speech which Speaks to the Eye: The Arena Chapel

the vault provides the *terminus post quem* for the pictures: they must have been painted after 1306/07 and consequently after the frescoes of the Arena Chapel. Some scholars have postulated a second visit to Padua by the painter. However, there are no reliable indications of a second stay.[300] And now that we know Giotto's life better, a sufficiently wide window of time is missing, during which a return to Padua could have taken place. Instead of assuming a single enormous work – in other words, a decoration that completely covered the ceiling – from Giovanni's text, one could equally conclude that Giotto's work consisted of individual panels scattered across the (presumably blue-painted) vault together with the stars. Such a volume of work would fit in the time between the Arena frescoes and Giotto's stay in Assisi in 1308.

There are good reasons to imagine a follow-up commission to the Arena frescoes: the chapel has a vault decorated with stars and images – Christ, Mary, prophets – which may have inspired the design in the Salone and which was later copied several times in Padua[301]; below it Giotto painted the personifications of virtues and vices, which could easily have proved their author qualified to visualise the planets and the signs of the zodiac. Some idea of the appearance of these pictures can be gained from two works: one is a manuscript of the *Liber Introductorius* of Michael Scotus illustrated in Padua in the early 14th century (Munich, Bayerische Staatsbibliothek, ms CLM 10268). One of the pictures, for example, shows the constellation of Andromeda in a form that can easily be derived

below the vaulting. For this reason they assume that the existing paintings there contain remnants of Giotto's paintings: G. Federici Vescovini, Pietro d'Abano e gli affreschi astrologici del Palazzo della Ragione di Padova, *Labyrinthos* 9, 1986, pp. 50–75, E. Frojmovič, Giotto's Allegories of Justice and the Commune in the Palazzo della Ragione in Padua, *Journal of the Warburg and Courtauld Institutes* 59, 1996, pp. 24–47, D. Blume, *Regenten des Himmels: Astrologische Bilder in Mittelalter und Renaissance*, Berlin 2000, pp. 70–85. But even if Giotto's paintings had really been partly on the walls, they would have been lost in 1420. In a contemporary report it is said that the walls stood naked (denudatus) after the fire: Sicco Polentone, 10 February 1420, quote from A. Barzon, *I cieli e la loro influenza negli affreschi del Salone in Padova*, Padua 1924, pp. 7.

300 Portenari is sometimes quoted in this context as saying that the paintings in the Palazzo della Ragione were executed in 1312 (A. Portenari, *Della felicità di Padova*, Padua 1623, p. 98). However, the background of this dating is revealing: Scardeone says that the paintings were designed by Pietro d'Abano, died in 1312 (B. Scardeone, *De Antiquitate Urbis Patavii*, Padua 1560, pp. 201–202). The other work Portenari used depends on this: A. Riccobono, *De Gymnasio Patavino*, Padua 1598, fol. 2. There it is said that the paintings were designed by Pietro d'Abano around ("circiter") 1312. On Pietro d'Abano as designer of the programme see below.

301 For example in the Oratorio di San Giorgio at the Santo: Bourda, *The Franciscans and Art Patronage in Late Medieval Italy*, pp. 124–130.

from Giotto's Desperatio.[302] It is precisely the dissimilarity of what is represented – a woman strangling herself in the chapel, a hermaphrodite tied to two trees in the book – that underlines how similar the forms of representation are (fig. 92, 86).

The other work is the seven images of planets in the choir of the Eremitani Church, probably painted by Guariento after 1360. They are imitated marble relief inlays in the manner of the allegories in the Arena Chapel. This form of representation corresponds to the position of the images at the pedestal of the decoration and certainly says nothing about the form of the images on the ceiling of the Salone. But the appearance and behaviour of the enthroned figures and their companions in the Eremitani Church – personifications of the Ages of Life – may well be inspired by Giotto's representations of the planets. The scene of Venus enthroned between a young man and a young woman, and the pair, who look at each other through the goddess with expression of amazement, are shown with a narrative quality similar to that found in the Arena Chapel.[303]

Fig. 92: Munich, Bayerische Staatsbibliothek: Michele Soto, Liber introductorius

Since Scardeone's book on the history of Padua from the mid-16th century, Pietro d'Abano, the "Paduan Faust of the Trecento" (Aby Warburg, alluding to the protagonist of Goethe's play), has been named as the author of the programme of the images, who would have helped to transform Giotto's allegorical language into an astrological

302 U. Bauer, *Der Liber Introductorius des Michael Scotus in der Abschrift Clm 10268 der Bayerischen Staatsbibliothek München*, Munich 1983, pp. 53–55.

303 Z. Murat, *Guariento: Pittore di corte, maestro del naturale*, Milan 2016, pp. 176–187. Blume, *Regenten des Himmels*, pp. 95–102. The connection with the Salone frescoes is explained by the fact that Guariento's pictures served as models for the repainting after 1420.

one.[304] This thesis is tempting for a variety of reasons: Pietro, who returned from Paris in 1303 and taught at the University of Padua starting 1306, is known to have mentioned Giotto in one of his works (2.3.1). He was a famous astrologer, and the description in Giovanni da Nono's work points to the advanced astrological character of the paintings in the Salone. Finally, after being accused of heresy in 1304, Pietro was under the expressed protection of the commune – that is to say, of those authorities who must have hired Giotto for the painting in the municipal palace. Nevertheless, the assumption is not really proven. In fact, it is possible to show how it came about: as early as 1440, Pietro d'Abano was named by Michele Savonarola as the "institutor" of the decoration of the Salone, however, not of that executed by Giotto, but of the painting after the fire of 1420. What the chronicler says is that the pictures created under his eyes were based on the *Astrolabium planum*, Pietro d'Abano's classic work on astrology. When Scardeone wrote more than 100 years later, the fire and the reconstruction were long forgotten, and so Savonarola's remark became the spark for the idea of a collaboration between Pietro d'Abano and Giotto.[305]

What remains after critical examination of the relevant sources and assumptions is the insight that Giotto, when creating pictures of planets and constellations in the Salone, did not work as a painter of religious narratives, the historical figure with whom we are familiar, but as one who took up and developed the more abstract visual language of the allegories. A look at another tradition concerning Giotto's Paduan activities complete this impression: in the middle of the 15th century Ghiberti mentions as Giotto's Paduan works the Arena Chapel and the decoration of the Salone in its state after the restoration of 1420; on the south wall he noticed the relatively easily to identify Christian allegories (Veneration of the Cross, Adoration of the Lamb and Eucharist, each with Old Testament counterparts) and called them "una storia della fede christiana".[306] This detail is important because it shows that Ghiberti is really talking about the Paduan salone and not about

304 A. Warburg, Italienische Kunst und internazionale Astrologie im Palazzo Schifanoja zu Ferrara, in: A. Warburg, *Die Erneuerung der heidnischen Antike: Kulturwissenschaftliche Beiträge zur Geschichte der europäischen Renaissance* (Gesammelte Schriften II), Berlin 1932, pp. 459–481, esp. 465. Scardeone, *De Antiquitate Urbis Patavii*, pp. 200–201.

305 Hartlaub, Giottos zweites Hauptwerk in Padua, p. 28. The close connection between Pietro d'Abano's *Astrolabium Planum* and the existing frescoes was explained by Federici Vescovini, Pietro d'Abano e il Salone di Padova.

306 *Il Palazzo della Ragione di Padova*, ed. C.G. Mor et al., Venice 1964, p. 81. For Creighton Gilbert, the mention of this theme is an argument for the idea that Ghiberti does not mean the Paduan Palazzo della Ragione, but the Florentine Palazzo della Parte Guelfa: this would prove that Ghiberti's arrangement of the works is not based on a topographical concept. C. Gilbert, The Frescoe by Giotto in Milan, *Arte Lombarda* n.s. 47/48, 1977, pp. 31–72, esp. 41.

another public palace. What is crucial here is the object that appears in Gilberti's text between the Arena Chapel and the Salone, which the author thus implicitly situates in Padua: a "Gloria mondana" (2.1.4): "an Earthly Glory is by his hand." Whether it was really a work by Giotto that was shown to the visitor from Florence cannot be determined anymore. It is clear, however, that the Paduans remembered Giotto as a painter of such subjects as the *gloria mondana*, i.e. an allegory of worldly fame or perhaps vanity.

The formulation "speech which speaks to the eye", with which this chapter is titled, comes from Dante ("visibile parlare").[307] This is how he characterizes the effect of three marble reliefs at the entrance to the Terrace of Pride in the *Divina Commedia* (Purg. 10, 28–96): They display three examples of acting with humility – one from the New Testament, one from the Old Testament and one from classical antiquity – as if the events were not only visibly but also audibly taking place in the present. Even the incense being burned in one of the fictional scenes can be smelled by the fictional viewers, Dante and Virgil. Since Julius von Schlosser, it has repeatedly been claimed that Dante was commenting here on the new pictorial culture around 1300 and in particular on the achievements of his compatriot Giotto.[308] If so, however, he would have done better to describe paintings instead of reliefs and to mention Giotto, as he did elsewhere, instead of Polycleitus. In reality, Dante was reformulating, in poetic exaltation, topic ideas about what images should ideally achieve. What we perceive in the passage as a cinematic effect stems from the tradition of the textual form of ekphrasis,[309] while the effect of presence comes from a mystically inspired theology of the image (more about this latter aspect later). On the other hand, Dante's verses make clear how close Giotto's Paduan images come to these ideals and that they are probably also aligned with them. This is true not only for the narrative images that make episodes from the past take place as scenes before the audience's eyes, but also for the allegorical ones that transform abstract concepts into sculptural scenes. In the following we will first discuss the prerequisites for this intensive form of pictoriality and then we will look at Giotto's further engagement with the concept developed in Padua.

307 M.A. Terzoli, Visibile parlare: ecfrasi e scrittura nella "Commedia", in: *Dante und die bildenden Künste: Dialoge – Spiegelungen – Transformationen*, ed. M.A. Terzoli and S. Schütze, Berlin and Boston 2016, pp. 23–45.

308 J. von Schlosser, Dichtkunst und Bildkunst im Trecento, *Corona* 8 (1938), pp. 620–640. Cf. G. Wolf, Dante's Eyes and the Abysses of Seeing: Poetical Optics and Concepts of Images in the Divine Comedy, in: *Visions and its Instruments: Art, Science, and Technology in Early Modern Europe*, ed, A. Payne, University Park, PA 2015, pp. 122–137.

309 J. H. McGregor, Reappraising Ekphrasis in Purgatorio 10, *Dante Studies* 121, 2003, pp. 25–41.

GIOTTO AVANT GIOTTO:

WORKS BEFORE AND AROUND 1300

The problem around which the present chapter revolves is essentially the following: is there a group of secure works by Giotto which can be considered as preliminary stages or preparatory works for the frescoes of the Arena Chapel? This means charting an "early Giotto", a Giotto in his formative phase, and this is not possible without style criticism, since there is only one written source that clearly indicates his activity before the Paduan years. Not meant by this is the frequently quoted sentence by Riccobaldo Ferrarese: The listing of the Franciscan churches of Assisi, Rimini, and Padua as scenes of Giotto's activity falls in the year 1313 (2.2.1); hence the text cannot provide any argument for the idea that the paintings in Assisi (or Rimini) preceded those in Padua. What is meant is rather the text transmitted by Giulio Mancini with the date 1298 for Giotto's mosaic in the atrium of St. Peter's in Rome, the Navicella. This piece of information was long considered to be demonstrably wrong on the basis of Lionello Venturi's research, but closer examination shows otherwise (2.2.5). However, the statement stands alone and a validation using stylistic arguments is recommended here too.

This also means that without historical (documentary) evidence one cannot seriously contribute anything to the problem of Giotto's formative years. For example, the Madonna from Santi Lorenzo e Leonardo in Castelfiorentino (now in the Museo della Collegiata there, fig. 93) is of no use as a stone in the mosaic of our knowledge of Giotto, even if it appears as number 1 in the catalogue of the Giotto exhibition in the year 2000.[310] After the panel had long been regarded as a work from the circle of the Sienese painter Duccio, in 1948 Roberto Longhi identified it as a joint work by Duccio and Cimabue. Finally, in 1985, Luciano Bellosi realized that it could only be a joint work by Cimabue and *Giotto*; the master had painted the mother, the student, still working in the workshop, painted the child.[311] Not much needs to be said about the devout naivety behind such ideas. Nor does it need to be pointed out at length that Bellosi did not use undisputed works by Giotto for comparison. What matters is that there are no relevant documents or early texts about the panel and that there is no evidence of activity in Castelfiorentino for either Duccio or Cimabue or Giotto. What we have before us is the work of a talented painter who had access to both Florentine and Sienese models and who also knew materials such

310 *Giotto: Bilancio critico di sessant'anni di studi e ricerche.* Exh. cat., ed. A. Tartuferi, Florence 2000, pp. 98–100 (L. Bellosi).

311 R. Longhi, Giudizio sul Duecento, *Proporzioni* 2, 1948, pp. 5–54. L. Bellosi, *La pecora di Giotto*, Turin 1985, pp. 177–178.

Fig. 93: Castelfiorentino, Museo della Collegiata: Madonna (unknown painter)

as those used by ornament painters in Assisi (see below). The Madonna does not provide an insight into the milieu from which the Paduan frescoes emerged, but shows what a painter could do with the models available around 1300.

THE ISAAC PICTURES IN THE UPPER CHURCH OF ASSISI

By contrast, the two Isaac scenes in the clerestory of the Upper Church of San Francesco in Assisi can be identified as preparatory stages for certain Arena frescoes – here the opinion of critics has been largely unanimous for over a century. The first scene shows how Jacob receives the blessing at the bed of his father Isaac (pl. XI), the second how Esau, the first-born, then comes to his father who realizes that he has blessed the wrong son (pl. XII):

> *And Isaac trembled very exceedingly, and said, Who? where is he that hath taken venison, and brought it me, and I have eaten of all before thou camest, and have blessed him? yea, and he shall be blessed. (Gen. 27: 33)*

Isaac's house, which is identical in both cases, resembles Mary's parental house in Padua (which is also used twice) not only in appearance but also in function (pl. V, VI). The invention of using a fictional building twice and thereby architecturally defining the unity of place in the framework of a narrative cycle of images, was first made with these images in Assisi and applied secondarily in Padua.[312] What is different in Padua, regarding the use of the house within the cycle, is that pictures with different settings are interposed between the two appearances and the lighting of the house changes significantly. At its

312 G. Pochat, *Bild – Zeit: Zeitgestalt und Erzählstruktur in der bildenden Kunst von den Anfängen bis zur frühen Neuzeit,* Vienna 1996, pp. 223–224. W. Kemp, *Die Räume der Maler: Zur Bilderzählung seit Giotto,* Munich 1996, pp. 20–22.

first occurrence, the front of the building appears brightly lit, while at the second, it is in shadow. The repetition here thus also has the effect of illustrating the temporal extension of the narrative.

However, the discovery of a close connection should not blind the critic to the differences: in the Assisian murals, for example, we are less clearly dealing with a house than in Padua. Rather, it is a box that surrounds (or frames) the figures; largely filling the picture field, it is assembled from disparate architectural elements. To put it bluntly, one could speak of an architecturally orchestrated niche for the persons in the picture. And even here one has to make concessions, because the group of figures and the box are – compared again with what we see in Padua – only superficially attuned to each other. This can be shown, for example, by the fact that the right-hand outer wall of the box has just the depth of one door width, while the figures are staggered at least two bed widths into the depth, although – as the curtains make clear – there is additional space behind them. The figures thus occupy a volume of space that the architecture painted around them does *not* provide. Furthermore, there is an additional layer of space in front of them within this architecture, and the motif that creates this effect is of particular interest.

At first glance, the carpentry work with the turned rods that appears in the foreground seems to be part of the bed. But the actual bed base is clearly visible on the left between the aforementioned object and the sheets. On the right, the twisted legs of the bed can also be seen. The way they reach down next to each other, not only behind the object, but also behind the marble threshold of the box, arouses doubts that the relationship between the foreground and the middle ground has been systematized in accordance with our expectations, which are shaped by Renaissance imagery and photography. In any case, the carpentry work in the foreground is a piece of furniture of its own. On closer inspection it turns out to be a splendid bench. It stands with the backrest facing the viewer, so that we can see above it the figures who could use the bench if they would step to the other side of Jacob's bed – and shrink to a fraction of their size at the same time. Due to its miniaturization, the bench does not simply occupy a layer of space in front of the figures. It creates a very peculiar effect: the group of figures and especially Jacob is not pushed into the depth of the pictorial space, but pulled to its front. Visible above the downsized bench, they gain in scale and presence in our eyes. It can be seen how this niche made up of furniture and architecture does not so much represent space or a bedchamber but is primarily intended to increase the presence of the figures.

It is precisely the reduction in size of the bench and the effects related to it that also show the distance of the Isaac pictures from the Arena pictures and from the Renaissance and post-Renaissance imagery as well. What the painter meant by the downsizing, and what was undoubtedly intended to help the users of the pictures and to improve or facilitate the perception of the group of figures, is not accessible at first glance to us. Already in Paduan interiors, scaled-down motifs would have been noticeable. As far as the Arena

Chapel is concerned, however, it should be remembered that the opening of the interiors towards the viewer, the so-called "Schauöffnung" ("show opening"), often has an unreal aspect.[313] Indeed, it is debatable whether a wall that has been removed and replaced by a frame motif or, as in Assisi, a shrunken bench is the more radical measure to improve the readability of the image. There is no question, however, that the reduction of foreground motifs was no longer used in Padua and would lose all legitimacy in the long run.

Anna's Paduan house can thus be described as an elaboration of Isaac's home that shows a development towards the practises of modern visual culture. The picture field and the architecture are now decoupled, for example through the stronger presence of the blue-brown picture mount on the right-hand edge of the picture, while the space of the figures and the architectural space are in coordination with each other (pl. V, VI). A lot of effort was put into making a considerable depth of space believable on the exterior of the construction, thereby overcoming the paradox of Isaac's box: just notice the introduction of the staircase, which suggests not only the usability of the building, but also depth. The proportions of figures and objects in the interior converge, their presence – whether person or furniture – is the same. The loggia creates an external zone and links it – albeit imperfectly – with the interior: in the picture of the Annunciation to Anna, the connection is made by a closed door which is slightly too low (through which the maid can at least hear what is going on inside)[314]; in the scene of Mary's birth the door is higher, open and used by the maid, but without her coming into any real contact with the people inside.[315] Overall the plausibility of the scenery is improved. The tiled roof, for example, ensures that we do not just see an architectural box as a setting for a scene, but a house. In terms of concept and motifs, however, much has been taken from Assisi, so much so that viewers hardly ever notice the differences between the pictures and many scholars have seen the boxes in Assisi with Paduan eyes. For example, no one has dealt with the disconcerting aspect of the dwarf bench in the foreground. Likewise, it has gone unnoticed that the box itself was borrowed from elsewhere and recycled in the clerestory of San Francesco.[316]

The throne of Mary in Cavallini's Annunciation mosaic in Santa Maria in Trastevere, Rome, stands in front of a kind of façade composed of micro-architectures (fig. 94). This motif probably refers to the Byzantine tradition of the Annunciation picture, which

313 The term „Schauöffnung" was coined by Anna Rohlfs-von Wittich: A. Rohlfs-von Wittich, *Das Innenraumbild als Kriterium für die Bildwelt*, *Zeitschrift für Kunstgeschichte* 18, 1955, pp. 109–135.

314 A. Schmarsow, *Italienische Kunst im Zeitalter Dantes*, Augsburg 1928, p. 87.

315 A. Mueller von der Haegen, *Die Darstellungsweise Giottos mit ihren konstitutiven Momenten Handlung, Figur und Raum im Blick auf das mittlere Werk*, Braunschweig 2000, pp. 46–47.

316 Roberto Salvini points to aedicula structures in ancient painting that allegedly prepared the boxes: R. Salvini, Bemerkungen über Giottos Frühwerke in Assisi, in: *Giotto di Bondone*, Constance 1970, pp. 169–207.

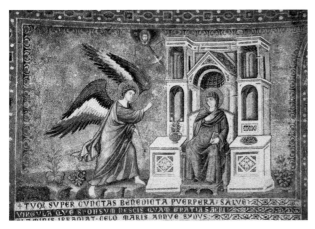

Fig. 94: Rome, Santa Maria in Trastevere, apse: The Annunciation (Pietro Cavallini)
Fig. 95: Detail from fig. 94

shows Mary as the temple virgin and makes her appear before an architectural backdrop representing the Temple in Jerusalem. However, Cavallini's façade gives no indication of a functional building. It is a structure that is limited to embellishing the picture and creating a backdrop for the figures. At the top left and right, a box was used, which not only corresponds to the boxes in Assisi in terms of their projection and openness to the viewer, but is also similar in each of its elements (fig. 95): These include not only the round-arched side "doors" but also the free-standing columns, which support a decorated architrave with a coffered underside. The painter of the Isaac pictures added a threshold and pediments above the side walls to the box; the whole structure was scaled up and certain parts were given narrative tasks, including the side door through which Isaac and his mother Rebecca make their escape in the second picture. Some things remained the same, however, and these features give the Isaac chambers their character as wall niches.

But of course, it also needs to be considered whether it was Cavallini who took the box from Assisi and reduced it to an ornament.[317] This is opposed by the fact that other motifs from the mosaic cycle of Santa Maria in Trastevere can be found in the two Isaac pictures. One of them is the dwarf bench: in the foreground of the scene of the Death of the Virgin stands an identical piece of furniture, only with the seat facing the viewer (fig. 96). Also relevant is the combination of one reclining and standing figures with a

317 M. Schmitz, *Pietro Cavallini in Santa Cecilia in Trastevere: Ein Beitrag zur römischen Malerei des Due- und Trecento* (Römische Studien der Bibliotheca Hertziana 33), Munich 2013, p. 212.

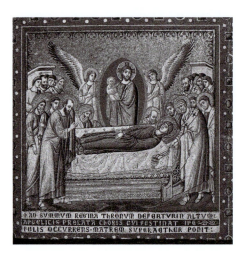

Fig. 96: Rome, Santa Maria in Trastevere, apse: The Death of the Virgin (Pietro Cavallini)

curtain and an architectural backdrop.[318] This is precisely what Cavallini's mosaic of the Nativity of the Virgin shows, a picture that would have to be considered the most important prerequisite for the Isaac frescoes if the boxes were not the significant motif in Assisi (fig. 97). But as soon as one sets aside the element of the box, it becomes clear that Cavallini's Birth of the Virgin actually offers much more than a misunderstood Byzantine formula plus "the notorious decorative pieces in the background" (this is how Wolfgang Kemp comments on the mosaic).[319] The picture is a narratively and perfectly spatially organised system of figures, furniture and architecture that has no equal in the period before and around 1300 – except in the context of the Isaac frescoes and in Giotto's output, as well as in other works by Cavallini. These include the fragmentary mural with the scene of Esau before Jacob, which is part of Cavallini's decoration of the nave of Santa Cecilia in Trastevere.[320]

At first glance, the two Isaac pictures in Assisi appear coherent and mature, yet they also seem to be casually assembled compilations of motifs developed and used by Cavallini. The concept is not based on the vision of a drama in a bedroom, but on the possibility of bringing together up-to-date visual elements in an improvised form: first, the spatial composition of a group of figures against a background; secondly, a foreground motif (the small bench); and thirdly, the architectural box. This was probably linked to the speculation that this combination would increase the presence and plausibility of what was shown and strengthen the credibility of the narrative, thus helping the viewer to accept ("believe") the images. And this was then obviously followed up in a modified form when it was transferred to Padua. It is symptomatic that the history of the "show opening" in Cavallini did not begin with a show opening but with a view into a niche, and the hist-

318 E. Rosenthal, *Giotto in der mittelalterlichen Geistesentwicklung*, Augsburg 1924, pp. 171–172. M. Meiss, *Giotto and Assisi*, New York 1960, p. 18.
319 Kemp, *Die Räume der Maler*, p. 45.
320 W. Paeseler, Cavallini e Giotto: Aspetti cronologici, in: *Giotto e il suo tempo. Atti del congresso internazionale per la celebrazione del VII centenario della nascita di Giotto (Assisi – Padova – Firenze 1967)*, Rome 1971, pp. 35–44, esp. 37.

ory of the "Handlungsöffnung"[321] ("action opening" – meaning, for example, side doors) similarly did not begin with an action opening but with an ornamental arch (fig. 95). In plain language: the boxes in Assisi and, subsequently, Giotto's Paduan rooms do not imitate experienced reality, but vary specific Late-Dugento motifs with regard to the viewer's perception.

The study of the frescoes in the clerestory in Assisi is therefore fruitful, although it does not quite meet the requirements made at the beginning of the chapter that the precedents of the Paduan frescoes should be found among the works *secured* for Giotto. There is an indication

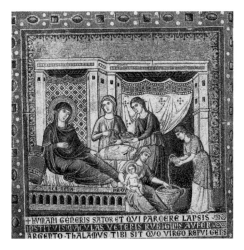

Fig. 97: Rome, Santa Maria in Trastevere, apse: The Birth of the Virgin (Pietro Cavallini)

of Giotto's authorship in the sources, but no clear evidence. The Isaac frescoes can, but do not have to be, included in Ghiberti's "quasi tutta la parte di sotto" (2.1.4). This only applies if, with Christine Knapp Fengler, one understands "parte di sotto" as "the lower (remote from choir) part of the (upper) church".[322] Unlike the St. Francis cycle on the lower wall of the nave, ascribed to Giotto by Vasari in the second edition of the *Vite* (2.1.10), these pictures remained unnoticed for centuries. Henry Thode was the first to regard them as Giotto's work and as important monuments in general.[323] Since then, they have been considered by some as Giotto's works and by others as the works of an anonymous painter ("Isaac Master"), who could be postulated as Giotto's teacher or forerunner; on one occasion the name Gaddo Gaddi, which has been handed down in Florence, was attributed to him.[324] Cavallini is also under discussion as the author.[325] Even if his presence in Assisi has not been proven by relevant written sources (i.e. from before Vasari),[326] this assumption seems less far-fetched than many other attributions in the field of early

321 Kemp's term: Kemp, *Die Räume der Maler*, p. 29.
322 Chr. K. Fengler, *Ghiberti's Second Commentary. The Translation and Interpretation of a Fundamental Renaissance Treatise of Art*, Ph. D. University of Wisconsin 1974, p. 103.
323 H. Thode, *Franz von Assisi und die Anfänge der Kunst der Renaissance in Italien*, Berlin (2) 1904, pp. 251–254.
324 F.J. Mather, *The Isaak Master: A Reconstruction of the Work of Gaddo Gaddi*, Princeton 1932.
325 Hetherington quotes the earlier literature on this subject: P. Hetherington, *Pietro Cavallini: A Study in the Art of the Late Medieval Rome*, London 1979, S. 157.
326 A collection of the texts in: B. Zanardi, *Giotto e Pietro Cavallini: La questione di Assisi e il cantiere medievale della pittura a fresco*, Milan 2002, pp. 253–254.

Italian painting; Cavallini's painted figures in Santa Cecilia in Trastevere (see below) share many physiognomic characteristics with the figures in the Isaac pictures, as well as the way in which the flesh coloured parts (faces and hands) are effectively modelled with fine brushstrokes and with more shadow than light[327] (fig. 98, 99). The works are also related technically: Cavallini's Santa Cecilia paintings and the Assisian Isaac scenes are the earliest known examples of what is called "buon fresco", painting executed consistently on the wet or kept wet plaster.[328] But of course, all these characteristics do not necessarily speak for the same artistic hand, and could also have had their origin in a kind of training relationship. This is particularly true of the fresco technique, which was soon to be found in the Arena Chapel and would become the standard technique of wall painting after, and because of, Giotto. The identification of the similarity to Cavallini does not exclude Giotto's authorship of the Isaac scenes. Incidentally, the attribution of the Isaac pictures to Giotto has become even more plausible since the restoration of the Cross of Santa Maria Novella. This is why I will return to the problem of authorship in connection with this work. First of all, we need to determine the contexts and the scope of the group of images, which one might neutrally call the Isaac-Master complex.

The context in the clearest sense is the upper church of San Francesco. It is usually imagined as a Franciscan convent church, and its murals are often interpreted from this perspective, i.e. as a Franciscan programme.[329] However, this does not consider the fact that, according to a, not preserved but reliably documented, rood screen, it was originally the lower church dedicated to St. Francis, that served as a convent church for the friars. In contrast, the upper church, which is consecrated to Mary, has been designated as a *Capella papalis*.[330] In general, the buildings in Assisi consist of a Franciscan monastery, which guarded the remains of the founder of the order, and a palace, which should allow the pope to hold court next to the grave of the most popular saint of his time.[331] Within this framework, the upper church was originally intended to serve the papal liturgy, i.e.

327 O. Sirèn, *Giotto and some of his followers*, 2 vols., Cambridge, Ma. 1917, vol. 1 p. 9.

328 S. Romano, Artista e organizzazione del lavoro medievale: appunti e riflessioni romane, *Ricerche di storia dell'arte* 55, 1995, pp. 5–20.

329 Cf. for example: G. Ruf, *Die Fresken der Oberkirche San Francesco in Assisi: Ikonographie und Theologie*, Regensburg 2004.

330 The fundamental scholarly work on the murals of the Upper Church is: H. Belting, *Die Oberkirche von S. Francesco in Assisi: Ihre Dekoration als Aufgabe und die Genese einer neuen Wandmalerei*, Berlin 1977. In Belting's work, the Franciscan and papal readings are interwoven. Nevertheless, the book presents the seminal arguments for the papal interpretation. All recent research is based on Belting's work, including: D. Cooper and J. Robson, *The Making of Assisi: the Pope, the Franciscans, and the Painting of the Basilica*, New Haven and London 2013.

331 A. Monciatti, *Il palazzo Vaticano nel Medioevo*, Florence 2005, pp. 49–56.

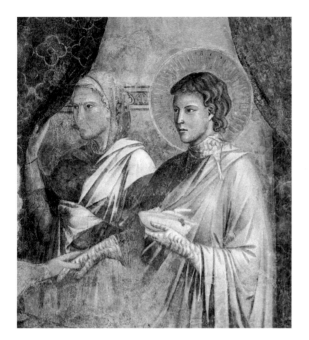
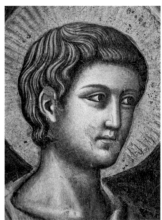

Fig. 99: Rome, Santa Cecilia in Trastevere, west wall: The Last Judgement, detail (Pietro Cavallini)

Fig. 98: Assisi, San Francesco, upper church, clerestory, north wall: Jacob before Isaac, detail

to make manifest the principle of *ubi papa ibi Roma* at the tomb of St. Francis. Among the Roman Papal Basilicas, St. Peter was most likely the model: as the Pope celebrated "super corpus beati Petri" (*Liber pontificalis*)[332] in St. Peter's Basilica in Rome, so in Assisi he could read the Mass above the body of St. Francis. Accordingly, the upper church not only had an altar in the centre of the crossing (i.e. above the tomb), which was designed for papal celebration *versus populum*, and – as we have only recently learned – a *schola cantorum* in the nave, but also a papal throne in the apse, which still exists.[333]

332 *Le Liber pontificalis*, ed. L. Duchesne, 3 vols., Paris 1955–57, vol. 1 p. 312.
333 P. Theis, *S. Francesco in Assisi: Eine Palastkirche des Papstes zwischen Rom und Avignon*, Phil. Diss. Vienna 2001. P. Theis, Die Oberkirche von S. Francesco in Assisi oder De missa pontificali: Zur Ausstattung eines päpstlichen Sakralraums, *Römische Historische Mitteilungen* 46, 2004, pp. 125–164. P. Theis, Visualisierung des Unsichtbaren: Päpstliche Liturgie in der Oberkirche von S. Francesco in Assisi, in: *Architektur und Liturgie*: ed. M. Altripp and C. Nauerth, Wiesbaden 2006, pp. 53–61. The western orientation of the complex and the celebration *versus populum* are also the reason why there was no retable on the high altar in either the upper or lower church. Cf. D. Bohde, Das verspätete Retabel: Überlegungen zur Funktion von Fresken und Tafelbildern in San Francesco in

Also, the pictorial decoration is largely based on the church's function as a papal basilica: This applies for example to the northern transept through which the pope entered the church from his palace: if we trust the tradition of the early 16th century and use a stylistic criticism with a narrow basis, it was Cimabue who painted the lower walls with a sequence of pictures showing the activity and martyrdom of Peter and Paul, the founders of the Roman Episcopal See. He used Roman designs, namely models in the manner of the cycle in the atrium of St. Peter's (surviving in drawings) and the frescoes of the Capella Sancta Sanctorum connected to the Lateran Palace.[334] At an analogous position in St. Peter's in Rome, in the north transept, there was a Peter cycle.[335] Just as clear is the reference to the function of a papal basilica in the clerestory of the nave: two double-row cycles, each running from the corner of the transept to the entrance wall, face each other; on the north side (beginning with the creation of the world) the story of the Old Testament is told, and on the south side (beginning with the Annunciation) that of the New. Within the New Testament images, a Marian focus is noticeable, which reflects the consecration of the church to the Virgin. Whether this is really answered within the Old Testament images by an accent on the theme of the younger or lesser brothers (Jacob, Joseph, Benjamin), which would allude to the Franciscans (*fratres minores*) and the consecration of the lower church to Francis, is a question of perspective.[336] It would not change the fact that this disposition in its entirety corresponds to the clerestory of Old St. Peter's in Rome and recurs in many churches that imitated Old St. Peter's.[337] As far as the programme is concerned, therefore, the Isaac images appear in a context that is not so much Franciscan as Roman and papal.

Apparently the initiative for the painting had also come from the papal court. A source from the second decade of the 14th century states that Pope Nicholas IV (1288–1292) had acted as the patron of the paintings in San Francesco.[338] As things stand, only the decor-

Assisi, in: *Curiosa Poliphili: Festgabe für Horst Bredekamp*, ed, N. Hegener et al., Leipzig 2007, pp. 139–147.

334 Belting, *Die Oberkirche von S. Francesco in Assisi*, p. 91.

335 A. Weis, Ein Petruszyklus des 7. Jahrhunderts im Querschiff der vatikanischen Basilika, *Römische Quartalschrift* 58, 1963, pp. 230–270.

336 A. Neff, Lesser Brothers: Franciscan Mission and Identity at Assisi, *The Art Bulletin* 88, 2006, pp. 676–706.

337 J. Garber, *Wirkungen der frühchristlichen Gemäldezyklen der alten Peters- und Pauls-Basiliken in Rom*, Berlin and Vienna 1918. H.L. Kessler, Caput et speculum omnium ecclesiarum: Old St. Peter's and Church Decoration in Medieval Latium, in*: Italian church decoration of the Middle Ages and early Renaissance*, ed W. Tronzo, Bologna 1989, pp. 109–146.

338 D. Cooper and J. Robson, Pope Nicholas IV and the Upper Church at Assisi, *Apollo* 157, 2003, pp. 31–35.

The Isaac Pictures in the Upper Church of Assisi

ation of the upper church could be being referred to here. The functionary probably responsible for the care of the building of San Francesco under this Pope as well as under his predecessors and successors was, as Hans Belting demonstrated, Cardinal Matteo Rosso Orsini, who was the Protector of the Franciscan Order from 1279 until his death in 1305. This important role is discreetly recalled in the Orsini coat of arms in Cimabue's cityscape of Rome on the crossing vault of the upper church.[339] Matteo Rosse was not only a nephew of Pope Nicholas III, aka Giovanni Gaetano Orsini (1277–1280), but also the scion of one of the great Roman noble families and one of the most important curials of his day.[340] It should also be considered that he was related both to Cardinal Jacopo Stefaneschi, the patron of Giotto's Navicella, and to Jacobina d'Este, wife of Enrico Scrovegni, founder of the Arena Chapel.[341] It was Stefaneschi who composed the inscription on his tomb in St. Peter's, thereby thanking Matteo Rosso for the support he had received.[342] Under these circumstances, the artists in charge of the painting certainly needed to learn about papal ceremonial and Roman standards of church decoration. At the same time, it can be assumed that they were only marginally involved with the Franciscans and their piety.

The recruitment of the artists also seems to have taken place in Rome or via Roman connections. Although Cimabue is considered a Florentine and his art has its fundamental roots on the banks of the Arno, the first documented mention of him comes from Rome (1272).[343] Ever since the murals of the Capella Sancta Sanctorum in Rome, consecrated in 1279, were uncovered, it has also become clear how much Cimabue's use of forms is based on this complex, which was commissioned by the pope: both the stereometric piles of buildings and the space-defining use of landscape formations are evident here in earlier forms.[344] The sporadic appearance of late Byzantine architectural motifs proves that he was also aware of stimuli that only later arrived on the Roman scene (see below).[345] Before Cimabue, there was a workshop active on the upper walls of the northern transept, which, according to stylistic findings, came from France or England.

339 R. Oertel, *Die Frühzeit der italienischen Malerei*, Stuttgart 1966, p. 54 and (for an overview of the older history of interpretation) footnote 10 on p. 223.

340 Belting, *Die Oberkirche von S. Francesco in Assisi*, pp. 87–97.

341 S. Carocci, *Baroni di Roma: Dominazioni signorili e lignaggi aristocratici nel duecento e nel primo trecento*, Rome 1993, pp. 387–403.

342 R. Morghen, Il cardinale Matteo Rosso Orsini, *Archivio della R. Società Romana di Storia Patria* 46, 1923, pp. 271–372, esp. 336.

343 J. Strzygowski, *Cimabue und Rom*, Vienna 1888, pp. 158–160.

344 S. Romano, Il Sancta Sanctorum: gli affreschi, in: *Sancta Sanctorum*, Milan 1995, pp. 38–125.

345 One example is a building with a U-shaped ground plan in the picture of Matthew on the crossing vault (destroyed in 1997). For this kind of painted architecture see here p. 206.

Alongside these artists there was one painter who, as Irene Hueck recognized, had been trained in late 13th century Rome.[346] This and the Roman motifs in the representation of the architectural structures by the "Gothic" (French or English) painters, which have the same background as the corresponding motifs in Cimabue, indicate that the workshop had renewed itself both personally and artistically in Rome before it took up work in Assisi.[347] Besides the presence of French prelates in Rome – including the popes Urban IV. (1261–64), Clement IV. (1265–1268), Innocent V. (1276), and Martin IV. (1281–85) – it was the memory of Paris, whose university was an almost inevitable stage in the life of a prelate like Matteo Rosso, that paved the way for painters from the core countries of Gothic art to come to Italy.[348] Finally, the Isaac pictures are connected to a complex of paintings in the decoration of the upper church, which is the area most clearly shaped by Roman art.[349] Here the style of one of the most important Roman masters was identified – that of Jacopo Torriti, who decorated the apses of Santa Maria Maggiore and the Lateran Church with mosaics. He or his workshop is said to have begun painting the vaulting and clerestory of the nave in the Upper Church.

But if the Isaac pictures have emerged from a campaign started by Torriti or Roman painters close to him, and indeed their repertoire of forms simultaneously benefits from the other great man of Roman painting, namely Cavallini, then their artistic con-

346 I. Hueck, Der Maler der Apostelszenen im Atrium von Alt-St. Peter, *Mitteilungen des kunsthistorischen Institutes in Florenz* 14, 1969, pp. 115–144. Supplementing: S. Romano, *La basilica di San Francesco ad Assisi: Pittori, botteghe, strategie narrative*, Rom 2001, pp. 49–100.

347 I owe a lot to an (unpublished) lecture by Antje Middeldorf-Kosegarten (*Bemerkungen zur "gotischen Werkstatt" im Nordquerhaus der Oberkirche von S. Francesco in Assisi*) which was given in honour of Gerhard Ruf at Assisi in 1993. Middeldorf-Kosegarten mentioned "Cimabuesque turrets" that were used in decorative architectural painting above the triforia instead of pinnacles, and of a "likewise Cimabuesque, characteristically multi-perspective town architecture" in the image of Christ in Majesty. However, a comparison with the painting of the Cappella Sancta Sanctorum, which has since been uncovered, shows that this form of architectural representation was already cultivated in Rome before Cimabue. In the context of the Gothic workshop, the features mentioned here refer more to Rome than to Cimabue.

348 J. Gardner, The French Connection: Thoughts about French Patrons and Italian Art, c. 1250–1300, in: *Art and Politics in Late Medieval and Early Renaissance Italy: 1250–1500*, ed. Ch. M. Rosenberg, Notre Dame and London 1990, pp. 81–102. J. Gardner, *The Roman Crucible: The Artistic Patronage of the Papacy 1198–1304* (Römische Forschungen der Bibliotheca Hertziana 33), Munich 2013, pp. 85–107. Morghen, Il cardinale Matteo Rosso Orsini, p. 275.

349 Joseph Strzygowski was the first to realize how closely the clerestory frescoes as a whole are connected with Roman image culture: Strzygowski, *Cimabue und Rom*, pp. 176–180.

text is evidently not limited to Assisi, but includes Rome. "La formazione di Giotto nella cultura di Assisi" is the title of an essay by Carlo Volpe, which, similar to what has happened here, tells the story of the pictorial decoration in the Upper Church as the prehistory of the Isaac pictures.[350] Volpe's formulation is to be countered by the fact that, where the paintings in the Upper Church are concerned, the artistic culture in Assisi can only be understood as a branch of that in Rome. And Rome was then a centre not only of art production, but of also power, to a degree that it had not been since antiquity.[351]

ROMAN PAINTING IN THE LAST DECADE OF THE THIRTEENTH CENTURY

Certainly only a fraction of what was painted in Rome at the end of the 13th century has been preserved and documented; nevertheless, with Torriti and Cavallini we can probably name the main, competing stars of this art scene. There is no doubt that Torriti was an artist believed by his contemporaries to be capable of extraordinary things, since, with the apse mosaics of St. John Lateran and Santa Maria Maggiore, he received incomparably large and prestigious commissions (fig. 100, 101). In addition, there was the small, but no less prestigious mosaic at the tomb of Pope Boniface VIII in St. Peter's. Strangely enough, however, posterity has not preserved the memory of him well. It is not his name, but that of Pietro Cavallini that entered early art literature, i.e. the texts before Vasari. While our idea of Torriti and his oeuvre is based on the three signatures he left on the works mentioned above, as well as his self-portraits as a Franciscan in both St. John Lateran and Santa Maria Maggiore, and thus exclusively on self-testimonies, our idea of Cavallini and his oeuvre is based on a short text about the artist in Lorenzo Ghiberti's *Commentarii*. Without these sentences, the scant record of primary sources concerning a man called "Petrus dictus Cavallinus", who was an adult in 1273 and worked as a painter at the court of Naples in 1308, would certainly not have attracted attention.[352] Of Cavallini's works listed by Ghiberti, one complex is completely preserved and two have come down to us in a fragmentary form: well preserved are the seven mosaic pictures below the 12th-century apse mosaic in Santa Maria in Trastevere (fig. 39, 94–97, 105, 106), which

350 C. Volpe, La formazione di Giotto nella cultura di Assisi, in: *Giotto e i Giotteschi in Assisi*, Assisi (2) 1979, pp. 15–59.

351 R. Brentano, *Rome Before Avignon: A Social History of Thirteenth-Century Rome*, Berkeley 1991.

352 Lorenzo Ghiberti, *I commentarii*, ed. L. Bartoli, Florence 1998, pp. 86–87. On the whole tradition: Hetherington, *Pietro Cavallini*, pp. 3–7.

according to the inscription were donated by Bertoldo Stefaneschi, brother of Jacopo Stefaneschi. Notwithstanding Giotto's Navicella mosaic, Ghiberti declared that "it was the best he had ever seen using this technique on the wall".[353] Significant fragments of the painted decoration of the church of Santa Cecilia in Trastevere also remain (fig. 9, 11, 99); the mosaic on the façade of San Paolo fuori le mura has been moved and reworked beyond recognition. Furthermore, there are drawings from the 17th century showing the paintings of Cavallini in San Paolo mentioned by Ghiberti: "all the walls of the central nave were painted with stories from the Old Testament".[354] In this case, however, it is difficult to decide which of the drawings reproduce Cavallini's paintings and which of them reproduce images from an early medieval layer of murals – incompletely covered by Cavallini.[355]

The language of late Dugento painting in Rome is characterized by two tendencies that can also be found in the work of the two main masters, albeit in different mixtures and at different stages of synthesis: one tendency is the reception of Antiquity, which goes as far as imitating or even continuing antique buildings and other works. In medieval Roman art, this phenomenon can be seen in several periods and at a particularly intensive level in the second half of the 13th century.[356] Torriti's apse mosaics are a good example of this. In the calotte of St. John Lateran, the artist integrated a piece of the early Christian predecessor mosaic (the central head of Christ) and surrounded it with a collection of late antique motifs (fig. 100): a jewelled cross, drinking stags, and, at the bottom, a river bank, populated by Erotes, which draws its water from the jugs of two river gods. The apse mosaic of Santa Maria Maggiore seems to be even more strongly inspired by Antiquity. The main motif is huge acanthus tendrils populated by birds, and, once more, a Nilotic landscape watered by river gods (fig. 101, 102). This time even a roman warship is cruising under full sails between Erotes practicing water sports. Both mosaics thus do not want to be perceived at all as new products, but as works that complete the churches, themselves dating back to early Christian times, in a way that does not disturb this long and ennobling tradition, but rather strengthens it.

353 Ghiberti, *I commentarii*, ed. Bartoli, p. 87: "Ardirei a dire in muro non avere veduto di quella materia lavorare mai meglo."

354 Ibidem: "dentro nella chiesa tutte le pareti della nave di mezzo erano dipinte storie del testamento vecchio."

355 St. Waetzoldt, *Die Kopien des 17. Jahrhunderts nach Mosaiken und Wandmalereien in Rom*, Vienna and Munich 1964, cat. 590–670. J. Gardner, Gian Paolo Pannini, San Paolo fuori le mura and Pietro Cavallini: Some Notes on Colour and Setting, in: *Mosaics of Friendship: Studies in Art and History for Eve Borsook*, ed. O. Francisci Osti, Florence 1999, pp. 245–254.

356 R. Krautheimer, *Rome: Profile of a City 312–1308*, Princeton 1980, pp. 180–202.

None of Cavallini's works, whether preserved or handed down in copy, follow a programme from Antiquity with such consistency. But even to him this repertoire was not alien. This is shown by individual motifs such as the shepherd playing the flute in the Christmas picture of Santa Maria in Trastevere (fig. 103), a mosaic that has already been mentioned in connection with Giotto's Nativity of Christ in Padua. As a possible model, the miniature fol. 44 v. in the late antique *Vergilius Romanus* might be suggested.[357]

The other tendency is the reception of late Byzantine painting. In connection with the restoration of the Byzantine Empire in 1261 by Michael VIII Palaiologos, a kind of Renaissance within artistic practice had taken place in the Greek area, based on models from late Antiquity and the turn of the millennium. Suddenly the East again had new material to offer, which, due to shared ancient foundations, was also well suited to merge with Western traditions. That the new Byzantine art in Rome did not go unnoticed may also have been ensured by Pope Nicholas IV, who not only commissioned the apse mosaics of St John Lateran and Santa

Fig. 100: Rome, San Giovanni in Laterano, apse mosaic (Jacopo Torriti)

Fig. 101: Rome, Santa Maria Maggiore, apse mosaic (Jacopo Torriti)

Maria Maggiore, but had previously, in the years 1272–1274, lived in Constantinople as papal legate.[358] In Torriti's work, it is above all the plasticity of the figures, defined by the

357 E. Rosenthal, *The Illuminations of the Vergilius Romanus. A Stylistic and Iconografical Analysis*, Dieticon and Zurich 1972, pp. 73–79. Paul Hetherington assumed that Cavllini's motive had a Byzantine background: Hetherington, *Pietro Cavallini*, p. 17. Krautheimer, on the other hand, advocated a Late Antique origin. Krautheimer, *Rome: Profile of a City*, p. 221.

358 Cf. the contributions in the anthology: *Niccolò IV: un pontificato tra oriente ed occidente*.

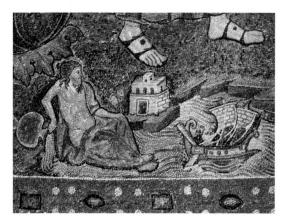

Fig. 102: Rome, Santa Maria Maggiore, apse mosaic, detail (Jacopo Torriti)

Fig. 103: Rome, Santa Maria in Trastevere, apse: The Nativity, detail (Pietro Cavallini)

drawing and lighting of the garments, that is attributable to late Byzantine models. Ernst Kitzinger called this phase of Byzantine painting *volume style*, and it is precisely in this sense, one might say, that Torriti perceived and absorbed the models.[359] The volumes do not give rise to an experience of space, but add haptic qualities to the simple and monumental contours, as they correspond to the preceding Roman painting, so that the bodies seem to bulge out of their surroundings like reliefs. Cavallini's figures also profit from the late Byzantine depiction of corporeality, but here other late Byzantine motifs are also included, namely those of the representation of architecture. In the mosaics of Santa Maria in Trastevere in particular, architectural volumes appear alongside the volumes of the figures, and in the viewer's perception the organic and inorganic bodies merge to form coherent structures.

One is inclined to describe the late Byzantine painted architectural structures as giving the fantastic and sometimes almost threatening impression of a world of oversized toys. Among the preserved monuments of Byzantine painting, they appear in monumental format for the first time in the murals of Sopoćani in Serbia, i.e. in the sixties of the 13th century.[360] In the nineties they are fully developed.

Atti del convegno internazionale di studi in occasione del VII centenario del pontificato di Niccolò IV. Ascoli Piceno (14–17 dicembre 1989), ed. E. Menestò, Spoleto 1991.

359 E. Kitzinger, The Byzantine Contribution to Western Art of the Twelfth and Thirteenth Centuries, *Dumbarton Oaks Papers* 20, 1966, pp. 248–258.

360 V.J. Djurić, *Sopoćani*, Belgrade 1963. V. Lazarev, *Storia della pittura bizantina* (Biblioteca di storia dell'arte 7), Milan 1967, pp. 298–300. R. Hamann-Mac Lean, *Grundlegung zu einer*

Fig. 104: Ohrid (Macedonia), Sveti Kliment: The Death of the Virgin (Eutychius and Michael Astrapas)

A good example is the decoration of the church of St. Clement in Ochrid, Macedonia, signed by the painters Eutychius and Michael Astrapas from Tessaloniki (from 1294/95 – fig. 104).[361] The buildings consist partly of real motifs such as gables and pent roofs, windows and balustrades, and partly of completely absurd elements: functionless giant consoles (which could just as well be called oriels), projecting flat roofs (cantilevers, as they could only be realized with reinforced concrete), pergolas that cannot

Geschichte der mittelalterlichen Monumentalmalerei in Serbien und Makedonien (Die Monumentalmalerei in Serbien und Makedonien 4), Gießen 1976, pp. 330–336.

361 H. Hallensleben, *Die Malerschule des Königs Milutin* (Die Monumentalmalerei in Serbien und Makedonien 5), Gießen 1963, pp. 22–25 and passim. Lazarev, *Storia della pittura bizantina*, pp. 302–303 and passim.

Fig. 105: Rome, Santa Maria in Trastevere, apse: The Adoration of the Magi (Pietro Cavallini)

be entered, and strangely playful ground plans (semicircular, u-shaped …). Once one has become familiar with these phenomena, it becomes clear what these fictitious buildings accomplish: they spatialize the scenes.[362] The floor plans and the many small forms that are projected in perspective serve to create a spatial structure. The variety of projections seems arbitrary, even chaotic to us, but they do open up the picture surface – if there were such a thing as a picture surface here. It would be too little to say that depth is created: for just as the architectural elements extend into the pictorial space, so do they seem to reach beyond the surface of the painted wall into the viewer's space. They move in on us. The image plane does not actually become transparent (in the sense of Alberti's window metaphor and in the sense of photography), but its existence is not implied at all. The painted or mosaicized bodies of the figures are given a stereometric environment that is as concrete as they are and ostensibly includes the real bodies of the viewers. This is quite different from the more or less flat backdrops behind the figures that had hitherto been common in the East and West. In Rome such backdrops appear as dainty arbours and apses, arranged parallel to the picture plane, as in Torriti's scenes at the foot of the calotte of Santa Maria Maggiore.

Among the architectures used by Cavallini, the playful building in the Adoration of the Magi with its oriel-like consoles and cantilever is closest in its motifs to the late Byzantine models (fig. 105). In contrast, the buildings in the mosaic of the Presentation in the Temple are less complex and largely reduced to their function as companions of the figures (fig. 106). The projection also seems to be simplified compared to the models. A diagonally positioned little house like the one behind Mary and Joseph also appears in the mosaics of the inner narthex of the Chora Church (ca. 1315), but it performs an acrobatic split with its wings, which interlocks the viewer's space with that of the picture (fig. 107). In Cavallini's work it stands taut like a guard in the second rank behind the figures. The same applies to the U-shaped building on the right, also borrowed from the Byzantine

362 Cf. A. Stojaković, La conception de l'espace defini par l'architecture peinte dans la peinture murale serbe du XIIIe siècle, in: *L'art byzantine du XIIIe siècle: symposium de Sopoćani 18 – 25 septembre 1965*, ed. V.J. Djurić, Belgrade 1967, pp. 169–178.

pictorial culture, which seems to have been tamed in comparison to its more space-consuming models. The result is a spatial effect, which, however, relates less to the viewer's body than in the East, but rather to the eye. As a complement, empirical reality is offered in the pictures. In the case of the Presentation mosaic, Cavallini cited, in addition to Byzantine architectural fictions, an altar canopy with a pyramid roof and lantern, of the kind that actually stood in many Roman churches.

In the picture of the Annunciation, for the Virgin's throne, the artist partly exchanged the late Byzantine details for those from the Roman pictorial tradition (note, for example, the apse in the centre of the façade, which Torriti used in a similar way), partly inserted motifs from the architectural reality of contemporary Rome. This explains the Gothic capitals on the columns placed in front of the boxes and the architraves and plinths inlaid with opus sectile (fig. 94, 95). It is not least the repertoire of the Cosmati workshops that is used to reshape Byzantine architectural fictions here. In this case, it is no longer fantastic architectural objects that provide company for the bodies of the protagonists, Gabriel and Mary, but rather a structure that is

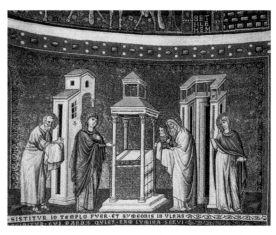

Fig. 106: Rome, Santa Maria in Trastevere, apse: The Presentation in the Temple (Pietro Cavallini)

Fig. 107: Istanbul, Kariye Camii, inner narthex: The Virgin Given Affection by her Parents

designed to be contemporary with the viewer and, as far as possible, coherent. Hand in hand with this goes the systematisation of the view, from both above and below, of the elements of the throne that will come to establish a fixated relation between picture and viewer.

Finally, in the picture representing the Nativity of the Virgin, a further motif appears alongside the architectural volumes and the Cosmati details, namely the curtains stretched out in front of a possible depth (fig. 97). It occurs with a very similar task in the

Fig. 108: Rome, Santa Maria Maggiore, nave, clerestory: Jacob before Isaac, Esau before Isaac

late antique nave mosaics of Santa Maria Maggiore and here in the Isaac scenes. Unfortunately, the second of these pictures, which, as in Assisi, showed the deceived first-born before Jacob, is only preserved in its upper parts. It is easy to see, however, that the curtain, gathered to one side in front of a dark ground, must have backed Esau in a manner similar to the way a curtain backs the maids in Cavallini's mosaic (fig. 108). What preceded the creations of the "Isaac Master" in Cavallini's work is thus a synthesis of late Byzantine, contemporary Roman and late antique material, as was probably only possible in Rome.

THE ISAAC MASTER ENSEMBLE

In the churches of the Friars there are no paintings of particular elaborateness (so we learn from the declaration of the Franciscan Order, compiled in 1312 on the occasion of the Council of Vienne and already quoted here), "except in the Church of Assisi, and these paintings were ordered by the Lord Nicholas IV out of veneration for the saint whose remains are buried there".[363] The fact that Nicholas IV was remembered as a commissioner of murals does not mean that the entire church complex of Assisi must have been decorated under this pope. Not even the entirety of the Upper Church could have been painted in the short years of his pontificate (1288–1292). The person most likely to be remembered was the one who had started the painting of the Upper Church after the decoration had stagnated following the installation of the stained-glass windows in the choir apse. Since Nicholas was the first Franciscan in the Chair of Peter, it seems plausible that under him the long neglected plans for a papal residence and a papal basilica at the tomb of the founder of the Order were resumed. In this case, the painting of the sanctuary, carried

363 F. Delorme, Notice et extraits d'un manuscript franciscain, *Collectanea Franciscana* 15, 1945, pp. 5–91, esp. 78: «... nec vidimus in ecclesiis fratrum sumptuositatem magnam picturam nisi in ecclesia Assisii, quas picturas dominus Nicolaus IV fieri precepit propter reverentiam Sancti, cuius reliquie iacent ibidem.» Pointing to this passage: Cooper and Robson, Pope Nicholas IV and the Upper Church at Assisi.

Fig. 109: Assisi, San Francesco, upper church, eastern vault ("Doctors' Vault", before1997)

out by the Gothic workshop and Cimabue, could be dated to the years around and after 1290. Then, around the middle of the nineties, the decoration of the clerestory of the nave would have been started. The incised number 1296, which is found in the passage that

connects the walkway of the nave with that of the north transept, fits with this.[364] However, such a graffito can hardly be treated as a building inscription. This makes further clues for the dating all the more important.

An iconographic argument, which, as far as I can see, is first found in August Schmarsow, runs as follows:[365] The vault of the east bay, which must be one of the most recent parts of the decoration in the nave clerestory, is painted with large figures of the four Latin Church Fathers (fig. 109). The so-called Doctors' Vault does not offer the first appearance of this group; for example, the figurines in the tendrils of the apse mosaic of San Clemente in Rome precede the Assisian Church Fathers by one and a half centuries. But it is their first truly monumental representation and shows the quartet of Gregory, Augustine, Ambrose, and Jerome as a counterpart or alternative to the representation of the four Evangelists – a new position in this respect. It is the beginning of a rich tradition of architecturally related pictorial programmes that has flourished well into modern times. Contemporary too was the central role played by the *Doctores ecclesiae* in the canonical and doctrinal thinking of Boniface VIII (1294–1303): "Shining and burning lamps have these set on the candelabra in the house of the Lord, so that the darkness of error disappeared," Boniface stated in the *Liber Sextus* (III, xxii), which he added to the *Corpus Juris Canonici* in 1298.[366] On two occasions, in 1295 and 1298, the Pope elevated the position of the holy four in the festive calendar, thus underlining the authority of the papal *magisterium*. Of course, neither of these dates can serve as a *terminus ad* or *post quem* for the decoration. But it is plausible that the pictorial decoration of the papal church reflects elements of the intellectual programmae of the corresponding pontificate, and so if the pictures do not simply vary a tradition here, then they belong to a bundle of measures with which the rank of the church fathers was raised in the time immediately afterwards.

The other argument is based on the occurrence of specific motifs: between 1298 and 1300, according to the heraldic evidence, the Sala dei Notari in the Palazzo Pubblico of nearby Perugia had been decorated; the painters working there repeated the combination of ornaments used in the clerestory of San Francesco, some of which had been developed during the previous campaigns in Assisi, while others were newly imported from Rome.

364 E. Lunghi, *The Basilica of St. Francis in Assisi*, Antella 1996, p. 48.

365 A. Schmarsow, *Kompositionsgesetze der Franzlegende zu Assisi*, Leipzig 1918, p. 105. X. Barbier de Montault, Le culte des Docteurs de l'Eglise à Rome, *Revue de l'Art chrétien* 34, 1891, pp. 275–290, esp. 276–277. D. Steger, Die bildliche Darstellung der vier großen lateinischen Kirchenväter vor ihrer Sanktionierung durch Papst Bonifaz VIII. im Jahr 1298, *Römische Quartalschrift für christliche Altertumskunde und Kirchengeschichte* 94, 1999, pp. 209–227.

366 „Per ipsos praeterea quasi luminosas ardentesque lucernas super candelabrum in domo Domini positas (errorum tenebris profugatis)." Quote from: Barbier de Montault, Le culte des Docteurs de l'Eglise à Rome, footnote. 1 on p. 276.

The Isaac Master Ensemble

Both decorations contain similar variants of the double tendril introduced by Cimabue in Assisi and show the console frieze in perspective, as had also been introduced by Cimabue. In addition, some connecting picture motifs can also be found.[367] The high standard of the painting in this hall was probably only possible because painters moved from the completed Assisian clerestory campaign to the service of the Commune of Perugia.

Accordingly, the clerestory of the nave was most likely painted in the years between 1294 (beginning of Boniface's pontificate) and 1298 (start of work in the Sala dei Notari in Perugia). How should we imagine the workshop which operated at that time? And how did it come about that at the end of the campaign there was a leap in quality?

Regardless of how much changed within the pictures, the clerestory painters remained true to the arrangement and ornamentation developed in the bay near the crossing at the beginning of the campaign. Since there is no break whatsoever, one can even assume that there was a unit responsible for the ornaments (a painter or a small team), that was the same from the beginning to the end of the campaign and that at least a part of that workshop, which started in the first bay and is associated with Torriti, was still at work in the fourth bay and on the entrance wall. Returning to the Madonna of Castelfiorentino mentioned at the beginning of the chapter (fig. 93): although Luciano Bellosi compares her child with a decoratively used angel in one of the eastern bays and thus thinks to have chosen a figure from an area where the activity of the young Giotto is plausible, this must nonetheless be countered by the fact that there are very similar angels in the vault further west; thus the models were not Giotto's property, but come from the ornamental repertoire of the workshop. This means that the angels should be attributed to the Torriti circle and not specifically to the Isaac Master or the young Giotto.[368] The large acanthus

367 Belting, *Die Oberkirche von S. Francesco in Assisi*, p. 172, Bellosi, *La pecora di Giotto*, pp. 14–17, P. Scarpellini, Osservazioni sulla decorazione pittorica della Sala dei Notari, in: *Il Palazzo dei Priori di Perugia*, ed. F.F. Mancini, Perugia 1997, pp. 211–233, and P. Scarpellini, Datazione comparata: Giotto e la basilica superiore di San Francesco: relazioni tra il ciclo assisiate e la decorazione pittorica della Sala dei Notari a Perugia (1298–1300), *Bollettino per i beni culturali dell'Umbria* 1, 2008, pp. 7–10. It is not true that there is also a motif in the Sala dei Notari that can only be taken from the decorative apparatus of the cycle of the Legend of Saint Francis (i.e. from the lower wall of the nave of the upper church of San Francesco): the console friezes in Perugia do not contain a central console seen from the front. This effect typical of the frame of the Legend of Saint Francis is missing in Perugia. The friezes here are a variation of Cimabue's console friezes in the choir and transept of the upper church. It seems, however, that the friezes in Perugia influenced those of the Saint Francis cycle by contributing to streamline Cimabue's motif.

368 Bellosi, *La pecora di Giotto*, pp. 177–178. *La basilica di San Francesco in Assisi* (Mirabilia Italiae 3), ed. G. Bonsanti, 4 (2) vols., Modena 2002, vol. 2 (2) nos. 1783–1796, esp. 1784 and 1789.

Fig. 110: Nave, clerestory of the first bay, south wall: The Wedding at Cana (Torriti's workshop)

frieze with alternating upright and inverted tufts in front of red and blue ground, which terminates the painted area at the bottom of the walls, i.e. above the walkway, and also appears next to the Isaac pictures (pl. XI, XII), can indeed be traced back to Torriti's workshop in Rome: it decorates a window soffit of the apse mosaic of Santa Maria Maggiore. Moreover, in view of the patterns used during the whole campaign and the painters who were probably active during the whole campaign, it is reasonable to assume that the work proceeded swiftly.

Torriti's style can be easily recognized in the first and second bay on the north wall and on the vault of the second bay by the facial forms of Christ (respectively God) and Mary. Max G. Zimmermann saw this already in 1899.[369] If it was not the very busy mosaicist himself who had come from Rome to Assisi, then it must have been an artist whom he had trained and who used his collection of models. Since only mosaics have been preserved as verified works of Torriti, it will not be possible to decide this on the basis of style-critical arguments. On the poorly preserved southern wall of the first bay, the picture of the Wedding at Cana has an arbour-like structure as its backdrop, which is also found in Torriti's work and in Santa Maria Maggiore (fig. 110). In the second bay, however, the situation is less clear. Here I am not so much concerned with the picture of the Arrest of Christ, from which a distinct "Maestro della Cattura" was occasionally developed, whom his admirers then promoted to a great one in the history of painting[370] (fig. 111). I imagine this painter as a talented member of the Torriti workshop who studied Cimabue's murals in the choir and transept of the Upper Church (which the ornamental painters certainly did). The figure of Judas, which looks as if it has been cut out of another painting and pasted into this one, is a weak point of the picture. More interesting is the Adoration of the Magi. The picture is badly faded, and yet it is unmistakable that behind Mary a three-dimensional fantasy architecture of late Byzantine design emerges (fig. 112). Here a motif appears which cannot be explained

369 M.G. Zimmermann, *Giotto und die Kunst Italiens im Mittelalter I: Voraussetzung und erste Entwicklung von Giottos Kunst*, Leipzig 1899.

370 F. Bologna, *La pittura italiana delle origini*, Rome 1962.

either by the older painting in Assisi or, as Alessandro Tomei has already recognized,[371] by comparison with the Torriti studio. Nevertheless, it is not alien to the visual culture of Rome, but is found in Cavallini's work. If one assumes that the scaffolding moved bay by bay from the crossing to the main portal, and thus that the two walls above the walkway were each more or less simultaneously painted from top to bottom (the latter has been confirmed by technical examination),[372] then a Cavallini motif – the buildings in the Adoration of the Magi – makes its appearance relatively early in the course of the campaign. Perhaps from the very beginning there were one or more people involved in the workshop, who had a Cavallini background in addition to their training in the Torriti circle.

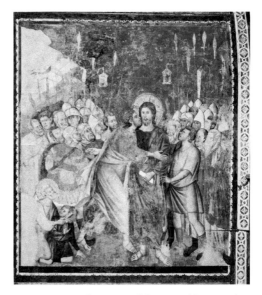

Fig. 111: Nave, clerestory of the second bay, south wall: The Arrest of Christ (Torriti's workshop)

In the following third bay, painters who worked on the south wall, used further syntheses of Torriti and Cimabue features, but their pictures have little to offer beyond that (and are certainly not works of the Sienese Duccio, as a Roberto Longhi believed, who apparently did not see a church in San Francesco, but rather a pantheon of early Italian painters marked by its completeness).[373] The one preserved picture in the upper register of the north wall also offers very little new (fig. 113). The two pictures below this, however, are the Isaac scenes, which are striking in every respect. After the workers had lowered the scaffolding floor here, Cavallini's teachings prevailed over Torriti's, which, although not hegemonic, had previously predominated. But more took place than the replacement of one Roman model by another: the pictorial elaboration and thus images' sense of presence is suddenly incomparably denser and richer. There is something sparkling about

371 A. Tomei, *Iacobus Torriti Pictor: una vicenda figurativa del tardo Duecento romano*, Rome 1990, p. 67.
372 C. D'Angelo, S. Fusetti, and C. Giantomassi, Rilevamento dei dati tecnici della decorazione murale della Basilica Superiore, in: *Il cantiere pittorico della Basilica Superiore di San Francesco in Assisi*, ed. G. Basile and P. Magro, Assisi 2001, pp. 15–35, esp. fig 4.
373 Longhi, Giudizio sul duecento, p. 36.

Fig. 112: Clerestory of the second bay, south wall: The Adoration of the Magi (Torriti's workshop)

Fig. 113: Clerestory of the third bay, north wall: The Expulsion from Paradise (Torriti's workshop)

the colour. Also more effort seems to have gone into the design. The figures in the upper picture, which represents the Expulsion from Paradise, are spread out on the surface and their underlying models are literally visible. The overlaps make it clear that the painter was lackadaisical in reworking the models. Here we find more or less the same problems that the so-called Maestro della Cattura struggled with. In contrast, below, in the Isaac pictures, every position and every gesture appear as if rehearsed and studied with the living model. The gesture of dismay that Isaac performs in the second picture with both hands – an astonished hand drawn to the body and a defensive hand stretched away from it – is as new and individual as it is characterized by its understatement and hence by a sense of dignity (fig. 114). Decades before Thode gave the pictures a prominent place in the history of painting, it was this eloquent gesture that caught the attention of Crowe and Cavalcaselle and made them pause for a moment during their hasty tour through the clerestory frescoes.[374] As for the narrative, there are now motifs that are thought out with considerable sophistication: in the first scene, attention should be paid to the maid who supports Isaac; she looks out of the picture with one eye and, as we become aware, shares with us knowledge that the old man does not have (pl. XI). Unlike us, she could inter-

374 J.A. Crowe and G.B. Cavalcaselle, *A New History of Painting in Italy*, vol. 1, London 1864, p. 216.

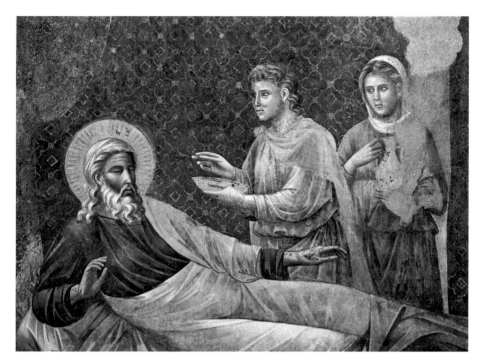

Fig. 114: Clerestory of the third bay, north wall: Esau before Isaac, detail

vene, and indeed she should.[375] Here, the viewer is emotionally provoked by a secondary character, a strategy also used by Giotto in Padua to make stories gripping. Not only did this painter have particularly original sources with the Cavallini mosaics (and a famous succession with the Arena frescoes), but he also worked more independently (even largely dispensing the use of prefabricated designs), with greater cognitive effort and was clearly committed to the content and meaning of the narrative. The comparison proves him to be an innovator and a great artist among otherwise respectable image producers.[376]

The rest of the clerestory can be connected to the Isaac scenes. And so these areas that can be described as the Isaac-Master Complex: the two Isaac pictures plus everything that follows on the clerestory walls and on the vault towards the entrance. There are twelve

375 Kemp, *Die Räume der Maler*, pp. 33–34.
376 Before Kemp, it was Millard Meiss and Alastair Smart in particular who highlighted the emotional aspect: Meiss, *Giotto and Assisi*, p. 14. A. Smart, *The Assisi Problem and the Art of Giotto: a study in the legend of St. Francis in the upper church of San Francesco*, Oxford 1971, p. 121.

Fig. 116: Rome, Santa Cecilia in Trastevere, clerestory: spiral column (Pietro Cavallini)

Fig. 115: Entrance bay, vault: St. Francis and St. Clare

large murals (some of which have been destroyed), numerous figures of saints and the four fields of the so-called doctors' vault. The sparkling colours, the great attention to the design, the repertoire determined by Cavallini and the relation to the pictures of the Arena Chapel remain the same, with sometimes fluctuating quality in detail. The latter may be explained by the fact that members of staff trained in Torriti's style continued to work but now under new conditions.[377] This is particularly evident for the saints at the entrance arch (fig. 115): Francis, Clare, Rufinus, Benedict, Dominic, and the others stand under painted double arcades supported by cosmatesque spiral columns; the latter is a motif that Cavallini seems to have introduced to painting in the nave frescoes of Santa Cecilia in Trastevere, and which may have been regarded as trend-setting (fig. 116). Conservative if not regressive, however, are the equally dignified and schematic faces, whose physiognomies hardly differ from those in the clerestory scenes of the western bays.

377 There was also the idea that the pictures in the fourth bay and in the entrance bay preceded the Isaac pictures in time. This is implausible from a technical point of view: Salvini, Bemerkungen über Giottos Frühwerke in Assisi, pp. 169–207.

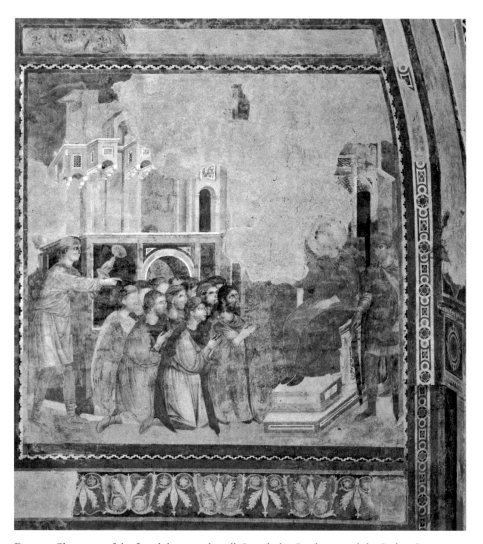

Fig: 117: Clerestory of the fourth bay, north wall: Joseph, his Brethren, and the Stolen Cup

If it is most likely that the entire campaign was carried out between 1294 and 1298, an independent proposal can be offered for the date of the last third of the paintings by means of the Cavallini mosaics in Santa Maria in Trastevere. As shown, the mosaics were exemplars for the scenes, not only in their repertoire mixed of late Byzantine and Cosmatesque elements, but also in details such as the architectural boxes; we can therefore be reasonably sure that it is them and not other Cavallini works, that were the basis for the paintings. And as Giovanna Ragionieri showed, the Trasteverian programme, financed by

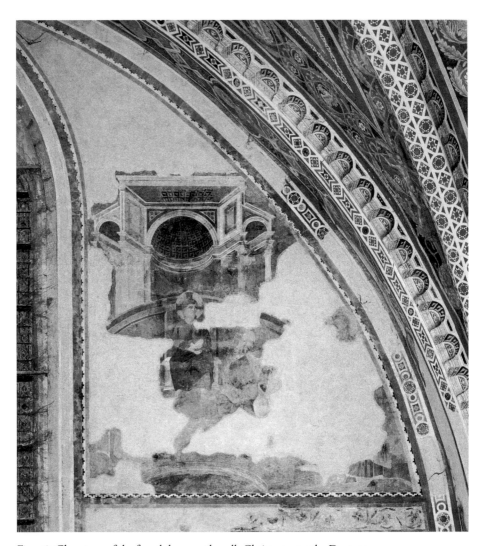

Fig. 118: Clerestory of the fourth bay, south wall: Christ among the Doctors

the Stefaneschi family, with the Marian scenes below the calotte, can be included as part of the competition between basilicas, mosaics and donor families taking place in Rome; most probably it was a response to the Marian programme in the apse of Santa Maria Maggiore, realized by Torriti and supported, at least in the final phase, by the Colonna family. This gives us a *terminus post quem* of either 1294, 1295 or 1296: in one of these years Torriti had completed the calotte of Santa Maria Maggiore, according to a fragmented

inscription handed down in various versions, and was able to begin the scenes below.[378] Cavallini's scenes in Santa Maria in Trastevere might have followed soon afterwards,[379] whose representational technique provided the basis for the "Isaac Master". In this case, the images of the Isaac-Master ensemble would come close to 1298 and precede the images of the Arena Chapel by little more than half a decade.

The painter's handling of Cavallini's visual vocabulary can be assessed well by looking at the picture with the Story of the Stolen Cup (fourth bay, north wall, lower register: fig. 117). The background is formed by a fantasy architecture of oriels, arches, cantilevers and Cosmatesque

Fig. 119: Arena Chapel, north wall of the nave: The Watching of the Rods at the Altar

378 G. Ragionieri, Chronologia e commitenza: Pietro Cavallini e gli Stefaneschi di Trastevere, *Annali della Scuola Normale Superiore di Pisa, Classe di lettere e filosofia* 3, 1981, pp. 447–467, esp. 460. 1294: this year is indicated by the inscription of a drawing in Edinburgh showing the mosaic: "fec. Nicola 4 dal 1288 al 1294" (Nicholas IV was in office from 1288 to 1292; J. Gardner, Copies of Roman Mosaics in Edinburgh, *The Burlington Magazine* 115, 1973, 846, pp. 583–591, esp. fig. 29). 1295: this year is based on a drawing in the Biblioteca Vaticana (Vat. Lat. 5408, fol. 9 v.–10 r. Waetzoldt, *Die Kopien des 17. Jahrhunderts*, fig. 277). 1296: this date has been handed down through a copy of the 16th century (Rome, Biblioteca Angelica Cod. 1729. G.B. de Rossi, Raccolta di iscrizioni romane, *Bulletino di Archeologia Cristiana* 5, 1891, pp. 73–101, esp. 95–96). The year 1290, which is also found in the Edinburgh drawing ("Fra Jacopo Torrita 1290"), has little relevance, since it is confirmed that on the mosaic was worked beyond the lifetime of Nicholas IV.

379 For the now obsolete dating of the Cavallini mosaics to 1291, which is based on unverifiable data, see Hetherington, *Pietro Cavallini*, pp. 14–15. Joachim Poeschke argues for a dating of the mosaics after 1296 by comparing the donor's portrait with Torriti's mosaic at the tomb of Boniface VIII, which has been handed down in drawings: J. Poeschke, Per la datazione dei mosaici di Cavallini in S. Maria in Trastevere, in: *Roma anno 1300: Atti della IV settimana di studi di storia dell'arte medievale dell'Università di Roma La Sapienza (19–24 maggio 1980)*, ed. A.M. Romanini, Rome 1983, pp. 423–432.

Fig. 120: Clerestory of the fourth bay, south wall: The Lamentation of Christ

ornaments, which is based on variations of the Byzantine style architectures in Santa Maria in Trastevere. The coherence of the projection corresponds to the façade in Cavallini's Annunciation picture. This increases the viewers' acceptance of what they seen. Provided we have the story ready to mind (Gen. 44), something emerges in the picture which is automatically recognizable as the palace of the Egyptian regent Joseph. In its plausibility, the painted building complex surpasses everything the late Byzantines and Cavallini had created. However, the buildings have little connection with the group of figures, and this can even be seen as a step backwards compared to Cavallini and late Byzantine

painting: A kind of screen is placed between the palace and the figures. Figures and buildings are equally impressive, but they do not work as a team, rather each element functions on its own. The buildings open up depth, but the figures seem to come towards us. The scene of Jesus among the Doctors is similar (fourth bay, south wall, upper register: fig. 118). The apse, decorated in cosmatesque style and seen from below, may derive from Cavallini (the throne of the Virgin in Santa Maria in Trastevere – fig. 94), but the centralised projection leaves this model behind and anticipates the scenes of the Betrothal of Mary in the Arena Chapel (fig. 119). Unlike in Padua, however, the apse in

Fig. 121: Arena Chapel, north wall of the nave: The Lamentation of Christ

Assisi is not linked to the actual scene. It takes place on a *synthronon* placed in front of the apse and seen from above. As far as the connection between architecture and figures is concerned, the Isaac pictures were an experiment that opened up possibilities initially not pursued in the pictures that followed in Assisi. However, even in the Isaac pictures, on closer inspection, the two elements – figures and scenery – turn out to be less synthesized than a reading through the eyes of the Paduan pictorial world would suggest. The spatial positioning of the figures in front of the architecture, as practiced in the picture with the Stolen Cup, can thus be seen as an authentic alternative to the Paduan solutions.

The closest proximity between a picture of the Isaac-Master complex and a picture in Padua (apart from the scenes in the boxes) can be found in the Lamentation of Christ (fig. 120, 121), although it is worth remembering the considerable difference in size: the clerestory frescoes in Assisi measure about three by three metres, covering more than twice the area of the fields in Padua. Nevertheless, the treatment of the fields is similar.

We will start by taking a single motif, namely, the eloquent flight motions of the angels. They have their prehistory in Assisi, namely in Cimabue's crucifixion pictures in the sanctuary, from where they travelled to the crucifixion picture of the Torriti workshop in the clerestory. Using this motif as an example, it can also be shown that in the Isaac Master complex the exploration of Cimabue's art continued as it was cultivated by the painters of the clerestory campaign. In Padua, Giotto then not only shortened the angels' bodies; one can also say that he disembodied the angels and thus reduced them to their

expressive dimension;[380] he also increased the number of angels and the rhetorical power of their gestures.

The spatial structuring of the groups around Christ's body is also remarkably similar in the two pictures. However, in the Assisi Lamentation, a dividing mountain ridge has been inserted between the figures – a motif that already appears in the Sancta Sanctorum murals and was subsequently also used by Cimabue. Giotto in Padua, on the other hand, relies entirely on the relationship between the bodies. He can afford to do so, because in comparison, the variations in his spatial arrangement of the figures are more manifold and better mastered: the Paduan Giotto knows how to turn each body in the picture in practically every position, an observation that extends also to their heads: half profile lowered (the woman behind Mary), three-quarters profile inclined (Joseph of Arimathea), profile lowered (Mary) etc. Everything is possible without sacrificing the expression of the faces. The same intention is apparent in Assisi, and the pictures here are also related to those in Padua in this respect. Finally, the spectrum of emotion is similar. It ranges from violent mourning to serenely standing at the side. In Assisi, as in Padua, serene seriousness is illustrated by the so-called gesture of Demosthenes: the hands crossed to form a stirrup.[381] Despite its prominent ancient root, the gesture is rare and closely connects the two images. In Padua, however, the diversity of affects is intertwined with the figures' uniform orientation towards Christ. Thus the picture appears more concentrated without being schematic.

Are we dealing with a mere perfection of the design developed for Assisi? The presentation of the dead body is fundamentally different. In Assisi, as much of the body as possible is shown. Because of its slanting position, it literally offers itself up to the viewer. The painter has built a pictorial narrative around an object of veneration, drawing on the older model in the nave of the Lower Church, from the previous generation. Christ's body is depicted there in a manner reminiscent of the Byzantine picture relic, which bears the name Amnos Aër (Shroud of the Lamb).[382] In contrast, in the Arena Chapel, the body is partly covered by the woman, seen from behind, who squats in front of it. The motif of the figure seen from behind, which is so important in this and other pictures in Padua, only occurs once in Assisi, namely in the Pentecost scene (on the entrance wall), and there its motivation is to depict the spatial situation and not to further the narrative. Hand in hand

380 C. Gilbert, Personages in Giotto without Physical Bodies, *Arte Medievale*, n.s. 2, 2003, 2, pp. 101–106.

381 M. Barash, *Giotto and the Language of Gesture*, Cambridge 1987, pp. 47–51. M.D. Edwards, The Impact of Rome on Giotto, *Bollettino del Museo Civico di Padova* 79, 1990, pp. 135–154, esp. 151–152.

382 H. Belting, *Das Bild und sein Publikum im Mittelalter: Form und Funktion früher Bildtafeln der Passion*, Berlin 1981, pp. 152–154.

Fig. 122: Assisi, San Francesco, upper church, eastern vault: St. Augustine's Scribe

with the artificially reduced visibility of the Corpus Christi, the representation of direct physical contact becomes more important in the Paduan Lamentation. In Assisi three, and in Padua five, people touch the body. Altogether, the body is not offered for worship in the Arena Chapel, rather the practice of its cult is performed with palpable intensity in the picture. This is what the scene shows the viewers, while they cannot participate in the activity directly. Their representatives in the picture are not, as in Assisi, those who directly surround the dead Christ, but those standing behind them with their great poignant gestures, who can only fulfil their desire to be close to the corpse with difficulty. John bends

so far forward that he has to throw his arms back in order not to lose his balance, an eloquent and unforgettable gesture – whether or not it has ancient models, as Alastair Smart believes.[383] If, in Assisi, proximity and accessibility is suggested – not least by the right hand of Christ, which wants to be held by us, just as John holds the left – then in Padua proximity and distance become the theme in an almost painful way. Equally, in Padua we are dealing more with a picture that provides a sense of a coherent parallel reality, one which is aimed at us not as participants, but rather as contemplating observers. Seen in this way, the Paduan picture is not a straightforward development, but a modification. And this modification can best be seen in the more distanced construction of the spectator.[384]

The part of the Isaac Master ensemble which differs most from the Paduan frescoes is the so-called Doctors' Vault (whose eastern section with the church father Hieronymus fell down during the earthquake of 1997 alongside parts of the entrance arch). The difference has partly to do with the formats and the gold ground. The latter was introduced by Cimabue as a kind of mosaic substitute, in the sense of it being an addition to the mosaic-decorated keystones on the crossing vault, the so-called Evangelists' Vault.[385] This set a standard that had to be equalled on the east vault if one did not want to reduce the importance of the church fathers. The splendour of the gold ground coincides with a peculiar opulence of motifs on the doctor's vault: each church father, accompanied by his secretary, sits on a highly elaborate substructure and is surrounded by conglomerations of architectural elements and furniture, decorated with Cosmati work, that is as splendid as it is intricate; its unfolding is generated and facilitated by the triangular shape of the picture field (fig. 109, 122). In the concreteness of their representation, the parts validate as much as they question each other. This includes the figures. Nowhere in Western painting is the peculiarity of late Byzantine architectural fiction so clearly reproduced as here. From this it can probably be deduced that the painter had access to these models not only at second hand, namely through Cavallini, but also directly. The inconsistent projection is also striking. The unregulated juxtaposition of elements reproduced from above and below makes the pictures dynamic and opens them up to the viewer. This too points back not so much to Cavallini but to late Byzantine pictoriality. Looking up to the Doctors' Vault the following conclusion is unavoidable: the Isaac Master is not a Paduan Giotto *in nuce*, as one might believe after a superficial inspection of the two Isaac pictures; rather,

383 Smart, *The Assisi Problem and the Art of Giotto*, pp. 94–95.

384 Similar observations: M. Schwartz, Bodies of Self-Transcendence: The Spirit of Affect in Giotto and Piero, in: *Representing Emotions: New Connections in the History of Art, Music and Medicine*, ed. P. Gouk and H. Hills, Aldershot and Burlington 2005, pp. 69–87.

385 M. Andaloro, Tracce della prima decorazione pittorica nella basilica di San Francesco ad Assisi, in: *Il cantiere pittorico della Basilica Superiore di San Francesco in Assisi*, ed. G. Basile and P. Magro, Assisi 2001, pp. 71–100, esp. 73–77.

THE NAVICELLA: VESTIGES

If the Isaac master is the young Giotto – and almost everything speaks for this, except the detailed, multiform draperies, to which there is nothing comparable in Padua – this would mean that he moved between the most important protagonists of the art scene in Rome in the second half of the nineties of the 13th century recieving his training or further education in this milieu. Yet it is neither inevitable nor pure coincidence that it is precisely at Assisi that he first becomes recognizable. Nor does it have anything to do with the aura of Saint Francis or the activity of his legendary teacher Cimabue there. The former view was left to us by the German patriot and cosmopolitan Henry Thode, who envisioned the pairing of Giotto/Francis as a kind of Italian counterpart to the pairing Bach/Luther, which was so dear to him.[386] The second corresponds to the Giotto of memory, and hence to the alleged disciple of Cimabue, the figure created in the Dante commentaries and popularised by Vasari in the 16th century (vol. 1, p. 36). In reality, the situation was probably this: a major commission at an important cultic and political site for the Curia outside the metropolis allowed for winning the work for someone who was still in the second tier in the metropolis itself. A little later the Roman scene was no longer dominated by two stars, but by three. At the side of Torriti and Cavallini came Giotto with a colossal and prominently placed mosaic. The so-called Navicella is an undisputable work of the artist. An early primary source from the patron's circle says that the picture was ordered by Jacopo Stefaneschi, paid for with 2,200 gold guilders, and executed by Giotto (1.4.5). The date 1298, on the other hand, has come down to us second-hand, but in a context whose reliability cannot be reasonablly questioned. The following quotation is from a liturgical manuscript of the Chapter of St. Peter: Jacopo Stefaneschi, cardinal and canon of St. Peter's, "arranged for the little ship of St. Peter to be made of exquisite mosaic work by the hand of the highly famous painter Giotto in 1298" (2.2.5).

The work was once Giotto's most popular creation and still attracted admiration in the 15th and 16th centuries: Leon Battista Alberti found the portrayal of affects exemplary, Vasari marvelled at the plasticity of the swollen sail (cf. 2.1.3, 4, 6, 8, 9, 10; 2.3.8, 10; 2.5.9; 2.7.4, 6). Nevertheless, it fell victim to the successive rebuilding of St. Peter's in the 16th and 17th centuries. Two old views clarify its original setting: a fresco in the apartment of Julius III in the Vatican (around 1550) and the engraving of Natale Bonifacio, which documents the relocation of the Vatican obelisk (1586 – fig. 123).[387] Both reproduce the mosaic

386 Cf. Thode, *Franz von Assisi und die Anfänge der Kunst der Renaissance in Italien*, p. 572.

387 H. Köhren-Jansen, *Giottos Navicella: Bildtradition, Deutung, Rezeption* (Römische Studien

Fig. 123: Relocation of the Vatican Obelisk in 1586, engraving by Natale Bonifacio, detail

clearly enough to show that it occupied the upper western wall of the Church of Santa Maria in Turri, which formed something like the gatehouse to the atrium of St. Peter's and stood opposite the facade and the main portal of the basilica. Those who wanted to visit the tomb of St. Peter thus entered the courtyard by passing under the Navicella. With the Navicella behind them, they moved towards the portal of the church and finally had the mosaic in front of their eyes when they turned to face the east in the atrium or under the arcades of the porch to say a prayer, as was customary among pilgrims and already noted by theologians in patristic times.[388] Jakob Rabus, chaplain at the Munich court, reports on his visit to the tomb of St. Peter in 1575 thus:[389]

The pilgrims turn immediately in the direction of the sunrise and the little vessel of Peter, which is at the top of the wall made of molten inlaid stones and looks very splendid and artistic; before it one kneels down and speaks a prayer or makes other visible reference.

Cardinal Baronius' prayer from the late 16th century is handed down:[390] "Lord, as you tore Peter from the waters, so tear me up from the waves of sin!" For Baronius, the mosaic was therefore a representation of St. Peter that was to guide devotion in the final stage on

 der Bibliotheca Hertziana 8), Worms 1993, p. 15, fig. 2, 3. The dissertation by Helmtrud Köhren-Jansen is the main work on the copies and the reception of the Navicella. For the engraving see also: M. Pelc, *Natale Bonifacio*, Zagreb 1997, no. 16.

388 Köhren-Jansen, *Giottos Navicella*, pp. 130–134.

389 The pilgrims „kehren sich umb stracks gegen Aufgang der Sonnen und das Schifflein Petri, welches oben an der Wand mit geschmelzten eingelegten Steinen sehr herrlich und kunstreich anzusehen ist; vor dem kniet man nieder und tut sein Gebet oder sonst eine andere äußerliche Reverenz." Jacob Rabus, *Rom: Eine Münchner Pilgerfahrt im Jubeljahr 1575 beschrieben von Dr. Jakob Rabus, Hofprediger zu München*, ed. K. Schottenloher, Munich 1925, p. 25.

390 C.B. Piazza, *Efemeride Vaticana per i pregi ecclesiastici d'ogni giorno dell'augustissima Basilica di S. Pietro in Vaticano*, Rome 1687, p. 388: "Domine ut erexisti PETRVM à fluctibus, ita eripe me à peccatorum undis."

the way to the disciple's tomb. Wilhelm Paeseler's recreation of the situation, presented as a drawing in 1941, continues to be convincing, although here, too, details remain unclear (fig. 124). The size of the picture can be reconstructed according to the measurement of the church dedicated to the Virgin, that have been handed down: it must have been about 13 to 15 metres wide and 9 to 10 metres high, competing in scale with a large apse mosaic.

Fig. 124: East façade of the Atrium of St. Peter's (Wilhelm Paeseler's reconstruction)

Now for the appearance: of little relevance is the "remake" created in the 17th century partly perhaps from original material and decorating the central lunette of the vestibule of the new church of St. Peter. The two most important sources for the overall appearance of the picture are rather the engravings of Nicolas Beatrizet (1559 – fig. 125) and Antonio Labacco (1567 – fig. 126), both of which were made with the intention of providing a reproduction of the then famous work of art (and not as devotional images and pilgrimage souvenirs). Deviating proportions prove that the two reproductions were made independently of each other.[391] Which print is more to be trusted in which respect, the laterally reversed and detailed engraving by Beatrizet or the laterally correct and poorly detailed one by Labacco, must be verified by separate comparisons with other reproductions. Labacco scores surprisingly well in the depiction of large structures. The oversized Christ and Peter, the location of the ship behind them, and the group of buildings correspond to Giotto's picture. This is confirmed by numerous copies, which may be inaccurate or incomplete in other points. For an idea of the overall composition one should stick to Labacco, perhaps imagining a reduced depth and a slightly contracted right hand third so that the car-

391 The opinion which I previously expressed, according to which Labacco's copy is partly dependent on Beatrizet's copy, is incorrect: M.V. Schwarz, Giottos Navicella zwischen "Renovatio" und "Trecento": Ein genealogischer Versuch, *Wiener Jahrbuch für Kunstgeschichte* 48, 1995, pp. 129–188. What is clear, however, is that Grimaldi's drawings from the early 17th century and the fresco copy in the Capella di Santa Maria dei Pregnati in the Vatican Grottoes are dependent on Beatrizet and therefore have no independent source value. Helmtrud Köhren-Jansen did not recognize this: Köhren-Jansen, *Giottos Navicella*, pp. 250–253.

Fig. 125: Engraving after the Navicella (Nicolas Betrizet)

touche with the inscription can be omitted. How close Peter's back really was to the bow of the ship, however, can probably not be determined anymore.

Labacco's most serious error, since it is relevant to the message of the image, is probably the turning posture of the figure of Christ, yet it fits so well with the story being told. Matthew (14: 22–31) reports as follows about Christ's actions after the Sermon on the Mount:

> *And straightway Jesus constrained his disciples to get into a ship, and to go before him unto the other side, while he sent the multitudes away. And when he had sent the multitudes away, he went up into a mountain apart to pray: and when the evening was come, he was there alone. But the ship was now in the midst of the sea, tossed with waves: for the wind was contrary. And in the fourth watch of the night Jesus went unto them, walking on the sea. And when the disciples saw him walking on the sea, they were troubled, saying, It is a spirit; and they cried out for fear. But straightway Jesus spake unto them, saying, Be of good cheer; it is I; be not afraid. And Peter answered him and said, Lord, if it be thou, bid me come unto*

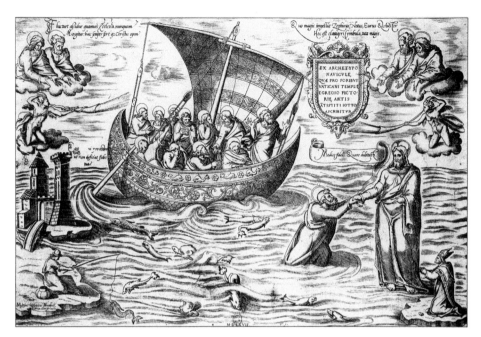

Fig. 126: Engraving after the Navicella (Antonio Labacco)

thee on the water. And he said, Come. And when Peter was come down out of the ship, he walked on the water, to go to Jesus. But when he saw the wind boisterous, he was afraid; and beginning to sink, he cried, saying, Lord, save me. And immediately Jesus stretched forth his hand, and caught him, and said unto him, O thou of little faith, wherefore didst thou doubt?

So it is quite in keeping with the account of the gospel that Labacco's Christ turns to Peter. Nonetheless, the frontal position of Christ, as is reproduced by Beatrizet and answered by Baronius in his prayer, is confirmed by the majority of the other copies: Giotto's Christ did not seek dialogue with Peter within the picture, but rather contact with the viewer in front of the picture.

The evidence of the so-called Beretta copy is of particular importance[392] (fig. 127). It is, an original-sized reproduction (at least as far as the represented objects are concerned) in oil on canvas, made by the painter Francesco Beretta in 1628, at which point the mosaic had

392 M. Lisner, Giotto und die Aufträge des Kardinals Jacopo Stefaneschi für Alt-St. Peter I: Das Mosaik der Navicella in der Kopie des Francesco Beretta, *Römisches Jahrbuch der Bibliotheca Hertziana* 29, 1994, pp. 45–95.

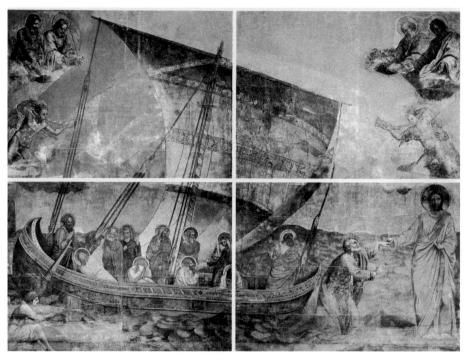

Fig. 127: Vatican, Rev. Fabbrica di San Pietro, copy after the Navicella (Francesco Beretta)

not been in situ for several years and its decay was already advanced. The picture had been removed in pieces from the wall of Santa Maria in Turri earlier (1610), when the church had been cleared for demolition; then the image was stored and finally (1617/18) reinstalled over a fountain on the north side of St. Peter's Square. It had been robbed of the frame border, and the picture field itself had also been reduced on every side. Large parts had not survived the removal and reinstallation procedures and were replaced. The hull of the ship appears to have been reduced in height. The entire gold ground and water surface as well as the figure and head of Peter, the figures on the clouds, the personifications of the winds, and the fisherman were certainly replaced. These measures and other repairs, including the feet of Christ, parts of his vestments of those of some of the disciples are documented by the final account of the restorer (1618).[393] The areas that were not renewed at that time may have been Giotto's work when Beretta made his copy. And in these zones and motifs he has probably reproduced Giotto's legacy relatively faithfully, because it can be assumed that the

393 A. Muñoz, I restauri della Navicella di Giotto e la scoperta di un angelo in mosaico nelle Grotte Vaticane, *Bollettino d'Arte* II, 4 (18), 1924/25, pp. 433–443, esp. 434, 436.

forms were copied by tracing them from a scaffolding. In fact, a baroque execution is easy to recognize in the figure of Peter, but not in those of the disciples in the vessel or in the figure of Christ. They clearly look more like Giotto's work than Reni's. The filigree, multiform fold structure is striking, for example in the robe of the apostle at the bow. According to the account of 1618, the restorer transferred this figure without making any repairs. These are forms that fit less to the Paduan Giotto and more to the Isaac Master. But of course, one must be cautious when comparing a painted copy of a mosaic that was a in poor condition with wall paintings.

In any case, Christ and the disciples in the ship can probably best be assessed in terms of colours, details, and proportions using Beretta's copy. This also makes it clear that we have to imagine the depiction of Christ not only as shown frontally, but also considerably oversized and in a solemn golden garment. He was detached from the narrative and directed towards the viewer – comparable to the Madonna della Carità in the Paduan Last Judgment, but also to the corpse in the Lamentation of Assisi.

Fig. 128: Drawing after the donor figure of the Navicella (Biblioteca Apostolica Vaticana)

The size and posture of the donor's figure are not correctly depicted in the engravings, but rather seem to have been adapted to modern expectations. In Beretta's copy only Stefaneschi's head is visible, and it is tiny. The difference in size between Christ and the donor was extreme, and one is almost reminded of the insect-sized appearance of Honorius III in the apse mosaic of San Paolo fuori le mura. In addition, the donor's head was not oriented towards Christ as in the engravings, but was "viewer-friendly" (but not in a modern and for us easily acceptable way), half turned out of the picture. And it is in this position that an extraordinarily high-quality drawing shows the figure of the donor; it was commissioned around 1590, when Giotto's mosaic was still in place and better preserved than in Beretta's time (BAV, Vat. Lat. 5407, fol. 58 r. – fig. 128). The crossed out inscription identifies the kneeling figure as Benedict IX. This naming of the donor goes back to Vasari's *Vite* in the 1568 edition (see vol. 1, p. 83) and was the basis for the commission for the draughtsman who was to collect portraits of popes for a publication on ecclesiastical history.[394] The correction of the name indicates that in this case what was known in Rome prevailed over the Giotto of memory created in Florence.

394 Waetzoldt, *Die Kopien des 17. Jahrhunderts*, p. 12.

 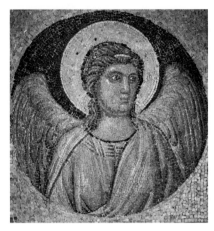

Fig. 129: Boville Ernica, San Pietro Ispano: Angel from the Navicella, state 1888

Fig. 130: Angel as fig. 129, present state

We do not know the excellent draughtsman by name, but we do know of a number of copies by his hand of which the originals have survived. On this basis, we can say that his copies are very accurate. What his drawing tells us about the physiognomy, posture, and clothing of the donor figure thus, probably corresponds quite exactly to Giotto's original. Only the height of the mitre fits the parament fashion around 1600 and thus the period of the publication project. Here the shorter mitre is more likely in the form that Beatrizet and Beretta transmit it. Stefaneschi was entitled to a mitre since his promotion to cardinal in 1296 (for his biography see below).

Most likely, Stefaneschi's figure was not a portrait in the same sense as Scrovegni's depiction in Padua, which is based on the optically objective form of the profile and aims at recognisability. The figure's distinguishability from a large number of portraits of other prelates was probably more important than being recognizably similar to a certain prelate. Nowhere else were so many pictures of living or recently deceased persons produced as in the workshops of those painters, mosaicists, and sculptors who worked for the members of the Curia. These portraits were immortalized members of a thousand-year-old society of popes and other ministers. Among them the numerous newcomers had to find their place and compete. Stefaneschi's appearance at the Vatican happened in the shadow of the following papal images (probably among others): Gregory IX (façade mosaic of St. Peter's), Innocent III (apse mosaic of St. Peter's), John VII (mosaic in the right aisle of St. Peter's) and three images of Boniface VIII (reclining figure, bust and mosaic picture).[395]

395 G.B. Ladner, *Die Papstbildnisse des Altertums und des Mittelalters 2: Von Innozenz II. bis Benedikt IX.*, Vatican City 1970, passim. *Fragmenta picta: Affreschi e mosaici staccati del Medioevo Romano.* Exh. cat., Rome 1990, passim.

The Navicella: Vestiges 233

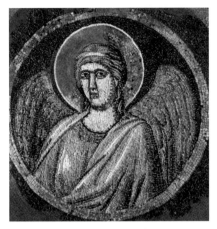

Fig. 131: Rome, St. Peter's, Grotte Vaticane: Angel from the Navicella, state 1924

Fig. 132: Angel as in fig. 130, state since 2009

In addition, there was the complete series of papal pictures in medallions, which surrounded the nave in two rows, one row early medieval, the other from the 13th century.[396] And even before Jacopo Stefaneschi received his portrait at the Vatican from Giotto, his less prominent brother Bertoldo had had himself in mosaic immortalized by Cavallini in Santa Maria in Trastevere.[397] These are conditions that are fundamentally different from those of portrait production in Padua. They will be considered when the problem of "Giotto as a portraitist" is discussed in the final chapter (see pp. 555–561).

So much for what the late 16th and early 17th century copies say about the Navicella. Preserved are two medallions of angels (the diameter of each *tondo* is 65 centimetres – this also proves that they belong together). They must have been part of the border frame abandoned in 1617/18, which is always missing in reproductions of the picture, but can be seen on the *vedute* (though no angels can be recognized there – fig. 123). One angel was transferred to the church of San Pietro Ispano in Boville Ernica. An attached inscription from the early 17th century identifies the medallion as part of the Navicella. The papal librarian Enrico Stevenson found the mosaic in badly damaged condition and published it in 1888 as a photograph based on a rubbing[398] (fig. 129). A few years later the fragment was so thoroughly restored that the angel must now be regarded as a work of the time around

396 Waetzoldt, *Die Kopien des 17. Jahrhunderts*, p. 71.
397 Hetherington, *Pietro Cavallini*, pp. 20–22.
398 E. Stevenson, Topografia e monumenti di Roma nelle pitture a fresco di Sisto V della Bibliotheca Vaticana, in: *Al Sommo Pontefice Leone XIII Omaggio Giubilare della Bibliotheca Vaticana*, Rome 1888, esp. p. S. 20 and pl. V, 3.

1900 and only of sentimental value (fig. 130). It was in this condition that Muñoz discovered the fragment for the second time and published it in 1911.[399] It tells a lot about the aesthetic longings of the modern Giotto audience that the *fin de siècle* beauty of Boville Ernica is often reproduced and discussed as an authentic Giotto work.

The other medallion remained at the Vatican. It was first mentioned in Torrigio's guide to the grottos of St. Peter's in 1618 and there described as part of the Navicella.[400] In 1924 it was discovered in damaged condition underneath its own Settecento copy.[401] There are several photographs showing it before addition were made to complete it (fig. 131). In 1950 the missing parts were filled in with painted plaster, which partly simulated the structure of a mosaic. In 1983/84 a restorer added two hands, a left arm, and a cross by painting over and accentuated the drapery with generous brushstrokes in various shades of green.[402] This was reversed in 2005, so that today the work is more or less back in the state in which it was discovered, which means that most of the tesserae and their plaster bedding date from Giotto's time (fig. 132).[403] Maria Andaloro describes the impression the angel makes as follows: "radiant and powerful, the mosaic fabric breathes."[404] There was probably a time when this could be said of the picture as a whole.

As in the case of the drapery details in the Beretta copy, the execution of the Vatican angel is notably distant from Giotto's work in Padua but relatively close to the Isaac Master, and even more so to Cavallini. It seems plausible to explain the resemblance to Cavallini by the activity of an assistant, and indeed mosaicists trained by Cavallini were certainly available as collaborators in Rome for a long time.[405] But in Padua, too, Giotto could hardly have painted every head in the border strips himself, and yet the style there is uniform and the painterly elaboration (not necessarily the artistic quality) of these heads corresponds to that of the most demanding parts in the most important scenes. If the medallion is thus a

399 A. Muñoz, Reliquie artistiche della vecchia basilica vaticana a Boville Ernica, *Bollettino d'Arte* 5, 1911, pp. 161–182.

400 Francesco Maria Torrigio, *Le Sacre Grotte Vaticane*, Viterbo (3) 1639, p. 93.

401 Muñoz, I restauri della Navicella di Giotto e la scoperta di un angelo in mosaico nelle Grotte Vaticane.

402 C. Kheel, Giotto's Navicella Byzantinised, *The Art Bulletin* 68, 1986, pp. 384–385.

403 D. Zari, Diario di un restauro, in: *Frammenti di Memoria: Giotto, Roma e Bonifacio VIII* (Bonifaciana 5), ed. M. Andaloro, S. Maddalo, and M. Miglio, Rome 2009, pp. 81–84.

404 M. Andaloro, Giotto tradotto. A proposito del mosaico della Navicella, in: *Frammenti di Memoria: Giotto, Roma e Bonifacio VIII* (Bonifaciana 5), ed. M. Andaloro, S. Maddalo, and M. Miglio, Rome 2009, pp. 17–35, esp. 19.

405 Cf. Gardner, *The Roman Crucible*, p. 294. Maria Andaloro considers whether Giotto (and Stefaneschi) did leave the execution of the mosaic entirely to Roman craftsmen. In doing so, she transfers modern ideas about the art form mosaic to the Middle Ages. Andaloro, Giotto tradotto.

The Navicella: Vestiges

product of Giotto's workshop, then it belongs to a pre-Paduan workshop and the similarity to Cavallini's mosaic art is one of the characteristics of this workshop as a whole.

Finally, the Navicella tradition includes a titulus. The verses "were once in very beautiful letters, called ecclesiastical letters by some, inlaid in marble on the frieze of the gates below the aforementioned Navicella", writes Sebastiano Vannini in 1642, whose description is supported by sources from the 16th century.[406] The titulus was therefore not directly related to the mosaic or part of the mosaic, as was sometimes assumed.[407] Rather, the bearer of the inscription was an architectural element and a kind of Cosmati work. That the words were referring to the mosaic is plausible from their content, however. The donor of the picture is the most plausible choice as author. Stefaneschi left several literary works (some of which will be discussed in connection with Giotto's polyptych for St. Peter's), and he is almost certainly the author of the tituli under Cavallini's mosaics in Santa Maria in Trastevere commissioned by his brother.[408] The four hexameters of the Navicella are handed down in several more-or-less identical copies, the oldest of which dates back to the first half of the 14th century.[409] Philip van Winghe's copy from the late 16th century is to some extent a facsimile: what Vannini called ecclesiastical letters was a gothic majuscule with uncial forms, which was also used for the tituli of the virtues and vices in Padua a few years later. But if one compares the rhymed verses in the Arena Chapel with the text of the Navicella, the Roman author's endeavour to employ classical Latin and the diction of (late) Antique epigraphs becomes clear:

Quem liquidos pelagi gradientem sternere fluctus
Imperitas fidumque regis trepidumque labantem
Erigis et celebrem reddis virtutibus almum
Hoc iubeas rogitante, deus, contigere portum

406 C. de Benedictis, La Vita del Cardinale Pietro Stefaneschi di Sebastiano Vannini, *Annali della Scuola Normale Superiore di Pisa. Classe di Lettere e Filosofia*, III, 6, 1976, pp. 955–1016, esp. 966: " ... già con bellissime lettere, da alcuni chiamate ecclesiastiche, in marmo intagliati nel fregio delle porte, che erano sotto la detta Navicella ..." W. Paeseler, Giottos Navicella und ihr spätantikes Vorbild, *Römisches Jahrbuch für Kunstgeschichte* 5, 1941, pp. 49–162, esp. 68.

407 Among others: G. Cascioli, La Navicella di Giotto a S. Pietro in Vaticano, *Bessarione* 32, 1916, pp. 118–138, esp. 131.

408 Hetherington, *Pietro Cavallini*, pp. 26–28. Ch. Paniccia. Jacopo Stefaneschi e Pietro Cavallini a Santa Maria in Trastevere: immagini scritte, scritture in immagine nel ciclo musivo con le "storie della Vergine", in: *Memoria e materia dell'opera d'arte*, ed. E. Anzelotti, C. Rapone, and L. Salvatelli, Rome 2014, pp. 45–56.

409 G.B. de Rossi, *Inscriptiones Christianae Urbis Romae*, II, 1, Rome 1888, pp. 323, 420.

To understand its content, as is so often the case, the assumptions that the reader holds before engaging with the text are decisive. The prevalent assumption regarding the text since the late 20th century is a political one, concerning the papal primacy. Arwed Arnulf's translation of the first verse seems to be based on this: "Whom you [God] instruct to smooth the liquid waters of the sea by walking."[410] If one assumes that "gradiens sternere" (smoothing by walking) is not simply a poetic way of describing Peter's steps over stormy waters, then an allegorical meaning can be postulated, and the verse may be interpreted as follows: God commissions Peter to rule the nations. Indeed, "sternere" can be read in a figurative sense as "peacemaking". In his famous letter to pope Eugen III (*De considera-tion*) Bernhard of Claivaux interpreted the floods into which Peter dares to venture as the world and the nations.

However, the verb "sternere" is not used in any related texts which means that in the *titulus* there is no clear invocation of this context. And where Saint Bernard interpreted the floods as the world and the nations, he departed from the passage in John 21:1-8, which tells how Peter came through the water to the risen Jesus, whom he saw standing on the shore from the boat.[411] From Matthew's text, which is less about Peter's determination than about his salvation, Bernard only took the motif of "gradiens super aquas" (walking on the water). In John, nothing is said about Peter's mode of locomotion, so that one could imagine that he masters the distance to the shore by swimming or wading.

Thus, one would have to find other formulations if one wanted to use one of Peter's marine adventures – be it the one reported by John or the one reported by Matthew – as an argument for the primacy of the pope. This can be illustrated by contrasting the *titulus* of the Navicella with the inscription in the seal of Pope Victor II (1055–1057):[412] "You who left the ship for me, take the key." Here the focus is on the strength of faith that sets Peter apart from the other apostles. This is the reason for assigning him the first rank among them. How little room the seal's wording leaves for interpretation or for misunderstanding hardly needs to be explained. There is also a striking difference between the texts with regard to the role of the speaker: whereas in the Navicella inscription it is the reader who speaks to Christ, according to the wording on the seal it is Christ who speaks to Peter. In

410 G. Köster, Aquae multae – populi multi: Zu Giottos Navicella und dem Meerwandel als Metapher päpstlicher Herrschaft, *Römisches Jahrbuch der Bibliotheca Hertziana* 33, 1999/2000 (2003), pp. 7–30, esp. 9: "Den du anweist, schreitend die flüssigen Fluten des Meeres zu glätten."

411 Cf. Köster, Aquae multae – populi multi, pp. 15–17.

412 "Tu pro me navem liquisti, suscipe clavem". I. Herklotz, Zur Ikonographie der Papstsiegel im 11. und 12. Jahrhundert, in: *Für irdischen Ruhm und himmlischen Lohn: Stifter und Auf-traggeber in der mittelalterlichen Kunst.* (Fs. B. Brenk), ed. H.-R. Meier and C. Jäggi, Berlin 1995, pp. 116–130, esp. 117. Herklotz assumes that the formulation aims at the passage in Matthew, but this would have to be proven.

The Navicella: Vestiges

fact, Peter's role as leader can only be established authoritatively through words spoken by Christ.

Before the assumption took hold that the image justified papal primacy, the most common understanding was that it served as a statement against the Babylonian Captivity of the Papacy, i.e. as an image advocating the transfer of the Curia from Avignon back to Rome.[413] In this case, the last line of the inscription with Tobias Leuker can be read like this:[414] "Order him [Peter] to enter the port, O Lord, especially since this one here [the donor, represented on his knees in prayer] is begging." In other words: God is to instruct Peter's successor residing in Avignon (since 1309) to come to Rome, represented by the metaphor of the port. Among the problems with this reading, however, is, firstly, that it cannot be linked to the creation of the mosaic in the late 13th century and, secondly, that we do not know how Stefaneschi felt about the fact that Avignon was the papal residence. On the one hand, he positioned himself on various occasions against the influence of the King of France on papal politics and criticised the late Clement V (Bertrand de Got) for never coming to the tombs of Peter and Paul,[415] but, on the other hand, he himself resided in Avignon from 1309 until his death in 1342 without a documented visit to Rome or Italy (see below). Above all, however, the formulation "contingere portum" ("to enter the port") is problematic, because the fundamental intention of the request should have been the idea of coming home, and thus not "to enter the port" but "to return to the port".

However, if the reader expects the text to convey not a political but a spiritual message (a reasonable assumption in the case of a scene from the Gospels in the forecourt of a church), a translation like the following is recommended. It allows the *titulus* to be read as a guide to a deeper experience of the story told in the picture:

> *Whom you call, that his step may level the floating waves of the sea,*
> *Whom you, because he is a believer, guide and raise up when he wavers in fear,*
> *Whom you restore to the virtues and make him a much-visited benefactor:*
> *Because he begs for it, O Lord, allow him to enter the port.*

413 L. Chiappelli, Nuovi documenti su Giotto, *L'arte* 26, 1923, pp. 132–136. W. Kemp, Zum Programm von Stefaneschi-Altar und Navicella, *Zeitschrift für Kunstgeschichte* 30, 1976, pp. 309–320.

414 „Demjenigen [Peter] befiel, oh Herr, in den Hafen einzulaufen, zumal dieser hier (sc. der kniend und betend dargestellte Jacopo Stefaneschi) inständig darum bittet." T. Leuker, Der Titulus von Giottos „Navicella" als maßgeblicher Baustein für die Deutung und Datierung des Mosaiks, *Marburger Jahrbuch für Kunstwissenschaft* 28, 2001, pp. 101–108, esp. 103.

415 Leuker, Der Titulus von Giottos "Navicella", p. 104.

The first line, in accordance with Matthew's report, records the invitation to Peter ("come!") and paints the drama of the walking on the sea, in which the author makes the reader aware of the bottomlessness of the surface under Peter's feet (with the term *liquidus*) and the storm-whipped roughness (*sternere*). The second line says that Christ guided the apostle until the moment of doubt and then saved him. The third line interprets the latter fact as the salvation of Peter's holiness; he did not go down in history as "one of little faith" and a sinner, but as one to whose tomb in Rome pilgrims flock, hoping for assistance. The last line refers to Peters cry "Lord, save me!" and suggests that the walk on the sea is the image of a life course at the end of which beatitude awaits. This is allegorized by the *portus*, a term that is not found in the biblical account, but is taken from another prominent text that the author covertly quotes. The 24th chapter of the *Meditationes* of John of Fécamp, based on the theology of St. Augustine and commonly considered a work of the Church Father himself, opens with the prayer:[416] "Blessed are all thy saints, my God, who have travelled over the tempestuous sea of mortality, and have at least made the desired port of peace and felicity." In the last verse it also becomes clear that the text is an intercession. One may find this situation paradoxical, because Peter attained eternal beatitude with his martyrdom, and so it seems absurd to ask God for such a future for the saint.

On the other hand, the knowledge about the heavenly future of the sea-walker is only of limited relevance here, because the entire text is written in the present and transports the reader into the time of the event. This corresponds to a mystical approach, such as that recommended in the *Meditationes Vitae Christi*. There the passage in the gospel of Matthew (like many other episodes in the gospels) receives the following commentary:[417] "Imagine him [Christ] and the disciples during these events, which are very beautiful and uplifting. And you can also consider the facts from a moral point of view, because in such a way [as we are told] the Lord acts spiritually on us every day." Anyone who actually imagines Peter's crisis of faith accurately and witnesses the events before their own spiritual eyes responds, predictably, with a prayer for Peter. And whoever, on the basis of such mystical experiences, then considers the story as a moral tale, and recognizes that

416 *Patrologia Latina* 40, col. 918: "Felices sancti Dei omnes, qui jam pertransistis hujus mortalitatis pelagus, et pervenire meruistis ad portum perpetuae quietis, securitatis et pacis." Translation: Augustinus, *The Meditations of St. Augustine, his Treatise of the Love of God, Soliloquies, and Manual*, trans. G. Stanhope, London 1818, p. 58. Cf. M. de Kroon, Pseudo-Augustin im Mittelalter: Entwurf eines Forschungsberichts, *Augustiniana* 22, 1972, pp. 511–530.

417 "Conspice bene ipsum ac discipulos in omnibus predictis, quia pulchra et devota sunt valde. In hoc igitur facto moraliter considerare potes quia Dominus quotidie nobiscum sic facit spiritualiter." *Meditaciones vite Christi*, by Johannes de Caulibus, ed. M. Stallings-Taney (Corpus Christianorum Continuatio Mediaevalis 53), Turnholt 1997, p. 140.

THE NAVICELLA: STEFANESCHI'S DONATION

The most significant connection between the Navicella image and the Navicella inscription is the identical construction of the recipient: seeing as well as reading, we are directed to Christ as an almost immediate counterpart to ourselves, we experience Peter's walk on the sea, crisis of faith, and salvation from a perspective focused on Christ's actions. This is also how the author of the entry in the *Liber Anniversarium* of St. Peter's Basilica (mid-14th century, 1.4.5) saw the picture: he saw "a picture of mosaic, which shows Christ pulling out the holy apostle Peter with his right hand as he walks on the water, so that he does not sink." What he did not see was a picture of mosaic which showed *Peter* walking on the water, etc. If Stefaneschi was the author or guiding spirit of the *titulus*, then he was probably also the one who developed the specific narrative perspective in the visual text. What prompted him to make his donation, what use of the image did he have in mind, and why did he hire Giotto?

Jacopo Stefaneschi came from a Roman noble family of Trastevere, traditionally friends of the powerful House of Orsini, which considered St. Peter' s to be its family church.[418] Jacopo's mother was the sister of Cardinal Matteo Rosso Orsini, already known to us: protector of the Franciscan Order and probably responsible for the painting of the upper church in Assisi, as well as archpriest of St. Peter's. Stefaneschi, who never received priestly ordination, studied in Paris with Giles of Rome (Aegidius Romanus), the *doctor fundatissimus* (as he was called later), one of the great scholars of his time.[419] Giles was close to the French royal family, for whom he wrote one of his major works, *De Regimine Principum*. A young nobleman from Rome might have been particularly attracted to his teachings on the virtue of *magnificentia*, contained in the twentieth chapter of this book and based on Aristotle: great occasions, especially those that concern God and the community, require

418 I. Hösl, *Kardinal Jacobus Stefaneschi: Ein Beitrag zur Literatur- und Kirchengeschichte des beginnenden vierzehnten Jahrhunderts* (Historische Studien 61), Berlin 1908. Carocci, *Baroni di Roma*, pp. 423–431. M. Borgolte, Nepotismus und Papstmemoria, in: *Person und Gemeinschaft im Mittelalter. Karl Schmid zum fünfundsechzigsten Geburtstag*, Sigmaringen 1988, pp. 541–556, esp. 551–552.

419 M. Dykmans, Jacques Stefaneschi, élève de Gilles de Rome et Cardinal de Saint-Georges (vers 1261–1341), *Rivista della storia della chiesa in Italia* 29, 1975, pp. 336–354.

great effort and do not allow austerity.[420] After the appearance of St. Francis this was no longer a matter of course, especially in the environment of the Curia.

Coincidence or not: Giles and Stefaneschi returned to Rome at more or less the same time. Stefaneschi's first career step at the Curia was to be admitted to the Chapter of St. Peter. This happened in 1294 under Celestine V (Pope July to December 1294, † 1296), the Hermit Pope, whose history Stefaneschi later wrote und whose abdication Giles of Rome legally legitimized in a report.[421]

The Orsini and the allied Roman noble families set the tone in the chapter of St. Peter.[422] A canonry at St. Peter's tomb (similar to a canonry at the Lateran Church or at Santa Maria Maggiore) was not only lucrative and honourable, but also a tried and tested stepping stone to the highest offices: Celestine's successor Boniface VIII (1294–1303) had likewise begun his career as canon of St. Peter's. In 1296 he appointed Stefaneschi as cardinal, who from this position would almost become Boniface's successor in 1304.[423] When he took the cardinal's purple, Stefaneschi was perhaps not yet thirty. His membership of the Chapter of St. Peter may have been what most distinguished and qualified him. Conversely, his elevation to the papal electoral body, which at that time consisted of only a few heads, strengthened the Chapter of St. Peter and the alliance of noble families there on which Boniface relied.

420 Aegidius Romanus, *Über die Fürstenherrschaft (ca. 122–1279). Nach der Handschrift Rom, Biblioteca Apostolica Vaticana, cod. Borgh. 360 und unter Benutzung der Drucke Rom 1556 und Rom 1607*, ed. and trans. V. Hartmann, Heidelberg 2019, pp. 211–214. C.F. Briggs, *Giles of Rome's De Regimine Principum: reading and writing politics at court and university, c. 1275-c. 1525*, Cambridge 1999.

421 J.R. Eastman, Giles of Rome and Celestine V: the Franciscan Revolution and the Theology of Abdication, *The Catholic Historical Review* 76, 1990, pp. 195–211.

422 A. Huyskens, Das Kapitel von St. Peter in Rom unter dem Einfluß der Orsini (1276–1342), *Historisches Jahrbuch* (Görres-Gesellschaft) 27, 1906, pp. 266–290. R. Montel, Les chanoines de la basilique Saint-Pierre de Rome des statutes capitulaires de 1277–1279 à la fin du papauté d'Avignon, *Rivista di storia della chiesa in Italia* 42, 1988, pp. 365–450 and 43, 1989, pp. 1–49, 413–479. R. Montel, Les chanoines de la basilique Saint-Pierre de Rome (fin XIIIe siècle – fin XVIe siècle): esquisse d'une enquête prosopographique, in: *I canonici al servizio dello stato in Europa secoli XIII–XVI*, ed. M. Millet, Modena 1992, pp. 105–118. J. Johrendt, *Die Diener des Apostelfürsten: Das Kapitel von St. Peter im Vatikan (11.–13. Jahrhundert)*, Berlin and New York 2011, pp. 178–187.

423 Often 1295 is given as the date of his appointment as cardinal. The correct date 1296 is due to Arsenio Frugoni's research: A. Frugoni, La figura e l'opera del Cardinale Jacopo Stefaneschi, *Atti dell'Accademia Nazionale dei Lincei. Rendiconti della Classe di Scienze morali, storiche e filologiche* 5, 1950, pp. 397–424, esp. 402–404. Stefaneschi's candidature at the Conclave of Perugia, which promised success for a short time, is attested to by the report of the Aragonese envoy: H. Finke, *Aus den Tagen Bonifaz VIII.: Funde und Forschungen*, Münster 1902, pp. 284, LXI–LXII.

The Navicella: Stefaneschi's Donation

All in all, Stefaneschi had every reason to identify with "his" basilica and to prefer to invest in his salvation through this institution. During the cardinal's long life, St. Peter's received extensive donations beyond the Navicella: images, paraments, real estate. They guaranteed him an everlasting commemoration of prayer by the chapter of St. Peter. The anniversary book of the Chapter speaks of the liturgical celebration of the day of his death and of three masses said each day at the altar of St. Lawrence and St. George (1.4.5). An objective sign of his attachment to St. Peter's Basilica and the fact that he saw in it a place of salvation is his burial there: although he had been staying mainly or even exclusively in France since 1305 – mostly in Avignon – and he had to have assumed that he would die there,[424] and although his highest dignity, the cardinalate, was linked to the Roman church of San Giorgio in Velabro, he chose his grave in St. Peter's. The question is whether his feelings were more about the church and its chapter, or the patron saint. As a canon, serving, at least as an ideal, at St. Peter's tomb, Stefaneschi was allowed to imagine himself under the disciple's special protection. Those successes which sober minded historians are inclined to ascribe to Stefaneschi's descent from the Roman nobility and his social and institutional connections, may have been attributed by the cardinal himself to the benevolence of St. Peter.

The role that Peter plays in St. Peter's today is defined by the staging developed by Bramante, Michelangelo and Bernini in order to triumphantly mark the central function of the papacy in the post-Reformation Latin Church. In contrast, in the old basilica and in pre-Reformation times, the role of Peter as a "famous" or "much-visited benefactor" ("celeber almus", as the Navicella *titulus* puts it) may have been clearer: a saint whose body, buried under the high altar, was visited by pilgrims from across the continent because they expected salvation. Like all saints, Peter had his own profile of competence an important element of which was that no one who had committed sins under Christ's eyes received more perfect forgiveness than he had. This dimension of his story was evident especially during Lent when the Church was crowded with people who wanted to confess their sins at his tomb. Stefaneschi was certainly aware of the aspects of Peter's story and his burial church that were linked to individual piety. In fact, the care of pilgrims and confessors was the most important pastoral task of the Chapter of St. Peter and therefore also of Stefaneschi as a canon.[425]

The chapter of St. Peter may also have been the driving force behind the announcement of the Holy Year of 1300, the first Holy Year.[426] It was a call for mass pilgrimage to Rome

424 M. Dykmans, *Le cérémonial papal de la fin du moyen âge à la Renaissance II: De Rome en Avignon ou le cérémonial de Jacques Stefaneschi*, Brussels and Rome 1981, pp. 28, 43.

425 S. de Blaauw, *Cultus et decor: Liturgia e architettura nella Roma tardoantica e medievale*, Vatican City 1994, vol. 2 pp. 743–751.

426 Johrendt, *Die Diener des Apostelfürsten*, pp. 335–350. A. Frugoni, *Il giubileo di Bonifacio VIII*, ed. A. De Vincentis, Rome and Bari 1999.

and especially to the tombs of the Princes of the Apostles. At its centre was the grave of Peter in the Basilica on the Vatican Hill, especially since this church also had important relics of St. Paul.[427] With the Papal bull *Antiquorum habet fide*, issued at the Feast of the Chair of St. Peter (22 February) in 1300, Boniface VIII promised the pilgrims a plenary indulgence. Stefaneschi wrote the history of the Holy Year 1300 in his book *De centesimo seu iubilaeo anno* and shaped the story of its success for posterity.[428] On the one hand, he emphasizes that the idea of organizing a Holy Year came about almost spontaneously due to the demands of pilgrims; on the other hand, he mentions rumours brought to the Pope from unnamed sources, which made such an event seem attractice. Nowhere else was the promotion of pilgrimage to St. Peter's tomb more spiritually and economically desirable than in the circle of the canons of St. Peter's. Here the possibility for strengthening the prestige of the Basilica and the Chapter across the whole Christian Word became apparent. It is difficult to say whether Stefaneschi's commission of the Navicella in 1298 was already aimed at the event of 1300, in the form that it subsequently took and in which it was described by him. But it is obvious that the donation of the mosaic has much to do with pilgrimage to the site and that the year 1300 was already foreseeable: a round anniversary of the birth of the Saviour, which would not be celebrated other than in a magnificent way.

The last stage of the path to St. Peter's tomb was a series of mosaics like no other in Rome and Stefaneschi, with Giotto's help, made it even more splendid. The sequence of images began with the Carolingian mosaic on the east wall of S. Maria in Turri, showing the enthroned Salvator with four martyrs (among them surely Peter and Paul), which was then continued with Stefaneschi's donation of the Navicella on the west wall of the same church. This was followed by the decoration of the façade of St. Peter's, which had been entirely renewed by Gregory IX (1227–41) and showed Christ enthroned between Mary and Peter, as well as the Twenty-Four Elders of the Apocalypse. The finale was the apse mosaic of the basilica, renewed under Innocent III. (1198–1216), which showed the Pantocrator between Peter and Paul above the tomb and throne of St. Peter.[429] The function and theme of the Navicella must also be contextualised in this series of mosaics: based on the ancient custom that pilgrims turned around and said a prayer before entering the Basilica, Stefaneschi offered an additional image, which allowed Peter to appear in a different role from that of the existing pictures. The mosaic presented the apostle as

427 M. Maccarone, L'indulgenza del Giubileo del 1300 e la Basilica di S. Pietro, in: *Roma Anno 1300: Atti della IV settimana di studi di storia dell'arte medievale dell'Università di Roma La Sapienza (19–24 maggio 1980)*, ed. A.M. Romanini, Rome 1983, pp. 731–752.

428 Jacopo Stefaneschi, *De centesimo seu iubileo anno*, ed. C. Leonardi, Florence 2001.

429 Waetzoldt, *Die Kopien des 17. Jahrhunderts*, pp. 65–71. M. Andaloro, *La pittura medievale a Roma 312–1431: atlante, percorsi visivi. Vol. I: Suburbio, Vaticano, Rione Monti*, Milan 2006, pp. 20–44.

the classic holy sinner, who, beginning with the story represented by Giotto, repeatedly failed Christ's expectations – showed himself to be of little faith, took up the sword, denied Christ – and yet, because of his trust, Christ forgave him again and again.[430] In the Gospel of Matthew, it is his cry "Save me" that proves the deep faith of Peter beyond his little faith. The pictorial text, executed in mosaic, concentrated on bringing the following moment to life: Peter is still knee-deep in water, but Christ has already reached out his hand at his request. It was therefore shown how Christ placed Peter's proof of faith above his previous indication of doubt and acted accordingly. And that is probably the motif that would have consoled the average believer and fascinated the theologian. If the story is understood as a lesson, the message is: falling into sin does not annul the relationship between God and man, the decisive factor is faith. In the *Legenda Aurea* (in the chapter on *The Chair of Saint Peter*) the following comment is found:[431] "No sinner should despair even if he, like Peter, has denied God three times, provided that, like Peter, he confesses God in his heart, by his speech, and through his actions." Stefaneschi reminded the pilgrims on their way to the tomb of this aspect of the figure of Peter. The inscription, which was placed on the gates leading into the atrium, but was related to the picture, linked the pilgrims' path very closely with the picture. As the text and the staging of the figure of Christ unanimously say, viewers should enter into a relationship with Christ that is as direct as possible, observing Peter's role in his interaction with Christ and relating it to their own existence.

THE NAVICELLA: GIOTTO'S NARRATION

Despite the clear documentary evidence, doubts have been raised about Giotto's authorship of the mosaic – and with good reason. In 1941, Wilhelm Paeseler pointed out how little the picture fits into the common ideas about Giotto's art and how much it is determined by a Late Antique or Early Christian vocabulary:[432] The sea, strikingly composed from rippled waves with fish in between, can be found in very similar form on Antique floor mosaics. The ship used by the apostles is an Antique ship. This assertion stands up brilliantly to the research into ancient and medieval shipbuilding that has been going on since Paeseler's work, and can be further specified: It is a Roman cargo ship.[433] The same

430 E. Dorn, *Der sündige Heilige in der Legende des Mittelalters*, Munich 1967. G. Braumann, Der sinkende Petrus, *Theologische Zeitschrift* 22, 1966, pp. 403–414.

431 "[...] ut nullus peccator desperet etiam si tertio, sicut Petrus, deum negavit, si tamen eum sicut ipse velit corde, ore et opere confiteri." *Legenda aurea*, ed. Maggioni, p. 274.

432 Paeseler, Giottos Navicella und ihr spätantikes Vorbild.

433 A. Göttlicher, *Die Schiffe der Antike*, Darmstadt 1985.

Fig. 133: Copenhagen, Ny Carlsberg Glyptothek: Jonah sarcophagus

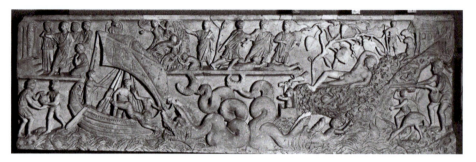

Fig. 134: Rome, Vatican Museums: Jonah sarcophagus

type of vessel is found on Early Christian Jonah sarcophagi, and the slanting position and the detailed representation of the rigging also correspond with these (fig. 133, 134). The wind gods of the Navicella – half air and half sea creatures – are also antique or at least antique-like. Beatrizet correctly shows them with dorsal fins. Pairs of such creatures flanking a ship are also found among the Jonah sarcophagi (fig. 133). This means that not only are set pieces in the Navicella of late antique origin, but so too is the backbone of the composition. The angler is a genre motif popular in ancient times and can be read as another quote from Antiquity. The same applies to the fact that Giotto introduced architecture in the scene. A lighthouse belongs to the convention of the late Antique seascape. And finally, even the figure of Christ can be found in a late antique work. Antonio Muñoz recognized this even before Paeseler did:[434] Christ appears frontally before the viewer in a gold robe with a scroll, ruler and teacher at the same time, in the apse of Santi Cosma e Damiano (6th century).

434 Muñoz, I restauri della Navicella di Giotto, p. 436.

The Navicella: Giotto's Narration 245

On the one hand, such an accumulation of antique motifs cannot be a coincidence; on the other hand, Paeseler undoubtedly was wrong when he saw in the Navicella a late antique picture that Giotto had only restored: One counter argument is the golden ground that recurs in all coloured reproductions of the Navicella; in a late antique mosaic a blue ground would be expected. Another counterargument is that none of the numerous copies and variations could have been made before the turn of the 13th and 14th centuries, which suggests that the picture did not exist before that time. In this dilemma – antique-like yes, antique no – there is only one solution: Giotto and Stefaneschi had chosen a pictorial form for the Navicella that would evoke Antiquity – comparable to Torriti's mosaic collages of antique set pieces in the apses of Santa Maria Maggiore and San Giovanni in Laterano (fig. 100, 101). A sentence written by the donor and already quoted fits this intention, albeit in very general terms (see vol. 1, p. 41). It is in a letter which Stefaneschi wrote to his teacher Giles of Rome shortly after his return to his home town: "The venerable times of the [Old] Romans now resume."

What qualified Giotto for the job in Stefaneschi's eyes was probably not that he was Florentine by birth, but that he was Roman by his visual culture. But perhaps it was an outside's view that enabled him to make particularly virtuoso use of the elements of this culture. The fusion of the ancient motifs and compositional elements into a subtle pictorial narrative is decidedly more complex than the juxtaposition of ancient quotation in Torriti's apses. And only a bold approach was able to transform the central Christ of a late antique apse into the main character of a narrative. It should be noted that at the same time, and once again commissioned by Stefaneschi, Cavallini also used the gold-robed Christ of Santi Cosma and Damiano, namely for the apse fresco in San Giorgio in Velabro, the cardinal's title church.[435] However, Cavallini remained so close to the original that the entire composition looks like a pasticcio built around the silhouette of the main figure.

Another special feature is the sovereign integration of late Byzantine and empirical material. As it is in most of its details, Beatrizet's engraving is probably close to the original in the depiction of the harbour complex (fig. 125), and this then also applies to the building at the rear, which in its small-scale elements and shifted perspectives quite obviously resembles the variants of Byzantine architectural fiction in Cavallini and in the Isaac-Master Complex. In contrast, the front tower with its sloping base appears "real". The blind arches point to the Torre dei Conti, which Cimabue portrayed in his Rome *veduta* in the crossing vault of Assisi along with other Roman landmarks. Giotto had probably worked out a mixture of late Byzantine and contemporary Roman motifs for his mosaic, as is also found in a less condensed form in Cavallini's mosaic of the Presentation in the Temple (fig. 106). Giotto used this mixture in place of the isolated lighthouse, which is part of the ancient sea scenes. Together with the bridge facing the viewer, which draws the gaze

435 Hetherington, *Pietro Cavallini*, pp. 66–72.

towards the gate, and the angler, who reflect Christ's description of Peter as the fisher of men, a rather concrete location was created, illustrating the last verse of the titulus: "O Lord, allow him to enter the port". Largely stripped of its late Byzantine elements, we encounter this complex of towers, rock, and bridge again in the Arena Chapel: it is the Golden Gate, in front of which Joachim and Anna meet (fig. 45). The shrunken upper floors of the towers in Padua still preserve a memory of the Byzantine prehistory of the architectural image.

It is especially through Leon Battista Alberti's description that Giotto's portrayal of the apostles has attained great art historical fame (2.3.7):

> *They praise the ship painted in Rome by our Tuscan painter Giotto. Eleven disciples [are portrayed], all moved by fear at seeing one of their companions passing over the water. Each one expresses with his face and gesture a clear indication of a disturbed soul in such a way that there are different movements and positions in each one.*

However, not everything about these sentences is correct: if one trusts the most detailed copies, Beatrizet's engraving and Beretta's painting (fig. 125, 127), there are at most four of the eleven apostles who are shown empathising with Peter, including the apostle at the bow, who may be Andrew, Peter's brother.[436] The others are obviously not afraid for Peter, but because they themselves are in distress on the boat. One of them even acts accordingly and tampers with the rigging. He probably wants to pull in the sail that is inflated to breaking point.

The figure crouching to his right is highlighted in a contradictorily way, being the only mariner to hide his face. In the account of the restoration of the Navicella of 1618 he is called "the weeper".[437] Margrit Lisner identified him as Thomas based on Beretta's copy.[438] However, it is noticeable that in the engraved reproductions of the 16th century, namely in Beatrizet and Labacco, this apostle is the only one who does not possess a halo[439] (fig. 125, 126). He may be Judas; the traitor's presence in the ship, which pious readers of the New Testament like to suppress, must be presupposed. In this case, the gesture illustrates his notorious disbelief and his despair, later to become his fate. The question thus arises as to whether the original in its pre-1628 state already contained the halo or whether its addition

436 Lisner, Giotto und die Aufträge des Kardinals Jacopo Stefaneschi für Alt-St. Peter I, p. 50.

437 Muñoz, I restauri della Navicella di Giotto, p. 434: "quello che piange".

438 Lisner, Giotto und die Aufträge des Kardinals Jacopo Stefaneschi für Alt-St. Peter I, p. 52.

439 Beatrizet had – probably by mistake – initially envisaged a halo, the outlines of which he made disappear in the drapery of the apostle standing behind when he finished the plate. Grimaldi's draughtsman, following Beatrizet's copy, added a halo (cf. footnote 391).

was a modification made by Beretta with a view to a new use intended for the picture. In this context, it is significant that the canvas copy is based on an altered catalogue of disciples. Perhaps one should speak of a post-Tridentine corrected catalogue. Once the addition of the halo removed the unholy Judas from the crew, the need for a replacement arose, and this made the introduction of St. Paul as helmsman possible. In fact, the helmsman in Beatrizet and in the other early copies is not a Paul type. Such a figure – stern gaze, dark beard and bald forehead – only takes the helm in Beretta's copy. The anachronistic presence of Paul and his power over the rudder turn the fishing boat on the Sea of Galilee into the ship of the Roman Church and the edifying narrative about Peter into an ecclesiological manifesto – a reading to which the image was, however, already open.

Not all the apostles are worried about Peter, but they are all full of fear, and the fact that Giotto articulated the differently motivated forms of fear in different ways – up to the point of converting anxiety into nautical action on the one hand and into self-abandonment, in Judas' case, on the other – constitutes the narrative of the picture; this narrative was much more thrilling and effective, and at the same time much less artificial than one might believe from a superficial examination of the copies. The components showing fierce action – the billowing sail, the bottomless sea, the hostile creatures in the air – are not to be underestimated in their effect. But the decisive factor was the transformation of the story into visible and empathy-challenging affects. These made the pilgrims not only fear for individual disciples and especially for Peter, but created a web of reactions that allowed them to experience the drama from all viewpoints.

Alberti's description falls short of the actual potential of Giotto's depictions of emotions. His text would fit better to Torriti's Death of the Virgin in Santa Maria Maggiore (fig. 135), executed shortly after 1296, than to the Navicella. Torriti has portrayed the Twelve as displaying varying signs of distress for one and the same reason: they mourn Our Lady. As with the Nativity scene (see p. 104), he used a Byzantine pictorial formula, the best versions of which, including an icon in St. Catherine's Monastery on Sinai and probably painted in 10th-century Constantinople, bring out the variants of the affects even more impressively and correspond even better to Alberti's text.[440] Nevertheless, Giotto may have benefited from reflecting on Torriti's Death of the Virgin and its Byzantine models, not only while working on the Navicella, but also earlier, in planning the Lamentation in Assisi.

A connection between the Navicella and the Death of the Virgin is also suggested by the fact that a particular motif in the Navicella can be explained most easily based on Torriti's mosaic, namely the old men on the clouds wearing halos, who point emphatically to the event and appear remarkably similar in all copies.[441] There are no sources that

440 Lazarev, *Storia della pittura bizantina*, p. 203.

441 W. Körte, Die Navicella des Giotto, in: *Festschrift W. Pinder zum 60. Geburtstag*, Leipzig 1938, pp. 223–263.

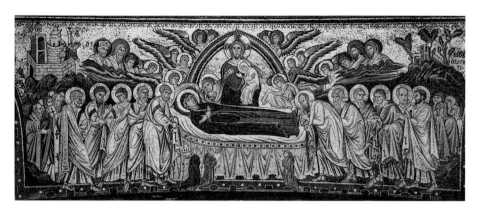

Fig. 135: Rome, Santa Maria Maggiore, apse: The Death of the Virgin (Jacopo Torriti)

could be used to name them. Among the suggestions for identification, the most plausible seems to be what the Vatican librarian Josephus Maria Suaresius suggested in the 17th century: he referred to the four figures as the Evangelists.[442] However, the event to which they are pointing is only told in one gospel, namely in Matthew. So, if the evangelists are really represented, their presence must be based on something other than the iconography. And here one now inevitably recalls Torriti's picture, where there are prophets appearing on clouds in an analogous place. In Santa Maria Maggiore this can only refer to prophets who are said to have foretold the Assumption of Mary; crowned and marked with a "D", one can see David, King and prophet, on the left cloud. Despite this, one would assume also in this case that the motif must have a broader background than simply an iconographic tradition. In fact, Torriti's motif stems from a misunderstanding of his Byzantine model: Byzantine Koimesis pictures – including the huge wall paintings in Sopoćani and Ohrid (fig. 104) – also sometimes show old men on clouds above the main scene. They represent the aged disciples, who are travelling in a miraculous way from their respective mission areas to Our Lady's death bed.[443] Since this legend was largely unknown in the West, it was natural for Torriti to reinterpret the motif as prophets. And this reinterpretation was then adapted and further developed by Giotto, perhaps encouraged by Stefaneschi, in whose eyes the presence of the evangelists gave his picture additional authority.

442 J. M. Suaresius, Notitia musivo expressae opere naviculae in Basilica Sancti Petri (Biblioteca Apostolica Vaticana, Cod. Barb. lat. 3084, Fol. 7r–9v.). Quote after: Köhren-Jansen, *Giottos Navicella*, p. 127.

443 *Lexikon der christlichen Ikonographie*, vol. 4, col. 333.

Torriti's Koimesis in Santa Maria Maggiore therefore probably belongs to the extensive Roman stock from which Giotto drew the material for the Navicella. This thesis is also supported by the miniature architectures on the left and right of Torriti's scene, labeled "Syon" and "Mons Oliveti", which may have inspired the concept of Giotto's toy-sized harbour, especially since "Syon" excels as a crypto-portrait of the Castel Sant'Angelo, as does Giotto's harbour with a crypto-portrait of the Torre dei Conti. If the connection is seen correctly, then Giotto has opened up what was artificial and schematic in the motif of the varied affects by rewriting the story of Peter's sea-walking and salvation that formed his commission: according to Matthew's text, the disciples are afraid of Christ, the supposed ghost that comes over the water. Based on Torriti, this would have been easy and effective to illustrate (and would also have corresponded to the pictorial tradition of Peter's walking on the sea).[444] Instead, the painter used the visual material he found to develop a new staging: some apostles empathize with Peter, others are afraid of the storm, and on top of that Giotto has depicted despair and frantic action. In this way, the old motif of various emotional reactions is made readable in a new form that illustrates the contingency of human behaviour. A glance at the group around the good centurion in the Crucifixion picture (pl. VIII, fig. 61) or a comparison with the resurrection of Lazarus (fig. 206) shows how this invention points ahead to the frescos of Padua. There, too, we encounter individuals whose behaviour cannot be predicted from the narrative, but appears emotionally independent

Giotto's mosaic was therefore both thrilling to look at and a challenge. Required was the viewer's willingness to empathize with the people depicted. Those who did so were rewarded with a series of individual stories. But a modern-day beholder would probably have felt a lack of coherence. The rescue operation gave the picture a focus while the opposing motifs, the wind gods and the "Evangelists", provided a compositional bracket. What was missing, however, was a consistent spatial structure constituted by the perspectival modulation of differences in size: the donor and the angler are presented small (instead of large) in the foreground, while the other figures took on very different formats, with the figure of Christ being the largest element by scale and the group of buildings by far the smallest although both are more or less in the same layer of the picture space. In comparison, Torriti's placement of the miniature architecture in the background of his Death of the Virgin seems more plausible. However, the dwarf bench in Assisi should also be considered here (pl. XI, XII): the young Giotto obviously had ideas about the role of size differences in the picture, which contrasted with his later work in Padua – let alone the ideas of modern times. The expectation is that the small-format environment makes the main motifs, namely the rescue group and the ship with its agitated crew, appear monumental and particularly dominant.

444 Köhren-Jansen, *Giottos Navicella*, pp. 47–79.

250 Giotto avant Giotto: Works before and around 1300

Worth mentioning here is the experience of St. Catherine of Siena, as described by William Flete shortly after the incident: When she visited St. Peter's in 1380 and said a prayer in front of the Navicella, the ship ("navicula Ecclesiae" says Flete) detached itself from the picture and sat on her shoulders – a burden under which she collapsed, only to die a short time later.[445] Giorgio Vasari experienced something completely different and yet similar before the Navicella (2.1.10): the inflated sail painted with mosaic appeared to him as three-dimensional as even a real sail could ("una vela, laquale ha tanto rilievo, che non farebbe altre tanto una vera"). The main group seems to have had a presence that made the border between inner-pictorial and extra-pictorial reality disappear.

HOW THE NAVICELLA WORKS ALLEGORICALLY

Anyone who is familiar with Hans Belting's comments on the Navicella will find the assessment presented here one-sided. For Belting, the mosaic is the founding work of an allegorical pictoriality, which he regards as typical for the 14th century. Though, according to Belting, the Navicella was "not yet" an "allegorical fiction", i.e. it did not show an action that was exclusively aimed at an allegorical reading (like the actions of the virtues and vices in Padua), but rather told a story worth telling. However: "With the separation from a biblical cycle and with the huge picture format, but also with the function as a facade picture, the mosaic became an independent programme picture".[446] And Belting thinks of this programme as referring to non-narrative content such as papal primacy or anti-Avignon propaganda.

It is certainly true that there were alternatives to a reading of the picture as a stirring narrative. One possibility was interpreting it as the ship of the church, as documented by William Flete in the 1380s. But it is doubtful whether this reading was intended by Stefaneschi and Giotto. The fact that it was later virtually imposed on the viewers by the addition of the figure of Paul speaks more against this than in favour of it. In contrast, its specific styling must have attracted attention right from the start. I will now return to the fact that the mosaic was conceived as an antique-like one. Most of the elements from Antiquity were used almost like quotations, so that they must have been registered as antique – if not by the pilgrims, then by thosee visitors to the church who had the competence

445 "Hoc verum fuit quando, ut intellexit, in sancto Petro navicula Ecclesiae posita fuit super renos suos portanda, tantum opressit eam quam moriendo cecidit in terram." R. Fawtier, Catheriniana, *Mèlanges d'Archéologie et d'Histoire de l'Ecole française de Rome* 34, 1914, pp. 3–96, esp. 44. Köster quotes other passages that are dependent on this: Köster, Aquae multae – populi multi, p. 12.

446 H. Belting, Das Bild als Text, p. 42.

to recognize antique images. This might have been particularly true of the Roman elite, whose members were always aware of the great history of their home city. These viewers could direct their attention not only to what was represented, the story of Peter's walk on the sea, but also to the means used in representing it. Following Saussure's semiotics, which distinguished between *le signifié* and *le signifiant* (the signified and signifier), these means could be called the representer.[447] The representer of the Navicella is a pictorial structure composed of antique elements.

Once this is recognised, the Navicella enters into a context that is as broad as it is specific. Art, culture and political theory in the city of Rome have appeared more or less continuously in an antique manner since the 11th century, but the zenith in the field of fine arts was reached in the late 13th century with Torriti's apse mosaics for S. Giovanni in Laterano and Santa Maria Maggiore. The two apses are connected with Giotto's work by a paradox: in all three works too many explicitly antique details have been combined for the structures as a whole to be of antique origin. It is reasonable to merge Torriti's apses and Giotto's Navicella, describing them as the most ambitious visual representatives of what is called the Roman *Renovatio*. The places for which the pictures were conceived are also comparable: three venerable basilicas, founded under the first Christian emperors, whose partly antique pictorial decorations are completed by the pseudo-antique mosaics. Stefaneschi's pious donation seems to have taken part in a competition, which had the goal of a worthy, in other words antique-like, renewal of the large Roman basilicas.

The rivalry between the basilicas and their chapters was also a rivalry between families. St. Peter's had taken great advantage from the pontificate of Nicholas III Orsini (1277–1286) and had almost outshone the Roman Episcopal Church on the Lateran. Under Nicholas IV (1288–1292), a counter-movement took place in favour of the Lateran Church and the Basilica of Santa Maria Maggiore, which had cultic ties to the Lateran Church. This not only brought Torriti his greatest commissions, but also benefited the house of Colonna. Just as the Orsini dominated the chapter of St. Peter, so the Colonna and their allies were present in the chapters of San Giovanni in Laterano and Santa Maria Maggiore.[448] The Colonna had pushed the election of Nicholas IV and under their protection the Pope took up residence at Santa Maria Maggiore, which was considered their family church. It was Cardinal Jacopo Colonna who, after Nicholas' death, saw to the completion of Torriti's apse mosaic in the Marian church.[449]

447 Cf. M.V. Schwarz, What is Style For?, *Ars* 39, 2006, pp. 19–30.

448 A. Rehberg, *Die Kanoniker von S. Giovanni in Laterano und S. Maria Maggiore im 14. Jahrhundert: Eine Prosopographie*, Cologne 1999. A. Rehberg, *Kirche und Macht im römischen Trecento: Die Colonna und ihre Klientel auf dem kurialen Pfründenmarkt*, Tübingen 1999.

449 J. Gardner, Pope Nicholas IV and the decoration of S. Maria Maggiore, *Zeitschrift für Kunstgeschichte* 36, 1973, pp. 1–50.

Giotto's activity for St. Peter's is connected with the counterstrike of the Orsini party. The latter consisted in undertakings as varied as a papal "crusade" against the Colonna, a substantial reform of the Chapter of San Giovanni in Laterano, which broke up old possessions, and new privileges for St. Peter' s: Boniface VIII expanded the chapter there and with it the career perspectives of men from the Orsini circle. The same context includes the preparation and proclamation of the Holy Year of 1300, which brought more pilgrims and therefore income to St. Peter's (and to St. Paul outside the walls), but (unlike the following Holy Years) did not benefit either the Lateran Church or Santa Maria Maggiore.

While Stefaneschi, through Giotto, gave the pilgrims a useful image just before they reached their destination and provided for his salvation with this good work, he was in competition both with the Colonna fraction as a member of the Orsini fraction and with the canons of San Giovanni in Laterano and Santa Maria Maggiore as a member of the Chapter of St. Peter's. One might object to this thesis that the Navicella, due to its location in the atrium, could hardly be regarded as a rival to the apses. On the other hand, the western wall of Santa Maria in Turri was the last place available around 1300 for a monumental mosaic at the Vatican. But above all, the antique-like pictorial language clarified the connection between the façade mosaic and the apses and made it clear that they were voices in the same discourse of Rome's return to her former greatness.

The function of this pictorial language can therefore be described as an allegorical one: It makes *renovatio* the second pictorial theme after the story of Peter's adventure. What seems more interesting, in the context of a Giotto study, than the image's micro-historical implications is the way the artist deals with the representing aspects, the perception of which opens up specific contexts and meanings. This emphasis on form returns in the allegories of the Arena Chapel in a clearly legible and more radical form. Here, the viewers cannot supress the fact that they are looking at "non-actual" pictures, that is, pictures of (sculptural) pictures. But also in the case of the Navicella, a wavering of perception between the represented narration and the forms and motifs of the representer may have raised the question for some Romans of whether they were dealing with a picture or with a picture of an (antique) picture.

THE CROSS OF SANTA MARIA NOVELLA: PREREQUISITES

The colossal *croce dipinta* in the Florentine Dominican church of Santa Maria Novella (pl. XIII) is documented as being the work of our painter in the will of Riccuccio di Puccio of 1312 and in a related account of 1314 ("crocifixo grande, che fece Giotto"; 1.4.1,

2).[450] A painted cross in the Conservatorio di Santa Chiara in San Miniato not far from Florence provides a *terminus ante quem* (fig. 136). It follows Giotto's cross not only in type but also in significant details (the limp hands clearly seen from below and the Golgotha mound with Adam's skull, a motif that had not been common on painted crosses until then) and bears the inscription: A.S. M.CCCI. DEODAT[us] ORLANDI. MEPINXIT. Thus by 1301, the painting of the Dominicans' cross must have been completed or at least so far advanced that the novel features could serve as a model for the Lucchese artist Deodato Orlandi.[451] In May 1301 Giotto already owned a house in Florence that was in close proximity to his parents' house in the parish of Santa Maria Novella, where the family had presumably been resided before Giotto's birth (1.1.7; 1.3.1, 2). Did Giotto return to his home town immediately after completing the Navicella in order to establish himself there? The payment for the mosaic would probably

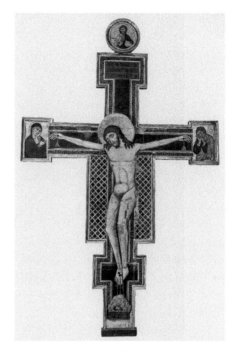

Fig. 136: San Miniato al Tedesco, Museo del Conservatorio: croce dipinta (Deodato Orlandi)

have been sufficient for this, even if only a fraction of the 2,200 gold florins that Stefaneschi spent actually flowed into the artist's pocket (1.4.5) – the equivalent of four or five houses in Florence of a comparable type to those of Giotto's neighbours (1.1.7). Did the painter receive, hand in hand with establishing himself, the spectacular commission for the cross in the church of that monastery where he had surely been known since childhood?

450 Giotto's authorship was nevertheless sometimes doubted (by Rintelen, Offner, and Smart, among others), but this was done – Ugo Procacci is right – against all reason: U. Procacci, Richard Offner: Corpus of Florentine Painting [...], vol. IV, VII, VIII, 1956–1958, *Rivista d' arte* 33, 1958, pp. 121–139.

451 G. Previtali, *Giotto e la sua bottega*, Milan (3) 1993, p. 41. *Cimabue a Pisa: La pittura Pisana del Duecento da Giunta a Giotto*. Exh. cat., ed. M. Burresi and A. Caleca, Pisa 2005, pp. 258–259 (A. d'Aniello). On Deodato: G. Concioni, C. Ferri, and G. Ghilarducci, *Arte e pittura nel Medioevo Lucchese*, Lucca 1994, pp. 263–264.

Or should we assume that the cross predates the Roman phase and was therefore already several years old when it impressed Deodato or his patron? Rather than draw on the long and difficult building history of the church, which spanned over a century (from 1246 to 1349),[452] I would first like to argue based on the character of the painting itself. The cleaning and restoration of the panel between 1987 and 2000 has made it much easier to determine its style.[453] And this now shows that, despite differences in technique, the work is very close to the Isaac Master complex in Assisi: this applies to the precious and exquisite colouring (including the red hair), the physiognomies, the projections of the faces, the modelling with much shadow and little light, and the richly shaped pleating of the robes (fig. 98, 146). This comparison not only increases the likelihood of Giotto's authorship of the paintings in the clerestory in Assisi, but also suggests a similar dating of these paintings and the cross. Crucial for the chronology, however, is that the busts of Mary and John on the cross are marked by features typical of Cavallini. John closely resembles the young disciples in Cavallini's Last Judgment in Santa Cecilia in Trastevere, only appearing less expressive with his somewhat smaller eyes (fig. 99, 146). If we maintain that (first) the painter of the Isaac frescoes was inspired by Cavallini's art, and (secondly) the cross in Florence is by the same painter, then he cannot have created the cross before his Roman phase. In this case, it must have been painted after his return from Rome or Assisi, i.e. after the frescoes.

But a link can also be established with the Navicella. It should be remembered that the draperies in the Isaac frescoes are comparable to those that appear in Beretta's painted copy of the mosaic. On the other hand, the only piece that has survived materially, the Vatican angel, is disappointing as far as the design of the vestment is concerned: although it appears to be more elaborately shaped than the Paduan vestments, it is hard to compare it with those of the Isaac frescoes. Now that Giotto's underdrawings on the cross have become visible through infrared photographs, common ground has become apparent at the level of the design. The preparatory drawing for the half-figure of John could have served as a basis for the creation of the Roman angel's drapery with mosaic tesserae, just as it could have served as a basis for the drapery of the Isaac frescoes and that of the cross, which were created with a brush. There are thus good reasons to date the *croce dipinta* to the period between 1298 (work on the Navicella in Rome) and 1301 (reception of Giotto's cross by Deodato Orlandi) and to assume that it is the work of a young master who had

452 Frithjof Schwartz presents the documents: F. Schwartz, *Il bel cimitero: Santa Maria Novella in Florenz (1279–1348): Grabmäler, Architektur und Gesellschaft*, Berlin and Munich 2009, pp. 427–456.

453 In the following section I draw on: M. Seidel, "Il crocifixo grande che fece Giotto": Problemi stilistici, in: *Giotto: La Croce di santa Maria Novella*, ed. M. Ciatti and M. Seidel, Florence 2001, pp. 65–157.

The Cross of Santa Maria Novella: Prerequisites 255

returned from the Eternal City and had been moulded by the art there, and who may have been intriguing, not least because of this, to his fellow citizens and the Dominicans, whose ideology included loyalty to the Curia.

When Giotto had left his home town again after only a few years to carry out another foreign commission in Padua, a sermon was delivered in Santa Maria Novella, in the presence of his cross, the subject of which would certainly have interested him from a professional point of view. Giordano da Rivalto, one of the great orators of the time, preached on Epiphany 1305 about the various media of divine revelation, using the Magi as an example. In the first place, Giordano said, it was necessary to honour the testimony of Holy Scripture, which gives an authorised account of the Magi and other holy persons. But:[454]

> *There is another great testimony about them, namely, the first paintings that came from Greece; for the paintings are the book of the laity and, moreover, of all people; because the paintings all originally stem from the saints. And since they had the most perfect knowledge imaginable, the figures of the saints were first made as they were, and that according to form, constitution, and type. For it came to pass that Nicodemus was the first to paint Christ on the cross on a beautiful panel in that type and form which Christ possessed, so that whoever saw the panel saw almost the whole event completely, so well was Christ painted in type and form. For Nicodemus stood by the Cross of Christ, when he was fastened there and when he was lifted up [...]. The saints made these paintings in order to give the peoples a more accessible idea of what had happened, so that these paintings, and especially the very old ones that came from Greece a long time ago, have the greatest authority.*

454 Giordano da Rivalto, *Prediche inedite del B. Giordano da Rivalto recitate in Firenze dal 1302 al 1305*, ed. E. Narducci, Bologna 1867, pp. 170–171: "Avenne ancora un'altra grande testimone, cioè le prime dipinture che vennero di Grecia di loro; onde le dipinture sono libro de' laici ed eziandio d'ogne gente; perocché le pinture vennono tutte da' santi primamente: acchiocché se ne potesse avere più compiuta conoscenza, si faceano le figure de' santi prima come erano, e nella figura, e nella condizione e nel modo. Onde si truova che Nicodemo dipinse Cristo in croce in una bella tavola, primamente a quella figura e modo che Cristo fu, che chi vedea la tavola, si vedea quasi tutto l'fatto pienamente, tanto era ben ritratta, secondo il modo e la figura, chè Nicodemo fu alla Croce di Cristo, quando vi fu posto e quando ne fu levato: e quella è la tavola onde uscì poi quel bello miracolo, onde si fa la festa del santo Salvatore. Così altresì troviamo che santo Luca dipinse la Donna nostra in sua una tavola ritratta, tutto appunto com'era, la quale tavola è oggi in Roma, e serbasi con grande divozione. Faceano i santi quelle dipinture per dare più chiara notizia alle genti del fatto: sicchè queste dipinture, e specialmente l'antiche, che vennono di Grecia anticamente, sono di troppo grande autoritade."

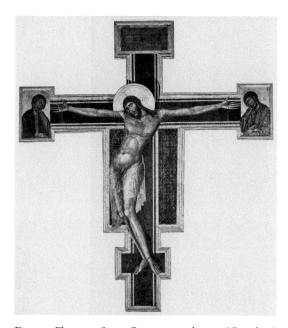

Fig. 137: Florence, Santa Croce: croce dipinta (Cimabue)

Nothing was new about this argument, neither the characterisation of the images as instruments of instruction for the laity, nor the attribution of a special authenticity to images that came from the Christian East; their originals, copied over and over again, were regarded as products of contemporary witnesses, one might say holy photo reporters. For the passage about the image of the Crucified, Giordano relied on a narrative concerning the Feast of the Exaltation of the Cross in the *Legenda Aurea*, which revolves around a miraculous "ymago domini crucifixi" made by the hand of Nicodemus.[455] What should have captivated Giotto more than that was the fact that his cross did not easily fit into the idea of being a reproduction of an authentic prototype.

Rather, Giordano's words would have been correct text for Santa Croce and the monumental cross there, which was also relatively new at the time (fig. 137).

Its authorship by Cimabue is plausible despite being founded on a slim body of evidence that goes back no further than the early 16th century. One can summarize the arguments as follows: On what basis, if not that of a local oral tradition, which would have corresponded in plausibility to the Giotto tradition present at Santa Croce at the same time (2.7.7), could Francesco Albertini have described the cross in his *Memoriale* as a work of Cimabue? The *terminus ante quem* for the cross is therefore autumn 1301, when Cimabue was active in Pisa according to documents, or his death in spring 1302.[456] The probable *terminus post quem* is the beginning of the new building of Santa Croce in 1295.[457] The cross with its dimensions of 3.90 by 4.33 metres would have been too large

455 *Legenda Aurea*, ed. Maggioni, pp. 934–935.
456 L. Bellosi, *Cimabue*, New York 1998, pp. 290–292.
457 Such a dating to Cimabue's late period was first suggested by Andreas Aubert: A. Aubert, *Die malerische Dekoration der San Francesco Kirche in Assisi: Ein kritischer Beitrag zur Cimabue Frage*, Leipzig 1907, p. 107. In contrast, Henry Thode argued for an early date: H. Thode, Studien zur Geschichte der italienischen Kunst im XIII. Jahrhundert: Guido da Siena und die toscanische Malerei des 13. Jahrhunderts, *Repertorium für Kunstwissenschaft*

The Cross of Santa Maria Novella: Prerequisites

for the modest predecessor church and – assuming its obvious use as a triumphal rood – would also have come too late. On the other hand, the panel could hardly have been erected in New Santa Croce before the second decade of the 14th century, because before then there was no part of the church ready for liturgical use.

This means that Cimabue's cross was intended for the new building, but was donated or commissioned long before the new building was in use – a situation that seems strange as long as one does not consider the cultic significance of the work: from the point of view of the laity, the triumphal rood was the most important image in a church and, in the case of Santa Croce, it represented, moreover, its dedication. Until the new building was partially ready for occupation, the cross must have been placed provisionally in Old Santa Croce. There, we assume, Cimabue's colossal *croce dipinta* was waiting to be transferred to the colossal new Franciscan church, the eastern parts of which were slowly rising from the foundations, when Giordano preached his sermon on the other side of the city in the Dominican church, which was also unfinished but already furnished and provisionally usable.

Unlike Giotto's cross, Cimabue's does in fact come from Greece in a sense, and viewers might discover in it a story that goes back through Byzantium to the time of Christ and Nicodemus. The strangely elegant swing of the hips, the arms spread out as if gesturing and the open hands, the head turned to the side with the eyebrows pointed toward the centre – all this reproduces, as is well known, the Middle Byzantine crucifixion icon and, at the same time, follows the mainstream of crucifixion images of Umbria and Tuscany since the middle of the 13th century.

The *croce dipinta* for the lower church of San Francesco in Assisi, donated by Elias and painted by Giunta Pisano in 1236, was probably decisive for the establishment of this type.[458] It has not been preserved, but everything suggests that it showed the Byzantine figure of the Crucified. This figure, which like a dancer performs a whole-body gesture expressing suffering, is as stirring as it is memorable, and corresponds to that mysticism of the Passion which was particularly popular among the Franciscans.[459] Nevertheless, it should not be addressed as a "Franciscan" type: Giunta's cross for San Domenico in

13, 1890, pp. 1–24, esp. 16. He was referring to a cross by Deodato Orlandi in Lucca dated 1288. This is still sometimes argued today. But one must not ignore how much Thode's knowledge of late Dugento painting fell short of the current state of scholarship: what he considered to be stylistic similarity must now be read as a question of type.

458 D. Campini, *Giunta Pisano Capitini e le croci dipinte romaniche*, Milan 1966. K. Krüger, *Der frühe Bildkult des Franziskus in Italien: Gestalt und Funktionswandel des Tafelbildes im 13. und 14. Jahrhundert*, Phil. Diss., Berlin 1992, pp. 158–167. S. Gieben, La croce con Frate Elia di Giunta Pisano, in: *Il cantiere pittorico della basilica superiore di San Francesco in Assisi*, ed. G. Basile and P. Magro, Assisi 2001, pp. 101–110.

459 Thode, *Franz von Assisi und die Anfänge der Kunst der Renaissance in Italien*, pp. 480–482.

Bologna, made a little later, also shows this type and the same is true of many other *croci dipinte* of the forties to the nineties, which were neither at home in a Franciscan nor in a Dominican church. It also spilled over into sculpture: Nicola Pisano's Crucifixion panel on the pulpit of the Pisa Baptistery shows the Byzantine image of the crucified Christ in a scenic context as a pantomime of suffering. Accordingly, around 1300 there was no reason to see in Cimabue's cross of Santa Croce a specifically Franciscan image, but rather one based on consensus and tradition. Those who knew of its Greek background also regarded it as authentic, following Giordano da Rivalto's argument.

All of this is absent from Giotto's cross, yet it may have been conceived as a strong response to the other. The outline and the relatively sparse pictorial decoration of the panel with a few half-figures indicate that its appearance was intended to be basically comparable with Cimabue's cross. (In both, a medallion with God the Father as a crowning element has been lost). The transparent loincloth is also a connecting element. As Anne Derbes showed, Cimabue had adapted it from a Byzantine crucifixion image.[460] In the East, the motif occurred occasionally without being the rule. In Cimabue and in Santa Croce it is to be understood based on the Franciscan discourse on nudity ("Nudus nudum Christum sequere"[461]), but, in Giotto and in the context of a Dominican church, it is a reference to the cross of Santa Croce. In size, Giotto's cross is well beyond the other: it measures 4.06 by 5.78 metres. We are dealing with the largest of the Italian painted crosses, which surpassed what had previously been the largest, namely that of Cimabue.

Those who want to understand this competition should not assume a contest of religious ideologies and thus a Dominican response to a Franciscan cult image. The rivalry was rather between two young and important Florentine convents: just as it was foreseeable around 1300 that the giant building of Santa Croce would surpass the building of Santa Maria Novella, which was already on a vast scale within the Florentine building tradition, Giotto's colossal cross was probably intended to eclipse Cimabue's enormous cross in return. It was a matter of effectively presenting the means for the souls' salvation that was offered in the two monasteries and, as a consequence, of attracting visitors, raising endowments and allowing the houses to flourish. It was precisely because the spiritual services and the clientele were essentially identical that made the images' appearance so important.[462] What could Giotto's cross give to the Florentines seeking salvation that Cimabue's cross could not?

460 A. Derbes, *Picturing the Passion in Late Medieval Italy: Narrative Painting, Franciscan Ideologies, and the Levant*, Cambridge 1996, pp. 27–34.

461 J. Châtillon, Nudum Christum nudus sequere: Note sur les origines et la significance du thème de la nudité spirituelle dans les écrits de Saint Bonaventure, in: *S. Bonaventura 1274–1974. Vol. 4: Theologia*, Assisi 1974, pp. 719–772.

462 D. Lesnick, *Preaching in Medieval Florence: The Social World of Franciscan and Dominican Spirituality*, Athens, Ga. 1989. In my opinion, this author overestimates the differences.

THE CROSS OF SANTA MARIA NOVELLA: A NEW IMAGE FOR THE FLORENTINES

Hardly anyone would call Giotto's cross the more beautiful of the two. Some beholder will even wonder how it happened that by Giotto's hands the harmonious and elegant appearance of the *croce dipinta*, created by Cimabue, disintegrated into a conglomerate of images held together more by the carpenter's work than by an aesthetic concept – indeed, we know from the investigations carried out during the last restoration that the carpentry was still being refined while under construction: the main panel with the velum was extended at the bottom, the panel for the feet lowered.[463] The processes of conception and execution thus intertwined and were characterised by improvisation. In the following, the premise is that this does not attest to a failure, but that Giotto's cross was intended to convey the sufferings of Christ in a fundamentally different and more argumentatively complex way. Perhaps one may call the concept a media-conscious one.

One astonishing aspect in the history of scholarship on the cross is how late its specific use of scripture, namely the text on the *titulus*, received attention (fig. 138). Unlike that in Cimabue's work, this is not the usual Latin inscription, but a trilingual one and, in fact, as was established in 2001, the earliest known trilingual inscription on a cross that is consistently correct. What is more, no serious older attempt is known, and it would take more than a century before further correct trilingual *tituli* were produced.[464] However, a trilingual *titulus* is required by the biblical text. In John (19:19–20) we read:

> *And Pilate wrote a title, and put it on the cross. And the writing was Jesus Of Nazareth The King Of The Jews. This title then read many of the Jews: for the place where Jesus was crucified was nigh to the city: and it was written in Hebrew, and Greek, and Latin.*

463 C. Castelli, M. Parri, and A. Santacesaria, Tecnica artistica, stato di conservazione e restauro della Croce in rapporto con altre opere di Giotto. Il supporto ligneo, in: *Giotto: La Croce di Santa Maria Novella*, ed. M. Ciatti et al., Florence 2001, pp. 247–272.

464 G. Sarfatti, A. Pontani, and St. Zamponi, Titulus Crucis, in: *Giotto: La Croce di Santa Maria Novella*, ed. M. Ciatti and M. Seidel, Florence 2001, pp. 191–202. G.B. Sarfatti, Hebrew Script in Western Visual Arts, *Italia: Studi e ricerche sulla storia, la cultura e la letteratura degli ebrei d'Italia* 13–14, 2001 (In memory of Giuseppe Sermoneta), pp. 451–547. Seidel, "Il cocifisso grande che fece Giotto", p. 75 points to the trilingual titulus of Giovanni Pisano's cross in the Opera del Duomo in Siena. However, no more can actually be seen there than the remains of a Greek inscription under the modern titulus INRI. How old and of what quality the corresponding Hebrew text was cannot be determined. Cf. G. Canocchi, M. Ciatti and A. Pandolfo, La scultura dipinta: Nota su alcuni restauri, *OPDRestauro: Quaderni dell'Opificio delle Pietre Dure e Laboratori di Restauro di Firenze* 3, 1988, pp. 29–41, esp. 33 and fig. 3 p. 32.

Fig. 138: Florence, Santa Maria Novella: Giotto's cross, detail: Titulus

The Gospel thus provided the wording of the inscription. The Latin version was available in the Vulgate and the Greek version was available wherever there was a Greek manuscript of the New Testament and someone who could read it, which was not often but may have been the case in Florence around 1300. A Hebrew text of the inscription did not exist. It had to be created through translation. Who had the necessary knowledge of Hebrew to do this? No Jews lived in Florence in the 13th and 14th centuries.[465] It has also been established that the letters reproduced by Giotto do not correspond to those used by his Jewish contemporaries in central Italy. The basis of the calligraphy is the Ashkenazic square script used by the communities in France and Germany, and also in the Veneto.[466] The translation and transcription of the words was therefore most likely done by a Christian whose Hebrew was grounded in a northern teaching tradition.

In the traveller and missionary to the Orient Fra Ricoldo di Montecroce (†1320), the Florentine convent had one of the few Christian scholars of this time who we know for certain had a knowledge of Hebrew. He demonstrated this in the third chapter of his *Libellus ad nationes orientales*, dated 1300, in which he dealt with central concepts of the Old Testament.[467] In his view, their lack of understanding was a barrier to the conversion of the Jews; it followed for him that theologians should learn Hebrew as a matter of principle. With this argument he seems to have convinced his brothers, because at the General Chapter in Piacenza in 1310, the Dominican Order declared its willingness to teach Hebrew in its schools.[468] In 1300 or 1301 at the latest,[469] Ricoldo returned from his long

465 N. Ben-Aryeh Debby, Jews and Judaism in the rhetoric of popular preachers: The Florentine Sermons of Giovanni Dominici (1356–1419) and Bernardino da Siena (1380–1444), *Jewish History* 14, 2000, pp. 175–200, esp. 180.

466 Kind information from Karl-Georg Pfändtner.

467 The oldest of the three surviving copies seems to be the one in Florence: BNCF, Conv. Soppr. C.8.1173, fol. 219r–244r. Emilio Panella edited the text: http://www.e-theca.net/emiliopanella/riccoldo2/adno.htm. Kurt Villads Jensen presented a synopsis: https://www2.historia.su.se/personal/villads-jensen/Riccoldo/0.introduction.pdf

468 C. Douais, *Essai sur l'organisation des études dans l'ordre des frères prêcheurs*, Paris and Toulouse 1884, p. 138, no. 6.

469 The terminus ante quem is 10 October 1301, when he appeared as a witness in Florence: St. Orlandi, *Necrologio di Santa Maria Novella*, 2 vols., Florence 1955, vol. 1 p. 310.

journey through Mesopotamia, Syria, and Palestine, which included an extended stay in Baghdad, where he studied the Koran. Back in Florence, he became the spiritual mentor of the same Riccuccio di Puccio who had donated a lamp to illuminate the cross before 1312 and who had left funds for its operation in his will (1.4.1). But whether Brother Ricoldo or another Dominican contributed the Hebrew version (already in the 13th century there were occasional recommendations to theologians of an at least passive mastery of this language)[470], the *titulus* reveals that Giotto's work was philologically supervised. The effort established a new form of truth, at least on the *titulus*. If in this case the image itself makes no claim to

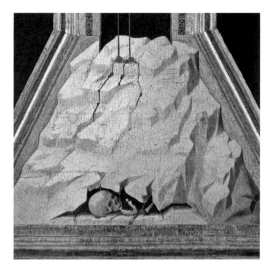

Fig. 139: Giotto's cross, detail: Golgotha

authenticity, the expectations about the audience that are suggested by the panel do. By presupposing the existence of a Greek- and Hebrew-speaking readership, the inscription simulates the historical Golgotha in the church.

This also raises the question of whether the portrayal of Mount Golgotha and its almost haptic staging in its own trapezoidal image field, appearing as a counterpart to the red rectangular field of the inscription, was only intended to provide a physically and visually stable foothold for the cross. Or was it intended primarily to make the sacred site of the event present in the most forceful, one might say icon-like, form possible (fig. 139)?[471] The examination of the carpenter's work shows that the Golgotha panel was probably a relatively late addition to the concept of the Santa Maria Novella cross – an *ad hoc* invention.[472]

For the figure of Christ himself, Giotto used a type common north of the Alps, which one might call the "Gothic" type in contrast with the "Byzantine" one known there as well. An example of the former is a canon page from a missal made in Paris in the middle of the 13th century for the church of Sainte-Geneviève (Paris, Bibliothèque Sainte-Geneviève ms. 90, fol. 167v):[473] bent hip, feet nailed one on top of the other, slack hands, and a face relaxed as if in sleep (fig. 140). Giotto was neither the first nor the only Ital-

470 Roger Bacon, *The "Opus Majus"*, ed. J.H. Bridges, London 1897, p. xlix.
471 M. Ciatti, The Typology, Meaning, and Use of Some Panel Paintings from the Duecento and Trecento, in: *Italian Panel Painting of the Duecento and the Trecento*, ed. V.M. Schmidt, New Haven and London 2003, pp. 14–29, esp. 19.
472 Castelli, Parri, and Santacesaria, Tecnica artistica,
473 R. Branner, *Manuscript Painting in Paris During the Reign of Saint Louis: A Study of Styles*, Berkeley 1977, Abb. 283.

Fig. 140: Paris, Bibliothèque Sainte-Geneviève, missal: canon page

ian artist of his time to work on this type. Nicola Pisano's Byzantine *crucifixus* on his Pisan baptistery pulpit was followed by a Gothic one on his Sienese cathedral pulpit; his son Giovanni then used only the Gothic type.[474] In Umbrian book and panel painting around 1300, a series of "Gothic" crucifixes is to be found. However, the evidence does not suggest that Giotto painted a cross for Assisi, as Luciano Bellosi believed, but rather, unsurprisingly, proves the topicality of transalpine patterns among other artists.[475] There are also "Gothic" crucifixes in late Dugento Rome: one could cite a fragment of the Crucifixion scene that belongs to the mural cycle of Sant'Agnese fuori le mura, which was inspired by French painting.[476] Finally, the only autochthonous Roman *croce dipinta*, a work almost completely deprived of its colour substance, which belonged to the furnishing of the church of Santa Maria in Aracoeli, also shows the Gothic type.[477] Pietro Toesca (1904) thought that it was a kind of precursor of the cross of Santa Maria Novella.[478]

474 Max Seidel seeks to deduce Giotto's type explicitly from Giovanni Pisano's crosses: Seidel, "Il crocifixo grande che fece Giotto", pp. 74–75.

475 L. Bellosi, Un crocifisso di Giotto nella basilica superiore di Assisi, in: *Il cantiere pittorico della superiore di San Francesco in Assisi*, ed. G. Basile and P. Magro, Assisi 2001, pp. 261–278. The date 1297 plays a certain role in Bellosi's argument. It is based on the alleged *terminus ante quem* for the Umbrian Missal in Florence, Bibliotheca Medicea Laurenziana (ms. Gadd. 7). It should be noted that this *terminus ante quem* was obtained from the absence in the calendar of Louis of France, canonised in 1297, and that it is a highly uncertain argument *ex silentio*.

476 S. Romano, *Eclissi di Roma: Pittura murale a Roma e nel Lazio da Bonifazio VIII a Martino V (1295–1431)*, Rome 1992, pp. 35–46, esp. fig. I, 2, 12. Cf. also p. 76 and fig. I, 12, 1: the fragment of a crucified Christ in San Marco, Rome, discussed there, however, belongs rather to the early Trecento.

477 I. Toesca, Una croce dipinta Romana, *Bollettino d'arte*, se. VI, 56, 1966, pp. 27–32.

478 In this context, the crucifixion scene in the dome mosaic of the Florentine Baptistery is also frequently cited, although documentary evidence and technical findings show that it is largely the product of a 15th century restoration. Schwarz, *Die Mosaiken des Baptisteriums in Florenz*, pp. 145–146.

The Cross of Santa Maria Novella: a new image for the Florentines

In the case of Giotto's cross in Santa Maria Novella, however, it was not so much the Gothic background of the figure that was the decisive visual argument as the way the figure was understood in comparison with Cimabue's cross. To put it in a nutshell: the pantomimic body (which spoke about suffering with gestures) was replaced by an anatomical body that was effectively speechless. What was abandoned in expression was replaced through presence. The only active element and thus the only movement that remains and gives the lifeless presence of the body a temporal dimension is the stream of blood that emerges from the side wound.

The Gothic type may have been predestined for such a turn away from rhetoric and towards the (meaningfully) silent presence of the body. But Giotto by no means developed the model in a straight line. If it is part of the Gothic *crucifixus* to be emaciated, Giotto's Christ in contrast has a full and impressive physicality. And this im-

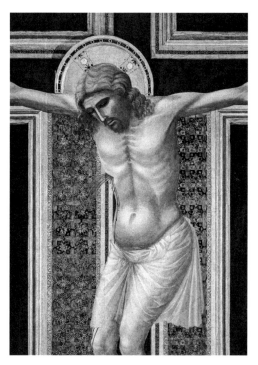

Fig. 141: Giotto's cross, detail: Christ's body

pression is partly due to Cimabue's model: among the conspicuous details of the cross of Santa Croce, which are derived neither from the Byzantine model nor from Giunta Pisano's pioneering adaptations, is the round belly, which is presented almost sensually by its lighting (fig. 141). The plasticity of this belly and of the entire body is probably owed to an encounter with the so-called Volume Style of late Byzantine painting, which Cimabue may have had in Rome, and also in Florence.[479] The belly reappears on Giotto's cross, whereby the problems of projection posed by Cimabue's model can hardly be overlooked: how to transfer the bulging belly of a stretched torso to the now bent body? The result is inconsistent and yet it is precisely at this point that Giotto's body of Christ achieves a haptic quality that determines the perception of the entire figure.

In the case of the hands, this quality even creates a trompe-l'oeil effect (fig. 142). Stretched and open hands belong to the Byzantine type, a motif that was often transferred to the Gothic type in Italy. Giotto adopted the hanging hands of the Gothic crucifixes, and transformed them: What can be read as gestural is eliminated. A spatial effect is intro-

479 Schwarz, *Die Mosaiken des Baptisteriums in Florenz*, pp. 56–94.

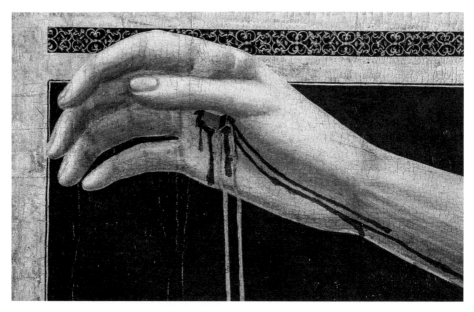

Fig. 142: Giotto's cross, detail: Christ's right hand

duced by a rotation around the horizontal axis. The thumb almost hides the nail of the cross, which nevertheless retains its status through its emphatically material representation. The impression is that we see the hands from below. And this is almost alarming when we actually stand beneath the cross. In this case, the visual effect is not undermined (which could also happen), but reinforced. Since after the restoration the cross was hung at a height of about four metres in the central nave of Santa Maria Novella, tilted slightly forwards, viewers experience how the hands virtually detach themselves from the painted surface and become part of the extra-pictorial reality.

Today's installation is probably similar to the original arrangement (pl. XIII). According to the liturgist William Durand, a position "in medio ecclesiae" was obligatory for a triumphal cross.[480] In larger churches, this meant a placement on, above or near the rood screen, so that the cross dominated the nave and could function as *the* cult image for the laity. Within the framework of the Dominican liturgy, it was also used by the monks when they left their choir stalls behind the rood screen after chanting and went into the nave. Then, as the *Ordinarium* of 1256 states, they should "bow before the cross which is

480 Guilelmus Durantis, *Rationale Divinorum Officiorum I–IV*, ed. A. Davril und T.M. Thibodeau (Corpus Christianorum, Continuatio Mediaevalis CXL), Turnhout 1995, p. 24.

The Cross of Santa Maria Novella: a new image for the Florentines 265

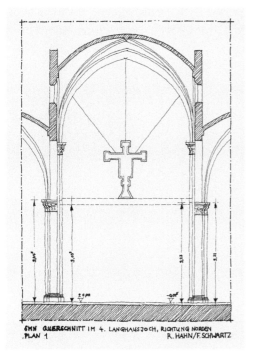

Fig. 143: Installation of Giotto's cross in Santa Maria Novella (reconstruction by Frithjof Schwartz)

Fig. 144: Havelberg, Cathedral: rood screen and triumphal cross

between the choir and the lay church".[481] The position between the second and third nave bays from the choir, where the rood screen stood in Santa Maria Novella until the 16th century, is therefore appropriate in terms of historical liturgy. However, it was probably a mistake to lower the cross to the height of the former rood screen platform. Frithjof Schwartz has identified traces of recesses at just over nine metres above ground level, i.e. at the level of the imposts of the arcades. This structure can only have served a beam that spanned the central nave. The cross did not stand on the rood screen, which was a very imposing architecture, but high above it on a transversal support[482] (fig. 143). On

481 "Omnes autem Fratres egregiendo [out of the choir] inclinent ante Crucem quae est inter Chorum et Ecclesiam laicorum." *Ordinarium juxta ritum Sacri Ordinis Fratrum Praedicatorum*, ed. L. Theissling, Rome 1921, p. 121.

482 F. Schwartz, In medio ecclesiae: Giottos Tafelkreuz in S. Maria Novella, *Wiener Jahrbuch für Kunstgeschichte* 54, 2006, S. 95–114. On the rood screen: M.B. Hall, The Ponte in S. Maria Novella: The Problem of the Rood Screen in Italy, *Journal of the Warburg and Courtauld Institutes* 37, 1974, pp. 157–173.

the screen itself were altars, adorned with pictures. Among them, on the right hand side on the altar of St. Louis, was a panel with a "San Lodovico", which was considered to be Giotto's work. This is what we read in the *Libro di Antonio Billi* and subsequently in Vasari (2.1.6, 9, 10).[483] Louis of Toulouse was canonised in 1317, and before that the Franciscan would hardly have been given an altar in a prominent place in a Dominican church. The rood screen, like the whole church, was gradually filled with worship sites and images, which was foreseeable, and accordingly it was wise to place the triumphal cross from the beginning in such a way that its effect would not be affected by their addition. A similar situation – an impressive rood screen with a triumphal cross high above it – was reconstructed in the Havelberg Cathedral (Brandenburg, fig. 144). The carved crucifixion group was created in the years after 1295.[484]

It is improbable that the lofty height of the cross in Santa Maria Novella made the hands painted by Giotto appear less real and the belly less voluminous. Much more likely was that a huge, heavy, dead body seemed to be hanging from a colossal cross-shaped panel "floating" above the nave and leaning slightly forward (three rings for suspension are preserved on the back). In contrast to the cross of Santa Croce, the outline of the cruciform panel and the body are compositionally decoupled, so that we can experience the body as detached from the panel. The appearance of the ensemble becomes complete once we take into account the oil lamp donated by Riccuccio, which used to be attached with an iron eyelet (which has been preserved) to the front of the cross beneath the feet of Christ. By means of a chain, the lamp could be lowered and refilled on the rood screen. It made the cross visible at all hours, and its light may also have added plausibility to the modelling of the body.

A further question is whether Giotto really painted the cross for the placement described above. Here, one can argue from the history of the building and its use, however sporadically it is documented. The part of the nave into which the former monk's choir projected from the transept was most likely built in the seventies and eighties of the 13th century and was under roof and usable by 1298 at the latest. This torso of the church was probably closed off by a dividing wall which was located where the rood screen would stand. In the following bay, built afterwards, there is a large door which formed the main entrance to the church from the town and also from Giotto's dwelling. The holy water font belonging to this portal, a donation by Pagno di Gherardo Bordoni, one of the richest inhabitants of the neighbourhood of San Pancrazio and *gonfaloniere* of the year 1298, bears the dates 1300 (on the base) and 1302 (on the basin).[485] Therefore, lay people were

483 J. Wood Brown, *The Dominican Church of Santa Maria Novella at Florence: A Historical, Architectural, and Artistic Study*, Edinburgh 1902, p. 120.

484 H. Muether, *Der Dom zu Havelberg*, Berlin 1954.

485 Wood Brown, *The Dominican Church of Santa Maria Novella at Florence*, p. 117. W. and E. Paatz, *Die Kirchen von Florenz: Ein kunstgeschichtliches Handbuch*, vol. 3 Frankfurt 1952,

The Cross of Santa Maria Novella: a new image for the Florentines 267

expected to enter the church at this point from 1302 onwards; by then the partition wall must have disappeared and a rood screen would have made sense. On the one hand, Giotto's work on the cross can be narrowed down to the years between 1298 and about 1301, on the other, it can be established that in Santa Maria Novella the most plausible time for the acquisition of a triumphal cross falls in the years between 1298 and 1302. This close chronological interlocking makes it probable that Giotto conceived the *croce dipinta* for the display that Frithjof Schwartz was able to reconstruct. It can even be assumed that Giotto collaborated on the conceptualisation of the installation.

Did the painter only have the Dominicans as partners in commissioning the work, or was there a donor? The commune is one option; its coat of arms with the red lily adorns the transversal arch in the vault above the rood screen, which the triumphal cross turned into a triumphal arch. However, the commune provided money for the construction of the church in 1295, 1297 and 1298, which would justify the coat of arms irrespective of the donation of the cross.[486] Likewise, the Laudesi confraternity may have acted as benefactor. They had donated the so-called Madonna Rucellai for Santa Maria Novella. We know this because the contract between the Laudesi and the painter Duccio from Siena, dated 1285, has been preserved.[487] Riccuccio di Puccio was a member of this brotherhood and, as is well known, in his will he provided for the perpetual illumination of the Madonna as well as the cross. A reason for this could have been that, like the Madonna, the cross had a special relevance for the Laudesi. But whether lay donors had a say or not, the spiritual interests of the laity must have been of importance in developing the work, since the triumphal cross was aimed at the lay area of the church. And there it transformed the space into Golgotha and made the crucified Christ physically present.

Suitable words to comment on the overwhelming appearance of the crucified body can be found in a popular hymn by Arnulf of Leuven (+1248), considered by some as a work of Bernard of Clairvaux, by others as one of Bonaventure: the *Rhythmica oratio ad unum quodlibet membrorum Christi patientis et a cruce pendentis*, also known under the title *Salve mundi salutare*.[488] The body of Christ, described as present in the text, is meditated on and interpreted limb by limb: feet, knees, hands, side, breast, heart, face. Two of the five stanzas dedicated to the feet read (*Ad Pedes*):

pp. 664–666. Schwartz, *Il bel cimitero*, pp. 176–212 und passim. DBI s.v. Bordoni, Gherardo (Z. Zafarana). The object was in the Bargello for a long time and returned to the church in 2017.

486 Paatz, *Die Kirchen von Florenz,* vol. 3, p. 666.

487 J.I. Satkowski, *Duccio di Buoninsegna: The Documents and Early Sources*, Athens, Ga. 2000.

488 *Patrologia Latina* 184, cols. 1319–1324. On Arnulf of Leuven: *Die deutsche Literatur des Mittelalters: Verfasserlexikon*, ed. K. Ruh et al., vol. 1, Berlin 1978, cols. 500–502.

Clavos pedum, plagas duras.	*The nails in your feet, the hard blows,*
Et tam graves impressuras	*and so cruel marks*
Circumplector cum affectu,	*I embrace with love,*
Tuo pavens in aspectu,	*Full of fear at the sight of you*
Tuorum memor vulnerum.	*Staring at your wounds.*
Dulcis Jesu, pie Deus,	*Sweet Jesus, loving God*
Ad te clamo licet reus:	*I cry to you, in my guilt*
Praebe mihi te benignum,	*Show me your grace,*
Ne repellas me indignum	*Do not turn away the unworthy*
De tuis sanctis pedibus.	*From your sacred feet.*

It provides a form of meditation that corresponds to the figures on the side panels of Giotto's cross (fig. 145, 146). Leaning back somewhat, Mary and John are absorbed in contemplation, making the sacrificed body the object of their reflection. Their gaze seems to be especially focused on Christ's hands. As we see these from below, so the two look at them from above., The following stanzas from the *Rhythmica oratio* might describe what they think in Giotto's and the audience's imagination (*Ad manus*):

Manus sanctae, vos amplector,	*Holy hands, I embrace you,*
Et gemendo condelector;	*and, lamenting, I delight in you,*
Grates ago plagis tantis,	*I give thanks for the gruesome wounds,*
Clavis duris, guttis sanctis,	*the hard nails, the holy drops,*
Dans lacrymas cum osculis	*and kissing I shed tears.*
In cruore tuo lotum,	*Washed in Your blood*
Me commendo tibi totum:	*I wholly entrust myself to You;*
Tuae sanctae manus istae	*May these holy hands of Yours*
Me defendant, Jesu Christe,	*Defend me, Jesus Christ,*
Extremis in periculis.	*In the final dangers.*

At the same time, the faces of Mary and John only sparingly hint at an inner life – and challenge the viewer precisely because of this. The comparison once suggested between the Mary panel on the cross and Leonardo's Mona Lisa, a painting that is similarly emotionally demanding and ambiguous, does not seem entirely absurd when viewed in this light.[489]

The side panels, relatively small in scale, with the large gold areas above the heads, recede behind the crucified body, but also behind the titulus and the Golgotha rock.

489 C. Saguar Quer, Los "Boni maestri di Leonardo", *Goya*, 2002, pp. 227–232.

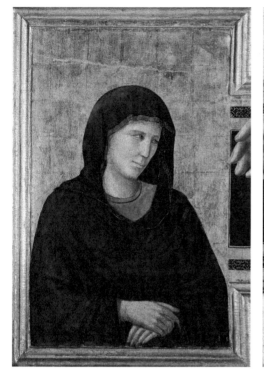 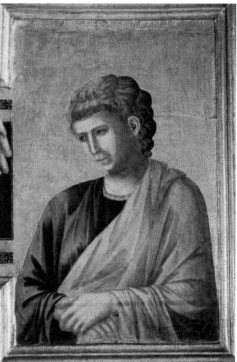

Fig. 145: Giotto's cross, detail: Mary Fig. 146: Giotto's cross, detail: John

This contrasts very clearly with the cross of Santa Croce, where Cimabue matched the appearance of Mary and John to the crucified Christ as closely as possible in format and expression.

It is also noticeable that Giotto's icons of inwardness are the only elements of the Santa Maria Novella cross that did not appeal to the painter Deodato Orlandi or his patron. Deodato's variant, created in 1301, shows half-figures gesticulating on the side panels (fig. 136). With Mary's gesture pointing with her right hand to the pierced right hand of her son, mirroring its posture, the painter even succeeded in a brilliant formulation. Nevertheless, the comparison makes clear above all the peculiarity of Giotto's underlying idea: his figures are simultaneously autonomous and withdrawn in terms of their presence, icons (images) next to a (real) dead body. Besides, they seem open to our empathy, which, however, does not allow us to experience their inner lives, but mirrors and confirms our experience of the dead Christ.

THE MADONNA OF SAN GIORGIO ALLA COSTA

To the question of what was the greatest artistic event in the Florence of Giotto's childhood, the following answer seems obvious: the Madonna Rucellai by the Sienese painter Duccio di Buoninsegna (considered by the Florentines since the 16th century to be the work of Giotto's alleged teacher Cimabue, and thus the work of a Florentine).[490] Moreover, it was not only a spectacular novelty, but probably also the largest panel painting in Florence and in Santa Maria Novella until Giotto created his cross (fig. 147). And just as Giotto's cross is the largest of the numerous central Italian *croci dipinte*, so is Duccio's Madonna of 1285 the largest of the equally numerous central Italian Madonna panels. Giotto's cross, including the lost crowning medallion with the image of God, was over 6 metres high; the Madonna Rucellai measures 4.50 metres. What also connects the two cult media is their homelessness within the current church space, which was remodelled in the 16th century. The impossibility of providing an appropriate place for the image finally drove Duccio's Madonna, last placed in the Cappella Rucellai, out of the church in 1948, and it would not have taken much for Giotto's cross to have followed her to the Uffizi.

The use of the Madonna panels, which became more and more frequent and monumental in the course of the 13th century, is an open problem. It now seems doubtful that they regularly decorated altars, as Hellmut Hager and Henk van Os assumed.[491] According to Bram Kempers, Duccio's Madonna, like Giotto's cross, was conceived and used as a triumphal arch image.[492] This would fit their enormous size and the fact that the donor was a brotherhood of laymen. Perhaps, then, we should imagine Giotto's cross and Duccio's Madonna Rucellai side by side, high above the rood screen, each illuminated by Riccuccio's lamp oil (the endowment in the will in fact names both images as beneficiaries) and accompanied, in this case, by another image that complemented the odd couple to form a triad of pa-nels similar to that depicted in one of the frescoes of the Legend of Saint Francis in Assisi (fig. 175). Another possibility is that Duccio's painting had its home in the area of the church where it is first documented in 1421, where Vasari

490 H.B.J. Maginnis, *Painting in the Age of Giotto: A Historical Reevaluation*, University Park 1997, pp. 64–78.

491 H. Hager, *Die Anfänge des italienischen Altarbildes: Untersuchungen zur Entstehungsgeschichte des toskanischen Hochaltarretabels*, Munich 1962. H. van Os, *Sienese Altarpieces 1215–1460: Form, Content, Function. Vol. 1: 1215–1344*, Groningen 1984.

492 B. Kempers, *Kunst, Macht und Mäzenatentum: Der Beruf des Malers in der italienischen Renaissance*, Munich 1989, pp. 59–64. See also: L. Bellosi, The Function of the Rucellai Madonna in the Church of Santa Maria Novella, in: *Italian Panel Painting of the Duecento and the Trecento*, ed. V.M. Schmidt, New Haven and London 2003, pp. 146–159. State of research on the Madonna Rucellai: *La Maestà di Duccio restaurata* (Gli Uffizi. Studi e Ricerche 6), Florence 1990.

probably came across it and where the panel remained, to some extent, when it was transferred to the Rucellai chapel in the 16th century: in the right arm of the transept next to the entrance to the chapel of St Gregory. Endowments prove that the Laudesi had a special interest in this chapel. In the chapel and in the transept in front of it, there would have been enough space for gatherings of the brotherhood. If one imagines the Madonna as the addressee of the Marian hymns sung by the Laudesi at their congregations, this position also seems more favourable than the one at a lofty height above the rood screen.[493]

Did Giotto, when conceiving the cross, compete with Duccio's panel? It can be assumed that this work had set standards in Florence that accompanied the young Giotto to Rome and Assisi, and influenced his interpretation of the paintings of Torriti and Cavallini. At least the ornamentation of the *tabellone* behind Christ's body can be cited as an indication of a direct reaction: More clearly than in Cimabue's cross, the purple-green-gold patterned surface with the light hem gives the impression of an intricately woven fabric. This and the Arabic-like star ornament are reminiscent of the throne velum of the Madonna Rucellai. As in the Madonna Rucellai, there are also pseudo-Arabic inscriptions as ornamental borders, which Giotto used to decorate the frames. Such motifs ensured that the cross did not fall short of Duccio's painting in terms of material splendour.

Fig. 147: Florence, Uffizi: The Madonna Rucellai (Duccio)

493 I. Hueck, La tavola di Duccio e la Compagnia delle Laudi di Santa Maria, in: *La Maestà di Duccio restaurata*. Gli Uffizi. Studi e Ricerche 6, Florence 1990, pp. 33–46. A Reisenbichler, *Madonna sancta maria che n'ai mostrato la via: Die großformatigen Tafelbilder der thronenden Madonna in der Toskana des Duecento*, Phil. Diss., Vienna 2006. A. de Marchi, Duccio e Giotto, un abbrivo sconvolgente per la decorazione del tempio domenicano ancora in fieri, in: *Santa Maria Novella: La basilica e il convento. I: Dalla fondazione al tardogotico*, ed. A. de Marchi, Florence 2015, pp. 124–155, esp.142–146.

Fig. 148: Florence, Museo Diocesano di Santo Stefano al Ponte: Madonna (Giotto)

The Madonna of San Giorgio alla Costa

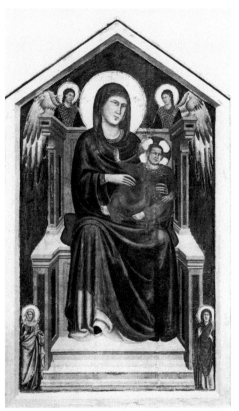

Fig. 149: Florence, Santi Simone e Giuda: St. Peter Enthroned (unknown painter)

Fig. 150: Florence, Santa Margherita in Montici: Madonna (unknown painter)

Duccio's panel was a benchmark in the field of Madonna panels for decades and also served Giotto as a model for his depictions of the Virgin on her throne. The Madonna from the church of San Giorgio alla Costa (fig. 148) is relatively weakly anchored in Giotto's oeuvre by written tradition, namely by Ghiberti's mention of a "tavola" created by Giotto in this church (2.1.4). On the other hand, it is stylistically so close to the cross of Santa Maria Novella that it can be treated without reservation as a work of our painter from the pre-Paduan period. This is how it was classified by Robert Oertel in 1937. The St. Peter panel from the Florentine church of San Pier Maggiore (now in Santi Simone e Giuda), dated 1307, is obviously a successor work, which confirms Oertel's assessment (fig. 149). Neither the importance of the small collegiate and parish church of San Giorgio, located on the left bank of the Arno in the shadow of the high medieval city wall and today replaced by a new Baroque building, nor the size of the panel suggest that Giotto entered into a competition with Duccio's Madonna, similar to his competition with Cimabue over crosses. The panel measures 1.80 metres by 90 centimetres in the trimmed state, but still includes traces of the crowning pediment at the top. Presumably, the Madonna

in the church of Santa Margherita in Montici, not far from Florence, is an adaptation of Giotto's composition and gives an impression of the untrimmed state of the painting (fig. 150). This would mean that the panel was not much more than 2 meters high and thus hardly more than half as high as Duccio's giant Madonna. However, it is connected to Duccio's Madonna, among other things by the magnificently woven and green-dominated throne velum with pseudo-Arabic inscription border.[494]

If one assumes that gazes and gestures constitute a kind of text that addresses the viewer, then Duccio's and Giotto's Madonnas tell him or her something very similar. Both times the serious gaze of the mother meets us somewhat from below. She has many things to reproach the viewer for, but does not point us to her Son, who will redeem these sins with his martyrdom. (This means, she does not perform the familiar hodegetria gesture, such as Cimabue's Madonna from Santissima Trinita.) Rather, the decidedly filigree hand rests, one might say possessively, on Christ's knee. (It does not hold the foot either, as on Coppo di Marcovaldo's Madonna panels, nor does the hand protectively approach Christ's upper body, as on Duccio's Maestà for Siena Cathedral.) Christ, for his part, is indifferent toward Mary, but speaks in a tense posture. The outstretched right foot shows in both pictures that the child is not to be perceived as passively sitting still. While Duccio's Christ seems to be giving an order with an expansive gesture to the right, Giotto's Christ focuses frontally on the viewer and teaches him; the scroll clearly indicates that he is teaching.

In both panels we are faced with a mother who does not make pacts with us, but puts us in the evil role of needing her son's sacrifice. That people are not only simply pitiable, but also ungrateful – that above all! – and cruel, is one of the *topoi* of Lauds as sung by confraternities.[495] We can sense this attitude in Duccio as well as in Giotto. In Giotto's work, however, the autonomy of the characters and the confrontation with the viewer is taken a step further. The stronger frontality of Mary's face and the form of Christ's behaviour contribute decisively to this. Equally important, however, is the heightened presence of the actors. In Duccio's work, the presence of the holy persons is programmatically mediated by the angels. They present the throne along with those on it – a staging that would go well with the picture's placement on a *tramezzo* beam high above the heads of the faithful. At the same time, the motif suggests something of a miracle. Thus, Duccio marked what had been handed down to him as the image of Our Lady, whether by his teachers or by St Luke, as a divine gift, thereby lending it additional authenticity. In con-

494 *La Madonna di S. Giorgio alla Costa di Giotto*, ed. M. Ciatti and C. Frosinini, Florence 1995, fig. XII p. 51.

495 L. Boscolo, Echi degli improperi liturgici del Venerdì santo nel repertorio laudistico, in: *Il teatro delle statue: Gruppi lignei di Deposizione e Annunciazione tra XII e XIII secolo*, ed. F. Flores d'Arcais, Milan 2005, pp. 161–188, esp. 172–173.

trast, Giotto's representation is characterised by belonging to a defined place. This can be seen in the throne, which is neither transported nor could have been transported. It is not a carpenter's work, as had been usual in Florence and Tuscany when depicting thrones for the Madonna until then, but rather an architectural object. That the two angels touch it demonstratively does not give credence to its status as a piece of furniture sent from heaven (as in the Madonna Rucellai and its successors), but rather attests merely to the presence of the angels.

Seen from above, the white marble surfaces of the side pieces of the throne bring us close to the figures. The crocketed pediment of the backrest was so important to the painter that he staged the emergence of its top above Mary's nimbus. The motif is reminiscent of the papal throne in the apse of the upper church of San Francesco in Assisi. In any case, Gothic state furniture is intended, which could be classified as a Roman bishop's throne. The painted Cosmatesque work, which appears similarly in the paintings of the Isaac Master complex in Assisi, unmistakably refers to artistry in Rome.

In general, the Madonna of San Giorgio can be characterised as a decidedly Roman adaptation of the Madonna Rucellai. The fact that Giotto used an architectural throne corresponds to Roman customs in the representation of the Virgin during the years around 1300. It is worth mentioning the Madonna frescoed by Cavallini on the tomb of Matteo d'Acquasparta († 1302) in Santa Maria in Aracoeli and the likewise painted Madonna in the so-called Templum Divi Romuli, as well as the Madonna mosaic in San Crisogono and the Madonna on the tomb of Pandolfo Savelli in Santi Bonifacio ed Alessio, dated 1296, which only survives in an 18th century engraving.[496] The large, round rather than oval face of Mary with the relatively wide open eyes, whose gaze rests on us, also proves to be Roman (fig. 151). Although Giotto's Virgin may lack the magic of the gaze of the Madonna Rucellai, the contact she establishes with the viewer is immediate; the orientation of her head towards the viewer underlines this. Behind this is a type for Mary used by Torriti, which he applied in the Coronation of the Virgin in Santa Maria Maggiore, but which also occurs in the Deesis Vault in Assisi and on the enthroned Madonna of the Templum Divi Romuli, and which can be traced back to the "icon" of Santa Maria del Popolo; this panel seems to be a generation older and belongs to the highlights of Roman painting of the 13th century[497] (fig. 152). Giotto's face of the Virgin is more elab-

496 S. Maria in Aracoeli: Hetherington, *Pietro Cavallini*, pp. 59–65. Templum Divi Romuli, San Crisogono, and Santi Bonifacio ed Alessio: P.C. Claussen, *Die Kirchen des Stadt Rom im Mittelalter 1050–1300*, vol. 1, Stuttgart 2002, pp. 382, 408–409 and 216–218.

497 I. Hueck, Der Maler der Apostelszenen im Atrium von Alt-St. Peter, *Mitteilungen des kunsthistorischen Institutes in Florenz* 14, 1969, pp. 115–144, esp. 139–141. S. Antellini, A. Tomei, C. Caldi, and F. Jahier, *Filippo Rusuti e la Madonna di San Luca in Santa Maria del Popolo a Roma: il restauro e la nuova attribuzione di un capolavoro medievale.* Exh. cat. Rome, Milan 2018.

Fig. 151: Florence, Museo Diocesano di Santo Stefano al Ponte: Madonna, detail (Giotto)

Fig. 152: Rome, Santa Maria del Popolo: Madonna di San Luca, detail

orate than these and therefore seems more credible. But it is its Roman design that sets it apart from everything that had so far been created in response to Duccio's Byzantine-inspired image of the Virgin in Florence.

Does Giotto pose curial authority against Luke's authority in Mary's physiognomy? It may be that it was the authority acquired by Giotto through his Roman activity that made his image acceptable to the Florentines as an alternative to Duccio's, but, in the case of the panel itself, it seems that it is not so much authority that matters as presence. Unlike in the case of the crucified Christ of Santa Maria Novella, however, it was not only a matter of physical presence, but also of emotional presence, the presence of the gazes. In today's reduced state of the panel, mother and child seem to approach the viewer. If the Madonna of Santa Margherita in Montici is on the whole a roughly faithful copy of Giotto's picture, this impression may originally have been even stronger (fig. 150). In the foreground, on either side of the throne, are two small figures of saints, which are even smaller than the angels behind the throne. If they also existed in the Madonna of San Giorgio alla Costa, they probably represented the two saints to whom the church was originally dedicated, George and Mamilianus. In the Madonna of Montici, the small-format foreground creates the effect that the highly sacred persons appear distant and close at the same time, while the impression of proximity prevails and a dynamic component unfolds. It is hardly a coincidence that this phenomenon is reminiscent of the dwarf bench in the Isaac scenes as well as of the fisherman and the harbour architecture in the Navicella.

SUMMARY: FROM PRESENCE TO IMAGE

The idea that the Isaac Master was Giotto's teacher or role model is attractive insofar as it would allow us to measure both the considerable distance between the Isaac frescoes and their context in Rome and Assisi as well as the distance between these frescoes and Giotto's work in Padua, which is no smaller. In terms of stylistic evidence, however, this would only be plausible if the authorship of the Santa Maria Novella cross could be taken from Giotto and given to this painter, and this is impossible in view of the very dense historical evidence for the *croce dipinta*. The cross binds together the Isaac Master complex and Giotto's oeuvre. Thus, instead of a great anonymous master, we are confronted with an astonishingly independent early oeuvre – consistent in the details of its formal language, despite a wide technical range: wall painting, mosaic, panel painting. It was produced within a few years before and around 1300, partly for clients in Rome and partly for clients in Florence, who posed very different requests to which Giotto reacted with flexibility. Where there was doubt, however, the Roman standards seem to have been binding for him and what can be discerned in terms of learning experience clearly points to Roman painting of the nineties. Nevertheless, the impression of autonomy dominates – in comparison not only with Torriti, with whose workshop Giotto was probably associated, but also with Cavallini, from whom he borrowed many ideas that were capable of being developed.

Against the backdrop of the Roman as well as the Florentine art scene – for Florence, in addition to Duccio's Madonna, Cimabue's activity and the more recent mosaics in the dome of the Baptistery should be mentioned – Giotto's early works are distinguished by giving the figures a physical presence hitherto unknown in the medium of painting. This is helped by the drapery style, rich in small forms, which defines the roundness of the bodies accurately so that they never appear "puffed up" and fantastic, as is so often the case in late Byzantine painting. The extent to which plasticity can be specified is shown by the cloak of the Madonna of San Giorgio alla Costa, whose haptic presence is hardly surpassed by the drapery studies of Quattrocento artists such as Ghirlandaio or Leonardo. One would be inclined to speak of a *sculptural* quality, were it not for the danger of reviving old speculations about Giotto and the sculptor Arnolfo di Cambio or about Giotto and French Gothic sculpture.[498] Young Giotto is certainly not "influenced" by sculpture,

498 Giotto and Arnolfo: A.M. Romanini, Arnolfo all'origine di Giotto: L'enigma del Maestro di Isacco, *Storia dell'arte* 65, 1989, pp. 5–26 and numerous other contributions by the same author. Giotto and Gothic sculpture: A.L. Romdahl, Stil und Chronologie der Arenafresken Giottos, *Jahrbuch der königlich preußischen Kunstsammlungen* 32, 1911, pp. 3–18, K. Bauch, Die geschichtliche Bedeutung von Giottos Frühstil, *Mitteilungen des kunsthistorischen Institutes in Florenz* 7, 1953–1956, pp. 43–64 and building on this: C. Gnudi, Su gli

but he gives his figures a physicality that we associate more with sculpture than with the painting of the time – including Giotto's painting in Padua.

Beyond the drapery forms, this sense of presence is created partly with means that have long been in use and are therefore easily understandable to us, and partly with means that seem unfamiliar today because they never found their way out of Giotto's early work. Among the easily comprehensible and promising means is a systematic approach to spatial projection that would lead to perspective and photographic optics and will one day assign the viewer's eye a fixed place in relation to the totality of the pictorial objects in the picture. Giotto seems to have learned the basics from Cavallini, whose precedents can in turn be traced back to the murals of the Capella Sancta Sanctorum. The most advanced form of application of these means was their combination with late Byzantine architectural fictions, as can be seen in the Vault of the Doctors in Assisi. These structures demand a great number of details to be shown in perspective if they are to be truly spatially legible and have an impressive effect. The fact that Giotto occasionally wove representations of real buildings into such structures, thus speculating on the effects of recognition was likewise based on Roman art; examples in Cavallini and Torriti have already been discussed. This continued in the Arena Chapel and, like perspective, is among the classic means of establishing credibility and concreteness in the visual media of the modern era.

But presence is also created by what we consider to be unrealistic differences in size: important pictorial objects are brought suggestively to the viewer across a defined foreground (or should we say: the viewer's eye is drawn to these objects?). In the case of the Isaac scenes and the Navicella, these foreground phenomena – exemplified by the dwarf bench and the toy harbour – form an almost unbridgeable contrast to perspective as we understand it in the light of Renaissance painting and of photography. One may speak of a "perspective of meaning" ("Bedeutungsperspektive"), but one must not forget that the result primarily creates visual experiences – of proximity and distance, intensity and marginality, for example.

So far unmentioned is the means of lighting. In the Isaac pictures, Giotto used light wherever there were forms that could appear three-dimensional (pl. XI, XII). There is no light direction in the sense of the painter considering where a light source could be located and how this would affect the appearance of the modelled surfaces. The effect is that of a relief made of figures and drapery, which bulges out of the shadow of the architectural box and into the bright church space. The same applies to the Madonna of San Giorgio alla Costa (fig. 148). There, all the structures close to the viewer are modelled with light and surrounded by a darkened environment. From this they rise and project

inizi di Giotto e i suoi rapporti col mondo gotico, in: *Giotto e il suo tempo. Atti del congresso internazionale per la celebrazione del VII centenario della nascita di Giotto (Assisi – Padova – Firenze 1967)*, Rome 1971, pp. 3–23.

into the real world. On the cross of Santa Maria Novella, on the other hand, there seems to be a veritable regimen of lighting (pl. XIII). The modelling light hits the rock, the body and the faces quite consistently from the left. In this case, Giotto may have seen a risk in the fact that the real light in the clerestory changes dramatically during the day: The church is oriented to the north, which means that in the morning practically all the light comes from the right, in the afternoon from the left. At night (when the vigil was held) all the light came directly from below, namely from Riccuccio's lamp. The consistent illumination from the left within the picture could serve to counteract this situation. At the same time, this would be a step in the direction of taking real light into account. In any case, the dramatic chiaroscuro and the shimmer on the surface of Christ's skin unfold great sensual power, also at times when the painted light situation does not match the real situation in the nave.[499]

The suggestion here is that the young Giotto's strategy for representation should be understood as follows: it aims to bring the subject represented before the viewer's eyes in such a way that it occupies as prominent a place as possible in our perception – a place that makes it compete with the real things around us. This explains why it was not enough for the painter to create relief-like bodies that bulge out of the picture plane, as is typical of late Byzantine art and its reception, especially in Torriti's mosaics; nor did he apparently aim to place the figures in an independently designed space, as it would emerge later as the space of perspective. Rather, the young Giotto created bodies in spatial situations that were developed around them. Their relationship to real space was left open. In this way, the viewers have opposite them not an image, but the volume of the depicted object, which unfolds simultaneously behind and in front of the surface coated with paint. What the young Giotto depicts thus has presence insofar as it relates to the reality in which the viewer lives – it complements our world and at the same time involves us in the simulated reality of the pictorial objects.

One of the fundamental concepts of the Christian doctrine of images is to recognize the difference between image and archetype as a difference between two realities. The image is real insofar as it is matter worked on by artists and insofar as it represents something; what is unreal is what appears in it: the object – that which is represented. The archetype, on the other hand, is real as part of God's creation, which encompasses both the world inhabited by the beholder and the world beyond populated by the saints. Its appearance in the image is unreal. For Giotto's contemporaries, the liturgist William Durand formulated these connections in a verse on the image of Christ:[500]

499 I had the opportunity to discuss these issues with Gerd Micheluzzi.
500 Guilelmus Durantis, *Rationale Divinorum Officiorum* I–VI, p. 35.

Effigiem Christi qui transis pronus honora,
Non tamen effgiem sed quod designat adora.
Esse Deum ratione caret cui contulit esse
Materiale lapis effigiale manus.
Nec Deus est nec homo presens quam cernis ymago
Sed Deus est et homo quem sacra figurat ymago.

Honour the image of Christ as you pass, bowing deeply,
Worship not the image, however, but him it represents.
It is contrary to reason to say that an image in stone
Shaped by the hand of man, should be God.
The picture you see is neither God nor man;
Yet God and man is he whom the sacred picture represents.

If William had addressed an image maker instead of an image user, he would probably have had to say: make clear that an image is an artefact and not the sacred person him- or herself! Otherwise the viewers might be in danger of mistaking the picture for the archetype.

Another important concept in the Christian doctrine of images is that images have a function in propagation.[501] Around the middle of the 13th century, Bonaventure speaks about this as follows:[502] "The introduction of images in the church was not done without a sensible reason. In fact, they were introduced for three reasons: It happened [first] because of the ignorance of the ordinary people, [second] because of the indolence of the affects and [third] because of the weakness of the memory." Not much later, Thomas Aquinas clarified Bonaventure's second reason in this way:[503] "To excite the affect of devotion, which is more effectively stimulated by what is seen than by what is heard." Instead of "exciting the affect", one could speak of intensity.

501 In the following, I draw on: F. Büttner, Vergegenwärtigung und Affekte in der Bildauffassung des späten 13. Jahrhunderts, in: *Erkennen und Erinnern in Kunst und Literatur*, ed. D. Peil and W. Frühwald, Tübingen 1998, pp. 195–213.

502 Bonaventura, *Commentaria in quatuor libros Sententiarum Magistri Petri Lombardi*, in: id., *Opera Omnia*. 10 vols, Quaracchi 1882–1902, vol. 1–4, esp. vol. 3, p. 203 (lib. III, dist. IX, art. I, quaest. II): "... imaginum introductio in Ecclesia non fuit absque rationabili causa. Introductae enim fuerunt propter triplicem causam, videlicet propter simplicium ruditatem, propter affectum tarditatem et propter memoriae labilitatem."

503 Thomas Aquinas, *Commentum in tertium librum sententiarum Magistri Petri Lombardi*, in: id., *Opera Omnia*, ed. S.E. Fretté, 32 vols., Paris 1871–1880, vol. 9 p. 155 (lib. III, dist. IX, quaest. I, art. II): "... ad excitandum devotionis affectum qui ex visis efficacius incitatur quam ex auditis."

Summary: From Presence to Image

Bringing the two ideas together, the real art of Christian image-making is therefore to "captivate" users emotionally through something that is nevertheless only an image in their eyes and is thus characterised by the visual presence not only of what is depicted but also of what it is that depicts it, i.e. the material and means of depiction. From these requirements, the dialectic of Cimabue's cross, for example, can be accounted for in this way (fig. 137): the authentic appearance of the person portrayed (based, as we have heard, on St. Nicodemus' visual documentation) as a beautiful pantomime of suffering that speaks to the heart – but which is clearly an artefact: an artfully painted surface. In the reality of the viewer, it manifests itself neither as God nor as man, but as a wooden panel that merely evokes ideas about God and man and thus steers them in the pastorally desired direction. The cross can be described as a pictorial object in which what represents (wooden panel, colour, painting, artistry) is as present as what is represented (Christ). But Giotto's cross of Santa Maria Novella (as well as, to varying degrees, every other early work of our painter) seems to leave behind the frame of this discourse. His one-sided argument of presence (which considers mainly what is represented and suppresses the visibility of the means) touches the delicate borderline between the reality of the image on the one hand and that of the archetype on the other (pl, XIII).

However, this argument is also not alien to the theological discourse on images: Bonaventure, for example, adds to the above-quoted remarks on images and their function:[504]

> *The images were introduced because of the indolence of the emotions, so that people who are not inspired to devotion to what Christ has done for us, as long as they only hear about it, may at least be inspired to devotion when they see it with corporal eyes almost present* (tamquam praesentia) *in figures and pictures.*

And Roger Bacon wrote in his Opus Maius, composed around the same time, inspired by ideas of preaching and mission:[505]

504 Bonaventura, *Commentaria in quatuor libros Sententiarum Magistri Petri Lombardi*, p. 203: "Propter affectus tarditatem similiter introductae sunt, videlicet ut homines, qui non excitantur ad devotionem in his quae pro nobis Chrisus gessit, dum illa aure percipiunt, saltem excitentur, dum eadem in figuris et picturis tamquam praesentia oculis corporeis cernunt."

505 Roger Bacon, *The "Opus Maius"*, pp. 210–211, 232–233 (translation): «Cum igitur opera artificialia, ut arca Noae, et tabernaculum cum vasis suis et omnibus, atque templum Salomonis et Ezechielis et Esdrae et hujusmodi alia pene innumerabilia ponantur in scriptura, non est possibile ut literalis sensus sciatur, nisi homo ad sensum habeat haec opera depicta, sed magis figurata corporaliter; et sic sancti et sapientes antiqui usi sunt picturis et figurationibus variis, ut veritas literalis ad oculum pateret, et per consequens spiritualis, O quam ineffabilis luceret pulchritudo sapientiae divinae et abundaret utilitas infinita, sic haec geometricalia, quae continentur in scriptura, figurationibus corporalibus ante nostros

282 Giotto avant Giotto: Works before and around 1300

> *Since artificial works, like the ark of Noah, and the temple of Solomon and of Ezechiel and of Esdras and other things of this kind are placed in Scripture, it is not possible for the literal sense to be known, unless a man have these works depicted in his sense, but more so when they are pictured in their physical forms; and thus have the sacred writers and sages of old employed pictures and various figures, that the literal truth might be evident to the eye, and as a consequence the spiritual truth also. Oh how the indescribable beauty of divine wisdom would shine and infinite profit would accrue, if this geometry, which is contained in the Scriptures, were put before our eyes as physical figures. For by these means the evil of the word could be swept away by a flood of grace.*

The author goes on to say that in this case it would be as if the viewers were lifted up by the flood together with Noah and his sons, and as if they were guarding the Tabernacle together with the people of Israel in the desert.

Bacon's text also makes clear how an artificial presence may be combined with a kind of mystical experience. Such an experience of unmediated immediacy can be provoked in two ways, firstly by the medium describing what the contents are that are to be recalled, and secondly by simulating the trigger for a specific experience. The first possibility involves a narrative moment. On this basis, the carved Christ-John groups, for example, which were created north of the Alps in the 14th century and are regarded by art historians as the epitome of mystical imagery, tell of the feelings of the protagonists, which can be directly replayed in the viewers perception.[506] Cimabue's cross can be understood as an early form of this kind of image; the painter shows three persons who speak of suffering both pantomimically and physiognomically and thus clearly enough. Giotto's frequent play with variations of affect – beginning with the Lamentation in Assisi and the Navicella – is a perfection of this and provides guidance to how an event can be re-enacted in the viewer's soul in a multifaceted and encompassing way. The cross of Santa Maria Novella is different: if one takes Bonaventure and Roger Bacon's claims into account, Giotto's crucified Christ provokes pious experience by means of his mere presence. In other words, instead of showing suffering, the panel confronts visitors with a pseudo-real body activating their acquired knowledge of Christ's suffering.

A similar example is given by the central motif in the fresco of the Lamentation in

oculos ponerentur. Nam sic mundi malitia diluvio gratiae deleta, attolleremur in sublimi cum Noe et filiis et omnibus animantibus suis locis et ordinibus collocatis. Et cum exercitu Domini in deserto excuberemus circa tabernaculum Dei." See: A. Power, *Roger Bacon and the Defence of Christendom*, Cambridge 2013, pp. 157–159.

506 H. Belting, *Bild und Kult: Eine Geschichte des Bildes vor dem Zeitalter der Kunst*, Munich 1990, p. 464.

Assisi, which, as already explained, draws on the Byzantine Amnos Aër cloth icon, but avoids reference to this textile itself. In this way, a venerable and authentic image within the image becomes a venerable body almost gliding out of the image and approaching the viewer as if ready to be touched (fig. 120). This variation also seems to be guided by the idea of mystical perception. A mystical aspect in Stefaneschi's Navicella text has already been noted: Giotto's pictorial concept responded to it by enlarging the figure of Christ and turning it towards the viewer, enabling the audience to experience Peter's salvation as present and as something that directly affected them.

Indeed, the enormous mosaic ship once almost did run out of the picture as if launching from a slip way and settled on the shoulders of a mystic. The latter was, as is well known, Catherine of Siena who, like so many, visited St Peter's during Lent in 1380 to make her confession and, while saying a prayer in front of the Navicella, had precisely this vision. More than that, she collapsed under the weight of the ship and never recovered. It was Millard Meiss who pointed art historians to this records in the saint's biographies.[507] Since one of Catherine's aims in life was to repatriate the papacy from Avignon to Rome, scholars have attempted to identify a political message in the picture. But whatever specific message Catherine or her biographers read into the mosaic does not necessarily say anything about Stefaneschi's and Giotto's intention. What was definitely inherent in the representation, however, was the intensity of the experience, which so overwhelmed Catherine.

The pictorial language of the young Giotto can thus be analysed with criteria from the theology of the image and identified as functional in intention: in addition to providing instructions for mental re-enactment, Giotto created the conditions for an immediate experience of what the images present. Immediacy means here that, in order to benefit from the images, their viewers need not have understood themselves as such. They were free to ignore the fact that they were not dealing with an object or event, and (only) with its representation, since what was represented approached them as if it were an element of reality, and they could see themselves in the role of eyewitnesses, if not participants. The young Giotto is not alone in this strategy; rather, it is a means that has been used frequently and sometimes even more decisively in Christian art since the High Middle Ages. Reference should be made here to the three-dimensional life-size representations of the Descent from the Cross that exist in Italy and Spain and which resemble attempts not to illustrate the event but to make it present as a kind of "statue theatre" (Vicopisano, Volterra, Tivoli, etc.).[508] In addition, combinations of panel painting and sculpture should be mentioned,

507 M. Meiss, *Painting in Florence and Siena after the Black Death*, Princeton 1951, p. 107. The passages are now collected and printed in: Köster, Aquae multae – Populi multi, note. 15 p. 12.

508 *La deposizione lignea in Europa: L'immagine, il culto, la forma*, ed. G. Sapori and B.

such as the image of the Virgin Mary in Santa Maria Maggiore in Florence, which was created soon after the middle of the 13th century: a Madonna enthroned in high relief bulges out into reality and dominates the painted scenes of her surroundings, relegating them to unreality.[509] What is special about Giotto is, firstly, that as a painter (and not as a sculptor), he strove for immediacy and had to act in a correspondingly subtle way; secondly, that he succeeded in confronting the effects of immediacy with that of imagery while at the same time reconciling them with each other (for example, on the cross of Santa Maria Novella, the body of Christ with the icons of Mary and John). And thirdly, that he, astonishingly, subsequently distanced himself from this concept in the Arena Chapel.

It is true that sections with different degrees of mediation are assembled on the chancel arch there (remotely comparable to the cross of Santa Maria Novella). But it is clear that the illusory parts – the celestial opening with the apparition of God on the throne, the projecting oriels and the *arcosolia* – are used as varieties that are expected to stand out (pl. II); the same applies to the mild and disparate illusionisms of the Last Judgment (fig. 7). In most of the scenes on the lateral walls, in the "regular" pictures, the effect of a direct physical relationship between the subject of the picture and the viewer is completely eliminated. In this context, it can be stated, based on an observation by Axel Romdahl, that this concept was not established at the beginning of the work, but was worked out in the upper row of pictures:[510] Especially on the side facing the Eremitani, there are figures and objects of an almost sculptural quality that do not need their own pictorial space. Note, for example, the first picture, Joachim's Rejection, where only the cut-off corner of the plinth prevents the Scola Cantorum, together with the precisely modelled figures, from sliding out of the picture and into the reality of the viewer (pl. IV). Or the washbasin in the Birth of the Virgin, which stands in the no man's land between the space of the picture and that of the viewer (pl. VI). This position is similar to that of an ointment vessel in the Ohrid fresco of the Death of the Virgin (fig. 104) and thus provides a view into the eastern borderland of Giotto's pictorial world as if peeking through a key hole. All in all, there is much to suggest that the new concept of a distanced imagery was developed, or at least decisively advanced, at the beginning of Giotto's activity in Padua.

In this context, it is worth once again comparing the Isaac pictures in Assisi (pl. XI, XII) with the Anna pictures in Padua, which were created at a fairly early stage of the work on the walls (pl. V, VI): not only are the Paduan figures now accommodated within the space of a house (instead of filling it or inflating it), but the house itself is now accom-

Toscano, Turin 2004. *Il teatro delle statue: Gruppi lignei di Deposizione e Annunciazione tra XII e XIII secolo*, ed. F. Flores d'Arcais, Milan 2005.

509 *L'"Immagine antica" della Madonna col Bambino di Santa Maria Maggiore: Studi e restauro*, ed. M. Ciatti and C. Frosinini, Florence 2002.

510 Romdahl, Stil und Chronologie der Arenafresken Giottos, pp. 4–9.

modated within the space of a picture (instead of opening up the picture plane). The loggia contributes to this effect by moving the main room off centre and decoupling its opening from the picture format. The use of the traditional brown and blue mount also plays a role. In the Isaac scenes it is only visible in narrow sections, its disappearance from the picture seems within reach. In Padua, on the other hand, Giotto does not hesitate to let us see considerable parts of the strip of brown ground below the blue backdrop. In this way, the house becomes the subject of the picture and is given the same status as the figures. How Giotto then develops this further by once again displacing the inverted passe-partout, but without giving the objects back their immediacy, has already been described (pp. 112–122).

That Giotto abandoned the idea of creating presence is also shown by the motif of the figure seen from behind. Since the Arena Chapel, this type of figure has been endemic in European painting and established itself more and more as a mediating element: an agent of the viewer in the picture. At first, however, its role was a distancing one: The scenes depicted in Padua are not so much played out before the eyes of the viewer as before the eyes of those people over whose shoulders we look from outside the picture. As already explained, the first figures seen from behind appear in Mary's Presentation in the Temple (fig. 44). They are two anonymous men who are talking about what

Fig. 153: Assisi, upper church, clerestory of the entrance wall: The Pentecost

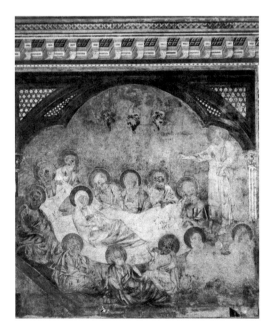

Fig. 154: Assisi, upper church, apse: The Announcement of the Death of the Virgin (Cimabue)

Fig. 155: Rome, Column of Marcus Aurelius: The Emperor on Campaign

is happening – and in a disparaging way. They do not represent the devout viewers of the picture, but those forces that did not want the depicted event to occur. There are no real precedents for these figures in the Isaac Master complex: in the foreground of the Pentecost scene on the west wall, four apostles are seated in such a way that we see them diagonally from behind (fig. 153), but here the painter obviously had to cope with a lack of space while still including thirteen figures. It is a completely different staging from that used later in Padua – inspired by Cimabue's picture of Mary's deathbed in the apse of the Upper Church, with its employment of opposing half-profiles of crouching apostles in the foreground, which in turn draw on Byzantine models (fig. 154).

The motif in the Arena Chapel most likely goes back to Giotto's Roman experiences.[511] In the reliefs of Roman state monuments from the time of the Empire, we often encounter figures seen from behind who, as in Padua, interpose themselves between the event and the viewer: for example, on the columns of Traian and Marcus Aurelius (fig. 155). Such monuments could well be known by the members of the workshop active in Assisi, from which the "Isaac Master" emerged: in the image of the Arrest of Christ there are accurate Roman legionary helmets, which can only have been copied from a state monument (fig. 111). The figure seen from behind is a motif adopted from ancient art, and as such would fit well into the context of the young Giotto. But it only played a role in Giotto's work once the Roman art scene was hardly relevant to him any more. He only needed figures seen from behind when he was no longer concerned with the immediate presence of his main figures and wanted to create an entity between them and the viewer.

The entity embodied by the figures seen from behind marks one difference between Giotto's early works and his works in Padua. Another marker is the occurrence of figures

511 Gerhard Schmidt traced the motif back to Gothic sculpture: G. Schmidt, Giotto und die gotische Skulptur: Neue Überlegungen zu einem alten Thema, *Römische historische Mitteilungen* 21, 1979, pp. 127–144.

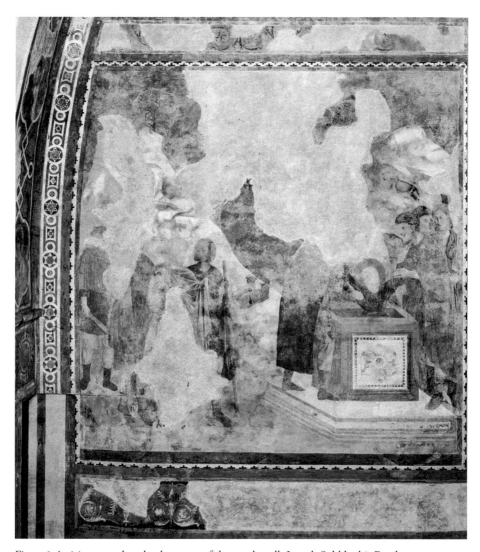

Fig. 156: Assisi, upper church, clerestory of the north wall: Joseph Sold by his Brothers

overlapped by the edge of the picture. In the few cases in which they are encountered in the Isaac Master complex, their purpose is defined by the narrative: in the second Isaac scene, for example, Jacob not only slips out of the architectural box, but simultaneously out of the picture field; shoulder and halo are cut off by the right hand edge (pl. XII). And in the picture of Joseph Being Sold, the painter has indicated the large number of his brothers by making the group appear to extend beyond the frame of the picture (fig. 156).

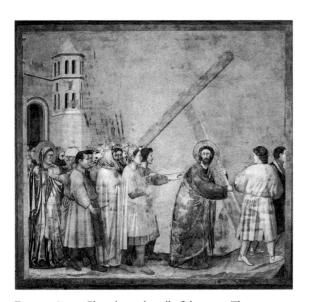

Fig. 157: Arena Chapel, north wall of the nave: The Carrying of the Cross

In Padua, the phenomenon of the cut off figure also occurs with narrative motivation: the Arrest of Christ shows an apostle escaping from the picture to the left, and in the Carrying of the Cross the participants in the procession come out of the city gate and into the picture at the same time (fig. 157). However, such a function for the motif is not the rule. Another effect is also important: many Paduan pictures are characterised by this motif when used for sections of structures that extend beyond the picture boundaries and are only partially shown. The altered treatment of the figures seen from behind and of the cut off figures together tells us that while the early Giotto simultaneously showed the subject both in reality and in front of the viewer's eyes, his Paduan works are conceptualized as adaptations of visual realities that exist independently from a viewer.

The third and at first glance most striking difference, is the form of representation of the clothes. While the early Giotto was particularly fond of fine draperies rich in form, which gave roundness to the bodies with shimmering pleated bows, in Padua he entrusted the creation of plasticity entirely to the phenomenon of light and shadow on the simply draped garments. At the same time, he now developed a kind of lighting regime: in the scenes on the Eremitani-side wall, the light hitting the figures comes predominantly from the right, in those on the palace-side wall, predominantly from the left.[512] It is questionable whether one should speak of a westerly or evening light streaming in through the large window of the entrance wall and conclude from this that there are elements of an illusionistic strategy. Cavallini's mosaics in Santa Maria in Trastevere should be mentioned: in all scenes, the figures and also the architecture are consistently and clearly illuminated from the left. Read illusionistically, this would be a counterfactual northern light. Giotto's harmonised lighting in Padua is not without precedent and is not an invention made for the Arena Chapel; rather, the painter again drew on Cavallini and on Roman experience. The light in the Arena scenes may come from the same direction, but it remains a light inside the pictures and is not a simulation of the real light in the space of the chapel.

512 P. Hills, *The Light of Early Italian Painting*, New Haven 1987, p. 43.

Both the simplification of the draperies and the standardisation of the lighting facilitate the reading of what is depicted as a second (i.e. inner-pictorial) reality. In fact, a price had to be paid for the clarity of the depiction of plasticity in Assisi, namely the obviousness of the means of depiction. It is not possible to read the elaborate draperies of these works without admiring their sophistication and noticing their artificiality. But hand in hand with the introduction of a new and simpler way of representing the garments, the mystically charged closeness of the viewer to the depicted body also ends. The newly robed figures integrate themselves into the pictorial realities. They do not impose on the viewer; we are free to decide whether we want to be more interested in the things and people in the pictures or the things and people in the world.

Just as presence is an aspect of mystical experience, so too is decision-making between the perception of the world and the experience of the sacred. The Dominican Henry Suso (1295–1366) said that the important thing is to drive out a wrong image or imagination with the right images or imagination ("daz man bild mit bilden us tribe"). Instead of surrendering to the phenomena of the world, the pious should experience, using images (mental but surely also physical images) of Christ and the saints, what is beyond all experience ("úber alle sinne"; Vita LIII).[513] For Suso (but certainly not only for him), contemplation of images was "one of the strategies of social withdrawal in order to practise a life of inwardness" (Thomas Lentes).[514] Seen in this light, it would be wrong to read Giotto's turn to the concept of autonomous pictorial worlds in Padua as a profanation of the religious image. Rather, he constructed new possibilities for intense experiences of images. Unlike in the painter's early work, the persons and objects in the pictures no longer compete with the persons and objects in the world; instead, the viewers have a choice and can either abandon themselves entirely to the consideration of one group or entirely to the consideration of the other. But for those who choose to focus on the people and objects in the pictures, Giotto connects distant spaces and allows them to participate in the painted worlds using the skills they have acquired in the actual world.

OUTLOOK: THE CROSSES IN RIMINI AND PADUA

Giotto's activity for San Francesco in Rimini is attested by Riccobaldo Ferrarese and must therefore predate 1313 (2.2.1). In the church, which had already been thoroughly reworked in the 15th century, only one picture has survived that could be identified as Giotto's, and

513 Heinrich Seuse, *Deutsche Schriften*, ed. K. Bihlmeyer, Stuttgart 1907, p. 191.

514 Th. Lentes, Der mediale Status des Bildes. Bildlichkeit bei Heinrich Seuse – statt einer Einleitung, in: *Ästhetik des Unsichbaren: Bildtheorie und Bildgebrauch in der Vormoderne*, ed. D. Ganz and Th. Lentes (KultBild 1), Berlin 2004, pp. 13–73, esp. 23.

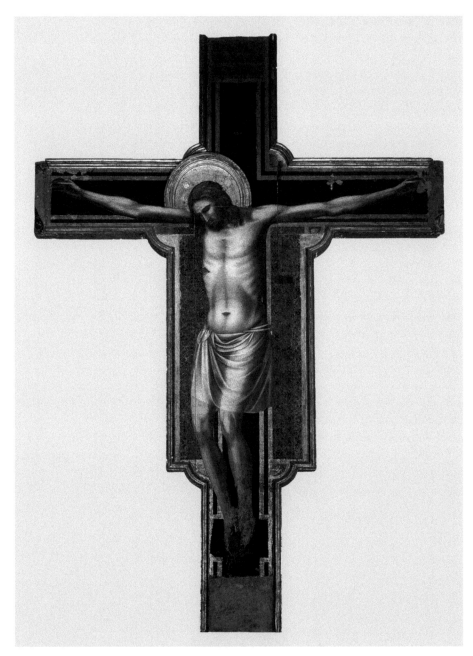

Fig. 158: Rimini, San Francesco: croce dipinta

perhaps it was really only this one that he had made there: a large *croce dipinta* – more precisely, the core of one (measuring 430 by 303 centimetres), without the panels with the mourners, without the hill of Golgotha and without the crowning (*cimasa*) with the image of the Salvator mundi. The latter, however, has survived in private ownership[515] (fig. 158, 159).

In connection with the examination of the croce dipinta of Santa Maria Novella around the year 2000, it became apparent that the Rimini cross is extraordinarily similar to the Florentine one,

Fig. 159: Private ownership: The Saviour from the Rimini Cross

right down to its details, just as, in turn, the cross from the Arena Chapel (fig. 160, – 223 by 164 centimetres) is similar to the one in Rimini.[516] It is interesting to note, however, that the Paduan cross hardly resembles the Florentine one. One can therefore treat the Rimini Cross as a kind of transitional work. And in this case it promises an insight into the obscure transition, in the course of which the Isaac Master became the Paduan Giotto.

Of course, an external reference for the dating would be desirable in this context. The *croce dipinta* of the church of San Francesco in the small town of Mercatello sul Metauro (Umbria, fig. 161), signed by "Johannes Pictor", is a largely faithful replica of Giotto's Rimini cross – one of two made by a Riminese painter or painters (the other cross is kept in the Museo Civico in Rimini). It would provide a *terminus ante quem* if only the date of the inscription were clearly legible. However, it is not possible to decipher whether the middle character is a V or an X, i.e. whether 1309 or 1314 is meant.[517] The two copies probably also give an idea of what Giotto's figures looked like on the lost side panels. If this is true, they did not correspond to the completely introverted mourners of the Santa Maria

515 M. Gaeta, *Giotto und die Croci dipinte des Trecento. Studien zu Typus, Genese und Rezeption. Mit einem Katalog der monumentalen Tafelkreuze des Trecento (ca. 1290-ca. 1400)*, Münster 2013, pp. 123–130. Federico Zeri has identified the fragment: F. Zeri, Due appunti su Giotto: I: la cuspide centrale del "Polittico Baroncelli"; II: la cimasa del crocefisso del Tempio Malatestiano, *Paragone. Arte* 8, 1957, 85, pp. 75–87.

516 On the cross of the Arena Chapel (quoting the earlier literature): *La Cappella degli Scrovegni a Padova*, ed. D. Banzato et al. (Mirabilia Italiae 13), Modena 2005, pp. 291–293 (Banzato). Although the cross is not mentioned in any early source, one may take it for granted that it belongs to Giotto's work for Scrovegni.

517 C. Volpe, *La Pittura Riminese del Trecento*, Milan 1965, p. 71 (no. 13).

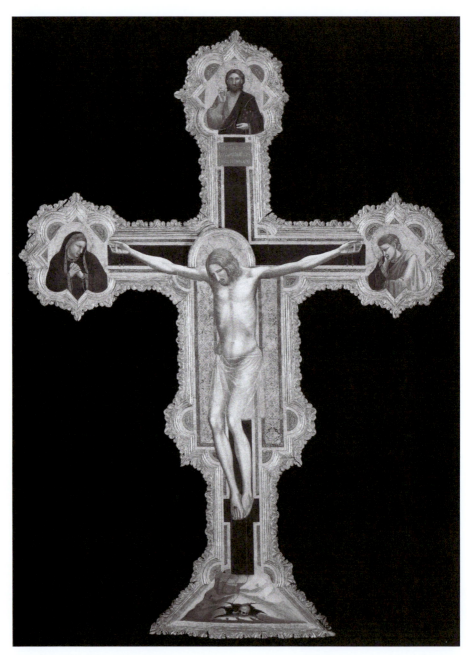

Fig. 160: Padua, Museo Civico: Croce dipinta from the Arena Chapel

Novella cross. Rather, John leaned his head on his right hand and with this gesture resembled not only Cimabue's John on the Santa Croce cross, but also the John on Giotto's cross for the Arena Chapel. As for Mary, the situation is unclear: the cross in the Museo Civico in Rimini shows her as a kind of mirror image of John, which follows the model of Cimabue's cross.[518] The higher quality copy in Mercatello shows her wringing her hands and thus corresponds with this unusual and particularly effective gesture on the cross in the Arena Chapel (fig. 160). We find the same type of Mary on the *croce dipinta* of the church of San Lorenzo in Talamello near San Marino, which is sometimes also attributed to Johannes Pictor and is in any case an echo, although not a copy, of Giotto's cross.

Alessandro Volpe has proposed a different and earlier *terminus ante quem* for the Rimini Cross, which must be discussed in light of these observations. Volpe wanted to find an echo of the *cimasa* Salvator of the Rimini Cross (formerly in a London private collection and now in an unknown location) in a figurative initial by the Riminese illuminator Neri showing the Deesis and dated to the year 1300.[519] However, for a work by Neri da Rimini, the modelling of Christ's face with light and shadow is unusually intense. On the other hand, the oval head shape is more reminiscent of Cavallini's heads than of the angular face of Christ on the fragment formerly in London.[520] And the half-figures of Mary and John accompanying Neri's judge are certainly taken from a croce dipinta, but there is nothing to suggest that it was one painted by Giotto: the Virgin with her pointing gesture has nothing to do either with the version on the cross in the Museo Civico or with the more plausible version on the Mercatello and Talamello crosses. On the other hand, Neri's variant of the Deesis initial painted in

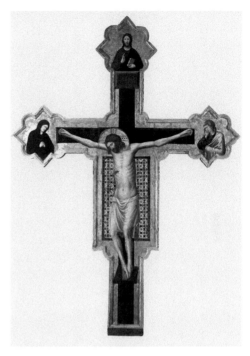

Fig. 161: Mercatello sul Metauro, San Francesco: croce dipinta (Giovanni da Rimini)

518 Ibid. p. 72 (no. 17). A. Volpe, *Giotto e i Riminesi: Il gotico e l'antico nella pittura di primo Trecento*, Milan 2002, pp. 88–100.
519 Ibid. p. 24.
520 Cf. G. Dauner, *Neri da Rimini und die Rimineser Miniaturmalerei des Trecento*, Munich 1998, pp. 77–83.

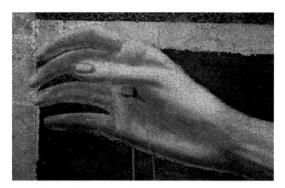

Fig. 162: Rimini, San Francesco: croce dipinta, Christ's right hand

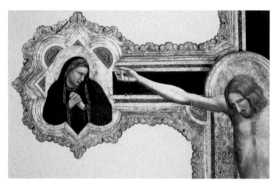

Fig. 163: Padua, Museo Civico: croce dipinta from the Arena Chapel, detail

1314 in a choir book for Bologna shows Mary wringing her hands and thus a type that probably does indeed go back to Giotto's Mother of God on the Cross in Rimini.[521] If Neri saw and studied Giotto's work, it was not before 1300 but afterwards.

Thus, in order to substantiate a dating close to the Florentine cross, it really only remains to point out the similarity of the heads of Christ in Florence and Rimini, which could be mistaken for each other, and the practically identical treatment of the hands. It is noticeable, however, that the head in Rimini is turned very slightly more into a profile and is very slightly less lowered, thus, as it were, clinging closer to the panel. Similarly, the hands are turned a little less forward, so they are also closer to the cross (fig. 162, 142). A subtle difference is also noticeable in the way the blood emerges from the nail wounds: On the Santa Maria Novella cross, two rivulets of fresh blood flow from the palm of the hand, whereas on the Rimini cross one of them flows invisibly down behind the back of the hand and only appears below the hand on the cross. This also shows that the connection between the crucified Christ and the cross, between the body presented and the panel, is closer in Rimini.

And in order to make a dating of the Rimini cross close to 1303 credible (i.e. close to the beginning of the work in the Arena Chapel), there remains finally the reference to the more elongated body in Rimini, which returns in a very similar fashion on the Paduan cross. In Rimini, as in Padua, the upper body does not fall into the room, but stands upright in front of the vertical beam. Also similar is the position of the legs, which is clearly improved compared to the Florentine solution, as it is more credible (fig. 158, 160, pl. XIII). The treatment of the ornamental details and the rendering of the suppedaneum,

521 Volpe, *La Pittura Riminese del Trecento*, p. 70 (no. 7), fig. 10.

for example, as well as the titulus, are also consistent at Rimini and Padua and different from the Florentine cross. So far, the sequence of the three crosses could be described as a straightforward development leading to a more image-like appearance of the same figure.

The conception of the hands on the Paduan cross contrasts with this (fig. 163): the palms are turned towards the viewer like the hands on the Byzantine crosses, but at the same time the fingers are painfully tightened, as on the Gothic crosses. The little finger in particular makes an appearance, almost touching the thumb. A zone of gestural expression emerges, into which some of an otherwise reduced sense of presence returns and which also contradicts the manifestation of the dead body. The mourners on the side panels are likewise strongly rhetorical. Unlike on the cross of Santa Maria Novella, the postures and gestures describe the emotions as captivatingly as they do precisely. The viewer is thus freed from the demand for introspection. As in Cimabue's work – but more subtly – we are again told what to feel, and, judging from the copies, this was also the case with Giotto's Rimini cross. Finally, one can compare the Paduan *cimasa* image with the Rimini one (fig. 160, 159), and here one is struck by the hand in Padua raised in blessing at shoulder height and turned towards the viewers. Those who stand in front of the Paduan cross are both addressed more clearly and relegated to a position below the picture. The generally more picture-like form of the cross was thus combined with isolated elements that gave sense of immediate presence.

ASSISI 1308 AND OTHER ST. FRANCIS-PROBLEMS

Having probably stayed in Padua until 1307 (pp. 34, 184; 2.7.1), Giotto must have re-sumed work in Assisi before 1309, as we learn from a document dated 4 January of that year (1.1.8). What he was working on, however, is not clear from the deed.

USE AND CONVERSION OF THE DOUBLE CHURCH

Anyone who wants to understand what tasks awaited a painter in Assisi in 1308 should pay attention to how the use of the church complex of San Francesco was reorganised at that time. The most striking measure from an archaeological point of view, and one that has long been registered by scholars, was the removal of the rood screen from the Lower Church.[522] The fact that there was a rood screen in the western bay of the nave next to the transept is evidenced by the wall cupboards and *sacraria* of two altars, which were located on either side on the platform. And that the barrier was not removed in the 16th or 17th centuries, when the rood screens usually disappeared, is proven by the tribune of the Stan-islaus Chapel, built in the first decades of the 14th century, which extends into the zone where one of the altars on the screen had previously been located.

This altar played a role in the life of St. Angela of Foligno: on 1 August of the Holy Year 1300, she wanted to receive communion together with nine of her spiritual sons "at the altar located on the *pulpitum* on the right side of the church of St Francis."[523] This would suggest that the rood screen stood until 1300 or longer – although not much longer as the existence of the Stanislaus tribune shows. The exact date of its demolition is difficult to determine. The marble slabs, sills and lintels decorated with Cosmati work, which were secondarily used on the parapet of the Stanislaus Chapel and in the pedestal incrustation of the Mary Magdalene Chapel and which Irene Hueck considered to be spolia from the rood screen, had certainly not belonged to the rood screen in the Lower Church, but to

522 B. Kleinschmidt, *Die Basilika S. Francesco in Assisi*, vol. 1, Berlin 1915, pp. 146–147.

523 "In festo sancti Petri ad Vincula, quando volebam communicare in missa quae debebat ab uno vestrum dici ad altare quod est in pulpito a latere dextero ecclesiae beati Francisci, tunc subito dictum fuit mihi: Ecce frater talis venit; et hoc dixit de uno filiorum qui novem eramus circa eam ante illud altare." *Il libro della Beata Angela da Foligno: Edizione critica*, ed. L. Thier and A. Calufetti, Grottaferrata 1985, p. 624. Irene Hueck pointed to this pas-sage in Angela's *vita*: I. Hueck, Der Lettner der Unterkirche von S. Francesco in Assisi: *Mitteilungen des kunsthistorischen Institutes in Florenz* 28, 1984, pp. 173–202. The dating of the event to the year 1300 according to: M.J. Ferré, Les principales dates de la vie d'Angèle de Foligno, *Revue d'Histoire Franciscaine* 2, 1925, pp. 21–35, esp. 29.

the *schola cantorum* in the Upper Church (see below). Nevertheless, these components must be considered here, because the removal of the singers' choir, which was typical of Roman churches and served the papal liturgy, was a measure that ultimately could only have made sense in the context of a transformation of the entire double church.

To sum it up, the process appears as follows: with the rood screen disappearing from the Lower Church, a combined conventual and pilgrimage church became a space predominantly or entirely left to the pilgrims and their pastoral care. Just as the rood screen had protected the gathering of the brothers in the choir from disturbances, so it had limited access to the much venerated tomb. Hand in hand with this, the *schola cantorum* was removed from the Upper Church. A papal basilica, of whose characteristic furnishings only the papal throne remained, was converted into a space that served mainly as a convent church and as a substitute for the choir of the Lower Church, which was now opened to pilgrims.

The background for the conversion was probably a realistic balance of interests between pilgrimage use on the one hand and papal ceremonial use on the other. Firstly, it must be noted that there were many pilgrims. This had not least to do with the indulgence granted by Honorius III (1216–1227) and increased by all subsequent popes, which made Assisi one of the great pilgrimages in Italy. After several years of preparation, it was republished in 1310 as a plenary indulgence based on the model of the Roman Jubilee Indulgence of 1300. The so-called Portiuncula Indulgence gave a pilgrimage to Assisi an appeal that could only be compared to a journey to Rome or the Holy Land.[524] Secondly, it should be noted: popes came to Umbria much less frequently than was probably anticipated in the mid-13th century when the church, monastery and papal palace were being built. And when the pope did come, he preferred to hold court in urban Perugia rather than Assisi – disregarding Francis' tomb. No pope had celebrated in the Upper Church since 1265.[525] So, it was only natural that the friars began to co-use the enormous space: the oldest relevant document dates from 1304 and states that the tertiaries took their vows there.[526]

The opportunity to face these truths, some pleasant and some unpleasant from a Franciscan point of view, and to act accordingly came about after Matteo Rosso Orsini died in

524 St. Brufani, Il dossier sull'indulgenza della Porziuncula, in: *Assisi Anno 1300*, ed. St. Brufani and E. Menestò, Assisi 2002, pp. 209–247. A.J. Minnis, Reclaiming the Pardoners, *Journal of Medieval and Early Modern Studies* 33, 2003, pp. 311–334. The previous grants and confirmations of indulgences in: G. Zaccaria, Diario storico della Basilica e Sacro Convento di S. Francesco in Assisi (1220–1927). I: Il Duecento, *Miscellanea Francescana* 63, 1963, pp. 75–141.

525 A. Potthast, *Regesta Pontificum Romanorum*, Berlin 1875, p. 1564.

526 G. Zaccaria, Diario storico della Basilica e Sacro Convento di S. Francesco in Assisi (1220–1927). II: Il Trecento, *Miscellanea Francescana* 63, 1963, pp. 290–323, esp. 291 (no. 144).

Perugia in the autumn of 1305. As Protector of the Order, he was not only responsible for the relations between the Order and the Curia, but surely also for the maintenance of the edifice of San Francesco. Therefore, we may presume that the decoration and furnishing of the upper church as a papal church had taken place under his custody (p. 211). This prelate, who was close to the Franciscans but decidedly a man of the Curia, was succeeded as protector by Cardinal Giovanni Minio di Muravalle (also Muravalle, Murrovalle). Having previously held the office of General of the Order, thus the fifteenth successor of St Francis, he was just as decidedly a man of the Order.[527] He would be a plausible candidate for someone who let the interests of the Order take precedence over those (now obsolete) of the Curia and may have opened up the upper church so that it could be adapted and used by the friars.

PALMERINO DI GUIDO AND OTHER PAINTERS ON SITE

The document from 1309 not only gives a time reference for Giotto's second stay in Assisi, but also provides insight into the circumstances of his activity at the time. It is a kind of receipt (I.1.8): "Palmerinus Guidii" repaid a loan in Assisi that he had taken out together with Giotto (who was not present at the current procedure in front of the notary). A painter with the uncommon name Palmerino is documented between 1299 and 1347 in Assisi and Gubbio.[528] He originated from Siena: in the earliest mention "Palmerinus pictor de Senis" was accused of an administrative offence. He was said to have blocked the street in front of his house in Assisi with objects from his property.[529] The last sign of life is the signature on a lost fresco in Assisi ("Palmerinus de Assisi"). In 1301, "Palmerinus Guidi" was registered as a resident in Gubbio, where he was later (sometime between 1314 and 1340) also recorded as a member of the Marian brotherhood of the *Laici* ("Maestro palmerino de Maestro guido"). In 1307 – shortly before his collaboration with Giotto – "Palmerinus pintor" appeared as a witness in Assisi. And in 1321 "Palmerinus pictor" was paid in Gubbio for the creation of a picture in the Palazzo Ducale at that time still the

527 J. Moorman, *History of the Franciscan Order from its Origins to the Year 1517*, Oxford 1968, pp. 589–591. G. Moroni, *Dizionario di erudazione storica-ecclesiastica*, vol. 45, Venice 1847, p. 180.

528 V. Martinelli, Un documento per Giotto ad Assisi, *Storia dell'arte*, 1973, pp. 193–208. G. Manuali, Aspetti della pittura eugubina del Trecento: Sulle tracce di Palmerino di Guido e di Angelo di Pietro, *Esercizi* 5, 1982, pp. 5–19. *Enciclopedia dell'Arte Medievale*, 12 vols., Rome 1991–2002, vol. 9 s.v. Palmerino di Guido (S. Manacorda).

529 *Le carte duecentesche del Sacro Convento di Assisi*, ed. A. Bartoli Langeli (Fonti e studi francescani V), Padua 1997, pp. 340–342 doc. 175.

Fig. 164: Gubbio, Palazzo Ducale: fragment of a Maestà (Palmerino di Guido)

seat of the city government; it showed Our Lady and the city saints.[530]

Two potentially relevant murals have survived in fragments. One, which contains the upper body of the Madonna, two angels and three of four heads of the city saints, is much more likely to have been painted around 1300 than around 1320. The other fragment shows two routinely, but carelessly, painted angels flanking the pediment from the Madonna's throne, as well as parts of a frame system with painted Cosmati work (fig. 164). In terms of style and motifs, this mural is embedded in a group of other fresco fragments and panel paintings in Gubbio that are otherwise more elaborately executed but similar in many other respects and belong to the second and third decades of the century. Among them is the so-called Maestà dei Laici, certainly painted after 1315, a mural from the church of the brotherhood to which Palmerino belonged (fig. 165). This group is obviously what remains of Palmerino's work in the years after his collaboration with Giotto.[531] Given this, we are dealing with a respectable painter who built on a Sienese schooling and probably also kept in touch with the art scene in Siena. He made use of Giotto's impulses, but rather selectively. We will come back to this.

What could have brought a painter from Siena to Umbria in the period before 1299? On the one hand, Duccio was rising to become the hegemon of painting in Siena at the time and this put pressure on his colleagues there; on the other hand, during the nineties in Assisi, the large-scale project of decorating the upper church of San Francesco, which was discussed in detail in the previous chapter, must have attracted artists. It may be assumed, therefore, that Palmerino had been involved in the campaign in the clerestory, which was probably concluded under Giotto's leadership in 1298 at the latest. Longhi, Toesca, and Previtali believed they had identified traces of Sienese style in the clerestory frescoes and personalised their observations with names such as Duccio and Memmo

530 E.A. Sannipoli, Palmerino di Guido, *L'Eugubbiano* 32, 1982, pp. 12–13.
531 *Gubbio al tempo di Giotto: Tesori d'arte nella terra di Oderisio*. Exh. cat. ed. G. Benazzi, E. Lunghi, and E. Neri Lusanna, Gubbio 2018, pp. 198–199, 202–209 (F. Mariucci and E. Lunghi). The identification of the corpus of works with the idea of a Maestro Espressionista di Santa Chiara is, in my opinion, inaccurate.

di Filippuccio.[532] This goes too far, but it should not be ruled out that there really is a connecting thread between the clerestory workshop in Assisi and Sienese painting around 1300. This thread could have to do with the person of Palmerino.

While the, by now successful, Giotto left Assisi after the conclusion of the campaign and took up work in Rome, Florence, and Padua, Palmerino stayed and expanded his business to the fully provincial Gubbio. Thus when Giotto had a new commission in Assisi in 1308, he could rely on his old colleague, who had developed an infrastructure there. Regardless of the person of Palmerino, it is important to realise that there seems to have been an artistic milieu in Assisi that the young Giotto had helped to establish. Exponents of this milieu were probably also those anonymous painters who – most likely in collaboration with artists from Rome – were entrusted with the decoration of the Sala dei Notari in nearby Perugia and reused a lot of material from the Assisan clerestory there (see pp. 210–211). Since they came from Assisi, they may have been available again there after the conclusion of the Perugian campaign.

Fig. 165: Gubbio, Museo diocesano: The Maestà dei Laici (Palmerino di Guido)

Hence, the Assisi of 1308 was a completely different place for Giotto than the Padua of 1303. Much that had not existed in Padua existed in Assisi a few years later: an audience attuned to Giotto's style – even if not to its latest manifestation – and fellow artists whose training was linked to Giotto's own background and who were able to adapt to Giotto's art as a context and model. While Giotto had been required to forge a bottega for the Paduan commission in a vacuum, the situation in Assisi was different.

In connection with his research on Assisi, Bruno Zanardi introduced the term *cantiere* (building site, shipyard) as an alternative to the term *bottega* established among art historians.[533] It is probably to be understood in this way: a *cantiere* is a group of artists and

532 Previtali, *Giotto e la sua bottega*, pp. 48–53. On the attributions to Memmo: H.W. Kruft, Giovanni Previtali: Giotto e la sua bottega, *Zeitschrift für Kunstgeschichte* 32, 1969, pp. 47–51, esp. 48.
533 B. Zanardi, *Il cantiere di Giotto: Le storie di san Francesco ad Assisi*, Milan 1996.

craftsmen who come together for a specific commission. Whereas one joins a *bottega* at a young age to learn from a master and leaves it years later as a competitor to that master, the *cantieri* form according to the demand for work, are made up of people who consider their training to be complete and do not necessarily rally around artistic leaders. Each one contributes what he can and what serves the realisation of the project. The painters' formal language is unified to the extent that the client and the public are willing to reward this.

Both terms – *bottega* and *cantiere* – may be simplifications, and the alliances of the muralists were probably always something of both. But if Padua was the ideal place for the formation of a *bottega* structure and Giotto the ideal head of one, then Assisi was the ideal place for the emergence of *cantieri*: there were painters in Assisi with similar horizons of experience, and for this reason alone it was not difficult for them to work together; there was a large and famous sanctuary where commissions could beckon at any time, and there was, in addition to further churches and communal buildings in the city, an environment where the artists could receive other and, if necessary, second- and third-rate commissions.

The document of 1309 naming Palmerino points to Giotto not as the head of a *bottega*, but as a member of a *cantiere*, a team of at least two painters that relied on local conditions and an existing infrastructure. Even if this does not mean that Giotto was cooperating with a colleague on an equal footing, his way of working may have differed markedly from that in Padua.

GIOTTESQUE PAINTING IN SAN FRANCESCO: THE LEGEND OF ST. FRANCIS

A total of four fresco complexes are possible results of Giotto's Assisi stay of 1308. Some of them have been explicitly mentioned as works by Giotto since the 16th century, others since the 19th century. At present, it is disputed in all cases whether Giotto or painters from his circle were responsible: first, in the upper church, the Legend of St. Francis; second, in the lower church, the Chapel of St. Nicholas; third, in the same place, the painting of the crossing and the north transept; fourth, in the same place, the Chapel of Mary Magdalene.

The Legend of St. Francis covers the lower walls of the nave of the upper church with 28 pictures, which are somewhat smaller than the clerestory frescoes (fig. 166). It was first described explicitly as Giotto's work by Vasari in 1568 (2.1.10) and, due to Vasari's words, is considered by many art lovers to be Giotto's most important work beside the Arena Chapel and evidence of an artist imbued with Franciscan ideas. It is well known that Vasari's premise was Ghiberti's formulation "tutta la parte di sotto", and that this

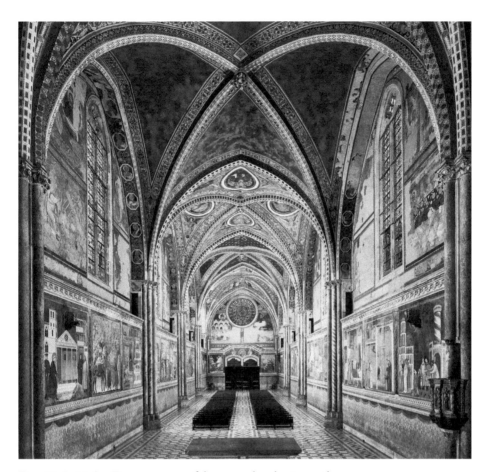

Fig. 166: Assisi, San Francesco, nave of the upper church, view to the east

does not necessarily refer to the Legend of St. Francis (but can equally relate to the Isaac Master complex or to the three Giottesque decorations in the lower church) (vol. 1, p. 22). In addition to the open question of authorship, there is also no consensus on the dating of the fresco cycle: it fluctuates between the eighties of the 13th and the thirties of the 14th century.[534] All the external clues to dating that scholars have pointed to over time have

[534] E.g. L. Bellosi, *La pecora di Giotto*, Turin 1985 (early) and J. Stubblebine, *Assisi and the Rise of Vernacular Art*, New York 1985 (late). A useful dicussionof the arguments: Th. De Wesselow, The Date of the St. Francis Cycle in the Upper Church of S. Francesco at Assisi: The Evidence of Copies and Considerations of Method, in: *The Art of the Franciscan Order in Italy*, ed. W.R. Cook, Leiden and Boston 2005, pp. 113–167, esp. 112–133.

proved irrelevant.[535] Despite these wide-ranging unclarities, three assumptions about the images have become certainties, although weighty counter-arguments can be put forward.

The first says that the cycle was "canonical" as a visual legend of St. Francis (Julian Gardner) and that it was "the decisive model for many other cycles of the saint until the end of the 14th century" (Ruth Wolff). The first objection to this is that the three-figure Assisi version of the stigmatisation image (Francis and the Seraph plus a friar with a book, fig. 233) is not very widespread; rather, the two-figure stigmatisation image (Francis and the Seraph) predominates in Franciscan iconography (see below). If the St. Francis cycle of the Upper Church had really had some kind of central function, the opposite would have been the case, especially given the importance of this scene. Secondly, it should be pointed out that not a single copy or variant of the entire cycle exists and that there are only a few copies or variants of particular pictures or groups of pictures (Pistoia, Rieti, Todi). For the sequence of pictures in Rieti alone, it can be said that the painter relied mainly on the St. Francis cycle in Assisi and that other models played a subordinate role.[536] Thirdly, the iconography of St. Francis found in cities that are saturated with images of this saint, such as Florence and Siena, has virtually no significant links with the St. Francis cycle in Assisi (on Florence see pp. 396–407). Despite these remarks, it should not be denied that from time to time painters borrowed from the St. Francis cycle of the Upper Church, but it was certainly not *the* resource from which the iconography of St. Francis in Trecento Italy was fuelled.

A second apparent certainty says that the cycle is the keystone in a holistically planned programme for the complete upper church. In fact, however, it is a foreign body in terms

535 This includes the reference to the state of the construction of the Torre del Popolo in the opening image of the cycle, which supposedly gives a *terminus ante quem* of 1305: L. Brancaloni, Assisi medioevale: Studio storico-topografico, *Archivium franciscanum historicum* 7, 1914, pp. 3–19, esp. 19. See on this: M.V. Schwarz, Ephesos in der Peruzzi-, Kairo in der Bardi-Kapelle. Materialien zum Problem der Wirklichkeitsaneignung bei Giotto, *Römisches Jahrbuch der Bibliotheca Hertziana* 27/28, 1991/92, pp. 23–57, esp. note 61 p. 43. A more recent attempt to gain a clue to the dating comes from Donal Cooper, who understands the allusion to the column of Trajan or Hadrian in the last picture of the cycle to be at the same time an allusion to the coat of arms of the Colonna family. The Colonna were expelled from the Patrimonium Petri in 1297, providing a *terminus ante quem* for the entire cycle, according to Cooper. D. Cooper, Giotto et les Franciscains, in: *Giotto e compagni*. Exh. cat. Louvre, ed. D. Thiébaut, Paris and Milan 2013, pp. 29–47, esp. 31. This author does not mention though that the family was rehabilitated in 1306 and allowed to return.

536 J. Gardner, The Louvre Stigmatization and the Problem of the Narrative Altarpiece, *Zeitschrift für Kunstgeschichte* 45, 1982, pp. 217–247, esp. 232. R. Wolff, *Der heilige Franziskus in Schriften und Bildern des 13. Jahrhunderts*, Phil. Diss., Berlin 1996, esp. p. 201. D. Blume, *Wandmalerei als Ordenspropaganda: Bildprogramme im Chorbereich franziskanischer Konvente Italiens bis zur Mitte des 14. Jahrhunderts*, Phil. Diss., Worms 1983.

of its narrative conception: while the images on the clerestory walls of the nave must be read – first the upper row, then the lower one – from the transept to the entrance wall, the legend of St. Francis runs around the nave: on the Old Testament side it follows the direction of the clerestory cycle, on the New Testament side including the entrance wall (i.e. over the longer distance) it runs against it; the life of Christ and the life of St. Francis, which is always stylised as Christ-like, cannot therefore be read in parallel. They proceed in the opposite direction and explicitly do not communicate with each other – even though the exegetes of the church space would like the contrary to be true.[537] This deficiency was counteracted in the detail of the execution of the St. Francis cycle by means of single motifs, but with little instructive results overall. It is difficult to imagine that the relationship between the sequences of pictures would not have been solved differently within the framework of a comprehensive concept. Besides, the St. Francis cycle is the element in the decoration of the Upper Church that departs from its original function as a papal church. Nor is it connected with the consecration of the space to the Virgin Mary. If the lower walls of the nave were decorated with painted curtains or (as in the Capella Sancta Sanctorum in Rome) with marble slabs, no one would think that the programme was not complete.

The opposite view prevails, but there is no evidence for the assumption that the cycle was painted immediately after the clerestory walls, i.e. in the years shortly before or after 1300. And the same artist or workshop was certainly not at work. I will return to the formal discrepancies. First, Millard Meiss can be quoted; he said that the young Giotto was either the Isaac Master or the creator of the Legend of St. Francis. In terms of style, he could not be both.[538] This is true, at least, if one regards style as the structure of the means of representation and not following in Morelli's footsteps by defining it merely as something on the surface, to which photographs of details do full justice.

The third questionable certainty is that of the "obvious unity of the whole" (August Schmarsow).[539] It is, however, clear to all critics that the first scene (on the north wall) and the last three scenes (on the south wall) must be separated from this "whole". The difference between the relatively small and slender figures in the picture showing the Homage

537 There are repeated attempts to prove the opposite, but they do not go beyond hypothetical links between single images or compositional schemes. Examples: S. Romano, La morte di S. Francesco, *Zeitschrift für Kunstgeschichte* 61, 1998, pp. 339–368, M. Rohlmann, Kontinuitäten im Verschiedenen: Über koordinierendes Erzählen, in: *Erzählte Zeit und Gedächtnis: Narrative Strukturen und das Problem der Sinnstiftung im Denkmal*, ed. G. Pochat, Graz 2005 (Kunsthistorisches Jahrbuch Graz), pp. 43–59, and A. Neff, Lesser Brothers: Franciscan Mission and Identity at Assisi, *The Art Bulletin* 88, 2006, pp. 676–706.

538 M. Meiss, *Giotto and Assisi*, New York 1960, pp. 24–25.

539 A. Schmarsow, *Kompositionsgesetze der Franzlegende in der Oberkirche zu Assisi*, Leipzig 1918, p. 67.

in the marketplace of Assisi, which opens the cycle (fig. 167), and the Donation of the Coat to the Poor Knight with the rather stocky figures, that follows is all too clear. The figures in the second picture and in the pictures that follow on the north wall are also more articulate in their movements. The opening picture, together with the last three murals of the cycle, which are in the same bay on the opposite wall, are said to have been painted by a pupil or by another artist; many call him the Cecilia Master after a retable in the Uffizi painted by the same hand, according to Crowe and Cavalcaselle.[540] With the exception of these four fields, however, the sequence of pictures is said to be of one piece, no matter how large and uniform one imagines the team of painters to have been – and one should imagine it to have been very large and not very uniform, for it was not even possible to impose a uniform physiognomy on the hero of the picture cycle. People who are not familiar with the biography of St. Francis are likely to have problems recognising the cycle as the life story of one person.[541]

Only Erik Moltesen's study of the St. Francis cycle, published in 1930, departs from the assumption of a fundamental, if not necessarily comprehensive and profound, coherence between the images. Moltesen divides the sequence of pictures into two groups of equal size: One painter, whom he calls the "sculptor" (*Plastiker*), adopting a slightly one-sided phrase, is said to have painted all but the first of the pictures on the north wall and the two pictures on the entrance wall; another painter who worked somewhat later, the "colourist" (*Kolorist*), is said to have been responsible for all the pictures on the south wall and for the first on the north wall.[542] Standing among the frescoes, this view proves plausible on the whole (except that, looking at the details, one must place a number of colleagues alongside both the sculptor and the colourist, see below). It is obvious, for example, and speaks for Moltesen's idea, that the images claimed for the Cecilia Master are not isolated but rather related to other fields on the south wall. In contrast, the opening picture of the cycle on the north wall (fig. 167) connects far more closely with the first scene on the south wall (Death of the Knight of Celano – fig. 168) than with these last three there, which have an even smaller figure scale (fig. 178). Margit Lisner was able to describe the differences in the colouring more precisely than Moltesen and confirmed (without intending to, by the way) his differentiation: in the "sculptor" area, the grey and brown of the Franciscan frocks and the variegation of the buildings often come into conflict. This is

540 A. Crowe and G.B. Cavalcaselle, *A New History of Painting in Italy*, vol. 1, London 1864, note. 1 p. 207. The real creation of the Cecilia Master was then carried out by Richard Offner: R. Offner, *The School of the St. Cecilia Master* (A Critical and Historical Corpus of Florentine Painting, sec. 3, vol. 1), Florence 1931.

541 M. Antonic, *Bildfolge, Zeit- und Bewegungspotential im Franzzyklus der Oberkirche San Francesco in Assisi*. Phil. Diss., Frankfurt 1991, p. 21.

542 E. Moltesen, *Giotto und die Meister der Franzlegende*, Copenhagen 1930.

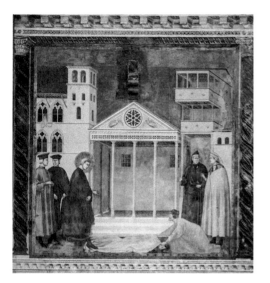

Fig. 167: Nave, lower north wall of the first bay: The Homage of the Simple Man (campaign 2)

Fig. 168: Nave, lower south wall of the forth bay: The Death of the Knight of Celano (campaign 2)

not the case in the "colourist" area, where a palette of many tones was used for the frocks, thus achieving a certain chromaticism and consistency of colouring.[543]

All in all, Moltesen's observations seem to prove that there was no mastermind in the creation of the St. Francis cycle whose artistic ideas were consistently authoritative, at least in a large core area. The cycle breaks down into two parts, held together by some basic agreements: They concerned the plot of the series as a whole and the format and costume of the figures as well as the settings in the individual pictures – but even these demands were not consistently implemented.

This assessment coincides in essential aspects with the observations made by the restorer and art historian Bruno Zanardi.[544] First, Zanardi examined the structure of the daily works and noted a different "disegno di progetto", a different strategy of execution, on the north and entrance walls on the one hand and on the south wall (including the opening scene on the north wall) on the other. Unlike Zanardi, however, I would like to

543 M. Lisner, Die Franzlegende in der Oberkirche von S. Francesco in Assisi: Farbgebung und Farbikonographie – Zur Giotto-Frage und zur Datierung, *Römisches Jahrbuch der Bibliotheca Hertziana* 33, 1999/2000, pp. 31–83, esp. 58.

544 Zanardi, *Il cantiere di Giotto* and B. Zanardi, Giotto and the St. Francis Cycle at Assisi, in: *The Cambridge Companion to Giotto*, ed. A. Derbes and M. Sandona, Cambridge 2004, pp. 32–62, esp. 49, 51–53.

308 Assisi 1308 and other St. Francis-Problems

conclude from this that there were two different *cantieri*, each with its own approach, the first of which, following Moltesen, could be called the sculptor-cantiere and the other the colourist-cantiere. Second, Zanardi noted that in the last scenes on the north wall and on the entrance wall, as well as in the first scenes on the south wall (that is, in the last pictures of the sculptor-cantiere and in the first pictures of the colourist-cantiere), at least one template of the same size was used for the proportioning of the faces. This template may have been a single material object that was passed on from one cantiere to the other. If this was not the case and there were two exemplars, one copied from the other or from a head in the wall paintings, the observation shows how one cantiere built on the images of the other. In any case, one of the means by which the painters tried to achieve a homogeneous appearance of the cycle becomes tangible here.[545] Thirdly, Zanardi noticed zones of identical painting technique in the treatment of the skin in both parts of the cycle of paintings. This may indicate that participants in one cantiere also worked in the other, or that there was some kind of continuity of training between painters of the two cantieri.

In those pictures where Moltesen sees the sculptor at work, there are often great similarities with heads from the Isaac Master complex in the clerestory, i.e. with works by the young Giotto or his assistants. Belting pointed out the "sculptural quality" of certain heads on the clerestory zone of the entrance wall and their similarity to the head of Francis in the Trial by Fire before the Sultan (St. Francis cycle).[546] The correspondence of the heads of Christ in the Ecstasy of St. Francis (St. Francis cycle) and in the Ascension of Christ (clerestory – fig. 169, 170) is also striking. There was also recourse to a work older than the clerestory: The picture showing the Expulsion of the Demons from Arezzo reproduces a constellation of figures from Cimabue's Fall of Simon Magus in the north transept.[547] But while Cimabue's habitus was not reproduced in the Arezzo picture, the peculiarities of the Isaac complex remain visible in many places. The painter – certainly an important member of the group – thus not only drew on the clerestory murals for specific motifs, but his painting was moulded by the formal language of these pictures. Presumably, participation in the clerestory campaign was part of his artistic experience.

On the other hand, the imagery in the Arena Chapel shapes that of the sculptor-cantiere. Characteristic are the figures overlapped by the edge of the picture, among them the

545 Since templates ("patroni") were easily obtained from the executed frescoes, I think it is a mistake to reconstruct the execution of the cycle on the basis of forms transported by templates. Incidentally, Zanardi's premises throughout are as dubious as his observations are relevant. Essentially, I believe that the author assumes too high a degree of rationality in the organisation of the working processes.

546 Belting, *Die Oberkirche von San Francesco in Assisi*, p. 242.

547 S. Romano, *La basilica di San Francesco ad Assisi: Pittori, botteghe, strategie narrative*, Rome 2001, p. 127.

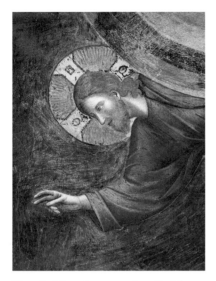
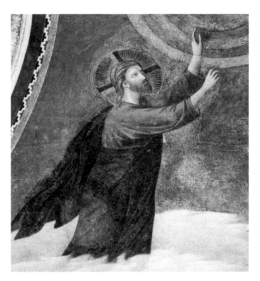

Fig. 169: Nave, lower north wall of the forth bay: The Ecstasy of St. Francis (campaign 1)

Fig. 170: Nave, clerestory of the entrance wall: The Ascension of Jesus, detail

severed donkey in the scene of the Miracle of the Spring, which is a variation on the severed donkey in the Paduan Nativity of Christ (fig. 171, pl. III). As far as the organisation of groups of figures is concerned, it is worth noting the gathering of people in the picture showing Francis Renouncing the Worldly Goods. The way the faces appear in front of, behind, next to, and opposite each other is reminiscent of the group around the good centurion in the Paduan Crucifixion (fig. 172, 61). However, unlike in Padua, no story emerges in Assisi, and the structure is nothing more than a formal means that serves to bring life to the work. "There should be quite a lot to be seen and the lot should present itself in a true variety", said Friedrich Rintelen, who did not accept the St. Francis cycle as being Giotto's work because of such superficialities.[548]

The buildings in this portion of the cycle are partly adaptations of late Byzantine architectural fictions, such as in the Doctors' Vault (Francis Renouncing the Possessions), and partly based on models from the Arena Chapel. The latter statement applies, for example, to the picture with the Miracle of the Crucifix of San Damiano (fig. 173): an obliquely positioned box with an open wall, marked at the same time as ruinous, represents the church and is easily recognisable as a variant of the Gothic shrine that houses the Pentecost event in Padua (fig. 50). This is possibly the last painting that Giotto did in the nave of the Arena Chapel.

548 F. Rintelen, *Giotto und die Giotto-Apokryphen*, Basel (2) 1923, p. 163.

Fig. 171: Nave, lower entrance wall: The Miracle of the Spring (campaign 1)

Fig 172: Nave, lower north wall of the second bay: The Renunciation of Worldly Goods (campaign 1)

Finally, this first part of the cycle also contains three pictures for which there are literal matches in a signed work by Giotto. These are the fields showing the Dream of Innocent III, the Confirmation of the Rule of the Order, and the Sermon to the Birds. With minor variations, they are found in the St. Francis panel in the Louvre, the "Opus Iocti Fiorentini" (1.6.2), which was originally in San Francesco in Pisa (pl. XV). We will return to this important connection towards the end of the chapter. What consistently distinguishes these and other scenes of the sculptor-cantiere from those in the clerestory, however, and what connects them generally with the pictures in the Arena Chapel and those on the Louvre panel, is that the figures and buildings form part of a separate pictorial world; immediate presence, produced by exaggerated modelling and meticulous drapery and characteristic of Giotto's early works, including the Isaac scenes, is avoided.

The pictures that Moltesen ascribed to his colourist are also close to Giotto. But while direct references to the clerestory frescoes and to the formal language of the pre-Paduan Giotto are completely absent now, the relationship to the Arena murals is even more

obvious. Motifs taken from there appear in abundance.[549] This includes spatial details transferred to scale.[550] Above all, however, there are concepts in this area that go beyond the pictorial language cultivated not only in the sculptor-cantiere, but also by the Paduan Giotto. Reference should be made to the appearances of crowds in the pictures showing the Death of St. Francis, the Discovery of the Stigmata, the Lamentation of the Poor Clares, and the Canonisation of Francis. Comparing the image of Christmas in Greccio (north wall) with the Discovery of the Stigmata (south wall), set in a similar ambience, gives an impression of the difference between the representational possibilities of the two campaigns or cantieri (fig. 174, 175). In the Greccio picture, the figures are grouped roughly as Giotto might have done in Padua. In the Stigmata picture,

Fig. 173: Nave, lower north wall of the second bay: The Miracle of the Crucifix (campaign 1)

by contrast, confusion is deliberately brought about. In this way, pushing "masses" are created and juxtaposed with some individuals who are not necessarily nameable, but help to mark the masses as the other, namely the masses.

Among these individuals, the two soldiers on the left and right are particularly interesting. Their framing and decorative function – underlined by their red robes and complementary movements – is unmistakable. Their elegantly twisted posture is notable. Precisely because of this, the pair of figures appears foreign. There is nothing comparable in Giotto's work or in the first portion of the St. Francis cycle. For these figures, the painter drew on an otherwise untouched collection of models: he used designs taken from the circle of the Sienese painter Pietro Lorenzetti. Hayden Maginnis once contrasted Giotto's monolithic treatment of the figure with Pietro Lorenzetti's organic equivalent, which was developed on a Gothic basis. And indeed, it can be said that in the scene with the Discov-

549 Here I refer to observations made by M. Roy Fisher und Yukihiro Nomura (among others): M.R. Fisher, Assisi, Padua and the boy in the tree, *The Art Bulletin* 38, 1956, pp. 47–52, Y. Nomura, Una proposta sulla datazione delle Leggende di S. Francesco nella Basilica Superiore ad Assisi, *Bijutsu shigaku* 10, 1988, pp. 1–27.

550 De Wesselow, The Date of the St. Francis Cycle, pp. 144–149. The comparison of the lamps, pp. 134–144, is also suitable to support my thesis.

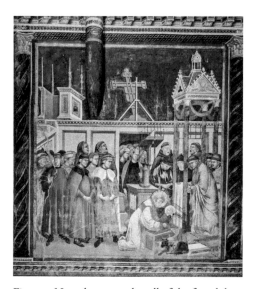

Fig. 174: Nave, lower north wall of the fourth bay: The Christmas at Greccio (campaign 1)

Fig. 175: Nave, lower south wall of the third bay: The Verification of the Stigmata (campaign 2)

ery of the Stigmata, two organic figures, dominating their vicinity with grand gestures, are set among many monolithic figures centred in themselves.[551] According to Hayden Maginnis and Max Seidel, Pietro Lorenzetti's frescoes in the Lower Church of Assisi were probably painted between 1316/17 and 1319,[552] and thus 1317 could tentatively be taken as the *terminus post quem* for the activity of the colourist-cantiere.

The red soldier on the left (fig. 176) literally originates from Pietro's Lower Church frescoes: one can compare him with the armoured man holding back Christ's followers in the picture of the Road to Calvary (fig. 177). A squatting figure is also taken from this cycle, namely from the Stigmatisation picture inserted there (fig. 234). The colourist and his colleagues have adapted this figure twice: In the context of the Apparition in Arles, he forms Francis' companion although the right arm has been changed; in the Sermon before Honorius III which precedes this scene, the right leg has also been modified.

Incidentally, this is not the first time that reference has been made to Sienese elements in the south wall section of the St. Francis cycle. According to Irene Hueck, the painted sculpture in the picture depicting the Liberation of the Heretic Peter (fig. 178) was done by Simone Martini; since she assumes that the frescoes date from around 1300, she imagines

551 H.G.J. Maginnis, *Pietro Lorenzetti and the Assisi Passion Cycle*, Ph. D. Princeton 1974, p. 7.
552 M. Seidel, Das Frühwerk des Pietro Lorenzetti, *Städel-Jahrbuch* 8, 1981, pp. 79–158

Fig. 176: The Verification of the Stigmata, detail (campaign 2)

Fig. 177: San Francesco, lower church, south arm of the transept, The Road to Calvary (Pietro Lorenzetti)

a Simone who was still a teenager.[553] In contrast, I assume that models were reproduced here and they (like comparative examples given by Irene Hueck) may have come from the sphere of the mature Simone Martini. But they could also be taken from the stock of his compatriot Pietro Lorenzetti, whose art is closely related to Simone's work. After Margrit Lisner attributed whole areas of the last scenes to Pietro Lorenzetti (instead to the ominous Cecilia Master) in 1995,[554] she modified her position somewhat in her renewed treatment of the St. Francis cycle in 1999. But at the same time she drew attention to a child's head in the Canonisation of St. Francis: in outline and details, it corresponds almost exactly to the head of the Christ child in Pietro's Montichielli Madonna (Siena, Pinacoteca Nazionale). According to Lisner, this indicates that Pietro Lorenzetti was in possession of copies based on motifs from the last frescoes of the Legend of St. Francis, which he

553 I. Hueck, Frühe Arbeiten des Simone Martini, *Münchner Jahrbuch der bildenden Kunst* 19, 1968, pp. 29–60.

554 M. Lisner, Giotto und die Aufträge des Kardinals Jacopo Stefaneschi für Alt-St. Peter II: Der Stefaneschialtar – Giotto und seine Werkstatt in Rom. Das Altarwerk und der verlorene Christuszyklus in der Petersapsis, *Römisches Jahrbuch der Bibliotheca Hertziana* 30, 1995, pp. 59–133, esp. 107.

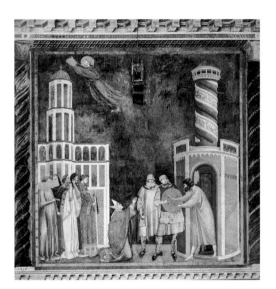

Fig. 178: Nave, lower south wall of the first bay: The Relief of the Heretic Peter (campaign 2)

used and modified.[555] In my view, this is – conversely – another indication of the use of models from Pietro Lorenzetti's workshop in the colourist-cantiere. In addition, collaborators of Pietro Lorenzetti may also have been physically involved in the last three pictures. A changed personnel structure in the cantiere would explain the stylistic deviation of the final triad quite well (fig. 178).

When it comes to dating the two parts of the fresco cycle, not only considerations of style and history of motifs are relevant, but also the remarkable fact that the opening image of the cycle was first omitted (by the "sculptor" and his team) and then added (by the "colourist" and his team). The section of wall on which this scene is painted is also the one from which the right-hand console for the bearer of the triumphal cross protrudes. It is made of wood and therefore not part of the building's original structure. The question as to why this section of the wall was initially left out of the fresco decoration can therefore best be answered by referring to the beam. It is clear, however, that it was not its presence that caused the problems, because the picture (fig. 167) shows how easily the console could be integrated – and so does the picture opposite with the left console (fig. 178). What alone could have held up the work was the plan to install the beam.[556] This means: the St. Francis cycle was begun hand in hand with the erection of a triumphal cross and was thus part of a liturgical reorganisation of the upper church, which in turn can only have been part of the fundamental functional reorganisation of the two superimposed spaces to which I referred at the beginning of the chapter. In this context, the St. Francis cycle was a contribution to the transformation of the papal palace church into a Franciscan conventual church. And for the same purpose, the cross erected by the minister general Elias in 1236 was probably

555 Lisner, Die Franzlegende in der Oberkirche von S. Francesco in Assisi, p. 73.
556 Irene Hueck assumes that a rood screen previously stood in the place of the beam. But unlike in the case of the Lower Church, there is no structural evidence of the existence of a rood screen in the Upper Church. It should also be noted that the papal basilicas in Rome did not have rood screens. I. Hueck, La Basilica Superiore come luogo liturgico: L'arredo e il programma della decorazione, in: *Il cantiere pittorico della Basilica Superiore di San Francesco in Assisi*, ed. G. Basile and P. Magro, Assisi 2001, pp. 43–69.

Giottesque Painting in Assisi: The Chapel of St. Nicholas

transferred from the rood screen of the Lower Church to the analogous place in the Upper Church, where the beam was to be installed.[557] A choir stall was certainly also erected. A document from 1349 proves that there was already one in the Upper Church before the existing Renaissance pews.[558] Unfortunately, we do not know how it was situated in relation to the Triumphal Cross and the St. Francis cycle.[559] We do not even know how the Renaissance pews were originally positioned.

If the work of the colourist and his colleagues, and thus the completion of the cycle, can be dated relatively late, this does not necessarily apply to the activity of the sculptor-cantiere within the contexts explored here. A date around 1308 and in some connection with Giotto's stay in Assisi seems worth considering. Basically, the question is by which path certain features of Giotto's Paduan style got into the fourteen older images: one possibility is that it came to Assisi and into the St. Francis cycle through Giotto himself. In this case, Giotto would have intervened in the creation of the pictures without doing much painting himself; there are only a few places in the frescoes where the Paduan style reappears at a level approaching the quality of the paintings in Padua. Of course, what I read as weaknesses can also be interpreted as features of the paintings' creation at an early period – as immaturities – and indicate that the Paduan repertoire presents itself here at a preliminary stage. But this assumption would not do justice to the cantiere character and stylistic syncretism of the campaign, in which different layers of Giotto's development appear side by side.

The other possibility is that the Paduan elements were brought to Assisi by a former Paduan assistant of Giotto. One has to imagine a painter who had emerged from the Paduan bottega and was now working with a guiding role alongside local hands in a cantiere formed for the large-scale commission of the Legend of St. Francis.

GIOTTESQUE PAINTING IN ASSISI: THE CHAPEL OF ST. NICHOLAS

Decisive in identifying the function of the Chapel of St. Nicholas are firstly its location, secondly a wall tomb above the altar, which was planned from the beginning, as the high-set central window indicates, and thirdly a side window from a neighbouring space. The

557 The Elias Cross is documented as standing on this beam in 1624. That it only arrived there in 1513 cannot really be inferred from the document of this year presented by Irene Hueck. She also admits this: Hueck, La Basilica Superiore come luogo liturgico, p. 52.

558 C. Cenci, *Documentazione di vita Assisana 1300–1530. Vol. 1: 1300–1448*, Grottaferrata 1974, p. 105.

559 Irene Hueck's suggestion is speculative. Hueck, La Basilica Superiore come luogo liturgico, fig. 10.

chapel is attached to the northern transept arm of the Lower Church. From the altar and the tomb, there is a line of sight to the high altar of the Lower Church and thus to the burial place of St Francis. In other words, the priest celebrating over the saint's body can see the altar and the tomb in the Chapel of St. Nicholas by turning his head (fig. 179). The side window, now walled up but usable until the 16th century, is in the west wall (fig. 180, left). It permitted a view of the altar of the chapel and tomb from an oratory accessible from the papal palace. The situation compares well with the windows from the palace in the Arena Chapel (pp. 94–95). What the Arena Chapel was meant to be for the inhabitants of the Arena Palace, the St. Nicholas Chapel was apparently meant to be for those of the papal palace. In other words, it was to supplement the large church with an intimate devotional space, a *capella secreta*, where the Pope could celebrate in a small setting, but also follow the celebration of his chaplain unseen. This shows that the planning of the chapel falls into the phase before the reorganisation of the double church, i.e. into a time when the presence of the Curia in Assisi was still expected.[560]

According to Pia Theis, the building was erected as a combination of a *capella secreta* and a burial space for Pope Martin IV (1281–1285)[561] The pontiff, who died in Perugia, had stipulated in his will that he should be buried in the habit of the friars in San Francesco in Assisi. However, when his successor Nicholas IV wanted to transfer the body, the citizens of Perugia did not hand it over. A second attempt to transfer the pope was made in 1297 under Boniface VIII and the protector Matteo Rosso Orsini. But even these two failed due to the resistance of the Peruginians, who wanted to keep the now miraculous body in their cathedral and who could not be lured by money and a two-year indulgence promised by the Pope.[562] The construction of the chapel probably belongs to the context of this second attempt to fulfil Martin's wish: the line of sight from the tomb of St. Francis to his planned burial place corresponds to the late pope's devotion to St. Francis; the merging of the *capella secreta* and the *mausoleum* corresponds to Martin's reputation of sanctity; the position of the tomb above the altar, which was still novel at the time, reflects Boniface VIII's own tomb planning in St. Peter's, which had taken final shape in 1296. In that year, the baldachin-shaped chapel was consecrated to house the tomb above its altar.[563]

560 There was also a *capella secreta* in the papal palace in Avignon: G. Kerscher, *Architektur und Repräsentation: Spätmittelalterliche Palastbaukunst zwischen Pracht und zeremoniellen Voraussetzungen. Avignon – Mallorca – Kirchenstaat*, Tübingen and Berlin 2000, p. 71 and passim.

561 P. Theis, *S. Francesco in Assisi: Eine Palastkirche des Papstes zwischen Rom und Avignon*, Phil. Diss. Vienna 2001.

562 G. Ladner, *Die Papstbildnisse des Altertums und des Mittelalters*, vol. 2, Vatican City 1970, p. 228 nach C. Crispolti, *Perugia Augusta*, Perugia 1648, p. 68. Crispolti quotes an otherwise unattested bull of Boniface VIII.

563 J. Gardner, *The Tomb and the Tiara: Curial Tomb Sculpture in Rome and Avignon in the Later Middle Ages*, Oxford 1992, pp. 107–109. M. Maccarrone, Il sepolcro di Bonifacio VIII

Fig. 179: Lower church, St. Nicolas Chapel, view to the south into the crossing

Fig. 180: Lower church, St. Nicolas Chapel, view to the north

What visitors encounter today – decorated with stained glass and frescoes and marked by over 50 red and white escutcheons – is a sanctuary not for the pope, but rather for the House of Orsini. In the central stained-glass window above the tomb, two members of this family are shown and identified by inscriptions: kneeling on top and presented by St. Francis to the Saviour is Gian Gaetano Orsini, who died young between 1292 and 1294; below, standing in front of St. Nicholas, is his long-lived brother Cardinal Napoleone (†1342). On the tomb, which bears no inscription, the person buried there is represented by the reclining figure of a young cleric. It is therefore probably Gian Gaetano Orsini who found his final resting place here instead of Martin IV. The donor of the tomb and the chapel's decoration was probably Napoleone.[564] This means that the building, not

 nella basilica vaticana, in: *Roma Anno 1300: Atti della IV settimana di studi di storia dell'arte medievale dell'Università di Roma La Sapienza (19–24 maggio 1980)*, ed. A.M. Romanini, Rome 1983, pp. 753–771.

564 An early modern burial register of San Francesco, pointed out by Igino Benvenuto Supino (I.B. Supino, La cappella di Gian Gaetano Orsini nella basilica di San Francesco d'Assisi, *Bolletino d'arte* 6, 1926/27, pp. 131–135), describes the complicated history of the chapel with a (probably too) simple formula: „Item, nella capella di Sancto Nicolò sta sepellito il corpo del s.re Gioan, fratello del d.o s.re Napolione cardinale, qual capella ancora esso signor Napolione fece edificare." Assisi, Biblioteca Communale, Miscellanea DD, n. 7. Registri delle Sepolture. Since all the information contained in the short text could have

having been used as a papal burial chapel, became a patronage of the Orsini family. Since Matteo Rosso Orsini in his function as Protector of the Order had been responsible for the construction, this was an obvious step. The dedication of the chapel to St. Nicholas can also be explained through the Orsini. It commemorates Nicholas III, the middle of the three Orsini popes, and thus the man to whom Matteo Rosso owed his career. And after Matteo Rosso's death in 1305, the second cardinal in the family, his cousin Napoleone, took over responsibility for the decoration. Since he had been appointed papal legate in Umbria by Boniface VIII in 1300, a commitment in Assisi was expected of him anyway.[565]

However, the painting of the room seems to have started under Matteo Rosso. Until 1913, the fresco above the entrance arch (fig. 179) showed the same constellation as the stained glass window in the axis, except that the saints were switched: a youthful cleric (according to the inscription Gian Gaetano) was presented by Nicholas to the Salvator, and a cardinal (according to the inscription Napoleone) was presented by St. Francis. Then, during restoration work, it was discovered that to the left and right of the two Orsini there were three more kneeling clerics with mitres, all of whom had been painted over al secco at an early stage and rendered invisible. During a restoration in 1974, it was discovered that the two Orsini had been painted on plaster areas that had been inserted later and had apparently replaced two other kneeling figures. There were thus originally eight kneelers, of which the inner two were soon replaced and the outer six erased. Irene Hueck identified the eight original figures with the members of the conclave of 1292–94 in Perugia.[566] While this electoral assembly was in session, Gian Gaetano Orsini lost his life in a riding accident and, as Jacopo Stefaneschi reports in his *Opus metricum*, this provided the assembled cardinals with the occasion to recall their mortality and their duties.[567] The whole thing ended in uproar with the election of Peter of Morrone aka Coelestine V, whose resignation from the papal office would then lead to those upheavals that forced the Curia to go to Avignon.

Hence, the subsequent use of the chapel built for Martin IV was probably first intended as a foundation created by the veterans of Perugia for Gian Gaetano Orsini. In addition to Matteo Rosso, Napoleone Orsini was also among the eight cardinals. At that time, in the years after 1297, Gian Gaetano was presumably transferred from his unknown

been taken from the stained glass window and the tomb, no direct source value needs to be assumed.

565 *La basilica di San Francesco in Assisi*, ed. G. Bonsanti (Mirabilia Italiae 3), Modena 2002, vol. 1.1 p. 431.

566 I. Hueck, Il cardinale Napoleone Orsini e la cappella di S. Nicola nella basilica francescana ad Assisi, in: *Roma anno 1300. Atti della IV settimana di studi dell'arte medievale dell' Università di Roma La Sapienza*, ed. A.M. Romanini, Rome 1983, pp. 187–197.

567 I. Hösl, *Kardinal Jacobus Gaetani Stefaneschi: Ein Beitrag zur Literatur und Kirchengeschichte des beginnenden vierzehnten Jahrhunderts*, Berlin 1908, pp. 49–50.

Fig. 181: Boston, Isabella Stewart Gardner Museum, retable or antependium (Giuliano da Rimini)

first place of burial to Assisi where the tomb was made. This assumption is supported by the fact that the tomb does not contain a coffin but a small ossuary.[568] After Matteo Rosso's death and the death of several other donors, Napoleone completed the fitting decoration of his brother's mausoleum alone.

This would result in a terminus post quem for the pictorial decoration of the chapel on Matteo Rosso's death on 15 September 1305. One can probably even speak of a *terminus ad quem*: The earlier and later kneelers in the painting on the entrance wall are obviously executed in the same forms, and this painter or bottega was responsible for all the pictures in the chapel. The earlier phase of paintings in the chapel may be separated from the later one only by a short period in the autumn of 1305. In addition, there is a *terminus ante quem*: motifs from the murals return on a retable or antependium that is from Urbania near Urbino; the painter Giuliano da Rimini signed it and dated it 1307 (Boston, Isabella Stewart Gardner Museum, fig. 181): ANNO. DNI. MILLO. SETTIMO. IULIANUS. PICTOR. DE. ARIMINO. FECIT. OCHO. PUS. TENPORE. DNI. CLEMENTIS. PP. QUINTO. John White introduced the panel to research in his framework of arguments for the dating of the Legend of St. Francis in the Upper Church.[569]

However, in Assisi, the history of the spiral columns, like those that adorn the Bos-

568 Kind information from Father Gerhard Ruf.
569 J. White, The Date of the Legend of St Francis at Assisi, *The Burlington Magazine* 98, 1956, pp. 344–351.

Fig. 182: St. Nicolas Chapel: St. Clare and St. Elizabeth (unknown painter)

ton panel, does not begin with the Legend of St. Francis, but rather with the murals of the clerestory above (entrance bay – fig. 115), and there must have been so many depictions of the Stigmatisation in the Franciscan milieu around 1300 that the Upper Church example is not necessarily the direct model for the one on the panel.[570] For the rest, the differences are numerous. A few may be mentioned here: The image on the panel shows two persons, the fresco three persons (fig. 233). The figures of the Seraph and Francis in the fresco are connected by rays, while those on the panel are not, which corresponds to the pre-Giottesque iconography of Francis – more on this later. The kneeling Francis on the panel has not only thrown his head back further, but also turned it more towards the audience. He is wearing sandals, while the one in the fresco is barefoot; on the panel the saint's wrists are bare, in the mural they are covered, a motif that reminds us that Francis was hiding the wounds.[571] What the two figures of Francis have in common, apart from their posture (which was fixed early on in representations of the Stigmatisation), is the beard, and this at least shows that the saint's beardedness speaks neither for a very early nor for a very late dating of the Legend of St. Francis, as Bellosi on the one hand and Stubblebine on the other suggested:[572] It also occurs in the first Trecento decade. But what is really significant when comparing the 1307 panel with the Assisi imagery, as pointed out by Millard Meiss, is the short-necked figures of saints, inscribed in closed outlines and clearly based on Giotto, that are encountered both in the Chapel of St Nicholas and on the panel, and which are certainly not an invention of Riminese painter whose approach was rather schematic. St. Clare on the panel

570 This was also the opinion of Bruce Cole: B. Cole, *Giotto and Florentine Painting 1280–1375*, London 1976, pp. 191–192.

571 Cf. W.R. Cook, *Images of St. Francis of Assisi in Painting, Stone and Glass from the Earliest Images to ca. 1320 in Italy: A Catalogue* (Italian Medieval and Renaissance Studies 7), Florence and Perth 1999, p. 76.

572 Bellosi, *La pecora di Giotto*, pp. 3–9. Stubblebine, *Assisi and the Rise of Vernacular Art*, p. 69–70.

Giottesque Painting in Assisi: The Chapel of St. Nicholas 321

looks like an unskilled variant of the figure of St. Clare in the chapel[573] (fig. 182). Giuliano da Rimini must have been in Assisi before he executed the panel, and on this occasion he saw both the frescoes by the young Giotto in the clerestory of the upper church with the Cosmatesque spiral columns and the frescoes of the Chapel of St. Nicholas in the lower church.

Thus, the painting of the Chapel of St. Nicholas can be dated to the period between 1305 and 1307 and cannot be considered the sought-after Giotto work of the year 1308. Nevertheless, the paintings are of considerable interest in the context of the study of Giotto, because the pictures, which are all in small format, are extremely high-quality works from his circle. This was not seen for a long time because of Vasari's arbitrary attribution of them to Giottino, a Florentine painter of the middle 14th century. Henry Thode was the first to associate the decoration with Giotto. For him, it was largely a work of his own hand.[574] Millard Meiss wrote that the style as a whole was "Giottesque in the Paduan sense."[575] The spatially projected, differently turned and at the same time powerful figures make this assessment understandable. And yet the professional biography of the principal painter or painters seems to extend back before the lessons received from Giotto. Where the figures do not follow Giotto's concepts, they are reminiscent of Cavallini's work in their distinguished simplicity and in the straightforwardness of their modelling. Nor were Giotto's lessons confined to his work in the state of Padua: the scene showing Nicholas Saving Three Youths from being Beheaded takes place against a late Byzantine architectural fantasy with Cosmatesque detail, reminiscent of the picture of the Stolen Cup from the Old Testament frescoes in the clerestory of the Upper Church (fig. 183, 117).

And at no point is a Paduan picture simply adopted: There is always, it seems, an attempt to relate Giotto's Paduan inventions back to an earlier state of representational discourse, to consolidate them on that basis and, starting from there, to develop them further in an individual way. This can be seen particularly well in the appearance of the buildings. Characteristic is the structure in which the three girls and their father sleep while St. Nicholas brings them presents (fig. 184): it is effectively a box with Gothic decoration similar to the room for the Last Supper and the Washing of the Feet in Padua (fig. 48, 57), but placed on an extra-wide brown ground strip and equipped with a projecting upper storey and an oriel, both of which are shown reduced in size. Further enriched and provided with evidencing motifs, such a hybrid architecture is then found once again in Constantine's Dream and achieves a character of its own (fig. 185). In con-

573 Meiss, *Giotto and Assisi*, pp. 3–4. Meiss also points to a second dated panel that reflects motifs from the Chapel of St. Nicholas: a retable or antependium in Cesi near Terni (Umbria); it bears the date 1308.

574 Thode, *Franz von Assisi und die Anfänge der Kunst der Renaissance in Italien*, p. 270.

575 Meiss, *Giotto and Assisi*, p. 3.

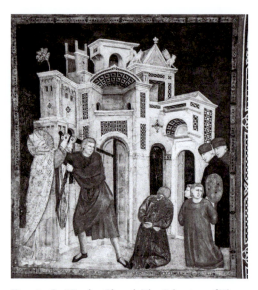

Fig. 183: St. Nicolas Chapel: The Salvation of Three Youths (unknown painter)

Fig. 184: St. Nicolas Chapel: The Charity of St. Nicholas (unknown painter)

Fig: 185: St. Nicolas Chapel: Nicholas appears to Emperor Constantine (unknown painter)

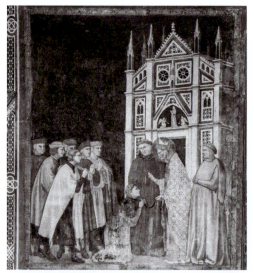

Fig: 186: St. Nicolas Chapel: The Rescue of a Young Man (unknown painter)

trast to the fourteen pictures of the first campaign of the St. Francis cycle, i.e. to the work of the sculptor-cantiere, both older and more recent features of architectural representation are synthesised in the Chapel of St. Nicholas and not merely used side by side.

On the other hand, as far as the relationship to the second campaign of the St. Francis cycle is concerned, i.e. to the colourist-cantiere, it can be shown how these pictures both profit from and surpass the St. Nicholas frescoes; they thus stand in a similar relationship to them as they do to Giotto's Arena frescoes. The church façade slanted into the picture of the Farewell of the Poor Clares to the Dead Francis is obviously taken from one of the St. Nicholas pictures (fig. 186, 187): the rescued man thanks the saint, who is standing in front of

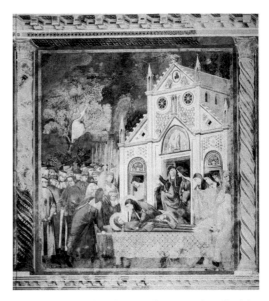

Fig. 187: Upper church, nave, lower south wall of the second bay: The Farewell of the Poor Clares (campaign 2)

the door of a Gothic church that represents his burial church in Myra. The building highlights the figure of St. Nicholas and provides an impressive backdrop for the action, but it is not a constitutive element of the pictorial narrative as in the St. Francis cycle, where the nuns rush out of the doors to the catafalque. In Giotto's own work, such structures are sometimes used by the people in the picture in a similar way, e.g. in the Paduan Encounter at the Golden Gate (fig. 45). But even this picture cannot compete with the Farewell of the Poor Clares either in the plausibility of the representation of the building or in the dynamic of the action emanating from its use. Here we see once again how the more recent images of the St. Francis cycle point beyond the possibilities available to Giotto and his pupils in the first decade of the 14th century.

The scene with the Return of Adeodatus to his Parents also seems to have inspired one of the later fields of the St. Francis cycle (fig. 188). The picture provides a spatial solution that is completely new and does not occur in Giotto's work. What looks at first glance like an elaborate box actually comes about by opening up the architectural frame of the picture and making a space for the action visible behind it, defined only by a curtain on the back wall, a strip of floor, furniture and figures. This is reminiscent of the Confirmation of the Stigmata, a picture in the St. Francis cycle that is just as unusual in its

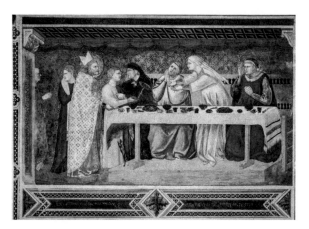

Fig. 188: St. Nicolas Chapel: The Return of Adeodatus to his Parents (unknown painter)

"tremendously bold treatment of the space" (Pietro Toesca)[576] (fig. 175). There, the beam of the triumphal cross, supported by consoles and abutting the frame on both sides, takes on the same role as the upper strip of the frame, also supported by consoles, in the Adeodatus picture. Both elements oscillate between extra- and intra-pictorial existence, so that in the St. Francis fresco, the intra-pictoriality is better motivated in terms of content. What the curtain on the back wall achieves in the Adeodatus picture, the apse achieves in the Stigmata picture: painted al secco and therefore poorly preserved, it is visible in the depths above the heads of the figures, in the manner of a backdrop.[577] Both motifs – curtain as well as apse – provide a rear closure, while nothing is communicated about their structural connection with the foreground elements. Here, as there, the interior is shown without any reference to the exterior construction. This clearly exceeds the standards of Giotto's representation of spaces. We have before us the first two cases of what Erwin Panofsky called an "interior by implication" in Early Netherlandish painting.[578] In the St. Francis legend, an experiment turns in an (almost) convincing solution.

The large picture of the Annunciation, which virtually forms the painted façade of the St. Nicholas Chapel towards the transept, has a spatial concept all of its own (fig. 189): here the painter relies on an illusionistic solution with remarkable skill. The space for action is formed by recessing the wall by the depth of a ceiling cassette and an arched frieze. Thus, the angel and Mary stand as if on a shallow terrace on either side of the chapel's entrance arch. Their bodies are powerful silhouettes and appear in a concise and telling posture. Combined with the sparingly used but effective details – curtain, cabinet niche, wooden chair and reading desk – the action seems to be very present. The picture competes with the presence that the young Giotto gave his figures. The illusionistic space, however, which is so important here, had only been developed by Giotto in Padua (on the choir arch). Again, it can be seen how the painter of the Chapel of St. Nicholas brought together vari-

576 P. Toesca, *Die Florentinische Malerei des vierzehnten Jahrhunderts*, Florence and Munich 1929, p. 26.
577 Zanardi, *Il cantiere di Giotto*, p. 294.
578 E. Panofsky, *Early Netherlandish Painting: Its Origins and Character*, Cambridge 1953, p. 37.

ous time layers of Giotto's formal language. In the present case, the aim was evidently to create a scene whose effect extended into the sanctuary of the Lower Church and appeared inviting to its visitors. Originally, i.e. around 1306, the mural was a standalone image, surrounded by a decoration that probably originated from the middle of the 13th century and which – apart from Cimabue's Maestà and perhaps the first apse decoration, about which nothing is known – was purely ornamental. It was only afterwards that the Annunciation was integrated into the cycle that adorns the northern transept and which some also consider to be a work by Giotto.

Before we turn to the further decoration of the transept and the crossing, a few critical sentences are necessary on the analysis of this interior transept façade presented by Bruno Zanardi, relying partly on technical and partly on stylistic findings.[579] Zanardi also recognises the difference between the Annunciation and the other scenes on

Fig. 189: St. Nicolas Chapel, façade to the transept: The Annunciation (unknown painter)

the wall. However, he does not believe that the Annunciation was alone at first and assumes that the decoration of the wall was designed as a whole and also executed as a whole, but that the St. Francis scenes below the Annunciation were subsequently modernised. For this purpose, the painters are said to have partially removed the plaster and executed new giornate with new figures. From the first phase, the upper strip of blue ground, the upper parts of the buildings, and individual figures in the scenes are supposedly still preserved in these paintings and therefore belong to the Annunciation in terms of production process – in other words, they are part of the campaign that created the frescoes in the Chapel of St. Nicholas. If one looks at the *giornate* plan used by Zanardi, it becomes clear where this thesis comes from.[580] According to this plan, there is no discernible break between the Annunciation and the St Francis scenes: the horizontal boundary of the *giornate* runs through the ornamental strip below the Annunciation and the band

579 B. Zanardi, *Giotto e Pietro Cavallini: La questione di Assisi e il cantiere medievale della pittura a fresco*, Milan 2002, pp. 131–148.
580 Ibid. plan 3 (LXXII–LXXIII).

thus belongs partly to the upper, partly to the lower day's work. However curious such a finding may be, it clearly speaks for continuous work at this point. But Zanardi's plan as a whole is inaccurate and even grossly wrong on this point. In fact, the ornamental strip with the inscription belongs entirely to the lower *giornate*.[581] The band was therefore replaced when the painting of the transept was continued. In this way, the painters wanted to hide the seam and the change of plan as neatly as possible, given that the Annunciation was also being thematically "appropriated" for the images of Christ's childhood.

PAINTING IN ASSISI: THE CROSSING AND NORTH TRANSEPT OF THE LOWER CHURCH

The vault above the crossing square of the lower church must originally have had the same massive band ribs that the visitor still encounters in the nave, but which were reduced to polygonal ribs. Hand in hand with this, the windows of the apse were given pointed arches. The chancel of the lower church, and thus the most important place for the worship of St. Francis, had to, as much as it was possible, present itself in modern Gothic forms. Above all, however, it received a figurative decoration: the Infancy of Christ, the Crucifixion and the posthumous miracles of St. Francis were grouped around the Annunciation in front of the St. Nicholas Chapel in the barrel-vaulted north transept; St. Francis enthroned and three Franciscan allegories appear against a golden background in the crossing vault, in the so-called *vele* (sails): a Passion cycle with a great Crucifixion and an image of the Stigmatisation of St. Francis adorn the barrel-vaulted south transept. One particularly important image has been destroyed: the Allegory of the Cross with St. Francis in the apse, which probably replaced an older apse image and which Ghiberti called "una Gloria" describing it as a work by Giotto's pupil Stefano (2.1.4).[582] The omnipresent images of St. Francis thematically connect the four sections (including the apse) into one

581 Compare Zanardi's plan (ibid.) with: *La Basilica di San Francesco ad Assisi,* ed. Bonsanti, vol. 1.1 fig. 1122. This shows that Zanardi's markings are shifted downwards by about 1 mm in relation to the representation. Cf. also: H.B.J. Maginnis, Assisi Revisited: Notes on Recent Observations, *The Burlington Magazine* 117, 1975, pp. 511–517, esp. 512 with note 5. The situation described there apparently coincides with the *giornate* listed in Zanardi's plan under numbers 15 and 17, which have to be assigned to the second campaign in the transept.

582 This apse decoration, predecessor of the existing one from the 17th century, has been fairly well handed down through several descriptions: Fra' Lodovico da Pietralunga, *Descrizione della Basilica di S. Francesco e di altri santuari di Assisi,* ed. P. Scarpellini, Treviso 1982, pp. 62–64, 288–292. E. Lunghi, La perduta decorazione trecentesca nell'abside della Chiesa Inferiore del S. Francesco ad Assisi, *Collectanea Francescana* 66, 1996, pp. 479–510. In the conclusions regarding idea and commissioning, Lunghi seems to me to go too far.

Painting in Assisi: the Crossing and North Transept of the Lower Church 327

programme.[583] They also connect them to the old painting in the nave: the posthumous miracles continue the mid-13th-century St. Francis cycle there; the Stigmatisation replaces its equivalent in the nave, which had been reduced to a devotional picture of the Seraph due to damage. The remodelling and decoration of the sanctuary was thus a reaction to the conversion of the double church and accompanied the release of this section of the room for the pastoral care of pilgrims.[584]

For Vasari, the *vele* frescoes were Giotto's works, a claim he made again on the basis of Ghiberti's "quasi tutta la parte di sotto", a statement that Vasari simply read differently now than he had when he was concerned with the Legend of St. Francis (vol. 1, p. 24). In contrast, the pictures in the north transept, which were always in the shadow of the *vele*, seem to be referenced at one point in his chapter on Taddeo Gaddi, but they are not clearly named there. The seemingly obvious expansion of the attribution to Giotto from the crossing frescoes to these pictures was then made by Crowe and Cavalcasella. Since then, the two complexes are usually assigned together sometimes to Giotto, sometimes to an artist or studio close to him. The name changes: Maestro oblungo, Parente di Giotto, Maestro delle vele ...[585] Why I would like to assign them to Giotto's pupil Stefano is explained below.

When considering the dating of the frescoes, it should first be noted that the painting of the north transept followed that of the Chapel of St. Nicholas and its "façade" with the Annunciation. Secondly, technical findings must be taken into account that are, however, ambiguous:[586] They can mean that the painting of the north transept was followed by

583 That it is a consistent programme is not a new assumption: A. Tantillo-Mignosi, Restauri alla Basilica Inferiore di Assisi. Osservazioni sul transetto destro, *Bolletino d'arte* V, 60, 1975, pp. 129–142 and 217–223, esp. 137–139 and D.W. Schönau, The "Vele" at Assisi: Their Position and Influence, *Mededelingen van het Nederlands Instituut te Rome* 44–45, 1983, pp. 99–109, esp. 100. See also: M.A.C. Dougan, *The Franciscan Allegories in the Lower Church at San Francisco, Assisi: Form and Meaning*, Ph.D. Athens, Ge. 1997.

584 M.V. Schwarz, Zerstört und wiederhergestellt. Die Ausmalung der Unterkirche von S. Francesco in Assisi, *Mitteilungen des kunsthistorischen Instituts in Florenz* 37, 1993, pp. 1–28. Similar: J. Robson, The Pilgrim's Progress: Reinterpreting the Trecento Frescoe Programme in the Lower Church at Assisi, in: *The Art of the Franciscan Order in Italy*, ed. W.R. Cook, Leiden and Boston 2005, pp. 39–70.

585 For information on the history of research, see: *La Basilica di San Francesco ad Assisi*, ed. Bonsanti, vol. 1.1 pp. 394–395, 419–421 and A. Mueller von der Haegen, *Die Darstellungsweise Giottos mit ihren konstitutiven Momenten Handlung, Figur und Raum im Blick auf das mittlere Werk*, Braunschweig 2000, pp. 286–298.

586 E. Pagliani, Note sui restauri degli affreschi Giotteschi nella Chiesa Inferiore di San Francesco, in: *Giotto e i Giotteschi in Assisi*, Assisi (2) 1979, pp. 199–208. Maginnis, Assisi Revisited, esp. diagram A on p. 512. R. Simon, Towards a Relative Chronology of the Frescoes in the Lower Church of San Francesco at Assisi, *The Burlington Magazine* 118, 1976, pp. 361–366 (The author's considerations regarding building history are disproved.)

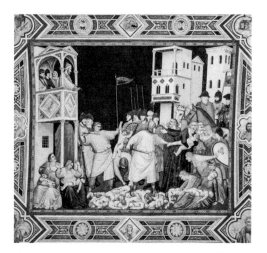 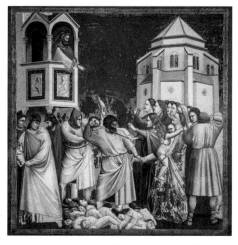

Fig. 190: Lower church, northern transept: The Massacre of the Innocents (Stefano)

Fig. 191: Padua, Arena Chapel, South wall of the nave: The Massacre of the Innocents

that of the crossing and then by that of the south transept. The findings may also mean that the entire sanctuary was painted in one go. The artists could have started in the crossing (or in the apse), from which the two transept arms were executed more or less simultaneously, followed by the transverse arches towards the crossing. Thirdly, it should be remembered that for the non-Giottesque frescoes in the south transept, a dating soon after 1316/17 can be obtained from the chronology of Pietro Lorenzetti's oeuvre. The *terminus ante quem* is 1319, when the commune of Assisi changed to the Ghibelline side and an extremely difficult situation for the city and the monastery began, which certainly did not allow any progress in the decoration of San Francesco for many years.[587] According to this, the Giottesque pictures in the north transept and in the crossing either belong to the period between 1306 and 1317/19 and thus could be the result of Giotto's activity of the year 1308 or – in line with the Lorenzetti frescoes – they date from around 1317 to 1319.

On the one hand, the paintings in the north transept can be read as straightforward follow-ups to the frescoes in Padua. Material from older phases of Giotto's art, as noticeable in the sculptor-cantiere's parts of the Legend of St. Francis and in the Chapel of St. Nicholas, cannot be found. Instead, the entire stock of Paduan imagery is used and

587 F. Ehrle, Die Beraubung des päpstlichen Schatzes in St. Francesco (1319 und 1320), *Archiv für Litteratur- und Kirchengeschichte des Mittelalters* 1, 1885, pp. 238–286. S. Nessi, *La basilica di S. Francesco in Assisi e la sua documentazione storica*, Assisi 1982, pp. 314–316. O. Capitani, Assisi: istituzioni communali e politiche, in: *Assisi anno 1300*, ed. St. Brufani und E. Menestò, Assisi, 2002, pp. 1–22, esp. 8–16.

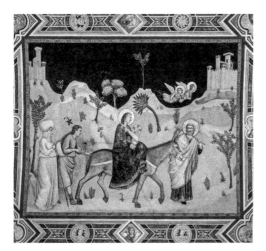 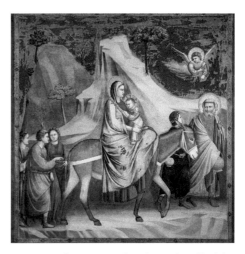

Fig. 192: Lower church, northern transept: The Flight into Egypt (Stefano)

Fig. 193: Padua, Arena Chapel, South wall of the nave: The Flight into Egypt

these elements are rearranged in a form that is always clear and well-structured. The figures are reduced in size in relation to the picture plane and the buildings depicted. Thus, more figures are involved and the story-telling gains in richness of detail. Often, however, the pictures also lose tension, as evidenced, for example, by a comparison between the two representations of the Massacre of the Innocents (fig. 190, 191). Just as the motifs are pulled apart in Assisi, the viewer's gaze also strays between the individual storylines. At the same time, empirical elements increasingly appear in Assisi: Architectural motifs that are identified as contemporary, and plants that appear to be different from each other in a botanically credible way. Indeed, this opens the viewer's eyes to "the manifoldness of the scenery of the world" (as Filippo Todini notes in his excellent analysis of the formal language of these paintings).[588] The fact that there are also negative consequences is shown by a comparison of the two pictures recounting the Flight into Egypt (fig. 192, 193): undoubtedly the donkey in Assisi comes closer to a zoologically based image, and yet the donkey in Padua is the more impressive animal.[589] And while the landscape in Assisi may be more varied and thus more in keeping with what landscape means to us ("an idyll of fairy-tale magic" is what Johannes Guthmann calls it in his book on early landscape painting published in 1902),[590] the two naked mountains in Padua are integral parts of a

588 *La pittura in Italia: Il Duecento e il Trecento*, Milan 1986, vol. 2 p. 396.
589 The camels in the picture showing the Adoration of the Magi are obviously renewed, as are the heads of the camel handlers, so they cannot be included in the comparison
590 J. Guthmann, *Die Landschaftsmalerei der Toskanischen und Umbrischen Kunst von Giotto bis Raffael*, Leipzig 1902, p. 19.

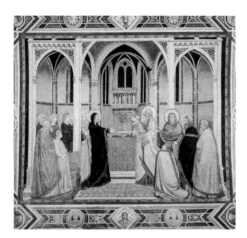 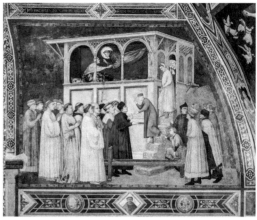

Fig. 194: Lower church, northern transept: The Presentation of Christ in the Temple (Stefano)

Fig. 195: Lower church, northern transept: The Raising the Young Man of Sessa (Stefano)

composition that takes danger and trouble as its theme. The final irritation, however, lies in the fact that the slight ascent of the path was not adopted and developed further, for this is a motif that contributes decisively to turning a narrative that could easily be about a Sunday ride into a flight. All in all, one may speak of a transfer of the Paduan pictorial world into clarity, beauty, and cultivated boredom.

On the other hand, there is one area in which the painters left Giotto's Paduan imagery qualitatively behind. This is in the rendering of architecture. I point to the wide Gothic halls that are positioned parallel to the picture plane and are symmetrically projected, which represent the Temple in Jerusalem in two frescoes. One is a vaulted three-aisled room with an apse where the Presentation of Christ takes place (fig. 194); the other, a flat-roofed, three-bay loggia in front of a vaulted portico where the twelve-year-old Jesus meets with the doctors. No less striking is the palazzo set at an angle, in which Francis is raising the young man of Sessa from the dead (fig. 195). This motif recalls the architectural staffage of a scene in Giotto's Bardi Chapel in Florence (Renunciation of Worldly Goods, fig. 251).[591] For various reasons, the Bardi frescoes are best dated to the years around 1318–20 (vol. 1 pp. 50–51, 53 and here pp. 381–383, 399). This, however, does not give a *terminus ad quem* or *post quem* for the paintings in Assisi, for Giotto's activity in the years leading up to the Bardi Chapel is not easily grasped; consequently not every motif that we encounter as new in the Bardi Chapel must have been new in Giotto's repertoire or an invention for the Bardi commission. But the observation nevertheless offers a hint that the pictures were created some time after the Arena Chapel and that means not in 1308, but years later.

591 Tantillo-Mignosi, Restauri alla Basilica Inferiore di Assisi, pp. 130–131.

Fig. 196: Lower church, northern transept: The Return to Nazareth (Stefano)

Fig. 197: Upper church, nave, lower north wall of the forth bay: The Expulsion of the Demons from Arezzo (campaign 1)

The view of Jerusalem in the north transept is also striking. The picture as a whole shows the Holy Family's journey home after the adventure of the twelve-year-old Jesus in the Temple (fig. 196). A window, converted early into an entrance to the lower church from the papal palace, cuts into the field. The painter has restricted the figures to the zone beside the arch and filled the section above the arch with an impressive view of Jerusalem which visibly tested his powers of invention. One source he used was the view of Arezzo in the earlier part of the St. Francis cycle[592] (fig. 197). This view in turn goes back to the cityscapes of Jerusalem and Bethlehem on the chancel arch mosaics of Roman churches (San Lorenzo fuori le mura and others). Just as these cities appear to be made of building blocks rising up out of what resembles a tall masonry vat or barrel, so also does Arezzo appear like a toy town made of blocks and hidden behind excessively tall fortifications. But now the buildings are rendered more spatially and intricately, so that the impression approaches the fantastical. This can be deduced from the Byzantinising architectural fictions that are used in the clerestory. However, it is precisely this sense of the fantastic that the transept painter did not allow in his Jerusalem image. He countered it, on the one hand, by standardising the projection, while, on the other hand, he used a second source that demanded concreteness in the representation of buildings. I believe, this was Duccio's

592 R.W. Bergmann, *Der Freskenzyklus der Jugendgeschichte Christi in der Unterkirche von San Francesco: Studien zur Monumentalmalerei des Trecento in Assisi*, Master thesis Erlangen-Nürnberg 1982, pp. 92–93.

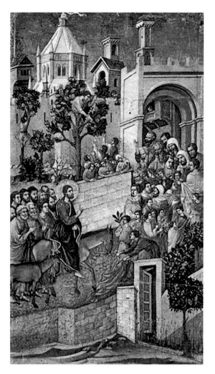 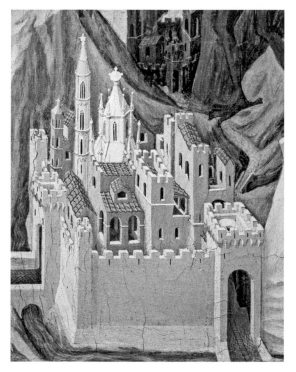

Fig. 198: Siena, Museo dell'Opera del Duomo: Maestà, The Entry in Jerusalem (Duccio)

Fig. 199: Siena, Museo dell'Opera del Duomo: Maestà, The Temptation of Christ, detail (Duccio)

mode of depicting architecture. I refer to the image of Jerusalem on the Maestà of Siena Cathedral (Entry into Jerusalem – fig. 198) and to the images of cities in the Temptation of Christ (fig. 199). These scenes are probably the origin of the portrayal of the temple as an octagon with an ambulatory, of the motif of the richly detailed view into the city gate, and of the slender towers with corner pilasters, which appear much more real, through the use of this architectural motif, than Arezzo's toy-block towers. Interestingly, Pietro Lorenzetti in the opposite transept arm also made use of Duccio's Jerusalem image (in the Entry into Jerusalem and Carrying of the Cross). Accordingly, it should be asked whether the Sienese motifs reached the Giottesque north transept painter via model books or via pictures executed by the Sienese south transept painter. The latter would fit in with a more or less simultaneous activity of the two artists and their workshops.[593]

593 Paul Schubring has already pointed out the importance of Sienese art for these frescoes: P. Schubring, Die Fresken im Querschiff der Unterkirche San Francesco in Assisi, *Repertorium für Kunstwissenschaft* 22, 1899, pp. 1–12.

Be that as it may, the elements adopted from Duccio in the Jerusalem image provide a *terminus post quem* for the north transept frescoes: as is well known, the completed Maestà was transferred from his studio to Siena Cathedral in 1311, and only from then on was Duccio's architectural fiction available to other artists as a model. Thus Giotto's authorship of these frescoes is unlikely, not only because one would not wish to accuse him of being so uncreative with his Paduan pictorial narratives, but also because they were probably painted some years after 1307/08 and therefore in a period in which the artist is quite regularly documented in Florence (1.1.10–17).

Fig. 200: Lower church, northern transept: St. Francis and the Dead Body (Stefano)

And this means, of course, that the allegorical frescoes above the crossing are also too late for Giotto's stay in Assisi in 1307/08. They will be discussed in detail in the third volume as an important document for Giotto's impact in the history of painting. It should only be emphasised here that in terms of style they are indeed closely related to the pictures in the north transept. This is particularly evident in a non-narrative mural in the transept, namely the picture below the Return of the Holy Family which fills the narrow field next to the door or former window. It shows Francis with a crowned dead body (fig. 200). The figure of the saint is connected by his large eyes and somewhat rigid habitus to the crossing frescoes (fig. 201). Thus, in addition to a narrative mode, the workshop also had a somewhat different allegorical, and, if you will, transcending mode of representation, which is manifest in the crossing pictures.

Giotto's allegories in the Arena Chapel are captivating since they bring verbal models down to a narrative formula, arm them emotionally and condense them into visual punch lines, and all this is absent in the Franciscan allegories. Their strength lies in their abundance of details and the splendid design of their allegorical speech with sometimes precious motifs such as a centaur and a bird-footed Cupid. In the allegory of Paupertas, this includes the children throwing stones at Lady Poverty (see vol. 3 pp. 74–75). The two boys are similarly found in the scene of the Renunciation of Worldly Goods in Giotto's Bardi Chapel, the one on the right even matches his equivalent verbatim. Again, as with the scene of the Raising of the Young Man in Sessa, the question arises as to what the connecting lines are between the frescoes of the crossing and north transepts in Assisi and the painting of the Bardi Chapel.

Fig. 201: Lower church, crossing vault: St. Francis enthroned (Stefano)

In any case, the abundance of motifs is important. The allegorical images do not focus on intellectual clarity and *brevitas*, but surely – as the golden background alone indicates – on magnificence: the intention was also to outshine the crossing of the Upper Church. After the reorganisation of the double church, the friars could hardly hold their prayers under Cimabue's images of the Evangelists, radiant with gold, while the tomb of the Order's founder on the floor below presented itself to the pilgrims as a humble place.

THE MARY MAGDALENE CHAPEL

The attachment of further chapels to the Lower Church is connected to the liturgical reorganisation of the entire complex. These additions turned a distinctively Franciscan ambience around the burial site of the order's founder and second Christ, into a church space that in some respects corresponded to the usual urban settlements of the Franciscans. The new side rooms made endowments possible and these enriched the liturgy and improved the financial situation of the convent.[594] In this way, the religious life of San Francesco gained a certain independence from the contributions of the Curia. In addition, there was a tendency in the Franciscan Order during the decades around 1300 that probably also affected the community in Assisi, namely that of "clericalisation":[595] the proportion of priests among the friars increased, and this required more altars and appropriate equipment so that they could fulfil their daily obligation to celebrate Mass.

It probably started with the Chapel of St. John, which Napoleone Orsini had added to the transept as a counterpart to the Chapel of St. Nicholas. There is much to suggest that he had planned during his midlife to be buried here with a view to the tomb of St. Francis

594 Theis, *S. Francesco in Assisi*.
595 R. Manselli, La clericalizzazione dei Minori e San Bonaventura, in: *S. Bonaventura francescano: Atti del XIV convegno storico internazionale, Todi 14–17 ottobre 1973*, Todi 1974, pp. 181–208.

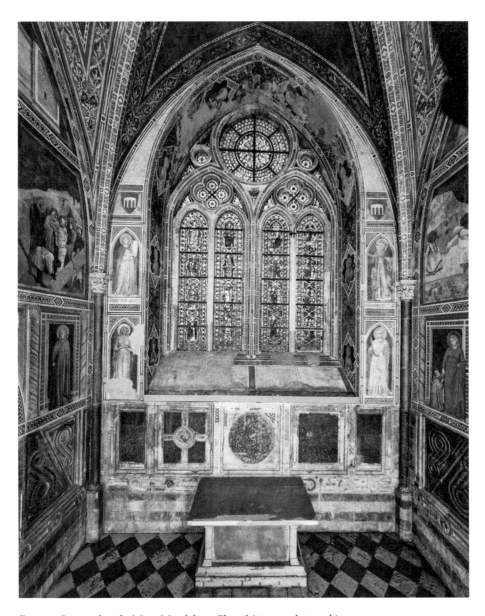

Fig. 202: Lower church, Mary Magdalene Chapel (view to the north)

and that of his brother.[596] The construction of the six chapels along the nave then seems to have been carried out in quick succession, with the Chapel of St. Nicholas continuing to serve as a benchmark and model in its details: in this way a high degree of uniformity of appearance was achieved. The technical and financial organisation of the building was apparently centrally regulated; as soon as donors had been found, the sum calculated or advanced for the construction was demanded from them. Such a procedure has been handed down in documents for the Chapel of St. Mary Magdalene and the Chapel of St. Martin, whose donors each had to pay 600 gold florins to the Order (the equivalent of a stately house in Florence).[597] These two nave chapels are also the only ones that could be allocated soon after their construction in the way the Order had probably imagined: they were to serve the liturgical memory of high clerics.

The standards of furnishing set by the St. Nicholas Chapel and realised in these two rooms included, in addition to stained glass windows and a complete fresco decoration, a marble incrustation of the lower walls. In the case of the Mary Magdalene Chapel, it consists of re-used material that originally belonged to the *schola cantorum* of the Upper Church (fig. 202). The fact that the construction of the chapels is connected with the liturgical transformation of the entire double church of San Francesco materialises here. The question of the dating of the frescoes in the Mary Magdalene Chapel is therefore not independent of the dating of the other Giottesque paintings in the double church. With the exception of the clerestory frescoes in the upper church, they all served to redesign the complex after a new decision had been made about the functions of the two superimposed churches.

As the benefactor for the Mary Magdalene Chapel, Teobaldo Pontano, a native of Todi, was won over. This is evident from his canting arms, showing a bridge, and from the donor portraits, as well as from a series of papal letters from the years 1322 to 1332. The one dated 9 January 1330 explicitly states that he had a chapel built at the Franciscans in Assisi and chose this as the place for his tomb.[598] Teobaldo was himself a Franciscan and

596 It is therefore assumed that he did not want to be buried either in Avignon, where he died in 1342, or in Rome, where the body was later transferred in accordance with his will. B. Kleinschmidt, *Die Basilika S. Francesco in Assisi*, vol. 2, Berlin 1926, p. 65. In the early modern burial register found by Igino Benvenuto Supino (I.B. Supino, *Giotto*, Florence 1920, note 41 p. 306) we read of the chapel and Cardinal Napoleone: "nella quale capella volse essere sepellito." But this need be no more than a conjecture based on the same circumstantial evidence.

597 I. Hueck, Ein Dokument zur Magdalenenkapelle der Franziskuskirche in Assisi, in: *Scritti di Storia dell' Arte in onore di Roberto Salvini*, Florence 1984, pp. 191–196. A.S. Hoch, A New Document for Simone Martini's Chapel of St. Martin at Assisi, *Gesta* 24, 1985, pp. 141–146.

598 BAV, Reg. Vat. 115, pars II, fol 650: "... nec non capelle quam in ecclesia dictorum fratrum, ubi suam sepulturam elegit, construi fecerat." The document is printed in: B.

The Mary Magdalene Chapel

bishop of Assisi from 1296 until his death in 1329. Before that he had been bishop first of Stabia and Castellamare (1282–1295) and then of Terracina (1295–1296). His dismissal from Terracina and investiture in Assisi, both of which can only have been initiated by the Pope, fall in the same year as the election of Giovanni Minio da Muravalle as General of the Order, and so it is obvious to connect them with Pope Boniface VIII's position in the poverty controversy.[599] A bishop of Assisi who was not in agreement with the new head of the order could have severely disrupted his anti-spiritualist and loyalist policy, which was so desirable to the Pope. In my view, an agreement between Teobaldo and Giovanni Minio, who then moved into the office of Protector of the Order in 1305 or 1306, is also the prerequisite for the awarding of the chapel to the bishop and, above all, for the use of building material from papal property in the chapel: again, we are talking about the spolia of the *schola cantorum*.

In the last decade of his life, Teobaldo was unexpectedly under great pressure: John XXII (1316–1334) held him responsible for the fact that Ghibelline troops had captured part of the papal treasure in Assisi in 1319 and demanded that he make compensation to the pope for the damage. Hand in hand with this, he urged the Franciscans to give up their demands on the bishop, whom he described as "oppressed by great poverty" ("onere multe paupertatis oppressum") in 1322.[600] By this time Teobaldo had only repaid 100 of the 600 florins that the convent had advanced for the chapel. In the following years he procured another 350 florins. He was thus not prepared to give priority among his financial obligations to his (quite questionable) debt to the Curia. When he died, the sum of 150 florins was still outstanding to the Franciscans; liturgical equipment intended for the chapel was rather reluctantly handed over to the convent from the estate confiscated by the Curia – events which can be deduced in detail from a papal letter of 8 June 1332.[601] Given this background, it can be ruled out that the bishop commissioned the decoration of the chapel in the period after 1319. Since there are otherwise no external clues for dating, the paintings are to be taken seriously as possible Giotto works of the year 1308. It was Henry Thode who claimed the previously little-noticed frescoes for Giotto. He also emphasised their closeness to the pictures of the Arena Chapel.[602]

Kleinschmidt, *Die Basilika von San Francesco in Assisi*, vol. 3, Berlin 1927, p. 7 and cited in: S. Nessi, *La basilica di S. Francesco in Assisi e la sua documentazione storica*, Assisi 1994, p. 445.

599 A. Fortini, *Assisi nel Medioevo: Legende, Avventure, Battaglie*, Rome 1940, p. 275. L.C. Schwartz, *The Fresco Decoration of the Magdalen Chapel in the Basilica of St. Francis at Assisi*. Ph. D. Indiana University 1980, p. 255.

600 Ehrle, Die Beraubung des päpstlichen Schatzes in St. Francesco, p. 271.

601 BAV, Reg. Vat. 116, fol. 374, fol. 374r–v, ep. 1719. The document is printed in: Hueck, Ein Dokument zur Magdalenenkapelle der Franziskuskirche in Assisi, p. 196.

602 Thode, *Franz von Assisi und die Anfänge der Kunst der Renaissance in Italien*, pp. 282–287.

338 Assisi 1308 and other St. Francis-Problems

The dedication and the picture programme simultaneously serve the expectations of a funerary chapel and those of the side room of a pilgrimage church. Indeed, Teobaldo was not only interested in San Francesco as his burial place, but also in the church as a pilgrimage destination: it was this bishop who issued the indulgence of Portiuncula in 1310, which once more upgraded Assisi as a place of pilgrimage. The research for this had been going on since 1307 at the latest, because in that year a witness questioned by Teobaldo had died.[603] The chapel was probably intended as a place where pilgrimage, confession (which is an essential part of pilgrimage), and the memory of the founder would merge. Among the holy sinners, Mary Magdalene is the most popular figure, even ahead of Peter: she is thus a model not only for someone who, like Teobaldo, desires to die blessed and hopefully awaits the Last Day, but also for pilgrims who, having reached the goal of their desire, confess in order to enjoy the promised indulgences.[604] A text dealing with repentance and forgiveness is found in the *Speculum Humanae Salvationis*, a work in the mystical spirit written not long after the foundation of the chapel and probably by the Dominican Ludolf of Saxony in Strasbourg:[605]

> *Oh, how great is your goodness, Lord, and how indescribable it is.*
> *Under no circumstances do you despise someone who repents!*
> *You did not reject: Peter, Paul, Thomas, and Matthew,*
> *David, Ahab, Manasseh, not the thief, not Achoir and Zacchaeus,*
> *not the woman of Nineveh, not the Samaritan woman, Rahab,*
> *Ruth and the adulteress,*
> *not Theophilus, Gilbertus, Thaides and Maria Aegyptiaca,*

This is also where the incorrect 1314 date for the beginning of Teobaldo's pontificate is found, which has been encountered in the literature ever since. However, there can be no doubt about the investiture in 1296. For information on the history of research, see: *La Basilica di San Francesco ad Assisi*, ed. Bonsanti, vol. 1.1 pp. 381–383 (A. Volpe).

603 M. Grouwels, *Historia Critica Sacrae Indulgentiae B. Mariae Angelorum vulgo de Portiuncula*, Antwerp 1727, pp. 96–103. Brufani, Il dossier sull'indulgenza della Porziuncula, p. 229.

604 L. Schwartz, Patronage and Franciscan iconography in the Magdalen Chapel at Assisi, *The Burlington Magazine* 133, 1991, pp. 32–36.

605 "O quam magna est pietas tua, Domine, et quam ineffabilis, / Qui nullum poenitentem cujusque conditionis despicis! / Non respuisti Petrum, Paulum, Thomam et Matthäum, / David, Achab, Manassem, Rahab, Ruth et adulteram, / Theophilum, Gilbertum, Thaidem et Mariam Aegyptiacam, / Eunuchum, Simeonem, Cornelium, Magdalenam, Longinum, et Moysi Mariam. / Non ergo propter immanitatem peccatorum nostrorum desperemus, / Quia diversos testes divinae misericordiae habemus." *Speculum Humanae Salvationis: Kritische Ausgabe*, ed. J. Lutz and P. Perdrizet, Leipzig 1907, vol. 1 p. 31. Veronika Decker pointed me to this text.

The Mary Magdalene Chapel

Fig. 203: Mary Magdalene Chapel, entrance arch: The Good Thief and Longinus

Fig. 204: Mary Magdalene Chapel, entrance arch: St. Paul and David

> *not the Eunuch, not Simeon, not Cornelius,*
> *not Magdalene, Longinus and not Mary the sister of Moses.*
> *Therefore, let us not despair over the multitude of our sins,*
> *for we have various witnesses of God's mercy.*

In addition to Mary Magdalene, the following holy sinners mentioned by Ludolf appear in the picture programme of the chapel: Peter, Paul, Matthew, David, Longinus and the thief (i.e. Gesinas, the good thief): these six are depicted on the broad reveal of the entrance arch and, as it were, monitor the connection between the nave of the church and the chapel (fig. 203, 204); beyond them appear Mary Aegyptiaca and Mary, the sister of Moses (i.e. the prophetess Miriam): these two are depicted on the window wall and are among the few parts of the fresco programme that can be "read" from the nave (fig. 202). Of those painted figures of saints that are identifiable, the majority fit into a canon of repentant sinners. Not mentioned in the *Speculum*, but present on the entrance arch of the chapel, is Augustine, whose *Confessiones* can be read as a prime example of the contrite confession of a sinful life that had been turned to holiness. Ultimately, among the nameable figures of saints, it is only Dionysius Areopagita (as identified by Lorraine Carol Schwartz on the entrance arch)[606] and the Empress Helena (window wall) who are not explicitly known as repentant sinners. The latter, together with the four crowned virgins in

606 Schwartz, The Fresco Decoration of the Magdalene Chapel in the Basilica of St. Francis at Assisi, p. 179.

the lower register of the entrance arch, could belong to the Magdalene's court as described in the offertory of the Mass text for Mary Magdalene's Day (Psalm 44, 10):[607] "Kings' daughters were among thy honourable women: upon thy right hand did stand the queen in gold of Ophir." Seen in this light, the figures – Helena and the virgins – would underline the Magdalene's rank in the hierarchy of saints.[608]

While the entrance arch and the altar wall are populated with the figures of many sinful and a few non-sinful saints, the main decoration of the room is the two cycles depicting the life of the Magdalene. There is the eleven-part cycle in the window, which can be seen from the main room and read with some effort. And there are – visible only to those standing in the chapel – the seven frescoed scenes from the Mary Magdalene legend, spread over the two side walls and the inner entrance wall. In addition, there are further non-scenic paintings: On the side walls, below the cycle, are the two images of the founder: Teobaldo as a bishop in front of St Rufinus, Assisi's first bishop, and Teobaldo as a Franciscan friar in front of St. Mary Magdalene, the patron saint of the altar. Then there are two single images of saints as counterparts to the donor images, namely St. Clare and a half-figure of an unknown crowned woman. Further paintings decorate the cross ribbed vault. Four medallions show Christ, Magdalene, Martha and – praying and wrapped in his shroud – the resurrected Lazarus (fig. 208). These four icon-like images repeat the Lazarus narrative from the west wall of the chapel in a mode that is directed more clearly towards the viewer. The vault programme explicitly addresses the theme of resurrection and focuses on the function of the chapel as a burial space: as it once happened to Lazarus, Teobaldo Pontano also would like to be called back to life from the grave by Christ on the Last Day.

SOULFUL LOOKS

The architecture of the narrow chapel with its four wall openings (one window, the entrance from the nave, one passage into the transept, and one into the neighbouring chapel) and a cross ribbed vault over short shafts is extremely unsuitable for decoration with a narrative picture cycle. The resulting lay-out of the frescoes makes it difficult for the visitor to follow the sequence of scenes. It is crucial to read the four lower pictures before the three upper ones. This bottom-up sequence is not singular, indeed it occurs fre-

607 *Missale Franciscanum Regulae codicis VI.G.38 Bibliothecae Nationalis Neapolinensis*, ed. M. Przeczewski (Monumenta studia instrumenta liturgica 31), Vatican City 2003, p. 441.

608 Another suggestion is to interpret Helena as a representative of Fides. N. Kenaan-Kedar, Emotion, Beauty and Franciscan Piety: A New Reading of the Magdalene Chapel in the Lower Church of Assisi, *Studi Medievali*, ser. 3, 26, 1985, pp. 699–710, esp. 707.

quently in stained glass. In the fresco cycles of Giotto's time, however, it is an exception. The advantage was that certain scenes, which required few personnel or showed the saint floating, could be placed in the awkwardly cut lunette fields. The result, however, is that the upper row of pictures is oddly set apart from the lower row in terms of composition. What actually saves the cohesion of the whole?

The fact that the saint is never depicted standing, walking or sitting, i.e. in an everyday human posture, contributes considerably to the effect and message of the sequence of images: instead, she kneels, lies, hovers or appears as a half-figure. Either she humbles herself or she is elevated. And whether she is glued to the earth or flying with the angels in the clouds, her features always seem unusually alive and animated.

Those responsible could not fall back on a standard visual form to narrate the life of the Magdalene. Both cycles in the chapel, the one in the window and the one on the wall, were conceived independently of each other and on an ad hoc basis. Some assistance for the designs was provided by New Testament picture cycles, namely where the paths of Christ and Mary Magdalene cross. So it is no surprise that two pictures in the painted Magdalene cycle can be identified as reprises of the pictures with the same theme in the cycle of the Arena Chapel. These are the Noli me tangere scene and the Raising of Lazarus. If one compares the versions more closely, however, one notices changes that help to determine the relationship of the images to each other and to arrive at conclusions about the form of the connection between the Arena Chapel and the Magdalene Chapel.

In the Lazarus picture, the line-up of the personnel is more spread out and the spatiality is slimmed down to a kind of frieze of figures (fig. 205, 206). In absolute terms, the picture format in Assisi is somewhat larger, with a width of approx. 250 centimetres (compared to approx. 2 metres), while the figures are roughly the same size. The appearance of Christ and his companions in the widened field is highly impressive. This is also related to the rotation of the main figure into profile, which was made possible and desirable by the frieze effect of the overall composition. The eye contact between Christ and Lazarus is also a strong motif. The golden inscription emanating from Christ's mouth with the words "Foras veni Lazare" illustrates that there is also an acoustic contact. This is possible because in Assisi, unlike in Padua, the buried person is depicted as already awakened and reacting. So the difference between the pictures is also a matter of content.[609] This is expressed most clearly in the kneeling figure of the Magdalene. In Padua, she is one of numerous secondary figures accompanying the miracle. In contrast, in Assisi she is the third protagonist alongside Christ and Lazarus (fig. 207). The question even arises as to which person in the picture is the decisive one to trigger Christ's action – the woman kneeling opposite of him or Lazarus.

609 This was overlooked by Supino, for example, who derived an argument against Giotto's authorship from the inscription: I.B. Supino, *La basilica di S. Francesco di Assisi*, Bologna 1924, p. 162.

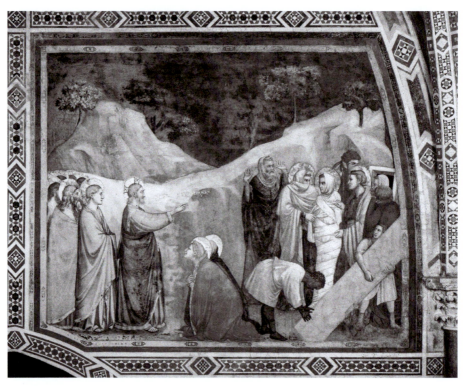

Fig. 205: Mary Magdalene Chapel: The Raising of Lazarus

In order to properly understand the depictions of the scene in Assisi and Padua in their peculiarities, it is advisable to consult both the biblical account and the *Meditationes Vitae Christi*. According to the text of the Gospel (John 11:1-44), Christ has to deal with the reproaches of Martha and Mary Magdalene for having caused the death of their brother Lazarus through his absence. And although the two were on their knees before him as they lamented, he "groaned in the spirit" ("infremuit in spiritu"), just as he was also "groaning in himself" a little later at the tomb of Lazarus, when the miracle was literally demanded by the bystanders. So it is not surprising that Christ is frowning in Padua. Mary Magdalene's brows are also furrowed, showing her not as a grateful disciple, but rather illustrating the reproaches she is making towards Christ. The theme in the Arena Chapel is thus the exegesis of the passage in John's Gospel, and it is not so much about the performance of the miracle as it is about the fact that Christ is willing to redeem people despite their sometimes insufficient faith in his grace. This fits into the overall programme of the Paduan murals, which, as we have seen, discusses the belief in redemption on the basis of characters and concepts such as Judas, Spes and Desperatio.

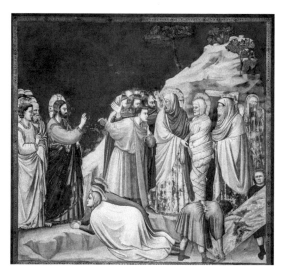 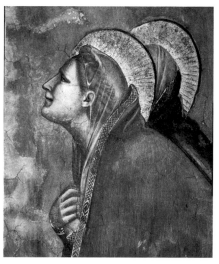

Fig. 206: Arena Chapel, north wall of the nave: The Raising of Lazarus

Fig. 207: Mary Magdalene Chapel: The Raising of Lazarus, detail

Unlike in the Bible, there is no mention of Christ's displeasure in the *Meditationes* (LXVI), but there are emotional dialogues during which streams of tears are shed. When Marta says that Lazarus would not have died if Christ had been there, he answers immediately and announces in no uncertain terms that he will raise him from the dead. Then he asks Martha to call her sister Mary Magdalene, "for he loved her particularly".[610]

> Immediately she rose and swiftly went to him and throw herself at His feet, speaking words similar to Martha's. When the Lord saw His beloved in affliction, tearful and bereft of her brother, He also could not restrain His tears, and cried.

610 «Marta vero cum scivit exivit et obviam et procedit ad pedes eius et dixit: Domine si fuisses hic, frater meus non fuisset mortuus. Dominus vero dixit quod resurgeret, et de resureccione aliqua tractatur adinvicem. Postea mittit eam pro Maria: hanc Dominus singularissime diligebat. Ipsa vero ut scivit festina surrexit et venit ad eum, et procidens similia verba Martha dixit. Dominus autem Iesus videns dilectam suam sic afflictam, lacrimosam et desolatam de fratre suo, non potuit eciam ipse lacrimas continere. Unde tunc lacrimatus est Dominus Iesus.» *Meditaciones vite Christi*, by Johannes de Caulibus, ed. M. Stallings-Taney (Corpus Christianorum Continuatio Mediaevalis 53), Turnholt 1997, pp. 229–230.

Fig. 208: Mary Magdalene Chapel, vault

And did then even the disciples weep? – at any rate, this question is put to the readers of the *Meditationes*. In the picture of the Chapel, Christ and the disciples do not weep, but Christ looks exceedingly kind and compassionate as he performs the miracle as a matter of course, the result of which is visible in Lazarus' living face. Mary Magdalene, on the other hand, weeps so unreservedly before Christ that she – just as she moves Christ and perhaps also the apostles to tears in the narrative – arouses the pity of even the most hardened Assisi visitors (fig. 207).

The picture in Assisi is thus based more on the *Meditationes Vitae Christi* than on the biblical text and uses the description given to Mary Magdalene there to develop this figure into a main character of the scene. It can be said that a scene created by Giotto in Padua for a Christological context mutates into a scene from the life of the Magdalene on the basis of the *Meditationes*. This even goes a little far in terms of content, because viewers probably tend to read the pictorial narrative in such a way that it is the Magdalene's tears that cause Christ to act. This casts Mary Magdalene in a role like that of Mary, the mother of God and arch-intercessor – a reading confirmed by the repetition of the theme on the vault (fig. 208). The figuration of the images there refers not only to the scene on the wall below, but also to the decoration of the central vault in the nave of the Upper Church and thus to the image scheme of a Deesis. This points in the direction of an exegesis that is actually given neither by the Bible nor by the Meditationes, but appears in the Mass text for St. Mary Magdalene's Day as a church prayer and which must have been welcome in a burial chapel dedicated to the Magdalene. The words that the Franciscans of the 14th century prayed are still spoken today:[611]

> *We pray, O Lord: may the intercessions of St. Mary Magdalene come to our aid, by whose supplications moved, You raised from the dead her brother Lazarus, who had already lain four days in the grave: You who live.*

611 "Beatae Mariae Magdalenae quaesumus domine suffragiis adiuvemur, cuius precibus exoratus quadriduanum fratrem vivum ab infernis suscitasti. Qui vivis." *Missale Franciscanum Regulae*, ed. Przeczewski, p. 441.

Fig. 209: Mary Magdalene Chapel: Noli me tangere

What makes the Magdalene the focus of the viewer's attention, however, is more than the role that a visitor to the chapel could ascribe to her in the narrative: above all, we are captivated by the presence of the tear-streaked face, completely lost in pain, displayed in profile, whose expression is reminiscent of the unrestrained crying of children and reminds one of an everyday experience. Compared to it, the weeping faces from earlier periods of painting – e.g. of the mourning half-figures of the painted crosses – only look like masks sending out stereotypical signals. Even in the Arena Chapel there is no truly similar face, either among the mothers of Bethlehem or among the women under the cross. Here, a special quality of the imagery developed for Teobaldo Pontano becomes apparent. If one imagines the painted figures as actors, then the performers of the Magdalene in Teobaldo's Chapel demonstrate a new and seemingly non-artistic method of generating facial expression: unreservedly emotional and appealing directly to the visitors' feelings. At least as far as the depiction of affect is concerned, the well-known outside perspective of the Arena pictures is abandoned.

Opposite the Lazarus picture, on the right wall of the chapel, is the Noli me tangere scene, which, from a contemporary Dominican and Franciscan point of view, illustrates

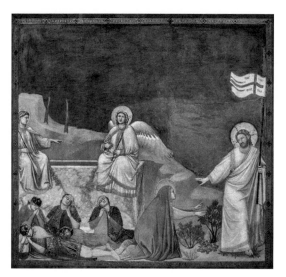 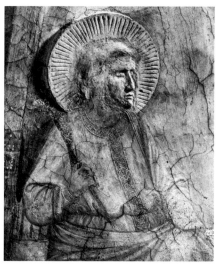

Fig. 210: Arena Chapel, north wall of the nave: Noli me tangere

Fig. 211: Mary Magdalene Chapel: Noli me tangere, detail

the pinnacle and exemplary quality of this saint's life (fig. 209): The risen Christ had first appeared to a sinner to make it clear that he had died for sinners.[612] The picture shows another poignant face of the Magdalene. In fact, the two appearances are staged as counterparts. Both times the "dilecta", as Christ calls her in the mystical diction of the *Meditationes*, kneels before her Lord and both times with explicit body language, enhanced by a red cloak that is designed for comparability. In the Lazarus picture she remains passive in her weeping, while in the other scene she reaches out from her kneeling position to the turning Christ as if seeking help. Comparing this appearance with the corresponding scene in the Arena Chapel, it becomes clear that the Paduan kneeler formed the starting point for both the weeping and the stretching Magdalene, and that both adaptations are similarly effective (fig. 210). The saint's arm position in the Noli me tangere picture in Assisi is hardly changed, and yet the extended upper body makes how the hands reach into nothingness much more vivid. The clearest difference between the two Noli me tangere-Magdalenes, however, is in the face of the woman in Assisi: her features make her longing subtly and directly present. The vulnerable red contour especially contributes to this. Such a line also occurs sporadically in Padua (for example in the angels of the Baptism of Christ). But it never has the effect it has here, where the red line creates the profile of the main figure and, one might say, elevates her face from the background.

612 K.L. Jansen, *The Making of the Magdalena: Preaching and Popular Devotion in the Later Middle Ages*, Princeton 2000, pp. 58–59.

Apart from the Mary Magdalene figure, the relationship between the Noli me tangere pictures in Padua and Assisi is definitely problematic and it is easier for a critic to dismiss the version in Assisi than in the case of the Lazarus pictures. This is not so much because of the figures of the angels, whose faces in Assisi are formed from stucco and gilded, and appear as a golden relief (fig. 211). I do not see why Giotto should not have experimented with such effects. The quality of the sculptural work is high, and the spatial turn of the angels' heads corresponds to Giotto's aspirations. If the relief were better preserved, the attempt to make the otherworldly physical and precious would probably be effective. Presumably, the golden relief had a magical effect in the sparsely lit sanctuary. More problematic is the absence of the guards in Assisi and that this absence was not compensated for compositionally. The same applies to the scattering of plant motifs throughout the picture, whereas in Padua they are assigned to Christ like props and complement his costume as a gardener.

Above all, however, the Christ figure with close-set eyes and over-articulated movement is problematic: Osvald Sirén called it marionette-like.[613] Compared to the Paduan model, it appears simplified and altogether more reminiscent of Cavallini than of Giotto. One is reminded of the frescoes in Santa Maria Donnaregina in Naples, paintings by a workshop that presents Cavallini's style in a somewhat schematised way.[614] Similar figures close to Cavallini's art can be found in the Chapel of St. Nicholas (fig. 184). If the Lazarus scene in Assisi as a whole is on a par with its counterpart in Padua, the same cannot be said for the Noli me tangere scene. In terms of design and certain details, however, both further develop what is laid out in Padua.

In terms of artistic rank, the three scenes in the lunettes of the upper walls again correspond to the Paduan frescoes: on the right wall the Elevation of the Saint to Heaven and her Feeding by Angels happen above an expressively modelled landscape seemingly cast in concrete. The *dilecta* presents herself with another poignant profile which speaks this time of bliss in the most direct way (fig. 212). Above the entrance, the Magdalene's Clothing by a Hermit is represented. Here the saint shows a profile evoking unreserved gratitude. The head appears in a dark crevice surrounded by a bare rock, which dominates the picture and makes the loneliness of the hermit's life in the narrow space of the pointed arched field believable (fig. 213, 214). On the left wall we see the simultaneous narration of her Last Communion and her Ascension. Kneeling in front of the altar, her face is shown in near-profile, tilted slightly forward, which is very demanding from the point of view of

613 O. Sirén, *Giotto and Some of His Followers*, Cambridge, Ma. 1917, p. 95.

614 Cf. E. Carelli and St. Casiello, *Santa Maria Donnaregina in Napoli*, Napels 1975, fig. 31–58. The connection between these frescoes and Cavallini is not documented, but stylistically evident. Cavallini's presence in Naples is documented for the year 1308: P. Hetherington, *Pietro Cavallini: A Study in the Art of Late Medieval Rome*, London 1979, p. 4.

Fig. 212: Mary Magdalene Chapel: The Elevation to Heaven

Fig. 213: Mary Magdalene Chapel: Zosimus Clothing Mary Magdalene

representational technique. The head continues experiments with the spatial mobility of the faces that are underway in the Arena Chapel (fig. 215). Giovanni Previtali pointed out the great resemblance of the angels to those in the Crucifixion of the Arena Chapel;[615] but in Assisi the movement and mien is gentle. What most clearly reaches beyond the Arena frescoes is, on the one hand, the silent devotion in the faces of two spectators presented in

615 G. Previtali, Le cappelle di S. Nicola e di S. Maria Maddalena nella chiesa inferiore di San Francesco, in: *Giotto e i Giotteschi in Assisi*, Assisi (2) 1979, pp. 93–127, esp. 121.

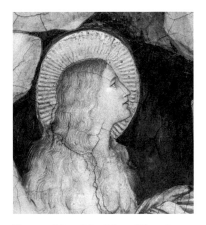

Fig. 214: Mary Magdalene Chapel: Zosimus Clothing Mary Magdalene, detail

profile, one old and one young; on the other hand, the simplicity of the architectural furnishings.

Another high-ranking scene alongside these is the Banquet in the Pharisee's House, which is next to the Lazarus picture and begins the cycle (fig. 216). The architectural box is a further development of the house that Giotto invented towards the end of his work in the Arena for the Last Supper and the Washing of the Feet (fig. 48). The Magdalene, who again appears as a kneeling figure in red, is positioned on the border between the box and a broad piece of passe-partout on the left edge. Again, the saint's profile is captivating, this time very slightly turned away and lowered over Christ's foot.

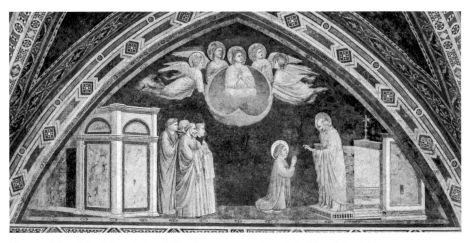

Fig. 215: Mary Magdalene Chapel: The Last Communion of St. Mary Magdalene

And the two donor images are equally high-ranking works. To the left of the entrance of the chapel below the banquet picture, Teobaldo Pontano appears in a fictitious niche, flanked by two painted spiral columns, in front of a back wall decorated by a framed field; he kneels in episcopal regalia before St. Rufinus (pl. XIV). The scene is no less eloquent than the corresponding scene in the Last Judgement in Padua: the saint stands unceremoniously. He addresses his successor with a serious but friendly look, his mouth open as if to speak. Theobaldo kneels in profile before him, highly ceremonial and with a bowed head, like a shy confirmand. While in Rufinus the emphasis is on sovereignty and dignity,

Fig. 216: Mary Magdalene Chapel: Banquet in the Pharisee's House

in Teobaldo individuality is portrayed in rich detail. The depiction of the head in profile is taken from the Paduan donor portraits, but the profile line is completely original. Moreover, the painter has further sharpened the sense of individuality. Despite the fact that in Padua the heads of Scrovegni and his clerical friend were each assigned their own *giornata*, and their execution could accordingly receive the painter's undivided attention, Teobaldo's facial features are even more elaborate and richer in detail within their outline.

While Teobaldo can only say a silent prayer before the greatness and holiness of his predecessor in office, he sensibly behaves very differently before the chapel's patroness: this second image of the founder, staged in the same form, is diagonally across the right of the altar below the Noli me tangere scene. Unlike in the narrative paintings, the Magdalene is depicted standing; Teobaldo, this time wearing a Franciscan habit, looks up at her (fig. 217). With his left hand he has grasped her right hand – or she has taken his hand. What is about to happen in the donor scene of the Arena Chapel between Scrovegni and Our Lady has already taken place here (fig. 1). The facial features of the founder appear changed compared to his appearance as a bishop: they are sunken from fasting; he wants to resemble the penitent saint. At the same time, his face is now strongly expressive. What

Fig. 217: Mary Magdalene Chapel: Teobaldo Pontano before Mary Magdalene

Rintelen experienced was a "disgusting display of outré childishness".[616] Sentimental as it is, the face corresponds to many of Mary Magdalene's profiles in the narrative images. One would like to speak of an assimilation of the founder to the figure of the Magdalene, but not to the rather reserved version before whom he kneels, but to the saint who interacts with Christ in many of the narrative images. Teobaldo not only venerates the Magdalene, he slips into her role. Interestingly, the completely different appearances of the founder before his predecessor and before the patroness of the chapel are achieved with exactly the same profile line, which the painter has only rotated and filled in differently.

Teobaldo and Rufinus, Teobaldo and Mary Magdalene are not treated like the saints in the entrance arch and on the altar wall, but rather as present in the chapel – just as Teobaldo as a corpse is in fact present in the chapel (in an unmarked floor grave). This illusionistic approach is very clearly expressed in the painted surroundings of the figures: a layer of space is opened up that is connected to the viewer's space and closed off to the rear, the depth of which is evoked not least by the suggestively corporeal spiral columns. Precedents are found in the Arena Chapel (except for the spiral columns, which originate from the Upper Church's clerestory or from Roman art). These consist in the vaulted niches above the painted cenotaphs and the flat niches in the pedestal decoration where the reliefs of the virtues and vices appear. In addition, reference should be made to the donor group on the west wall, which is more closely connected to the liturgical reality of the chapel than to the fictitious event of the Last Judgement. In Teobaldo's chapel, all this comes together and unfolds its own intensity.

The painter of the frescoes in the Mary Magdalene Chapel intensively explored the frescoes of the Arena Chapel. He was at the same time more sensitive and more open than the other painters in Assisi who profited from the Arena frescoes, including the makers of the St. Nicholas frescoes. Above all, he succeeded in realising an atmosphere of psychic liveliness that transcends what can be observed in Padua. The most important medium for this liveliness is the face of the Magdalene, whose changing, empathy-provoking expression makes her the *dilecta* not only of Christ, but of the beholders as well. It has an air of sweetness and corporeality that is related to the spiritual character of this holy sinner and penitent and would later give rise to the Mary Magdalene images of the Renaissance and Baroque, unsettling in their erotic nature. But the sentimental atmosphere certainly also has much to do with the role the saint played in the piety of Bishop Teobaldo. One can imagine this spirituality as conventualist – a combination of asceticism and mysticism, based on moderation and close to the spirit of the *Meditationes Vitae Christi*. Such a subtle and precise interpretation of the Arena frescoes is best attributed to Giotto himself. Of all the Giottesque works preserved in Assisi, only the Bishop's Chapel can be considered the project on which Giotto worked in 1308.

616　Rintelen, *Giotto und die Giotto-Apokryphen*, p. 214.

ON THE CONNECTION AND SEQUENCE OF THE MURALS

To conclude the topic of Assisi and to verify the results, the perspective must be inverted: how does the thesis that Giotto painted in the Mary Magdalen Chapel in 1308 fit into the history of the decoration of San Francesco? Of the Giottesque frescoes, the Chapel of St. Nicholas certainly preceded it; among its creators, who were trained in Giotto's early work as well as in the Roman art scene and were perfectly attuned to each other, there was at least one who had also looked over Giotto's shoulder in Padua. This is shown not only by the pictures, but also by the decorative parts. Although they are mainly developed from the ornamentation of the Upper Church, the bands in the embrasures of the windows, for example, show a mixture of vegetal and Gothic architectural elements, which points to Giotto's repertoire of motifs in Padua. Giotto may have worked in the Mary Magdalene Chapel with one or more painters from the St Nicholas Chapel team. This would explain the Cavallinesque rather than Giottesque Christ figure in the Noli me tangere scene.

There is one picture in the Mary Magdalene Chapel that stands out. It shows the Saint's Journey to Marseilles and the miracle she worked of the dead pilgrim breastfeeding her child[617] (fig. 218). The picture is sometimes compared with the Navicella, and with good reason, for the architectural motif composed of bridge and gate is probably taken from the mosaic (fig. 125). What the painter altered results from the change in content from "harbour" (Navicella titulus) to "Marseille" (Mary Magdalene legend). For the adaptation, a cityscape in a "masonry vat" developed from late antique tradition was used, whereby this model was most likely the Arezzo *veduta* in the first portion of the Legend of St. Francis (fig. 197); the towers, which are sparsely detailed and appear all the more stereometrical, also point to this. A look at the Navicella also shows some distance to Giotto's art: a ship scene in the manner of the Navicella would fit far better into the cycle than this overloaded composition, which ultimately fails to fulfil its function: burdened by too many episodes and too many motifs, the plot cannot be understood even in its basic features without precise knowledge of the text. In its details, the picture is only superficially adapted to the style of the other images in the chapel: the Magdalene's face, for example, lacks all sweetness. Finally, technical deficiencies should be noted: Strikingly large parts, indeed whole areas, were executed al secco and have flaked off. Nevertheless, the theme of the picture is important in the context of the overall programme of the chapel, since it is about Mary Magdalene as the protector of the pilgrims.

Like this scene, the four figures of saints on the altar wall of the chapel and some in the entrance arch are not by Giotto. There, alongside the high-quality and inventive figures that must have been designed and executed by him (Dionysius, Augustine, Paul, David,

617 *Legenda Aurea*, ed. Maggioni, pp. 631–638.

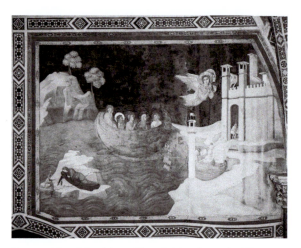

Fig. 218: Mary Magdalene Chapel: Miracle on the Way to Marseille

Gesinas, Longinus), are some that look as if they were created according to Giottesque patterns, without their painter having more than a basic idea of Giotto's current style. The vastness of their distance from Giotto is best seen by comparing the female saints with the busts of holy women in the Paduan frame system, which are products of painters from Giotto's *bottega*: in Assisi, there is a lack of both plasticity and individuality.

The group with whom Giotto worked was therefore not, or only partly, brought from Padua or Florence. This fits with the document that proves Giotto's stay in Assisi and points to a collaboration with the Assisi-based painter Palmerino di Guido. There are scholars who want to find Palmerino among the painters of the Chapel of St. Nicholas.[618] But what we know of Palmerino's style is further from Giotto's painting than anything in this chapel. The pictures in the Mary Magdalen Chapel that least fit Giotto's art are probably the busts of two saints in quatrefoils that decorate the arch to the transept (fig. 219): we see elongated, pointed faces, barely rounded in their modelling, with prominent noses and wig-like hairstyles. They are close to faces that probably belong to Palmerio's work in Gubbio, including the so-called Maestà dei Laici (fig. 164, 165). The more decisive attempts at modelling in Assisi can be explained by a striving for uniformity in the painting of the chapel. In any case, the two busts are works painted under the conditions of a form of organisation that harmonises better with the term *cantiere* than with the term *bottega*.

The first half of the St. Francis cycle was probably created more or less in parallel with the paintings in the chapels of St. Nicholas and St. Mary Magdalene. If the Marseille view in the latter chapel is really based on "Arezzo", then the first campaign even preceded Bishop Teobaldo's project by at least half a step. Conversely, there are no traces of the Mary Magdalene frescoes in the St. Francis pictures. The difference is particularly clear in the spatiality: in the fourteen older scenes of the St. Francis cycle, there is no tendency towards frieze composition as in the Magdalen Chapel, but an effort to spatially stagger the groups and buildings one behind the other, which often exceeded the painters' abilities. Giotto's post-Paduan system, which is easier to use, should have been welcome to them.

618 E. Neri Lusanna, Percorso di Guiduccio Palmerucci, *Paragone Arte* 28, 1977, 325, pp. 10–39.

The painters of this *cantiere* were trained in several different phases of Giotto's art, much like the team working in the Chapel of St Nicholas, but the share of the Arena frescoes was more present and the artists were less well attuned to each other. I imagine a group of painters that included a Paduan collaborator of Giotto, but in which veterans of the clerestory campaign also had a say. They had probably been involved in the painting of the Sala dei Notari in Perugia in the meantime. This explains some motifs that appear similarly in Perugia and in the St. Francis cycle and can be traced back to inventions of the clerestory campaign.[619]

So much for the first phase of Giottesque paintings in the context of the remodelling of San Francesco. It may be dated around 1306/07/08. Part of this thesis is the assumption that the work in the Upper Church was temporarily left undone after the execution of fourteen pictures of St. Francis ("sculptor cantiere"), an idea that may seem arbitrary. On the other hand, the rift between the Sermon to the Birds and the Death of the Knight of Celano is evident,[620] if one is only willing to disregard the problematic dogma of the "obvious unity of the whole". Apart from that, it is an open question which case is more astonishing: a caesura within the cycle or the fact that the unprecedentedly extensive series of pictures on the life of the *Poverello* was ordered and executed at all. Who might be identified as the patron? One considers the Curia – as before with the other pictures in the upper church. But it is doubtful that papal interest in a further decoration of the space was still great at that time. Rather, the Order was probably the initiator – from whatever financial resources.

It is a fact that the Franciscans were fundamentally critical of any decoration of their churches, but a more open attitude could be justified when it came to the church over the tomb of the founder of the Order. In the years around 1310, however, the Spirituals, under the leadership of Ubertino of Casale, polemicised particularly furiously against everything that embellished the churches and the cult. Although the Spirituals had little direct

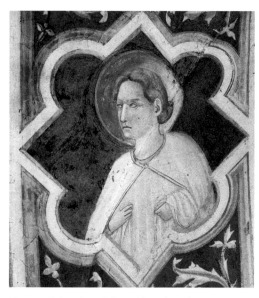

Fig. 219: Mary Magdalene Chapel: Unknown Saint (Palmerino di Guido?)

619 Cf. Bellosi, *La pecora di Giotto*, p. 16.
620 Cf. Lisner, Die Franzlegende in der Oberkirche von San Francesco in Assisi, p. 45.

356 Assisi 1308 and other St. Francis-Problems

influence in the Curia-affiliated convent of Assisi, the friars there could hardly ignore the fundamentalist position altogether. They only became irrelevant in 1317 with the bull *Quorundam exigit* in which John XXII made the Spiritualist movement illegal and thus discredited their views.[621] A temporary suspension of work on the paintings out of ideological caution seems an obvious option.

The second phase of Giottesque fresco painting in San Francesco began in the choir area of the Lower Church. This must have been around or soon after 1315 – perhaps in 1317, the year in which not only had the Spirituals lost all authority, but also during which two donations to San Francesco "pro operibus" and "pro opere" are attested.[622] The creations were shaped by pastoral ambitions: explanation of the Order's aims and the characteristics of the Order's saint. The painters of the northern transept of the Lower Church were trained in a now orthodox sense in Giotto's style, as it had been constituted in Padua and developed further in the following years. Works such as the clerestory frescoes of the Upper Church, the fourteen pictures of the St. Francis cycle already completed by this time, and the paintings of the Chapel of St. Nicholas were already outdated in their eyes. On the other hand, they may have experienced Giotto's pictures in the Magdalen Chapel as a contemporary modification of the Arena frescoes. I would like to attribute the frieze-like appearance of their compositions to these pictures or to other works by Giotto from around or after 1310. The ornamental parts, too, are based on the mixture of motifs developed for Padua and repeated quite exactly in the Mary Magdalene Chapel, while explicit adoptions from the clerestory of the Upper Church and from the Chapel of St. Nicholas no longer occur here either.

Presumably we know the name of the master painter. If the cut-out head of a frescoed personification, which is now in Budapest (fig. 220), really comes from the apse or the choir arch (this provenance is not completely documented, but it is plausible), and if Ghiberti's assertion is correct that the apse decoration was the work of Stefano, one of Giotto's three canonical disciples, then we can assume the following, based both on stylistic findings and on considerations of the organisation of labour: it was this artist,

621 F. Ehrle, Die Spiritualen, ihr Verhältnis zum Franciscanerorden und zu den Fraticellen, *Archiv für Literatur- und Kirchengeschichte des Mittelalters* 1, 1885, pp. 505–569, 2, 1886, pp. 106–164 and 249–336, 3, 1887, pp. 553–623, 4, 1888, pp. 1–190, esp. 4, 1888, pp. 116–117. Belting, *Die Oberkirche von San Francesco in Assisi*, pp. 19–21. M.D. Lambert, *Franciscan Poverty*, St. Bonaventure NY 1998, pp. 157–270. J. Miethke, Der "theoretische Armutsstreit" im 14. Jahrhundert. Papst und Franziskanerorden im Konflikt um die Armut, in: *Gelobte Armut. Armutskonzepte der franziskanischen Ordensfamilie vom Mittelalter bis zur Gegenwart*, ed. H.-D. Heimann, A, Hilsebein, B, Schmies, and Chr. Stiegemann, Paderborn, 2012, pp. 243–283.

622 Zaccaria, Diario storico della Basilica e Sacro Convento di S. Francesco in Assisi II, pp. 291–292 (nos. 145–146)

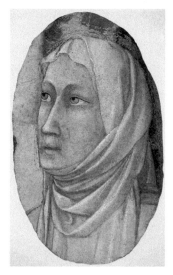

Fig. 220: Budapest, Szépmüvészeti Muzeum: head of a personification from Assisi (Stefano)

Fig. 221: Lower church, southern transept: The Flagellation of Christ (Pietro Lorenzetti)

described in the earliest relevant sources as Giotto's pupil (2.1.3, 4), who began the painting of the choir and transept and under whose direction it was almost three quarters completed.[623] In the third volume I will return to Stefano's contribution to the history of painting. It is worth noting here that Stefano is the only pupil about whom a sentence by the master has survived – the only art-critical statement by Giotto that has been passed down. More than half a century after Giotto's and several decades after Stefano's deaths, Filippo Villani wrote that Giotto had said that Stefano's figures were so alive that all they lacked was the ability to breathe (2.1.3). Of course, this is not credible in the literal sense and it does not really fit the style of the frescoes in Assisi either. On the other hand, there are more pertinent motifs that first appear here and then in Giotto's Bardi Chapel. This could indicate an equal relationship between the two painters in the second and third decades of the 14th century.

Completely new impulses then came to Assisi with the work of the Sienese Pietro Lorenzetti in the southern transept arm. Just as Stefano and his colleagues worked within Giotto's Paduan style and its subsequent developments, Pietro evolved Duccio's pictorial language – but in a much more creative way. Part of this creativity is due to

623 The latest contribution to the Budapest Head: *Giotto: Bilancio critico di sessant'anni di studi e ricerche*. Exh. cat. ed. A. Tartuferi, Florence 2000, pp. 124–126 (M. Boskovits).

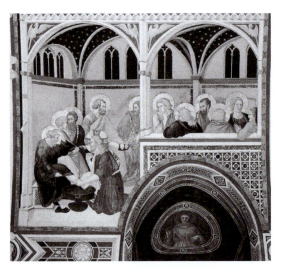

Fig. 222: Lower church, southern transept: The Washing of the Feet (Pietro Lorenzetti)

Fig. 223: Upper church, nave, lower north wall of the first bay: The Donation of the Mantle (campaign 1)

the fact that he also had an eye on the Giottesque traditions.[624] The exotically styled room in which he sets the Flagellation of Christ can easily be explained as a combination and bold variation of the fantastic pictorial spaces of the Chapel of St. Nicholas (fig. 221, 184, 185). In contrast, the very rationally laid out room for the Washing of the Feet is a variant of the room in which the Presentation in the Temple takes place in the north transept (fig. 222, 194).

All the Giottesque and non-Giottesque layers that had been deposited in Assisi were then built upon by the painters who completed the St Francis cycle in the Upper Church ("colourist cantiere"). The actual modernity of these paintings, with which one could begin studies of Giotto's survival, is concealed behind references back to the sculptor cantiere, in whose production even memories of the early Giotto are embedded. The fact that a quarter of a century of the history of painting becomes present in the cycle presumably accounts for the success of the complete St. Francis series as a supposedly standard-setting work by Giotto. It is a gallery of 28 works which – as can be most perfectly seen in the Donation of the Mantle to a Poor Knight (fig. 223) – serves the cliché of a medieval and archaic Giotto and simultaneously – in scenes such as the Verification of the Stigmata (fig. 175) – the cliché of Giotto as the first Renaissance painter. But if the Francis cycle is considered an early work

624 Seidel, Das Frühwerk von Pietro Lorenzetti, pp. 144–154.

by Giotto, then the emergence of these paintings is a kind of eruption that unleashes all the possibilities of Trecento painting at once and in perfection.

GIOTTO'S ST. FRANCIS PANEL (LOUVRE) AND THE LEGEND OF ST. FRANCIS IN ASSISI

The nature of the relationship between the total of four scenes on the monumental St. Francis panel in the Louvre signed by Giotto (pl. XV) and the corresponding scenes in the fresco cycle in Assisi is controversial. The problem arises most sharply with the predella pictures and the murals on the south and entrance walls – i.e. in zones where the sculptor-cantiere worked – because in these cases the connections are very close. Were the frescoes the models for the pictures on the panel or vice versa? Should we imagine that Giotto, when designing the scenes for the panel, followed the painters of the sculptor-cantiere, who in Assisi had created more or less official versions of the events? Or – conversely – did the team of muralists pick up gripping new pictorial ideas from Giotto? Or – which is probably what most people interested in the subject believe – did Giotto paint both picture ensembles? Does not the very similarity of the visual formulations speak for this thesis and thus for a personal involvement of Giotto in the St. Francis cycle?[625]

A close examination of the two representations of the Dream of Innocent III can help answer this question. So far it has been overlooked that the picture on the panel (fig. 224) is not only related to the fresco of the same theme, but also to the fresco of the cycle of St. Francis in Assisi which shows the Vision of the Palace (fig. 225). In Bonaventura's *Legenda Maior*, which provided the text for the cycle, the event from the saint's youth reads as follows (I, 3)[626]: "Now on the night following, when he had yielded himself unto sleep, the divine mercy showed him a fair and great palace, together with military accountments adorned with the sign of the Cross of Christ." Whereas the palace in the picture is easily recognisable as a Byzantine architectural fiction with some set pieces of real architecture added and is therefore in keeping with the pre-Paduan Giotto, the scene in Francis' bedchamber is unmistakably a kind of mirror image of that in Pope Innocent's

625 Toesca, *Die Florentiner Malerei des vierzehnten Jahrhunderts*, p. 19. Bellosi, *La pecora di Giotto*, pp. 80–85. *Giotto e compagni*. Exh. cat. Louvre, ed. D. Thiébaut, Paris and Milan 2013, pp. 76–93 (L. Pisani and D. Cooper).

626 "Nocte vero sequenti, cum se sopori dedisset, palatium speciosum et magnum cum militaribus armis crucis Christi signaculo insignitis clementia divina monstravit." *Fontes Franciscani*, ed. E. Menestò and St. Brufani, Assisi 1995, p. 783. Translation after: Bonaventura, *The Life of Saint Francis*, trans. E. Gurney Salyer, London 1904, p. 9.

Fig. 224: Paris, Louvre, St. Francis Panel from S. Francesco, Pisa: The Dream of Innocent III

bedchamber as depicted by Giotto on the Paris panel. In the fresco, the "divine mercy" or Christ has stretched out his pointing arm in accordance with the imposing size of the palace; in contrast, St. Peter on the panel, while pointing at Francis, has only raised his forearm. Otherwise, the posture and gestures of the two figures are largely the same. The sleeping postures of the Pope and St. Francis are also similar. That the lateral posture is more pronounced in Francis and that the figure appears more voluminous because of

the tucked-up leg, can be traced to the Paduan background of the muralist: it is an adoption of the postural motif of Mary turning on her bed towards the manger in the Christmas scene of the Arena Chapel[627] (pl. III).

Even the arrangement of the curtains, which seems unimportant at first glance, coincides on the panel and in the mural: The back curtain of the alcove is drawn open a little, so that the indicative gesture of Peter (in Paris) and Christ (in Assisi) extends beyond the patterned foil of the textile and appears against the golden respectively blue background; the front curtain is fully drawn open, gathered and looped around the front support of the alcove on the side of the vision.

Fig. 225: Upper church, nave, lower north wall of the first bay: The Vision of the Palace (campaign 1)

These two patterns of figural and furnishing motifs have even more in common with each other than the papal bedchamber on the Paris panel and the corresponding part of the Pope's Dream in the Assisi fresco cycle (fig. 224, 226). Not only does the arm position of the sleeping Innocent prove to be different in the two narratives, but there is also a striking difference in content due to the presence or absence of Peter. Bonaventure tells the story of Innocent's vision as follows (III, 10)[628]: "For in a dream he saw, as he recounted, the Lateran Basilica about to fall, when a little poor man, of mean stature and humble aspect, propped it with his own back, and thus saved it from falling." Not a word about Peter. With his appearance, the scene on the Paris panel diverges from Bonaventura's account. And Peter does not take part in this event in any other written or painted version of the legend of St. Francis.

But his presence fits the situation in Pisa. Giotto's panel had its home in the Minorite church of San Francesco there before it was taken to Paris under Napoleon. According to the conviction of the Pisans, Peter, when coming from Palestine, had landed in their city and founded the first Christian community in Italy – even before that of Rome. The

627 Cf. Lisner, Die Franzlegende in der Oberkirche von S. Francesco in Assisi, p. 61.
628 "Videbat namque in somnis, ut retulit, Lateranensem basilicam fore proximam iam ruinae, quam quidam homo pauperculus, modicus et despectus, proprio dorso submisso, ne caderet, sustentabat." *Fontes Franciscani*, p. 802. Translation after: Bonaventura, *The Life of Saint Francis*, p. 31.

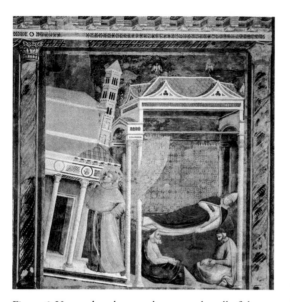

Fig. 226: Upper church, nave, lower north wall of the second bay: The Dream of Innocent III (campaign 1)

collegiate church of San Piero a Grado, on the site of the old Pisan harbour, marks the place of his first mass on Italian soil and was therefore an Italy-wide pilgrimage destination. On the occasion of an episcopal visitation in 1262, it was noted that the church was sometimes so overcrowded that visitors were in danger of suffocating.[629] In accordance with the popularity of the church and its patron, it underwent a lavish redecoration in the first decade of the Trecento.[630]

The appearance of Peter on the panel can thus be explained as an adaptation of the narrative for the Pisan patron (a member of a powerful family, as will be shown), or for a Pisan audience in general: by using a *topos* and placing the founder of the papal office at the side of the dreaming pope,[631] it became possible to weave the local saint into the *vita* of the patron saint of the church and the order. It is also possible that the significance of the additional figure is both local and Franciscan: just as the Pisan community of St. Peter preceded the Roman community, the Franciscan settlement in Pisa, allegedly founded in 1211, preceded the Roman one established in 1212 – at least according to a tradition of the Order documented since the 17th century.[632] Peter's appearance in a Franciscan church in the Petrine city of Pisa may also allude to this advance.

The question raised at the beginning of this section, of which of the pictures is the prototype and which is the remake, can now be formulated more precisely: Did Giotto

629 D. Herlihy, *Pisa in the Early Renaissance: A Study in Urban Growth*, New Haven 1958, pp. 38–39.

630 J.T. Wollesen, *Die Fresken von San Piero a Grado bei Pisa*, Phil. Diss., n.p. 1977. M. Burresi and A. Caleca, *Affreschi medievali a Pisa*, Pisa 2003, pp. 77–81, 208.

631 Cf. C. Frugoni, *Francesco e l'invenzione delle stimmate: Una storia per parole e immagini fino a Bonaventura e Giotto*, Turin 1993, pp. 222–224.

632 Moorman, *A History of the Franciscan Order*, p. 64. M. Ronzani, La chiesa e il convento di S. Francesco nella Pisa del Duecento, in: *Il Francescanesimo a Pisa (secc. XIII–XIV) e la missione del Beato Agnello in Inghilterra a Canterbury e Cambridge (1224–1263). Atti del Convegno di Studi Studi (Pisa 2001)*, ed. O. Banti and M. Soriani Innocenti, Pisa 2003, pp. 31–45.

combine the motifs of two murals of the St. Francis cycle in Assisi on the panel in such a way that he thereby could serve his Pisan patron's devotion to St. Peter? Or did painters of the sculptor cantiere trim the Pisan version of Innocent's Dream according to the Bonaventure report and at the same time use the motif of Giotto's Pisan Dream for another fresco on a related theme? A *pentimento* in an inconspicuous place in the fresco with the Pope's Dream can help to decide. The curtain at the back of the al-

Fig. 227: Detail from fig. 226

cove was initially depicted as half drawn open. Only when the painter was working on the *giornata* below did he decide to show the curtain closed. To this end, he painted over the tight sequence of folds on the right al secco with correspondingly broadly curved folds, which have since flaked off and are no longer clearly visible (fig. 227). The partially opened curtain, as first planned, corresponds to the staging of the pointing Peter on the panel and the pointing Christ in the mural with the Palace Dream. In the Palace Dream fresco, the curtain is open wider than it is in the Pope's Dream on the panel; and in the frescoed Pope's Dream, it would have been open even a stretch further. Without a figure at this point, an open curtain would have exposed a view of the blue surface of the inverted passe-partout, which would have been as visually distracting as it was senseless.

This provides an argument that Giotto's Papal Dream on the Paris panel is the prototype of the composition. It was first transferred to another narrative in Assisi and adapted for the fresco with the Palace Dream. Then, when the picture with the Papal Dream was being executed in Assisi and the composition was being used for the same scene as in Pisa, the incompatibility of Peter's appearance as it had been conceived for Pisa became apparent. Thus, instead of the figure of the apostle, the magnificently decorated field of the drawn curtain was introduced; this, however, leaves a dead zone that fits poorly with the picture's Giottesque pictorial language.

Additionally, in Assisi the rendering of the narrative of the dream, namely Francis' action to save the Lateran church, was adapted to fit the degree of reality of the scene in the bedchamber: on the panel, Francis is a relatively small figure and there is a gap between the church and the palace. In the mural, on the other hand, the dreamer and the dreamt, the palace and the church are treated as equal and coherent components of a single scene. It should also be noted how the church building has been altered: Giotto's buckling architecture becomes one that sways as a whole, which Francis, while standing

Fig. 228: Paris, Louvre, St. Francis Panel from San Francesco, Pisa: The Approval of the Rule

on the swaying base, tries to keep from capsizing. The fresco strays from the narrative in a way that is difficult to understand without Giotto's image as a visual intermediary.

Accordingly, the short St. Francis cycle on the panel is not a condensed version of the extensive cycle on the wall conceived for a special use, as Julian Gardner assumed.[633]

633 Gardner, The Louvre Stigmatization.

Rather, Giotto's very specific cycle of four was the nucleus from which the broad 28-part cycle was developed. To be precise: the three predella pictures provided the basis for the older half of the frescoed St. Francis cycle. Among its fourteen murals, in addition to the variant of Giotto's Dream of the Pope, there are also near-copies of the other two predella images, which show the Confirmation of the Rule of the Order by Innocent III and the Sermon to the Birds. And in these cases, too, one can study the variations and in doing so learn something both about the approach of the sculptor and his colleagues, and something about how Giotto, exceptionally, worked in a small format on the panel.

In the case of the Confirmation of the Rule of the Order, it is easy to see how

Fig. 229: Upper church, nave, lower north wall of the third bay: The Approval of the Rule (campaign 1)

the muralists reduced the size of the figures relative to the picture format and enlarged the architectural motifs (fig. 228, 229). At least the first measure was unavoidable, for Giotto used unusually large figures on the predella of the Paris panel (apart, however, from the "poor" Francis, who appears somewhat more frail than the other persons throughout the piece). In this way, Giotto tried to maintain the clarity of his pictorial language even in the small format. A similar phenomenon is often observed in book painting, and so one could speak of a miniature mode. When taking over the scenes, the muralists had the problem that they had to fill the proportionally unchanged basic features of the composition with relatively smaller figures (that is, figures that could not be enlarged to the same extent as the picture field). This led them, for example, to turn the Pope's court, which in Giotto's work is steeply staggered into the depth of the room, towards the viewer. This was not entirely successful: it only works if the viewer succeeds in perceiving the cardinal's head above the Pope's blessing arm as part of a figure and this as part of the group. The Franciscans at the back of the kneeling saint did not produce enough volume in the panel as well. In their place the muralists placed a stack of kneelers, which is a steeper variation of the group of Joseph's brothers in the scene with the Stolen Cup in the clerestory (fig. 117) and is one of the least successful motifs completed by the sculptor cantiere.[634]

634 Cf. Lisner, Die Franzlegende in der Oberkirche von S. Francesco in Assisi, p. 61.

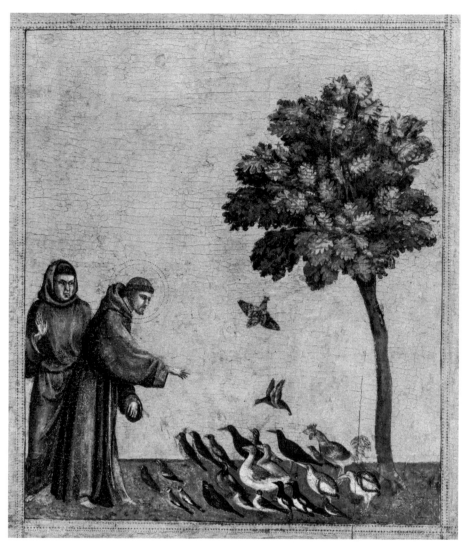

Fig. 230: Paris, Louvre, St. Francis Panel from San Francesco, Pisa: The Sermon to the Birds

No less problematic in the mural is the appearance of the ceiling construction. The enlargement of the architectural motifs seems unreal here: do the seven arcades on consoles actually represent a built space, or is it an accumulation of architectural components – as in late Byzantine painting, in Cavallini and in the "Isaac Master"? Giotto's audience hall can easily be explained by the inventions in the Arena Chapel: it is a version of the Hall of Caiaphas (pl. VII), only here staged with more architectural effort and projected sym-

metrically, following the central position of the scene on the predella. Without the Hall of Caiaphas, the room in Assisi cannot be explained either, but its advanced structure is hidden behind an antiquated combination of motifs.

In the Sermon to the Birds on the entrance wall, the last fresco painted by the sculptor-cantiere, the most important change concerns the figure of the preacher (fig. 230, 231). Giotto's long-limbed, slender Francis – a character at once expressive and elegant – who with his grand gestures stands out strikingly against the gold background, turns into a ponderous figure. In this case, it should be noted that the sculptor-team had already used the panel's striking bird preacher elsewhere by the time the fresco on the entrance wall was ready for execution. The figure stands mirror-inverted

Fig. 231: Upper church, nave, lower entrance wall: The Sermon to the Birds (campaign 1)

and with an altered rear arm in the centre of the image on the right hand wall, which narrates the Vision of the Fiery Chariot in a somewhat helpless manner (fig. 232) – helpless, because according to Bonaventure (IV, 4) the chariot had to drive inside the house instead of ascending into the sky above it. So a figure was needed to point the brothers in the house to the chariot above, and this was found in the preacher from the panel, whose bent-over posture and lowered arm were originally meant for the birds.

However, the preacher in the mural of the Sermon to the Birds, gesticulating calmly rather than energetically, also fits better with the type of the main figure in the Assisan legend of St. Francis. Although the painters did not succeed in giving the saint a uniform physiognomy, his appearance as a whole is nevertheless of a uniform character. Giotto used a different type on the panel throughout. Julian Gardner has drawn attention to the black beard the saint has there. The "barba nigra" explicitly corresponds to the description in the *Vita Prima* of Thomas of Celano (XXIX, 83), written shortly after Francis' death, a text that assigned the saint a Christ-like, eschatological role and, like other texts by Thomas of Celano, had been out of circulation for decades by that time.[635] Bonaventura's mild Francis and his sometimes beardless, sometimes brown-bearded illustra-

635 Gardner, The Louvre Stigmatization, p. 225. *Fontes Franciscani*, p. 358.

Fig. 232: Upper church, nave, lower north wall of the third bay: Vision of the Fiery Chariot (campaign 1)

tion in the St. Francis cycle of the Upper Church is a long way from the fervent saint that Thomas had wished to bring to mind. Giotto's Pisan Francis, however, resembles this type. This is perhaps most evident in the juxtaposition of the stern faces of Francis and Christ-Seraph in the panel's main scene (pl. XV).

Unlike the predella images, the main image of the panel has left no clear traces in the corresponding fresco of the Assisan cycle (fig. 233). The problem begins with Giotto's figure of Francis, which may or may not have been used. The statement made in connection with Giuliano da Rimini's panel may be repeated here: in the Franciscan milieu of the time around 1300, there were countless images of the stigmatised Francis; in order to be able to credibly trace one preserved image directly back to another, there must be a dense structure of correspondences. In contrast, it is clear that the mural as a whole, with its three figures, deviates significantly from Giotto's two-figure composition. If the panel was the starting point for the conception of the mural, then the muralist has nonetheless distanced himself strongly from the model. Assuming that the dating suggested above for the activity of the colourist cantiere is correct, the painter had a more recent and, in the literal sense, closer reference for the picture at his disposal, and this offered – an exception among the images of the Stigmatisation – a three-figure composition.[636]

The extra third man calls into question the solitude of the saint on Mount La Verna, which is constitutive of the narrative – for if Francis had not been alone, he would not have had to face the issue, widely discussed by Bonaventure, of how to inform his confreres about the miracle of the stigmata. Most often, the squatting Franciscan in the pic-

636 In total, only four representations of this type have come to my attention from 13th and 14th century Italy. In addition to the two discussed here, there is a fresco in Lodi, San Francesco (Cook, *Images of St. Francis of Assisi*, no. 92 pp. 121–122) and a privately owned panel from Naples (Frugoni, *Francesco e l'invenzione delle stimmate*, p. 214 and fig. 22), both of which probably are variations of the mural in the upper church.

Fig. 233: Upper church, nave, lower south wall of the forth bay: The Stigmatisation (campaign 2)

Fig. 234: Lower church, southern transept: The Stigmatisation (Pietro Lorenzetti)

ture is named as Brother Leo, and his role is described as that of a witness.[637] This reading, however, can be based neither on Bonaventure nor on the other biographical writings on Francis of the 13th and early 14th centuries, but only on the *Fioretti*, a text rich in motifs that was edited between ca. 1380 and 1390.[638] The report there that Leo was an eyewitness is most likely based on the linking of two separate passages in Bonaventure's *Legenda maior* with a prestigious but dubious piece of writing. The first passage of Bonaventure (XI, 9) describes how a companion seeks out Francis on Mount La Verna and receives a written blessing from him. A parchment with lines addressed to a brother Leo from the hand of the saint has indeed been preserved – and is a highly venerated relic. Attached to the saint's words on the same sheet is an account of the stigmatisation allegedly authored and written down by this Leo. It has long been clear that this text derives from Bonaventura's report and was penned long after Leo's lifetime.[639] Therefore, the document may be called prestigious *and* dubious. The second relevant passage in Bonaventure is found in

637 Ibid. p. 210.
638 K. Ruh, *Geschichte der abendländischen Mystik 2: Frauenmystik und Franziskanische Mystik der Frühzeit*, Munich 1993, p. 394. E. Grau, Franziskusbiographie, in: *800 Jahre Franz von Assisi: Franziskanische Kunst und Kultur des Mittelalters*. Exh. cat., Krems 1982, pp. 64–90, esp. S. 74.
639 J. Merkt, *Die Wundmale des heiligen Franziskus*, Leipzig 1910, p. 46.

Chapter XIII: before describing the miracle of stigmatisation, the author mentions a friar who is staying with the saint on Mount La Verna (more on his activities there shortly). The author does not presuppose that he was identical with the friar mentioned in Chapter XI and since the friar is not referred to again in the further course of Chapter XIII, the author and his readers probably assume that he left Francis alone some time before the stigmatisation.

So the fact is, firstly, that according to the texts available to our painters, no one was present at the stigmatisation and so no one witnessed it; to name a witness would be fabrication. Secondly, it should be noted: the alleged brother Leo in the picture does not behave as a witness should but is rather reading. This activity draws attention to the prehistory of the stigmatisation as told by Bonaventure and to the anonymous brother who appears there briefly (we are back to the passage in chapter XIII): at Francis' behest, he opens the Gospel book three times, and each time he happens upon the Passion. From this Francis derives his mission to seek full Christ-likeness, which then leads to the appearance of the seraph and the stigmatisation "one morning around the feast of the Exaltation of the Cross" (XIII, 3). In the text, this information follows immediately, but it is clear that a longer time has passed.[640] The friar reading in the fresco is therefore neither Leo nor a witness. Rather, it is the book he is holding that matters. It is a motif, intended to clearly link the visualised event with its biblical source of inspiration.

The probable model for the fresco is Pietro Lorenzetti's Stigmatisation in the Lower Church (fig. 234). Here the reference to the biblical narrative is necessary and the book is an almost indispensable prop: Pietro's Stigmatisation is part of a Passion cycle and could easily be perceived as a foreign body in this sequence of images if the reason for its inclusion were not explained. And that is what the book achieves: viewers can tell themselves that the friar is reading the very thing they see painted around the stigmatisation image, namely the passion of Christ, from which Francis drew inspiration. Pietro Lorenzetti has taken some pains to make it clear that the reading friar is not really present at the event of the stigmatisation. He has assigned him a magnificent church, which tells us that he does not share the eremitic life of the saint. Moreover, the painter has placed a kind of ravine between the reader and Francis, over which – as if to prove that it is not a mere crevice in the earth – a bridge passes.

Interestingly, a gorge also separates Francis and Leo in the *Fioretti*. According to this text, the friar has to cross the chasm once a day to bring water and bread to the saint.[641] And this in turn provides the narrator with an explanation of why Leo can observe what happens to the saint in his solitude. The shared motif of the ravine raises the question

640 W. Prinz, *Die Storia oder die Kunst des Erzählens in der italienischen Malerei und Plastik des späten Mittelalters und der Frührenaissance 1260–1460*, 2 vols., Mainz 2000, vol. 1 pp. 71–72.

641 Summary of the passage: Ruh, *Geschichte der abendländischen Mystik 2*, p. 394.

of whether – along with Bonaventure and the parchment with the blessing – Pietro Lorenzetti's fresco, located close to the saint's tomb at the focal point of the cult of Francis, provided the inspiration for the stigmatisation account in the *Fioretti*. In this case, the mural is a key monument not only to the iconography of St Francis in San Francesco, but also to the late medieval biography of the saint in general, and this insight in turn would be the lever with which to break the hermeneutic circle of a historically misguided reading of the stigmatisation images.

Looking at the detail of the fresco in the Lower Church allows us to see the picture in the St. Francis cycle in the Upper Church more precisely. In the Upper Church, the coupling of the unobserved miracle with the presence of the friar is also explained, but this painter explains it by other means. Instead of the ravine, it is a kind of rock wall that separates the foreground containing the friar from the middle ground containing the saint and thus also the physical location of the two men. Rather than developing individual motifs (as the author of the *Fioretti* does), this version of the scene adapts Pietro Lorenzetti's iconographic solution by focusing on its central messages: one is that Francis was alone on his mountain when the miracle occurred; the other is its connection to the Bible and to Francis' source of inspiration, as established by the separately placed friar. After all, the picture is below the New Testament clerestory cycle, which includes the Passion. Following the example of the Lower Church, but under more complicated conditions, the friar and the book open up these images as a context for the legend of St. Francis.

But the Pisan panel was also important for this picture of the Francis cycle, even if only in a very specific detail. This becomes apparent when looking at the rays that connect the seraph and the saint: in the panel and in the Upper Church they start as a bundle of lines from the wounds of the Seraph while only the middle line arrives at the corresponding wound of the kneeling person. This makes the relationship of cause and effect unmistakable. If the sequence of images proposed here is correct, then the Pisan rays are the oldest of their type in the iconography of St. Francis. Giotto's motif is a kind of dogmatically thought-out derivative of those rays which in the older pictures emanate from the seraph as a totality (and not from its individual limbs) and strike Francis' entire body. Giotto's rays say unequivocally: the wounds of the saint are physical products of the wounds of Christ/Seraph (and not psychic fabrications of the saint).[642] The first to adopt this visual argument in Assisi was Pietro Lorenzetti, who, however, did not reproduce the elements literally. Here it is single golden lines that connect the wounds; what is the source point and what is the target point is taken for granted. And the lines connect the right hand of the seraph with the right of the kneeler and the left with the left. On the Pisan panel,

642 H. Belting, Franziskus: Der Körper als Bild, in: *Bild und Körper im Mittelalter*, ed. K. Marek et al., Munich 2006, pp. 21–36.

the transfer is a mirror image. In this motif, the Sienese seems to strive for a perfection beyond Giotto. However, we should also note Pietro Lorenzetti's inconsistency with the feet: here the wound on the seraph's right foot imprints the wound in Francis' left foot and the wound in the seraph's left foot imprints that in the saint's right foot. The "colourist", on the other hand, adhered closely to the Pisan model – both for the hands and the feet – and thus clearly gave preference to Giotto's design in this important point.

AN IMAGE OF ST. FRANCIS FOR THE PISANS

The Louvre panel was probably painted between the frescoes of the Arena Chapel and Giotto's stay in Assisi in 1308, i.e. in the second half of 1307 or the first half of 1308 (pl. XV). A dating after the Mary Magdalene frescoes of 1308 cannot be ruled out from the outset. But this would imply that the first part of the Upper Church's Francis cycle, with its loans from the panel as they were examined in detail here, should also be dated later than the Mary Magdalene murals. And that in turn would mean: The *schola cantorum* of the Upper Church, whose spolia were installed in the Mary Magdalene Chapel in 1308 or earlier (i.e. during or before Giotto painted), had been dismantled long before the St. Francis cycle was begun. In contrast, it is plausible to assume that the measures for the liturgical remodelling of the church were largely carried out synchronously, an assumption that brings the deconstruction of the singers' choir, the beginning of the work on the St. Francis cycle and the painting of the Mary Magdalene Chapel close together in time.

The panel was most likely painted in Florence and shipped from there down the Arno to Pisa. The church of San Francesco had shortly before become the home of a large-format panel of Florentine production: a huge Madonna that also entered the Louvre at the beginning of the 19th century. Since the early 16th century at the latest, since Billi's *Libro*, it has been regarded as a work by Cimabue and was in any case created in succession to or in competition with the Madonna Rucellai painted in 1285 by Duccio for the Laudesi of Santa Maria Novella in Florence[643] (fig. 235). In this context, the depiction of the robe with its abundant pleating emphasising the bodily forms is striking. This is unusual in Florentine and Tuscan painting of the late 13th century and can best be explained as a combination of Duccio's drapery forms with those of the "Isaac Master", i.e. from the works of the young Giotto. This, in turn, fits in with the documentary records of Cimabue, which indicate that he was active in Pisa in the years before his death, i.e. in 1301 and 1302. The panel could therefore be the work of a Cimabue who had entered into artistic competition with Giotto and was facing up to him

643 Cf. Bellosi, *Cimabue*, p. 274.

with his own weapons, namely by means of the conciseness and corporeal presence of his figures. At the same time, it may have been this picture that drew the attention of members of the Pisan elite to Florence and led to a panel being ordered from Giotto, who had just returned from Padua, not long after Cimabue's death.

The Pisan Madonna, like the only slightly larger Madonna Rucellai in Florence, could have been made for a confraternity. In contrast, Giotto's panel bears the coat of arms of the Pisan Cinquini family on the frame.[644] Despite the possibly very different situations in which they were commissioned, however, the pictures have common features; while not making them appear as counterparts, they invite comparison. Both are crowned by pediments and are monumental in scale. The Madonna measures 424 by 276 centimetres, the Francis panel 314 by 162 centimetres, so that in both cases the main figure is clearly larger than life. Thematically, too, they are comparable. It is true that Julian Gardner

Fig. 235: Paris, Louvre: Madonna from San Francesco in Pisa (Cimabue)

wanted to problematise the Francis panel as a "narrative" and thus as a highly unusual type of altarpiece around 1300. But, apart from the question of whether it is an altarpiece at all, a St. Francis receiving the stigmata from Christ/Seraph can be understood as a narrative as well as a non-narrative image in the same way as can the image of the Virgin holding the Christ child on her lap. Moreover, the layout of the panel seems to me to allude to an image of the Virgin Mary. With the few secondary scenes at the base, it is less reminiscent of the classical biographical icons of St. Francis (which are, however,

644 The coat of arms was first referred to by: A. da Morrona, *Pisa illustrata*, Pisa 1794, vol. 3 pp. 74–77. The identification was only successful belatedly: C.B. Strehlke, Francis of Assisi. His Culture, His Cult, and His Basilica, in: *The Treasury of Saint Francis of Assisi*. Exh. cat., New York 1999, pp. 23–51, esp. 42. And independently of this: M. Burresi and A. Caleca, Pittura a Pisa da Giunta a Giotto, in: *Cimabue a Pisa: La pittura Pisana del Duecento da Giunta a Giotto*. Exh. cat. ed. M. Burresi and A. Caleca, Pisa 2005, pp. 65–90, esp. 88.

374 Assisi 1308 and other St. Francis-Problems

among the premises of Giotto's concept), but rather of Florentine Madonna panels from the mid-13th century: the Madonna of Santa Maria Maggiore with two scenes below the throne and the Madonna di Greve with one are both worth mentioning.[645] One can therefore say that the Francis panel, or at least its main image, is not intended as a visual narrative at all, but as something like a Madonna version of the saint, especially since here as there it is about representations of the Incarnation: through Mary's body, God becomes a child, while in Francis' body Christ appears for the second time as the Crucified.

However, the balance between the holy and the godly figures on the Louvre panel (that is Francis and Christ in the form of a seraph) is somewhat different from that of a Madonna (which shows Mary and Christ as a child). The fact that the picture is truly not of one figure but of two is emphasised by the two chapels. In an allusion to the monastery founded by Francis on Mount La Verna in 1214, most of the stigmatisation pictures show a chapel on the right. Occasionally, however, there are also two chapels, as in the oldest surviving representation of all, the one on the panel in San Francesco in Pescia from 1235. There Francis kneels in the posture of Christ on the Mount of Olives in front of a land-scape backdrop framed by two buildings.[646] Giotto must have drawn on such an early model. This is also supported, as we have seen, by the zealot type he used for Francis. In addition, the godly person appears not only once in the main picture, namely as a seraph, but also on two further occasions, namely in pictures of the two chapels. In the form of a picture within the picture, we see Christ together with his mother in the tympanum of the church in the foreground. This half-figure representation in miniature is the most vivid image of the Madonna left by Giotto (fig. 236). The way mother and child look at each other seems inspired by Giovanni Pisano's deadly serious statue of the Virgin in the Arena Chapel, but in Giotto's work a moment of tenderness is added. One thinks of parting – and thus once more of the Passion and the suffering on the Cross. Christ is also present in an image in the second chapel. This time the viewers do not see him, but in the door the left side panel of a painted cross with a half-figure of the lamenting Virgin Mary is visible.[647] Finally, he also appears in the predella as a picture within a picture. On the façade of the collapsing Lateran Church, Christ stands in the centre with his arms outstretched, alluding to the posture of the Seraph on the cross (fig. 224). In fact, in Giotto's time, the Lateran Church had a façade mosaic depicting Christ. The head and

645 A. Preisler, *Das Entstehen und die Entwicklung der Predella in der italienischen Malerei*, Phil. Diss., Hildesheim 1973, pp. 48–54.

646 Cook, *Images of St. Francis of Assisi*, no.141 pp. 165–168.

647 Belting, Franziskus: Der Körper als Bild, p. 32. The assignment of the second chapel to Brother Leo is, in my opinion, inaccurate. See below.

the right hand, raised in blessing, are still preserved and visible.[648] Therefore, it is clear that the motif of the outstretched arms is an adaptation for the panel in Pisa. The painter has thus done much to surround the pictorial appearance of the seraph with images of Christ, and in this way to confirm his identity and to comment on it. Giotto's representation is, to a significantly higher degree, more an image of Francis *and* Christ than a Madonna is an image of Mary and Christ.

Fig. 236: Paris, Louvre, St. Francis Panel from S. Francesco, Pisa: The Stigmatisation, detail

Accordingly, the Cinquini donated to the Franciscan church and its visitors an image of St. Francis that subtly communicates with an image of the Madonna and, through the appearance of St. Peter, just as subtly brings out local cult traditions: an ambitious concept! Of course, it need not have been conceived in this form by the donors, but is rather a concept developed in collaboration between the Franciscans, the patrons and the painter. However, one should not neglect the patronal family's contribution either. The Cinquini seem to have been involved from the beginning and quite explicitly in the new building project of San Francesco, which was begun during the final years of the 13th century. Their coat of arms with the *vaio* (vair) pattern is also found on the church's architecture: a large version sits to the left and right of the window inside the second transept chapel from the right. This room was probably the family chapel of the Cinquini and they had probably invested a lot of money already in the foundations of the church for the right to be buried and liturgically cared for there. We will encounter similar circumstances in the Florentine Franciscan church of Santa Croce (cf. pp. 388–395, 510–516). But none of the Florentine families presents their coat of arms there as conspicuously or as monumentally as the Cinquini do in Pisa.

The Cinquini had become rich through trading with France and Catalonia around the middle of the 13th century.[649] The first prominent figures were, on the one hand, Natuccio Cinquini, who died between 1299 and 1301, and who distinguished himself not only as a merchant and banker, but also as a poet in a Provençal-infused *volgare*,[650] and, on the

648 Gardner, The Louvre Stigmatization, p. 228.
649 D. Herlihy, *Pisa nel Duecento*, Pisa 1973, pp. 202–203, 211. E. Cristiani, *Nobiltà e popolo nel comune di Pisa*, Naples1962, pp. 273, 452–453.
650 DizBI s.v. Cinquini, Natuccio (M. Pagano).

other hand, Villana Cinquini, who appears as a "mirarum virtutum femina" in the vita of St. Gherardesca (*Acta Sanctorum*): While praying for the city of Pisa, she was granted a vision in front of an image of the saint.[651]

The most important personality in Giotto's time seems to have been her grandson Giovanni (Vanni) Cinquini. Between 1288 and 1311 he officiated several times as a member of the *Anziani*, i.e. the city government, and served as vicar to the archbishop. As one of two consuls, he was entrusted with the administration of the island of Sardinia at least between 1303 and 1307, a function that may be assumed to have been extremely lucrative. So it is no wonder that he, together with the second Pisan consul, was also active as a builder in Cagliari. There he left a marble sculpture of an elephant, a long inscription and his coat of arms on the Torre dell'Elefante.[652] Besides Vanni, of course, other less exposed Cinquini could be Giotto's patrons (e.g. the priest and jurist Benedetto Cinquini, who, according to a surviving inscription, donated a painted cross to the church of San Lorenzo alla Rivolta in 1309), but Vanni is a plausible candidate.[653]

If the biographer of St. Gherardesca was correctly informed, Vanni named one of his sons (i.e. a great-grandson of Villana) Francesco; together with three of his brothers, he joined the Dominican Order. This seems to indicate an agreement between Vanni and parts of the family with the ideals of the new orders. As San Francesco in Pisa was an extraordinarily influential and active monastery – close to the Archbishop of Pisa and since 1254 the seat of the inquisition for the whole of Tuscany[654] – the interests of a businessman and politician were perhaps more easily combined with spiritual ideas in this place than one might think. The altar of the family chapel is a possible location for the panel, but it is more likely that it was in the nave. Together with the Triumphal Cross, perhaps also together with Cimabue's Madonna, the image could have been placed on or above the rood screen, which once divided the hall of the church, looking into the space of the laity.[655] The two shields with the Cinquini arms are small, but they are placed far down on the side rails of the frame and would therefore have been legible if the panel had been placed in an elevated position. They would have indicated a donation dedicated to

651 *Acta Sanctorum, Maii tom. VII,* ed. F. Baert and C. Janning, Paris and Rome 1866, pp. 161–176, on Villana esp. pp. 161 and 175.

652 S. Petrucci, Per una storia politica di Cagliari pisana. I burgenses Castelli Castri, *Rivista dell'Istituto di Storia dell'Europa Mediterranea* 15, 2015, pp. 207–269. R. Coroneo, Sulla scultura dell'Elefante nella torre omonima del Castello di Cagliari, in: *Tempi e forme dell'arte. Miscellanea di Studi offerti a Pina Belli D'Elia,* ed. L. Derosa and C. Gelao, Foggia 2011, pp. 145–151.

653 R. Roncioni, Delle Famiglie Pisane, ed. F. Bonaini, *Archivio Storico Italiano* 6, 2, 2, 1848, pp. 815–890.

654 M. d'Alatri, L'inquisizione francescana nell'Italia centrale nel sec. XIII, *Collectanea Franciscana* 22, 1952, pp. 225–250 and 23, 1953, pp. 51–165.

655 *Giotto e compagni,* p. 90 (D. Cooper).

the use of a wide audience of pious Pisans. But certainly Giotto's picture did not only reach the audience in Pisa. The importance of the Pisan monastery suggests that Giotto's panel had a location from which it attracted attention beyond the region. The suggestion that Giotto's ingenious invention of the stigmata rays radiated from Pisa to the whole Franciscan world, including Assisi, is in keeping with not only the importance of the painter but also that of the monastery.

What is easily overlooked against the background of the well thought-out imagery is the extraordinary painterly quality of the panel, evident above all in the depiction of the vegetation. Instead of the schematic dwarf trees we know from the Arena Chapel, we encounter trees of various kinds, including oaks. This is certainly not an end in itself: the condition of the trunks and branches indicates the barren surroundings of the mountain region in which Francis spent his temporary hermit life. At the same time, the lighting, and especially the shadowed sections, lends the leafy crowns a spatiality and plausibility that no painter before Giotto had achieved.

GIOTTO AUTONOMOUS: THE BARDI CHAPEL AND THE WORKS OF THE SECOND DECADE

Just as the date of the frescoes of the Arena Chapel in Padua can be determined from the history of its foundation and construction, can those of the Bardi Chapel. The circumstantial evidence is less dense but still offers useful clues – at least for the lower temporal limit: from when was it possible to paint the murals? Since when could they have been seen and used? For the determination of the temporal ceiling, on the other hand, a comparison of motives is helpful and leads to the simple conclusion: the later the dating, the less likely it is.

First, however, it should be admitted that the evidence for Giotto's activity in the Franciscan church of Santa Croce cannot be traced back further than to Ghiberti, who only writes in the *Commentarii* that the painter left "four chapels and four panels" there (2.1.4). Billi's book also refers to four chapels as Giotto's works, which are "adjacent to the main chapel, three towards the sacristy and one on the other side, likewise adjacent to the main chapel" (2.1.6). This includes the Bardi Chapel; it is the first to the right of the choir chapel, i.e. towards the sacristy. The Bardi Chapel and the neighbouring Peruzzi Chapel (the second towards the sacristy) are also named as Giotto's works by Francesco Albertini in his guide to Florence compiled around the same time; the painter and priest probably drew on the tradition not only of the artists' circles but also of the local clergy (2.7.7): "Two chapels, namely that of St. John and that of St. Francis between the main altar and the sacristy, by Giotto's hand." The Peruzzi chapel dedicated to the two St. Johns and the Bardi chapel dedicated to St. Francis are also the only ones from Billi's book whose fresco decoration has survived.

The Chapel of the Twelve Apostles that follows after the Peruzzi Chapel (the Giugni Chapel, the third towards the sacristy) has been deprived of its images, as has the chapel "on the other side, likewise adjacent to the main chapel". This refers to the Tosinghi-Spinelli Chapel, dedicated to the Assumption of Mary, which flanks the choir like a counterpart to the Bardi Chapel. Vasari saw the frescoes in these two spaces, classified them as works by Giotto according to Billi's book, and gave descriptions of them as Giotto's Santa Croce decorations number three and four (after the Bardi and Peruzzi chapels, 2.1.10):

> In the third, the Giugni Chapel, dedicated to the Twelve Apostles, the martyrdoms of several of them are painted by Giotto's hand. In the fourth, belonging to the Tosinghi and Spinelli and dedicated to the Assumption of Mary, Giotto painted the Nativity and Marriage of Mary, the Annunciation, the Adoration of the Magi and how Mary presents the Christ Child to old Simeon, which is a particularly

Fig. 237: Florence, Santa Croce, Choir chapels, façade to the nave

beautiful representation; for apart from the lively emotion that one notices in this old man who receives Christ, the gesture of the child who stretches out its little arms in fear of him and turns frightened towards its mother could not be more finely and beautifully expressed. At the death of the Virgin, however, the disciples and a large number of angels with torches in their hands are very beautiful.

Vasari omitted one scene: the Assumption of Mary, preserved in poor condition, which is not in but above the Tosinghi Spinelli Chapel, and yet belongs to its pictorial programme (fig. 237). Since the image visualises the dedication title, it can even be called the main image of the chapel. The same applies to the picture above the Bardi Chapel, which shows the stigmatisation of St. Francis and thus the most significant event from the life of the chapel's saint (fig. 238). Moreover, it represents the consecration of the entire Church both to the Holy Cross and to St. Francis: the latter, in fact, had become an image of the Holy Cross through the stigmata he had received after weeks of solitary fasting on Mount La Verna on the feast of the Exaltation of the Holy Cross. (Strictly speaking, according to Bonaventure, *Legenda maior*, XIII, 2, the event had occurred "circa Festum Exaltationis sanctae crucis", but this *circa* went largely unnoticed).[656]

Francis had fasted also out of devotion to Mary and because he wanted to celebrate one of her feast days, namely, that of her Assumption (*Legenda maior*, IX, 3).[657] In addition, it can be said that the themes of the Assumption and Stigmatisation are similar in that both events culminate in an encounter with Christ that transforms the protagonists.[658] The two pictures seem to relate to each other, and at the same time to contribute significantly to the adornment and programme of the main space of the church. This is matched by the identical format of the fields and figures, as well as the similarity of the painted framing and the filling of the spandrels above the chapel arches. Symmetry was particularly emphasised here. Continuing these parts, Agnolo Gaddi, son and pupil of Giotto's pupil Taddeo, then created an elaborate painted façade after the middle of the Trecento, which completely encloses the opening of the main chapel (fig. 237).

In the Stigmatisation above the Bardi Chapel, Giotto contributed an image to the decoration of Santa Croce that was almost as important as Cimabue's cross. And it is this fact that allows it to be dated. Such a picture was undoubtedly desired from the beginning, but at what point did it become possible as a mural? A delivery of wood documented for Christmas 1310 suggests that the transept of Santa Croce was roofed in 1311.[659] From this point on, it was possible to paint in (and perhaps also above) the chapel, but the church interior was still a building site. As Eva Maria Waldmann argued, this situation only changed around 1319/20, when the first bays of the nave were built – the struc-

656 *Fontes Franciscani*, ed. E. Menestò and St. Brufani, Assisi 1995, p. 891.

657 J. Gyárfás-Wilde, Giotto-Studien. I: Die Stellung der "Himmelfahrt Mariae" und der "Stigmatisation des hl. Franziskus" in Giottos Werk, *Wiener Jahrbuch für Kunstgeschichte 7*, 1930, pp. 45–94, esp. 52.

658 D. Blume, *Wandmalerei als Ordenspropaganda: Bildprogramme im Chorbereich franziskanischer Konvente Italiens bis zur Mitte des 14. Jahrhunderts*, Phil. Diss., Worms 1983, p. 91.

659 E.M. Waldmann, *Vor Vasari – Die Geschichte des Innenraums von S. Croce in Florenz*, Phil. Diss. Vienna 2003, doc. 6.

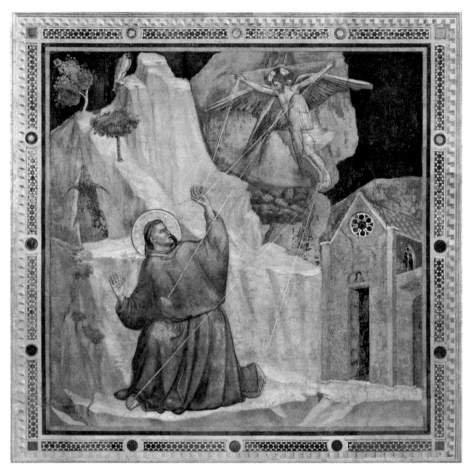

Fig. 238: Florence, Santa Croce: The Stigmatisation, mural above the Bardi-Chapel

ture between the transept and the eastern side portals. This created a place of worship consisting of the chapels, the transept and a short nave accessible from both the street and the convent. It was certainly soon closed by a temporary wall so that it could be used and the Old Santa Croce (documented by excavations), which stood in the way of the westward continuation of the nave, could be torn down. Giovanni Villani explicitly states that the old church served the friars' worship until the eastern parts of the new church were completed.[660] And the amount of space the new building had to provide before the old church could be abandoned is indicated by the number of friars documented in the

660 Giovanni Villani, *Nuova Cronica*, ed. G. Porta, 3 vols., Parma 1990, vol. 2 p. 21 (IX, vii).

Giotto Autonomous: The Bardi Chapel and the Works of the Second Decade 383

year 1300, that is, at least 123.[661] The time at which the service was transferred can be derived from the first tomb that found a place in the new nave. It must be assumed that the brothers were able to take liturgical care of it since it would otherwise have found its place in the crypt. The tomb was that of Gastone della Torre, the patriarch of Aquileia, who died in Florence in the summer of 1318, and received a wall tomb on the south side of the eastern bay. The commission was given to the sculptor Tino da Camaino, who certainly completed the monument before leaving Florence at the turn of the year 1319/20, so that the body of the patriarch could be laid to rest in it.[662]

The Bardi frescoes therefore almost certainly date from between 1311 and around 1320. That the painter stayed in Florence and the environs is attested for 1311–15, 1318, and 1320 1.1.9–22). It is noticeable that he invested a lot of money in land in the years 1321–23 (see vol. 1, p. 53). This and the situation in Santa Croce make the creation of the picture cycle in the years immediately before or around 1320 seem most likely. It was a time when a basic visual decoration of Santa Croce was produced or installed, partly permanently, partly provisionally.

If this dating is correct, then it must apply to the entire painting of the Bardi Chapel, for stylistically there is nothing to separate the stigmatisation from the images found in the chapel itself. The date then also applies to the counterpart of the Stigmatisation, namely the Assumption of Mary above the other neighbouring chapel of the choir. However, this can hardly be a work by Giotto. While the Bardi frescoes can be linked to the Arena frescoes and those of the Mary Magdalene Chapel in Assisi, this is not true of the image of the Assumption. It should also be noted that none of the early authors explicitly claims it for our painter; unlike the Stigmatisation, which is explicitly mentioned in Billi's book, it does not seem to have been considered a work by Giotto in the tradition on which Vasari relied. Even if the wall paintings in the Tosinghi Spinlli Chapel had really been by Giotto's hand, as the author of Billi's book claims, the only surviving picture of the programme, namely the one above the chapel, must have been done by another painter. It is the work of an artist who, judging by its rather striking stylistic character, also painted in Assisi, namely a fresco in the sacristy of the Lower Church, and who, like so many others in Florence and Central Italy, was just beginning to come to terms with Giotto's ideas.[663]

661 D.R. Lesnick, *Preaching in Medieval Florence: The Social World of Franciscan and Dominican Spirituality*, Athens, Ga. 1989, pp. 44–45.

662 W.R. Valentiner, *Tino di Camaino: A Sienese Sculptor of the Fourteenth Century*, Paris 1935, p. 59. See also p. 157: in January 1320, Tino was verifiably in Siena.

663 The connection with the mural in Assisi was recognised by Alberto Graziani, who named the painter as Maestro di Figline after a panel in the Collegiata of Figline Valdarno, which I am not convinced belongs to the other two works: A. Graziani, Affreschi del Maestro

SANCTITATIS NOVA SIGNA

Fig. 239: Detail from fig. 238

Comparing the Stigmatisation above the chapel with the stigmatisation picture from Pisa, which is several years older and signed by Giotto, can easily lead to doubts about Giotto's authorship of the Bardi frescoes, because almost everything is different in the two visualisations of the event (fig. 238, pl. XV). This begins with the type used for Francis. Instead of the black-bearded stern saint in the spirit of Thomas of Celano, we find a beardless, gentle, boyish Francis. However, it is obvious that this has more to do with the ideas of the commissioning authorities than with those of the painter. The St. Francis of the Bardi and the Friars of Santa Croce is an anti-fundamentalist saint, integrated into the Church and the urban societies of Italy, who does not stand in the way of his heirs when they want to make the Franciscans a "normal" order, offering not only change but also continuity. This is what Rona Goffen has demonstrated.[664]

The second difference does not seem to fit this statement: Giotto omitted the left-hand chapel of the Pisan panel in Florence. Instead, we see a cave as a counterpart to the right-hand chapel. It is accessible via a kind of rock plateau and seems suitable as a dwelling for a hermit. Julie Gyárfás-Wilde and Rona Goffen have tried to relate the motif to a narrative tradition which says that Francis had to seek refuge from Satan's persecutions in a cave before receiving the stigmata. But apart from the fact that there is no devil in the picture, this story first appears in the late 14th century as a kind of appendix to the *Fioretti di San Francesco*.[665] One cannot help but understand the painted cave from Thomas of Celano's zealotic image of Francis. What is meant is the austere, unworldly hermit who

di Figline, *Proporzioni* 1, 1943, pp. 65–79. *La basilica di San Francesco in Assisi* (Mirabilia Italiae 3), ed. G. Bonsanti, 4 (2) vols., Modena 2002, vol. 2 no. 2248.

664 R. Goffen, *Spirituality in Conflict: Saint Francis and Giotto's Bardi Chapel*, University Park and London 1988.

665 Gyárfás-Wilde, Giotto-Studien, p. 53. Goffen, *Spirituality in Conflict*, p. 61 and note 15 p. 119.

sought the closeness of God in rock crevices rather than in chapels and preferred the distant company of a solitary falcon to other humans (all authors, by the way, mention the bird and Giotto painted it brilliantly – fig. 239). The cave most probably goes back to a text attributed to Thomas of Celano because of its motifs and in any case inspired by him, the hymn *Sanctitatis nova signa*.[666] Unlike the biographies of Francis by this author, which were replaced by the more semantically open ones by Bonaventure, this text was not withdrawn from the Franciscan repertoire but remained in liturgical use. Thus an aspect of early Francis survived in the liturgy of the saint's feasts. The hymn says the following about the events leading up to the stigmatisation:

Montis antro sequestratus	*Alone in a mountain cave*
Plorat, orat humi stratus;	*He weeps, he prays stretched out on the earth.*
Tandem mente serenatus	*Finally, he hides serenely*
Latitat ergastulo.	*In the dungeon.*

The motifs of life in a cave and hermitism continues for two more stanzas, so it is not a minor matter. The main subject of the song, however, is the praise of the *stigmata* as well as the invocation of Francis as he is sanctified by these signs. The rousing opening verse summarises the text well:

Sanctitatis nova signa	*New signs of holiness*
Prodierunt lauda digna	*Produce appropriate praise.*
Mira valde et benigna,	*That they are most miraculous and beneficent*
In Francisco credita.	*in Francis, is our belief.*

The mural above the chapel seems to be less a part of the painted legend that was relocated from the chapel than a special hymn to the stigmata, the "Sanctitatis nova signa", which resounds visually throughout the church. Based on this assumption, the third difference to the Pisan picture can be classified. The main figure is depicted in an unusually complex spatial posture for Giotto, simultaneously directed (within the picture) towards the seraph and (outside the picture) towards the viewers in the church. This double twist has to do with the changed narrative: on the one hand, since the winged creature is ap-

666 Edition: *Legendae S. Francisci Assisiensis saeculis XIII et XIV conscriptae ad codicum fidem recensitae a Patribus Collegii*. Analecta Franciscana sive chronica alique varia documenta 10, Florence 1941, pp. 402–403. That the hymns were in use in the 14th century is clear from the edition report p. 398, which mentions three manuscripts of this period: Assisiensis 330. Miscellaneus; Portiunculae s.n. Graduale O.F.M., incip. Felix; Senensis X V 1, Graduale Franciscanum.

proaching Francis from behind this time, a moment of surprise is introduced that emphasises the extraordinary nature of the situation. On the other hand, the way the saint turns around and how he looks at the seraph with emotion both speak for a conscious participation in the event: one would think neither that the seraph was conjured up by the saint's prayer or originated from the saint's imagination, nor that the stigmatisation struck the saint without his desire. Bruce Cole has pointed out that all accounts of the stigmatisation, including those of Bonaventure, describe the saint as psychically active and, for all the ambivalence of his emotions between delight and horror, emphatically welcoming the event. And that is what Giotto's figure above the Bardi Chapel represents like no other representation of the stigmatised Francis.[667]

Finally, the orientation of the kneeling Francis towards the viewer not only makes the painting more accessible, but also ensures that the figures of the saint and Christ/Seraph, each with their five wounds, can be perceived as virtually the same body, only duplicated. If the rays in the Pisan panel represent both the transmission and the physical reality of the *stigmata*, the staging in Florence additionally suggests the identity of the *stigmata* on Francis and Christ. The rays now also tell their own stories: the ray emanating from Christ's right hand descends into the saint's left hand in such a way that one has the feeling that the saint is moving his hand towards the ray in order to receive it. The ray from Christ's left, which goes into Francis' right, passes behind the saint's head. This pushes the figure as a whole towards the viewer. The rays make the drama and psychology of the situation resonate with a spectacular figuration in which the miracle gains an unquestionable presence.[668]

If one looks for a parallel for such conciseness in Giotto's oeuvre, one comes to the virtues and vices of the Arena Chapel. There, too, we encounter solo performances (some with

667 B. Cole, Another Look at Giotto's Stigmatization of St. Francis, *The Connoisseur* 181, 1972, pp. 48–53.

668 This course of the rays was reconstructed during the restoration in 2011–2014 on the basis of findings visible to the naked eye: A. Bandini, A. Felici, M. R. Lanfranchi, and P. I. Mariotti, I recenti interventi di restauro sulle pitture murali di Giotto e del Maestro di Figline nel transetto della basilica di Santa Croce, *OPD Restauro* 26, 2014, pp. 268–290. The previous course of the rays, which had connected the right hand of the seraph with the right hand of Francis and the left hand with the left hand, was probably a product of the 1957 restoration. Findings suggesting this intervention do not seem to have existed. Cf. U. Procacci, Relazione dei lavori eseguiti agli affreschi di Giotto nelle capelle Bardi e Peruzzi in S. Croce, *Rivista d'Arte* 19, 1937, pp. 377–389, esp. 386. Nonetheless, this course of the rays served as the basis for far-reaching interpretations. Cf. H. Belting, Franziskus: Der Körper als Bild, in: *Bild und Körper im Mittelalter*, ed. K. Marek et al., Munich 2006, pp. 21–36, esp. 34. Based on Frugoni, Belting wanted to read a profound transformation of the idea of the stigmata from the course of the rays as it was between 1957 and 2011.

the appearance of God or the devil) that offer only a few narrative motifs and yet make highly complex statements. Giotto's conciseness proves to be not only a performative but also an allegorical mode that can make other content present in the narrative. In the case of the picture in Santa Croce, this extra content is the message of the extraordinary importance of the stigmata, which far exceeds all previously known forms of sanctity.

Besides, the emblematic appearance of Giotto's painting certainly also has much to do with the conditions of its effect over a long distance. It would have been surprising if the experienced monumental painter, as well as the Bardi and the Franciscans, had not already had the church in its completed form in mind when they conceived the mural – even if it was clear to all involved that this situation was many decades away. This means that

Fig. 240: Medallion above the entrance arch of the Bardi chapel: Personification

a view of the image from a distance of up to 100 metres had to be expected. Another effect that was certainly calculated was how it would appear when seen from the lay area, above the rood screen that was to bear Cimabue's cross (fig. 137) and did so from about 1340. The fact that a wooden cross is visible behind the seraph in the fresco – unlike on the Louvre panel and the stigmatisation pictures in Assisi – makes it clear how Giotto worked towards a visual link with the triumphal cross. Three sets of stigmata – two painted by Giotto and one by Cimabue – should invite comparison and meditation on their interdependence.[669] In fact, the fresco is clearly legible from an astonishingly great distance – this is also a conceptual achievement and not simply the result of its enormous size (3.90 by 3.70 metres).

Below the picture in the spandrels are two six-foil medallions with heads. It would be better to say that there are simulated openings from which the busts of a young man (fig. 240) and a girl look almost imploringly into the church. Their halo and their nudity show that they are personifications, but the painter does not tell us what they stand for. Perhaps more important than the meaning was that they catch our eye and help make the stigmatisation image into an event.

669 K. Krüger, *Der frühe Bildkult des Franziskus in Italien: Gestalt- und Funktionswandel des Tafelbildes im 13. und 14. Jahrhundert*, Phil. Diss., Berlin 1992, p. 178. Krüger, however, assumes that the cross was hung in the choir.

THE ST. FRANCIS CHAPEL OF THE BARDI

If the visual hymn to the wounds is part of the initial decoration of the main space of Santa Croce and at the same time part of the programme of the Bardi Chapel, it is an important argument for the assumption that the latter was the first figuratively painted room in the church. Its preferential treatment makes sense because it is not merely one of many chapels, since its altar dedicated to St. Francis is almost a second high altar. According to the founding inscription of 1295, the church in its entirety is dedicated not only to the Holy Cross but also to the patron saint of the order.[670] Only the choir was a more distinguished place than the Bardi Chapel, but at the same time it was also a highly sensitive location. Handing it over in its entirety to a patron family could easily be perceived as a sell-out. In fact, the choir chapel was among the last to receive a patron family and, through Agnolo Gaddi, an appropriate fresco decoration. This happened at a time when figurative murals in this place must have seemed long overdue and the feeling of a need to catch up probably outweighed any other consideration.[671]

All in all, it is clear that the Chapel of St. Francis was the highest-ranking room that the friars could entrust without hesitation to a donor family and whose adorning, instructive and moving decoration with pictures could be realised in this way. At the same time, of the spiritual clients of the Florentine Franciscans, the Bardi were the neediest insofar as they were the wealthiest. Hardly anyone in Florence who had become worried by the phrase concerning the rich man, the camel and the eye of the needle, so virulent in the 13th and 14th centuries, was in greater need of doing good works, and none would have found it easier to finance them. The extent to which Bardi patronage in Santa Croce was linked to the prominent position of this family and to the hopes administered by the Franciscans can be seen, firstly, in the fact that not only money was given, but also sons. Around the year 1300, two Bardi are to be found in the otherwise not particularly noble convent: a Benedettus de Bardis and a Mattheus de Bardis.[672] Secondly, the peculiarity of the situation can be recognised by the fact that the church was far from the residences of the Bardi, which were located beyond the Ponte Rubaconte on the other bank of the Arno, while the Peruzzi, for example, belonged to the parish of the Franciscans and Santa Croce was the closest possible recipient of good works.[673]

670 *Santa Croce: La basilica, le cappelle, i chiostri, il museo*, ed. U. Baldini and B. Nardini, Florence 1983, p. 14.

671 N.M. Thompson, The Franciscans and the True Cross: The Decoration of the Cappella Maggiore of Santa Croce in Florence, *Gesta* 43, 2004, pp. 61–79

672 Lesnick, *Preaching in Medieval Florence*, p. 186.

673 J.C. Long, *Bardi Patronage at Santa Croce in Florence, c. 1320–1343*, Ph. D. Columbia University 1988, pp. 124–125.

The St. Francis Chapel of the Bardi

Presumably a Bardi had already given money for the new construction of the Franciscan church at an early stage – long before the foundation stone was laid (as is documented in the case of the Peruzzi), and presumably it had already been determined at that time which chapel was to be assigned to his family. Donato d'Arnoldo Peruzzi had linked his bequest to a temporal clause: within a period of ten years from 1292, the construction of the new church had to begin and the erection of the chapel had to be foreseeable (p. 510). This was to protect him from his money being undetectably absorbed in the building of the whole complex. Similar provisions may have been made with regard to the Bardi Chapel.

A chapel had several functions: From the Franciscan point of view, it served above all for the daily reading of the Mass by the priests of the order and for the cult of the chapel's patron, who in the case of the Bardi Chapel was a central figure in every respect. From the point of view of the founders, it served for the liturgical memoria for their souls, which would sooner or later stew in purgatory. This meant, on the one hand, memorial services by the Franciscans, and on the other hand, a place where the living family members could go to pray for the departed and have events that invited such prayers, e.g. the holding of meals for the poor (as documented from the time around 1600 for the Peruzzi Chapel). The fact that the chapel was located "behind" the rood screen in the completed church should not lead to confusion, because outside the times of the friars' services, the rood screen portals were certainly open to all church visitors. However, the male Bardi (the sight of whom did not seem likely to provoke lewd thoughts in the friars) certainly also visited their chapel during the services.

The founders desired that their graves and those of their relatives would be laid out in or near the family chapel. Since the crypt of Santa Croce runs under the Bardi Chapel, burials in the space itself were hardly feasible. Therefore, the dead Bardi were buried in front of the chapel in the transept. And here, according to the oldest surviving burial register of Santa Croce, the *Sepultuario* of 1439, rested a "Messer Ridolfo de' Bardi" while to the right of him were the "Fossa delle donne di detto Messer Ridolfo e suoi dicendenti".[674]

Ridolfo, called Doffo, was an important figure in the history of the family and the company. Active in business since 1298 at the latest (in Flanders and Naples, among other places), he was the head of the banking and merchant house from 1310, first together with his uncle Lapo, then after Lapo's death together with his uncle Gualterotto, and from 1331 alone. Under him, the Bardi Company experienced its peak and its collapse. The expansion into England pursued by Doffo involved the house in the English state bankruptcy

674 ASF, ms. 619, fol. 14v.–18r. Published in: D.S. Pines, *The Tomb Slabs of S. Croce: A New "Sepultuario"*, Ph. D. Columbia University 1985, pp. 624–631, esp. 626. Long, *Bardi Patronage at Santa Croce in Florence*, pp. 128–129 says that the sepultary names Ridolfo as patron. This is not quite correct.

Fig. 241: Bardi Chapel, north wall

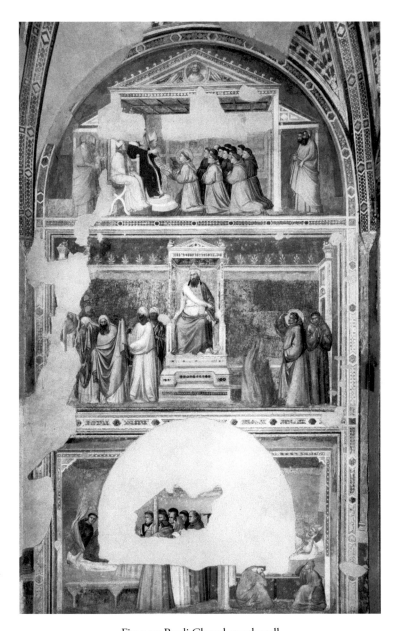

Fig. 242: Bardi Chapel, south wall

392 Giotto Autonomous: The Bardi Chapel and the Works of the Second Decade

and led to insolvency in 1346. He then tried to set up a new company in England. The last thing that is known about his life is that Doffo went before the notary in Westminster on 9 February 1357 and transferred the management of the new company to his son Pietro.[675] At that time he must have been very old. It can therefore be assumed that his death and burial in Santa Croce occurred not long afterwards.

Ridolfo's biography and the position of his tomb in front of the chapel make him the first choice as the person who had the family chapel decorated and thus acted as Giotto's contractor. (It was probably from the inscription on the tomb that Vasari concluded the same, and that is why he names Ridolfo as Giotto's patron in the second edition of his *Vite*: 2.1.10.) Returning from a long stay in England in the spring of 1318, Doffo was in the city in the years around 1320. Thus he may have made the arrangements with Giotto himself and was able to follow the progress of the work. Probably, however, Giotto and Doffo had less leeway in the planning of the murals than either Giotto and Scrovegni or, in the case of the Navicella, Giotto and Stefaneschi had had. For in Santa Croce there was a centralised interest that guided the decoration of the church in its entirety. This can be illustrated by reference to the picture above the chapel, which (in all likelihood) Doffo and his family paid for, but which described the spirituality of the convent and served the pastoral care of the church visitors. And the same is basically true of the pictures inside the chapel: due to the consecration of the altar to Francis, the programme of the paintings was predetermined in outline, and even in detail it had to create an image of the founder of the order and co-patron of the church that echoed the view of the friars. The delicate task of the patron and the painter was to make the interests of the founding family effective within this framework.

The six scenes in the Bardi Chapel (each about 450 centimetres wide and the four rectangular ones 280 centimetres high) are easy to decipher in terms of their respective significance for the Franciscans (fig. 241, 242). The upper one on the left wall shows the Renunciation of Worldly Goods and addresses a core competence of the Order with its commandment of poverty; opposite is the Approval of the Rule of the Order by Pope Innocent III (and – made present in the pediment relief – by St. Peter himself); the relevance of this act was denied by the fundamentalist Spiritual wing of the order, and was therefore of all the greater importance to the Conventuals of Santa Croce.[676] Underneath these images follow, on the left, the Apparition of Francis in Arles, which represents the ongoing presence of the Order's founder among the friars, and on the right, the Trial by Fire Before the Sultan in Cairo, an event that addresses the missionary activity of the

675 A. Sapori, *La crisi delle companie mercantili dei Bardi e dei Peruzzi*, Florence 1926, p. 86. A biography of Ridolfo de' Bardi has been drawn up by Jane Collins Long: Long, *Bardi patronage at Santa Croce in Florence*, pp. 130–131. The date of death given by her, 1360, could not be verified.

676 Goffen, *Spirituality in Conflict*, p. 69.

The St. Francis Chapel of the Bardi 393

Franciscans, as well as their preaching competence. The lower register is occupied by images dealing with the blessed death of Francis and the miracles that accompanied it and that proved the sanctity of the deceased. Below the trial by fire on the right wall, two scenes are combined in one picture field. Both events are reported by Bonaventure at the end of the fourteenth chapter of the *Legenda Maior* (6): On the right is the Dream of Bishop Guido of Assisi, who was on a pilgrimage at the time of Francis' death and to whom, far from Assisi, the saint appeared and – according to Bonaventure – took his farewell with the words: "Behold I leave the world and go to heaven."[677] A similar miracle is depicted in the same field to the left. Bonaventure relates the following:[678]

> *Moreover, a Brother named Augustine, who was then Minister of the Brethren in Terra di Lavoro [Campagna], an upright man, having come unto his last hour, and some time previously having lost his the power of speech, in the hearing of them that stood by did on a sudden cry out and say: "Tarry for me, Father, tarry for me, even now I am coming with thee!" When the Brethren asked and marvelled much unto whom he thus boldly spake, he made answer: "Did ye not see our Father, Francis, who goeth unto heaven?" And forthwith his holy soul, departing from the body, followed the most holy Father.*

Due to the installation of a wall tomb in the early 19th century, the picture field has been partially destroyed. Only the back of Augustine, who had sat up in bed, can still be seen. But we can see his words: a youthful Franciscan appears behind the bed curtain, stretching his head and looking out of the picture in deep surprise (fig. 243). Giotto wants to make clear to us here his emotional reaction to the sound of a voice that no one had expected to hear again.[679]

Damaged as it is, the scene with Brother Augustine nevertheless provides a clue that enables us to return to the dating problem. This clue is in the fresco island in the middle of the picture field that was undisturbed by the installation of the sarcophagus (vol. 3,

677 „Ecce, relinquo mundum et vado ad caelum." *Fontes Franciscani*, p. 904. Translation after: Bonaventura, *The Life of Saint Francis*, trans. E. Gurney Salyer, London 1904, p. 153.

678 "Minister quoque fratrum in Terra Laboris tunc erat frater Augustinus, vir utique sanctus et iustus, qui in hora ultima positus, cum diu iam pridem amisisset loquelam, audientibus qui astabant, subito clamavit et dixit: Exspecta me pater, exspecta, ecce iam venia tecum! Quaerentibus fratribus et admirantibus multum, cum sic loqueretur audacter, respondit: Nonne videtis patrem nostrum Franciscum, qui vadit ad caelum? Et statim sancta ipsius anima, migrans a carne, patrem est secuta sanctissimum." *Fontes Franciscani*, p. 904. Translation after: Bonaventura, *The Life of Saint Francis*, p. 153.

679 B.B. Walsh, A Note on Giotto' "Visions" of Brother Agostino and the Bishop of Assisi, Bardi Chapel, *The Art Bulletin* 62, 1980, pp. 20–24.

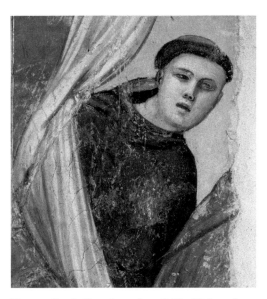

Fig. 243: Bardi Chapel, south wall: The Vision of Brother Augustine, detail

fig. 138). There we find a sequence of heads typical of Giotto's figure groups since the Arena Chapel: in the foreground is a profile (showing a Franciscan with hood), diagonally behind him and slightly overlapping is a half-profile (of a bald head), and behind this and almost concealed is another half-profile (with dark hair). Julian Gardner has observed that the same sequence of heads recurs in one of the two pictures of the Velluti Chapel, namely, in the last chapel towards the sacristy in the right transept.[680] It is a fresco decoration archaic enough to have already provoked an attribution to Cimabue.[681] The paintings are far behind Giotto's (and equally Cavallini's or Duccio's) standards of representational skill. Since Giotto's motif is used in one of the pictures, the murals must nevertheless be later than those of the Bardi Chapel or more or less contemporaneous with them. Anyone who places the Bardi Chapel in Giotto's late period, as is sometimes done,[682] must also date the Velluti frescoes to the late twenties or even the mid-thirties – and no one would do that. Even an assumed date of around 1320 makes the Velluti painter appear to be a Dugento fossil. There are good arguments that the Velluti Chapel served as an interim sacristy during the construction of the church; for this reason it seems to have received a painting in parallel with the Bardi Chapel in the first decoration campaign of Santa Croce – namely around 1320.[683]

Back to the programme of the Bardi Chapel: at the bottom on the left wall is the picture showing the confirmation of the stigmata on the body of the saint and at the same time the ascension of his soul (which, according to Bonaventure's *Legenda Maior*, had already

[680] J. Gardner, The Early Decoration of Santa Croce in Florence, *The Burlington Magazine* 113, 1971, pp. 391–393. See also: M.G. Zimmermann, *Giotto und die Kunst Italiens im Mittelalter I: Voraussetzung und erste Entwicklung von Giottos Kunst*, Leipzig 1899, p. 222.

[681] Thode, *Franz von Assisi und die Anfänge der Kunst der Renaissance in Italien*, p. 238.

[682] Borsook gives an overview of the dating decisions regarding the Bardi and Peruzzi chapels: E. Borsook, Giotto nelle Cappelle Bardi e Peruzzi, *Città di Vita* 21, 1966, 4, pp. 363–382, esp. note 11. Among the more recent authors who date the chapel to Giotto's late period are: F. Flores d'Arcais, *Giotto*, Milan 1995, p. 337 and A. Monciatti, *"E ridusse al moderno": Giotto gotico nel rinnovamento degli arti* (Uomini e mondi medievali 57), Spoleto 2018, pp. 259–260.

[683] Waldmann, *Vor Vasari*.

Fig. 244: Bardi Chapel, north wall: The Confirmation of the Stigmata

Fig. 245: Detail from fig. 244

happened) (fig. 244). This scene, which follows the stigmatisation in the legend, is also used to describe the saint's special position as the second Christ: it is presented here as both being notarial and divinely authenticated. At the same time, this scene, like the posthumous miracles at the bottom on the opposite wall, also had a relevance beyond the ideology of the order and could be read in terms of the interests of the Bardi. What could they hope for from a good work done in a Franciscan church, if not that their bier would one day be surrounded by praying and lamenting Franciscans (fig. 244, 245). And what greater thing could they expect than that at the hour of their death and wherever they were, Francis would in some way come to their side and accompany them on their way?

GIOTTO'S ST. FRANCIS CYCLE

The architecture of the Bardi Chapel and the other chapels in the transept of Santa Croce is simple: the spaces are narrow and high, almost like a chimney. Their walls are unarticulated; the polygonal ribs of the cross vault rest on corner consoles. Only the window with the columns on the jamb and the simple tracery shows architectural ambition. To this, Giotto added four painted columns in the corners of the Bardi Chapel, which incorporate the sculptural consoles of the vault as capitals. In this way he transferred the built architectural system of the Assisan Mary Magdalene Chapel to Florence.

The partly preserved tondi in the vault of the Bardi Chapel show Francis and allegories of the Order's virtues, repeating the programme in the crossing of the Lower Church in a condensed form (fig. 246, 247). On the altar wall, Giotto painted a Gothic trompe l'oeil architecture with niches between the painted corner columns and the window, in which representations of four saints were positioned (pl. XVI, fig. 248–250). This is again reminiscent of the Magdalen Chapel (fig. 202), but now the Gothic forms are far more sophisticated and the system as a whole is more complex. Giotto succeeded here in designing a Gothic façade that is not only respectable as long as it appears in the medium of painting, but would also be convincing as built architecture. Interestingly, Arnolfo di Cambio's Florentine cathedral façade did not play a significant role as a model; Giotto's design seems less additive and ultimately more French. The system is reminiscent of the inner west wall of Reims Cathedral, which is entirely made up of niches for figures.[684] In fact, the resemblance to French High Gothic architecture continues in the structure and the details. We will return to this. The images of the saints standing in the niches also appear more complex than in the Magdalen Chapel. This time they have appearances that oscillate between sculpture and liveliness. The pedestals and the compactness of their outlines suggest sculptures and thus lifeless images. Their colours and spontaneity of expression point to the presence of living people.

The best preserved is St. Clare, standing at the bottom on the Gospel side. With her head tilted and her mouth slightly open, she is the opposite of an inanimate image (fig. 249). Her attentive, serious gaze is not easily forgotten by anyone who once felt struck by it. In the storey above, in the best place of the four, stands the holy Franciscan prince and bishop Louis of Toulouse from the House of Anjou (fig. 250). His canonisation occurred in 1317 and thus in the period immediately before the painting. Presumably, his very prominent placement in the programme is a tribute to the recent recognition of his saintly status.[685] Who stood opposite him on the epistle side is unclear. (The restorers

684 W. Sauerländer, *Gotische Skulptur in Frankreich 1140–1270*, Munich 1970, p. 160.

685 Canon, *Spirituality in Conflict*, p. 55 with the comment that the date of canonisation is not in itself suitable as a *terminus post quem* for the frescoes.

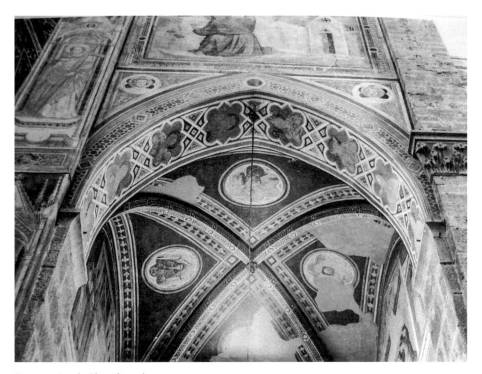

Fig. 246: Bardi Chapel, vault

Fig. 247: Bardi Chapel, vault, Allegory of Poverty

of the 1850s added a St. Louis of France, which was removed in the 1950s.) The counterpart of St. Clare is a poorly preserved figure of Elizabeth of Hungary.

On the side walls, Giotto stretched the frame system for the pictures between the painted corner columns; the horizontal and vertical elements consist of painted Cosmati friezes. This continues the pattern that the painter had developed for the Arena Chapel. The distinction between the three registers with a special treatment of the upper one can also be observed in the Arena Chapel: the arches of the lunettes are decorated with foliage, unlike the Cosmatesque architectural elements below. On the two lower levels, a

Fig. 248: Bardi Chapel, altar wall: St. Clare

triple frame with a red band is inserted into the architectural framework; in the arched fields of the upper register, we find a narrow uncoloured strip instead. This means that the pictures there are somewhat less detached from the viewer's world than the ones below.

Those who assume that the 28-part Legend of St. Francis in the upper church of Assisi was authoritative for many other St. Francis cycles, including the seven murals of the Bardi Chapel, must refer to the first picture of the Bardi cycle (left wall, top) and the fifth in Assisi (fig. 251, 252). The Renunciation of Worldly Goods is depicted both times with the same arrangement of the figures, which can be traced back to the St. Francis cycle of the lower church of San Francesco, i.e. to the middle of the 13th century (fig. 54). Five motifs speak for a direct connection with the St. Francis cycle in the upper church: Bernardone's yellow robe, his posture including the way he holds his son's clothes over his left forearm, the bishop's blue-grey cloak, the saint's folded hands raised to heaven, and the presence of two children. These are elements that Giotto took from the mural in Assisi's upper church.

But he also changed many of the things developed by the painters of the sculptor-cantiere in order to affirm and emotionally heighten the event: instead of two stacks of buildings doubling the opposing groups of figures, there is a large centrally placed palace whose spatial positioning and projection emphasises the figure of Francis and at the same time transforms the viewer into someone standing below and looking up; the result is that the Bishop Francis group virtually leans towards us. Bernardone, whose behaviour in Assisi was once characterised as "impatient",[686] becomes in Giotto's work a truly frenzied man whom the bystanders have to restrain. The bishop does not put the cloak around Francis' waist, but wraps him with it. And Giotto turns the children into naughty stone-throw-

686 G. Pochat, *Bild – Zeit: Zeitgestalt und Erzählstruktur in der bildenden Kunst von den Anfängen bis zur frühen Neuzeit*, Vienna 1996, p. 227.

 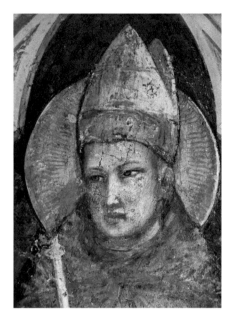

Fig. 249: Bardi Chapel, altar wall: St. Clare, detail

Fig. 250: Bardi Chapel, altar wall: St. Louis of Toulouse, detail

ing boys. For these two figures there is another source in Assisi, in Stefano's allegory of poverty in the lower church (vol. 3 pp. 74–75). Just as interesting as the question of their source, however, is that of the function in the narration of the picture: the stone-throwers are corrected in a similar way to Bernardone. Thus, the sight of them invites us to comment on his misbehaviour. Similarly, the people simply standing around behind the bishop in the mural of the upper church become a differentiated group; a canon dressed in red catches the viewer's attention, obviously disapproving of his superior's behaviour. Overall, Giotto's version is not only more vivid than the Assisian one, but is characterised by the fact that everything that happens is controversial.

James H. Stubblebine has declared the mural in Assisi to be a variant of Giotto's invention for the Bardi Chapel[687] – a weak variant, one would have to add, in order to make a plausible version of this argument. In reality, it is more likely that its painter, whom Giotto presumably knew and who had probably been trained by him had already worked on an old pictorial pattern in his spirit. Giotto took up this thread, achieving an even greater intensity of narrative.

687 J.H. Stubblebine, *Assisi and the Rise of Vernacular Art*, New York 1985, p. 23.

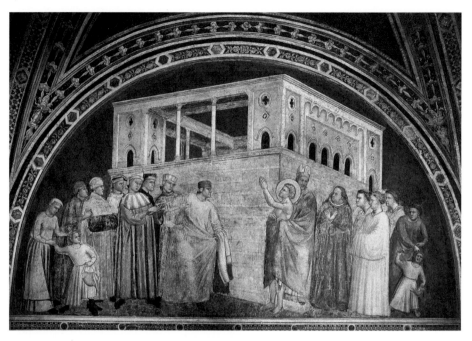

Fig. 251: Bardi Chapel, north wall: The Renunciation of Worldly Goods

Fig. 252: Assisi, upper church, lower north wall: The Renunciation of Worldly Goods (campaign 1)

For the second scene (right wall, top – fig. 253, 254) Giotto could reuse a design of his own that had been included by the painters of the first campaign as the seventh image in the Assisan Francis cycle, namely the Confirmation of the Rule from the Pisan St. Francis Panel (pl. XV, fig. 228, 229). In doing so, however, the painter changed so much that little remained of the model: the papal court was reduced in size and the two groups – the Curia and the Franciscans – were set against each other in profile. This creates a dialogue at eye level between Innocent III and Francis – unlike on the panel, where Francis appears submissive,

Fig. 253: Bardi Chapel, south wall: The Approval of the Rule

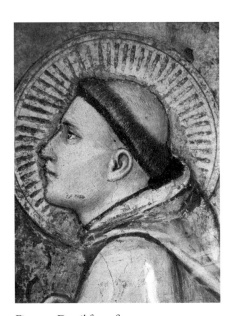

Fig. 254: Detail from fig. 253

and also unlike in the fresco in Assisi. There things look very formal – because of the old model from the clerestory, which was used for the group of Franciscans. The ceiling of the hall, which is clearly seen from below, connects the scene in Santa Croce to the world of the viewer and here too creates the impression that the protagonists are leaning towards us.

All the other pictures seem to be inventions made especially for Doffo Bardi's commission. This can be verified in the third picture of the cycle, the Trial by Fire before the Sultan (right wall, centre): First, the composition has nothing in common with the painting of the same subject in Assisi, not even in its basic layout; secondly, the narrative has highly original features,

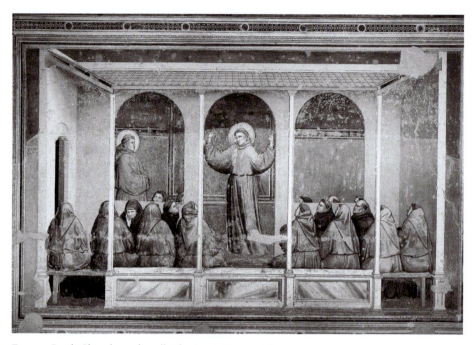

Fig. 255: Bardi Chapel, north wall: The Apparition at Arles

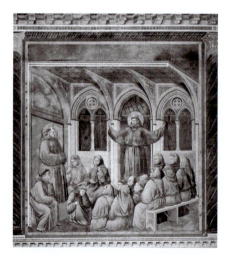

Fig. 256: Assisi, upper church, lower south wall: The Apparition at Arles (campaign 2)

to which I will return. They modify Bonaventura's text in a surprising and certainly not universally understandable way. In the fourth image, the depiction of the Apparition in Arles (left wall, centre), one might again consider a relation to Assisi possible (fig. 255, 256). But in fact there are no points of contact that could not be explained first by the fact that the same text was used, and secondly by the obvious idea that on the occasion of a sermon the preacher stands, while the listeners sit. It can even be shown that in Florence and Assisi Bonaventura's text was understood differently (*Legenda Maior* IV, 10): while Anthony was preaching, Brother Monaldus saw St. Francis "uplifted in the air, his hands outstretched after the manner of

a cross, blessing the Brethren", and he perceived this while he was "looking, by a divine impulse, towards the door of the Chapter-house".[688]

The Monaldus of Assisi is sitting with the others in the chapter house. He looks at the door, and in the opening of this door, which leads out of the chapter house and into the cloister, the painter presents Francis to us. In the Bardi mural, Giotto has left open which one of the brothers is Monaldus. This is not a shortcoming, but rather brings the viewer of the picture into the Monaldus role. We identify with those brothers who sit and look up in the front layer of the space, which is clearly described as wing of the cloister. Thus, in this picture, Francis appears in a door leading from the cloister into the chapter house. On one occasion then "ostium capituli" was read as the door *to* the chapter house, and on the other, as the door *from* the chapter house. This means that in one case Monaldus is in the chapter house and in the other – together with the viewers of the picture – he is in the cloister.

THE BARDI STYLE

Incidentally, it is only this immersion in narrative detail that makes it clear what a complex spatial structure the image of the Bardi Chapel reproduces in the simplest possible manner (fig. 255). The cloister is cut open in such a way that at first glance one sees an elegant hall in which the brothers are sitting. Only a second glance reveals the chapter house, to which the space opens with a door and two windows. Everything seems to be set up parallel to the picture plane, so that the floating Francis, in an uncontested central position, appears to the brothers as well as to us, overcoming the depth of the space. On closer inspection, however, the deeper the spatial layers behind the picture plane are imagined to be, the more they are shifted to the left (i.e. towards the entrance of the chapel): the openings of the chapter house are shifted in relation to the pillars of the cloister, as is the wall structure of the hall in relation to the openings. Like the boxes in the pictures of the Arena Chapel, this architecture is set on a brown-blue passe-partout, which is visible on the right. But the depicted structure with its three architecturally marked layers appears at the same time richer and clearer than what we know from Padua. Creighton Gilbert saw the painter taking a decisive step towards perspective precisely here.[689] In any

688 "… quidam frater probatae virtutis, Monaldus nomine, ad ostium capituli divina commonitione respiciens, vidit corporeis oculis beatum Franciscum in aere sublevatum, extensis velut in cruce manibus, benedicentem fratres." *Fontes Franciscani*, p. 811. Translation after: Bonaventura, *The Life of Saint Francis*, p. 42.

689 C. Gilbert, Florentine Painters and the Origins of Modern Science, in: *Arte in Europa: Scritti di Storia dell'Arte in onore di Edoardo Arslan*, Milan 1966, pp. 333–340, esp. 336.

case, Giotto presents us with a masterpiece in the depiction of painted space developed in the service of narrative, without drawing attention to his invention. Rather, he hides the complexity of the concept behind a composition that is easily readable due to its extended width.

However, there is also something ambiguous about the picture: if the composition seems to suggest a frontal viewer position and a segregated pictorial space, the shifting of the layers situated one behind the other points to a viewer standing on the left. The latter also applies to the asymmetrically projected palace monolith in the fresco above, which requires a viewer not only standing below it, but also positioned to the side (Renunciation of Worldly Goods – fig. 251). In the picture opposite this one, which shows the Approval of the Rule, it is the reverse. Here the viewer is at the bottom right (fig. 253). All three murals mentioned are thus carefully but noticeably attuned to being seen from the transept. And the same applies to the other three, except that the shifts in the motifs there are even more discreet, right down to the entirely inconspicuous but nevertheless perception-influencing deviation of the vanishing lines in the Throne of the Sultan of Cairo (fig. 259). It was John White who first pointed out this peculiarity of the Bardi frescoes in 1957.[690]

Similar effects are encountered in Padua, for example on the choir arch. I am referring to the oriels of the Annunciation scene projecting into the viewer's space and the *arcosolia* open to the viewer's space (pl. II). As we have learned, the Last Judgment scene (fig. 7) is also connected to the world of the viewer, albeit in a somewhat undecided form. However, nothing of this is to be found among the pictures on the Paduan side walls. For this very reason, Theodor Hetzer and others have argued that they are pictures almost in the modern sense: small framed worlds that are self-sufficient and create a viewer themselves. This sets them apart from the pictoriality of the early Giotto, which insists on the presence of the pictorial objects.

In the Bardi Chapel, however, the artist does not strive to return to this kind of the physical presence of the depicted objects and figures. This is shown by the nonchalant manner of painting, which is stingy with details (e.g. hands) and effects and represents the opposite of the painting style of the early Giotto.[691] Among the secondary figures there are faces that the painter has only sketched with a few brushstrokes – such as the two Franciscans kneeling at the feet of the laid-out saint in the Confirmation of the Stigmata to the

690 J. White, *The Birth and Rebirth of Pictorial Space*, London 1957, p. 72. However, it is not true that this is a continuation of phenomena that are typical of the scenes in the Arena Chapel.

691 Cf. E. Borsook, The recovery of the Santa Croce Murals, *Portfolio and Art News Annual* 4, 1961, pp. 55, 57, 156–158, esp. 156: "The project appears to have been undertaken with great sureness but in considerable haste."

 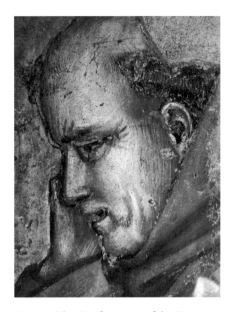

Fig. 257: The Confirmation of the Stigmata, detail from fig. 244

Fig. 258: The Confirmation of the Stigmata, detail from fig. 244

lower left (fig. 257). Despite all the economy of the painting, the spatial projection of the heads is perfect. More precisely: it is the mastery of spatiality that makes such a reduction of elaboration possible. Without noticing, the viewer's gaze glides to the more elaborate and expressive physiognomies.

Certain garments are very vividly worked out and really draw the eye, including the dramatically folded yellow robe of an imam in the picture of the Proof of Fire (fig. 259). Here a haptic effect is performed. Right next to it there is an analogous drapery, which is only hinted at with a few purple brushstrokes. It was painted over al secco and must originally have been just as haptic as the yellow robe. Sometimes, however, robes are only formed with a simple sequence of vertical lines of shadow and light, which hardly create any plasticity. The mantle of the man holding Bernardone back is noteworthy in this respect (fig. 251). This selective presentation of plasticity stands out from the elaborate draperies of the young Giotto as well as from the robed figures in the Arena Chapel, which were modelled with uniform care.

That physical presence is not the central ambition of the imagery is also shown by the restrained colouring dominated by grey-brown, which is not to be found in any other Giotto work. One might describe it as a Franciscan colouring, In the Bardi murals, a world of its own emerges, partly painted in an emphatically improvised manner and predominantly coloured in various shades of white, grey and brown. There are faces in it that

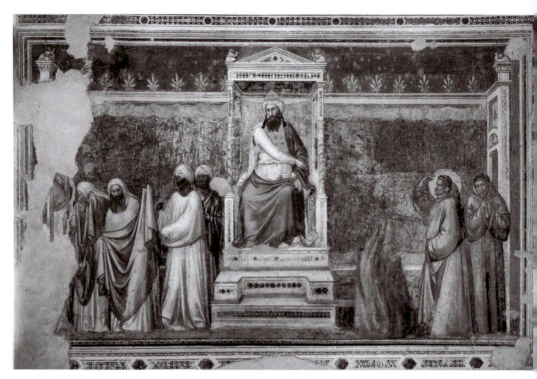

Fig. 259: Bardi Chapel, south wall: The Proof of Fire

speak to us directly, despite the simplicity of their representation: I have already referred to St. Clare on the altar wall (fig. 249). Other examples are: the young Franciscan listening open-mouthed to the words of the brother Augustine (fig. 243); Francis in profile looking at the Pope with unreserved trust (fig. 254); the brother kneeling behind the bier of the dead Francis and looking into his face, weeping (fig. 245), and in the same picture field the brother standing at the foot of the bier – grief has transformed his face into a landscape of wrinkles (fig. 258).

The pictorial concept of the Bardi Chapel can be described thus: what appears in the pictures is not intended to become present in our reality (as in the early Giotto), nor is it intended to be a closed reality which we encounter, which we consciously decide to perceive and into which we empathise with from a distance (as in the Arena Chapel), but rather to show a form of pictorial world which opens up to the viewer. The lighting contributes a lot to this: In the scenes on the right wall, the light comes consistently from the left, in those on the left wall from the right. In this way, Giotto took up certain experiments in the Arena Chapel and gave them a new direction. In Padua, the painted western light (e.g. in the Birth of the Virgin) does not connect the pictorial objects to reality. This

interior is dominated by the real southern light from the windows facing the Eremitani. The Florentine chapel, however, is really lit by the large east window, if not exclusively then at least primarily. Pictorial light and real light seem to relate to each other, just as pictorial space and real space seem to. The images' emotional immediacy also entails an opening of the pictorial world. Likewise, the differences in elaboration, which guide the viewer's gaze and direct our attention to particularly meaningful passages in the pictures, fit in with this. It has always been the case that painters have worked on the important parts of their pictures more carefully than on the unimportant ones. In Giotto's Bardi murals, this creates a dramaturgy.

CAIRO IN FLORENCE

> *With such firmness of mind, with such courage of soul, and with such fervour of spirit he preached unto the Soldan aforesaid God Three and One and the Saviour of all, Jesus Christ, that in him was manifestly and truly fulfilled that saying of the Gospel: "I will give you a mouth and wisdom, which all your adversaries shall not be able to gainsay nor resist." For, as the Soldan beheld the marvellous fervour of spirit and valour of the man of God, he heard him gladly and did right earnestly invite him to tarry with him. Then the servant of Christ, taught by the heavenly counsel, said: "If thou, together with thy people, wilt be converted unto Christ, for the love of Him I will right gladly tarry among you. But if thou art hesitating whether to give up the law of Mahomet for the faith of Christ, do thou command that a great fire be kindled and I will enter the fire with thy priests, that even thus thou mayest learn which faith is the surer, and holier, and most worthy of being held. Unto whom the Soldan made answer: "I do not believe that any of my priests would be ready to expose himself unto the fire in defence of his faith, or to undergo any sort of torture." For he had seen that, so soon as mention of this was made, one of his priests, an aged man and one in authority, had fled from his presence.*

In this passage of his *Legenda maior* (IX, 8), Bonaventure describes Francis' attempt to end up as a missionary and martyr in Babylon (i.e. Old Cairo) in 1219.[692] From his report, the

692 "Tanta vero mentis constantia, tanta virtute animi tantoque ferovere spiritus praedicto Soldano praedicavit Deum trinum et unum et Salvatorem omnium Iesum Christum, ut evangelicum illud in ipso claresceret veraciter esse completum: Ego dado vobis os et sapientiam, cui non poterunt resistere et contradicere omnes adversarii vestri. Nam et Soldanus admirandum in viro Dei ferovem spiritus conspiciens et virtutem, libenter ipsum audiebat et ad moram contrahendam cum eo instantibus invitabat. Christi vero servus superno illus-

Fig. 260: Assisi, upper church, lower north wall: The Proof of Fire (campaign 1)

following elements are easily found in the fresco (fig. 259): the enthusiasm of the preacher, which can be read in the emphatic gesture of the raised arm and the speaking hand, and which contrasts effectively with the silent and, it seems, somewhat despondent praying of his companion, brother Illuminatus;[693] the positive image of the Sultan, "a perfect gentleman and king" (John Ruskin)[694] on a beautiful throne, which could be a product of the Roman Cosmati workshops and would be worthy of a pope; and, finally, the priest who, followed by two colleagues, disappears through a door on the left edge of the picture. The two seek to conceal themselves with their robes, one from the gaze of the Sultan, the other from the sight of a charismatic orator threatening them with a trial by fire. The conspicuous and so carefully painted yellow cloak plays a major role in the scene and stands for disbelief and betrayal. What Giotto has changed from the text is that there really is a fire. This is consistent with the analogous scene in the Assisian St. Francis cycle and may have been inspired by it (fig. 260). However, Giotto's fire is a rather unreal specimen. This is reflected in the fact that its flames, like the robes of the figures, are modelled with light and shadow. In its compactness, it resembles the fires in

 tratus oraculo: ‚Si vis', inquit, ‚converti tu cum populo tuo ad Christum, ob ipsius amorem vobiscum libentissime commorabor. Quodsi haesitas propter fidem Christi legem Mahumeti dimittere, iube ignem accendi permaximum, et ego cum sacerdotibus tuis ignem ingrediar, ut vel sic cognoscas, quae fides certior et sanctior non immerito tenenda sit'. Ad quem Soldanus: ‚Non credo, quod aliquis de sacerdotibus meis se vellet igni propter fidem suam defensendam exponere, vel genus aliquod subire tormenti'. Viderat enim, statim quemdam de presbyteris suis, virum autheticam et longaevum, hoc audito verbo, de suis conspectibus aufugisse." *Fontes Franciscani*, S. 860 f. Translation after: Bonaventura, *The Life of Saint Francis*, pp. 101–102.

693 Sometimes Francis' gesture is read as a shadowing of the eyes, as in Prinz, *Die Storia oder die Kunst des Erzählens*, p. 109 ("aposkopein"). The orientation of the hand and the active position of the fingers, however, point to a speech gesture. How Giotto paints a shadowing of the eyes can be checked on the central pediment from the Baroncelli altar (fig. 292).

694 J. Ruskin, *Mornings in Florence Being Simple Studies of Christian Art For English Travellers*, New York 1903, p. 55.

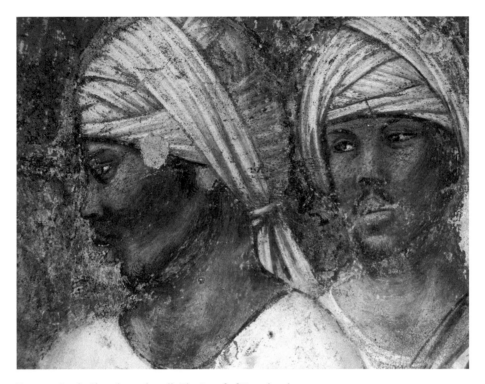

Fig. 261: Bardi Chapel, south wall: The Proof of Fire, detail

the allegory cycle of the Arena Chapel (Invidia, Infidelitas, figs. 87, 88). There, as is known, we are not dealing with luminous real flames, but with flames as made by a sculptor in coloured marble, which Giotto then reproduced in painting (at least that is the fiction behind this form of representation). So, the question is whether the fire in the Bardis' Proof of Fire is deliberately made unreal in order to be recognisable as only ideally present.

Overall, the effort to authentically transpose Bonaventura's text is unmistakable, and this also applies to the basically open atmosphere of the painting, which makes everything accessible to our gaze. We can see that there is nothing that can threaten the saint. As in the text, so in the picture there is no thought of the longed-for martyrdom. Compare the dramatic situation in the Assisi mural, where Francis stands abandoned in the centre of the picture and behind the Sultan's throne are armed men whose actions seem unpredictable. For this reason, too, the two Africans to the right of the Sultan's throne in the Florentine picture deserve special attention (fig. 261). They do not appear in Bonaventure's text (nor in the many attempts to describe Giotto's fresco that are fixated on Bonaventure[695]), and

695 E.g. Goffen, *Spirituality in Conflict*, p. 73.

yet they must fit into the narrative in a meaningful way. Who are they, what do they do?[696] First of all, it is noticeable that they are strikingly different from the two Africans that Giotto had painted up to that point (as far as we know). Bulbous nose, upturned red lips, tufts of frizzy hair: a cliché underlies both the physiognomy in the Arena Chapel (in the Flagellation of Christ – fig. 49) and that in the Magdalen Chapel (in the Raising of Lazarus – fig. 205). While Wolfram Prinz assumed that the head in the Arena Chapel was the portrait of a man living in Padua or Florence,[697] it is obvious to me that the painter need not have seen a person of colour to develop these profiles. The form of the nose and the tufts of frizzy hair as marks of servants who are foreign and certainly thought of as dark-skinned can already be found in the Adoration of the Magi on Nicola Pisano's pulpit in Siena.[698] In contrast, such considerations do not apply to the figures in the Bardi Chapel. The appearance of the two Africans there ignores the cliché:[699] The faces are narrow, the noses well-shaped, only the lower lip is prominent, an artfully shaved thin moustache adorns the rather short upper lip. Nothing can be seen of the hair because of the turbans. The two figures appear in no way diminished. Rather, the slender men in their wide robes, standing conspicuously upright, appear at least as distinguished as they are foreign.

Their proximity to the throne links them to the Sultan. Like the Sultan, they look angrily at the imams; the one in front accelerates their retreat by pushing. His pointing gesture is striking. The black finger, which stands out precisely against the white tunic, is directed at Francis across the imaginary fire. While the Sultan, pointing into the fire, speaks in conformity with Bonaventure's text about the Imams shying away from the test of fire, Giotto has entrusted it to the African to speak about the readiness of St Francis. In Bonaventure's narrative, the Sultan is the second positive figure alongside Francis. In Giotto's narrative, however, the black servants or bodyguards compete with the Sultan in this role. They are brought to the foreground by the painter in a manner reminiscent of how he placed a saintly decurion, invented by him, next to the canonical saintly centurion in the crucifixion scene of the Arena Chapel. However, the role of the Africans is even more in need of explanation than that of the decurion, who fits seamlessly into the narrative.

In the imagination of Giotto and his patrons, we are confronted with black Africans serving at the Cairo court, who understand the preaching of St. Francis and agree with

696 Further evidence at: M.V. Schwarz, Ephesos in der Peruzzi-, Kairo in der Bardi-Kapelle, *Römisches Jahrbuch der Bibliotheca Hertziana* 27/28, 1991/92, pp. 25–57, esp. 46–52.

697 Prinz, *Die Storia oder die Kunst des Erzählens*, p. 559.

698 P.H.D. Kaplan, *The Rise of the Black Magus in Western Art*, Ph. D. Ann Arbor 1983, pp. 7–11.

699 It was Johan Jakob Tikkanen who drew attention to the special position of the two figures in Giotto's oeuvre: J.J. Tikkanen, *Der malerische Styl Giotto's: Versuch einer Charakteristik desselben*, Helsinki 1884, p. 23.

it. The position and actions of the two men become comprehensible as soon as we assume that they are Christians. Moreover, such an idea would have corresponded to reality. Black Africans in Egypt in the 13th and 14th centuries were probably not Muslims but monophysite Christians, either Ethiopians or Nubians. Northern Nubia was a kind of Egyptian colony from the late 13th century onwards, and numerous Nubian slaves and servants were living in the cities of the lower Nile.[700] Since monophysite (unlike Catholic) Christians were under the protection of the Sultan, the Nubians could maintain a church in Cairo which was dedicated to St Martin. We know this because in 1346 the Franciscan Niccolò di Poggibonsi was allowed to hold mass there on his way to the Holy Land and reported on it in his *Libro d'Oltramare*.[701] The situation depicted by Giotto thus proves to be surprisingly well-founded historically.

Looking into the question of who in Florence could possess such information, it can be mentioned that Doffo Bardi's company traded in Egypt. The *Practica della Mercatura* of his employee Francesco Balducci Pegolotti informs us about this. Written down around 1340 and based on a wealth of knowledge acquired over decades of service to the Bardi, the book can be characterised as a "guide to commercial geography" (Eduard Friedmann).[702] In Alexandria, we read, the Bardi agents bought pepper and silk as well as rare drugs. They sold oil, amber, furs, woollen cloth and other things.[703] The question is not whether Doffo – either from his own experience or through his employees – could be informed about the Christian population of Egypt, but whether it was permissible for a merchant to boast of such knowledge. Since 1291, when the army of the Sultan of Cairo captured Acre and thus ended the history of the Crusader states in Palestine, Egypt was considered the mortal enemy of Christianity, and the Curia tried to enforce a trade embargo. This did not really succeed. But the Venetians at least refrained from trading in Egypt between 1323 and 1344.[704] To address the visitors of Santa Croce with knowledge about the internal situation in Egypt could therefore not really be in the interest of a founding family that wanted to do a good work against the sins associated with the acquisition of money in Egypt and elsewhere.

700 Y. Beshir Imam, *Die Einwirkungen der mamelukischen Beziehungen zu Nubien und Begaland auf die historische Entwicklung dieser Gebiete*. Phil. Diss. Hamburg 1971, pp. 66–67.

701 G. Golubovich, *Bibliotheca Bio-Bibliographica della Terra Santa e dell'Oriente Francescano*, 5 vols. Quaracchi 1906–1927, vol. 5 p. 13. J. Cuoq, *Islamisation de la Nubie chrétienne*, Paris 1986, p. 86.

702 E. Friedmann, *Der mittelalterliche Welthandel von Florenz in seiner geographischen Ausdehnung (nach der Practica della Mercatura)*. Abhandlungen der K.K. Geographischen Gesellschaft in Wien X, 1, Vienna 1912.

703 Francesco Balducci Pegolotti, *La practica della mercatura*, ed. A. Evans, Cambridge, Ma. 1936, pp. 69–76.

704 A. Ashtor, *Levant Trade in the Later Middle Ages*, Princeton 1983, pp. 44–63.

For the Friars of Santa Croce, however, the situation was different. Francis' Egyptian adventure was followed by papal instructions for the Order to carry out missionary work in Africa, focusing on the countries south of Egypt. An ecclesiastical union was to place the Christians in Nubia and Ethiopia under the Pope's authority. At the same time, several attempts were made to found a Franciscan monastery in Damietta, the place where Francis had landed in the course of the Fifth Crusade. Finally, in 1307, a foundation succeeded in Alexandria.[705] It can therefore be assumed that it was generally welcomed when Franciscans were informed about Egypt and showed this knowledge. Nevertheless, I do not consider the founder's role to be meaningless in this context. Even if it was desirable to have the relevant knowledge within the Order, that does not entail that it was the case for friars of Santa Croce; nothing is known of Florentine Franciscans who were in Africa. And if it was better for the merchants not to display this knowledge openly, they could still feed it into a Franciscan-legitimised context.

Moreover, one must assume that Giotto saw at least one Nubian or Ethiopian face to face: the two men in the picture correspond too little to a physiognomic cliché and resemble too closely the real inhabitants of north-east Africa, to be pure inventions. Even the white turban can be localised. Such turbans are still part of the street scene in Sudan, i.e. in former Nubia. In 1321, an edict was issued in the North Nubian kingdom of Dongola forbidding Christians to wear white turbans,[706] which indicates that it was common or customary until then. And that Nubians came to Florence as servants of merchants travelling to Egypt is more plausible than that it happened in connection with the mission. Staff from distant lands were plentiful in the commercial metropolis of Florence. For the years between 1366 and 1397, the *Registro degli schiavi* has survived and lists over 250 people, the vast majority of whom are described as "Tartars". If the Nubian painted by Giotto had still been alive at that time, however, he would probably not have been named in this register, because if he was a baptised Christian, he could not have been a purchased slave.[707]

The lively local colour in the Proof of Fire is probably due not only to Giotto's skill but also to a symbiosis between the founding family and the Franciscans. Their interaction enabled an authentic and at the same time complex imagining of the event and brought it into the present in accordance with the appeals in the *Meditationes Vitae Christi*. It must have been Giotto, however, who guided this collaboration and transformed its results into paint.

705 Golubovich, *Bibliotheca Bio-Bibliographica della Terra Santa e dell'Oriente Francescano*, vol. 2 p. 141.

706 C.W. Wilson, On the Tribes of the Nile Valley, North of Khartum, *The Journal of the Anthropological Institute of Great Britain and Ireland* 17, 1888, pp. 3–25, esp. 5.

707 L. Olschki, Asiatic Exotism in Italian Art of the Early Renaissance, *The Art Bulletin* 26, 1944, pp. 95–106, esp. 104–105.

ROME: THE "CAPELLA" IN ST. PETER'S (1312/13)

Which works can have been created in the decade between the firmly dated Magdalen Chapel (1308) and the Bardi Chapel (c. 1318–20)? In the context of this question, a Florentine document of December 1313 is of interest (1.1.11). It makes it likely that Giotto maintained a residence in Rome shortly before this date, but after September 1312 (1.1.10), and thus worked there. Since we know that he carried out other commissions for Cardinal Stefaneschi and St. Peter's in addition to the Navicella, it seems obvious to link his recent stay in Rome with this patron. On the one hand, there is the so-called Stefaneschi Altarpiece in the Vatican Pinacoteca. However, in the case of an ensemble of panel paintings, it is doubtful that the production required a long stay at its place of destination. The panels could just as well have been painted in Florence. In addition, the narrative parts show reflections of Pietro Lorenzetti's forms of representation, which could only have been developed at the end of the second decade of the 14th century and in the context of Pietro's fresco cycle in the transept of the Assisan lower church (see below).

The other work that can be considered is a complex in St. Peter's mentioned several times in the sources: the paintings of the "Tribuna" (so called in the *Liber Anniversarium* of the Basilica and in Billi's *Libro*) or "Capella" (so called in Ghiberti). While the *Liber Anniversarium* does not name an artist, Ghiberti and the author of Billi's book believed that these murals were executed by Giotto (1.4.5; 2.1.4, 6).

But this cannot be proven. One reason is that the frescoes are lost. If the terms "tribuna" and "capella" refer to the apse of St. Peter's, as many art historians believe, the murals would have perished in 1592. At that time, the last remains of the old choir, preserved until then in a protective building on the construction site of New St. Peter, were demolished. In this case, however, the complete lack of documentation would be astonishing. The apse mosaic was drawn several times and has been handed down to us quite precisely. It would also be astonishing, given the double prominence – that of the artist and that of a place that was among the holiest in Christendom – that the images do not appear in any guidebook or record by a proud Florentine – except Vasari. He cites paintings by Giotto in this place, but his statements are contradictory: while in 1550 he only quotes Billi's libro and says that Giotto painted the "tribuna", the 1568 edition reports that Giotto left five scenes from the life of Christ in the "tribuna". This suggests that an inspection of the apse in its protective structure has taken place between the two versions. And the result of this visit was ambivalent. These paintings now also appear in Vasari's *vita* of Giotto's pupil Stefano, but in much greater detail and are described as being Stefano's works: in the main chapel of St. Peter's, where the altar of St. Peter stands, Stefano is said to have painted *al fresco* various scenes from the life of Christ between the apse windows ("fra le finestre che sono nella nichia

414 Giotto Autonomous: The Bardi Chapel and the Works of the Second Decade

grande").[708] And then a torrent of praise follows, culminating in the statement that Stefano had surpassed his teacher Giotto in *disegno* and in other things with these pictures. One probably reads the two passages from the *Vite* of 1568 correctly by imagining that Vasari, on his visit to the site, found recognisably later murals instead of the expected ones by Giotto. These he tried to integrate in his narrative by ascribing them at least to Giotto's *school*.

Perhaps a clue to the "Tribuna" frescoes is provided by two Giottesque heads of the same scale and impressive quality in a private collection in Assisi – one of the type of an apostle, the other with the clothing of a cleric. These are fragments of fresco painting which were subsequently united on a panel and heavily overpainted on this occasion (41 by 46 centimetres, fig. 262). The inscription on the back says that they originate from an interior wall of St. Peter's Church that was torn down in 1610.[709] The date hints at which part of the basilica they may come from: not from the apse, the transept or the choir-side part of the nave (components that had long since disappeared by then), but either from the stump of the nave which coexisted for a long time with Michelangelo's domed building, or from the atrium area, where the Navicella met its fate in the same year, 1610.[710] If the fresco that was disassembled at the time was really by Giotto, and if it was still in its original place, then Stefaneschi's Tribuna could have been located in the atrium or in the eastern nave of St. Peter's.

An inscription of the year 1543 provides a more reliable hint (2.8.3). As long as the eastern part of the old nave was in use, the marble slab was there – accompanying a fresco that had been transferred at great expense and then was lost in the early 17th century. It showed the Madonna and was painted – so the inscription says – by Giotto. According to Grimaldi's *Descrizione della Basilica Antica di S. Pietro in Vaticano*, it was located in an underground *confessio* belonging to the altar of St. Processus and St. Martinianus. This altar, together with the famous bronze figure of St. Peter, was situated under the organ loft erected by Alexander VI.[711] All these elements, organ, loft, statue, altar, came from the demolished western parts and annexes of St. Peter. The Madonna, too, must have been

708 Giorgio Vasari, *Le Vite de' più eccellenti pittori scultori e archittetori nelle redazioni den 1550 e 1568*, ed. R. Bettarini and P. Barocchi, Testo II, Florence 1967, p. 136.

709 V. Marinelli, Contributo alla conoscenza dell'ultimo Giotto, in: *Giotto e il suo tempo. Atti del congresso internazionale per la celebrazione del VII centenario della nascita di Giotto (Assisi – Padova – Firenze 1967)*, Rome 1971, pp. 383–399. A. De Marchi and S. Romano, Giotto e la basilica di San Pietro: Le "imagines collectae", in: *Giotto, l'Italia*. Exh. cat. ed. S. Romano and P. Petraroia, Milan 2015, pp. 132–139.

710 H. Bredekamp, *Sankt Peter in Rom und das Prinzip der produktiven Zerstörung*, Berlin 2000, pp. 102–103.

711 G. Grimaldi, *Descrizione della Basilica Antica di S. Pietro in Vaticano. Codice Barberino Latino 2733*, ed. R. Niggl, Vatican City 1972, p. 63: "Imago Deiparae Virginis, quae hodie sub fornice novi pavimenti asservatur in ambitu sacrae confessionis, est manu Iotti egregii pictoris."

salvaged from one of these parts of the old basilica, i.e. either from the transept and its annexes (the apse itself stood, as I said, even longer) or from the western part of the nave. The funder of the action was Nicola Acciaoli, a Florentine who lived in Rome. Vasari describes the technical problems in his *vita* of Perin del Vaga.[712] In the edition of 1568, he added that a (donor's) picture existed "in piedi di detta Madonna", which Perin documented with a drawing. It allegedly showed Orso dell'Anguillara, who had been a Roman senator since 1337 and whose name had a certain notoriety due to his participation in Petrarch's coronation as poet in 1341. This extension of the narrative is suspicious in itself. Moreover, only the very young Orso could have acted as a patron of the old Giotto, and in years when the painter's stay in Rome is neither proven nor probable. Presumably Perin del Vaga's sheet with the Trecento figure, which Vasari had in mind when he revised the *Vite*, had nothing to do with the Madonna. Instead, the two heads in Assisi could have belonged to the Madonna, so that 1610 would be the date of her second translocation and thus of her disappearance – a vague possibility, however. Reliable, in contrast, is the minimal information that the inscription plate communicates: even before Vasari's compilations led to the multiplication of (un)certainties about Giotto's oeuvre that are so hard to handle, there was mural painting to be seen in St. Peter's Basilica, which Giotto was considered the author of.

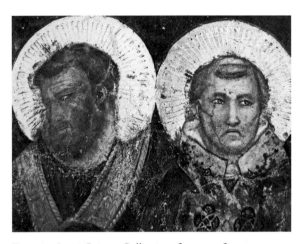

Fig. 262: Assisi, Private Collection: fragment from St. Peter's, Rome

If the Madonna was indeed Giotto's work and belonged to Cardinal Stefaneschi's commissions, then the "tribuna" or "capella" was not identical with the main apse, but was one of the many liturgical centres that had been established over centuries in the western area of the most important church in Christendom. The shortlist includes the Oratory of Santa Maria in Choro Canonicorum or Santa Maria de Cancellis, which was located in the nave immediately in front of the left pillar of the triumphal arch – not only because of its dedication to Mary, but also because it was the meeting place, the "choir",

712 Vasari, *Le Vite*, ed. Bettarini and Barocchi, vol. 5 p. 153. J. Weißenberger, *Römische Mariengnadenbilder 1473–1590: Neue Altäre für alte Bilder; zur Vorgeschichte der barocken Inszenierungen*, Phil. Diss. Heidelberg 2007, pp. 99–109.

416 Giotto Autonomous: The Bardi Chapel and the Works of the Second Decade

of the Chapter of St Peter's, to which Stefaneschi belonged.[713] As long as the church was complete, the painting could not be overlooked in its prominent place – that is, both in Ghiberti's time and at the time when the Libro di Antonio Billi was written. After the destruction of the western sections and after the central picture of the programme had been transferred to the nave in 1543, the assumed site of Giotto's decoration moved to the choir chapel of the basilica. This is the problem Vasari had to deal with before it was resolved through the demolitions in the final years of the Cinquecento.

THE CHOIR CHAPEL OF THE BADIA

The little that remains of the Badia frescoes may also belong to Giotto's activity of the second decade of the 14th century. Both Ghiberti and the author of the *Libro di Antonio Billi* (2.1.4, 6) say that Giotto executed the painting of the "capella maggiore" or "capella del altar maggiore" among other works in the Badia. In Florence, this was an extremely prestigious commission and it is a tragedy that the murals were treated so badly in the 17th century and so carelessly in the mid-20th century.

Unlike the Franciscans of Santa Croce, the Benedictines of the Badia did not have to rely on any benefactors if they wanted to rebuild their church and furnish it with images. Founded in 978, the abbey, the oldest and most noble monastery in the city, had accumulated extensive possessions in the centuries that had passed since then, and no commandment of poverty prevented the abbot and monks from demonstrating this. According to Giovanni Villani, the Gothic church, which replaced the 10th-century building, was begun in 1284. A total of four altar consecrations are recorded for the period between 1309 and 1314, including the consecration of the high altar by the Archbishop of Pisa on 5 April 1310 (Passion Sunday).[714] The choir chapel – trapezoidal instead of rectangular due to the difficult spatial conditions in the innermost city centre – was therefore probably completed

713 S. de Blaauw, *Cultus et decor: Liturgia e architettura nella Roma tardoantica e medievale*, 2 vols., Vatican City 1994, pp. 665–666 and passim. Cf. Chr. Smith and J.F. O'Connor, *Eyewitness to old St. Peter's: a study of Maffeo Vegio's "Remembering the ancient history of St. Peter's Basilica in Rome": with translation and a digital reconstruction of the church*, Cambridge 2019, p. 275 with considerations as to whether the canons' choir and the Marian chapel should be treated as one place or two places.

714 Paatz, *Die Kirchen von Florenz*, vol. 1 pp. 265, 297. E. Sestan, M. Adriani, and A. Guidotti, *La Badia Fiorentina*, Florence 1982, p. 61. K. Uetz, *La Badia di Firenze: Die Abteikirche von Florenz 969–1310*, Phil. Diss. Bamberg 2003, p. 165. F. Carrara and F. Facchinetti, *La Badia Fiorentina dalla Fondazione alla fine del Trecento*, ed. F. Zeuli, Florence 2018, pp. 73–105. The document for the consecration of the high altar is a charter of indulgence: A.S.F. Diplomatico, Badia Fiorentina, 5. April 1310.

The Choir Chapel of the Badia

in this year; presumably the whole church, which is not large, was already under a roof. It is not easy to find a reason that could have prompted the Benedictines to leave their choir chapel without a suitable decoration for a long period. Consequently, the years 1310–12, i.e. the years immediately before the Roman sojourn, are the most likely for Giotto's activity on behalf of the Benedictines. Giotto's contractor in this case was probably Abbot Azzone II († 1327), who may have already been in office in 1310 and later became involved when Giotto's son Bondone was to be given a benefice[715] (1.5.1). In terms of the development of Giotto's career, the paintings may have been important as the painter's first fresco decoration for a Florentine patron. Vasari's assertion that the Badia murals are "Giotto's first paintings" is vaguely related to this conclusion. That Vasari's statement is not based on facts has already been discussed (vol. 1, p. 28). The correspondence is therefore a coincidence.

Vasari saw Giotto's murals while they were still largely intact and described one picture in more detail. It showed

> *a Madonna of the Annunciation, in which he [Giotto] expressed the fear and dismay of the Virgin Mary at the greeting of the angel Gabriel so vividly that it almost seemed as if she wanted to flee from it in excessive terror.*

A fresco with a Mary of the Annunciation surrendering herself in a particularly dramatic form to her *conturbatio*, as required by the Gospel of Luke (1: 29), was uncovered in 1940 in the former choir, which was later downgraded to the right transept arm of the present church (fig. 263). The information provided by the conservator in charge, Ugo Procacci, about the original location of the fragment, which was removed in 1959, is less than precise.[716] However, if one combines Procacci's text with what can be found out about the position of another fragment, that shows a shepherd (see below), it becomes clear that the Annunciation was halfway up the altar wall and thus clearly visible in the centre of the cycle of images depicting the life of Mary, the patron saint of the church. Sadly, the figures are incomplete. Before the frescoes were whitewashed in 1627, the two heads had been cut out to save some of the painting praised by Vasari; however, the rescued pieces have been

715 S. Romano, La Badia Fiorentina: Il ciclo ad affresco, in: *Giotto, l'Italia*. Exh. cat. ed. S. Romano and P. Petraroia, Milan 2015, pp. 64–75, esp. 73.

716 Cf. *Omaggio a Giotto*. Exh. cat. ed P. Dal Poggetto, Florence 1967, pp. 12–14, esp. 14. Recently, doubts have been raised as to whether this fragment and the others treated here really come from the choir chapel and not from the right side chapel. F. Bandini, L. Cinelli, and C. Frosinini, Il restauro di tre affreschi strappati provenienti dalla Badia Fiorentina realizzati da Giotto e bottega tra il 1315 e il 1325, *OPD restauro* 27, 2016, pp. 174–186, esp. 186. However, this does not take into account that Vasari saw the Annunciation explicitly in the choir chapel.

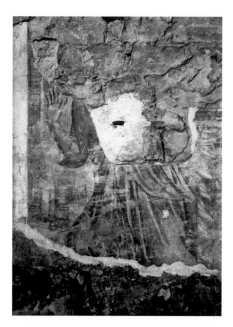

Fig. 263: Florence, Polo Museale Regionale della Toscana, fragment from the Badia: The Annunciation

Fig. 264: Detail from fig. 263

lost. What has survived is, among other things, Mary's hand raised in fright, which gives an impression of the height of the painterly quality (fig. 264). And despite the fragmentation, the unusual conception of the scene is also still recognisable. Surprising for Giotto is the complicatedly twisted figure of Mary – head and upper body turned towards Gabriel, right hand and lower body turned away from him. This posture, which attracts the viewer's attention through its contradictory nature, is reminiscent of the stigmatised Francis above the Bardi Chapel. The theme of Mary's *conturbatio* was not new in Florentine painting: the scene on the Madonna of Santa Maria Maggiore dates from the middle to late 13th century and is more restrained, but nevertheless convincing in terms of body language. Therefore, what was original in the Badia was, above all, the dramatic conception.

In addition, two other essential fragments were "saved". Some scholars want to understand Procacci's indications in such a way that the fragment of the lunette with the shepherd was located in the south corner of the east wall and thus belonged to the crowning image of the altar wall.[717] However, there is a photograph showing the piece still *in situ*, and here the blind arcade that has adorned the east wall since the 17th century is clearly visible on the right-hand side, which reveals that this picture occupied the uppermost

717 S. Romano, La Badia Fiorentina.

Fig. 265: Fragment from the Badia: a shepherd with animals *(in situ)*

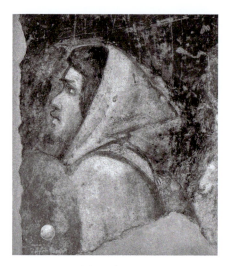

Fig. 266: Detail from fig. 265

Fig. 267: Fragment from the Badia: Presentation of the Virgin

zone of the north wall (fig. 265). In addition to the head of a shepherd, the fragment contains two of his animals. The artistic ambition is evident, among other features, in the depiction of the goat rearing up against a tree and eating buds. As André Chastel has shown, this is a motif that the painter probably adopted from ancient pastoral iconography.[718] Most commentators conclude from the man with the animals that the image told one of the stories that, according to the Gospel of James, occurred while Joachim was with his shepherds. These are rare pictorial themes that can best be explained as a reference back to the programme of the Arena Chapel. However, if we compare the fragment with the scenes in Padua (fig. 59, 74), it becomes clear that Giotto in no way reused any

718 A. Chastel, L'ardita capra, *Arte Veneta* 29, 1976, pp. 146–149.

The Choir Chapel of the Badia

of these compositions. Within the framework of a detailed Marian cycle, these themes nevertheless remain the most likely – perhaps in combination with Joachim's Expulsion from the Temple. Such a double image – Expulsion from the Temple and Annunciation to Joachim – is found in an analogous position in the Baroncelli Chapel painted by Giotto's pupil Taddeo Gaddi, and could be an echo of the Badia frescoes there.[719]

The shepherd is a secondary figure and yet his face is "of intense expression", as Edi Baccheschi's catalogue of Giotto's works puts it (fig. 266).[720] That Previtali and some other authors declare the head to be a pupil's work is hard to understand.[721] Apart from its expressive power, the swift, confident and open technique is striking. It is certainly closer to the painting style practised in the Bardi Chapel than to what we know from the Arena Chapel and the Mary Magdalene Chapel or even from the early Giotto. The same applies to the tonality of the skin, hair and hood.

According to Procacci below the shepherd fragment, a narrow fragment showing a powerfully staged façade and part of the frame system was found (fig. 267). On the frame strip at the top are four words of an inscription: "[C]LARA EX [S]TIRPE DAVIT". They belong to a Marian hymn that exists in different versions. One version ends with these words and reads like this: "Nativitas gloriosae virginis Mariae ex semine Abrahae, orta de tribu Iuda, clara ex stirpe David."[722] The inscription must have started at the west corner of the north wall and indicates that an image depicting the Virgin's birth was located there. What scene then did the following picture with the façade show, which, according to Procacci, was adjoined by the Annunciation on the east wall? Usually the Presentation of the Virgin is suggested, and the façade would then be that of the Temple in Jerusalem, whose stairs Mary is climbing. In this case, the figure with a halo standing near the right edge of the picture in front of the façade can be identified with Zacharias, the father of John the Baptist, although it is not necessarily clear from the apocryphal Gospel of James that Zacharias was present at this event. In Padua, Giotto and his advisors had interpreted the passage differently; no one with a halo appears among the priests. In Florence, on the other hand, which venerates John the Baptist as the city saint, the presence of his father was certainly welcome in the context of scenes from the Life of the Virgin.

719 A. Ladis, *Taddeo Gaddi: critical reappraisal and catalogue raisonné*, Columbia and London 1982, pp. 88–112.

720 G. Vigorelli and E. Baccheschi, *L'opera completa di Giotto*, Milan 1977, p. 97.

721 Previtali, *Giotto e la sua bottega*, pp. 330–331.

722 *Corpus Antiphonalium Officii*, ed. R.-J. Hesbert, 6 vols., Rome 1963–1979, vol. 3 p. 345. The antiphon edited by Hesbert (No. 3850) ends with "David", but there are also versions which add the final part of the hymn listed by Hesbert under No. 3849. See Global Chant Database: www.globalchant.org/text-index.php?letter=Nativitas-gloriosae-virginis.

422 Giotto Autonomous: The Bardi Chapel and the Works of the Second Decade

Those authors who consider the cycle of the upper church of San Francesco in Assisi to be Giotto's work compare the diagonally placed church façade behind this figure with the façade in the Farewell of the Poor Clares[723] (fig. 187). However, two differences between the buildings should be noted: firstly – and this has already been mentioned – the church in Assisi is an element of the narrative; the painter (a member of the colour-ist-cantiere) made a point of showing how the people move through the portals towards the bier. In this respect, the picture seems to be more developed than the Badia fragment. Secondly, the church façade in the Florentine fragment is a more complex structure. It is presented with a portico that creates a highly differentiated spatial structure behind Zacharias. In this respect, the Badia fragment is the more sophisticated creation. This multi-layered spatiality combined with the simplicity of the architecture, in which the Gothic formal language is only heard from afar, connects the fragment with the Bardi frescoes in San Croce.

Much of the specific qualities of the Badia murals remains hidden, leaving a regrettable gap in our idea of Giotto's development. The little that has survived, however, redeems the paintings of the Bardi Chapel from their isolated position: this applies to certain striking and complex patterns of movement, the improvised painting style and the multi-layered architectural representation. At the same time, the fragments show that the Bardi-like elements in Stefano's north transept frescoes of the Lower Church in Assisi do not necessarily go back to the Bardi frescoes themselves.

EL COMUNE COME ERA RUBATO (FLORENCE, BARGELLO)

"Inside the palace of the Podestà of Florence (Bargello), he painted the commune being robbed and the chapel of St. Mary Magdalene", writes Ghiberti, raising many problems with few words (2.1.4). The following is about the allegory of the plundered commonwealth; I will deal with the problems of the chapel in connection with Giotto's late works. The allegorical composition – certainly a mural – has not survived, but there are two written sources beyond Ghiberti that we can consult. The way to follow is shown by two studies that the literary scholar Salomone Morpurgo dedicated to his friend Igino Benvenuto Supino.[724] One source is Vasari's description (2.1.10 [p. 129]). It locates the painting in the

723 *Giotto: Bilancio critico di sessant'anni di studi e ricerche*. Exh. cat. ed. A. Tartuferi, Florence 2000, p. 132 (A. Tartuferi).

724 S. Morpurgo, *Un affresco perduto di Giotto nel Palazzo del Podestà di Firenze (Per le nozze di Igino Benvenuto Supino con Valentina Finzi)*, Florence 1897. S. Morpurgo, Bruto, "il buon giudice", nell'Udienza dell'Arte della Lana in Firenze, in: *Miscellanea di Storia dell'Arte in onore di Igino Benvenuto Supino*, Florence 1933, pp. 141–163.

"sala grande del podesta di Firenze", calls it by the title created or passed on by Ghiberti ("il comune rubato da molti") and then gets lost between motifs that could never have been suitable to allegorise a deprived commonwealth. In fact, Vasari is not writing about Giotto's fresco in the Bargello, but about a surviving mid-14th century mural in the Palazzo dell'Arte della Lana. It presents Brutus as a Roman consul and just judge and can be read as an allegory of justice. This source therefore leads nowhere. The other text is a sonnet that appears in early modern editions sometimes under the name of Dante, sometimes under the name of Antonio Pucci; today it is considered Pucci's work and a text from the middle to late 14th century. It laments the fate of a "commune" which the author sees before him (as an image?) while it is being ransacked:[725]

Fig. 268: Arezzo, Monument to Guido Tarlati: Il Comune Pelato (Agostino di Giovanni and Agnolo di Ventura)

Omè, Comun, come conciar ti veggio	*Alas, commune, how I see thee battered*
sì dagli oltramontan' sì da' vicini,	*by the strangers as well as the neighbours*
e maggiormente da' tuoi cittadini	*and worst of all by thy citizens,*
che ti dovrien tenere in alto seggio!	*who should appreciate thee!*
Chi più ti de' onorar quel ti fa peggio;	*They do not honour but treat thee all the worse;*
legge non v'ha che per te si declini:	*there is no law that is in thy favour:*
co' raffi, con la sega e con gli uncini	*with rasps, with the saw, and with hooks*
ognun s'ingegna di levarne scheggio.	*each one tries to cut off a piece for himself.*

725 The following text, prepared by Michaela Zöschg and Christian Opitz, uses the version consulted by Morpurgo as a basis, but also takes into account the critical edition by Giuseppe Corsi: *Rimatori del Trecento*, ed. G. Corsi, Turin 1969, pp. 820–821, cf. also pp. 793–795. Morpurgo also quotes a second Pucci sonnet, which, however, certainly did not refer to Giotto's mural but to another allegorical composition in the Palazzo Vecchio: cf. M.M. Donato, Immagini e iscrizioni nell'arte "politica" tra Tre e Quattrocento, in: *Visibile parlare. Le scritture esposte nei volgari italiani dal Medioevo al Rinascimento*. Atti del Convegno Internazionale di Studi, Cassino-Montecassino 1992, ed. C. Ciociola, Naples 1997, pp. 341–396, esp. 382–386. The wheel-of-life motif points to this. I would have missed this connection without the advice of Christian Opitz and Michaela Zöschg.

Capel non ti riman che ben ti voglia;	*Not a hair remains nor is granted to thee:*
chi ti to' la bacchetta e chi ti scalza,	*one takes away thy sceptre, another thy shoe,*
chi 'l vestimento stracciando ti spoglia.	*one will tear thy garment from thy body.*

Ogni lor pena sopra te rimbalza,	*Each of their punishments bounces back at thee,*
e niuno è che pensi di tuo doglia,	*and there is none to think of thy grief,*
o s' tu t'abassi quando sè rinalza;	*or whether thou wilt perish when he rises;*

ma ciascun si rincalza.	*but each one enriches himself.*
Molti governator per te si fanno	*Many make themselves masters through thee*
e finalmente son pure a tuo danno.	*and in the end they are only to thy damage.*

Ghiberti's title and these verses drew Morpurgo's attention to a relief on the tomb of Bishop Guido Tarlati in Arezzo Cathedral (fig. 268). This is one of the most elaborate and striking funerary monuments of the Trecento, designed, according to Vasari, by Giotto (2.1.10). It is signed by the sculptors Agostino di Giovanni and Agnolo di Ventura and dated 1330. The relief – the third in a series of sixteen – clearly stands out from the others in terms of conceptual quality. The basis of the composition is Giotto's Flagellation of Christ in the Arena Chapel (fig. 49), from which the variation of the motifs is carefully thought out. The relief bears an inscription that reads: IL COMUNE PELATO, recalling Ghiberti's wording. In the context of the cycle, the image has the task of allegorising the alleged crisis of the municipality of Arezzo, which Guido's takeover of the city's rule in 1321 is said to have put an end to. If the portrayal of the Comune rubato in the Florentine Bargello advertised republican virtues, the Comune pelato in Arezzo Cathedral justified the establishment of a tyranny.

In any case, the relief provides a visual source for the reconstruction of Giotto's mural. Likewise, the sculpted copy or variant provides a *terminus ante quem* for the painted original: Tarlati died in 1327 and after that the rule of his party and family in Arezzo disintegrated very rapidly. Under these circumstances, 1330 must be the date of completion of the gigantic monument; it could not have been realised later.[726] Accordingly, Giotto's fresco must have been painted before 1330. This describes – updated only in its details – the state of knowledge reached by Salomone Morpurgo by 1933.

726 R. Davidsohn, *Geschichte von Florenz*, 4 vols., Berlin 1896–1927, vol. 3 pp. 661–662. H. Wieruzowski, Art and the Commune in the Time of Dante, *Speculum: A Journal of Medieval Studies* 19, 1944, pp. 14–33, esp. 23–24. G. Pelham, Reconstructing the program of the tomb of Guido Tarlati, Bishop and Lord of Arezzo, in: *Art, Politics, and Civic Religian in Central Italy 1261–1352*, ed. J. Cannon and B. Williamson, Aldershot 2000, pp. 71–99.

Giotto's composition, however, has been copied or varied a second time (fig. 269). A lady enthroned, besieged from all sides, approached from the lower left by a particularly obtrusive small figure (and with this motif, too, the scene corresponds to the Comune pelato in Arezzo) – this is how *Constantia* is depicted in Francesco da Barberino's *Documenti d'Amore*. There are two illustrated manuscripts, one with painted and one with drawn pictures.[727] Fig. 269 shows Constantia in the edition with drawings, which was once considered Francesco's autograph and the model of the other codex (BAV Barb. lat. 4077, fol. 46r).

Admittedly, the *Comune* is a man and he is really being plundered: shoes, purse, clothes, sceptre, beard and hair, everything is snatched by the selfish citizens. In contrast, Francesco's *Constantia*

Fig. 269: Francesco da Barberino, Documenti d'Amore (Cod. Barb. Lat. 4077): Constantia (unknown artist)

is a woman and things are being brought to her, or, more correctly, she is partly being lured by them, and partly being threatened. But the arrangement of the figures around the enthroned character is similar, and in its consistency this composition stands out pleasantly from the others in Francesco's work, which mostly seem improvised. If his picture-making as such was inspired by Giotto's allegories (namely those in Padua), then he, or rather his draughtsman guided by him, adopted and adapted a concrete Giotto model for the Constantia. When Francesco returned home to Florence in 1314/15 and finally in 1317, he probably had in his luggage his book on love either finished, including a draft for the picture programme, or as a "work in progress". The illustrated fair copies, both kept in the Biblioteca Vaticana, are likely to have been produced not much later in Florence: as far as the style of the illustrations is concerned, despite their different authorship and technique – in one case they are coloured drawings, in the other opaque colour paintings – they both are based on Giotto's art, but do not fit in with what is known about Giottesque book illumination in Padua and Bologna. The fashion – wide sleeves,

727 Editions: Francesco da Barberino, *I Documenti d'Amore di Francesco da Barberino secondo i manoscritti originali*, ed. F. Egidi, 4 vols., Rome 1905–22 and Francesco da Barberino, *I Documenti d'Amore (Documenta Amoris)*, ed. M. Albertazzi, 2 vols., Lavis 2011.

high collars – points to the twenties in both cases. As early as 1319, at the latest, Stefano took up a motif from the *Documenti* illustrations in the figure of Cupid in the allegory of Castitas on the crossing vault of the Lower Church in Assisi (vol. 3 pp. 76–77). In 1320/21, a motif from the illustrations was also used in Florence. The subject here is the allegory of death on the tomb of the Florentine bishop Antonio degli Orsi, which was made by Tino da Camaino and to which the body was transferred on 18 July 1321.[728] There is much to suggest that the original version of the *Documenti d'Amore* illustrations was also created before 1319 – and this thus would give the *terminus ante quem* for Giotto's mural.

The third copy or variant of the Comune rubato can be confusing in this context. Again disturbed by a particularly intrusive approach from the lower left, a (female) *communitas* is enthroned on the south wall of the Paduan Salone, i.e. in the hall with Giotto's astrological representations on the wooden vault until the fire of 1420. The picture thus raises the question of whether the Salone's conglomerate of frescoes that exists today includes or reflects traces of Giotto's programme: should we assume that the Florentine Comune rubato was a duplicate of an invention for the Paduans that Francesco da Barberino saw during his stay in Padua before 1308, together with the allegories of the Arena Chapel?[729]

An inscription that apparently belonged to the painting but has disappeared is preserved in Hartmann Schedel's notes, made in Padua in 1466 (Munich, Bayerische Staatsbibliothek, cod. 418, fol. 131r-v):

> Dicit commune seu communitas:
> Sic me dilacerat, sic me omne genus cruentat.
> Heu nulla hos pietas, nulla hos clementia temptat.
>
> *The commune or communitas speaks:*
> *So mutilate me, so torment me all the people.*
> *Neither decency nor pity stops them.*

728 W.R. Valentiner, *Tino di Camaino: A Sienese Sculptor of the Fourteenth Century*, Paris 1935, p. 64.

729 E. Frojmović, Giotto's Allegories of Justice and the Commune in the Palazzo della Ragione in Padua: a Reconstruction, *Journal of the Warburg and Courtauld Institutes* 59, 1996, pp. 24–47.

Julius von Schlosser found Schedel's text and related it to the Salone decoration, which was remade after the fire of 1420.[730] Based on this, the connections are as follows: The *Communitas* in the Paduan Salone does not reflect a Paduan work by Giotto, but rather the Florentine mural. Giotto's composition in the Bargello was attractive to the Paduan elite both as a political allegory and as a work by Giotto. The change of gender in the picture and its title from the *volgare* masculine (il comune) to the Latin feminine (communitas) corresponds to humanistic educational standards as they had taken hold in the late 14th and early 15th centuries.

Having gained an idea of the appearance of the mural in the Bargello and narrowed down the time of its creation to the years between c. 1307–09 (the painter's return from Padua or Assisi) and 1319 (the earliest echo of the *Documenti d'Amore* illustrations), one can attempt to determine the function of the medium in the political culture of Florence. The Bargello was the official residence of the *podestà* (the mayor or city bailiff), i.e. the chief executive of the municipality. Here he resided with his *curia* and his *familia* and tried to govern the Florentines on the basis of the decisions made by their council. From 1290 onwards, his term of office was limited to half a year, so that he had no chance to build up his own power base. He had to be of noble birth and not a Florentine; this seemed to the citizens to guarantee high thinking and independence.[731] It is also significant in this context that in the years after 1313 the vicars of the King of Naples resided in the Bargello either as or instead of a *podestà*. The palace was extended under them in the years after 1316. This is what Giovanni Villani reports in his chronicle and what the preserved invoices confirm, which at the same time show that it was the commune of Florence that paid for the work.[732] The commune may therefore have commissioned the allegory. But it could also have been an office holder, either one of the *podestà* before 1313 or one of the royal vicars afterwards. The difference in meaning would be small.

Giotto's image demonstrated what the *podestà* had to achieve. It is not by chance that the picture argues from a negative claim. This perspective is particularly persuasive because it allows us to see what the state would be without central power, i.e. without what the *podestà* stood for: a helpless victim of the selfishness of its citizens. A close look at the relief in Arezzo makes it clear how dramatically this must have been staged: the figure of

730 J. von Schlosser, Giustos Fresken in Padua und die Vorläufer der Stanza della Segnatura, *Jahrbuch der kunsthistorischen Sammlungen des allerhöchsten Kaiserhauses* 17, 1896, pp. 13–100.

731 G.B. Uccelli, *Il Palazzo del Potestà: Illustrazione storica*, Florence 1865, pp. 13, 62–70. *Statuto del Podestà dell'anno 1325*. Statuti della Repubblica Fiorentina 2, ed. R. Caggese, Florence 1921.

732 W. Paatz, Zur Baugeschichte des Palazzo del Podestà (Bargello) in Florenz, *Mitteilungen des kunsthistorischen Institutes in Florenz* 3, 1919–1932, pp. 287–321.

428 Giotto Autonomous: The Bardi Chapel and the Works of the Second Decade

the equally majestic and defenceless old man contrasted with the figures of the ruffians in their fashionable dress, who – as ruthless with each other as they are to him – behave as if they were dealing with a clothes rack. If Giotto's fresco is authentically reproduced in these motifs, then our painter had succeeded in representing a rather abstract idea (which even today is not at all easy to convey in political discourse) in a highly emotional way. With Giotto's allegory displayed behind his desk, one imagines, the office of *podestà* gained in both sympathy and assertiveness. Those who asserted their own particular interests suddenly found themselves in the role of a crook.

OGNISSANTI: THE MADONNA

There are few paintings where there is as much consensus among authors concerning their dating as in the case of the large panel of the Madonna in the Uffizi, which came there from the Florentine church of Ognissanti (fig. 270): some – among them Thode and Toesca – had placed it before Giotto's stay in Padua, but since then it has generally been said to have been painted around 1310. This is astonishing, for it is in fact one of Giotto's most difficult pictures to gauge a time frame for. As far as I can see, there is only one external argument for the dating, which we owe to Giovanni Previtali: the St. Peter panel in the Florentine church of Santi Simone e Giuda, dated 1307, is, as has already been pointed out, a work for which Giotto's Madonna of San Giorgio served as a model and the standard against which it was to be measured (fig. 149). Nothing, however, connects the St. Peter panel to the Ognissanti Madonna. From this we can conclude that Giotto's more recent Madonna was not available to the painter, which means that it probably did not yet exist in 1307.[733] It is therefore almost certain that the Ognissanti Madonna was painted after Giotto's stay in Padua and probably also after his stay in Assisi in 1308.

It is mentioned by Ghiberti among Giotto's works for Ognissanti, together with a large *croce dipinta* preserved in the monastery, a panel depicting the death of the Virgin ("la morte di Nostra Donna"), other panels of an unnamed theme, a painted chapel of an unknown programme and a frescoed supraport with the Madonna in half-figure (2.1.4). If these references are all correct, then Ognissanti was, along with Santa Croce, the church in Renaissance Florence in which Giotto was best represented. Only one of the panels is documented before Ghiberti: According to a notarial deed of 1417 (1.4.7), in the church there was "an altar with a panel nobly painted by the late famous painter Master Giotto, located in front of the entrance door to the choir, on the right as one enters the church from the street." The picture mentioned in the document thus adorned the altar at the rood screen on the epistel side. Around 1540, the Anonimo Magliabechiano also saw a

733 Previtali, *Giotto e la sua bottega*, pp. 87, 343–344.

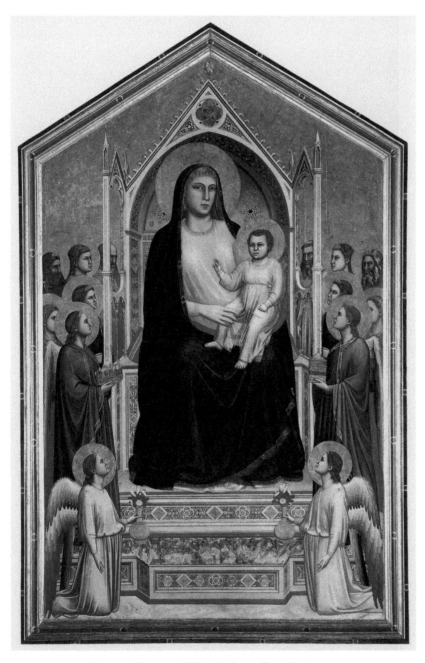

Fig. 270: Florence, Uffizi: Madonna from Ognissanti

panel by Giotto at the rood screen ("nel tramezzo"). It was "non molto grande", a remark that would not have been suitable for characterising the Madonna in the Uffizi, which measures 3.25 by 2.04 metres (2.1.7). Incidentally, the quoted sentence is one of the very few passages in the text of the anonymous author revealing that he wrote from his own experience when he was not copying from the *Commentarii* and Billi's book. Finally, Vasari reports about a small panel ("tavolina") by Giotto at the rood screen of the Ognissanti church about a decade later, and explicitly states here, in the *Vite* of 1550, that it was the Death of the Virgin (2.1.9). I will deal with Vasari's mention of the picture in the edition of 1568 later. It should be pointed out here only that between the first and second printings of the *Vite*, a number of things had happened in Ognissanti: in 1561, after much toing and froing, the monastery founded by the Humiliates in the 13th century had passed into the possession of the Franciscans; and in 1566, the Franciscans had removed the rood screen, so that everything that had belonged to it and its altars was displaced.[734]

Vasari also mentions the enthroned Madonna in both editions, but, like Ghiberti, is silent about its location. We cannot even be sure that he saw it in the church. The first author who saw the panel and states where it was is a 17th century chronicler, the Franciscan Antonio Tognocchi di Terrinca. He did not encounter it in the church in 1691, but in the "scuola", a kind of chapel within the convent of Ognissanti. Accordingly, as Irene Hueck has shown, the old belief that the panel was the retable of the high altar is not supported by anything.[735] The altar on the epistle side in front of the rood screen is not really a suitable location for the Madonna either, because the Giotto panel mentioned there in 1417 was far more likely to have been the Death of the Virgin. So we do not know the location for which the Madonna was painted and nor can we be sure of its patron.

Of course, the panel may have been commissioned by the Humiliates – a community of monks and friars who, like so many in Florence, earned their living by producing woollen cloth, but also did good works with the profits.[736] Indeed, the panel seems attuned not only to the consecration title of the church, but also to the order that oversaw it: among

734 Paatz, *Die Kirchen von Florenz*, vol. 4, pp. 407–408.

735 I. Hueck, Le opere di Giotto per la chiesa di Ognissanti, in: *La "Madonna d'Ognissanti" di Giotto restaurata* (Gli Uffizi. Studi e Ricerche 8), Florence 1992, pp. 37–50. Stefan Weppelmann identifies the vessel that the right angel wants to hand to Mary as a pyx. From this he deduces an eucharistic context for the panel and its function as an altarpiece. St. Weppelmann, Raum und Memoria: Giottos Berliner Transitus Mariae und einige Überlegungen zur Aufstellung der Maestà in Ognissanti (Florenz), in: *Zeremoniell und Raum in der frühen italienischen Malerei*, ed. St. Weppelmann, Petersberg 2007, pp. 128–159, esp. 138. But the vessel is too big for a pyx. Incidentally, a vessel for ointments makes more sense as a gift to Mary than a vessel for hosts.

736 A. Benvenuti Papi, Vangelo e tiratori: Gli umiliati ed il loro insediamento fiorentino, In: *La "Madonna d'Ognissanti" di Giotto restaurata*, pp. 75–84.

the eight hard-to-identify saints, who probably represent "all the saints" (ogni santi), a monk in white robes stands prominently on the right behind the throne; Giotto must have intended either Bernard of Clairvaux or the monk-father Benedict.[737] In one case as in the other, it is a founding saint and a role model for the Humiliates, who were dedicated to the *Ora et labora* principle, lived according to a modified Benedictine rule and were close to the Cistercians in their emphasis on manual labour.[738] The spiritual stamp of the Order was thus discreetly put on the panel. It was once suggested that this also applied to the use of light-coloured cloth. The white, instead of the usual red, undergarment of Our Lady and the light grey tunics of the angels in the foreground are supposed to allude to the monks' habit of homemade, undyed woollen cloth, according to Julian I. Miller and Laurie Taylor-Mitchell in their study of the picture.[739] The heavy quality of the fabric used for Mary's robe, however, does not meet "modest" standards, and in addition to angels dressed in grey and white, there are also those in green ad blue robes.

In contrast, those who see the commission of Duccio's Madonna Rucellai as typical of large Madonna panels expect a Marian brotherhood as patron, and indeed there was one at the church of Ognissanti. Among the little we know about this corporation is that it was founded with the support of the Humiliates in 1336, perhaps just within Giotto's lifetime.[740] Is it conceivable that the founding members of the brotherhood were the donors of the panel? In the Baroncelli Altarpiece we know of a panel that Giotto certainly painted after 1327/28 (pp. 453–467). Compared with this work, there is nothing to suggest that the Ognissanti Madonna was also painted during Giotto's last creative period. This, in turn, brings into focus the logic of the current dating: if one imagines the style of the Arena frescoes – the careful elaboration and modelling, the objectivity of the description of the subject, the avoidance of conspicuous features – translated into the tempera technique, one arrives at the Ognissanti Madonna.

And the relation to the works in Padua can be further concretised: if the shutter with God the Father, executed as a panel painting, is detached from the chancel arch and the programme of the Arena chapel (as has been done through its transfer to the museum), it appears to be almost a counterpart to the Florentine Madonna (fig. 271). This affects even

737 M. Lisner, Significati e iconografia del colore nella „Madonna d'Ognissanti", in: *La "Madonna d'Ognissanti" di Giotto restaurata* (Gli Uffizi. Studi e Ricerche 8), Florence 1992, pp. 57–68.

738 D. Castagnetti, La regola del primo ordine dell'approvazione alla "Regula Benedicti", in: *Sulle tracce degli Umiliati*, ed. M.P. Alberzoni et al., Milan 1997, pp. 163–250.

739 J.I. Miller and L. Taylor-Mitchell, The Ognissanti Madonna and the Humiliati Order in Florence, in: *The Cambridge Companion to Giotto*, ed. A. Derbes and M. Sandona, Cambridge 2004, pp. 157–175, esp. 168–169.

740 B.M. Wilson, *Music and Merchants: The Laudesi companies of republican Florence*, Oxford 1992, pp. 118–119.

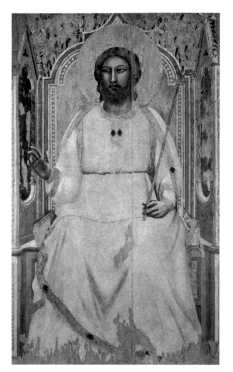

Fig. 271: Padua, Museo Civico: panel with God the Father from the Arena Chapel

such inconspicuous elements as the small asymmetries in the projection of the throne architecture: in the God the Father panel, at the level of the seat cushion, we can see most clearly how the side pieces of the throne are aligned differently in their depth so that we see the left piece somewhat more from the right than we see the right from the left. The throne architecture of the Madonna is shifted in the opposite direction but to the same degree. With the naked eye, the deviating projection can be seen in the protruding lower step, whose left flank is seen more from the left than its right flank is from the right. This was observed on the occasion of the restoration of the panel, which was completed in 1989, and used as an argument for its original placement on the right hand altar in front of the rood screen in the Ognissanti church.[741] Allegedly, this perspective corresponds to viewing the panel from the half-left. However, if the same phenomenon occurs on the God the Father panel, which was undoubtedly placed axially in the Arena Chapel, this conclusion is not compelling.

Interestingly, this phenomenon is not found in the Paduan allegory of Justice (fig. 82). Her throne, which is three-dimensional in a novel way, is admittedly the model for the motifs of the throne of the Ognissanti Madonna. The projection, however, is different: Giotto rendered the throne of Justice symmetrically. The Madonna of San Giorgio alla Costa, on the other hand, shows a very pronounced shift in its axis (fig. 148), which is probably not perceived to its full extent only because the panel has been reduced in size and thus the seat is no longer seen as a whole: the asymmetry of the projection must have been stronger than in the Madonna of Ognissanti, so that the right hand part of the throne could be seen at a relatively obtuse angle from the left while the left part could be seen at a relatively acute angle from the right. Such an opening in the architecture in the panel of San Giorgio alla Costa corres-

741 La *"Madonna d'Ognissanti" di Giotto restaurata*, p. 16 and A. Natali, Lo spazio illusivo, in: *ibid*, pp. 51–55.

ponds to the pictorial concept of the pre-Paduan Giotto: since the throne opens up, he sets the figure free and releases it into the real world.

This effect is reduced in the God the Father panel in Padua. The depicted body now exists in a space of its own, as defined by the throne. The irregular features that the painter leaves in place establish its plausibility. The visualising of a small deviation of the axis ensures that the representation does not appear frozen and so the viewer has the feeling of being fixed in front of it. This is exactly what is achieved with the Justitia. The axiality there becomes recognisable in comparison as an "unrealising" element that complements the stone colour and makes it clear: we are not dealing with a breathing creature in a completely three-dimensional space, but with a relief sculpture. The Ognissanti Madonna takes up the position of the Paduan God the Father panel. However, as the strongest signal of a deviation from the axis comes from the lower step of the throne, which is at the same time given in an accentuated top view, the pictorial space is subtly characterised as one that is accessible rather than closed.

AVE VIRGO VIRGINUM

The insight that she is present in a space that is at least visually accessible can also be used as a criterion for setting her apart from Duccio's Madonna Rucellai, which set the standard in young Giotto's Florence (fig. 147): While this Madonna comes to the viewer in a miraculous way, the Ognissanti Madonna invites us to step before her throne. Duccio's angels carry the Madonna into the church and the world of the viewer; Giotto's angels flank the path that would lead the viewer out of the church interior and to the Madonna, if only we could really walk it. The gifts they bring, flowers, a crown, an ointment vessel, could be our gifts – flowers and certainly other things were brought by the Florentines to the wonderworking Madonna of Orsanmichele (fig. 350). However, the painter makes it clear in many ways that this is not quite the case, and that the picture is a world of its own, better than the real one: it can neither be entered nor enriched with gifts. The unreal elements in the painting comprise the obtrusive geometric figures, including the very present halos, which are complemented by the tracery circle on the throne pediment, as well as the sophisticated colouring: Theodor Hetzer pointed out the distribution of vermilion, «this most dangerous colour», which counteracts spatiality.[742] But the desire that this picture would be different insofar its space could nonetheless be real, and thus accessible, is suggested to the viewer and does not seem to be out of question.

742 Th. Hetzer, Giotto und die Elemente der abendländischen Malerei – Betrachtungen zu Giottos Ognissanti-Madonna in Florenz, in: *Beiträge zur geistigen Überlieferung*, Godesberg 1947, pp. 266–310.

 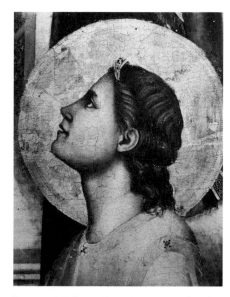

Fig. 272: Madonna from Ognissanti, detail

Fig. 273: Madonna from Ognissanti, detail

What else is inviting? The eyes of the angels and the saints lead us through the picture. They are directed at Mary and Christ, helping to focus our attention on the main figures. The gazes within the picture are of great emotional power, not least through the use of faces in profile for the four angels who are closest to the viewers. And the effect is most intense in the two kneelers. Their gaze and posture, including the hands, sunk down as if speechless, evoke the impression of a delighted rapture (fig. 272, 273). This is reminiscent of the profiles of the "dilecta" in the Mary Magdalene Chapel in Assisi (fig. 207, 214), and I assume that with the emotionally charged profiles of the Ognissanti Madonna, Giotto took up and developed a motif that he had invented there to flesh out the Magdalene iconography.

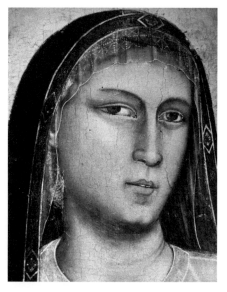

Fig. 274: Madonna from Ognissanti, detail

Ave Virgo Virginum

The Lady's gaze is aimed directly at the viewer (fig. 274). Despite the fact that one feels intensely included, one has the impression that the painter did not find it easy to create this effect. The head is turned to a relatively high degree; this gives the gaze a certain spontaneity (in contrast to the Madonna of San Giorgio alla Costa and Duccio's Rucellai Madonna). But the alignment of the pupils becomes questionable on closer inspection. The face is decidedly more individual than in the San Giorgio alla Costa panel (fig. 151). The slightly open mouth, which allows the teeth to be seen between the lips, now suggests speaking – i.e. most likely a gentle encouragement to the addressees of the picture. For some Renaissance-trained eyes, the intensity of this face is somewhat repulsive. That is why it was painted over and "regulated" in the early modern period: the mouth was closed and the chin integrated into the oval.[743] For contemporaries, it can be assumed, the face was moving precisely because of its strangeness, which could be experienced as individuality and presence. Even in Giotto's oeuvre it is not easy to name something comparable. To establish its prehistory, we may think back to the bust of St. Magdalene in the frame system of the Arena Chapel, whose gaze Giotto administers to the visitor there as a spiritual antidote to the hell of the Last Judgement (fig. 77). The combination of an intense gaze and a turning of the head evokes the memory of St. Clare in the Bardi Chapel (fig. 249). But while the Ognissanti Madonna still shows traces of experimentation in the alignment of the pupils, the appearance of the Franciscan saint is perfect.

Two peculiarities still need to be mentioned: first, the presence of the bodies of mother and child under the robes. The breasts of the Ognissanti Madonna are almost as present in our perception as her face. Their prominent appearance in the picture can be read, as is well known, as an argument for grace: how could Christ not lend an ear to the intercessions of the woman who fed him at the bosom?[744] To give a text: On the Mengot epitaph in Heilsbronn, probably painted around 1370, Mary shows Christ her breast and says by means of a scroll: "Because you sucked at this, my son, I ask forgiveness for that one". That one is the donor. And Christ reacts by turning to God the Father saying, "See my wounds, Father, do what my mother asks of you."[745]

743 Cf. D. Wilkins, On the Original Appearance of Giotto's Ognissanti Madonna, *The Art Quarterly* 33, 1970, pp. 1–15. Wilkins considered the overpaintings removed in the late 19th century to be the original state.

744 S. Marti and D. Mondini, „Ich manen dich der Brüsten min, das du dem Sünder wellest milte sin!" Marienbrüste und Marienmilch im Heilsgeschehen, in: *Himmel, Hölle, Fegefeuer: Das Jenseits im Mittelalter*. Exh. cat. Zürich and Cologne, ed. P. Jetzler, Munich 1994, pp. 79–90.

745 "Haec quia sucsisti fili veniam precor isti." – "Vulnera cerne pater fac quae rogetat mea mater." A. Stange, *Deutsche Malerei der Gotik*, vol. 2, Munich and Berlin 1936, pp. 169–170. *Die Parler und der Schöne Stil: Europäische Kunst unter den Luxemburgern*. Exh. cat. ed. A. Legner, vol. 1, Cologne 1978, p. 380 (G. Bräutigam).

436 Giotto Autonomous: The Bardi Chapel and the Works of the Second Decade

Beyond the semantic, her emphatic physicality is also a very empirical feature in a picture that is concerned to make what is depicted credible. This also applies to the second element I want to point out: The throne is made of precious coloured marble, but Mary places her feet on a simple wooden board. This may be an allusion to the material of the cross and to her foreknowledge of the Passion. But the board underneath also protects against cold feet, and this surely went through the viewers' minds as well. The board transforms the throne, which is as magnificent as only one provided from the beyond can be (far more magnificent than the throne of the Madonna of San Giorgio alla Costa and all Roman Madonna thrones), into an object that has a connection to the everyday experience of the viewer. The world in Giotto's picture is undoubtedly better than ours, but certain details can definitely be understood from our world, and so the otherworldly scenery that Giotto painted in the panel appears of relevance in the world of its devout users.

In front of their image of the Virgin, Coppo di Marcovaldo's famous Madonna del Bordone of 1261, the oldest known large panel of the Madonna, the Servites of Siena sang the hymn *Ave Virgo Virginum*:[746]

> *Hail, Virgin of virgins; hail, Light of lights; hail, Mother of grace.*
> *Hail, salvation of men; hail, hope of consolations; hail, way to home.*
> *Hail, Virgin Mary; hail, Most Gracious; hail, Most Venerable.*
> *Hail, daughter of God, hail, gentle Mother, hail, Unspeakable One.*
> *Hail, radiance of glory, shining at noon above all the stars.*
> *Hail, O gate of grace, fountain of mercy, sweeter than all.*
> *Salute, light of heaven, salute, peace of the faithful, salute, most blessed one.*
> *Salute, our joy, consoler of hearts, salute, most gracious.*
> *We cry unto thee, O Lady, incline thine ear to the supplication of the supplicants,*
> *that through thy medicine we may reign with thee in heaven. Amen.*

746 P.M. Branchesi, Libri corali del convento di S. Maria dei Servi di Siena (sec. XIII–XVIII), *Studi storici dell'ordine dei Servi di Maria* 17, 1967, pp. 116–160, esp. 147. "Ave, Virgo Virginum, ave lumen luminum, ave mater gratie. Ave, salus hominum, ave, spes solaminum, ave, via patrie. Ave, virgo Maria, ave plena gratia, ave, venerabilis. Ave, dei filia, ave, genitrix pia, ave, ineffabilis. Ave, splendor glorie, fulgens in meridie super luminaria. Ave porta venie, fons misericordie, dulcis super omnia. Salve lux celestium; salve, pax fidelium, salve, beatissima. Salve, nostrum gaudium, consolatrix cordium, salve benignissima. Supplicamus, domina, aurem tuam inclina, precantium precibus. Ut tua medicina regnemus, pax divina, tecum in celestibus. Amen." A. Reisenbichler, *"Madonna sancta Maria che n'ai mostrato la via": Die großformatigen Tafelbilder der thronenden Madonna in der Toskana des Duecento*, Phil. Diss. Vienna 2006, p. 31.

Giotto's image was to have its effect on its users accompanied by similar songs of the Humiliates, and this may have helped to create the spiritual milieu from which the Marian brotherhood of Ognissanti emerged a few decades later.

OGNISSANTI: THE CROSS

Unlike the Madonna, the cross that Ghiberti mentions and which was kept in the sacristy of the church before a restoration was undertaken in 2005, is considered to be a poor quality work (fig. 275). The size is enormous and only slightly smaller than the Santa Maria Novella cross: 485 by 380 centimetres.[747] It is clear that it is a kind of modified and enlarged copy of the cross of the Arena Chapel. This is most evident in the peculiar shape of the panel with its half and quarter circles, as well as the frame that runs around the entire complicated outline. For its vegetal ornamentation it is easier to find models in the Veneto than in central Italy.[748] It may seem disappointing that Giotto simply repeated these features in Florence; on the other hand, the novelty value of the cross for the Florentines was high precisely because of this. Put positively: Giotto offered his compatriots an invention that his Paduan audience had inspired him to make.

And the mourning figures on the side panels are entirely new designs: Mary in particular, with her hands veiled and crossed in front of her chest and weeping unreservedly enough to make her appear ugly, is a figure that one can hardly forget (fig. 276). The position of the crucified man's hands is also new: the fingers are curved towards the viewer and shortened in a daring way, so that we see little more than the crests and the curve of the fingernails: an effect that is both spatial and image-like; this effect had not previously appeared on Giotto's *croci dipinte* – in Santa Maria-Novella, Rimini, Padua – but it was anticipated in the crucifixion scene of the Arena Chapel (pl. VIII). Also new, finally, is the gesture of God the Father. It is not the usual gesture of blessing or speech as on the Paduan and Rimini crosses. Rather, this time the Father holds his hand over the Son. At this point, however, problems of representation become apparent. The painter has not succeeded in illustrating the spatial position of the hand, and this makes the reading difficult. Unmastered difficulties are rare in Giotto's works.

747 *L'officina di Giotto: Il restauro della Croce di Ognissanti*, ed. M. Ciatti, Florence 2010. M. Gaeta, *Giotto und die Croci dipinte des Trecento. Studien zu Typus, Genese und Rezeption. Mit einem Katalog der monumentalen Tafelkreuze des Trecento (ca. 1290-ca. 1400)*, Münster 2013, pp. 141–149.

748 A.M. Spiazzi, La cornice lignea, in: *La croce di Giotto: Il restauro*, ed. D. Banzato, Milan 1995, pp. 41–49. D'Arcais, La Croce giottesca del Museo Civico di Padova, *Bollettino del Museo Civico di Padova* 73, 1984, pp. 65–82, esp. 74.

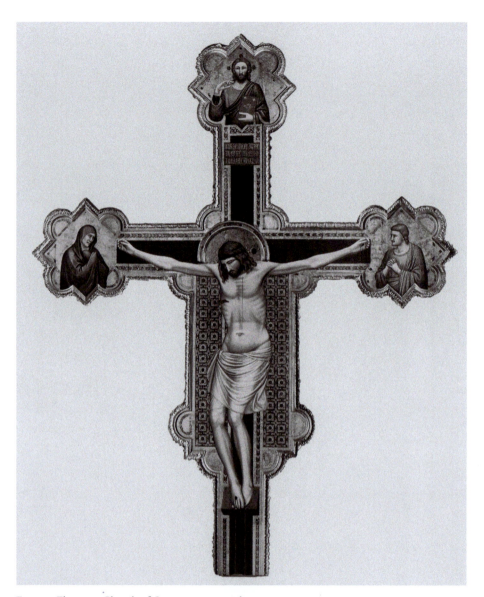

Fig. 275: Florence, Church of Ognissanti: croce dipinta

All in all, it seems reasonable to assume that this is predominantly the work of collaborators, executed under the eyes and with the help of the master in parallel with the Madonna. The cross was undoubtedly intended for the rood screen of the church. Its size and lack of a home in today's church speak for this. Also, the Death of the Virgin

was originally on an altar at the rood screen. Should we conclude from this that the large Madonna was also intended for placement on or at the rood screen, as Irene Hueck has suggested?[749] The reason for the commission of several panel paintings could have been that the rood screen was being erected or rebuilt. Unfortunately, too little is known about the building history of the Ognissanti church for this connection to be followed up in a promising way: in 1251, the Humiliates received the land from the bishop to build a church there in honour of all the saints. In 1257, they seem to have already had a cloister. In 1258, they had a bell cast. At least it cannot be ruled out that the nave was only completed in the early 14th century.[750]

Fig. 276: Florence, Church of Ognissanti: croce dipinta, detail

OGNISSANTI: THE (SO-CALLED) DEATH OF THE VIRGIN

In the Vite of 1568, Vasari reports about the Death of the Virgin that the picture had been "taken away by someone who, perhaps out of love for art ... did this with this picture, which seemed too little respected here." (2.1.10). Obviously Vasari is not talking about a theft. I recall that the rood screen of the Ognissanti church had been taken down shortly before, and thus the right altar of the screen, the ancestral place of the picture, no longer existed. On this occasion, the panel was probably moved to the cloistered area of the monastery. After that, silence fell over the panel in Florence. Thus it may seem unlikely that the Giottesque Death of the Virgin panel, which turned up in a Roman collection in the early 19th century, was later sold to a collector in England and subsequently acquired for the Berlin Gemäldegalerie shortly before the First World War, is Giotto's work for Ognissanti[751] (fig. 277). But, in addition to the extraordinary quality of the Berlin picture,

749 Hueck, Le opere di Giotto per la Chiesa di Ognissanti, p. 6.
750 Paatz, *Die Kirchen von Florenz*, vol. 4, pp. 407–408. A. Amonaci, Per una ricostruzione della storia del primo chiostro del convento di San Salvatore di Ognissanti a Firenze, *Archivium Franciscanum Historicum* 81, 1988, pp. 284–330.
751 The first scholar to see a work by Giotto in this panel seems to have been Waagen: J. H. Waagen *Treasures of Art in Great Britain*, vol. 3, London 1854, p. 374. The identification

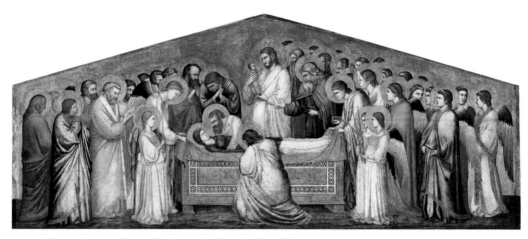

Fig. 277: Berlin, Gemäldegalerie: The Death of the Virgin

the following arguments for their identity may be adduced: firstly, according to the shape of the panel, it is indeed a small altar retable (75 by 178 centimetres), a gabled dossal, as had been common since the middle of the thirteenth century, even if not painted with a scene. (In contrast, the usual decoration of a dossal was a series of busts of saints.) Secondly, representations of the Death of the Virgin are rare in Trecento panel painting. From Florentine painters, there are only three other pictures besides the Berlin one, and these are copies – including the iconographic anomalies to which I will return. Thirdly, the identity with the Ognissanti panel is supported by the fact, proven by its copies, that the picture was in Florence and was used as a model.[752] Fourthly, Vasari's description fits the Berlin panel. Here is the somewhat more accurate version from 1550 (2.1.9):

> ... *a small panel in tempera, on which, painted by Giotto with boundless care and depicted with perfect design and vividness, is the death of our Lady with the apostles holding the exequies and with Christ carrying the soul in his arms.*

Moreover, Ghiberti had noticed that angels also appeared alongside Christ and the disciples (2.1.4). Ghiberti and Vasari thus had an adaptation of the Byzantine Coimesis icon before

with the Ognissanti panel goes back to the following contribution: F.M Perkins, Una tavola smarrita di Giotto, *Rassegna d'Arte*, 1914, pp. 193–200.

752 W. Suida, Giottos Tafel des Todes der Maria im Kaiser-Friedrich-Museum, *Jahrbuch der preußischen Kunstsammlungen* 44, 1923, pp. 127–135, esp. 129–130. Previtali, *Giotto e la su bottega*, p. 117.

their eyes, and the Berlin Death of the Virgin is such an adaptation. However, it does not follow on seamlessly from the Byzantine pictures, nor from their Roman adaptations by Torriti and Cavallini for the Marian cycles in Santa Maria Maggiore and Santa Maria in Trastevere, which Giotto must have had in mind as representative versions of the theme. The panel combines the moment of death depicted there with the act of burial.[753] Actually, in Giotto's work the theme of the funeral is the dominant one. In Giotto's scene, Mary does not rest on a bed or catafalque, but two angels lift her with the help of a cloth into a sarcophagus decorated with Cosmati work, while one of the disciples lends a hand. Mary's face is bound to keep her mouth closed, just as Giotto later painted the face of Drusiana resurrected on the bier in the Peruzzi Chapel. That Mary not only died but was also buried, and that her immaculate body would have been exposed to decay without the intervention of her Son, is part of the story as told in the *Legenda Aurea*.[754] Usually, however – and this is also the case in the choir of the Arena Chapel – it is not the funeral itself that is depicted, but rather the procession to the tomb that is inserted between the scene of death and the triumphal events of the Resurrection and Ascension. There was, however, one place where the visualisation of Mary's burial played a role, and Giotto and his patrons were undoubtedly aware of it.

We are talking about Siena Cathedral. In the large round window of the choir, which according to surviving documents was made in 1287/88 and probably by Duccio or with his collaboration, the Burial, Assumption and Coronation of Mary appear from bottom to top on the central axis.[755] In this case, the burial forms the contrasting material for the joyful turn of the story, while Christ's appearance in the circle of the apostles at the tomb not only establishes a reference to the iconography of coimesis, but also promises the occurrence of the miracle (fig. 278). Duccio later gave the scene of the burial its own picture field on the top section of the cathedral Maestà (fig. 279). In doing so, he took up the programme in the round window, but the decision also has to do with the fact that for the Maestà, in addition to the Assumption, which was to occupy the central position in the row of the crowning panels, six further scenes were needed for the story of Mary's death (including the death itself and Mary's funeral procession).[756] Duccio was thus under pressure to design more scenes of the Virgin's final days than had been made for any other similar cycle within the sphere of Latin pictorial conventions.

753 Stefan Weppelmann points out the complexity of the pictorial narrative and describes the theme as "Transitus Mariae": Weppelmann, Raum und Memoria. Giottos Berliner Transitus Mariae, pp. 144–148.

754 *Legenda Aurea*, ed. Maggioni, p. 787–789.

755 *Duccio: Alle origini della pittura senese.* Exh. cat. Siena, ed. A. Bagnoli et al., Milan 2003, pp. 166–183.

756 J. White, *Duccio. Tuscan Art and the Medieval Workshop*, London 1979, p. 84 (reconstruction)

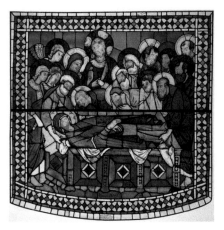 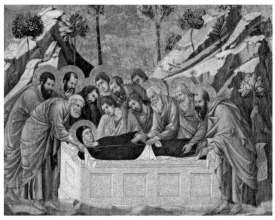

Fig. 278: Siena, Cathedral, round window in the choir: The Entombment of the Virgin

Fig. 279: Siena, Museo dell'Opera del Duomo: Maestà, The Entombment of the Virgin (Duccio)

Instead of pointing to these images in Siena for the iconography of Giotto's Death of the Virgin, reference is usually made to the tympanum of the southern west portal of the Florentine cathedral.[757] There, according to Francesco Rondinelli, who had still seen the Gothic portals destroyed in 1636, "the passing of Mary was portrayed with many statues; she was seen lying dead, and Christ holding her soul close in his arms, and all the apostles standing around the dead body."[758] Of these figures, created by Arnolfo di Cambio in the course of the construction of the façade from 1296, the body of Mary with an apostle holding her legs has been preserved in Berlin's Bode Museum, along with a fragment of the statue of Christ:[759] Mary is lying on a pall with her arms crossed; the apostle seems to be trying to put the cloth around her legs (fig. 280). This situation, however, will only be understood as part of a burial scene by those who are not aware of the tradition of transalpine Gothic sculpture that is essential to Arnolfo's art. I would like to point out a tympanum at the north transept in Chartres (middle portal) and a tympanum at the south transept in Strasbourg (left hand portal). These are coimesis im-

757 M. Boskovits, *Frühe italienische Malerei*. Gemäldegalerie Berlin: Katalog der Gemälde, Berlin 1988, p. 60.

758 ".. era con molte statue rappresentato il Transito di Maria, la quale si vedeva morta giacere, e Cristo, che l'Anima di lei strettamente teneva in braccio, e tutti gli Apostoli, che circondavano il corpo morto." G. Richa, *Notizie istoriche delle chiese fiorentine*, vol. 6, Florence 1757, p. 53.

759 M. Knuth, I frammenti della Dormitio Virginis di Arnolfo di Cambio a Berlino, in: *Arnolfo: Alle origini del rinascimento Fiorentino*. Exh. cat. ed. E. Neri Lusanna, Florence 2005, pp. 509–512.

ages, with Mary on her deathbed and the apostles taking care of her corpse by wrapping it in a cloth.⁷⁶⁰ The burial itself is not shown, but rather its prelude: reverent care for the dead body. This clearly does not conform to the theme of the Berlin painting. Nevertheless, at least the motif of the apostle bending over the corpse seems to have been adopted by Giotto from Arnolfo's sculpture. The function of this gesture, however, is modified: Giotto's apostle grasps around Mary's torso. In this context, it should be noted how difficult it is for viewers of Duccio's panel to judge whether Mary is being placed in or onto something. It is this ambiguity that Giotto removes through the use of the apostle, whose hands plunge into the depths of the sarcophagus.

Fig. 280: Berlin. Bode Museum: The Death of the Virgin, fragment (Arnolfo di Cambio)

What cannot be explained by either Duccio or Arnolfo, nor by the coimesis images in the Roman Marian churches that faithfully follow Byzantine models, is the large number of angels on the panel. In Cavallini's work, there are two angels flanking Christ; in Torriti's work, several more angels hover behind Christ's aureole. In Arnolfo's group of figures, as in Rome, there may have been angels assigned to Christ. In the Sienese window there are three angels on the left behind the apostles. In the panel from the Maestà there are no angels at all. Giotto, however, allows a large number of them to enter the picture. In this context, one can refer to the *Legenda Aurea* and certain legends, some of them very old, that had been incorporated into it: there, angels are present as Christ's companions both at Mary's deathbed and at her tomb.⁷⁶¹ But Giotto's angels hardly take notice of Christ. Arriving on foot from the right, they take over auxiliary liturgical activities, such as blowing the embers in the thurible (fig. 281, 282). In fact, it is angels and not apostles, as in Siena, who perform the funeral service. One almost has the impression that the angels are about to take control of the ceremony.

Or do they gently give a different direction to the activities depicted? Among the prayers that are common at funerals and that the viewer imagines being spoken in the liturgy painted by Giotto is this:

760 W. Sauerländer, *Gotische Skulptur in Frankreich*, Munich 1970, pl. 78, 131.
761 *Legenda Aurea*, ed. Maggioni, pp. 779–810. R. Hammerstein, *Die Musik der Engel: Untersuchungen zur Musikanschauung des Mittelalters*, Bern and Munich 1962, pp. 91–94.

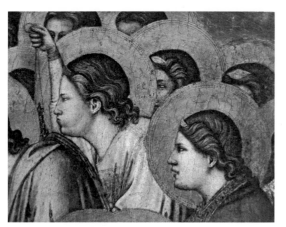 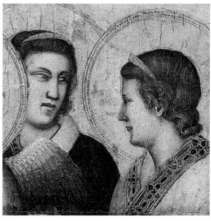

Fig. 281: Berlin, Gemäldegalerie: The Death of the Virgin, detail

Fig. 282: Berlin, Gemäldegalerie: The Death of the Virgin, detail

In paradisum deducant te Angeli,
in tuo adventu suscipiant te martyres,
et perducant te in civitatem sanctam Ierusalem.
Chorus angelorum te suscipiat,
et cum Lazaro quondam paupere
aeternam habeas requiem.

May the angels lead you into paradise;
may the martyrs receive you at your arrival
and lead you to the holy city Jerusalem.
May choirs of angels receive you
and with Lazarus, once poor,
may you have eternal rest.

Moreover, among the cycles of the Life of Mary in French cathedral sculpture produced between the late 12th and mid-13th centuries, there are some in which, instead of or alongside a coimesis scene, angels are shown rushing to help Mary get up from her deathbed, thus beginning her bodily ascension (Senlis – fig. 283; Mantes, Chartres).[762] The angels are not so much part of Christ's escort as medics acting on his behalf; their actions make the event vivid and physical. Since Giovanni Pisano used the motif in 1313 for the tomb of Margaret

762 Sauerländer, *Gotische Skulptur in Frankreich*, pl. 42, 43, 46, 47, 78, 79.

of Brabant in Genoa, we may assume that it was known in Italy.[763] The variants in the tympanum reliefs of Notre-Dame in Paris and the priory church of Longpont near Paris are also interesting: similar to the scene on Giotto's panel, angels approach and lift Mary over the sarcophagus with the help of a cloth[764] (fig. 284). A closer look reveals that in doing so they do not lay the body down, but rather lift Mary out of the tomb, newly inspired and awakened by Christ. Certainly Giotto does not mean the same procedure, but the character of his funeral ceremony is strikingly transformed by the intervention of the angels: the miracle of the resurrection, with which the story will end, has already begun. Vasari's description of the lost Death of the Virgin in the Tosinghi-Spinelli Chapel (p. 180) should also be recalled here: there were "a great number of angels with torches in their hands." The image of the Assumption of Mary had been placed above the chapel to serve as a counterpart to the Bardi Stigmatisation. One can conclude that the appearance of the angels at Mary's deathbed in the chapel was intended to give a kind of preview of this event.

In addition, it is striking how casually things happen on Giotto's panel. In Torriti's and Cavallini's mosaics, but also in the French reliefs, the apostles are symmetrically arranged to the left

Fig. 283: Senlis, Cathedral Notre-Dame, central portal of the western façade: Mary on her Deathbed

Fig. 284: Paris, Cathedral Notre-Dame, left portal of the western façade: scenes from the Life of the Virgin

763 J. Tripps, Eine Schutzheilige für Dynastie und Reich: Giovanni Pisano und das Grabmal der Margarete von Brabant in Genua, in: *Grabmäler der Luxemburger: Image und Memoria eines Kaiserhauses*, ed. M.V. Schwarz, Luxembourg 1997, pp. 27–49, esp. 38.
764 Sauerländer, *Gotische Skulptur in Frankreich*, pl. 153 and fig. 79.

Fig. 285: Bardi Chapel, north wall: The Confirmation of the Stigmata, detail

and right of the death bed and at least to some extent hierarchically ordered. Also in Duccio's more loosely grouped depictions, Peter and Paul are reliably the ones who place the body in the tomb and thus play a role that is singled out in a clearly defined way. In the Berlin panel, on the other hand, we find a confusing crowd, where the disciples are predominantly to the left of the sarcophagus, while the angels dominate on the right. Peter and Paul stand out, but not because of their placement, but as if by chance: Peter because his orange robe is particularly well accentuated in a kind of gap between other figures, Paul because of the glow of his bald forehead at the apex of the left group of figures. Hints of compositional symmetry are presented and immediately withdrawn: on each side a steel-blue robe catches the eye, but one is worn by an angel, the other by an apostle. At the head and foot of the sarcophagus are pairs of angels with candles, but while at the head one angel covers the other, at the foot we see both.

On the other hand, an asymmetry is noticeable that rebels against the centring pediment of the panel. This is, namely, the gap in the curtain of figures to the left of Christ and the three figures who create or emphasise this gap through their behaviour: the hand-wringing disciple, the apostle holding the body and the one kneeling in front of the sarcophagus, thus creating an opening as well as causing compositional disorder. All in all, an effect is created that does not suggest the performance of a ritual. And even where liturgical matters are explicitly depicted, the situations or forms chosen are as improvised as possible: the blowing of incense by an angel at the foot of the sarcophagus; the sprinkling of holy water on the corpse, for which the apostle does not use an aspergil but a small twig; the booklet from which Peter reads, where the use of a prestigious missal would be expected; the fact that while some angels sing, others speak to each other familiarly, thus making the amiable nature of the angels vivid (fig. 282).

The unpretentious celebration is probably intended to bring out the human character of the Mother of God. The way in which her soul is depicted is consistent with this – quite different from all the older images of the Death of the Virgin: childlike and trusting – in need of redemption like any human being – the soul turns to Christ and he holds the

swaddled child lovingly and carefully and devotes all his attention to it. If the argument of the large panel of the Madonna of Ognissanti is that Christ cannot deny his ear to a woman who has nourished him, then the small panel seems to tell another episode from the story of this commitment of love. In this way, Giotto has struck a note that is alien to the corresponding figures in Torriti and Cavallini, but also in Duccio and Arnolfo.[765]

If we look for other possible connections among Giotto's works, we may arrive at the Bardi Chapel. This applies to details: especially the friar kissing Francis' left hand in the Lamentation scene (fig. 285) and the hand-wringing apostle on the panel between Christ and Paul; they resemble each other in the way the face is foreshortened and the eminent difficulties in execution are almost, but not completely, mastered. At least Giotto seems to have taken a step further in the Bardi Chapel. The Bardi Chapel also offers opportunities for connection where higher-level phenomena are concerned, such as the increased spatiality and the opening towards the viewer: it is hardly noticeable, but Mary's sarcophagus in the Berlin panel stands at a slight angle. This may be derived from Cavallini's Death of the Virgin, where the bed is also slightly shifted, and may also be tight to Giotto's emphasis on the informal in the scene. In fact, however, the entire composition of the picture is affected by the slanting position of the sarcophagus. The preponderance of the group of figures on the right, dominated by the angels, and the turning figure of Christ can be understood from here as effects within the pictorial space. These harmonise with a placement of the panel on the right hand altar in front of the screen. The picture seems to have been conceived in such a way that it opens itself up to the viewer from the left. It is a phenomenon that is also encountered in a very similar way in the paintings of the Bardi Chapel.

In addition, the somewhat overwrought play on the varying inclinations of the heads and the use of profiles are reminiscent of the Mary Magdalene Chapel. The fact that the physiognomies are also related to the frescoes in the north transept of the Lower Church confirms the idea that Stefano, who was working there, left the Giotto workshop not long before the Bardi Chapel.

GIOTTO AUTONOMOUS

Giotto's works between his return from Padua and c. 1320 seem to have been characterised by a relatively continuous elaboration of what he had developed for the Arena Chapel. Indeed, in the eyes of its central Italian audience, the Paduan style would have possessed all

765 The group of Christ and Mary from Arnolfo's Death of Mary has been preserved and is in the Opera del Duomo, Florence: *Il museo dell'Opera del Duomo a Firenze*, ed. L. Beccherucci and G. Brunetti, Naples n.d., pp. 221–222, pl. 23.

the charms of novelty. What is surprising, however, is that the painter partly abandoned the closed form of image that he had developed in Padua and in which Theodor Hetzer, for example, saw the direct precursor of the modern image; he now also experimented with a more open pictorial system. Many works from these years do not continue to offer an abrupt alternative between looking at the world and looking at the picture as in Padua, but rather once again seek the proximity of the viewer – similar to what the works before and immediately around 1300 had done. In addition to that, the post-Paduan pictures in no way connect with the pre-Paduan ones. In the more recent pictures it is not so much a matter of making something appear in the world of the viewer as it is of building easily accessible bridges for the viewer into a pictorial world that is largely the Paduan one, only more varied, more spacious, more emotional and more pleasing. The Florentines had an appreciation for this: the choir chapel of the Badia, the state allegory in the Bargello and the Bardi Chapel – more desirable commissions were hardly available, and they came to Giotto from practically all sides: from a noble old monastery, from the city government and from a family of high finance.

GIOTTO PLURALISTIC: THE PERUZZI CHAPEL IN FLORENCE AND THE LATE WORKS

There are a number of external clues for the chronology of Giotto's painterly work after c. 1320, i.e. during the last 15 years of his life. However, they are of different value: for example, his activity in the Capella Magna and Capella Secreta of the Royal Castle of Naples is dated to the years 1328 to 1333 by numerous documents (1.2.1–7), but the Capella Secreta is not even preserved as a building and the murals in the great chapel are lost except for small fragments. I will go into what can be deduced from them later. The frescoes in the chapel of the Rocca di Galliera in Bologna are completely lost. Giacomo Ronco in his chronicle and the Anonimo Fiorentino in his commentary on Dante report that the "cardinal legate", i.e. Cardinal Bertrand du Poujet, was the commissioner (2.2.2, 2.5.7). If this is true, the murals must have been painted after 1327.

In contrast, the painting of the chapel in the Bargello mentioned in Ghiberti's catalogue of works in Florence is not only dated, but also almost completely preserved. However, the date given by the inscription contradicts Giotto's authorship of the murals: the text states that "this work" was "made" under the Podestà Fidesmino de Varano.[766] Fidesmino presided over the Florentine city administration in the second half of 1337 (since in this case the *annus incarnationis* was not used, this refers to the months from mid-July 1337 to mid-January 1338).[767] Those who nevertheless want to claim the decoration for our painter must therefore assume that Giotto began it before Fidesmino's tenure and that the frescoes were finished by his workshop – perhaps under the direction of Giotto's sons Francesco and Bondone – several months after his death in January 1337.[768] In this case, the oral tradition on which Ghiberti relied would have preserved only half the story. Another possibility is that this tradition was inaccurate.

Here, for once, we have an insight into the forefield of Ghiberti's text. It is linked to the story of a Dante portrait and a self-portrait by Giotto. Between 1381 and 1390, Filippo Villani reports that such a pair of portraits is in the chapel (2.1.3). In the decades before,

766 "Hoc opus factum fuit tempore potestarie magnifici et potentis militis Domini Fidesmini de Varano, civis Cmarinensis honorabilis potesatis. Ann. Dni. MCCCXXX ... A ... X ..." Cit. after G. Previtali, *Giotto e la sua bottega*, Milan (3) 1993, p. 348.

767 *Statuto del Podestà dell'anno 1325*. Statuti della Repubblica Fiorentina 2, ed. R. Caggese, Florence 1921, p. 1.

768 I. Hueck, Ipotesi per la bottega "Giotto e Figli", *Annali della Scuola Normale Superiore di Pisa*, Ser. IV, 1–2, 2000 (*Giornata di studi in ricordo di Giovanni Previtali*, ed. F. Caglioti, Pisa 2002), pp. 53–60.

narratives about a friendship between Dante and Giotto had been established in order to explain the painter's appearance in the *Commedia*. At first, Cimabue was integrated into the circle (2.5.4), only then did the pair of friends emerge (2.5.5). As far as the position of the heads in the chapel is concerned: in the earlier version of his work on the famous Florentines, Filippo Villani says that the self-portrait and the portrait of Dante are to be seen in the chapel on the retable (mentioned in no other source), but in the later version and in the Italian translation he names the painted altar wall as the site of the figures. This gives the impression that he first reproduced someone else's opinion (concerning the retable), which he then checked and found confirmed in a slightly different form (the altar wall), or at least believed this to be the case.

During the 15th century, the Florentines recognised another pair of portraits of Dante and Giotto located in Santa Croce. The authors first claimed it for Taddeo Gaddi and then for Giotto himself (2.5.8, 9). In addition, the Bargello Chapel remained in discussion as the stage for Dante's appearance enacted by Giotto: the author of Billi's book maintains to have seen Giotto's Dante portrait (without a self-portrait) on the altar wall (2.1.6). He was followed by Vasari, who likewise did not identify Giotto at Dante's side, but instead identified portraits of Dante's well-known contemporaries, Brunetto Latini and Corso Donati.

In fact, when the frescoes of the Bargello Chapel, painted over in the 17th century, were being uncovered in 1839 in the search for the portraits, a figure passable as Dante was found among the pious hoping for salvation in the picture of the Last Judgement on the altar wall (fig. 286). Probably it was this face with the concentrated expression which the Florentines of the late 14th century recognised as that of their exiled national poet. However, anyone who soberly considers the facts – Dante had been dead for 16 years and Giotto for half a year when the murals were commissioned according to the inscription – will conclude it is just the wishful thinking of the late 14th century that is at the root of the identification of the figure with Dante and of the attribution of the decoration to Giotto. The state of Dante' s veneration in Florence at that time and the rehabilitation of the exiled poet were being projected into the preceding decades and onto a place at the centre of state power.[769]

The frescoes of the Bargello Chapel are dated works, but their dating contradicts the authorship by Giotto – not to mention their fluctuating quality and lack of innovative features. Presumably they were carried out by a kind of *cantiere* that came together to get the job done within the Podestà's six-month term. It consisted of painters who – as was standard in Florence at the time – had learned a variety of Giottesque lessons;

769 M.V. Schwarz, Giottos Dante, Dantes Giotto, in: *Dante und die bildenden Künste: Dialoge – Spieglungen – Transformationen*, ed. M.A. Terzoli and S. Schütze, Berlin 2016, pp. 163–184. Cf. E.H. Gombrich, Giotto's Portrait of Dante, *The Burlington Magazine* 121, 1979, pp. 471–483.

for example, they were able to repeat Giotto's technique of creating fictitious figures for the heads of the Last Judgement, among them the supposed head of Dante. Nevertheless, models seem to have been more important than real learning experiences from the Giotto workshop. For the Magdalene pictures, the painters used designs from the Magdalene Chapel in Assisi, and for the pictures from the life of John the Baptist, models from the Peruzzi Chapel. I will return to the alleged Dante portrait later in connection with Giotto's afterlife (vol. 3 pp. 31–38).

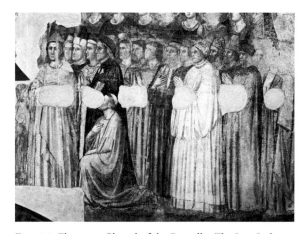

Fig. 286: Florence, Chapel of the Bargello: The Last Judgement, detail

THE MURALS OF THE CAPELLA MAGNA IN NAPLES

Today, the great chapel of Naples' Castel Nuovo, founded in 1307 and dedicated to the Assunta, is impressive above all for its size and austerity. Whoever enters it from the courtyard and through the main portal stands in a steeply proportioned hall lit by extremely narrow Gothic lancets and adjoined by a square choir. From afar, the situation is reminiscent of the Arena Chapel, but the space in Naples is larger and higher, and there is no vault in the nave. Instead, the hall is covered with an open roof truss floating high above the visitors' heads. If this entire room was really painted by Giotto, as Pietro Summonte assures us half a century after the destruction of the murals (2.6.6), and as would also corresponds to the duration of the work as documented in the charters (1.2.3, 7), then the decoration was the largest commission our painter ever received. It is certain that Giotto's most prominent client was its patron. King Robert the Wise was not only impressive to his contemporaries and especially the Florentines; later generations also regarded him as a model of an outstanding ruler. Accordingly, with the loss of the frescoes that covered the now empty walls until about 1470, we are missing both Giotto's main work of his later years and one that would perhaps be considered his most important prior to the Arena Chapel. It is also the work that would be best embedded in the early humanist culture after its mention in Petrarch (2.7.2) and through its connection with Robert the Wise. We are also missing a work so demanding that Giotto's approach could hardly have been unaltered. What sets the murals of the Peruzzi Chapel so clearly apart from those of the Bardi Chapel and the other works in the succession of the Arena frescoes may therefore

Fig. 287: Naples, Chapel of the Castel Nuovo, decoration of a window jamb

have to do with the special requirements of the Naples phase.

What has been preserved are fragments from the decoration of the window jambs (fig. 287). Compared to the Arena Chapel, their opulence is striking: Instead of one, two ornamental bands were laid side by side in the jambs, the inner one imitating the finest opus sectile and the other consisting of floral motifs whose material presence leaves the vegetal ornaments in Padua behind. Above all, however, the increase becomes apparent in the hexagons, tracery frames, and medallions, motifs which, as in Padua, interrupt the decorative bands at regular intervals: unlike there, they are adorned with heads. Some are persons in contemporary costume, others seem to belong to an Old Testament context, and others are saints with halos. Without knowledge of the lost pictures on the walls, the attempt to identify them would be hopeless. The Giottesque habitus is obvious throughout; the quality is stable without ever being gripping – which corresponds to the images' decorative function. With Giovanni Previtali it has become clear that the types and forms depicted can be consistently compared with works by Giotto and his pupils.[770] The heads give an impression of the qualitative and personal margins of Giotto's Naples workshop, which seems to have had more features of a *bottega* than of a *cantiere*. As works of art and media of piety, the frescoes of the Capella Grande are lost, but as objects of study for the state of Giotto's and his collaborators' representational technique around the year 1330, they are still available, albeit in a very limited form. I will refer to them from time to time in the following.

It is not easy to say more about Giotto's activity in Naples without speculating.[771] The problems of the narrative tradition, especially concerning the Naples years, have already been addressed (vol. 1, pp. 22–23). The best documented activity seems to be that for the Franciscan double monastery of Santa Chiara, founded in 1310. There are two independent statements from the early 16th century (2.1.6, 2.6.6). And in the convent of Santa Chiara, which was a building site at least until 1340, there is some Giottesque painting.

770 Previtali, *Giotto e la sua bottega*, pp. 129–131.
771 Cf. P. Leone de Castris, *Giotto a Napoli*, Naples 2006.

The altar wall of the nuns' choir in particular gives an example of high quality painting. It showed a monumental Crucifixion scene with a large crowd as well as other pictures. In addition to the figure of the impenitent thief and mourning angels from the Calvary, some impressive heads from a Lamentation have been preserved, which are similar to the paintings in the north transept of the Lower Church of San Francesco in Assisi.[772] From the stylistic point of view, it is therefore easier to connect them to Stefano or his circle than to Giotto himself or his Naples bottega. As far as dating is concerned, it is fundamental that the main figure of the central scene, the crucified Christ, must have been painted on the part of the wall that had been created by bricking up the window connecting the nuns' choir with the main space of Santa Chiara. The reason for this construction work was the erection of the tomb for King Robert the Wise from 1343. The wall constitutes the rear of the monument. One probably has to imagine the Calvary as part of the staging for the royal tomb for the Poor Clares.[773] The fragments in the nuns' choir therefore tell us nothing about how Giotto painted under Robert the Wise, but show how a pupil or pupil's pupil of Giotto served the memory of this king.

THE BARONCELLI RETABLE

Therefore, the only works that are well preserved, that are proven to have been created by Giotto – even through signatures (1.6.2) – and that can be attributed to his late years on the basis of reliable information, are the altarpiece in Bologna with the graffito "1326", which fits into the history of this foundation, and the altarpiece in the Chapel of the Baroncelli family in Santa Croce in Florence. In both cases, the retables are structured by Gothic architecture; in total, there are four "Gothic" retables in Giotto's oeuvre. Hence, it makes sense to treat this group as a whole and to begin with the Baroncelli altar, because here much of the context for which it was intended is still preserved. The dating also depends on the building for which it was made.

That the destination of the retable was the Baroncelli chapel is made sure by several factors: firstly, the presence of the retable in the chapel can be documented back to the early 16th century (2.1.6–10), secondly, the Baroncelli coat of arms appears on the flanks of the predella, and thirdly, the predella, which has been preserved in its original form

772 Ibid, pp. 73–74.

773 T.M. Galliano, *Il complesso monumentale di Santa Chiara in Napoli*, Naples 1963, pp. 54–58. On the programme of the monument: T. Michalsky, "Quis non admireretur eius sapientiam ...?" Strategien dynastischer Memoria am Grab König Roberts von Anjou, in: *Grabmäler: Tendenzen der Forschung an Beispielen aus Mittelalter und früher Neuzeit*, ed. W. Maier et. al., Berlin 2000, pp. 51–73.

Fig. 288: Florence, Santa Croce, Baroncelli Chapel (murals by Taddeo Gaddi)

with its width of 321 centimetres (height 31 centimetres), fits exactly to the mensa of the altar, which has also been preserved in its original form (fig. 288, 289).[774] Unlike the Bardi and Peruzzi chapels, that of the Baroncelli is not part of the original construction project of Santa Croce. It was subsequently placed in front of the south facade of the transept. At the entrance to the chapel is a wall tomb, accessible from both the transept and the chapel, in which an unidentified member of the patronage family rests. The monument bears the following inscription:[775]

+ IN NOMINE DOMINI ANNI. M.CCC.XX.VII. DEL MESE DI FEBRAIO SIDIFICHIO & CHOMINCIO. QUESTA / CAPELLA. P BIVIGLIANO & BARTOLO & SALVESTRO MANETTI. & PVANNI & PIETRO BANDINI. DE / BARONCELLI. AONORE. & REVERENTIA DELNOSTRO SIGNORE IDDIO. & DELLA SUA MADRE. / BEATA VERGINE MARIA. ANNUNTIATA. ALCHUI ONORE LHAVEMO. CHOSI POSTO NOME. / PER RIMEDIO & SALUTE DELLE NOSTRE ANIME. & DITUTTI INOSTRI MORTI.

There were therefore five members of the Baroncelli family who had the chapel built beginning in 1328 (according to our calendar), among them Bartolo Manetti Baroncelli, whose role as defender of the Republic in the battle of Altopascio in 1325 gave him heroic status.[776] Apart from that, the Baroncelli were a family of bankers and merchants, based not far from Santa Croce, and closely linked to the Peruzzi family and company.

774 J. Gardner, The Decoration of the Baroncelli Chapel in Santa Croce, *Zeitschrift für Kunstgeschichte* 45, 1982, pp. 89–114, esp. 98–100.

775 Cit. after ibid. p. 111. The abbreviations were resolved where possible.

776 R.J.H. Janson-La Palme, *Taddeo Gaddi's Baroncelli Chapel: studies in design and content*, Ph.D. Princeton 1975, pp. 339–345.

Fig. 289: Florence, Santa Croce, Baroncelli Chapel: Giotto's retable

If the construction of the chapel was started at the beginning of 1328, it is unlikely that the retable for its altar was made earlier. Since Giotto's years in Naples must also be excluded, only the months of February to November 1328 (cf. 1.2.1) and the period between 1334 (cf. 1.1.67) and 1336, the year before Giotto's death, can be considered for the creation of the panels. The similarity of certain heads on the altar and in the decorative bands of the Capella Grande in Naples, which Previtali pointed out, also harmonises with a creation immediately before or after the Neapolitan phase.[777] In addition to Previtali, who concentrated on the predella, the rendering of the three-quarter profile of prophetic characters in the main panels should be mentioned here: These are designs not previously found in the Giotto studio and which the painter either developed for the altarpiece and used secondarily in the Capella Grande, or vice versa. A conspicuous detail of the figures' clothing also fits a late date: the wide sleeves worn by Christ and some of the angels that reach just above the elbow. Such sleeves are also found in Ambrogio Lorenzetti's allegories for the Palazzo Pubblico in Siena and in the fresco with the Triumph of Death in the Camposanto in Pisa, i.e. on monuments of the thirties. This observation makes a dating of the Baroncelli Altarpiece to 1334–36 somewhat more probable than its creation in 1328.

The appearance of the retable has been badly affected by a remodelling in the 15th century. Only the predella with the signature is in its original state. The beam shows four im-

[777] Previtali, *Giotto e la sua bottega*, pp. 129–131.

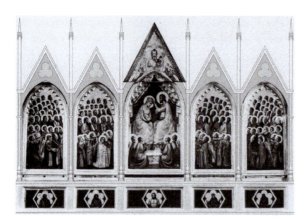

Fig. 290: Baroncelli Retable, reconstruction by Monika Cämmerer

ages of saints in hexagonal medallions and in the centre the *Imago Pietatis*, which is directly before the priest's eyes when he transforms the wine and bread into those substances depicted by Giotto: the flesh and blood of the suffering Christ (fig. 291). Everything above it looked different: Monika Cämmerer has created a convincing reconstruction[778] (fig. 290). The five large panels of the main storey, conceived as pointed arcades, were mounted axially over the five images of the predella. Between them were slender Gothic pillars surmounted by pinnacles with finials. The panels themselves were crowned by gables. The wider central panel (73 as opposed to around 53 centimetres) had a higher pediment than the others. It was detached, has survived and entered the San Diego Museum of Art[779] (fig. 292). As is clear, the ensemble originally presented itself in a decidedly different way than it does today: not as a kind of architecturally orchestrated painting, but as small-scale Gothic architecture reminiscent of the façade of a church or the side front of a golden shrine for relics. Even seen from a distance, the altarpiece would have been an attractive object with a high emblematic value, its silhouette evoking preciousness and modernity.

Painted retables whose frames resemble Gothic architecture had not existed in Italy for long. There is much to suggest that it was Duccio who invented this type for the Maestà of Siena Cathedral, begun in 1308 and transferred from his studio in 1311.[780] Similar to the

778 M. Cämmerer, Giottos Polyptychon in der Baroncelli-Kapelle von Santa Croce: Nachträge und neue Beobachtungen, *Mitteilungen des Kunsthistorischen Institutes in Florenz*, 39, 1995, pp. 374–393.

779 It was not recognised as part of the Baroncelli retable until 1957: F. Zeri, Due appunti su Giotto: I: la cuspide centrale del "Politico Baroncelli"; II: la cimasa del crocefisso del Tempio Malatestiano, *Paragone. Arte* 8, 1957, 85, pp. 75–87.

780 The "tabula" for Santa Chiara in Pisa described in a contract with Cimabue in 1301 was not necessarily a precursor. It showed the Madonna and various scenes and had pillars and a predella ("predula"), but whether the whole thing appeared in the form of a Gothic architectural system remains open. Cf. H. Hager, *Die Anfänge des italienischen Altarbildes: Untersuchungen zur Entstehungsgeschichte des toskanischen Hochaltarretabels*, Munich 1962, p. 113 and A. Prieser, *Das Entstehen und die Entwicklung der Predella in der italienischen Malerei*, Phil. Diss., Hildesheim 1973, pp. 9–10.

Baroncelli altar, the architectural parts of the Maestà are largely lost. There is, however, a 15th-century Sienese panel in the Berlin Gemäldegalerie that combines a scene from the life of St. Anthony Abbas with an interior view of Siena cathedral. One of the lateral pinnacles of the Maestà can be seen half-hidden at the back right (fig. 293). This shows how imposing the golden architectural setting was.[781]

The situation is reminiscent of the large stone retable of the Elisabeth Church in Marburg, which was probably ready for the consecration of the high altar on 1 May 1290: mighty pinnacles with gables and tracery arcades between them and niches underneath for the presentation of sculptural images and relics (fig. 294). The role of the architecture seems overpowering here. But it can be assumed that architecture and images were in a balanced relationship when painted panels filled the arcades, originally made possible by a sliding mechanism. The interplay of painting and architecture was probably the everyday appearance of the altar.[782]

Today, the Marburg altarpiece stands as good as alone – comparable only to a few wooden retables on Gotland. On this island in the Baltic Sea, some High Medieval pictorial forms have been preserved. As far as early retables are concerned, reference should be made to the altar in Lojsta and the one from Ganthem, which has found its way into Stockholm's National

Fig. 291: Baroncelli Retable, predella: Imago pietatis

Fig. 292: San Diego, California, Museum of Art: central pediment of the Baroncelli Retable: God the Father

781 H. van Os, *Sienese Altarpieces 1215–1460: Form, Content, Function. I: 1215–1344*, Groningen 1984, p. 147 (K. van der Ploeg).
782 R. Hamann und K. Wilhelm-Kästner, *Die Elisabethkirche zu Marburg und ihre künstlerische Nachfolge*, vol. 2, Marburg 1929, pp. 91–112. A. Köstler, *Die Ausstattung der Marburger Elisabethkirche: Zur Ästhetisierung des Kultraums*, Phil. Diss., Berlin 1995, pp. 98–105. V. Fuchß, *Das Altarensemble: eine Analyse des Kompositionscharakters früh- und hochmittelalterlicher Altarausstattung*, Phil. Diss., Weimar 1999, pp. 184–86.

Fig. 293: Berlin, Gemäldegalerie: St. Anthony Abbas Attending Mass (Sienese painter)

Fig. 294: Marburg, Elisabeth Church, retable of the high altar

Museum. Similarly to the Maestà, here panel painting was combined with carpentered Gothic architecture and in particular with mighty pinnacles on the outer left and right.[783] It seems that this architecturally articulated form of altarpiece was a type that was endemic in the countries north of the Alps around 1300 and the precursor to the winged altars of the Late Gothic period – no matter whether it was executed in wood or stone, whether it was changeable like the Marburg altarpiece or static like the retables in Lojsta and Ganthem. Such structures must have been in the minds of Duccio and his patrons when they conceived the Maestà. Their orientation towards the transalpine models went hand in hand with an ambition to top everything that had existed in Italy in the field of altarpieces and images of the Madonna, simultaneously initiating the Gothic turn that the cathedral building in Siena took in the following years.[784]

783 N. Wolf, *Deutsche Schnitzretabel des 14. Jahrhunderts*, Berlin 2002, pp. 281–282. P. Tångeberg, *Retabel und Altarschreine des 14. Jahrhunderts: Schwedische Altarausstattungen in ihrem europäischen Kontext*, Stockholm 2005, pp. 43–58 (Ganthem) and 90–93 (Lojsta).

784 D. Norman, *Siena and the Virgin: Art and Politics in a Late Medieval City State*, New Haven and London 1999, pp. 21–43.

The Architectural Polyptych or Buttressed Altarpiece (as Christa Gardner von Teuffel calls the type) created in Siena soon made its way to Florence: this happened with the polyptychs of the Sienese painter Ugolino di Nerio, who was trained in Duccio's circle.[785] The commission for the high altar of Santa Croce, a work that has been preserved in parts, documented in its entirety and reconstructed as an animated film (fig. 295), probably reached him around or soon after 1320 (i.e. after the completion of the eastern parts of the church, see above).[786] The Alamanni family financed this undoubtedly very costly work.[787] Documents attest that Ugolino also created the high altarpiece for Santa Maria Novella, and that it was installed there in 1320.[788] The altarpiece for the Franciscans seems to have been a kind of direct follow-up commission to the altar for the Dominicans. This fits in with their competition between the monasteries, which has already been mentioned in connection with the triumphal crosses (see p. 258). Simone Martini's and Pietro Lorenzetti's polyptychs for Santa Caterina in Pisa and for the Pieve in Arezzo, which are comparable in structure to the Santa Croce altarpiece, are from 1319 and 1320.[789] Henk van Os has stated that around 1320 the impression must have prevailed in central Italy that the most prestigious decoration for a high altar

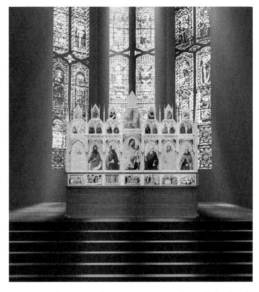

Fig. 295: Florence, Santa Croce, Retable of the High Altar (Ugolino di Nerio, reconstruction)

785 C. Gardner von Teuffel, The Buttressed Altarpiece: a Forgotten Aspect of Tuscan Fourteenth Century Altarpiece Design, *Jahrbuch der Berliner Museen* 21, 1979, pp. 21–65, esp. 48.
786 G. Coor-Achenbach, Contributions to the study of Ugolino di Nerio's Art, *The Art Bulletin* 37, 1955, pp. 154–165.
787 St. Weppelmann, Geschichten auf Gold in neuem Licht: Das Hochaltarretabel aus der Franziskanerkirche Santa Croce, in: *Geschichten auf Gold: Bilderzählungen in der frühen italienischen Malerei*. Exh. cat. Berlin, ed. St. Weppelmann, Cologne 2005, pp. 26–50, esp. 33–34.
788 The evidence compiled at: J. Cannon, Simone Martini, the Dominicans and the Early Sienese Polyptych, *Journal of the Warburg and Courtauld Institutes* 45, 1982, pp. 69–93, esp. 87–88.
789 Van Os, *Sienese Altarpieces* I, pp. 65–71.

460 Giotto Pluralistic: The Peruzzi Chapel in Florence and the Late Works

was a Sienese polyptych.[790] But surely it was not about the origin of the artists from Siena, but about the effect of the buttressed altarpiece.

Ugolino was both a faithful and creative pupil of Duccio. With the work for Santa Croce, not only did an architectural retable come to Florence, but also a new example of Duccio's ability to make events and characters present. In this he was a rival to Giotto. In their occasionally sinister intensity, his saints may have been even more gripping to some viewers. Most of the 35 large and small panels that made up the Santa Croce altarpiece have survived and are scattered around the world; there is also a drawing from the late 18th century showing the structure before it was dismantled.[791] With its seven large, three-quarter-figure "icons" as the main images, it was a distinctly different system from Duccio's Maestà. Basically, the series of pictures in Santa Croce, despite its later origin, represented a more traditional form of the central Italian altarpiece: an oversized dossal with a substructure and superstructures. A direct precursor would be Duccio's polyptych ("No. 28") in the Pinacoteca in Siena, which already consisted of individual panels but did not yet have a Gothic framing.[792] However, it was precisely the Gothic architectural setting and the crowning crest of pediments and pinnacles that connected the two giant retables – the Maestà and the altar of Santa Croce – and made Ugolino's work a modern picture ensemble even by Sienese standards.

Anyone standing in the crossing of Santa Croce after the completion of the Baroncelli altar, say sometime around 1335, would have seen the golden altarpiece of Ugolino di Nerio on the main altar, its delicate pinnacles reaching into the air (fig. 295), and, like an echo, at some distance to the right, Giotto's no less golden and delicate retable on the altar of the Baroncelli chapel (fig. 290). And approaching one as well as the other, one could not only venerate the depicted saints and in both cases Mary, but also learn something about the artists. On one altar one read (according to 18th century tradition): UGOLINO DE SENIS ME PINXIT,[793] on the other, as is well known: OPUS MAGISTRI IOCTI. One altar showed the coats of arms of the Alamanni, the other, those of the Baroncelli.

It is therefore likely that Giotto's design reacted to that of Ugolino di Nerio. But it seems to be decidedly more than just a response to Ugolino and the Alamanni. If we include the founding work of the type – Duccio's Maestà – in the comparison, it becomes clear that the Baroncelli altar combines Ugolino's polyptych system (and at the

790 Ibid. p. 74.

791 Boskovits, *Frühe italienische Malerei*, pp. 162–176. H. Loyrette, Une source pour la reconstruction du polyptyche d'Ugolino da Siena à Santa Croce, *Paragone Arte* 29, 1995, 342, pp. 77–88.

792 White, *Duccio: Tuscan Art and the Medieval Workshop*, pp. 67–72.

793 G. della Valle, *Lettere Sanesi di un socio dell'Academia di Fossano sopra le belle arti*, vol. 2, Rome 1786, p. 201.

same time a system in the manner of the Marburg retable) with Duccio's scene of the adoration of Mary, which is depicted in a single continuous picture (fig. 296): On the one hand, we have several main panels separated by pillars and thus a clearly divided structure. On the other hand the main panels are one representation as in Duccio's work. It runs behind the architectural elements, so to speak. It is precisely this aspect of a representational continuum that is additionally emphasised in the 15th century reconstruction, which brought the panels closer together, and so Giotto's retable has not only lost much of its Gothic character, but also much of its formal tension and sophistication.

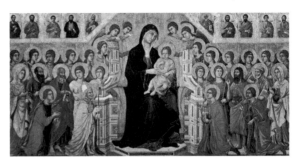

Fig. 296: Siena, Museo dell'Opera del Duomo: Maestà, main panel (Duccio)

The theme of the Coronation of the Virgin complements the programme of murals in the chapel – and opens the question of whether it is the intellectual starting point or the crowning finale. For the consecration of the chapel to Christ and Maria Annunziata, as documented in the inscription, one fits as well as the other. Therefore, it is not possible to draw conclusions as to whether the murals or the panels were conceived first: The immensely creative frescoes by Giotto's old collaborator Taddeo Gaddi depict the life of Mary up to the birth of Christ and the Adoration of the Magi. Giotto's altarpiece presents the triumphant conclusion of Christ and Mary's shared story and recommends it for meditation, a meditation that can only be an inner rejoicing – for Mary's sake, but also for the sake of the viewer who sees our intercessor installed in the heavenly hierarchy.

The central panel with the actual act of coronation would in itself be an appropriate picture of this event. Following the example of Ugolino's high altar, the painter could have combined it with other images of saints, such as "icons" of the four who appear on the predella to the side of the *Imago Pietatis* and whose presence was obviously important to the patrons: Zenobius (?), John the Baptist, Francis and Onophrius. Instead, Giotto added a celestial scene to the central picture on both sides, which appears as its continuation. This frees the central panel from its pictorial nature and creates distance from the narrative style of the wall paintings. The extension allows us to experience what is depicted on the central panel as an overwhelming otherworldly event. This corresponds to the strategy Duccio used to stage Mary's majestic role in heaven on the Maestà. Compared to the Sienese altarpiece, however, the number of saints and angels is multiplied in Giotto's work and the grouping is so crowded that the halos are almost ornamentally clustered. We do not so much experience a heavenly court paying homage to its queen in a ceremony (as is the case in Siena) but rather the mass of celestial dwellers who stream in filled with joy.

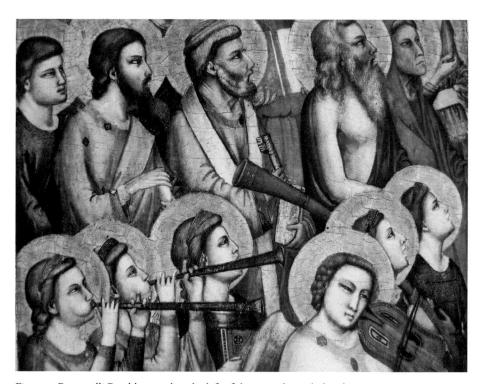

Fig. 297: Baroncelli Retable, panel to the left of the central panel, detail

Seen closely, this jostling takes place in an orderly fashion. Next to the central panel there are persons who can be assigned to an Old Testament choir of patriarchs: On the left, having grown old, are Adam and Eve, who witness the activity of the new Adam and Eve (fig. 297); in an analogous position opposite, Abraham (with little Isaac) and John the Baptist make their appearance (fig. 298). The latter was not only the city saint, but was also considered the last of the prophets. The Old Testament saints are followed on both sides by the apostles – led on the left by Peter and on the right by Paul. Then come the "martyrs" (two men with palm leaves can be discerned on the right side of the left panel) and then the "confessors", i.e. members of religious orders and the church hierarchy. Finally, on the far left and the far right follow the few representatives of female *sanctitas* summoned by Giotto and his patrons. However, neither the structure of the groups (as in the Paduan Last Judgement) nor the division into panels constitutes the visualisation of a ceremonial, i.e. a protocol-regulated appearance of the saints. On the contrary, we have to read the mass of heads independently from the composition if we want to recognise the individuals and from them the groups. And at times the painter even seems to have taken the problem of identification a little lightly: Who is actually Francis, the co-patron

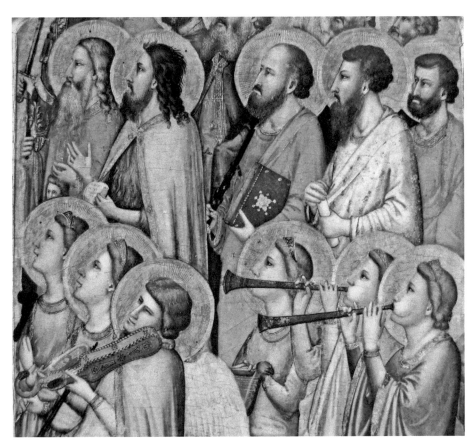

Fig. 298: Baroncelli Retable, panel to the right of the central panel, detail

of the church? Is he the one standing in front of a nun (Clare?) on the left hand panel in the middle, or the one standing next to another friar (Dominic?) on the right hand panel at the bottom left? During the Trecento and early Quattrocento, the Baroncelli altarpiece was probably Giotto's most frequently adopted and varied work. Reference may be made here only to the adaptations by Jacopo di Cione (?) for the high altar of San Pier Maggiore in Florence (London, National Gallery)[794] and by Allegretto Nuzi (?) for a church presum-

794 R. Offner and K. Steinweg, *Jacopo di Cione* (A Critical and Historical Corpus of Florentine Painting, sec. 4, vol. 3), New York 1965, pp. 31–42. D. Bomford, J. Dunkerton, D. Gordon, and A. Roy, *Art in the Making: Italian Panel Painting before 1400*. Exh. cat., London 1989, pp. 156–189, 197–200.

Giotto Pluralistic: The Peruzzi Chapel in Florence and the Late Works

ably in the Marches (Southhampton, Art Gallery).[795] In these and many other cases, the painters improved the identifiability of the individual figures.

In a departure from Duccio's Maestà, but also from the traditional iconography of the Coronation of the Virgin, Giotto provides the background to the event with angelic music: the singing of the angels, in which the saints partly join in, is accompanied by instruments. The accurately portrayed orchestra is extensive; it includes brass and woodwind, strings and two organs. The painter has oriented its acoustic effect towards Christ and Mary: the loudest instruments, the four trumpets, are positioned at the outer edges of the scene so as not to overwhelm them with sound.

One is tempted to cite the mosaic of the Coronation of the Virgin above the west portal on the interior façade of Florence Cathedral as the model for the angelic orchestra. This, however, brings a problematic work into play: Frank Jewett Mather has noted breaks in the mosaic surface and concluded that it is in secondary use und had been moved to this location. It probably comes from the predecessor of the existing cathedral and was created before the decision was made in 1294 not to modernise the old cathedral but to build a new one.[796] In the early Trecento, the mosaic was perhaps the most prominent image of its subject in Florence and will therefore have been relevant for the choice of theme for the Baroncelli altar. It was evidently the model for Mary's unusual gesture of prayer on the altarpiece: arms crossed in front of the chest instead of folded hands or hands gesticulating in supplication.[797] The angels playing music (with their cymbals, woodwind and brass instruments), however, fitted between the reveals and the main group, obviously belong to a reworking; this is shown, for example, by the differences in the representation of the shadows. By adding the musicians, the image, having been removed from its original location, was made suitable for its place on the retro façade of the new building.[798] They were most likely created after the demolition of the western parts of the old cath-

795 *La pittura in Italia: Il Duecento e il Trecento*, 2 vols., Milan 1986, vol. 2 fig. 631.

796 F.J. Mather, *The Isaac Master: A Reconstruction of the Work of Gaddo Gaddi*, Princeton 1932, pp. 42- 50. Summary of recent work: M. Boskovits, *The Mosaics of the Baptistery of Florence*, Florence 2007 (A Critical and Historical Corpus of Florentine Painting, sec. 1, vol. 2), Florence 2007, pp. 591–594. Boskovits considers the current location to be the original one, but does not give any arguments.

797 An overview of the iconography of the coronation of Mary is given in: Ph. Verdier, *Le couronnement de la vierge: Les origines et les premiers développements d'un thème iconographique*, Paris and Montréal 1980.

798 Cf. A. Peroni, Arnolfo architetto: il problema della controfacciata, in: *Arnolfo: Alle origini del Rinascimento fiorentino*. Exh. cat. ed. E. Neri Lusanna, Florence 2005, pp. 108–137. Of course, the mosaic cannot be used as evidence for the dating and attribution of the supporting architecture.

edral, which took place in 1357, and in connection with the transfer of worship to the new space. And this means that it is not Giotto's angelic orchestra that depends on the one in the cathedral, but that the one in the cathedral depends on Giotto. The mosaic in the cathedral was first the model for the Coronation of Our Lady in Santa Croce – i.e. for the two main figures – and this representation, in its expanded form, then became the model for the reworking of the mosaic in the cathedral.

The synaesthetic orchestral version of the Coronation of Our Lady was probably an idea developed for the Baroncelli altar – either by Giotto or with his advice. A prerequisite for this was a wording in the offertory of the Mass for the Feast of the Assumption of Mary. It is the feast to which the image of the Coronation refers: "Assumpta est Maria in caelum: gaudent Angeli, collaudantes benedicunt Dominum, alleluja." Usually this is translated like this: "Mary is taken up into heaven; the angels rejoice and, mingling their praises, bless the Lord, alleluia." The idea of singing angels is suggestive. However, this does not automatically justify the use of instruments. Those, on the other hand, are suggested by a passage in the homilies of Gerhard of Csanád, which Jacobus of Voragine quoted in the *Legenda Aurea* for the feast of the Assumption of Mary and thereby popularized:[799]

> *Today the heavens welcome the Virgin joyfully, Angels rejoicing, Archangels jubilating, Thrones exalting, Dominationes psalming, Principalties harmonizing, Powers harping, Cherubim and Seraphim hymning and leading her to the supernal tribunal of divine majesty.*

799 "Hodie uirginem beatam celi susceperunt letando, angeli gaudendo, archangeli iubilando, throni exultando, dominations psallendo, principatus harmonizando, potestates citharizando, cherubim et seraphim hymnizando atque ad superne diuine maiestatis tribunal ducendo," *Legenda Aurea*, ed. Maggioni, pp. 789–790. English text after: *The Golden Legend: Readings on the Saints*, by Jacobus de Voragine, trans. W.G. Ryan, Princeton 1993, vol. 2 p. 84. This passage was referred to by: A. Gilette, Depicting the Sound of Silence: Angels' Music and "Angelization" in Medieval Sacred Art, *Imago Musicae* 27, 2014/15, pp. 95–125, esp. 107–108 and at the same time by: J.M. Salvador Gonzáles and S. Perpiñá García, Exaltata super choros angelorum: Musical Elements in the Iconography of the Coronation of the Virgin in the Italian Trecento Painting, *Music in Art* 39, 2014, pp. 61–86. A miniature of the Assumption of Mary signed by Niccolo di Ser Sozzo in the so-called Caleffo Bianco (Siena, Archivio di Stato, fol. 7r), which Reinhold Hammerstein pointed out, is probably to be seen in the succession of Giotto's invention rather than as a precursor. Millard Meiss has shown that the leaf was inserted subsequently into the codex, written in the thirties. R. Hammerstein, Die Musik der Engel: Untersuchungen zur Musikanschauung des Mittelalters, Bern and Munich 1962, pp. 225–226; M. Meiss, Note on Three Linked Sienese Styles, *The Art Bulletin* 45, 1963, pp. 47–48.

Nevertheless, nothing is known before Giotto about a proper concert of angels on the occasion of Mary's exaltation and coronation. Björn R. Tammen has pointed out how strange the idea actually is that bodiless spiritual beings make use of man-made sound-producing devices. Even in the 15th century, when following Giotto's model, fiddling, trumpeting and organ-playing celestial beings had long since become the norm, an author known as a music theorist was annoyed by the fact that painters took the liberty of depicting angels playing instruments.[800] So Giotto was by no means on safe ground when he visualised the praise of the angels in a physical form.

In addition, the music-making angels are important for the composition of the scene: the kneeling figures allow the ornament of the halos to be spread over almost the entire height of the panels. They also provide additional cohesion to the representation: by having the first angel kneeling on the left and the first angel on the right repeat the spatial orientation of Mary and Christ respectively, the painter transfers the rhythm of the main group to the side panels.

All in all, the conflict between the sequence of panels in the retable and the mass scene spanning the panels emerges as a fundamental motif of the medium conceived by Giotto. The conflict articulates the fact that the otherworldly event made visible here cannot be captured in a traditional picture. In other words, Giotto uses the polyptych not as a vehicle for presenting a plurality of images, but as a means of transcending the image. Of course, this makes little impression on modern audience. But one must imagine that the scene, which is continuous across the five panels, was really a novelty for the viewers of Giotto's time and could only be experienced as a paradox and challenge to perception.

And the depiction on the central gable may have been equally perplexing (fig. 292): a quatrefoil shows God the Father holding the insignia of his reign and a little branch, probably indicating Mary as the offspring of the root of Jesse. Giotto's painting here makes us see something that is an immense privilege to see, vouchsafed only to children who become angels (Matthew 18:10): "Take heed that ye despise not one of these little ones; for I say unto you, that in heaven their angels do always behold the face of my Father which is in heaven." Giotto also depicts the angels and shows them flying in; but unlike the viewers of the picture, they are hardly able to bear the sight of God: some shade their eyes, some use glasses that are obviously blackened with soot, as if they wanted to observe the sun. The desire to see something that exceeds one's own ability to see was no mere theory: a certain Taddeus de Florentia (for some Giotto's disciple Taddeo Gaddi) complained in a letter to the theologian Simone Fidati that he had almost gone

800 B.R. Tammen, Engelsmusik in der Buchmalerei des 14. und 15. Jahrhunderts: Erscheinungsweisen und Funktionen eines allzu vertrauten Bildmotivs, *Das Mittelalter* 2, 2006, pp. 49–85, esp. 49.

blind while observing a solar eclipse in 1339[801] – whereby we do not know whether he, like Giotto's angels, used technical aids. The paradox that we can easily see something in Giotto's painting, the sight of which the eyes of the angels cannot bear to look at, becomes very real and challenging in the scene. In the altarpiece, Giotto programmatically gives insight into the world beyond.

THE ARCHITECTURAL POLYPTYCHS: GIOTTO'S GOTHIC

The Baroncelli altarpiece may have been Giotto's last buttressed altarpiece, but it was certainly not his first; and if the design was really about entering into a dialogue with Ugolino's high altar of Santa Croce, our painter had long been prepared for it. His most extensive relevant work was probably the altar commissioned by Cardinal Stefaneschi for St Peter's in Rome, which is now on display in the Vatican Pinacoteca. Giotto also painted it in a double sense: he not only painted on it, but additionally depicted it in painting – and the latter he did twice, namely as a picture within a picture and as a picture within a picture within a picture: on the central panel of the reverse side (we will see how it may be determined to be the reverse side) we see Stefaneschi kneeling, as he presents the polyptych, reduced to the size of a model, with his hands covered, to St. Peter (fig. 299). And on the model in the picture, the cardinal with the model can be seen again in tiny detail. As with the church model in the donor's portrait of the Arena Chapel, the artist has portrayed something that did not (yet) exist in its finished state when he painted it. Unlike the Arena Chapel, however, the retable was probably completed according to the plan reproduced here – together with the ornamentation of its golden pinnacles, pediments, crockets, and finials, of which hardly anything remains today.

The representation deserves special attention for two reasons: On the one hand, it transmits, partly directly, partly indirectly by a process of elimination, the original arrangement of the preserved ten (of originally twelve) individual panels, which would otherwise certainly be disputed. On the other hand, the model, reproduced with great attention to detail, can be seen as an argument that Giotto was also the designer of the wooden architecture: the altar portrait illustrates how framing and painting were to be perceived as *one* medium. Likewise, the volume and materiality of the object become clear in the picture; it is not a "panel", but really a kind of golden façade of noticeable depth. The Sienese retables had a similar appearance. But the Marburg high altar is an even better comparison (fig. 294). Like the retable of the Elisabeth Church, the Roman one was a structure that was shaped to a high degree by relatively few but aesthetically powerful architectural elements.

801 I. Maione, Fra Simone Fidati e Taddeo Gaddi, *L'Arte* 16, 1914, pp. 107–119.

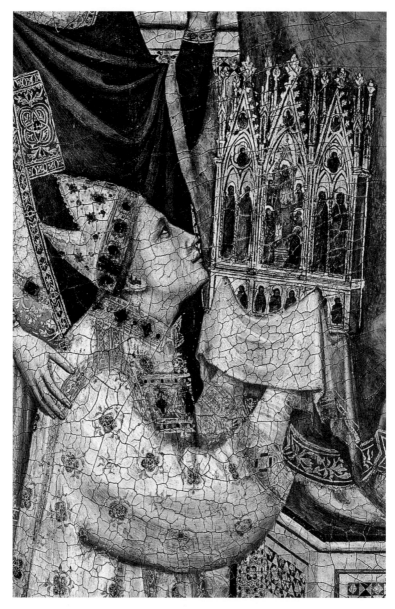

Fig. 299: Rome, Pinacoteca Vaticana, Stefaneschi Altarpiece: the donor and his donation

Moreover, the architectural system that was applied to the Stefaneschi altarpiece and the Marburg retable is practically identical: three arcades of more or less the same height, surmounted by tracery-structured gables, held by four pinnacles. The motifs appear in a precisely defined spatial layering: In front are the pinnacles, behind them the pediments, behind them the arcades. It is a strikingly simple system, highly elaborate in detail, which fits well into the repertoire of Gothic architecture in north-eastern France of the middle to late 13th century, including its Rhenish succession. One speaks of the Rayonnant Style ("radiant style") or also of the court style of Saint Louis.[802] This coherent system differs markedly from the additive Gothic style as realised by Arnolfo di Cambio in the façade of the Florentine cathedral and in his Roman ciboria, but also from the additive Gothic style of the Sienese retables, which has an even less clear structure.

Was the architectural polytychon invented twice, once by Giotto and once by Duccio? The introduction of the type is indeed contextualised better by the situation in Siena than in Florence, where, moreover, the patrons of Ugolino's altars used products from Siena. One must realise how novel Duccio's Maestà was in many respects. The combination of several pictorial forms into one "hyper-picture" (Klaus Krüger)[803] or, in other words, into a Cinemascope simulation of the court of the Queen of Heaven, must have impressed contemporaries immensely (fig. 296) – Giotto included. When painting the Baroncelli Altarpiece, he was still dealing with the leap in quality that had occurred in the Maestà. On the one hand, the main image of the Maestà is based on the Madonna as a panel, the largest example of which Duccio had created himself with the Madonna Rucellai (fig. 147); on the other hand, it is based on what had until then been common as an altarpiece in central Italy, that is, a row of saints decorating a dossale, a low rectangular or gabled board (fig. 320). In addition, there is the presentation of additional scenes, some of which were placed below the main picture as a predella, some on the back, and some as crowning elements. Here, the predecessor retable in the cathedral was probably decisive as a model: it showed a half-figure of Our Lady (the so-called Madonna del Voto) between a total of twelve scenes from the life of Mary and the Passion and topped by the Coronation of Mary.[804] The combination and surpassing of local image types ultimately characterise the ensemble created by Duccio more than the reference to the forms of the Gothic retable in northern Europe. The idea suggests itself that his adoption of the architectural

802 Hamann und Wilhem-Kästner, *Die Elisabethkirche zu Marburg und ihre künstlerische Nachfolge*, vol. 2 pp. 91–93 with reference to Strasbourg. R. Branner, *St. Louis and the court style in gothic architecture*, London 1965.

803 K. Krüger, Die Entwicklung des Altargemäldes in Italien im 14. Jahrhundert, *Kunsthistorische Arbeitsblätter* 12, 2004, pp. 37–48, esp. 45.

804 B. John et al., *Claritas: Das Hauptbild im Dom zu Siena nach 1260: Die Rekonstruktion*, Altenburg 2001.

470 Giotto Pluralistic: The Peruzzi Chapel in Florence and the Late Works

frame was not so much a prerequisite as a consequence of the monumental augmentation of the altarpiece.

Giotto's arrangement of his retables can thus be described as a second invention, since the panel structures and frame systems he designed follow the models developed by Duccio and his successors only in the use of a predella. For the most part, he drew on other sources, namely those that were in tune with transalpine Gothic architecture. In this context, it should be remembered that he is not recorded in Florence in the years 1316 and 17. If we look at the *Ottimo Commento* (2.5.3), it seems possible that he worked in Avignon at that time – either on Stefaneschi's commission or for someone else (vol. 1, p. 48). It is conceivable that he saw retables similar to the Marburg one there. Small-scale Gothic architecture based on Parisian tradition certainly existed in the south of France, whatever its use was.

French Gothic architecture also found its way to Italy in the form of goldsmith's work. A particularly beautiful Parisian reliquary from the second half of the 13th century forms part of the treasure of San Francesco in Assisi (fig. 300). Unfortunately, it is unclear whether it arrived there as a gift from the French royal house in 1285 or 1348.[805] In the first case, the sight of it would probably be one of Giotto's first experiences with Gothic forms. In system and detail, the structure corresponds equally to the Marburg and the Stefaneschi altarpiece, except that the side panels are considerably smaller and folded back at an angle – peculiarities which Giotto could certainly have neglected when designing a retable.

Another possible source is the Gothic small-scale architecture used at the tombs of popes and other members of the Curia of the decades before and around 1300. A Gothic style similar to Rayonnant had a breakthrough in this usage with the monument to Clement IV in Viterbo († 1268), who came from France: The elegant canopy with ornate arcade and steep pediment is a signed work by the Roman sculptor Pietro di Oderisio (fig. 301). As Peter Cornelius Claussen could demonstrate, this master had gained work experience somewhere north of the Alps.[806] Activity at Westminster Abbey is probable on the basis of the signatures; from the head of the reclining figure it is possible to prove in terms of style that Pietro had contact with the sculptors of Reims Cathedral. According to the design, his architecture is as Gothic as its incrustation with *opus sectile* is Roman. Including the two-dimensional decorative motifs in the spandrels of the architectural parts, one

805 *L'art au temps des rois maudits: Philippe le Bel et ses fils 1285–1328*. Exh. cat., Paris 1998, pp. 193–195 (D. Gaborit-Chopin). *Arnolfo: Alle origini del Rinascimento Fiorentino*. Exh. cat., ed. E. Neri Lusanna, Florence 2005, pp. 448–459 (G. Ameri).

806 P.C. Claussen, Pietro di Oderisio und die Neuformulierung des italienischen Grabmals zwischen opus romanum und opus francigenum, in: *Skulptur und Grabmal des Spätmittelalters in Rom und Italien*, ed. J. Garms and A.M. Romanini, Vienna 1990, pp. 173–200.

The Architectural Polyptychs: Giotto's Gothic 471

Fig. 300: Assisi, Museo del Tesoro della Basilica di San Francesco: reliquary

Fig. 301: Viterbo, San Francesco: Monument to Clement IV (Pietro di Oderisio)

would call the canopy a prefabricated part for the Stefaneschi altar. At the canopies of other monuments, which are based on Clement's tomb, pinnacles were soon added (for example at the tomb of Pietro Gaetani in Anagni, who died in 1299).[807]

Also interesting is the incised tomb slab of Bertoldo Stefaneschi in Rome, at Santa Maria in Trastevere, which, as if it were the drawing of a plan, presents a structure consisting of a pointed trefoil arch, a pointed arcade, a pediment with crockets, and lateral pinnacles (fig. 302). Under a canopy similar to that at Clement's monument, there is a group of three arcades with pediments at the tomb of Benedict XI in Perugia († 1304), which join together to form a tabernacle for figures and simultaneously form a figuration similar to the Stefaneschi altar.[808] It should be noted that Bertoldo Stefaneschi

807 J. Gardner, *The Tomb and the Tiara: Curial Tomb Sculpture in Rome and Avignon in the Later Middle Ages*, Oxford 1992, fig. 49.
808 Gardner, *The Tomb and the Tiara*, fig. 72, 124. The date of Bertoldo Stefaneschi's death is not known. However, judging by the course of his career, it is unlikely that it was far into

Fig. 302: Rome, Santa Maria in Trastevere, tomb slab of Bertoldo Stefaneschi

was the cardinal's brother and that Cardinal Stefaneschi and Pope Benedict XI were on friendly terms. This does not mean, of course, that Giotto must have taken the motif from the tombstone in Trastevere or the monument in Perugia; but the context indicates that the patron of the altar moved in circles that appreciated Gothic architecture and valued perfection in this field. Whether the basis of Giotto's design was an altarpiece in the manner of the Marburg one or individual motifs that he himself assembled into a Gothic retable remains obscure. What can be said for certain is that he made greater efforts than the Sienese painters to create a professional and systematic architecture in the sense of French Gothic. He must already have had some basic ideas when he painted the Arena Chapel, for the throne of Justitia there reflects knowledge of works such as the reliquary in Assisi and the tomb of pope Clement (fig. 82). However, it lacks the elegance that results from the intellectual penetration of the system. The all too fragile throne construction of the Ognissanti Madonna is also not quite up to the system, while the tabernacles on the posts of the backrest could have been taken directly from the Assisan reliquary (fig. 270).

In contrast, the painted Gothic architecture that organises the altar wall of the Bardi Chapel is perfect (pl. XVI). This also applies to the multi-layering of the architectural motifs above the arcades of the figure niches. The layers are not only implied, but objectified with great representational effort and are presented to the viewer as an essential element of this type of architecture. While working on the altar wall decoration of the Bardi Chapel, Giotto thus seems to have immersed himself (once again) in the grammar of Gothic architecture. Perhaps one can recognise in this an echo of his possible stay in Avignon in 1316/17. Be that as it may, it was only his insight into this system that enabled him to create retable designs that transposed the

the 14th century: S. Carocci, *Baroni di Roma: Dominazioni signorili e lignaggi aristocratici nel duecento e nel primo trecento*, Rome 1993, p. 430.

The Stefaneschi Altarpiece: Dating and Placement 473

transalpine Gothic style more authentically than any other Italian painter, sculptor or architect had managed in the 14th century. But Florentine colleagues also benefited from Giotto's Gothic. Later I will discuss the polyptych for San Firenze in Florence, which the painter Pacino di Buonaguida created sometime after 1310 and which, despite a different disposition of the panels, is based on the architectural system elaborated by Giotto (fig. 319).

THE STEFANESCHI ALTARPIECE: DATING AND PLACEMENT

The altar in the Pinacoteca Vaticana is secured as Giotto's work and Stefaneschi's donation by two facts: firstly, there are the crests of the Stefaneschi family that were observed by the Vatican librarian Giacomo Grimaldi in the 17th century on the now lost frame of the predella and that were mentioned in his *Index omnium et singulorum librorum Bibliothecae Sacrosanctae Vaticanae Basilicae* of 1603 ("In base stemmata ipsius cardinalis cernuntur").[809] On the Baroncelli altar, too, Giotto placed the donors' heraldic devices on the predella; the information is therefore credible in every respect. Secondly, as is well known, the altar can be claimed for Stefaneschi and Giotto through an entry in the Anniversary Book of the Chapter of St. Peter (1.4.5).

Both mentions are, however, irrelevant to the question of dating. Even if Grimaldi writes in his aforementioned library catalogue that Giotto had painted the "tabula" "around the year of our Lord 1320", this does not help, because obviously this figure is based neither on a scriptural source nor on hearsay, but on his own estimation.[810] In contrast, the appearance of the monk with a mitre kneeling before Peter opposite Stefaneschi and offering him a book instead of an altar model seems to provide a serious clue within the picture (fig. 315). Following a hint by the church historian Ignaz Hösl, Martin Gosebruch named him as Pope Celestine V, who was canonised in 1313. Gosebruch identified the book as Stefaneschi's *Opus Metricum*, which can be read as a description of Celestine's

809 G. Grimaldi, *Index omnium et singulorum librorum Bibliothecae Sacrosanctae Vaticanae Basilicae* (BAV, inv. 405), fol. 121r. M. Cämmerer-George, *Die Rahmung der toskanischen Altarbilder im Trecento*, Strasbourg 1966, p. 121.

810 Grimaldi, *Index omnium et singulorum librorum Bibliothecae Sacrosanctae Vaticanae Basilicae*, fol. 121r: "Tabula ex nuce Indica in utraque facie manu Jotti pictoris eximii circa annum Domini MCCCXX depicta." It is therefore inaccurate if authors claim that the altar was dated 1320 according to Grimaldi. This is also found in: W.F. Volbach, *I dipinti dal X secolo fino a Giotto* (Catalogo della Pincoteca Vatikana I), Vatican City 1979, p. 48 and *Giotto: Bilancio critico di sessant'anni di studi e ricerche*. Exh. cat. ed. A. Tartuferi, Florence 2000, p. 155 (G. Ragionieri).

474 Giotto Pluralistic: The Peruzzi Chapel in Florence and the Late Works

life and legacy and was completed by 1319 at the latest.[811] Other identification of the monk and bishop are: St. Augustine (according to Julian Gardner) and St. Nicholas (according to Ferdinando Bologna). These do not help in the question of dating. In this case, the only valid indication would be the mitre that Stefaneschi wears on one of the two donor portraits. This would mean that the creation of the altar could be dated to the entire time-span of his cardinalate from 1296 until Giotto's death in 1336. Gardner used this leeway to date the work to the Jubilee year 1300. For him, the Stefaneschi altar and not Duccio's Maestà is the first architectural polyptych. That a work realised by Giotto for St. Peter's Church in Rome could have established a genre is indeed a plausible idea. On the other hand, a closer look reveals that Giotto did much to make Stefaneschi appear aged in the two portraits on the altar (fig. 299). No matter what time he had originally traced the cardinal's profile line, when he used it for the altar's donor images he added crow's feet and other wrinkles. If he had wanted to portray a man of about thirty, he would have had no reason to do so.

Another argument for the dating can be gained from an iconological problem. The side panels of the front show the martyrdoms of Peter and Paul (fig. 303, pl. XVII, XVIII). The painter based his designs on the visual formulations common in late 13th-century Rome, as preserved in the Capella Sancta Sanctorum at the Lateran and documented by drawings after murals in the vestibule of Old St. Peter's. Cimabue had also used them in the north transept of the Upper Church of San Francesco in Assisi. In the Crucifixion of Peter, in Giotto's, as in Cimabue's, case, the model appears almost as a quotation (pl. XVII, fig. 304): in the centre we see the inverted cross and on the right and left two antique tomb buildings which were regarded as emblems of the *Ager Vaticanus*.[812] In Cimabue's and Giotto's scenes of the martyrdom of St. Paul, the canonical model appears more discreetly, but is nevertheless evident: in the centre of the pictures, as if he were the main figure, stands the executioner with the sword; the severed head of the apostle already lies on the ground. Giotto clearly shows the three springs that purportedly rose where the

811 I. Hösl, *Kardinal Jacobus Stefaneschi. Ein Beitrag zur Literatur und Kirchengeschichte des beginnenden vierzehnten Jahrhunderts* (Historische Studien 61), Berlin 1908, p. 118 note 18. M. Gosebruch, Giottos Stefaneschi-Altarwerk aus Alt-St. Peter in Rom, in: *Miscellanea Bibliothecae Hertzianae* (Römische Forschungen der Bibliotheca Hertziana 16), Munich 1961, pp. 104–130. That with the appearance of Celestine V there is not only a *terminus post quem* of 1313, but also a *terminus ante quem* of 1317 (John XXII's Bull *Quorundum exigit*) is a false interpretation. It ignores the fact that veneration of saints and ecclesiastical politics are different social practices: the devotion to an ascetic saint at the Curia and a politics of the Curia directed against the ascetic spirituals are not mutually exclusive. Cf. A. Mueller von der Haegen, *Die Darstellungsweise Giottos mit ihren konstitutiven Momenten Handlung, Figur und Raum im Blick auf das mittlere Werk*, Phil. Diss., Braunschweig 2000, p. 282.

812 M. Demus-Quatember, *Est et alia pyramis*, Rome and Vienna 1974.

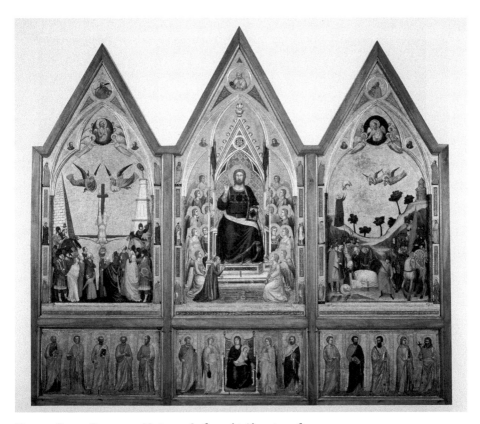

Fig. 303: Rome, Pinacoteca Vaticana, Stefaneschi Altarpiece: front

apostle's head struck the ground three times (pl. XVIII). This follows a Roman legend that was little known outside the *urbs*; it did not even find its way into the *Legenda Aurea*. Analogous to the Vatican buildings, one could call the springs the landmarks of the Abbey of Tre Fontane.[813] With these motifs, our painter met the expectations of his Roman audience, just as Cimabue had served the expectations of his curial patrons in Assisi.

It is revealing to see how Giotto simultaneously also altered the two pictorial formulas and, in doing so, made a choice that appears surprising compared to his other compositions.[814] Contrary to what the decidedly vertical format of the panels should have suggested, he increased the number of figures and reduced their size. This led to compositions and pictorial narratives not otherwise found in his oeuvre. In the case of the

813 G. Moroni, *Dizionario di erudizione storico-ecclesiastica*, vol. 13, Venice 1842, pp. 60–61.
814 Lisner, Giotto und die Aufträge des Kardinals Jacopo Stefaneschi für Alt-St. Peter II, p. 80.

Fig. 304: Assisi, San Francesco, upper church, north arm of the transept: The Crucifixion of Peter (Cimabue)

Paulus panel, the painter compensated for the resulting difficulties by introducing the subplot of the Miracle of Plautilla's Veil – taken from the *Legenda Aurea* and otherwise not found in Rome.[815] Narrating the scene as an event separate from the actual martyrdom could not be easily deduced from the text. This shows once more how important an additional focal point of action in the picture was to Giotto.[816] The Plautilla scene, for its part, required and enabled the introduction of a landscape that was more than a background; it becomes a motif that shapes the middle strip of the picture and helps to manage coping with the vertical format (pl. XVIII, fig. 305). In the Crucifixion of Peter the problems are even more obvious (pl. XVII): the figures gather at the bottom of the picture like water in a vat; the painter had to cover the zone above them largely with Peter's legs and buildings. For the upper zone, the *Legenda Aurea* again assisted by providing the report of a miracle: a book is shown from which Christ (depicted by Giotto as winged and with an angel as his companion) lets the dying apostle read and draw inspiration for his last sermon.[817] But without the horsemen, the composition would not work. They link the figures at the bottom of the panel with the architectures rising into the heights of the gold ground. On the Paulus panel, too, the riders are part of Giotto's contribution to the narrative and there, too, they are of great importance compositionally.

What Giotto added to the Roman formulations was personnel from a picture type which, among German-speaking art historians, has been called "volkreicher Kalvarienberg" (crowded calvary) since Elisabeth Roth's dissertation (1958).[818] And especially the

815 G. Bauman, The Miracle of Plautilla's Veil in Princeton's Beheading of Saint Paul, *Record of the Princeton University Art Museum* 36, 1977, pp. 3–11.
816 *Legenda Aurea*, ed. Maggioni, p. 581–582.
817 Idid. p. 569.
818 E. Roth, *Der volkreiche Kalvarienberg in Literatur und Kunst des Spätmittelalters*, Berlin (2) 1967.

decked-out horsemen hint at which concrete source our painter consulted: it was Pietro Lorenzetti's large Crucifixion in the southern transept of the lower church in Assisi (fig. 306). The pair of horsemen in front of the terebinth in the Martyrdom of Peter is taken directly from this scene: we see a half-profile to the right and a profile to the left aligned in conversation. This is precisely how the two horsemen meet at the feet of the Good Thief in Assisi. But even those who simply praise Giotto's grouping of the figures in the two scenic panels can easily get into a rut that carries them away from the Paduan Giotto or the Giotto of the Bardi Chapel. Margrit Lisner writes:[819]

fig. 305: Stefaneschi Altarpiece, front, The Decapitation of St. Paul, detail: Plautilla's veil

> *In Giotto's entire oeuvre, it is difficult to find any other depiction in which the gestures of the figures, the coherence and the interplay of movement and gaze are so manifoldly understood and effortlessly integrated into the quiet flowing back and forth of the composition as in the Crucifixion of Peter.*

As we know, the Sienese painted the murals in Assisi most likely between 1316/17 and 1319. The Calvary scene was a reinterpretation of the theme of the Crucifixion, with the painter specifically wanting to outdo a slightly earlier picture on site, namely the Crucifixion by Giotto's pupil Stefano in the northern transept of the Lower Church, to which Pietro's work appears like a more splendid counterpart. In general, there seems to have been a competition in San Francesco regarding painted crucifixions. Cimabue had already designed tradition-breaking visualisations of the event for the transept walls of the upper church. One of the things that set Pietro Lorenzetti apart from Cimabue and Stefano was the introduction of horsemen. In including them, he drew on the crucifixion relief at Giovanni Pisano's pulpit in Pisa Cathedral. But Pietro's riders – unlike Giovanni's – are magnificently decked out in keeping with contemporary fashion and contribute less to the action than they do to the atmosphere. They are efficiently used supernumeraries. One could speak of a Hollywood effect: The riders enrich the scenery and make it believ-

819 Lisner, Giotto und die Aufträge des Kardinals Jacopo Stefaneschi für Alt-St. Peter II, p. 83 with reference to Gosebruch, Giottos Stefaneschi-Altarwerk aus Alt-St. Peter in Rom, pp. 119–121.

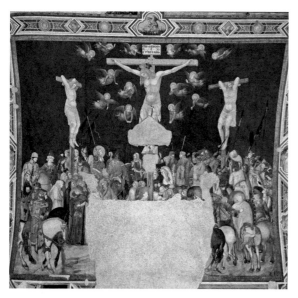

Fig. 306: Assisi, San Francesco, lower church, south arm of the transept: The Crucifixion (Pietro Lorenzetti)

able. The role of the riders in Giotto's scenes at the Stefaneschi altar can be described in a similar way.

This implies a *terminus post quem* of 1316/17 for the altarpiece, and it also means that the work was executed after, rather than before, the Bardi Chapel. The panels were most likely painted in Florence. However, Giotto could hardly have done without a preparatory visit to Rome, which may have given him the opportunity not only to refresh his knowledge of the iconography of the martyrdoms of Peter and Paul in Rome, but also to find out about the state of affairs in Assisi during a side trip. In contrast, Stefaneschi need not have left Avignon. It is more likely that his two later commissions to Giotto – the one for the "Tribuna" and the one for the retable – were intended as substitutions for the cardinal's physical presence in Rome. Without taking on the dangers of travel and without neglecting his duties at the Curia, he was able to demonstrate *pietas* and care addressing God and his fellow canons in the medium of Giotto's painting.

This leads to the question of the location Stefaneschi intended for the altarpiece. As with the case of the "Tribuna" or "Capella", the readers of the relevant sources, beginning – as far as I can see – with Francesco Maria Torrigio in the second edition of his *Sacre Grotte Vaticane* (1639), automatically assumed that the retable was destined for the central place of worship at the Vatican, i.e. for the high altar of the basilica above St Peter's tomb.[820] However, we know that the liturgy was celebrated at this altar *versus populum*. Whether it was the pope or his appointee who celebrated, the retable, towering almost three metres high, would have completely hidden the celebration, its miraculous results

820 F.M. Torrigio, *Le Sacre Grotte Vaticane*, Rome 1639, p. 196. Occasionally the altar of the Confessio was also suggested as a location, but it was small and stood against the wall, so that it can be excluded: W. Kemp, Zum Programm von Stefaneschi-Altar und Navicella, *Zeitschrift für Kunstgeschichte* 30, 1967, pp. 309–320, esp. 312.

The Stefaneschi Altarpiece: Dating and Placement

and – perhaps even less tolerably – the celebrant from the *populus*.[821] This problem gave rise to the idea that the retable must have been movable; when there was a service, it was taken away.[822] But apart from the practical problems with this, the question arises here as to whether an altarpiece is there to decorate the church interior or whether it should serve to adorn the service. In addition, the explicitly architectural structure of the Stefaneschi altar artfully evoked the opposite of portability. And finally, the polyptych was also unsuitable for this location in terms of the character of its images: since the stipes of the high altar stood close to the edge of the podium above the venerated tomb, the side *versus populum* – either the Peter or the Christ side – could only have been seen from a considerable distance, and neither is obviously designed for this. The Christ side with the martyrdoms is designed to be decidedly near-sighted, and the other side is also not equipped with anything that would suit seeing from a distance.[823] Wolfgang Fritz Volbach concluded from all this that the Stefaneschi altar on display in the Vatican Pinacoteca since 1932 and previously stored in the sacristy of St. Peter's (and documented there since Vasari) was not the altarpiece mentioned in the sources and therefore not a work by Giotto.[824] However, this ignores the fact that all other indications point in the opposite direction.

A suggestion made by Bram Kempers and Sible de Blauuw is more plausible, namely, that Giotto's and Stefaneschi's altarpiece was *not* intended for the high altar of St. Peter's. The Anniversary Book states that Giotto's retable stands "super eiusdem basilicae sacrosanctum altare" (1.4.5). This phrase cannot simply be translated as "on the high altar", since, first, altars are always entitled to the epithet "highly sacred", secondly, the common terms for "high altar" are "altare maius" and "altare summus", and thirdly, there is no definite and no indefinite article in Latin. The correct translation is therefore: "on the or a highly sacred altar of the basilica". But even if one assumes that the term must be understood in the definite form, that altar which was called "*the* highly sacred altar" by the members of the chapter of St. Peter's and for which the book was kept need not be

821 Wolfgang Kemp has pointed out the problem: Kemp, Zum Programm von Stefaneschi-Altar und Navicella, pp. 312–313. Later, the sources were compiled and the assumption could be secured: B. Kempers and S. de Blaauw, Jacopo Stefaneschi, Patron and Liturgist: A new hypothesis regarding the date, iconography, authorship and function of his altarpiece for Old Saint Peter's, *Mededeelingen van het Nederlands Instutuut te Rome* 47, n.s. 12, 1987, pp. 83–113 and figs., esp. p. 95.

822 H. Hager, *Die Anfänge des italienischen Altarbildes: Untersuchungen zur Entstehungsgeschichte des toskanischen Hochaltarretabels*, Munich 1962, p. 194.

823 A drawing made by Luca Virgilio for the Milan exhibition catalogue once again shows the problems very clearly – although it was made to show solutions: P. Zander, Giotto e la basilica di San Pietro: Il polittico nella basilica, in: *Giotto, l'Italia*. Exh. cat. ed. S. Romano and P. Petraroia, Milan 2015, pp. 114–127, esp. fig. 1.

824 Volbach, *I dipinti dal X secolo fino a Giotto*, p. 48.

the high altar of the basilica. The term can also mean the altar at which the Chapter cele-brated and which was virtually a second high altar, i.e. the altar in the so-called Chorus Canonicorum or Santa Maria de Cancellis.[825] Once again, we are talking about the space in front of the pillar of the triumphal arch on the Gospel side. I believe that we are dealing with the same section of St. Peter's whose pictorial decoration Giotto had already created in 1312/13 on Stefaneschi's commission. As we have seen, the murals, which included an image of the Madonna, could only have been on the pillar or an extension of the pillar. And a few metres away from this backdrop, one has to imagine the retable, and in front of the retable, the choir stalls of the canons enclosed by low parapets. When they gathered there to pray, they looked at Giotto's altarpiece and received spiritual inspiration from it, including the inspiration of saying a prayer for their brother Cardinal Stefaneschi, who was serving in Avignon.

THE STEFANESCHI ALTARPIECE: PETER AND PAUL AND THE HOLINESS OF ROME

Although scholars have typically described a two-sided retable with a predella, they could just as easily have described two two-sided retables placed one above the other, for the predella is unusually high (43 centimetres) – compared to Duccio's Maestà, Ugolino's Santa Croce altar, and the Baroncelli altar. But presumably ideas about which individual parts an altarpiece should be composed of and how it should "transport" its contents were generally less fixed in the early Trecento than we might expect from our knowledge of the polyptychs of the late and middle Trecento. If we mentally remove the upper images from the Stefaneschi altar, we are left with a low retable that could be called a bilateral dossal; this is a form that can also be found elsewhere in the first half of the Trecento.[826] There is no doubt about which side is the front: it is the row of pictures showing the Madonna enthroned between two angels in the middle and the twelve apostles at the side. Directly adjacent to the Madonna and the angels on the central panel are Peter on her right and Paul on her left (fig. 307). The other ten disciples follow on the side panels. What we have

825 Kempers and de Blauuw, Jacopo Stefaneschi, Patron and Liturgist. This thesis is taken up in the following contribution: Chr. Smith and J.F. O'Connor, *Eyewitness to Old St. Peter's: a study of Maffeo Vegio's "Remembering the ancient history of St. Peter's Basilica in Rome": with translation and a digital reconstruction of the church*, Cambridge 2019, pp. 272–284. Inci-dentally, Kepers and de Blauuw do not consider Giotto to be the author of the altar, but an Avignonese painter from the circle of Simone Martini (p. 92).

826 J. Gardner, Fronts and Backs: Setting and Structure, in: *Il contributo dell'analisi tecnica alla storia dell'arte*, ed. H.W. van Os und J.R.J. van Asperen de Boer (Atti del XXIV Congresso Internazionale di Storia dell'Arte, Bologna 1979), Bologna 1983, pp. 297–322, esp. 300.

Fig. 307: Stefaneschi Altarpiece, front, central panel of the predella

before us is the most obvious programme for an altar dedicated to the Virgin in a church of the Apostles, just, indeed, like the altar in the chapel of Santa Maria de Cancellis. The row of pictures above it is more difficult to understand: an enthroned Christ surrounded by angels occupies the centre (178 by 88 centimetres) and the martyrdoms of the princes of the Apostles can be seen on the left and right (167 by 82 centimetres).

The appearance of Christ enthroned (fig. 308) relates to at least two, perhaps even three or four other images. Not only Christ himself, but also other images of Christ are made present in this figure. This explains his aloofness, or perhaps better, unrealness, an impression that can be objectified by looking at the projection. The rigid symmetry of figure and seat does not follow Giotto's Madonnas: from Our Lady of San Giorgio alla Costa to the one on the predella of the Stefaneschi altar, they always appear slightly asymmetrical. As a result, they seem to be animated. The same applies to the enthroned God the Father above the triumphal arch of the Arena Chapel. In contrast, the exact symmetry of Stefaneschi's Christ is found earlier in the allegory of Justitia in the Arena Chapel and thus in a depiction that presents us not with reality but with an artefact.[827]

The first reference image of the Christ figure on the central panel is another famous panel with the enthroned Salvator in Rome: the highly venerated icon, "not painted by human hands", in the Capella Sancta Sanctorum of the papal palace at the Lateran. The image existed not only as an original and as a variant painted on the wall of the

[827] Julian Gardner used these differences as an argument for the early dating of the Stefaneschi altarpiece: J. Gardner, The Stefaneschi Altarpiece: A Reconsideration, *Journal of the Warburg and Courtauld Institutes* 37, 1974, pp. 57–103, esp. 89. John White has already shown that this cannot work: White, *Duccio: Tuscan Art and the medieval workshop*, p. 142.

Fig. 308: Stefaneschi Altarpiece, front, central panel: Christ enthroned

chapel (fig. 309), but had also spread across the Roman countryside in a series of copies. And in Rome it was not always found exclusively at the Lateran, but during the night before the Assumption it was carried in a procession to Santa Maria Maggiore, where the Son in the form of image visited his mother.[828] Whoever takes this context into account understands that Giotto's enthroned Christ is not a surprising feature at an altar of Mary. The other point of reference is the apse mosaic of Old St Peter's (fig. 310), which showed Christ enthroned between figures of Peter and Paul (as on the retable the image of Christ appears between pictorial narratives of the martyrdoms of Peter and Paul). Looking at the central panel, the pious beholders could think of the icon of the Sancta Sanctorum and at the same time recognise in it a repetition of the main figure in the apse image. When sitting in the choir stalls, most of the canons could probably see both images simultaneously. The third point of reference – uncertain, but worth considering – is also an apse decoration: the mosaic of the basilica of San Paolo fuori le mura. It also shows Christ enthroned between Peter and Paul, with an additional figure on the left and right: Andrew (Peter's brother) and Luke (who, as the author of the Acts of the Apostles, is Paul's biographer). My assumption that viewers of the altar were also reminded of this image is based not least on the depiction of St Paul's martyrdom on the retable; Paul himself is buried not far from the mosaic, and his body was visited by the same pilgrims who also prayed at the tomb in St Peter's. If this is true, it can be said that Giotto's enthroned Christ exemplifies a significant part of Rome's sacred topography.

Fig. 309: Rome, Lateran, Capella Sancta Sanctorum: Christ enthroned (unknown painter)

The most important sacred object alongside the apostle's tomb and the greatest pilgrimage attraction of St. Peter's – apparently even above the tomb – was the so-called Veronica, an image of the face of Christ imprinted on a cloth, or so it was believed. It was kept in a tabernacle in the right aisle – documented by a drawing in Grimaldi's *De-*

828 Gardner, The Stefaneschi Altarpiece, pp. 73–74. H. Belting, *Bild und Kult: Das Bild vor dem Zeitalter der Kunst*, Munich 1990, pp. 363–364. G. Wolf, *Salus Populi Romani: Die Geschichte römischer Kultbilder*, Phil. Diss., Weinheim 1990, pp. 37–78. *Il volto di Cristo*, Exh. cat. Rome, ed. G. Morello and G. Wolf, Milan 2000, pp. 39–63.

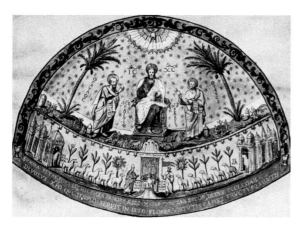

Fig. 310: Rome, Archivio di San Pietro (A 64 ter, c 50): copy after the apse mosaic of Old St. Peter's

Fig. 311: Mirabilia Urbis Romae (BAV, Inc. VI 17): The Showing of the Veronica (woodcut)

scriptio of the old St. Peter's Church on fol. 92v. The chapter of St Peter's was responsible for presenting it to the pilgrims (fig. 311). The Veronica is the last – again uncertain but worth considering – point of reference for the enthroned Christ on the panel. Admittedly, Giotto's figure contains no references to the shape of the relic, i.e. to the textile material of the image and the fact that it showed only the face. On the other hand, the Veronica was *the* Christ relic of St. Peter's. It was permanently present in the church, at times visible but more often invisibly contained in its case. And so we may be faced with a complementary reference in the retable: Stefaneschi and Giotto show their audience the one, who is in the church not only in prayers and pictures, but also as a relic and thus physically present.

In the case of the martyrdoms of the apostles on the side panels, it should be noted that Giotto not only modernised and enlivened the common Roman pictorial formulas with the motifs from the "Crowded Calvary", but also thereby upgraded the events depicted – and this was probably the most important objective for the change. This is particularly evident in the scene of St. Peter (pl. XVII): as if it were Christ who is being crucified, a woman embraces the trunk of the cross and thus forces herself into the role of Mary Magdalene,[829] the role that Giotto himself invented in the Arena Chapel (p. 93). Introduced to Assisi by his pupil Stefano (in the north transept of the Lower Church – fig. 312), the kneeling Magdalene had been adopted by Pietro Lorenzetti in his Calvary scene in the south transept; this can be said although the part of the fresco is missing

829 Supino, *Giotto*, p. 69.

precisely where the Magdalene was, since there is a complete copy in the Sacro Speco.[830] Mary Magdalene was thus already established as a participant in the event of the crucifixion. The fact that the pseudo-Magdalene of the Stefaneschi altar approaches Peter corresponds on the one hand to his responsibility as the patron of the penitent and the refuge of sinners. On the other hand, the alignment of Peter's crucifixion with Christ's crucifixion transforms Peter's martyrdom into a kind of redemptive passion. If Peter humbly rejected the resemblance to Christ when, according to the legend, he demanded to be crucified upside down, Giotto nonetheless pictorially restored Christlikeness to his death. The Francis-

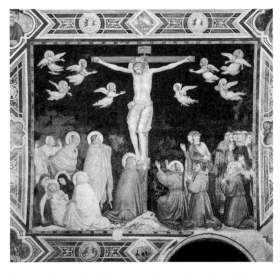

Fig. 312: Assisi, San Francesco, lower church, north transept: The Crucifixion (Stefano)

can devotional model of *christoformitas* may have been involved in this – but the essential idea, it seems to me, is again one that has to do with topography.

This is also indicated by the fact that Giotto specified the topographical details in the Paul scene. On the Peter panel, in accordance with the pictorial tradition, two ancient sepulchral buildings mark the Ager Vaticanus (pl. XVII). These are the so-called Romulus Pyramid, which stood upright until the 16th century, and the Terebinthus Neronis, which had already disappeared in the High Middle Ages, a structure which was described as follows in the 12th century (I quote from the *Descriptio Basilicae Vaticanae* by Petrus Mallius): "This building was round with two circles like the Castle (of the Holy Angel). The edges of the circles were covered with stone slabs that served as eaves. Next to this building, the Apostle Peter had been crucified."[831] Giotto obviously did not see the monument anymore, but, like Cimabue, adopted the pyramidal type developed in the painting of late Dugento Rome, which is not only called Terebinthus, but also has a (terebinth) tree growing on it. This probably has to do with the uncertainty as to how one should read the

830 S. Romano, *Eclissi di Roma: Pittura murale a Roma e nel Lazio da Bonifacio VIII a Martino V (1295–1431)*, Rome 1992, pp. 345–349.

831 "Quod aedificium rotundum fuit, cum duobus geronibus, sicut castrum; quorum labia erant cooperta tabulis lapideis pro stillicidiis. Et juxta hoc aedificium cruxifixus fuit Petrus apostulus." Cit. after R. Valentini and G. Zucchetti, *Codice topografico della cittá di Roma*, 4 vols., Rome 1940–53, vol. 3 pp. 375–442, esp. 431.

statement in the late antique *Passio Apostolorum Petri et Pauli* that Peter found his tomb "sub terebinthum [...] in locum, qui appellatur Vaticanus": Is this phrase about a terebinth tree or the monument called Terebinthus?[832] Be that as it may, on the Petrus panel the references to the area at the Vatican are as precise as possible, without the painter having to do more than follow the conventions.

On the other panel, in accordance with tradition, the location south of the walls is characterised by the three springs and its rural situation. In addition to this, Giotto introduces a round building on a hill (pl. XVIII, fig. 305). This is most likely the tomb of Caecilia Metella, an ancient mausoleum visible from afar on the Via Appia. Already in Giotto's time, it bore the popular name Capo di Bove. It is an obvious landmark for the southern outskirts of the city and as such it has been used as an image alongside the Pauline shrines of Tre Fontane and San Paolo fuori le mura since at least the 15th century.[833] In Giotto's time, it was not a forgotten and remote ruin, but a centre of Roman social life. The Caetani family, connected to the Stefaneschi and the Orsini, from which Boniface VIII came, had acquired the *rotunda* in 1302 and developed it into a luxurious country residence with a palace and a Gothic chapel.[834] All in all, it seems that the two side pictures of the retable were not only intended to show Christ-like passions, but also to remind their viewers that Rome was the location of these events. The images suggest that the Christ-likeness of the Roman apostles is paralleled by the Golgotha-like holiness of the Roman earth, itself soaked in the blood of the apostles – from the Vatican in the northwest to Tre Fontane in the south. And the two medallions in the pediments above the scenes also seem to me to propagate the sacredness of the place (pl. XVII, XVIII): The *tondo* on St. Peter's side shows Abraham, to whom and his descendants the Promised Land was given by God for the first time; the *tondo* on St. Paul's side shows Moses, who received Palestine for Abraham's offspring for the second time.

Stefaneschi, based in Avignon, recommended to his fellow canons in Rome that they meditate on the theme of the city of Rome as a promised land. It is a programme that is in the spirit of the Holy Year 1300: this applies to the emphasis on Peter and Paul, whose funeral churches were at the centre of pilgrimage and spirituality of the Holy Year. This also applies to the accent on the Lateran church set by means of the Christ panel; Boniface VIII

832 F. Tolotti, Dov'era il terebinto del Vaticano?, *Mélanges de l'Ecole Française de Rome. Antiquité* 91, 1979, pp. 491–524.

833 Reference is made to the Rome plan of Pietro del Massaio from 1469. Cod. Vat. Lat. 5699, fol. 127r. A.P. Frutaz, *Le piante di Roma*, 3 vols., Rome 1962, no. LXXXVII. From then on, the motif is encountered frequently.

834 M. Righetti Tosti-Croce, Un'ipotesi per Roma Angioina: La cappella di S. Nicola nel Castello di Capo di Bove, in: *Roma Anno 1300: Atti della IV settimana di studi di storia dell'arte medievale dell'Università di Roma La Sapienza (19–24 maggio 1980)*, ed. A.M. Romanini, Rome 1983, pp. 497–511.

The Stefaneschi Altarpiece: Peter and Paul and the Holiness of Rome 487

had subsequently included the Lateran in the cult events with the festivities for Easter and the Assumption of Mary.[835] But this also applies to the idea that the Jubilee was – as one would say today – a sustainable event whose significance did not end with the beginning of the year 1301. It was noted that Rome's urban development was shaped by the Jubilees for centuries.[836] Stefaneschi himself, with his *Liber de centesimo seu iubilaeo anno*, wrote the most important text about the first Jubilee, clearly addressing posterity; in doing so, he alluded to Virgil and the *Aeneid* and characterised the Holy Year as the beginning of a great future:[837] "With the hundredth return of Phoebus, a golden age is dawning." It may well be that many pious Romans, and among them Stefaneschi's fellow canons, imagined themselves after 1300 to be in a new era in which Rome assumed a spiritual role. They had attended to the huge number of pilgrims attracted by the Jubilee in St. Peter's, preaching and hearing confessions, and continued to attend to them in the years that followed. Especially in the difficult phase of the Avignonese papacy, the spirit of the Jubilee was certainly more than nostalgia for them. The virulence of this spirit in Rome is perhaps best demonstrated by the fact that the initiative for a new Holy Year in 1350 came not from the Pope and not from the Curia in Avignon, but from the Romans.[838]

The arguments given by Giotto's painting for the sanctity of Roman earth were, on the one hand, the persistent presence of Christ in the city through images and relics and, on the other, the martyrdoms of Peter and Paul, whose sacrifices formed the foundation of the salvific power that had accumulated in the city. In the first of the two "heroic songs" (*Eroyca carmina*), which come at the end of his *Liber de centesimo*, Stefaneschi wrote about the two apostles:[839]

> Nam gemini roseis Urbem sacrare triumphis
> Luce pari, nec Roma deest, nec premia servi
> Iudicis, hinc cumulant templis sua munera divi.

835 A, Frugoni, *Il Giubileo di Bonifacio VIII*, ed. A. de Vincentis, Rome and Bari 1999. M. Maccarrone, L'Indulgenza del Giubileo del 1300 e la Basilica di San Pietro, in: *Roma Anno 1300: Atti della IV settimana di studi di storia dell'arte medievale dell'Università di Roma La Sapienza (19–24 maggio 1980)*, ed. A.M. Romanini, Rome 1983, pp. 731–752, esp. 749–750. A. Ilari, La canonizzazione bonifaciana del giubileo, in: *La storia dei Giubilei. 1: 1300–1423*, Florence 1997, pp. 184–197.

836 G. Palumbo, *Giubileo Giubilei: Pellegrini e pellegrine, riti, santi, immagini per una storia dei sacri itinerari*, Rome 1999, p. 203.

837 "Aurea centeno consurgunt saecula Phoebo." Iacopo Stefaneschi, *De centesimo seu iubileo anno: La storia del primo giubileo (1300)*, ed. C. Leonardi, Florence 2001, p. 34.

838 A. Paravicini Bagliani, Clemente VI e il giubileo del 1350, in: *La storia dei Giubilei. 1: 1300–1423*, Florence 1997, pp. 270–277.

839 Stefaneschi, *De centesimo seu iubileo anno*, p. 34.

> *For through their rose-coloured triumphs won on the same day, the twins have made the city a holy city. All Rome was present, the judge received the honours he deserved. Since then, the saints have filled Rome's churches with gifts.*

All this should be read neither as a patriotic boast nor as a political manifesto. The idea that the altar was intended as an appeal to the Pope to return to Rome from Avignon (as was once speculated in connection with certain secondary branches of the interpretation of the Navicella)[840] only superficially fits the ostentatious Rome-centricity of the pictures. On the one hand, it would have been inappropriate to place such an appeal in St. Peter's Church in Rome instead of in Avignon. On the other hand, Rome's presence on the panels has a clearly spiritual dimension that draws on the mysticism of suffering and the hope of redemption. This is shown by the frames of the two martyrdom scenes, which are occupied by figures of unidentified saints; they participate in the events with all the signs of grief and horror and instruct us, who stand before the images, to do the same. Interestingly, at one point this also works in the opposite direction, namely among the figures within the picture. Three horses in the Paulus scene turn their heads conspicuously to the right, which is incomprehensible until one associates their gazes with the lamenting saint at the bottom right of the frame (pl. XVII). Unlike the riders, the animals – wise animals, like the ox and donkey at the Nativity in Padua and the camel in the Adoration of the Magi there – hear those voices which echo the meaning of the events around them and which we too should hear. The Passion is also present in the donor's appearance before the enthroned Christ (fig. 308): the kneeling man preparing to kiss Christ's feet wears violet, the liturgical colour of the Passion season.[841] And likewise, the deeply sad look of the Madonna on the predella can only be explained as an explicit reference to Mary's foreknowledge of her son's suffering (fig. 307). This subtext of the picture ensemble would have become fully clear, however, only during the celebration in front of the retable, when the priest raised the host so that the white disc became visible between the passions of the apostles and in front of the enthroned Christ (fig. 303).

THE STEFANESCHI-ALTARPIECE:
PETER AND PETER AND THE CURIA AT AVIGNON

While the rhetoric of the front of the altarpiece unfolds in dramatic contrasts of presentation, the back is uniformly tuned. The predella panels showed saints in a manner unusual for Giotto, as three-quarter figures set in fields punctuated with ornament. Only the

840 Mueller von der Haegen, *Die Darstellungsweise Giottos*, p. 283.
841 Lisner, Giotto und die Aufträge des Kardinals Jacopo Stefaneschi für Alt-St. Peter II, p.74.

left panel with Stephen, Luke (?) and James minor (?) has survived (today mounted in the centre, fig. 313).[842] The upper row of pictures presents Peter enthroned in the centre and on each of the side panels two other apostles in relief arcades (fig. 314). Immediately to Peter's right is Paul, the other Roman among the disciples, while the first to Peter's left is his brother Andrew. James the Elder, the patron saint of the donor, follows on the right, and John, the favourite disciple, on the left. So far, this is a programme very precisely attuned to Peter and the Roman cult of the apostles. If the donor describes Rome as a holy city on the front, he devotes himself to St. Peter's Church on the back – and, as will be shown, puts it in a new light.

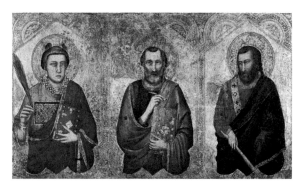

Fig. 313: Stefaneschi Altarpiece, panel from the reverse of the predella

An essential prerequisite for the enthroned Peter on the central panel is certainly the bronze figure of Peter, which is now in St. Peter's itself, but which was originally placed in the church of San Martino behind the choir of the great basilica[843] (fig. 315, 316). The figure was long considered a work of Antiquity. In reality, it is a classicist work from around 1300 – comparable to the Navicella in this respect. Since San Martino belonged to the chapter of St. Peter's, the commission for the figure probably came from the circle of the canons and their relatives – and this also recommended it to the painter as a point of reference in the conception of the altar. But the point of the depiction is not that the bronze figure (re)appears on the panel as a quotation (as various Roman images of Christ appear on the front as superimposed quotations): for one thing, the painter has changed its costume, marking a difference from the statue. Instead of philosopher's clothing, Peter wears liturgical vestments: a red *mantum*, of the kind the pope receives at the investiture, over a white choir shirt.[844] On the other hand, the apostle of the altar seems quite alive and present, among other things through his slightly asymmetrical projection. Also important is the seat, which, unlike Christ's seat on the main side, is not an overly orchestrated fantastic throne; it presents itself as a splendid but absolutely appropriate creation of a local workshop for a papal church. In addition we should mention the mouth that is slightly

842 Ibid. pp.70–71.
843 P. Réfice, "Habitatio Sancti Petri": Glosse e alcune fonti su S. Martino in Vaticano, *Arte Medievale* II, 4, 1990, pp. 13–16.
844 Lisner, Giotto und die Aufträge des Kardinals Jacopo Stefaneschi für Alt-St. Peter II, pp. 63–64.

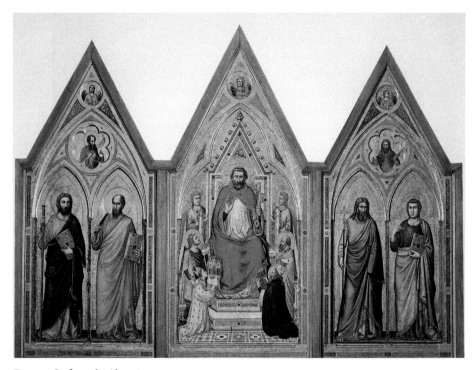

Fig. 314: Stefaneschi Altarpiece, reverse

open, as if speaking, and the right hand's gesture, which appears like a snapshot and is completely different from the gravitational gesture of the metal figure. The panel does not make the bronze figure of St Peter present, but rather the person of St Peter himself and enters into competition with the sculpture. Simultaneously, the painted image brings the apostle as celebrant into the liturgical life of the basilica of St. Peter.

And here he meets Stefaneschi, who kneels before him and – encouraged by St. George, the patron saint of his title church of San Giorgio in Velabro – presents him with the altar model (fig. 299). Stefaneschi wears the vestment of a cardinal deacon in the liturgical colour white, as was prescribed for the Feast of the Chair of St. Peter.[845] The fact that this scene appears twice, that is once again on a tiny scale on the model being presented, is an artistic bravura and confirms the image's claim to reality and the relevance of the depiction: the retable is declared in all clarity as a gift to St. Peter, even if it was not intended for an altar dedicated to him.

845 Ibid. pp. 64–65.

The Stefaneschi-Altarpiece: Peter and Peter and the Curia at Avignon 491

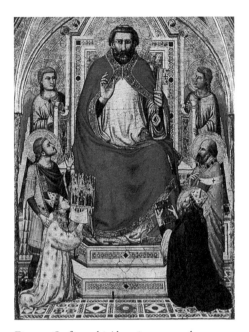

Fig. 315: Stefaneschi Altarpiece, central panel of the reverse, detail: St. Peter enthroned

Fig. 316: Rome, St. Peter's, bronze statue of St. Peter (from San Martino in Vaticano)

The second kneeler before the throne wears a white surplice under his cloak like Peter (fig. 315). He, too, encounters the apostle in a liturgical space visually constituted by vestments. He is distinguished from Stefaneschi not only because of his halo, but also because of his lost profile, and is thus to be perceived in a different way from the donor: more vividly and truly integrated into the narrative.[846] Along with the donor and Peter, he is the main character in the picture and on the entire back of the retable. Identifying him is one of the central problems in reading the altar, and so an in-depth look at the arguments is recommended. The following constitutes what may be taken as certain: The kneeling man is a saint,[847] he is a member of a religious order (from the black or blue-black hooded cloak, however, many orders come into question), he is a bishop, and, since he presents a book to St. Peter, he seems to be an author. Given the way he acts towards Peter, the relationship with the disciple seems to be a close one. But there is also a clear difference in

846 Mueller von der Haegen, *Die Darstellungsweise Giottos*, p. 235.
847 Even this basic prerequisite for identification is not met by Lübke's proposal. His naming of the figure as Boniface VIII is only mentioned for the sake of completeness: W. Lübke, *Geschichte der italienischen Malerei vom 4. – 16. Jahrhundert*, vol. 1, Stuttgart 1878, p. 123.

their dignity, for another saint appears behind the kneeling man, as if he, like Stefaneschi, needed a protector; according to the pallium, he should be a pope. Finally, the kneeling man must have been an unmistakably well-known personality in the circle of the picture's users, otherwise the painter would have added something to his figure to help with the naming.

Little of what has been said, apart from his episcopal office (which he held in Myra), applies to St. Nicholas, who is Ferdinando Bologna's candidate – but more applies to St. Augustine, Church Father and Bishop of Hippo, Julian Gardner's candidate. He can be considered a member of an order if one sees him as the founder of the Augustinian Canons, and a black pluviale would also fit in with this. However, in Augustine's case, a special relationship to St. Peter is not given. Likewise, it is unclear on what basis Augustine's appearance on the retable could have been expected by its contemporaries; the painter could hardly have left him without an attribute.

In contrast, all the framework conditions fit Celestine V and thus the saint mentioned by Hösl and Gosebruch. First, he was a monk, namely a Benedictine. Since he was seen as a hermit, this may not have been common knowledge, but it was known to Stefaneschi, who mentions the fact in his *Opus Metricum*.[848] In addition, a black hooded cloak, as worn by the Benedictines, is part of the habit of the order of hermits he founded out of the spirit of St. Benedict. It would not be the only case in which he was depicted in Benedictine garb: in an initial of the so-called Codex of St. George, a missal for St. Peter's commissioned by the same Cardinal Stefaneschi (BAV, C. 129, fol. 123r.), he also appears in a black Benedictine habit.[849] Secondly, he was also a bishop, namely bishop of Rome for a few months; elected pope in the summer of 1294, he had resigned in December of the same year. If he were depicted as such, however, one would expect him to wear a pallium with his mitre.[850] Presumably, we are faced with a diplomatic formulation that avoids placing unnecessary emphasis on either the saint's papacy or his controversial resignation. The representation with mitre alone is based on the persistence of the episcopal consecration, which was not affected by his resignation. This is how Giles of Rome, Stefaneschi's teacher, in *De renunciatione pape* 1297 had presented the unprecedented situation in terms of canon law.[851] Thirdly, Celestine was also an author. He left behind what is believed to

848 F.X. Seppelt, *Monumenta Coelestinina: Quellen zur Geschichte des Papstes Coelestin V.*, Paderborn 1921, p. 9.

849 M.V. Schwarz, Ubi Pictor ibi roma: Local Colour and Modern Form in Stefaneschi's Codice di San Giorgio, in: *Wege zum illuminierten Buch: Herstellungsbedingungen für Buchmalerei in Mittelalter und früher Neuzeit*, ed. Chr. Beier and E. T. Kubina, Vienna 2014, pp. 105–125, esp. 107–108.

850 Gardner, The Stefaneschi Altarpiece, p. 87.

851 P. Herde, *Cölestin V. (1294) (Peter von Morrone). Der Engelpapst* (Päpste und Papsttum 16), Stuttgart 1981, pp. 171–176.

The Stefaneschi-Altarpiece: Peter and Peter and the Curia at Avignon 493

be an autobiography. It would be better to say: a collection of the miraculous events that had happened to him since his childhood and which mark out his life as that of a saint. The text formed an important basis in the canonisation process.[852] I would rather associate the codex that the kneeling man is holding with this book, than with Stefanschi's *Opus Metricum*, which can also be regarded as a text about Celestine: it would be absurd for the man described in the book to be handing it to somebody else rather than receiving it. Fourthly, his relationship with Peter was close (this is another condition for identifying the figure); he was connected to the apostle, on the one hand, through the papal office, and on the other through his religious name, also Peter. The saint is venerated either as Peter Coelestinus or as Peter of Morrone. The standing saint behind him may be Celestine I, after whom he chose his papal name.[853]

Fifthly, by identifying the kneeling man as Petrus Coelestinus, one also meets the demand for the relevance and distinctiveness of his appearance. Apart from the Holy Year, the surprising election, the turbulent tenure and the shocking resignation of the old man, who from the beginning had the reputation of sainthood, may have been among the most spectacular things that had ever happened to Stefaneschi and many of his fellow canons. For most of them, he was probably the only saint whose personal acquaintance they had made. Stefaneschi had met him immediately after his election in his hermitage in the Abruzzi and reports about it in his *Opus Metricum*.[854] For Stefaneschi in particular (but certainly not only for him), the memory of Peter of Morrone was also painful: the decisive steps in Stefaneschi's career were marked by the promotion by Boniface VIII. And it was Boniface, aka Cardinal Benedetto Gaetani, who had advised (some said urged) Celestine to resign, only to profit from this move as his successor and then to hold him like a prisoner. Boniface was even accused of hastening the saint's death.[855] Incidentally, the dispute with the French crown, which overshadowed Boniface's pontificate and in the end turned it into a disaster, was a reaction to the doubts nurtured by French prelates about the legit-

852 A. Frugoni, *Celestiniana* (Istituto Storico Italiano per il Medio Evo: studi storici 6–7), Rome 1954, pp. 56–67. G.P. Ferzoco, Church and Sanctity: The Hagiogaphical Dossier of Peter of Morrone, in: *Normes et pouvoir à la fin du moyen âge. Actes du colloque: La recherche en études médiévales au Québec et en Ontario*, ed. M.-C. Déprez-Masson (Inedita et Rara 7), Montréal 1989, pp. 53–69. G.P. Ferzoco, Peter of Morone (Pope Celestine V), Autobiography, in: *Medieval hagiography. An anthology*, ed. Th.F. Head, New York 2000, pp. 729–744.

853 G.B. Ladner, *Die Papstbildnisse des Altertums und des Mittelalters*, vol. 2, Vatican City 1970, p. 282. For the alternative naming of the figure as Clement I and the reasons against it, see: Lisner, Giotto und die Aufträge des Kardinals Jacopo Stefaneschi für Alt-St. Peter II, footnote. 25 p. 67.

854 Seppelt, *Monumenta Coelestiniana*, S. 46.

855 Herde, *Cölestin V. (1294)*, pp. 161–162.

494 Giotto Pluralistic: The Peruzzi Chapel in Florence and the Late Works

imacy of Celestine's abdication and about the legitimacy of his successor.[856] One can call the Celestine Affair the original sin of the late medieval papacy. His canonisation in 1313, which King Philip the Fair of France had been working towards since 1305, was not least a means of coping politically and spiritually with the (poor) decision of the conclave of Perugia and the violent regiment of the Gaetani Pope, as well as of justifying the retreat of the Curia to Avignon, i.e. to dependence on France. All in all, the insight into Celestine's holiness must have fundamentally shaken the world view of many members of the Curia, if not of the Curia as a whole. Stefaneschi's *Opus metricum* is proof of this: it began as a work about Celestine, continued as a panegyric on Boniface VIII, and concluded as a commentary on the canonisation of Celestine. In the end, it became a history book describing the difficult path of a saint in the world, instead of being primarily a pamphlet against Boniface's enemies (who were mostly Celestine's friends).[857] The work on the last part of the book, where the focus is clearly on Celestine, falls in the years between 1315 and 1319 and thus probably precedes the commission for the altarpiece of St Peter's by only a few years.

The rear of the retable probably did not have a liturgical function in the proper sense. But it must have been visible from the crossing of St Peter's and thus also from the area in front of St Peter's tomb. If the Chapel of Santa Maria de Cancellis and the Chorus Canonicorum were not (or not always) one but rather two separate, albeit closely connected, spaces (as is sometimes suspected),[858] then the rear side faced this chapel and contributed to its pictorial decoration. In any case, it made sense to extend the programme to the reverse side with an ensemble of devotional images. This also gave the opportunity to have the donor appear again and explain his motivation. For this purpose, Giotto simulated a kind of liturgical encounter within the picture. Particularly exciting is the role assigned to Petrus Coelestinus. It is only at second glance that it becomes clear to the viewers: the central panel shows not one, but two saints named Peter, namely both the Roman Peter and the, if you will, Avignonese one, the one canonised by the Curia in Avignon. When one Peter kneels as a small figure before the other, this says something about the humility of Petrus Coelestinus and characterises him as a "young" saint, but at the same time makes him a character who is spiritually close to the viewers. Stefaneschi and Giotto ensure that devout viewers experience Peter, the ex-pope, as the one who gives access to Peter, the apostle. In addition, the picture and those who pray before it make Petrus Coelestinus at home in Rome and in the Church of the Apostle's Tomb. That he

856 Ibid. pp. 161–190.

857 Seppelt, *Monumenta Coelestiana*, pp. XXIX–XLV. Th. Haye, *Päpste und Poeten: Die mittelalterliche Kurie als Objekt und Förderer panegyrischer Dichtung*, Berlin and New York 2009, pp. 236–243.

858 Cf. Smith and O'Connor, *Eyewitness to old St. Peter's*, p. 275.

The Badia Altarpiece: Predella, Patronage, Dating 495

had only been there once briefly while alive, and never as a pope was something all the saint's admirers must have felt to be tragic and unjust.

THE BADIA ALTARPIECE: PREDELLA, PATRONAGE, DATING

The polyptych with five half-figures of saints (340 by 91 centimetres, Uffizi – fig. 317) spent most of the 19th and the early 20th century in the monastery of Santa Croce in Florence. It was there that Henry Thode saw it, attributed it to our painter, and recalled Ghiberti's mention of four panels by Giotto "nell ordine de' frati minori" (2.1.4).[859] When it was recovered during the Second World War, a label with the inscription "Badia di Firenze" was found on the back. This means that the altar was taken away from the Badia and placed in the San Marco depot when the Florentine convents were dissolved under Napoleon in 1810; in 1813, however, it was not returned but taken instead to Santa Croce.[860] Given its Badia provenance, Giotto's authorship becomes significantly more plausible. Unlike Santa Croce, the Benedictine church had few altars and certainly only one of monumental scale; Ghiberti's mention of Giotto painting not only the murals of the main chapel but also the retable of the high altar ("dipinse la capella maggiore e la tavola": 2.1.4) is very plausibly referring to the work in the Uffizi. With a Madonna in the centre and St. Benedict on the far right looking at her, the polyptych seems suitable for adorning the high altar of a Benedictine church dedicated to Mary. Peter's appearance and the fact that he is wearing the papal pallium also hint at this monastery, if Julian Gardner is right. He pointed out that the Badia was exempt and thus directly subordinate to the successor of St. Peter. Therefore, the monks could easily imagine themselves in a particularly close relationship with the prince of the apostles.[861]

When Giotto's murals fell victim to the rebuilding of the church in the 17th century, the retable was moved to the refectory of the monastery. It was there that the historiographer Placido Puccinelli saw it; in an appendix to his text he describes an accompanying predella:[862] "and under the figures of the Saints, there are some small ovals in which are

859 Thode, *Giotto*, Bielefeld 1899, p. 138.

860 U. Procacci, La tavola di Giotto dell'altar maggiore della chiesa della Badia fiorentina, in: *Scritti di Storia dell'Arte in onore di Mario Salmi*, Rome 1962, vol. 2 pp. 9–45.

861 J. Gardner, Giotto in America (and Elsewhere), in: *Italian Panel Painting of the Duecento and Trecento*, ed. V.M. Schmidt, New Haven and London 2003, pp. 160–181, esp. 161.

862 P. Puccinelli, *Istoria dell'eroiche Attioni di Ugo il Grande, Duca della Toscana, di Spoleto, e di Camerino, Vicario d'Italia per Ottone III. Imperatore, e Prefetto di Roma*, Milan 1664, Cronica pp. 4–5, 455: "e sotto le figure dei Santi, sono certi piccioli ovati ne' quali sono dipinti per mano del medemo Giotto li Principi Ugo, et Vuilla sua Madre, la quale tiene nelle mani il modello di questa nostra Abbadia."

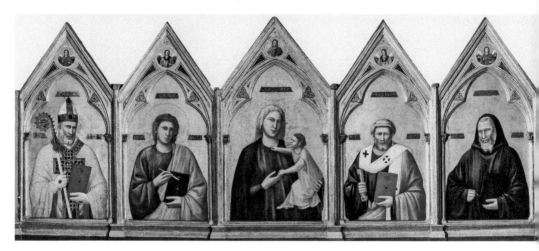

Fig. 317: Florence, Uffizi, retable from the Badia

painted, by the same Giotto, the Princes Ugo and Vuilla, his mother, who holds in her hands the model of our abbey." That there was originally a predella with additional small images cannot be a surprise in light of the Baroncelli altar. The Badia polyptych in its present state has no base; the plinth on which the panels are mounted is modern. Willa of Tuscany († 979) had founded the Badia and was honoured there as a great benefactress. Her son Count Ugo († 1001) was buried in the immediate vicinity of the altar (today, he rests in a monument created by Mino da Fiesole which stands against the former altar wall).[863] The images of Countess Willa and Count Ugo also reveal something about the patronage of the retable: if its programme was dedicated to the liturgical commemoration of the founder family, then it was not a donation from outside, but can only have been financed by the monastery itself.

Since its provenance from the Badia became known, almost all authors have considered the altarpiece to be an early work by Giotto, i.e. a creation from around or before 1300.[864] The starting point for this is Vasari's misunderstanding of the classification criteria in Ghiberti's list of works (vol. 1 p. 31). In contrast, the following correlation is obvious: if the retable was intended for the high altar of the Badia, it would be surprising if it were made before 1310. In that year, the high altar was consecrated in the new building of the

863 Sh. Zuraw, The Public Commemorative Monument: Mino da Fiesole's tombs in the Florentine Badia, *The Art Bulletin* 80, 1998, pp. 452–477.
864 History of research: *Giotto: Il restauro del Polittico di Badia*, ed. A. Tartuferi, Florence 2012, pp. 54–59 (A. Tartuferi).

church, which had been in progress since 1284 (see p. 380).[865] And with a view to the results developed here on the Baroncelli and Stefaneschi altars, there are other clues to its dating: as a buttressed altarpiece, it could hardly be from before 1311 (at least if Duccio's Maestà is the founding work of this type in Italy). If we also assume that the type came to Florence with Ugolino di Nerio and the high altar of Santa Croce or the lost high altar of Santa Maria Novella, and thus also into the field of vision of Giotto's customers, we could place the retable around or after 1320.[866] This brings us into the chronological period of the Stefaneschi Altarpiece, and the Badia Altarpiece is indeed connected to it in many ways. First and foremost, the framing corresponds both in terms of its system and in many of its details (cf. fig. 299, 303): the picture panels of the main storey (three in the case of the Roman altarpiece, five in the case of the Florentine) are surmounted by ogival arcades on semi-columns crowned with capitals (the columns are lost in the Roman work, but can be reconstructed from "impressions" in the gold ground); elegant tracery forms are fitted into the arcades and their spandrels are decorated with painting in a similar way; gothic pediments rise above the arcades, containing picture medallions; in the Roman work they are recessed in relief, in the Badia altar the roundels are painted. Looking at the similar proportions of the elements, one would go so far as to say: it is the same rigorous and thoughtful design, adapted to the two different occasions by the same team of carpenter and painter.

A common background for the planning of the Stefaneschi and Badia altars also becomes evident when comparing the four angels in the pediment medallions of the Badia altar (fig. 318) with the angels of the Stefaneschi altar, which appear in analogous positions on the panels of the St. Peter side: we find the same colour scheme and the same composition (fig. 314). This makes it all the more obvious that there is a difference in quality. The Roman angels lag behind the Florentines ones in beauty and expression; their modelling seems coarsened, their heads too big. The two Roman variants seem less controlled. It is an accidental detail and yet it can be concluded from this that the painting of the Stefan-

865 This connection was pointed out by: P. Venturoli, Giotto, *Storia dell'arte*, 1–2, 1969, pp. 142–158, esp. 152, 155.

866 In contrast, the reference to the metal dossal, which was created in 1313 by the goldsmith Andrea Pucci Sardi from Empoli for the high altar of the Baptistery (Florence, Museo Nazionale del Bargello), seems to me to be of no further relevance: *Oreficeria sacra Italiana*. Exh. cat. ed. M. Collareta and A. Capitanio, Florence 1990, pp. 20–27. A. de Marchi, La tavola d'altare, in: *Storia delle Arti in Toscana: Il Trecento*, ed. M. Seidel, Florence 2004, pp. 15–44, esp. 21. Firstly, the narrow bar with the numerous busts of saints is a clearly different type of object from the painted retables. Secondly, the architectural elements might not be original. They start unseemly close above the heads of the figures and partially overlap the enamel ornaments in the register above. They were probably added later to bring the object in line with retables such as the one of the Badia.

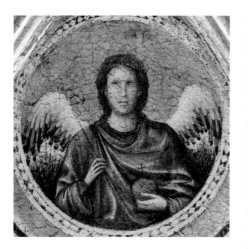

Fig. 318: Florence, Uffizi, retable from the Badia, angel

eschi retable is to a greater extent the product of a collective than the other. At this point, it is worth taking a side look at another Florentine buttressed altarpiece, which, however, is not a work by Giotto. This is the retable from the high altar of San Firenze (fig. 319). Signed by Pacino di Buonaguida, who had been active since 1303 at the latest and who, together with Giotto, had belonged to the guild of doctors and apothecaries since the late twenties or early thirties (1.3.4), the altarpiece must have been created between 1315 and 1330, as recorded in the incompletely preserved inscription.[867] It shows traces of several of Giotto's panels: The Crucifixion in the centre is based on the Ognissanti cross (fig. 275), and only the gestures of Mary and John are reversed. What is of more interest here: the shape as a whole and the design of the frame are variations of the Badia and Stefaneschi altarpieces (fig. 317, 299, 303); St. Nicholas is designed according to the model of the half-figure St. Nicholas on the Badia altarpiece.[868] The other saints are based on those of the Stefaneschi altarpiece (fig. 314); in fact, the medallion images are partly literal copies after the medallions on the Roman retable – this, by the way, is a further argument that the Stefaneschi altar was made in Florence. The San Firenze retable seems to belong to a shared context with the Badia and Stefaneschi altars. Pacino, who learned from the Badia altar, may have been one of Giotto's collaborators on the Stefaneschi altar.

In addition, the Stefaneschi and Badia altarpieces are possibly also connected by an administrative act in faraway Avignon: namely, the deed issued in the summer of 1324, which brought Giotto's son Bondone the parish in Vespignano and enabled various synergies between the church property and the property of Giotto's family (1.5.1). The driving forces behind this papal favour, which was certainly granted more to the father than to the son, were, in addition to a prelate unknown to us, on the one hand Stefano di Francesco Stefaneschi, the great-nephew and confidant of the commissioner of

867 R. Offner, *Elder Contemporaries of Bernardo Daddi* (A Critical and Historical Corpus of Florentine Painting. sec. 3, vol. 2, pt. 1), Florence, p. 12. *Dal Duecento a Giovanni da Milano*. Cataloghi della Galleria dell'Accademia di Firenze: Dipinti 1, ed. M. Boskovits and A. Tartuferi, Florence 2003, no. 39. From the year MCCCX is readable, followed by either an X or a V, with space for a maximum of 2 more characters.

868 Raimond van Marle attributed the Badia altar to Pacino: R. van Marle, *The Development of the Italian Schools of Painting*, vol. 3, The Hugue 1923, p. 245.

the Roman altar (perhaps even its co-donor) and on the other hand the abbot of the Badia, Azzone II, who must have contracted for the Florentine altar. It is of course conceivable that Giotto's services, to which this intervention responded, were performed some time previously: the members of the Stefaneschi family may have remembered the Navicella and the painting of the "Capella" in St. Peter's, and the abbot may have remembered the murals in the choir of his church. But if Giotto' recent achievements were the trigger, then it was most likely the two retables. In this case, one would have to assume that they were both created in the years shortly before 1324. Such a dating of the group is supported by the observation that the catchy form of the architecturally structured polyptych with half figures, which had been developed for the Badia Altarpiece, was used by other Florentine painters from the mid-twenties onwards: these

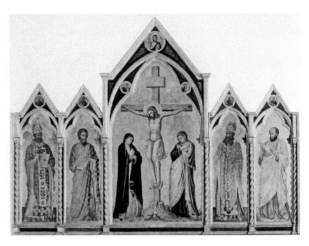

Fig, 319: Florence, Accademia, Retable from San Firenze (Pacino da Buonaguida)

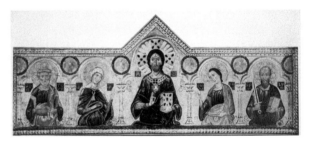

Fig. 320: Florence, Uffizi, Dossal (Meliore)

works include the three-part retable from Ognissanti (Uffizi) signed by Bernardo Daddi and dated 1328, the five-part polyptych distributed among various American collections, which comes from the same artistic milieu and bears the date 1334 on the central panel in Philadelphia, and the five-part altarpiece from the oratory of San Pietro alle Stinche (today in San Martino in Lucarelli, Radda), which probably also belongs to the Daddi circle and certainly to the same period (according to Offner, to the years around 1330).[869] Today these comparable examples are all without a predella, but this need not have been the case originally.

869 Cämmerer-George, *Die Rahmung der toskanischen Altarbilder im Trecento*S, pp. 65–68. De Marchi, La tavola d'altare, p. 20. R. Freemantle, *Florentine Gothic Painters: From Giotto to Masaccio*, London 1975, pp. 49, 51.

With the restoration completed in 2009, the figures of the Badia altar have regained the powerful, if somewhat artificial, sense of presence that Giotto's contemporaries had to contend with. The saints confronted them in a context that oscillated between the traditional and the progressive: in terms of its general form, the retable was part of the tradition. The dossal for an unknown Florentine church in the Uffizi, signed by the painter Meliore and dated 1271, also consists of a row of five half-figures[870] (fig. 320). A second dossal of the same type, signed by the same painter and dated 1270, was found in the church of San Francesco in Barberino Val d'Elsa.[871] Since similar altarpieces from the late 13th and early 14th centuries are also encountered elsewhere in Tuscany, this was probably a common type and would have been familiar to the audience.[872] Giotto made use of it – and seemingly in such a way that this should be noticed. This is indicated by the inscription fields for the names, which were not otherwise common in his work, but are conspicuous in Meliore's retable.[873] It is possible that he was specifically quoting the retable of the high altar of the old church, which was certainly created before construction of the new church began in 1284 and may have been in use again in the new church after 1310. It was this type that Giotto redesigned in the form of a buttressed altarpiece and thus turned into something new and unusual: he disassembled the picture board into individual panels and replaced the applied arcade motifs with "real" architecture, which at the same time corresponded to the standard of the latest Sienese polyptychs and the style model of Gothic altarpieces such as the one in Marburg. The result was an architecture that not only decorates the cluster of figures, but literally carries them and constitutes them as an ensemble. A picture board that shows something became an object-like structure that clearly *is* something. This change also plays a role in the perception of the painting: instead of a sequence of half-figures, we see individual pictures, each of which exclusively shows one person (or two on the central panel) in a magnificent golden setting, ready for dialogue with the viewer.

870 M. Boskovits, *The Origins of Florentine Painting 1100–1270* (A Critical and Historical Corpus of Florentine Painting, sec. I, vol. I), Florence 1993, pp. 652–662.

871 N. Catalano, *Il fiume del terrestre Paradiso*, Florence 1652, pp. 474–476.

872 Van Os, *Sienese Altarpieces*, pp. 18–20.

873 H.B.J. Maginnis, *Painting in the Age of Giotto: A Historical Reevaluation*, University Park 1997, p. 150.

THE BADIA ALTARPIECE: STRATEGY OF REPRESENTATION

The appearance of the saints is simultaneously characterised by distance and intensity. There was a strong feeling of intensity because the five figures originally stood raised over the predella facing the priest and, over his shoulders, the members of the convent in their choir stalls – and clearly displaying their emotions. The gazes of Our Lady, John, Peter and Nicholas rest on us, only Saint Benedict looks at Mary. Their affects are visualised with restraint, and yet different attitudes seem to be communicated: Nicholas examines us, Benedict mourns the sacrifice that Christ and Mary will make, Peter expresses his dismay (fig. 323), John looks at us questioningly (fig. 321). His semantically relatively open gaze establishes the closest contact between one of the saints and the viewer. For the two saints on the outer panels, Giotto used types that can be associated with the production of painters from the young Giotto's circle, especially the Chapel of St. Nicholas in Assisi.[874] For dating, this use of old models is irrelevant, all the more so as the observation does not apply to the other three heads.[875] Mary's appearance is unmistakably based on the physiognomy of the Ognissanti Madonna and has practically no points of contact with the panel of San Giorgio alla Costa, as would be expected from an early dating of the work (fig. 322, 274, 151). Comparing the modelling of the nose, the not only physiognomic but also stylistic distance to the early panel and the closeness to the Ognissanti Madonna are perhaps clearest. In relation to the Ognissanti Madonna, the expression is more open and more expectant than it is strict. Completely new in Giotto's oeuvre is the Christ Child, specifically his friendliness and spontaneity, but also his eager and exclusive turning to his mother, which considerably strengthens her role. However, what should concern the pious viewers above all is how Christ is the only one to break out of the serious mood of the assembly of saints, which is dominated by the foreknowledge of his Passion.

A reduced variety of forms, together with its gold ground, ensures that the figures do not come too close to us: for example, if a book is held four times in the same way and a thumb rests on the cover four times in the same way, this shows restraint in the use of representational technique. Such features can be perceived as a weakness and an unresolved problem of form, perhaps even serving as an argument for dating the retable to Giotto's early period. However, one can also recognise in this Giotto's intention not to penetrate too far beyond what indispensably had to be represented and thus to become lost in the broad field of the real. The same applies to the modelling of the figures: their roundness, especially in the faces, appears very clearly; on the other hand, the surfaces look as if they

874 O Sirén, Some Paintings by a Follower of Giotto, *The Burlington Magazine* 43, 1923, pp. 259–269, esp. 259.

875 Cf. A. Tartuferi, Il restauro del polittico di Badia, in: *Giotto: Il restauro del Polittico di Badia*, ed. A. Tartuferi, Florence 2012, pp.12–29, esp. 21–22.

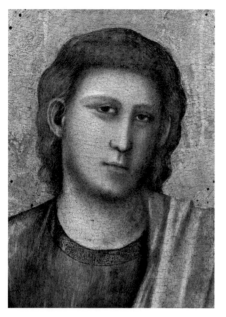

Fig. 321: Florence, Uffizi, retable from the Badia, St. John the Evangelist, detail

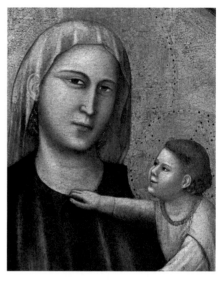

Fig. 322: Badia Retable, central panel: Virgin and Child, detail

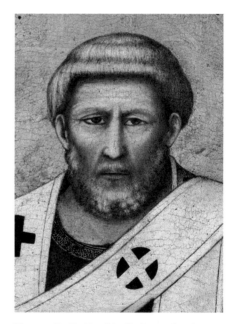

Fig. 323: Badia Retable, St. Peter, detail

have been smoothed out. The painted beards of the two old men on the left and right are too decorative to be true. Overall, the impression is that the figures are simultaneously unreal and yet present both psychologically and physically. Only in the case of the mother and child did the painter use means that explicitly testify to the reality of what is depicted: the virgin's ear shining through the veil, her incredibly precisely modelled nose, and the child's soft, airy hair.

THE BOLOGNA ALTARPIECE

Giampietro Zanotti's 1732 edition of Malvasia's handbook on Bolognese painting is a godsend for Giotto research. Here we find the only indication of the original location of the polyptych signed by Giotto that is now on display in Bologna's Pinacoteca Nazionale[876] (218 by 136 centimetres, fig. 324): the church Santa Maria degli Angeli (also Santa Maria del Angelo or Chiesa degli Innocenti) outside the Porta di San Mamolo, which was suppressed and demolished in Napoleonic times.[877] Zanotti saw the retable in the sacristy, although it previously stood on the high altar, "from where it was removed to make way for a new and inferior painting". He describes the panels, quotes the signature and expresses his incomprehension that the work was unmentioned in the older editions of Malvasia's book. In addition, Zanotti shares what he had been able to find out about the early history of the church and tries to link this information to Giotto's altarpiece: the little church was built by Gero (Zerra) Pepoli around 1330, generously endowed and given to an order of hermits (this and the location outside the walls are reminiscent of the Arena Chapel). According to Zanotti, it was most likely the founder of the church, Zerra Pepoli, who had commissioned the retable from Giotto.[878] This idea is indeed obvious. All considerations as to whether Cardinal Bertrand du Poujet, who wanted to develop Bologna into a papal residence, could have been the commissioner; and whether the altar was intended for a more important church instead of Santa Maria degli Angeli, seem speculative in comparison.[879]

876 Carlo Cesare Malvasia, *Le pitture di Bologna Che nella pretesa, e rimostrata sin' ora da altri maggiore antichità, e impareggiabile eccellenza nella Pittura, con manifesta evidenza di fatto, rendono Il Passeggiere Disingannato, ed Instrutto*, terza edizione, ed. Giampietro Zanotti, Bologna 1732, pp. 355–356. State of research on the retable: *Pinacoteca Nazionale di Bologna. Catalogo generale 1: Dal Duecento a Francesco Francia*, ed. J. Bentini u.a., Bologna 2004, pp. 64–68 (L. Bellosi) and *Il polittico di Giotto nella Pinacoteca Nazionale di Bologna*, ed. D. Cauzzi and C. Seccaroni, Florence 2009.

877 *Memorie storiche di tutte le chiese distrutte o chiuse ne'passati tempi con un cenno di alcune di esse state riaperte nella città di Bologna e suo contorno*, Bologna 1828, p. 38.

878 „S. Maria degli Angeli: Edificata, e largamente dotata da Gero Pepoli del 1330, e data a certi frati Romiti da Murano […] In essa presentemente non v'ha cosa considerabile di Pittura, ma bensì nella Sagrestia v'ha una Pittura in caselle dorate di mano di Giotto Fiorentino, che dovette essergli fatta fare dal suddetto Gero Pepoli. In essa si vede la Madonna col Bambino Gesù, che l'accarezza, e da un lato l'Angelo Gabriele; e dall'altro l'Archangelo Michele, e appresso Ss. Pietro, e Paolo, e cinque testine sotto in alcuni tondetti; la quale Pittura stava una volta all'Altar maggiore della Chiesa da cui fu levato per cedere ad una nuova pessima pittura. Sotto lo scanno della Madonna si legge: Op. Magistri Jocti Floren." Malvasia, *Le pitture di Bologna*, ed. Zanotti, pp. 355–356.

879 Cf. M. Medica, Giotto e Giovanni di Balduccio: due artisti toscani per la sede papale di

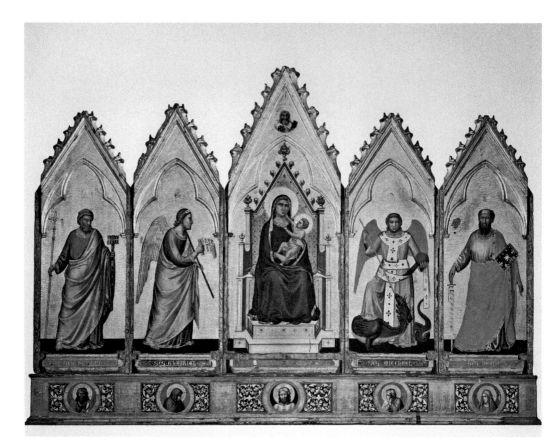

Fig. 324: Bologna, Pinacoteca Nazionale: Retable from Santa Maria degli Angeli

Zerra Pepoli was an otherwise low-profile member of an extremely influential family. His father Romeo was considered fabulously rich and was the city lord of Bologna. Zerra himself had been a member of the Consiglio del Popolo since 1292 and was received by Emperor Henry VII with the Bolognese delegates in 1313. For the rest, however, he was overshadowed by his studious and energetic brother Taddeo. In 1321, the Bolognese nobility rose up against the supremacy of the Pepoli and expelled the family. Romeo died of old age in 1322 in exile in Avignon. When Bologna came under papal control in 1327 and Cardinal Bertrand du Poujet ruled as city lord, the Pepoli returned under Taddeo's leadership. From 1337 he governed Bologna as papal vicar. He died in 1347. The date of Zerra's

Bologna, in: *Giotto e le arti a Bologna al tempo di Bertrando del Poggetto*. Exh. cat. Bologna, ed. M. Medica, Milan 2005, pp. 37–53.

The earliest record of Santa Maria degli Angeli dates from 1326: a procurator of the exiled Zerra Pepoli took care of the affairs of this church on his behalf. This can be read in the *Miscellanea* on the History of Bologna by Guiseppe Giudicini, published in 1872, who exploited documents from the Bolognese archives – unfortunately without quoting and evidencing them precisely.[881] Giudicini concluded from the notice: if the church was Zerra's foundation, then it must have been built by him and occupied by the friars before the expulsion of the Pepoli, i.e. before 1321. This gives a wide range for the dating of Giotto's retable. Even the family's years of exile in 1321–27 cannot be ruled out. Especially if Zerra or another member of the family had wanted to do something for their church (and show their presence in Bologna) under these circumstances, the commissioning of a famous painter who did not live in Bologna would have been an obvious move. Nor can the dating be narrowed down on the basis of Giotto's biography. In any case, there is no justification for linking the retable with the painter's stay in Bologna, which falls in the years after 1328 and most likely in 1334[882] (cf. 2.2.2).

In 2005, various carvings were observed on the back of the central panel, including the sequence of characters that can be read as "ad cccxxvi". It would be careless to interpret the graffito simply as an inscription and to say that the altar was not only signed (on the front) but also dated (on the back). However, in the light of the document from 1326 quoted by Giuidicini, the date 1326 seems relevant. It is plausible that the marks were applied by the craftsmen in Bologna who assembled the altar, which was delivered in individual parts from Florence.[883]

880 N. Rodolico, *Da commune alla signoria: Saggio sul governo di Taddeo Pepoli in Bologna*, Bologna 1898, esp. pp. 211, 216. A. Benati, F. Bergonzoni, et al., *Storia di Bologna*, Bologna 1978, pp. 175–178. M. Giansante, *Patrimonio famigliare e potere nel periodo tardo-communale: Il progetto signorile di Romeo Pepoli banchiere bolognese (1250 c.–1322)* (Dipartimento di Paleografia e Medievistica: Fonti e saggi di storia regionale, quaderni 1), Bologna 1991. On Zerra Pepoli: Pompeo Scipione Dolfi, *Cronologia delle Famiglie nobili di Bologna*, Bologna 1670, p. 588.

881 G. Guidicini, *Miscellanea Storico-Patria Bolognese*, Bologna 1872, pp. 132–134.

882 Often 1328 is mentioned as terminus post quem, but this is inaccurate for the reasons mentioned: cf. for example E. Skaug, *Punch Marks from Giotto to Fra Angelico: Attribution, Chronology, and Workshop Relations in Tuscan Panel Painting*, 2 vols., Oslo 1994, vol. 1 p. 86 and Flores d'Arcais, *Giotto*, p. 356.

883 D. Cauzzi, Giotto e il polittico di Bologna: data e possibile, ulteriore firma, *Paragone Arte* 56, 2005, 4, pp. 91–96. In contrast, it is less plausible that there is a second signature on the reverse.

For the layout of the retable, Giotto drew on the rear side of the Stefaneschi altarpiece (fig. 314): Two standing figures are presented on each side of a picture with an enthroned figure. Unlike in the Roman polyptych, however, whose frame system is conceived from the front with the martyrdoms of Peter and Paul, the standing figures of the Bolognese altar were given their own panels. This led to steeper proportions in the framework and some variations in the architectural elements and their decoration. The arcades, for example, are supported by consoles instead of columns. Under the five-part structure that resulted, Giotto inserted a low predella as in the Sienese retables and as he had probably already used at the Badia altar. As far as I can see, our painter thus created the first architectural polyptych with full figures and predella and in doing so made a significant contribution to the development of the Italian retable. From the middle Trecento onwards, this type was the standard design for altarpieces.

What obscures the view of this key role is that the painters of later generations did not follow the Bolognese altar in its most striking aspect. I am referring to the scenic presentation of the figures: Gabriel on the first panel on the right hand side of the central panel turns towards the Madonna enthroned there. As explicitly as possible, he acts as the messenger of the Annunciation, even opening his mouth to speak and holding a document with the clearly legible words of the angelic salutation. The close connection between the Madonna panel and the Gabriel panel echoes the dedication title of the church: Santa Maria degli Angeli. In contrast, Gabriel's counterpart has no corresponding contact with the central panel. And yet Giotto also made it clear that the archangel Michael, depicted there, was in the midst of action. The dragon at his feet is more than just an attribute, given its precise description as seven-headed. And as the angel energetically places his foot on the back of the beast, he abandons the form of a saint's image directed towards the viewer. Finally, the figures placed on the far left and right, representing the city of Bologna with its cathedral dedicated to St. Peter, take up the motifs of the angels' movements and also become actants. Peter, who stands in the better place and is assigned to Gabriel, imitates the angel in his turn of the body, as if he is about to support him in the Annunciation. In the same way as Gabriel holds the scroll and the caduceus, the apostle handles the keys and the cross-staff. Paul has set himself up frontally like Michael, and, just as the latter carries a spheira and a lance, he uses a book and a sword. The figures on the right of the central panel are more attractive in their emphasis. The energetic, immensely physical Peter with his expressive face may be counted among Giotto's most impressive inventions (fig. 325). Peter and Gabriel are also superior to the other two saints in the quality of their execution. It is precisely in their weaknesses that those two join the apostle figures on the back of the Stefaneschi altarpiece. The Bolognese Paul with his imprecise features seems almost like a variant of the Stefaneschi Paul (fig. 326). The simple face of Michael with his coarse nose finds a parallel among the decorative heads in the Capella magna in Naples,

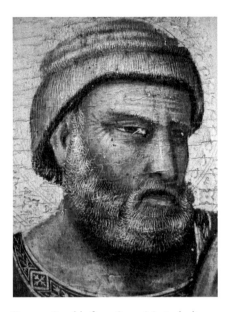 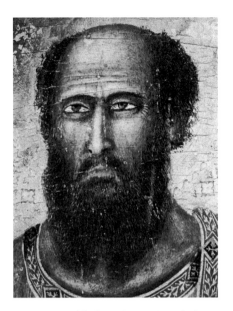

Fig. 325: Retable from Santa Maria degli Angeli, detail: St. Peter

Fig. 326: Retable from Santa Maria degli Angeli, detail: St. Paul

as Pierluigi Leone de Castris has pointed out,[884] providing a further argument that the figure of the archangel is executed by a collaborator rather than by the head of the workshop. It need not have been the same person; what becomes tangible is that in both cases a difficult design by Giotto was inadequately realised in a similar form. All in all, it gives the impression that Giotto painted the central panel and the panels to the right himself, or at least supervised them intensively, but left the other two to collaborators acting relatively independently or to colleagues who had been hired, thus overburdening their skills somewhat.

The painter seems to have identified with the representation on the central panel in a personal form (fig. 327): the step leading to Mary's throne bears the inscription: OPUS MAGISTRI IOCTI DE FLORENTIA (1.6.2). Of the three Giotto signatures, it is the only one that is within the picture instead of on the frame and can thus be assigned to a specific item depicted in the picture. Like the Ognissanti Madonna and the Madonna of the Stefaneschi altar, the Bolognese Virgin looks at the viewer with little encouragement. But the child, even more vividly than the child on the Badia altar, tries to free her from her rigidity. Although Christ has to struggle and stretch, he caresses her cheek. In response, she presses the child against her. Those who pray in front of this picture

884 P. Leone de Castris, *Arte di Corte nella Napoli angioina*, Florence 1986, p. 352.

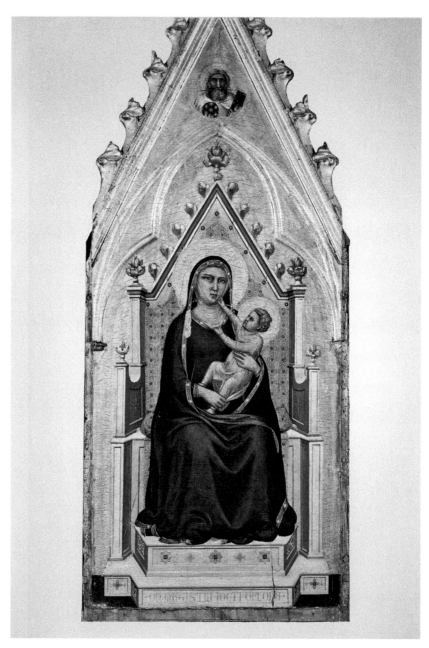

Fig. 327: Retable from Santa Maria degli Angeli, central panel

Fig. 328: Retable from Santa Maria degli Angeli, predella: Mary

Fig. 329: Retable from Santa Maria degli Angeli, predella: Mary Magdalene

experience their own request for intercession as an imposition on the one hand, but, on the other, as being legitimised by the child's actions and his obvious willingness to sacrifice himself. What is formulated as a question with the lively child in the Badia retable becomes a statement here. And in this prayer to the Mother of God and her Son, precisely modelled by the painter, Giotto wants to be included. Duccio proceeded in a similar way at the Maestà: there, too, on the step of Our Lady's throne, the sentence can be read: "Holy Mother of God, give peace to Siena, and – because he painted you like this – [eternal] life to Duccio". (MATER SCA DEI / SIS CAUSA SENIS REQUIEI / SIS DUCCIO VITA / TE QUIA PINXIT ISTA)[885] If one wanted to transfer the text to the Bolognese altar, one would have to exchange "Siena" for the Pepoli family, and the specific theme of peace (which in Duccio's case refers back to the Battle of Montaperti, the indirect cause of the painting's donation) would be dropped in favour of the general theme of redemption, but with the request for eternal life for the painter remaining.

As on the Baroncelli altar (and possibly also on the Badia altar), the predella presents the Eucharistic theme, only in Bologna it appears more intense and is clearly shown as a sacrifice. The intensity of its depiction in Bologna also results from its dramatic staging and high painterly quality. The personnel depicted is linked on the one hand to

885　Cit. after J. White, *Duccio. Tuscan Art and the Medieval Workshop*, London 1979, p. 100.

Giotto Pluralistic: The Peruzzi Chapel in Florence and the Late Works

the Passion narrative and on the other hand to the theme of the Last Judgement. Side by side with the *Imago pietatis* are Mary, wrapped in her blue cloak and seemingly uttering lamentations (fig. 328), the disciple John, wringing his hands, John the Baptist, who stares fixedly down before him, and finally Mary Magdalene, exhausted by grief or penitential exercises and with uncombed hair (fig. 329). The Magdalene's appearance is reminiscent of the iconography of the Crucifixion, which Giotto had invented decades earlier in Padua and adapted for the Stefaneschi altarpiece: just as Mary Magdalene kneels at the foot of the cross in the Arena Chapel and anoints Christ's feet with her hair, so too has she now found her way onto the Bolognese predella and to the liturgical location where Christ's sacrifice is repeated again and again. Mary Magdalene kneeling under the cross was a motif that no longer belonged to Giotto alone, at the latest since the crucifixion pictures of the Assisan Lower Church (p. 432). Nevertheless, it is unlikely that another painter could have made use of it in such a derivative and yet meaningful way. We have often seen how intelligently Giotto was able to visually shape narratives. On the Bolognese altar, this intelligence is now encountered in a directly theological application. Seen together with his signature, something of the painter's spirituality seems to come to life in the medium of his painting.

THE STS. JOHNS' CHAPEL OF THE PERUZZI

> *Furthermore, if the Minorites of Florence were to enlarge or rebuild their church within ten years after his death, he wanted his aforementioned brothers to spend the sum of 200 lire from his estate to build a chapel in this church according to the will of his same good brothers.*

With these words, on 21 November 1292, a notary wrote down one of the testamentary dispositions of Donato Peruzzi, who only a short time before had become an independent and wealthy man through the death of his father Arnaldo. Four of the ten or more brothers of the testator were present as witnesses, the "aforementioned" or "good brothers": Pacino, Tommaso (aka Masino), Arnaldo junior and – a namesake of our painter – Giotto Peruzzi.[886] This is the oldest surviving written source not only on the Peruzzi Chapel, but

886 ASF, Diplomatico, Fondo Strozziano-Uguccioni, Spogli Strozziani, Libro DDD, No. 60, IIa Serie, c. 224: "item voluit quod si fratres minores de florentia crescerent eorum ecclesiam vel de novo facerent infra decem annos post obitum suis testatoris quod dictos suos fratres expendant de bonis suis pro hedificanda una cappella in dicta ecclesia ad voluntatem ipsorum fratrum suorum libras ducentas bonorum den. flor. parvorum ..." The

The Sts. Johns' Chapel of the Peruzzi

also on the new building of Santa Croce. The foundation stone of the church was laid two and a half years later in May 1295, and soon afterwards the Peruzzi chapel must have been built along with the choir chapel, the Bardi chapel and the other chapels on the transept.

In terms of liturgical and visual importance within the cult system of Santa Croce, the Peruzzi chapel lags behind the Bardi chapel – one might say to the same just noticeable degree as the Peruzzi family and company lag behind the Bardi family and company: the Peruzzi chapel is not adjacent to the choir chapel like the Bardi chapel, but is adjacent to the Bardi chapel; it does not open onto the central aisle of the nave, but onto the right transept arm or the right aisle; it is not dedicated to the founder of the order and second patron of the church, like the Bardi Chapel, but to the two Sts. Johns. While this dedication also refers to Francis, whose patron saint was John the Baptist, the relationship in this case is indirect. And unlike in the case of the Bardi foundation, there is no picture on the wall above the chapel that would help to decorate the overall space of the church. If in the case of the Bardi Chapel we may presume an interest in completing it for the occasion of the liturgical activation of the eastern part of Santa Croce around 1319/20, this is true to a lesser extent in the case of the Peruzzi Chapel; here, a purely ornamental decoration, as has been proven for the Pulci Chapel,[887] may have been sufficient in the beginning. In addition, the striking difference in style to the frescoes of the Bardi Chapel and to anything that could somehow be compared to Giotto's Arena frescoes is of importance for considerations regarding the dating of the murals.

That it was our painter who decorated the Peruzzi chapel with murals is proven by the same sources that are used for his work in the Bardi Chapel (2.1.4, 6 and most reliably by Albertini's Florence Guide: 2.7.7). Nevertheless, in the Peruzzi pictures we encounter an artist we do not know. More resolutely than anywhere else in the surviving oeuvre, Giotto has left the ground of his Paduan achievements and set out on something new. But anyone who wants to doubt his authorship on the basis of this difference (for which the sources certainly leave room) would also have to take into account that the pictures were already used as models in the chapel of the Bargello in the year after Giotto's death, i.e. they were almost certainly painted during our painter's lifetime. The adoption of the figure of Zacharias from the scene of the Naming of the Baptist in Santa Croce into the scene showing the same event in the Bargello, for example, is an obvious and unmistakeable indication.[888]

copy was discovered and published by: I.B. Supino, *Gli albori dell'arte fiorentina*, Florence 1906, pp. 138–139. For the date of the father's death, see: S.L. Peruzzi, *Storia del commercio e dei banchieri di Firenze*, Turin 1930, p. 255.

887 R. Offner, *The Works of Bernardo Daddi*. (A Critical and Historical Corpus of Florentine Painting, sec. 3, vol. 3), ed. M. Boskovits, Florence 1989, pp. 12–13.

888 Previtali, *Giotto e la sua bottega*, fig. 389.

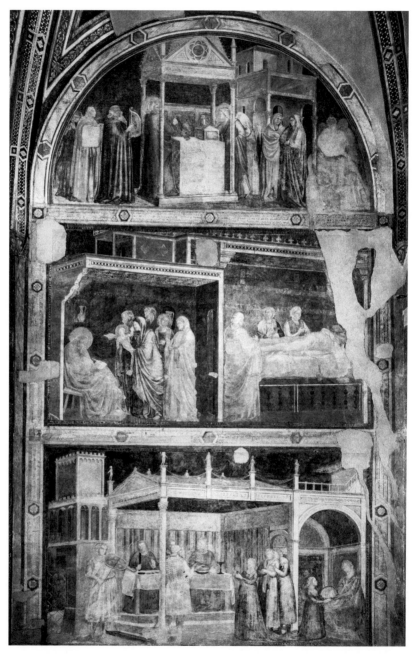

Fig. 330: Florence, Santa Croce, Peruzzi Chapel, north wall: scenes from the Life of John the Baptist

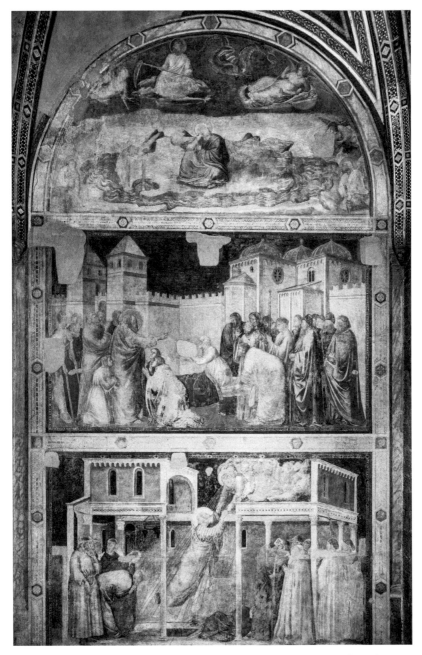

Fig. 331: Florence, Santa Croce, Peruzzi Chapel, south wall: scenes from the Life of John the Evangelist

Apart from the style, the technique is surprising. Unlike all his other surviving murals, Giotto executed the ones for the Peruzzi completely *al secco*; he painted them entirely (and not only in parts, i.e. adding certain colours and details) on the dry plaster. Possible explanations for this are the advanced age of the painter and the existence of other serious obligations – for example, from the spring of 1334 the directing of the cathedral building lodge. It should also be remembered that Giotto moved several times during the last years of his life (vol. 1, p. 62): the return from Naples did not mean returning to an unchanged environment, rather the painter seems to have rebuilt a Florentine infrastructure in two steps. This need not have included a bottega for fresco-painting. As far as the fresco technique is concerned, it may be assumed that the necessity of always having to complete "day works" brought with it time pressure and a considerable amount of organizational effort, and was one of the downsides of this way of working. Painting *al secco*, on the other hand, meant the comfort of a self-determined work rhythm. Slow or irregular working, little professional support and high quality standards could be combined "on the wall" only using this technique.[889]

In his work on the history of the Peruzzi family, compiled in the mid-19th century and never published, Luigi Passerini wrote – unfortunately without giving a source – that the paintings were commissioned by Giovanni di Riniero Peruzzi, a grandson of Donato's brother Pacino, who died in 1358.[890] This is not necessarily correct. Passerini may have drawn conclusions from the coincidence between the dedication of the chapel to the two Johns and his candidate's Christian name. But the dedication of the chapel had probably already been determined by the Franciscans when the construction of the church began and thus perhaps even before Giovanni's birth. The fact that the name Giovanni, which does not occur at all among the older Peruzzi, was common among the generation born around 1300 may be attributed to the patrons of the family chapel (instead of, conversely,

889 F. Bandini, La cappella Peruzzi. Analisi della tecnica di esecuzione delle pitture, in: *Progetto Giotto: Tecnica artistica e stato die conservazione delle pitture murali nelle cappelle Peruzzi e Bardi a Santa Croce*, ed. C. Frosinini, Florence 2016, pp. 77–91. See also L. Tintori and E. Borsook, *Giotto: La cappella Peruzzi*, Turin 1965, pp. 22–23: the authors infer from the technique a strong involvement of collaborators and the use of small-scale preparatory drawings, neither of which I find plausible.

890 BNCF, Miscellanea Passerini, vol. 156, inserito 18bis, tav, 12. A critical transcription and evaluation is given by: C. Frosinini and A. Monciatti, La cappella Peruzzi in Santa Croce a Firenze, in: *Medioevo: I Committenti. Atti del convegno internazionale di studi*, Parma 2010, ed. A.C. Quintavalle, Milan 2011 pp. 607–617, esp. 607 and note 20 p. 616. See also: Tintori and Borsook, *Giotto: La cappella Peruzzi*, p. 10 and note 39 p. 43. E. Borsook, Notizie su due Cappelle in Santa Croce a Firenze, *Rivista d'Arte* 36, 1961/62, pp. 89–107, esp. 99–101.

The Sts. Johns' Chapel of the Peruzzi 515

the dedication of the chapel to the name of a founder).[891] Apart from that, the Peruzzi generation, to which Giovanni di Riniero belonged, was not yet able to dispose of the family assets independently during Giotto's lifetime. Until the collapse of the company, which failed in 1343 for more or less the same reasons as that of the Bardi, Giovanni does not appear as a shareholder in the relevant lists.[892] And even when the Peruzzi fed the poor in Santa Croce in 1335 – I refer to a record in the Peruzzi account books that Eve Borsook has linked to the chapel – Giovanni di Riniero is not named among those who contributed.[893] For the period during which Giotto lived and painted, the sons of Arnaldo and his brother Filippo, as well as some of their sons, presided among the Peruzzi and represented the family and the company in public. The most distinguished of Donato's brothers, who bore the unusual name of Giotto headed the firm from 1331 and died a few months before the painter. He held every important state office during his long life and can be considered one of the most influential figures in the Florentine public sphere from the second decade of the 14th century onwards. However, his brother Tommaso, who led the company between 1303 and 1331 and died in 1347, was hardly less important. The only members of the following generation (i.e. Giovanni di Riniero's parents' generation) who had made it to the "top floor" of the company by the mid-thirties were Tommaso's sons Bonifacio and Pacino.[894]

Of Arnaldo's sons who started families, Donato, who had left the initial funds for the erection of the chapel, is the only one who is hard to capture for the modern historian. We know no more than the contents of his will of 1292 and Passerini's unverifiable statement that he was still alive in 1299.[895] This slight echo of his biography in the existing documents is most likely explained by the fact that Donato died before the restructuring of the firm, which took place in 1300 and created a lot of charter material. Assuming all this, and also assuming that the family chapel represented, both in a concrete and in a figurative sense, a legacy of Donato di Arnaldo, and that the painting was intended to complete his foundation, it can be concluded that the murals were supported by the entire family and were the responsibility of Donato's brothers as well as Donato's and their children – regardless of who in the family was in charge of managing the project.[896] The entries in the Peruzzi account books, which Alessio Monciatti pointed out in 2010, match

891 Consult the family tree compiled by Edwin S. Hunt: E.S. Hunt, *The medieval super-companies: A study of the Peruzzi Company of Florence*, Cambridge 1994, pp. 252–254.

892 Hunt, *The medieval super-companies*, pp. 261–265.

893 *Libro di Giotto e della Chompania.* Florenz, Biblioteca Riccardiana, Cod. 2417, carta 9 links. Published in: Tintori and Borsook, *Giotto: La cappella Peruzzi*, p. 95 no. 2.

894 Hunt, *The medieval super-companies*, pp. 21–35 and passim.

895 Tintori and Borsook, *Giotto: La cappella Peruzzi*, p. 10.

896 So alredy: F. Bologna, *Novità su Giotto: Giotto al tempo della cappella Peruzzi*, Turin 1969, p. 56.

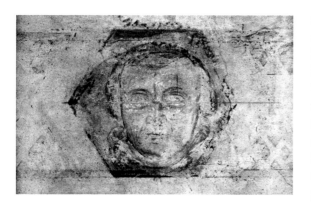

Fig. 332: Peruzzi Chapel, decorative head from the moulding

this: from July 1335, unspecified work took place in the "chapella loro de la Croce", which may or may not be connected with Giotto's activity. What is decisive here is that the not very high costs of 27 lire 10 soldi and 8 denari were borne by four nephews of Donato, grandsons of his uncle Filippo.[897] According to this, when the decoration was conceived, the painter Giotto was most likely targeting people more or less his own age and of the next generation for work. With the painter, his audience aged.

The overall decorative system closely follows the model of the neighbouring Bardi Chapel: fictitious columns in the corners; between them on the side walls, in painted frames, two images each from the life of John the Baptist on the left and John the Evangelist on the right (280 by 430 centimetres – fig. 330, 331). The mouldings between the two pictures each show four masterfully painted character heads in hexagonal frames; the breath-taking quality of these embellishing details indicates that Giotto was more or less alone on the scaffolding most of the time (fig. 332). Above this, under the vault, the lunette fields follow, somewhat less emphatically framed and thus somewhat closer to the world of the viewer. The vault itself is decorated with four medallions depicting the evangelists. Just as the pedestal zone of the Bardi Chapel can be reconstructed according to the fictitious marble incrustation in the Peruzzi Chapel, so can the altar wall of the Peruzzi Chapel be imagined as analogous to that of the Bardi Chapel (pl. XVI): four niches with figures of saints, with the two Johns certainly among those depicted. Only a medallion with an Agnus Dei slaughtered on the altar has survived above the window, a theme in which motifs from the roles of the Baptist or Forerunner and the Evangelist or Apocalyptic meet: The Evangelist John describes how the Baptist calls Christ the Lamb of God (John 1: 29 and 36), while the recurring vision of a lamb is one of the main motifs in the Apocalypse. The meaning of the animal is more or less always the same: the lamb stands for Christ sacrificed or prepared for sacrifice. Thus, its appearance in the chapel not only links the biographies of the two Johns, but also establishes a connection with the Eucharistic place on the altar where mass was said for the Peruzzi.

897 Frosinini and Monciatti, La cappella Peruzzi, p. 610. *I libri di commercio dei Peruzzi*, ed A. Sapori, Milan 1934, pp. 36. 333–334.

TWO LIVES IN SIX PICTURES

The legends of the Baptist and the Evangelist are among the most elaborate biographies of any saint. The life of the Baptist was of particular interest to the Florentines, as he was their city saint, venerated in the Baptistery, the most important Florentine church next to the cathedral. Around 1290, a visual legend of the Baptist in fifteen pictures was created there; it expanded the mosaic programme of the dome and clarified the role of the church as a place of worship for the city's patron saint. This was followed from 1330 onwards by a legend of St. John in the form of twenty bronze reliefs, largely based on the mosaics. This is today's south door of the baptistery, which was created by Andrea Pisano for the main entrance, the east portal. Against the background of this flood of images from the life of the Baptist, it becomes clear what it meant to employ only three images each for the presentation of the two saints – and of the Baptist in particular: With such a selection, each of the scenes had to be carefully justified in terms of its meaning. Ultimately, it was a question of defining the profile of the respective saint to make it suitable for cultic use at the chapel.

The selection for John the Evangelist (on the right wall in the lunette: John on Patmos, in the centre: John raising Drusiana, at the bottom: Ascension of John, fig. 331) points quite clearly in the direction of end-time fear and hope for the afterlife.[898] As an exile on the island of Patmos, John receives visionary testimony of the coming of the Last Judgement, which the faithful may look forward to with hope; on the deceased Drusiana in Ephesus he demonstrates the power of faith over death; instead of having to wait in his tomb in the same city for the Last Day, John is granted corporeal resurrection – a scene that is rarely visualised despite its popular textual basis in the *Legenda Aurea*.[899] Since the joint veneration of the two St Johns can be traced back to early Christian times, the status of the Evangelist as co-patron of the chapel does not really require explanation.[900] Moreover, the Legenda Aurea points out that the Evangelist died on the anniversary of the Baptist's birth; those who commemorate the birth of the latter should not forget the former.[901] The selection of scenes from his life, however, requires explanation and here it is obvious how his role is aligned with the interests of the patron family: Giotto presents the

898 Cf. L. Schneider, The Iconography of the Peruzzi Chapel, *L'Arte* 17, 1972, pp. 91–104 and J.F. Codell, Giotto's Peruzzi Chapel Frescoes: Wealth, Patronage and the Earthly City, *Renaissance Quaterly* 41, 1988, pp. 583–613.

899 *Legenda Aurea*, ed. Maggioni, p. 95. J.F. Hamburger, *John the Divine: The deified evangelist in medieval art and theology*, Berkeley 2002, p. 157.

900 Hamburger, *John the Divne*, p. 65. Cf. D. Blume, *Wandmalerei als Ordenspropaganda: Bildprogramme im Chorbereich franziskanischer Konvente Italiens bis zur Mitte des 14. Jahrhunderts.* Phil. Diss., Worms 1983, p. 93.

901 *Legenda Aurea*, ed. Maggioni, p. 549.

518 Giotto Pluralistic: The Peruzzi Chapel in Florence and the Late Works

Evangelist as the protector of their (future) dead. This is reminiscent of the way the Bardi had previously appropriated St. Francis in some of the pictures in their chapel. Since 1305, many members of the Peruzzi family had been buried in Santa Croce, including Giotto Peruzzi, and certainly some were lying in front of the chapel, just as members of the Bardi family were lying in front of theirs.[902]

The left wall and thereby the role assigned to the Baptist is more difficult to understand (fig. 330). The lunette presents the Annunciation to Zacharias, below is the birth and naming of the Baptist, and at the very bottom, in a bold and complex picture (of a type that has been called "Simultanbild", simultaneous picture, in German-language art history since Ehrenfried Kluckert's dissertation),[903] Giotto shows the dance of Salome, fatal for John, and the presentation of his severed head first to Herod and then to Herodias (pl. XIX). The accent placed on the naming episode fits John's role as patron saint of Francis, which was probably the decisive motivation for consecrating the chapel to the Baptist. Thomas of Celano reports in the *Vita Secunda* (I, 3) that the future Poverello had received the name of John the Baptist from his mother. Bonaventure elaborated this information into a programme of succession in his *Legenda Maior* (*Prologus*, 1), which was current in Giotto's time: Francis had explicitly followed the example of the Baptist when he preached repentance.[904] And it is precisely this idea that seems to be alluded to in the scene painted by Giotto, for the infant who is brought to his father gesticulates in the manner of the Preacher in the Desert: just born, he is already delivering a sermon (fig. 333). A source for this, be it a picture or a text, is not known. It seems to be an invention by Giotto, who combined various details into a visual anecdote: on the one hand, the *Legenda Aurea* highlights that John had possessed prophetic gifts even before his birth (with reference to the event on the occasion of the visitation of Elizabeth to Mary, which Luke 1:41 relates). On the other hand, it is reported how easy and joyful his birth was.[905] To create from this an infant who was hardly born and yet already preaching and thus an unrivalled prodigy in one of St. Francis' areas of competence was certainly daring – but obviously met the expectations of the audience.

The choice of the theme for the lunette can also be explained: the fact that John's birth was announced by an angel, namely by the same archangel Gabriel who had also appeared before Mary (the *Legenda Aurea* attaches great importance to this), connects the

902 Tintori and Borsook, *Giotto: La Cappella Peruzzi*, S. 14.
903 E. Kluckert, *Die Erzählformen des spätmittelalterlichen Simultanbildes*, Phil. Diss., Tübingen 1974. The premise was Kurt Weitzman's term "simulaneous method". Cf. U. Rehm, Wieviel Zeit haben die Bilder? Franz Wickhoff und die kunsthistorische Erzählforschung, *Wiener Jahrbuch für Kunstgeschichte* 53, 2004, pp. 161–189.
904 *Fontes Franciscani*, ed. E. Menestò and St. Brufani, Assisi 1995, pp. 445, 777–778.
905 *Legenda Aurea*, ed. Maggioni, p. 547.

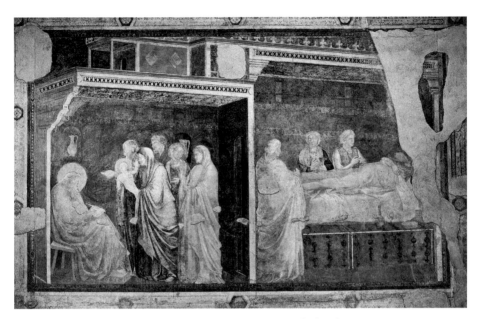

Fig. 333: Peruzzi Chapel, north wall: The Birth and Naming of John the Baptist

biography of the Baptist with that of Christ. In this way, the image highlights the theme of Christ-likeness, which was always fascinating for the Franciscans. What poses problems is the lower picture. It is sometimes claimed to show John's Passion, but in fact it does not (pl. XIX). His execution itself is omitted and thus it lacks what could be considered the climax of a Christ-like biography (and is also presented as this in the mosaics of the Baptistery)[906]. In contrast, the frivolous circumstances that frame this event in the narrative sequence are precisely visualised and interpreted: Salome's dance and the handing over of the head by Salome to Herodias correspond to the account in the Gospel (Mark 6, 22 and 28): "... and danced, and pleased Herod and them that sat with him" "... and the damsel gave it [the head] to her mother." Giotto's narrative differs from the Biblical account insofar as the head is first brought before Herod, who then directs the executioner to Salome as the recipient. Mark (6: 27–28) tells this more fluidly: "And immediately the king sent an executioner, and commanded his head to be brought: and he went and beheaded him in the prison. And brought his head in a charger, and gave it to the damsel: and the damsel gave it to her mother." The fact that the head takes a diversion via Herod's banquet table points to another textual source, namely a legend of John that was popular for a

906 M.V. Schwarz, *Die Mosaiken des Baptisteriums in Florenz: Drei Studien zur Florentiner Kunstgeschichte*, Cologne 1997, p. 126.

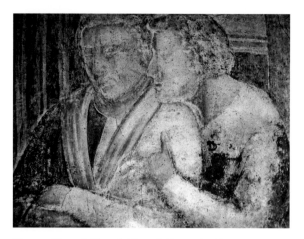

Fig. 334: Peruzzi Chapel, Herod's Feast, detail. servants

Fig. 335: Peruzzi Chapel, Herod's Feast, detail: the musician

time in Florence and Tuscany, but otherwise not very widespread. It was used both by the mosaicists who created the picture cycle on the Baptist in the dome of the Baptistery and by Andrea Pisano 40 years later for individual scenes when working on the bronze door of the Baptistery.[907] The text is preserved only in a *volgare* translation of the early 14th century. After describing the beheading, the narrator continues:[908]

> *And the officer took the head, and bloody as it was, he brought it before the eyes of the king. When the guests who were dining saw this, they were all dismayed and full of grief, for it seemed terrible to them to witness such a thing. So the feast was spoiled. And to this day it happens that all the vain rejoicing sometimes turns into great sadness. And the king had the head handed to the girl.*

907 M. Aronberg-Lavin, Giovannino Battista: A Study in Renaissance Religious Symbolism, *The Art Bulletin* 37, 1955, pp. 85–101. M. Aronberg-Lavin, Giovannino Battista: A Supplement, *The Art Bulletin* 43, 1961, pp. 319–326. The author points out that the attribution of the translation to Domenico Cavalca on which the first article was based is inaccurate. Schwarz, *Die Mosaiken des Baptisteriums in Florenz*, p. 125.

908 Domenico Cavalca, *Vite di alcuni Santi scritte nel buono secolo della lingua toscana*, Florence 1734, p. 255: "L'uficiale prese la testa, e così sanguinosa la portò suso dinanzi alla faccia del Re. Quando costoro, che mangiavano, vidono questa cosa, furono tutti istupefatti, e con tristizia molto, che pareva loro una terribile cosa questa a vedere, sicchè fu guasta la festa; e al dì d'oggi interviene, che le molte vane allegrezze ritornano talvolta in grande tristzia. E il Re fece dare la testa in mano della fanciulla."

As in the legend, so in Giotto's mural, the feast is ruined by the incident, and the painter depicted this by devoting himself to the supporting characters: there is the guest on the right at the table, who, in contrast to Mark, does not look at the dancer and expresses pleasure, but holds a carving knife and stares at it as if it were the executioner's sword, while he raises his left hand in complaint (fig. 341). Then there are the two whispering servants on the left, who unquestionably disapprove of what is happening, and finally the musician also reveals through his sombre face how reluctant he is to take part in the event (fig. 334, 335).

But did the painter also visualise the motif of the story that deviates most strikingly from the biblical account? The evangelist Mark knows that Herod liked to hear John preach, but was incited against him by his wife Herodias, just as she manipulated Salome against John. Accordingly, Herod was "exceeding sorry" (6: 26) when Salome requested John's head after her performance. The Tuscan legend, by contrast, describes in detail that Herod and Herodias were in alliance: Salome's dance and the girl's wish, expressed in response to Herod's question, were a set-up. It was clear from the start that the feast was to be used to get rid of John and to make the king look as innocent as possible. The motif is also found in short form in the *Legenda Aurea*. Herod, the reader learns, was in agreement with Herodias and, when Salome expressed her wish, he only feigned sadness.[909] As for Giotto's Herod, it is clear that he plays a dazzling role (fig. 336). The gesture of his right hand not only redirects the head to Salome, but also dismisses his own guilt and perhaps even assigns it to Herodias. The finger bowl over which the gesture appears is obviously a quotation from another story. It makes the viewer think of Pilate washing his hands and of the words (Matthew 27: 24): "I am innocent of the blood of this just person". If we read the movement of the hand according to Mark, it stands for weakness and indolence, if we read it according to the Tuscan legend and the *Legenda Aurea*, it

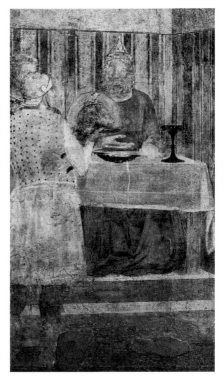

Fig. 336: Peruzzi Chapel, Herod's Feast, detail: Herod

909 *Legenda Aurea*, ed. Maggioni, p. 874.

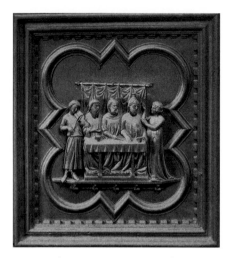

Fig. 337: Florence, Baptistery, South Door: The Dance of Salome (Andrea Pisano)

Fig. 338: Florence, Baptistery, South Door: The Beheading of John the Baptist (Andrea Pisano)

stands for hypocrisy. The fact that both readings are possible is likely to have caused conversation among the visitors to the chapel and intensified their perception of the scene. All in all, the picture was probably conceived both as moralising and as an admonition: the elimination of the preacher does not eliminate the unpleasant truths he speaks, but rather results in a kind of spiral of increasing sins – a pastoral argument that is more likely to have been developed on the part of the Franciscans than on that of the donors.

If one wants to appreciate the narrative achievement in which the argument is delivered, one has to ask where Giotto found visual material in such abundance that he could afford to simply omit the main action and in this way exclusively focus on the messages of the side events. This enquiry leads back to the great Florentine cycles from the Life of John and raises the question of whether the treasure trove of motifs available to Giotto was developed there. In the dome of the Baptistery, the corresponding events are narrated with three images along the lines of Mark's account: the Dance of Salome, the Beheading of the Baptist, Salome Giving the Head to Herodias. Unfortunately, there is not much to be done with the pictures themselves, because they are no longer the mosaics that Giotto had seen, but 15th century renewals.[910] Some of their motifs even hark back to

910 Schwarz, *Die Mosaiken des Baptisteriums in Florenz*, pp. 142–151. The conservation problems of the mosaics and their poor documentation are not methodically reflected by Miklos Boskovits' study: M. Boskovits, *The Mosaics of the Baptistery of Florence* (A Critical and Historical Corpus of Florentine Painting, sec. 1, vol. 2), Florence 2007. All visual per-

Fig. 339: Florence, Baptistery, South Door: The Presentation of John's Head to Herod (Andrea Pisano)

Fig. 340: Florence, Baptistery, South Door: The Presentation of John's Head to Herodias (Andrea Pisano)

Giotto's Peruzzi scene. The themes of the fields, however, were probably retained and perhaps also basic features of the compositions, which correspond more to the norms of Cimabue's time than to those of the Quattrocento. The second series of images of the Baptist is a kind of extension and modernisation of the mosaic cycle and has also already been mentioned: it decorates the oldest of the bronze doors of the same church. There, Andrea Pisano represented the relevant passage of the Vita in four reliefs: the Dance of Salome, the Beheading of the Baptist, the Presentation of the Head to Herod, and the Presentation of the Head to Herodias by Salome (fig. 337–340). Of particular interest is the third picture, which was inserted into the sequence of scenes given by the mosaic cycle. Following the Tuscan legend just as Giotto did, Andrea describes a diversion of the head across the banquet table: a kneeling servant hands it to Herod, who points to Salome waiting at the other end of the table (fig. 339).

It has long been suspected that there is a connection between Andrea Pisano's reliefs and Giotto's murals. Considerations about this seem particularly promising because the work on the reliefs of the door can be dated by documents to the years from 1330 onwards. In 1332, the wax models of the scenes were completed; up to this point, suggestions may still have been incorporated into the reliefs, while from then on they might have been available as inspiration for Andrea's fellow artists. In the following years, the slabs

ception is subjected to the paradigm of "connoisseurship", so that restoration campaigns become "masters".

524 Giotto Pluralistic: The Peruzzi Chapel in Florence and the Late Works

were cast and refinished. The last work is documented for the summer of 1336. On St John's Day of that year, the portal seems to have been solemnly consecrated.[911]

The comparisons concern two complexes. One is the Naming scene (fig. 333): here as there, in Andrea's door relief and in the central picture on the left wall of the Peruzzi Chapel, Zacharias has crossed his legs and, using his knee as a support, writes the name his son is to receive on a parchment, while a group of people approaches him, led by a figure carrying the baby John; in Andrea Pisano's work, who followed the Tuscan legend, it is Mary,[912] in Giotto's it is a midwife. The similarities in the composition and the design of the figures are usually evaluated in the sense of a dependence of Andrea on Giotto.[913] Indeed, the way the women standing in the back look at each other may be called a typical Giotto motif. But it was already widely available at the time, and its use in Andrea's work is not necessarily a borrowing from the mural. A significant difference between the two versions of the story concerns the presence of the two men who appear behind the women in Giotto's work; the one in front holds a small knife. It seems plausible to see this as an extension of Andrea's scene, following Luke 1: 59: "They came to circumcise the child". But it is certainly also possible to postulate that Andrea's narrative is a reduction of Giotto's scene to Luke's central phrase (1: 63): "And he asked for a writing table, and wrote, saying, His name is John." However, in comparing, one should look to a third version of the scene, which is the earliest, namely the mosaic image in the baptistery. The picture, which is in an area executed by Cimabue and his workshop, was almost three-quarters remade in the 19th century, but a part of the seated Zacharias remained and so the following can be said:[914] this figure is the prototype of both Giotto's and Andrea's figure, but the bronze Zacharias with his deeply bent back is closer to the mosaic. This means that Andrea did not take the main figure of his scene from Giotto.

The other possibility of comparison is offered by the dancing Salome, who gains erotic presence in the mural as in the relief less by using her body than by using her hands, which caress the air,[915] and through the two musicians who accompany the dance. In this case, too, Giotto's Lira da braccio player is regarded as the model for the one in the relief (fig. 341, 337). However, it should be pointed out that although the two play the same

911 G. Kreytenberg, *Andrea Pisano und die toskanische Skulptur des 14. Jahrhunderts*, Munich 1984, pp. 20–26, collection of documents pp. 179–181.

912 Cavalca, *Vite di alcuni Santi*, p. 191.

913 This started with: I. Falk und J. Lanyi, The Genesis of Andrea Pisano's Bronze Doors, *The Art Bulletin* 25, 1943, pp. 132–153.

914 Schwarz, *Die Mosaiken des Baptisteriums in Florenz*, p. 97.

915 T. Hausamann, *Die tanzende Salome in der Kunst von der christlichen Frühzeit bis um 1500: Ikonographische Studien*, Phil. Diss. Zürich 1980, p. 410. According to Eve Borsook, it is not a dance position, but a gesture of supplication: Tintori and Borsook, *Giotto: The Peruzzi Chapel*, p. 28.

instrument in a similar way (i.e. both artists depicted the same thing), Andrea's tools are derived from the French Gothic fund of models that gives his art its unique character within the Italian sculpture of his time. Attention should be drawn to the extremely lively musician in a Provençal manuscript from around 1290 (Graz University Library, cod. 32, fol. 106v) and the music-making angel in a Parisian Apocalypse manuscript from 1313 (Paris, BNF, ms. Fr. 13096, fol. 67r) – a figural invention that can be traced back almost a century in France.[916] Giotto's musician, on the other hand, appears static and is a modified version of the musician in the Arena fresco showing Mary's Return to her Parents' House (fig. 342). The fact that both times – at the door and in the chapel – a lira da braccio player is standing at Herod's table, guiding the bow in the same way and Salome dancing to it similarly, indicates that one artist was inspired by the other, but the direction of the inspiration cannot be inferred from this finding.

Fig. 341: Peruzzi Chapel, Herod's Feast, detail: the musician and a guest

In contrast, the analysis of the narratives is revealing. Giotto's selection and bold recombination of motifs is difficult to imagine without Andrea Pisano's visual processing of the story as a prerequisite. There, extending the mosaic cycle and following the Tuscan legend of St. John, those three secondary scenes were arranged for the first time so that they came before and after a main scene (the beheading). Giotto would then combine these into one picture, omitting the main scene. And the question of narrative provides a second argument for the priority of Andrea: it is difficult to imagine that the storyline

916 For the first example see: M. Schuller-Juckes and E.Th. Kubina, *Die illuminierten Handschriften der Universtätsbibliothek Graz 1225–1300* (Die illuminierten Handschriften und Inkunabeln in Österreich ausserhalb der Österreichischen Nationalbibliothek 3, 1), Vienna 2022, no. 81, esp. fig. 814. For the second example see: *Apocalypse 1313* (facsimile), Barcelona 2006. An earlier version of the musician can be found in the Prodigus window of Bourges Cathedral: W. Kemp, *Sermo corporeus: Die Erzählung der mittelalterlichen Glasfenster*, Munich 1987, pl. 14.

Fig. 342: Arena Chapel, north wall of the nave: The Virgin's Return in Her Parents' House, detail

in the Peruzzi Chapel, told in a complicated overlapping of events, could be easily understood by an audience that did not know the full four-part version of the same passage on the bronze door, and this ability could only be assumed after the door was in place. It should be remembered that Andrea Pisano's valves were intended to close and open the main liturgical portal of the Baptistery, the doorway through which the parents and godparents of little Florentines entered the church of the city's patron saint from the Duomo on certain feast days. Once the valves were installed, the story with its three subplots could be taken for granted as part of the basic visual literacy of the people of the city of St. John – but not before.

This means also that Giotto's narrativizing of the circumstances of John's death not only points in a certain exegetical direction, but its reading also links the chapel's pictorial programme to the city's main sanctuary. Moreover, the two cycles were intertwined by patronage: the Peruzzi were among the leading families in the Calimala guild, the oldest and most important of the Florentine corporations in which the cloth merchants and bankers were organised. Donato's brothers Pacino, Filippo and Tommaso, as well as his father Arnaldo, can be identified as members, some of them in prominent positions.[917] The "Ars et Universitas Mercatorum Callismale" was entrusted with the maintenance of the Baptistery. The idea of having bronze doors made, decorating them with a cycle of images of the legend of the church's patron saint, and calling on Andrea Pisano to execute them, had thus matured in a circle in which members of the Peruzzi family had a say.[918]

917 G. Filippi, *L'arte dei Mercanti di Calimala in Firenze ed il suo più antico statuto*, Turin 1889, esp. p. 191. Peruzzi, *Storia del commercio e dei banchieri di Firenze*, pp. 255, 257. L. Fabbri, Calimala e l'Opera di San Giovanni: il governo del Battistero di Firenze fra autorità ecclesiastica e potere civile, in: *Il Battistero di San Giovanni: conoscenza, diagnostica, conservazione. Atti del convegno internazionale Firenze 2014*, ed. F. Gurrieri, Florence 2017, pp. 72–85.

918 We owe the information about the progress of the work on the doors to the excerpts made by Carlo Strozzi from the documents of the Calimala Guild: Kreytenberg, *Andrea Pisano*, p. 179.

And knowledge of this, which was certainly widespread in Florence, may also have contributed to an interlinked perception and reading of the two cycles of the Baptist.

The comparison not only grants access to important contexts for the images, but also provides a *terminus post quem* that is almost a *terminus ad quem*. In those years in which the portal reliefs were created and in which it became apparent what the images would look like Giotto was still in Naples. By autumn 1334 at the latest, however, he was back in Florence (1.1.67). At this time, he probably registered that Andrea's door reliefs had been the major artistic and media event in his hometown during the years of his absence. He died at the beginning of 1337, after having visited Milan (2.1.1). The Peruzzi murals can therefore only have been painted between summer or autumn 1334 and summer or autumn 1336. Their unveiling must have roughly coincided with the final installation and consecration of the portals at the Baptistery. In the same years, the Florentines were offered an authoritative pictorial *vita* of John at the central place of veneration of this saint and a speculative Franciscan interpretation of aspects of his life at Santa Croce, two cycles that could illuminate and enrich each other, and behind both offers, albeit in different capacities, were the Peruzzi.

Finally, some entries in the Peruzzi business books, which Eve Borsook has pointed out, fit in with this chronological approach to the murals. They refer to donations for *pietanze* (meals for the poor), which the Peruzzi organised in Santa Croce on the feast day of John the Evangelist (27 December). The oldest known document refers to the year 1335 (see p. 455). Further evidence comes from the years 1336, 37 and 38. From the year 1409 it is recorded that the Peruzzi celebrated 27 December "ogni anno" with a meal for the poor. And finally, there is a report from 1599 (?) that Lisa, widow of Ridolfo Peruzzi, hosted the "Festa di S. Gio. Evag.ta" in the "Capella di Peruzzi" – this information is particularly interesting.[919] If we assume that the tradition was indeed established in 1335 and that the feeding was held in the family chapel from the beginning, then 27 December 1335 would indeed be the *terminus ante quem* for the conclusion of Giotto's activity, and the period during which the murals were made would narrow down to the second half of the year 1334 and the year 1335. This fits with Monciatti's archival find that some work was going on in the chapel in the summer of 1335 and had to be paid for (see above).

THE PERUZZI STYLE

The psychological complexity and sophistication manifested in the Feast of Herod is one of the hallmarks of the Peruzzi pictures. It is especially the figure of the musician that demonstrates these characteristics: the body may swing with the melody like that of the

919 Tintori and Borsook, *Giotto: La Cappella Peruzzi*, p. 14 and p. 96 nos. 4, 5, 6, 7, 11.

violinist in Andrea Pisano's relief, who in this way almost becomes a dancing counterpart of Salome, but his head does not swing with it and his facial expression speaks of great distance to everything that is happening before his eyes and which is accompanied, if not made possible, by his playing. Giotto had used secondary figures to comment on the content of his scenes before, but he had not until then introduced an opposition between their formal and psychological roles (i.e. an opposition between the person's action and his or her attitude towards it). It has become common to look back with regret on the restoration to which the murals were subjected in the sixties of the twentieth century: all the overpaintings and additions disappeared at that time and what remained were indeed unattractive ruins of images. However, those who compare the musician's head before and after the restoration will think about the problem differently. In the overpainting of the sixties of the 19th century, nothing of the toughness and intelligence of Giotto's invention emerged, instead, flat sentimentality prevailed. In addition, the juxtaposition also shows how sophisticated Giotto was as a narrator and how naïve a painter of the mid-19th century thought him to be. If the overpaintings had not been removed, we would not know essential qualities of Giotto's art in its late phase.

Other characteristics of the Peruzzi pictures are their heightened corporeality and spatiality. The sad state in which the painting has been preserved leaves the impression that these phenomena did not necessarily occur together – so that a body appeared here and a space there. I imagine, however, that powerful bodies originally populated wide spaces and moved about in them – as is still comprehensible in the Feast of Herod (pl. XIX). The widening and greater complexity of the spaces continues a tendency that is already apparent in the Bardi Chapel, but gains a new quality in the Peruzzi Chapel. Here, the spaces appear permeable and the bodies move freely. If one imagines that these peculiarities were perhaps already inherent in the Naples murals that were painted shortly before, what may have been lost to us there becomes discernible. Another of the peculiarities of the Peruzzi murals is the sumptuous material equipment of the narratives and figures. In this context, reference should be made to the chest covered with red leather and studded with iron bands in front of Elizabeth's bed in the central picture of the Baptist wall (fig. 333), to the Biedermeier striped wall hanging in Herod's banquet loggia, and to the antique-like figural decoration of the roof (pl. XIX). The fact that Giotto quotes real buildings and among them the Roman Torre dei Conti has occurred since the Navicella. However, a version of the Torre dei Conti as impressive as the one in the Peruzzi Chapel, which stands next to Herod's loggia and perhaps represents John's dungeon (copies of the fresco show the decapitated body of the Baptist behind the grille)[920] had not occured in Giotto's work before. This building has shed any prop-like quality, as was the case with the architecture in the Arena Chapel. Liberated from the conditions of the figure com-

920 Ibid. pp. 25–28.

positions, the tower almost stands free and projects just enough above its surroundings to appear large when viewed from below. The powerful impression made by the buildings is intensified by their orientation towards the viewer. This is another phenomenon with which Giotto had already experimented in the Bardi Chapel. It should be borne in mind, however, that on the one hand the painter was picking up on his pictorial language from before the Arena Chapel, while on the other the narrow Bardi Chapel – like the Peruzzi Chapel – does not permit a frontal view of the images. A pictorial world closed off from the real space, as developed in the Arena Chapel, would hardly have been readable. However, in certain Peruzzi pictures, the opening up to the viewer acquires a quality that resolutely goes beyond what is opportune and a continuation of the familiar.[921] Here again, one can refer usefully to the scene of Herod's Feast. If one looks into the chapel from the outside at an angle, the pseudo-Torre dei Conti not only appears imposing, but it also looks as if it were standing freely next to the hall (fig. 344). The corner column of the loggia does not seem to be in a pictorial space, but in the viewer's. The whole architectural complex of Herod and Herodias' palace, including the queen's chamber, presents itself to us as if one could move into it from the real space. This again contributes to the interplay of space and figures: just as the column seems to stand free, so does the soldier with the Baptist's head behind it.

Fig. 343: Santa Croce, view into the Peruzzi Chapel with the north wall

Fig. 344: Santa Croce, view into the Peruzzi Chapel with the south wall

921 Francesca Flores d'Arcais pointed this out: F. Flores d'Arcais, *Giotto*, Milan 1995, pp. 255–257.

The phenomenon is equally clear in the picture above (fig. 343). The piece of wall that Giotto depicted next to the seated Zacharias connects to the real wall when seen from the transept and seems to project into the real space like a console, an effect that is supported by the fact that its upper part actually looks like a console. Zacharias' room and behind it that of Elisabeth extend into a depth that is simultaneously the painted and the real depth of the Peruzzi Chapel. The lunette picture of the Annunciation is also impressive. Here, a building has been placed to the right of the ciborium only because it expands the pictorial space into the depth of the chapel.

If the spatiality of the murals tends towards having an illusionistic quality, then the same can be said of their corporeality, except that its unfolding is not dependent on certain viewer positions. But its effect is even more hampered by the extensive destruction of the upper layer of the painting than that of the space. The monumentalised silhouettes and the small heads, which make the figures appear tall, are easily recognisable, as are the pathetically ponderous movements that characterise even the female figures: it is striking, for example, how the green-clad midwife leans forward to show Zacharias the newborn preacher, and how the yellow-clad one leans back behind her, as if it were necessary to create a counterweight (fig. 333). The impression of corporeality and heaviness was probably completed by the draperies, only a small part of whose coloured surfaces have been preserved. What we see is more three-dimensional and rich in form than the vestments in the Arena, Mary Magdalene, and Bardi chapels; but it does not have the virtuosic quality of the Isaac frescoes and the cross of Santa Maria Novella. The fabrics fall in large, partly broken forms, precisely modelled by light and shadow, which often take on a life of their own. The best preserved is the grey-green coat of a man in the middle picture of the right wall, which shows the Revival of Drusiana (pl. XX, second figure from the left). Below the raised arm, a multifaceted figuration of wrinkles unfolds, on which the light plays in a way that does not occur elsewhere in Giotto's oeuvre. At this point, the depiction of the fabric acquires a haptic quality that had probably not been achieved before in post-antique European painting. Wherever the uppermost layer of paint is preserved, in addition to a variety of forms, complex colour tones can be seen that emphasise the materiality of what is depicted. In addition, details are visible whose subtlety surpasses anything in Giotto's oeuvre: the ornamented gold borders on the musician's robe, the intricately inlaid surface of his violin (fig. 341), and the Gothic carving on the musician's harp in the Annunciation painting. Reference should also be made to the now largely flaked still life that was set up on the leather-covered and iron-bound chest in front of Elisabeth's bed, consisting of a box, a bottle, and a glass. The objects must originally have seemed immensely present and physical (fig. 333). What might have distinguished the pictures most clearly from Giotto's earlier works was probably the splendour and almost gapless density in which the material appearance of things came before the viewer's eyes. In this, the Peruzzi murals were close to the works of Simone Martini and the Lorenzetti bothers on the walls

The Peruzzi Style

and vaults of Assisi and Siena. In Giotto's work of the twenties and thirties competition with the Sienese painters is perceptible again and again and finds its most consistent expression in the Peruzzi Chapel.

The group of whisperers in Herod's Faest (fig. 334) was developed on a basis supplied from Siena. One servant does not obediently fold his arms as he should (think of the servant in the Paduan Wedding of Cana, fig. 47), but crosses them dismissively, and he does not bow but leans back, while the other joins him and says something in his ear that seems to confirm his dismissive attitude. The first servant is a figure encountered almost verbatim in a fresco by Ambrogio Lorenzetti.[922] Originating from the chapter house of San Francesco in Siena, it is now in the church (fig. 345). It was probably painted shortly before 1329, because in that year Ambrogio's brother Pietro Lorenzetti used a kind of replica of the room depicted for the predella of his Carmelite altarpiece.[923] Ambrogio's picture shows Boniface VIII anointing St. Louis of Toulouse as bishop in 1296 and admitting him to the Franciscan Order. The man with the crossed arms represents a member of the Naples court who – like the king – has no choice but to look on sullenly as the crown prince renounces his inheritance and embarks on a career of poverty. Another courtier stands to his left and puts a comforting hand around his shoulder. In this case, the appearance of the observers as a pair has something conciliatory about it. In the Peruzzi Chapel, Giotto exchanged the one coming from the left for one approaching from the right. Subliminally aggressive figures like this also exist in Ambrogio's painting, such as the profiteer of the story, the later King Robert, who stands to the right of the centre in the same row as the couple, pointing his thumb at himself. Giotto's conversion of Ambrogio Lorenzetti's group of figures transforms a resignation shrouded in sadness into almost open disapproval.

Incidentally, Giotto was the taker (the one who borrowed from Ambrogio) only in the moment and with the detail described here. As far as the overall composition and Ambrogio's rendering of space is concerned, he was the giver, but that was some time ago. Indeed, important sources for Ambrogio's image can be found in the Bardi Chapel (if it was not the Choir of the Badia where Giotto had made the relevant inventions). As Andrew Peter already saw in 1940, the arrangement of figures is a variation of Giotto's scene with the Confirmation of the Rule of the Order[924] (fig. 253). The design of the

922 Eve Borsook who dates the Peruzzi murals earlier, sees the relation in reverse. For her, Giotto inspired the Sienese version of the group: Tintori and Borsook, *Giotto: La cappella Peruzzi* p. 15.

923 E. Borsook, *The Mural Painters of Tuscany: From Cimabue to Andrea del Sarto*, Oxford 1980, pp. 33–34. A. Peter, Giotto and Ambrogio Lorenzetti, *The Burlington Magazine* 76, 1940, pp. 3–8.

924 Idid.

Fig. 345: Siena, San Francesco: The Episcopal Consecration of St. Louis of Toulouse (Ambrogio Lorenzetti)

architectural enclosure is based on spaces that Pietro Lorenzetti and Simone Martini had already developed using models by Giotto, but for the intricacy, the setting for the Apparition in Arles in the Bardi Chapel was certainly an additional inspiration (fig. 255). Since we know that Ambrogio was in Florence in the mid-twenties, and probably worked mainly in this city, it is possible that he studied Giotto's frescoes. Giotto's knowledge of Ambrogio's motifs, on the other hand, is astonishing and clearly shows that not only did the Sienese painters take the Florentine seriously, but that the Florentine also had his Sienese colleagues in mind.

EPHESUS IN FLORENCE OR A WINDOW TO THE WORLD

A new quality in the staging of a scene using architecture is achieved in the middle image of the south wall, which shows the Raising of Drusiana (pl. XX). John White, the historian of painted space, stated that with this picture "the tyranny of the single solid in its limited, clinging envelope of space is ended."[925] I would prefer to put it a little differently and say: the mural is a rigorous rejection of a scheme developed by Giotto himself and wildly successful beyond his oeuvre; it consists of filling a pictorial field with one or more blocks or boxes by placing them in front of an inverted passepartout or on a landscape stage. An architectural prospectus that stretches across the entire width of the picture and seems to extend beyond it to the left and right has never been seen before, neither in Giotto's work nor in that of other painters. Through its internal structure, the panorama helps viewers to order the groups of figures and better understand the narrative: a city gate stands behind the evangelist and his entourage and a church rises behind the participants of the funeral procession; where the praying hands of Drusiana and the blessing right

[925] J. White, *Art and Architecture in Italy 1250 to 1400* (Pelican History of Art), Harmondsworth 1966. p. 222: Cf. J. White, *The Birth and Rebirth of Pictorial Space*, London 1957, p. 76.

Ephesus in Florence or a Window to the World 533

hand of the evangelist meet (i.e. met), a bend in the course of the city wall creates attention. As clear as this function of the backdrop is, it is also clear that the meaning of the imposing architecture is not exhausted by its compositional task.[926]

The story depicted reads like this in the *Legenda Aurea*: After years of exile on the island of Patmos, John returns home to Ephesus:[927]

> *As he entered the city, a woman named Drusiana, who had been a dear friend of his and had looked forward more than anyone his return, was being carried out for burial. This woman's kinsmen, and the widows and orphans of Ephesus, said to Saint John: "Here we are about to bury Drusiana, who, following your directions, nourished all of us with the word of God. Yearning for your return she used to say: 'Ah, if only I could see the apostle of God once more before I die!' And now you have come back, and she was not able to see you." John thereupon ordered them to set down the bier and unbind her body, and said: "Drusiana, may the Lord Jesus Christ raise you to life! Arise, go to your house and prepare food for me!" Drusiana got up and went straight to her house as the apostle had commanded, and it seemed to her that she had awakened from sleep, not form death.*

The city backdrop thus stands for the location of the miracle under the walls of Ephesus, just as the island in the picture above stands for Patmos. But even this does not explain the peculiarity of the depiction: the church building in the lower picture of the same wall (fig. 346) also represents a specific structural and geographical situation, namely the saint's tomb and resurrection church in the same city of Ephesus. Yet there we are dealing with precisely that type of architectural monolith in front of a passe-partout or – as John White says – in an envelope, which was already used by the young Giotto in Assisi (Isaac scenes).

926 For the following remarks, I draw on my own work: M.V. Schwarz, Ephesos in der Peruzzi-, Kairo in der Bardi-Kapelle. Materialien zum Problem der Wirklichkeitsaneignung bei Giotto, *Römisches Jahrbuch der Bibliotheca Hertziana* 27/28, 1991/92, pp. 23–57. There, the statements are backed in more detail.

927 "Cum autem urbem ingrederetur, Drusiana eius dilectrix que suum plurimum desideraverat adventum mortua efferebatur. Parentes igitur eius, vidue et orphani dixerunt ei: 'Sancte Iohannes, ecce Drusianam efferimus que tuis semper monitis obsecundans nos omnes alebat. Tuum quoque plurimum desiderabat adventum dicens: O si videam apostulum dei antquam moriar. Ecce tu venisti et te videre non potuit.' Tunc iussit feretrum deponi et corpus resolui dicens: 'Dominus meus Ihesus Christus susciter te, Drusiana. Surge et vade in domum tuam et para mihi refectionem!' Statim illa surrexit et cepit ire de iussione apostoli, ita ut sibi videretur quod non deh morte, sed de sompno excitasset eam." *Legenda Aurea*, ed. Maggioni, p. 88.

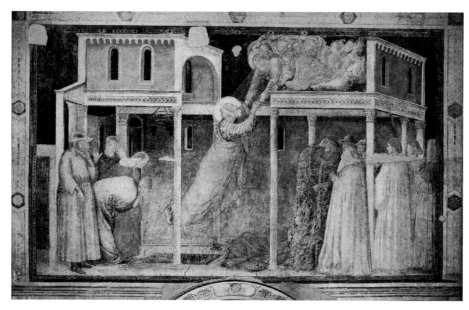

Fig. 346: Peruzzi Chapel: The Ascension of St. John the Evangelist

The most striking element of the depiction is the building behind the funeral procession. We are looking at the choir, apse, transept and the left choir annex of a domed church; through the concreteness and plausibility of the details depicted, it appears as clearly as an architectural portrait as the model of the Arena Chapel in the Last Judgment for Enrico Scrovegni does (fig. 347). Oswald Sirén believed that Giotto had painted here a view of the Santo in Padua, the burial church of St. Anthony. Giotto had worked for the monastery and must have known its church well[928] (fig. 348). The huge cruciform building under its six domes was probably just completed when he arrived in Padua in 1303. We may assume that the church in the Drusiana picture, as in the picture below, represents the church of St. John in Ephesus, the burial and – perhaps – resurrection church of Christ's favourite disciple; its existence was known at the time, at least through legends. Seen in this light, it would make sense to use the burial church of St. Anthony, Francis' favourite disciple, as a substitute for this building. Moreover, the arched friezes and the rose window are motifs that also appear on the Santo. What is missing in the picture, however, besides the ambulatory of the choir and the drums of the domes, are the choir towers, which are important for the appearance of the Santo and would surely have been included in a portrait.

928 Sirén, *Giotto and Some if His Followers*, vol. 1 p. 69.

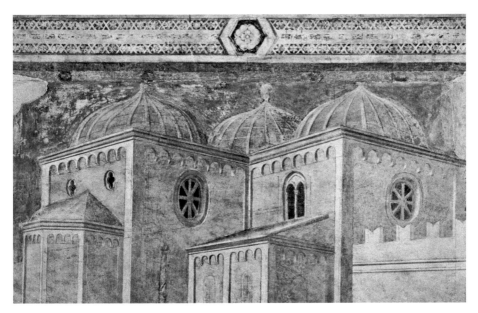

Fig. 347: Peruzzi Chapel: The Raising of Drusiana, detail

The Santo is an extremely unusual building in high and late medieval Italy. The patron and architect were obviously competing with the nearby burial church of another saint, that of the Evangelist Mark in Venice.[929] The Santo owes its domes to this church. In Venice, there are five: one over the crossing and one over each of the four arms of the cruciform church; since the nave in Padua was longer, there are six here, namely two instead of one over the west arm of the church. San Marco, however, is in itself an extravagant building. It owes its ground plan and domes to the model of the church of the Holy Apostles in Constantinople. This was erected by Emperor Justinian, and it is known that he had a second church

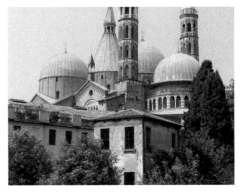

Fig. 348: Padua, Il Santo, choir, view form south east

929 H. Dellwing, Der Santo in Padua, *Mitteilungen des kunsthistorischen Institutes in Florenz* 19, 1975, pp. 197–240, esp. 203.

built on more or less the same plan – in Ephesus over the tomb of John the Evangelist: Justinian's chronicler Prokop reports on the foundation of a new church of St. John by Justinian and that it followed the shape of the church of the Holy Apostles. The ruins and excavations give a clear idea of the building's appearance (fig. 349): it was cruciform with six domes (in this aspect more similar to the Santo than to San Marco and the Holy Apostles' Church, which according to old descriptions had five domes), the domes had no drums and were covered with metal plates; it possessed large side rooms in the angles between the choir and the transept.[930] In other words, with the domed church in the mural, Giotto seems to have created not a placeholder but a veritable portrait of the Ephesian Church of St. John.

Fig. 349: Vienna, Ephesos Museum: model of the southern part of the Byzantine city with St. John's Church

And the portrait-like features extend to its urban context. Unlike ancient Ephesus, the Byzantine city was situated on a hill a little inland. The church divided the walled district into two unequal parts, leaving only a kind of passage between the choir and the city wall. The choir must have towered high above the wall. In Giotto's painting, the choir even pierces the city wall. But this peculiarity was the result of a decision that Giotto only made during the working process. The preliminary drawings for the architectural parts, made with the help of large rulers, are still clearly visible in the pictures, and so it can also be seen that the crown of the wall should originally have passed in front of the church; in doing so, it would have almost concealed the choir (fig. 347).

St. John's Church was not the only impressive structure in the city; there was also a citadel a little to the north of the church, which is not shown in the picture, and at a short distance to the south of the church a large early-byzantine city gate, the so-called Gate of Persecution.[931] The gate painted in the picture corresponds to this building in terms of its position and of its two square towers, which were raised in the Middle Ages. What contradicts the real topography of the city is the projection of the two buildings: the gate appears in the picture as seen from the east-southeast, the church as seen from the

930 A. Thiel, *Die Johanneskirche in Ephesos*, Wiesbaden 2005. H. Hörmann, *Die Johanneskirche* (Forschungen in Ephesos IV, 3), Vienna 1951.

931 J. Keil, *Ephesos: Ein Führer durch die Ruinenstätte und ihre Geschichte*, Vienna 1964, p. 33. W. Müller-Wiener, Mittelalterliche Befestigungen im südlichen Ionien, *Istanbuler Mitteilungen* 11, 1961, pp. 5–122, esp. 91–97.

Ephesus in Florence or a Window to the World

east-northeast. However, a photo taken from a model of the city in the Ephesus Museum in Vienna shows that this discrepancy does little to change the impression (fig. 349).

How did Giotto come to his knowledge of the site? One cannot rule out the possibility that he was in Ephesus in person. The city, which in his time was called Ayasoluk (derived from Hagios Theologos, i.e. from the Greek honorific name of John), had been under the rule of a Turkish emir since 1304, but was visited by travellers from Christian countries. This is how we know that the church of St. John was still largely intact in the 14th century. Ludolf of Sudheim, a priest from Westphalia who visited Ephesus on his way to Jerusalem, reports (1348):[932] "In this city there is a beautiful church, built in the shape of a cross, with leaden roofs, adorned with mosaics and marble in noble form, and untouched until this hour." Although partly used as a mosque, partly as a market hall, the building was accessible to Christian pilgrims. For an entrance fee, they were led to the evangelist's tomb. What they encountered there, however, was unclear in Giotto's time: there was no agreement among the visitors as to whether the saint was resting in the crypt of the church or whether he was already physically dwelling in heaven, as the *Legenda Aurea* reported.[933] Even far away from Ephesus, this question moved people's minds. Giordano da Rivalto discussed it in 1305 in a sermon in Santa Maria Novella before the Florentines. His words also reveal what was behind the problem: John was the only apostle who was not a martyr but his life's journey nevertheless needed a worthy finale:[934]

> *Likewise, God has guarded his body, for he has not caused it to suffer, neither from fire, nor from iron, nor from death, nor has his body felt decay; it is not known exactly: either his body has been resurrected, or it is in some way unharmed; this is what the saints believe.*

Giotto's picture under the Drusiana miracle proves that the Peruzzi and the Franciscans of Santa Croce were convinced of the incomparably more spectacular version of the story; for them, John had risen corporally. Those who visited the church in Ephesus with this belief did not miss a venerable corpse, but felt comforted there by a miraculously empty

932 "In hac civitate pulchra est ecclesia in modum crucis facta, plumbo cooperta, opere mosaico et marmoribus nobiliter decorata et adhuc integra." Ludolf von Suchem, *De itinere Terrae Sanctae Liber*, ed. F. Deycks, Stuttgart 1851, p.24.

933 *Legenda Aurea,* ed. Maggioni, p. 95.

934 Giordano da Rivalto, *Prediche inedite del B. Giordano da Rivalto dell'Ordine de' predicatori*, ed. E. Narducci, Bologna 1867, pp. 429–441, esp. p. 441: "Simigliantemente gli guardò Iddio il corpo suo, chè non gli lasciò sostenere pena, né di fuoco, né di ferro, né di morte, né il suo corpo non sentì corruzione; o è risuscitato, o è in qualche modo intero che non si sa: così credono i santi." The relevance of the text for the Peruzzi murals was realised by Frosinini and Monciatti, La cappella Peruzzi in Santa Croce a Firenze, p. 616.

540 Giotto Pluralistic: The Peruzzi Chapel in Florence and the Late Works

tomb which, whether in its visual quality or not, resembled the tomb of Christ in Jerusalem.

In any case, a good reason to visit Ayasoluk was pilgrimage. A route that went via the city of the evangelist seems to have been one of several possibilities for a journey to the Holy Land, as undertaken by many pious Italians. Its duration was calculated in months and it was also affordable for middle-income people[935] – including Giotto. However, one would expect it to have been recorded if Giotto had made a pilgrimage to the Levant.

The other reason for visiting Ayasoluk was trade. As Pegolotti reports in his *Pratica della Mercatura*, in the city he calls Altoluogo (derived now from Ayasoluk), alum, grain, wax, rice and unspun hemp could be purchased; recommended goods for sale were French woollen cloth, silver, wine and silk.[936] Ship passages to Altoluogo were available from Christian-ruled Rhodes, where Pegolotti had resided for a long time as a representative of the Bardi Company. And in Rhodes the Peruzzi company had one of its most important foreign branches. It also seems important that the Peruzzi, together with the Bardi, were the main financiers of the state of the Knights Hospitalers after the order's conquest of the island in 1309.[937] While the probability of the painter's pilgrimage to Ephesus cannot ultimately be calculated, it is plausible to assume that important members of the family commissioning the murals were there on business and could have brought back knowledge of the city's appearance to Florence.

But the Franciscans should not be forgotten in this context either. They were pastorally active in the eastern Mediterranean region, both in Christian and Islamic dominated areas.[938] It is therefore not surprising that a Franciscan house existed on the coast very near Ayasoluk in a settlement inhabited by "Lombards" (i.e. Italians). Ludolf von Sudheim also reports on this.[939] Some years earlier, between 1318 and 1322, a Franciscan named Cunradus officiated as the Latin Archbishop of Ephesus. He was instructed to reside on the soil of his diocese.[940] This does not necessarily mean that he actually set foot in the city of Ayasoluk, but his pontificate made the place even more interesting for the Friars Minor. Similarly to the artist, however, it is impossible to know whether Florentine Franciscans were ever in Ephesus.

935 G. Pinto, I Costi del pellegrinaggio in Terrasanta nei secoli XIV e XV, in: *Toscana e Terrasanta nel Medioevo*, ed. F. Cardini, Florence 1982, pp. 257–282.

936 Francesco Balducci Pegolotti, *La Pratica della Mercatura*, ed. A. Evans, Cambridge, Ma. 1936, pp. 55–57.

937 Hunt, *The medieval super-companies*, pp. 72, 84 and passim.

938 G. Golubovich, *Bibliotheca Bio-Bibliographica della Terra Santa e dell'Oriente Francescano*, 5 vols, Quaracchi 1906–27.

939 Ludolf von Suchem, *De itinere Terrae Sanctae Liber*, p. 25.

940 Golubovich, *Bibliotheca Bio-Bibliographica della Terra Santa*, vol. 3, 1919, p. 193.

It is most likely, then, that information about the appearance of the city flowed through the channels of the Peruzzi company to Florence and into Giotto's studio. It need not have been in the form of drawings. Perhaps descriptions were enough, and perhaps the reference to the Santo in Padua helped to make the shape of the church clear to the painter. This would explain the Santo features on the painted church, namely the Romanesque arched friezes and the Gothic round window, which did not exist in Ephesus. But what was the motivation for the architectural portrait? How unnatural the use of such a portrait was is shown in the picture below, where St. John's Church appears once again, but not as a reproduction of the real building. Instead, we see a synthetic spatial structure with openings for show and action, designed to visualise the narrative as well as possible. Optimised storytelling was certainly also at stake in Giotto's Miracle of Drusiana, albeit in a different form: whoever visited the chapel should not only be able to relive the event in his soul, but at the same time receive authentic information about the appearance of the evangelist's holy place – a knowledge that otherwise only came with the dangerous undertaking of pilgrimage. One could say that the *veduta* enabled Florentines to make a virtual pilgrimage.

It is hardly a coincidence that the Drusiana picture occupies the same position in the Peruzzi Chapel as the Trial by Fire does in the Bardi Chapel. Both pictures can also be seen from the crossing of Santa Croce, and they invite comparison. In both scenes, Giotto and his patrons come up with surprising indications of authenticity that owe much to the business activities of the donor families – a knowledge that is spiritually re-evaluated by the paintings. But if the Bardi had the local colour of Cairo imported for a Florentine audience, the other picture can be said to transfer the Florentine viewers to Ephesus. This effect is due to a new form of the construction of reality that Giotto apparently invented while working on the Drusiana picture and which John White was the first to notice, starting from the problem of the representation of space (see above). It is not about objects presented as if in a (transparent) envelope or on a passe-partout; rather, what appears within the boundaries of the image is an integral whole that is detached from a more comprehensive totality by the frame. What is implied in the more recent paintings of the Arena Chapel, where the painter adds cut figures and figures seen from behind to the pictorial objects, with which he thus questions the edges of the picture, is accomplished here as a matter of course: The painting simulates a view into another world.

This makes the Drusiana scene the only picture by Giotto, and probably the first picture in the history of European painting, that can be described with Leon Battista Alberti's window metaphor: as a simulation of a rectangularly framed view. However, the metaphor should not be understood in a photographic sense. This becomes clear on a close reading of the passage:[941] the painting surface, according to Alberti in *De Pic-*

941 "Principio, dove io debbo dipingere scrivo uno quadrangolo di retti angoli quanto grande

tura (cf. 2.5.8), is a rectangle "which is considered to be an open window …" Since the middle of the 19th century at the latest, one can now only think of the reproduction of a gaze. But then the text takes a different direction: "… an open window through which I see what I want to paint. Here I determine as it pleases me the size of the men in my picture." So, Alberti's linguistic image, when applied to Giotto's Drusiana Miracle, does not mean that the artist must have seen the walls, towers and domes of Ephesus as well as John, Drusiana, and their companions in some form – even if only as a mental image in front of the inner eye – before beginning the process of design. Rather, the window effect seems to have to do with the kind of information that has been processed in the image and to be there to emphasise the authentic quality of this information. In the effect of a window, a specific form of representation and a specific object of representation come together.

VARIETY

If my reconstruction of Giotto's late oeuvre is correct, his work was less homogeneous than it was in the phase between the Arena frescoes and the end of the second decade of the 14th century. By this I do not mean that he seems to have made considerable use of helpers, for example on the Stefaneschi and Bolognese altarpieces. Apparently, his reputation at times brought him more commissions than he could handle on his own or with the "invisible" collaborators who were well attuned to his approach. A certain inconsistency in what left his studio seems typical of a famous pre-modern artist. Nor does variety mean that there are no stylistic lines of connection between the individual works. The complex, dramatic drapery forms in the Peruzzi Chapel find their counterpart in the Stefaneschi altar,[942] just as the spatial formation of the groups of people can be observed here as well as there: not only are bodies attached to each other, but – more clearly than in the Arena Chapel, for example – space is established between them and openings are created towards the viewer. And the figures of the Peruzzi Chapel with their small heads and powerful silhouettes are close to the similarly powerful half-figures of the Badia retable. Other connections have already been pointed out. Giotto's inventions of his late years are definitely intertwined. If the main work of this phase had been preserved, the painting

io voglio, el quale reputo essere una finestra aperta per donde io miri quello che quivi sarà dipinto; e quivi ditermino quanto mi piaccino nella mia pittura uomini grandi." L.B. Alberti, *Della Pittura. Über die Malkunst*, ed. O. Bätschmann, trans. S. Gianfreda, Darmstadt 2002, p. 92. Translation after: L.B. Alberti, *On Painting*, trans. J.R. Spencer, New Haven and London 1966, p. 56.

942 Lisner, Giotto und die Aufträge des Kardinals Jacopo Stefaneschi für Alt-St. Peter II, p. 99.

of the Capella magna in Naples, it would perhaps be clear that there was a centre where experience converged and from which innovations emanated.

But even then, the overall impression would probably remain heterogeneous. The contrast between the smooth elegance of the Baroncelli altarpiece and the resistant pathos of the Peruzzi murals is particularly difficult to bridge. If this were a young artist, one would suspect experimentation. In the case of a master who had already twice developed a coherent concept for a formal language and who had stayed with the second one for decades and been extremely successful with it, it is more plausible to attribute the situation to a change in his environment. But it was not the circle of clients that changed. In fact, there is a lot of continuity: Stefaneschi again, the Badia again (probably under the same abbot), murals again in Santa Croce for a family of the Florentine moneyed aristocracy (whereby the responsible members of the Peruzzi family probably even belonged to the same generation as the patron of the Bardi frescoes), again a panel painting for a foreign family (after the Cinquini in Pisa, now the Pepoli in Bologna). Only the King of Naples represented a new type of patron. His giant commission in the Capella magna, however, probably contributed more to unifying than to diversifying Giotto's work.

What had changed profoundly was Giotto's position in the artistic scene. Important commissions such as those for the high altars of Santa Maria Novella and Santa Croce, which went to Ugolino di Nerio from Siena, and for the painting of the south transept of the Lower Church in Assisi, which went to Pietro Lorenzetti, also from Siena, instead to Giotto or a member of his school, show that he had lost his monopoly on modern painting in Florence and beyond. It is also worth remembering the knighthood that Simone Martini had received in Naples in 1317, which indicates that Giotto's appointment 10 years later was not a matter of course. Other artists had learned to present figures and narratives in a similarly vivid and multi-layered way. On the one hand, this put Giotto under pressure to invent; the Drusiana scene gives a spectacular taste of this, a breakthrough comparable to the innovations the painter had worked out in the years before and after 1300. On the other hand, the loss of his monopoly forced flexibility; to protect his reputation, he could not simply leave broad fields of activity to his competitors and their respective specialities. Here, reference should be made to his architectural polyptychs. Giotto's design is an alternative to the polyptychs of the Sienese: simpler and more elegant in their frames, lay-out and representations. In general, judging from what Giotto took up and what he responded to, it seems clear who the most important competitors were: the Lorenzetti and the Sienese in general.

GIOTTO'S PAINTING AND THE VISUAL CULTURE
OF HIS TIME

The sequence of the confirmed and probable works by Giotto is assumed to be as follows. The placement is determined by the earliest plausible dating. It should be noted that the degree of probability of the given time-ranges varies; the reason behind each indication can be found in the text. The city name after the date refers to Giotto's whereabouts, which often but not always, coincides with the location or destination of the work.

1294–98	Assisi: San Francesco, clerestory murals ("Isaac Master")
1298–1300	Rome: Navicella
1300–01	Florence: Cross of Santa Maria Novella
1300–02	Florence: Madonna of San Giorgio alla Costa
1302–03	Florence or Rimini: Cross in San Francesco, Rimini
1303–05	Padua: Arena Chapel
1305–07	Padua: Il Santo, Palazzo della Ragione
1307–08	Florence: St. Francis Panel for San Francesco, Pisa
1308	Assisi: Mary Magdalene Chapel
1309–18	Florence: Ognissanti, Madonna and Cross
1309–19	Florence: Comune Rubato
1310–18	Florence: Frescoes in the Badia
1311–18	Florence: Ognissanti, Death of the Virgin
1312–13	Rome: St. Peter's, murals of the "Capella"
1318–20	Florence: Santa Croce, Bardi Chapel
1320–26	Florence: Stefaneschi Altarpiece for St. Peter's in Rome
1320–28	Florence: Badia Altarpiece
1326	Florence: Bologna Altarpiece
1328–33	Naples: Capella magna and Capella parva
1328 or 1334–36	Florence: Baroncelli Altarpiece
1334–36	Florence: Santa Croce, Peruzzi Chapel

This chronological order is not based on a developmental model that has been imposed on Giotto's oeuvre. As far as possible, the dates have been worked out independently, object by object, in some cases also by forming a group around a dated work. However, the study is not only about individual works, their succession, context and meaning, but also about Giotto's contribution to visual culture. It is therefore important to present the

Giotto's Painting and the Visual Culture of his Time

sequence of works as a history of innovation, revision, and reception. And these processes can only be evaluated if one looks beyond his oeuvre and includes the history of visual media during the decades around 1300 in this contextualisation. That Giotto contributed much that was new to the world of his viewing, praying, and painting contemporaries is beyond doubt. The other problem is from which sources he drew and to which impulses he responded. In which situations was he the driving force behind developments and in which situations was he driven by developments elsewhere?

FLORENCE BEFORE 1300

Whoever, under these auspices, asks about the environment in which Giotto's work is embedded, must come to terms with the fact that the beginning of the story lies in darkness. We know little about Giotto's experiences and nothing about his activity before the mid-1290s; we do not even know how old he was at that time (on the irrelevance of the dates of birth mentioned in the literature, see vol. 1, pp. 39–40): He may have been around twenty or younger, but also around thirty or older. What is certain, however, is that by 1292 at the latest, he became aware of the extraordinary importance that painting, especially religious painting, could have. That year, a picture became the talk of Florence. It is not preserved and nothing reliable is known about its appearance. And yet the events have left their mark on piety in the city to this day; every visitor to the church of Orsanmichele can attest to this. Giovanni Villani reports (VII, 155):[943]

> *In the said year, on the third day of July, great and apparent miracles began to be seen in the city of Florence, thanks to a painted figure of Saint Mary on a pillar of the loggia of Orto San Michele, where grain is sold. In large numbers and in a visible way, the sick were healed, the paralysed raised up, the raging calmed.*

Since the hall was not yet a church but a market at that time, the incidents were beyond the control of the clergy. The guardians of the faith in the city, the Dominicans and the Franciscans, therefore tried to contain the attention the painting received, but this only upset the Florentines. The chronicler also reports on this. A sonnet by Guido Cavalcanti

943 Giovanni, Matteo, and Filippo Villani, *Croniche*, ed. A. Racheli, Trieste 1857, p. 169: "Nel detto anno a dì 3 del mese di luglio, si cominciarono a mostrare grandi e aperti miracoli nella città di Firenze per una figura dipinta di Santa Maria in uno pilastro della loggia d'Orto San Michele, ove si vende il grano, sanado infermi, e rizzando attratti, e isgombrando imperversati visibilemente in grande quantità."

Florence before 1300

addressed to Guido Orlandi sings of this ambivalence as clearly as it does of the miracles themselves:[944]

Una figura della Donna mia	*An image of My Lady,*
s'adora, Guido, a San Michele in Orto,	*They worship, Guido, in San Michele in Orto;*
che, di bella sembianza, onesta e pia,	*It is lovely, honest, and pious,*
de' peccatori è gran rifugio e porto.	*And a great refuge and harbour for sinners.*
E qual con devozion lei s'umilia,	*And whoever humbles himself with devotion,*
chi più languisce, più n'ha di conforto:	*Finds the more comfort the more he suffers:*
li 'nfermi sana e' domon' caccia via	*The sick are cured, their demons driven away,*
e gli occhi orbati fa vedere scorto.	*And squinting eyes see straight again.*
Sana 'n publico loco gran langori;	*It heals bad sicknesses in a public place;*
con reverenza la gente la 'nchina;	*With reverence the people kneel unto it*
d[i] luminara l'adornan di fòri.	*And they adorn it with lights all around.*
La voce va per lontane camina;	*The rumour goes a distant way;*
ma dicon ch'è iodolatria i Fra' Minori,	*But the Friars Minor call it idolatry*
per invidia che non è lor vicina.	*Out of envy because it's not in their vicinity.*

Many art historians like the metaphor of the "power of images". But this should not obscure the fact that what is really at stake are questions such as the following: What tasks does a culture assign to the visual media? How does a specific use of media affect the attitude of the users? Which needs are satisfied, reinforced or otherwise changed? How do producers adjust to the role assigned to images? Florence's citizens not only experienced miracles from 1292 onwards, but also carried out discursive work on the cultic use of visual media – based on the example of an image that was in the public eye. A miniature in the Codex Biadaiolo (Florence, Biblioteca Laurenziana, Tempiano 3, fol. 7r) shows either the painting that had become miraculous in 1292 or, if it was lost in the fire of 1304, its first successor – modernised by the mid-14th century illuminator (fig. 350). It is crucial that the Madonna has her place in the midst of the activity of a market (the illustration shows activity overheated by a famine); the image figures as an ambassador of the beyond in the uncertain human world.[945] It would be astonishing if such a role had not challenged a young painter

944 Italian text after: Guido Cavalcanti, *Le Rime – Die Gedichte*, ed. G. Gabor and E.-J. Dreyer, Mainz 1991, p. 134.

945 G. Pinto, *Il libro del biadaiolo: Carestie e annòna a Firenze dalla metà del '200 al 1348*, Florence 1978.

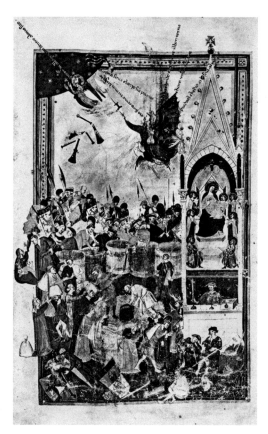

Fig. 350: Codex Biadaiolo: The Corn Market of Or San Michele (unknown painter)

full of talent and ambition. Not far from where Giotto's preoccupation with images began was a miraculous and much-discussed image of the Virgin.

As the son of a Florentine artisan – this can also be assumed – Giotto received his first artistic training in Florence. However, there is no serious indication of which master he worked under. We have already seen that the story of an apprenticeship with Cimabue cannot be regarded as such an indication (vol. 1, pp. 14–18). In connection with the wedding preparations of Giotto's brother Martino, another Florentine painter named Vanni di Duccio is documented among the family's friends in 1295 (1.1.3). He must have been a respected citizen; as a painter, his name appears a quarter of a century later in the list of members of the doctors' and apothecaries' guild, directly behind Giotto's name. If this does not prove his special professional standing, it does point to a prominent role in the life of the corporation (1.3.4). Nevertheless, his importance for Giotto remains mysterious, because nothing is known about Vanni's works.

However, other paintings have survived that must have provided standards for the young Giotto in Florence: firstly, Duccio's Madonna Rucellai in the parish church of Giotto's family (fig. 147). She did not work miracles, but to the Florentines, who were both visually and spiritually receptive, she must have seemed like a miracle of beauty and expression; according to Guido Cavalcanti, being "di bella sembianza, onesta e pia" was part of the qualifications of the picture in Orsanmichele, and in this the Madonna panel of the Dominicans was its equal. The name of his older contemporary, who was active in Siena, was thus familiar to Giotto from his youth. (The question will arise of when then the older painter became aware of the art of the younger one.) Secondly, mention should be made of the mosaics in the church where Giotto, like all other Florentines, was probably baptised and

Fig. 351: Florence, Baptistery, dome mosaic: three scenes from the Life of the Baptist (Corso di Buono)

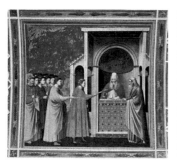 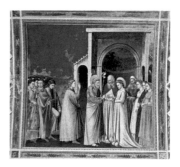

Fig. 352: Padua, Arena Capel, north wall of the nave, three scenes from the Life of the Virgin

where he took part in many services.[946] The more recent parts of the dome decoration consist of pictorial cycles from the Old and New Testaments and follow the decoration of Roman basilicas, where such large cycles had been common since late antiquity. The pictures are partly by Cimabue, partly by Corso di Buono, partly by late Dugento artists unknown to us.[947] Both the large panel of the Madonna and the monumental narrative cycle, two challenges that Giotto faced several times in his life, were encountered by him in spectacular examples during his childhood or youth.

946 Cf. G. Previtali, *Giotto e la sua bottega*, Milan (3) 1993, pp. 32–36: The mosaics of the Baptistery also play a major role for Previtali, who tries to understand Giotto entirely from Florentine contexts. However, his premises, both with regard to the mosaics and Giotto's oeuvre, are completely different.

947 M.V. Schwarz, *Die Mosaiken des Baptisteriums in Florenz: Drei Studien zur Florentiner Kunstgeschichte*, Cologne 1997, pp. 119–123 and M. Boskovits, Florentine Mosaics and Panel Paintings: Problems of Chronology, in: *Italian Panel Painting of the Duecento and Trecento*, ed. V.M. Schmidt, New Haven and London 2003, pp. 486–498.

The insight that Giotto's Madonna panels would look different without the benchmark of Duccio's Madonna Rucellai is already established.[948] Less studied is the relevance of the mosaic cycles. But one of Giotto's important inventions as a narrator is grounded in the pictures of Corso di Buono: the continuity of the setting across several images.[949] It is about three scenes from the *vita* of the church patron, which appear on the north-east section of the dome and show, one after the other, John Preaching to the People, Baptising, and Pointing to Christ (fig. 351). The events take place against a landscape backdrop whose basic features remain the same: in all three pictures a mountain towering above the size of the figures occupies the right half of the field. The rock, developed from Byzantine models, leans to the right and a spring – the Jordan River – rises from it. The furnishing of this scenery with trees changes, so that the figures and groups are always accentuated somewhat differently according to the state of the narrative. But the dominant impression is that the setting is identical and the events are progressing in the same place. If, among the works that have survived from the environment of the young Giotto, there is a phenomenon that could be identified as a model for his *chronotopoi* (e.g. the architectural boxes in the Assisan Isaac scenes and in the Paduan images from the Life of the Virgin based on them, pl. XI, XII and V, VI), then it is here. The Paduan scenes of the betrothal of the Virgin, also a triad, compare particularly well. With them Giotto skilfully draws out the story of Mary's youth (fig. 352). The adaptation consisted in transferring the setting from the medium of landscape to the medium of architecture and in the suppression of elements of variation – the changing greenery. However, in the case of the house in which Mary's birth is announced and in which she is later born, Giotto has the lighting changed (pl. V, VI).

The older parts of the dome mosaics in the Baptistery – according to the inscription by the Franciscan Jacobus from the second quarter of the 13th century – also still impressed the visitors to the church; evidence can easily be found that Dante used the hell scene for his description of the Beyond[950] (fig. 52). It is equally certain that Giotto, when he had to design the picture of the Last Judgement in Padua, drew on motifs from Jacobus' Last Judgement on the dome of the Baptistery (p. 33). Finally, it is worth men-

948 Cf. H.B.J. Maginnis, *Painting in the Age of Giotto: A Historical Reevaluation*, University Park 1997.

949 M.V. Schwarz, Chronotopos con variazioni / Corso di Buono come narratore innovativo: tre immagini dai mosaici della vita di San Giovanni nel Battistero di Firenze, *Rivista d'arte* ser. 5, 4, 2014, pp. 1–12.

950 M.V. Schwarz. Zackenstil des Südens: Zur Höllenlandschaft im Florentiner Baptisterium, ihren Voraussetzungen und ihrer Rezeption, in: *Europäische Bild- und Buchkultur im 13. Jahrhundert*, ed. Chr. Beier and M. Schuller-Juckes, Vienna 2020, pp. 33–50. M.V. Schwarz, "in sul fonte del mio battesmo": Dante's Baptismal Font in an Unknown Floor Plan of the Florentine Baptistery, *Rivista d'arte* ser. 5, 11, 2021, pp. 1–14.

tioning a small campaign in the choir room of the church by Byzantine mosaicists in the seventies of the 13th century, the outcome of which expanded Cimabue's repertoire and may also have impressed Giotto.[951] In Giotto's childhood and youth, Florence had an art scene in which a wide range of those artistic forms were present at a high, sometimes innovative level, that were available in the Mediterranean at that time as instruments of visual communication: there were Middle Byzantine and Veneto-Byzantine forms (in Jacobus' work), Late Byzantine forms from first and second hand, and Roman patterns from second hand (in the mosaics of the seventies and nineties up to the activity of Cimabue and Corso di Buono), finally Sienese forms through Duccio's panel in Santa Maria Novella. It was a lively and changeable art scene – whose features, looking with unbiased eyes, can also be found in the Florentine panel paintings of the time.[952] Nothing that concerned representational technique could then be considered normal and a matter of course, and what could be considered traditional had not been so for very long.

GIOTTO'S ROME

Different conditions prevailed in the place where our painter received what was probably his second lesson. It was the one that shaped his formal language in its entirety and made him an artist in his own right. I have already dealt with the painting scene in the city of Rome with its locally-based – not to say eternal – tradition of concern for Antiquity and the modernising aspects that it took from late Byzantine art, as well as with how Giotto placed himself as a third star in its artistic firmament alongside Torriti and Cavallini thanks to Stefaneschi's commission for a mosaic in the atrium of St. Peter's (p. 230). With the Isaac pictures in Assisi and the Navicella, an artist emerges who perfected and developed Roman art using its own resources. He perfected it by making deeper use of the ancient fundus, he developed it further in creating new forms of corporeality and spatiality – adopting late Byzantine tendencies – and connecting his works to the world of the viewer in a captivating way. In spite of all its novelty, his art had a place in the cultural scene of the Eternal City; what Giotto invented could be connected to what existed.

951 Schwarz, *Die Mosaiken des Baptisteriums in Florenz*, pp. 56–94.

952 Cf. M. Boskovits, *The Origins of Florentine Painting 1100–1270* (A Critical and Historical Corpus of Florentine Painting, Painting, sec. 1, vol. 1), Florence 1993.

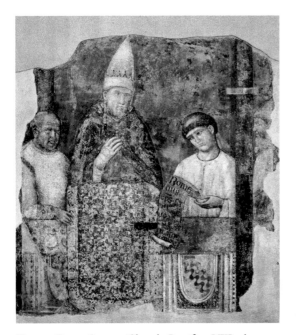

Fig. 353: Rome, Lateran Church: Boniface VIII takes Possession of the Lateran, fragment (unknown painter)

The fact that his formal language attracted attention and was taken up by others can be seen in a number of murals in the city and its surroundings. For example, the frescoes in the Sacro Speco in Latium, which bear the signature of the painter Conxulus.[953] Better known is the fresco from the benediction loggia of the Lateran Palace, preserved as a fragment and in a 17th century copy. It showed this loggia, Pope Boniface VIII blessing and a crowd of people, including horsemen, at his feet (fig. 353, 354). This scene was accompanied by two further images representing the baptism of Constantine and the foundation of the Lateran Church. An inscription dated the architecture that bore the mural to the year 1300, which gave reason to recognise the proclamation of the Jubilee in the depiction.[954] However, since the Lateran Church was not included in the Holy Year celebrations from the beginning, this is not very likely. A more plausible suggestion is to identify the scene as the seizure of the Lateran by the newly elected Boniface in 1295.[955] Since the 17th century the mural had sometimes been claimed for Giotto, but sometimes also for Cimabue. Cesare Brandi pointed out the plasticity of the figures in 1952 and from this gained stylistic arguments

[953] S. Romano, *Eclissi di Roma: Pittura murale a Roma e nel Lazio da Bonifcio VIII a Martino V (1295–1431)*, Rome 1992, pp. 127–137.

[954] Onofrio Panvinio, *De praecibus urbis Romae sanctioribus basilicis, quas septem ecclesias vulgo vocant liber*, Rom 1570, p. 182. C. Mitchell, The Lateran Frescoe of Boniface VIII, *Journal of the Warburg and Courtauld Institutes* 14, 1951, pp. 1–6. G.B. Ladner, *Die Papstbildnisse des Altertums und des Mittelalters*, vol. 2, Vatican City 1970, pp. 288–296. L. Vayer, L'affresco del Giubileo e la tradizione della pittura monumentale Romana, in: *Giotto e il suo tempo. Atti del congresso internazionale per la celebrazione del VII centenario della nascita di Giotto (Assisi – Padova – Firenze 1967)*, Rome 1971, pp. 45–59.

[955] S. Maddalo, Bonifacio VIII e Jacopo Stefaneschi: Ipotesi di lettura dell'affresco della loggia Lateranense, *Studi Romani* 31, 1983, pp. 129–150.

for an attribution to Giotto.⁹⁵⁶ In fact, there are Giottesque features. However, any other respectable painter who, against the background of the works of Cavallini, emulated the works of our painter, is equally possible as the author. Giotto reception in this case involved the transfer of Giotto's tangible forms to a profane subject. It was not another saint or patriarch who gained the characteristic presence of the figures painted by the young Giotto, but the reigning pope and his entourage. If the fresco was really about Boniface's legitimacy as Roman bishop and successor to the hermit Pope Coelestine (dubious for the reasons we know), then it was the effects developed by Giotto in the religious field that made it intuitively credible.

Fig. 354: Boniface VIII takes Possession of the Lateran (copy, Milan, Bibl. Ambrosiana, ms. F inf. 227, fol. 3)

The highest-ranking surviving – albeit poorly preserved – monument of early Giotto reception in Rome is the mosaic scenes on the façade of Santa Maria Maggiore. According to the donor images and heraldic devices, they were financed by the House of Colonna. While the decoration on the upper zone of the façade is signed by Filippo Rusuti and was certainly created before the expulsion of the Colonna by Boniface VIII in 1297, the clearly different pictures below were probably added after the rehabilitation and return of the family, i.e. in 1307 or later.⁹⁵⁷ Four scenes illustrate the history of the founding of the famous church. Especially in the second picture, the Dream of the Patrician John, the enclosure depicted looks like a variant of the architectural boxes in the Isaac

956 C. Brandi, The Restauration of the Lateran Fresco, *The Burlington Magazine* 1952, pp. 218–220. The first attribution to Giotto in: Alfonso Ciaconio, *Vitae et res gestae Ponticum Romanorum et S.R.E. Cardinalium*, Rom 1677, col. 304.

957 C. Bertelli, Römische Träume, in: *Träume im Mittelalter: Ikonologische Studien*, ed. A. Paravicini Bagliani and G. Stabile, Stuttgart and Zürich 1989, pp. 91–112. Romano, *Eclissi di Roma*, p. 107. Ferdinando Bologna dates the mosaics to the years1318–19: F. Bologna, *I pittori alla corte angioina di Napoli 1266–1414*, Rome 1969, p. 134.

Fig. 355: Rome, Santa Maria Maggiore, façade: The Dream of the Patrician John (unknown mosaicist)

pictures on the clerestory in Assisi – including the side entrance and the dwarf bench in the foreground (fig. 355, pl. XI, XII). In addition, there are elaborations of late Byzantine architectural fictions beside and above the box, which are also reminiscent of motifs in the Isaac Master complex (fig. 117). The degree of physical presence the artist gave the figures cannot be easily judged due to the state of conservation, but there is nothing to suggest that it did not correspond to the spatiality of the picture and was therefore originally more or less on a par with the Isaac scenes. The motifs of the mosaics, however, not only refer to the Isaac Master complex, but also to the decoration of the St. Nicholas Chapel in the Lower Church, which was created about ten years later (1305–07, fig. 183–185). On the façade and in the chapel, the artists seem to have engaged with Giotto's art on a comparable level.

There are also connections with the St Francis cycle on the lower wall of the upper church in Assisi: Julian Gardner, who dates the mosaics early (before the expulsion of the Colonna), noted how the extraordinarily dense group of figures in the Roman picture showing the Miracle of the Snow (fig. 356) is very similar to the left-hand group of figures in the Renunciation of the Worldly Goods (fig. 172); Gardner is certainly correct in assuming that the scene of Santa Maria Maggiore is the precedent for the one in the Legend of St Francis.[958] The "sculptor" has only exchanged the mosaicist's pair of children for the chatting pair of children from Giotto's Paduan Flight into Egypt (fig. 193), and has enlivened the group in general according to Paduan standards (p. 309). If this finding is not deceptive and the return of the Colonna really provides the *terminus post quem*, then the mosaic scenes on the Roman façade cannot have been created long after this event, i.e. not long after 1307.

The mosaics on the façade are thus side-effects of Giotto's Roman output of the nineties, and they are linked in addition to creations by those painters working in Assisi who

958 Gardner, Pope Nicholas IV and the decoration of Santa Maria Maggiore, pp. 40–41.

were among the earliest beneficiaries of Giotto's Paduan inventions. If we assume what is only natural, namely that the Colonna, having returned home from exile, re-entered the competition between the Roman families with the new mosaics for Santa Maria Maggiore, we can note that they did so in a formal language that no longer referred to antiquity and Byzantium (as was the case with the pictures done a few years earlier on their behalf by Torriti and Rusuti for the same church). Instead, it referred to an imagery that art historians associate with Giotto and that was perhaps already then connected with the creator of the Navicella mosaic. This formal language was also influential beyond Rome and contributed, for example in Assisi, to a kind of consensus that established Giotto's art as a guiding model.

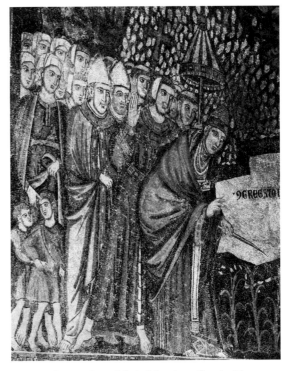

Fig. 356: Rome, Santa Maria Maggiore, façade: The Miracle of the Snow, detail (unknown mosaicist)

THE VISUAL MEDIUM FINDS ITSELF

But this had yet to occur when Giotto offered his Roman creations to a Florentine audience in the years 1300 to 1303. How he took on the competition with Duccio's Madonna Rucellai and Cimabue's Cross of Santa Croce was already discussed. The famous passage in Dante's *Purgatorio* indicates that his competition with Cimabue's work was soon commented on publicly.[959] With certain reservations – we only know of panel paintings – it can be said that Giotto now placed even more emphasis on the immediacy of representation than he had in his works for his curial patrons. The adaptation for the Florentine audience may have freed this quality, for its understanding was not dependent on a particular cultural competence, i.e. on knowledge of the visual culture of Rome. Immedi-

959 M.V. Schwarz, Dantes Giotto, Giottos Dante, in: *Dante und die bildenden Künste: Dialoge – Spiegelungen – Transformationen*, ed. M.A. Terzoli and. S. Schütze, Berlin 2016, pp. 163–184.

acy was, moreover, something that could be set against the warm humanity of Duccio's Madonna Rucellai, then decades old but still relevant. In addition our painter retained explicitly Roman motifs. They probably gave his works in Florence additional authority and persuasiveness.

What cannot be seen is that Giotto at that time responded to what may be considered, along with his own works, as the most spectacular event in the visual culture of Florence during the years just before and around 1300: the making of the lower zone of the cathedral façade with its sculptural decoration by Arnolfo di Cambio. When Giotto drew on Gothic forms, he took them from elsewhere. But the motifs of 12th-century Florentine incrustation architecture, made topical again by Arnolfo's planning, soon played a role in the Arena Chapel in combination with Roman ornamental and architectural forms. Just as Giotto appeared in Florence around 1300 as an artist with a Roman profile, a few years later he would present himself to the Paduans as a Roman *and* a Florentine. But that does not mean that this was understood there.

The Florentine works of these years were followed by one of the most astonishing paradigm shifts in the history of art – maybe even more astonishing than that which had led to the Isaac pictures. The turnaround in drapery forms, first noticeable in the Arena Chapel, is perhaps the easiest to explain (we have already dealt with this): the rich structures of the early phase (Isaac scenes, Cross of Santa Maria Novella) seem extraordinarily physical, but at the same time urge us to perceive what intricate artistry produced them. Seen in this light, the simpler forms that Giotto then used stand not only for a retreat from the rendering of bodily presence, but above all for a withdrawal of the presence of the artist himself – we are to look at the bodies that appear and not at the artistry that the painter uses to make them appear to us. In contrast, a real change of direction can be seen in the following fact: whereas around and before 1300 Giotto strove to give the objects of his pictures a presence in the world of the viewer, he is now concerned with creating a pictorial world in which they are fully contained. There – behind glass, as it were, or behind the painted surface – the viewer must visit them with his eyes, and to do so he cannot remain mentally in the world he inhabits. This approach to representation may have been prepared in the cross at Rimini and was quickly perfected in the pictures on the walls of the Arena Chapel. There one can also observe how the pictorial fields fill up more and more while the work on the walls progresses, and how the objects become more and more interrelated, until the pictures become small but complex systems that are viable on their own – without any connection to the world in front of the painted surface. This applies to image fields like the one showing Christ before Caiaphas (pl. VII) or the Lamentation, where there are only pictorial objects and – apart from the blue foil, which can be read as the sky – nothing more is to be seen of a support for these objects, i.e. of the time-honoured vehicle that I have called the inverted passe-partout.

The shift yields an advantage in terms of perception and can probably be explained

on this basis. Giotto's previous strategy, which consisted of virtually bringing the more or less sacred bodies and objects into reality, usually leads to fragile results: the viewer's perception fluctuates between accepting the illusion and unmasking it. In contrast, the perception of the closed pictorial worlds is stable. As a result, the second generation of Giotto's images corresponds much more to the function that modern media theory (insofar as it is phenomenologically oriented) ascribes to the media: they liberate content from material conditions. They are "Physikentmachtungsmittel" (Lambert Wiesing):[960] means of disempowering physics. Programmatically delimited from the given environment and detached from the circumstances of their production, Giotto's new images make the persons and narratives freely available to their audience, independent of real space and time. Theodor Hetzer described the result as follows: Giotto succeeded in inventing the modern picture. A closer look reveals that Hetzer saw Giotto's pictures through the lens of a modern reading of Leon Battista Alberti's pictorial concept (cf. vol. 3, pp. 194–199). Giotto's pictures are far from being painted gazes, and are still conglomerations of motifs selected for their relevance. However, these conglomerations are dense, unified and autonomous in a hitherto unknown way. In this respect, they are not only integrated into contemporary visual culture, but also stand out of it.

Perhaps they were even less integrated in Padua than they would have been in other places. If the miniatures in the so called *Epistolario* of Giovanni Gaibana and the mural showing the Deposition from the Cross in San Benedetto Vecchio represent Paduan painting of the late 13th century,[961] then it had a strong late Byzantine character and corresponded to Ernst Kitzinger's concept of the "volume style" with bodies bulging out of the picture plane. It was precisely this form of representation of pictorial objects from which Giotto now decidedly departed.

THE PORTRAIT: A ROMAN MEDIUM RENOVATED

It was probably Roman connections that brought Giotto to Padua (pp. 182–183). But here he performed before an audience of which the vast majority were not at all familiar with the background of what he offered. And yet it was in Padua where he was particularly successful in developing certain Roman forms that had travelled with his repertoire. Along with architectural and decorative motifs, the portrait is one of them. No other city in the Latin world produced as many portraits as Rome into the 13th century. These are portraits

960 L. Wiesing, Was sind Medien? in: id., *Artifizielle Präsenz: Studien zur Philosophie des Bildes*, Frankfurt 2005, pp. 149–162.

961 F.L. Bossetto, *Il Maestro del Gaibana: Un miniatore del Duecento fra Padova, Venezia e l'Europa*, Milan 2015.

556 Giotto's Painting and the Visual Culture of his Time

in the broader sense: representations of certain personalities – whether recognisable or not – that do not, or only indirectly, serve the cult of saints.

And no authority used the medium of portraiture to such an extent to represent its tasks and claims as the Pope and the Roman Curia. Under Boniface VIII, this went so far that it was met with consternation outside the Roman mediasphere. The trial of idolatry against the late pope, orchestrated by Philip the Fair, sheds light on the situation.[962] In contrast, the portrait genre does not seem to have had any (noteworthy) history in Florence, for example. In the case of the only known donor figure, the small praying man in the apse mosaic of San Miniato al Monte, dated 1297, we do not even know whether it belongs to the original composition or owes its existence to the thorough reworking of the picture in 1860/61.[963] Indeed, Giotto's probable first attempt in this field, the donor figure of the Navicella, is in many ways explained by the Roman flood of images of prelates in which Stefaneschi's portrait had to find a place. It should also be noted that among the seven surviving or recorded portraits executed by our painter, there are only two that were not conceived as members of this society: we are talking about Scrovegni and the unknown cleric in the Arena Chapel (fig. 1, 4, 5). As for the others: the three Stefaneschi portraits on the Vatican hill (one in the mosaic, two on the altarpiece, figs. 128, 299, 308) make the cardinal present at a centre of curial representation; the two portraits of Bishop Teobaldo Pontano are in a church whose assembly of portraits showing prelates and members of the curia (spread over the chapels of St. Nicholas, St. Mary Magdalene, St. Martin and St. Catherine) relates to the larger Roman one (pl. XIV, fig. 217). It should also be noted that where Teobaldo kneels before St. Rufinus with the latter touching his head, this motif directly follows Roman conventions. Nicholas IV appears in the same way in the apse mosaic of the Lateran Church and is blessed by the Virgin; in Bertoldo Stefaneschi's appearance as a donor in Santa Maria in Trastevere, Peter gives him a blessing in this form. But even in Scrovegni's portrait, Giotto's Roman experiences are present (fig. 1): the way the Knight of the Arena presents a large architectural model of his chapel, lovingly rendered in order to be recognisable, links up – directly or indirectly, intentionally or unintentionally – with Nicholas III's donor image in the Capella Sancta Sanctorum from the late seventies of the 13th century (fig. 357).

962 K. Sommer, *Die Anklage der Idolatrie gegen Papst Bonifaz VIII. und seine Porträtstatuen*. Phil. Diss., Freiburg 1920. *Boniface VIII en procès: Articles d'accusation et déposition des témoins (1303–1311)*, ed. J. Coste, Rome 1995.

963 W. and E. Paatz, *Die Kirchen von Florenz: Ein kunstgeschichtliches Handbuch*, 6 vols., Frankfurt 1940–1954, vol. 4 pp. 238, 285–286. M.V. Schwarz, M. Boskovits: The Origins of Florentine Painting [...], *Kunstchronik* 48, 1995, pp. 275–286. D. Kocks, *Die Stifterdarstellung in der italienischen Malerei des 13.–15. Jahrhunderts*. Phil. Diss., Cologna 1971, pp. 98–99.

But Giotto did not simply export Roman traditions, he went beyond them with a contribution of great importance. All the portraits in his oeuvre, with the exception of the oldest in the Navicella mosaic of 1298/1300, are profile figures with very individual heads. While the half-profile was in keeping with tradition, the profile as a portrait form was new. A closer look at Giotto's profile portraits should not begin with Stefaneschi's appearances on the altarpiece for St. Peter's – Giotto knew the cardinal as a young man, and it is uncertain whether he met him again after 1300. It is unclear how these portraits came about. If one compares the other images, one can notice: the two representations of Teobaldo Pontano are physiognomically almost identical, while the faces of Pontano, Scrovegni and the Paduan prelate differ significantly (fig. 4, 5, 217, pl. XIV). To make people recognisable and distinguishable – these were the criteria, which

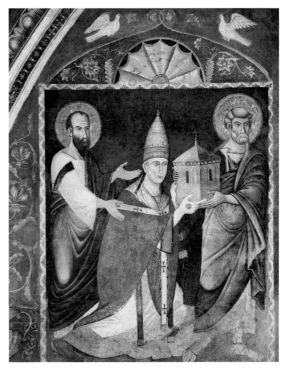

Fig. 357: Rome, Lateran, Capella Sancta Sanctorum: Honorius III with Peter and Paul (unknown painter)

are still obvious today, that the Parisian court physician and poet Évrart de Conty († 1405) defined as the anthropological mission of the face.[964] Against this background, portrait quality means: recognisability and distinguishability of individuals in the visual medium. Distinguishability is clearly established in Giotto's profile portraits; recognisability by contemporaries is not proven by this. However, a passage in Pietro d'Abano's commentary on Aristotle makes it clear that this was a well-known concept in Giotto's environs. Writing in Padua during the years between 1306 and 1310, and probably aware of the donor images of the Arena Chapel, the scholar cites Giotto as an example of an artist skilled in producing recognisable imagines of specific people: through images such as Giotto's, we gain an idea of the subject that is of such a kind that we would recognise the person if

964 St. Perkinson, *The Likeness of the King: a prehistory of portraiture in Late Medieval France*, Chicago 2009, p. 153. Évrart de Conty, *Le livre des eschez amoureux moralisés*, ed. F. Guichard-Tesson and B. Roy, Montréal 1993, pp. 30–31. Perkinson seems to me to overestimate the novelty value of Évrart's statement.

Giotto's Painting and the Visual Culture of his Time

he or she encountered us. To clarify what he means by a similar image, Pietro has previously referred to pictures "as the oboli show in which the faces of Roman emperors such as Caesar, Nero and the like are found sculpted" (2.3.1). Like Giotto's donor images in Padua, the Roman coins present the head in profile.

The combination of profile and inscription on coins made the profile a classical manifestation of the portrait. But it need not have been the example of the coins that suggested to Giotto the change from the half-profile to the profile. John Pope-Hennessy and Lorne Campbell suspected that the highly individualised profile portraits of the Italian Renaissance were based on silhouettes.[965] Even if written sources are missing, this sounds plausible and even more plausible where early profile portraits are concerned. A coincidence is important: on the one hand, similarity can be objectified optically in the contour of the profile alone (at least this was true before it was possible to record and compare biometric data with the help of computer programmes),[966] and on the other hand, the contour of the profile can be recorded with the simplest optical technology: possible options are the outlining of the shadow, backlit tracing or drawing in front of a rasterised background. Presumably, it was part of pre-modern painting practice to use every possibility to make form-finding simple and accurate, just as painters, as we know, used every possibility to optimise the process of form transfer, for example through the use of stencils. Accuracy of form-finding and efficiency of transfer seem to coincide in the two Pontano portraits in Assisi: The profile obviously follows the same template – whether obtained from the shadow or in the backlight – that Giotto then applied to the wall at different angles.[967]

In addition, the shadow has an indexical character, an idea documented in the 14th century. In Dante's *Commedia* (*Purg.* III, 16–30), the cast shadow is the mark of the real human body ("l'ombra della carne") and makes it distinguishable from the illusory bodies of the deceased who dwell in the world beyond.[968] And as a reproduced shadow intended

965 J. Pope-Hennessy and J. Wyndham, *The Portrait in the Renaissance* (Andrew W, Mellon Lectures in the Fine Arts 12), New York 1966, p. 3. L. Campbell, *Renaissance Portraits: European Painting in the 14th, 15th and 16th Centuries*, New Haven and London 1990, p. 160.

966 J. Lipman, The Florentine Profile Portrait in the Quattrocento, *The Art Bulletin* 18, 1936, pp. 54–102, esp. 59–60. M. Collareta, Modi di presentarsi: taglio e visuale nella ritrattistica autonoma, in: *Visuelle Topoi. Erfindung und tradiertes Wissen in den Künsten der italienischen Renaissance*, ed. U. Pfisterer and M. Seidel, Munich and Berlin 2002, pp. 131–145, esp. 137–138.

967 Cf. P. Seiler, Giotto als Erfinder des Porträts, in: *Das Porträt vor der Erfindung des Porträts*, ed. M. Büchsel and P. Schmidt, Mainz 2003, pp. 153–172, figs. 5a and 5c: The deviations visible in Seiler's comparison can be traced back to a lack of precision in the redrawing or to poor copies.

968 V.I. Stoichita, *Eine kurze Geschichte des Schattens*, Munich 1999, p. 45.

to retain the portrayed person in the physical sense, the portrait was invented in mythical prehistory, according to Pliny (*Naturalis historia* XXXV, 43) and similarly Quintillian (*Institutio Oratoria* II, 7): passages that were known to Giotto's contemporaries.[969] This is a reminder that, according to the conviction of pre-modern Christians, certain "true" images of Christ are indexically constituted, including the Veronica icon, the prototype of which is said to have been created by pressing a cloth to the face – producing an image and a touch relic of the Saviour combined.[970] Against this backdrop, Giotto's turn to the profile appears at once pragmatic and theoretically justified from different perspectives, presenting itself not only as an invention but also as a synthesis.

Giotto's approach to portraiture was probably to use the outline of the shadow (in the broadest sense) and then to insert the inner elements into the outline. The inserting appears to have been done in a conventional way. In contrast to the outline, the inner elements seem prefabricated and differ little from the corresponding facial details of the figures in the narratives.[971] Hand in hand with this, there was some leeway for styling. This is shown again by the two portraits of Teobaldo Pontano, which differ not only in the angle of inclination of the profile, but also in the rendering of the eye region: In the head looking up, the brow arch is shown from below, in the other it is not. The small difference, which Giotto also employs in other cases, ensures a clear differentiation on the basis of the roles: Teobaldo, the penitent before Mary Magdalene, and Teobaldo, the minister, before his predecessor Rufinus.

The profile portrait was soon imitated throughout Italy: here only an early echo in the region will be discussed, the pair of donors on the triumphal arch of San Fermo Maggiore in Verona, dated 1314 ("mille tecete quatuorda") in an inscription that is no longer legible today.[972] The painter adapted, as is known, the pair of donors of the Arena Chapel (fig. 1). I have therefore already briefly discussed them in order to understand the rhetoric of those in Padua more precisely (p. 51). Eager to give an opinion, Harald Keller saw in the Veronese kneelers (and not in the two Paduans) a leap in quality to the modern portrait

969 Cf. E. Castelnuovo, Il significato del ritratto pittorico nella società, in: *Storia d'Italia, 5.2: I documenti*, Turin 1973, pp. 1033–1094, esp. 1048.

970 H. Belting, *Bild und Kult: Eine Geschichte des Bildes vor dem Zeitalter der Kunst*, Munich 1990, pp. 233–252.

971 Cf. Keller, Die Entstehung des Bildnisses am Ende des Hochmittelalters, *Römisches Jahrbuch für Kunstgeschichte* 3, 1939, pp. 227–356, esp. 299–300 and, following Keller's argument, Seiler, Giotto als Erfinder des Porträts. However, a distinction must be made between the large and the small forms: the small ones are interchangeable, the large ones are not.

972 G. Gerola, Il ritratto di Guglielmo Castelbarco in San Fermo di Verona, *Madonna Verona: bollettino del Museo Civico di Verona* 1, 1907, pp. 86–93.

Fig. 359: Padua, Arena Chapel; Statue of Enrico Scrovegni (unknown sculptor)

Fig. 358: Verona, San Fermo Maggiore: donor portrait of Guglielmo Castelbarco (unknown painter)

striving for similarity.[973] In reality, the cartoonish features that enrich the profiles (which are certainly traced as in Padua) point back to traditional methods of establishing singularity and distinguishability. Daniele Gusmerino and above all Guglielmo Castelbarco pay for their augmented individuality with the viewer's antipathy – quite unlike Scrovegni and his spiritual friend (fig. 358). If the merits of the two had not been so clearly stated in the accompanying inscriptions, their sinister and erratic appearances would hardly have provoked intercessions.

All in all, there is much to suggest that Giotto invented the indexical, and in this sense the formally similar portrait in Padua. In this context, Laura Jacobus' reflections on Enrico Scrovegni's sculptural portraits are of particular interest: in the two sculptural images in the Arena Chapel, the statue of the praying donor now in the sacristy and the reclining figure of the deceased on the tomb in the apse, the reproduction of the head is said to be based on casts made for this purpose.[974] This assumption is plausible for the face of the standing figure (fig. 359): it was certainly made during the sitter's lifetime as part of an initial project for a tomb (pp. 64–65) and probably even before the painted portrait of Giotto, to which the head is undoubtedly linked through similarity. As Laura Jacobus

973 H. Keller, Die Entstehung des Bildnisses, p. 331.
974 L. Jacobus, The Advent of Facsimile Portraiture in Italian Art, *The Art Bulletin* 99, 2017, pp. 72–101.

proves, this is especially true for the profile line. In this context, it is of interest that the treatise by Cennino Cennini, who worked in Padua and saw himself in Giotto's school tradition, contains practical instructions for making plaster casts from the faces of living persons.[975] The head of the statue or the plaster model for it could have been used later by the sculptor of the tomb figure in the apse and worked on differently. In any case, plaster masks had to be thoroughly modified when the forms were transferred to a permanent material; like the drawn outline, the cast could only be the raw material for the production of a portrait. Like the silhouette, the cast barely reproduced the shape of the eyes, for example, as these had to be protected during the moulding process. Be that as it may, if it is true that a plaster mask of Scrovegni's face was made for the head of the standing figure, then the inventions of the indexical portrait in two and three dimensions are close to each other, and can be related to Giotto's activity in Padua.

DIALECTIC OF SUCCESS

Giotto completed the paradigm shift that turned the experience of presence into attention-absorbing peep boxes, in a place where his art had little connection to its environment. This provided the artist with a period during which he could enjoy the intellectual property of his concept undisturbed. However, just as it is likely that Giotto had built up a bottega to carry out Scrovegni's commission (p. 145), so it can be assumed that it was dissolved or downsized after the work was completed. The released members may then have made the invention known elsewhere. And Giotto himself also ensured that it became known through his subsequent work for patrons in Florence, Pisa, Assisi, and Rome.

The following decade seems to me to be characterised by the fact that not only Giotto, but also other ambitious painters experimented with the Paduan results. However, it was not so much his Florentine colleagues who began to compete with Giotto. An impression of how far behind they were can be gained by looking at the context in which the frescoes of the Bardi Chapel appeared to the Florentine public at the time when cultic activity began in the new building of Santa Croce. On the one hand, there was the Assumption of Our Lady above the Tosinghi Spinelli Chapel. It is the counterpart to Giotto's Stigmatisation and a work that did not challenge Giotto but painfully affirmed his role: the unknown painter used Giotto's style to modernise and enliven his figures – but not his composition. This is flat and simple and contradicts Giotto's simultaneously impressive and complex Stigmatisation, although visitors are supposed to relate the paintings to each other. Then there was the Velluti Chapel: the representational technique in these murals

975 Cennino Cennini, *Il libro dell'arte*, ed. F. Brunello and L. Magagnato, Vicenza 1982, pp. 199–203

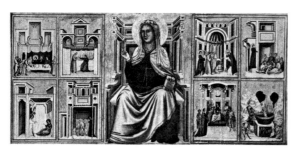

Fig. 360: Florence, Uffizi, Retable or Antependium: St. Cecilia and scenes from her life (unknown painter)

was basically still at the level of the nineties of the 13th century. When the painter adopted a Giotto motif from the Bardi Chapel (a discovery made by Julian Gardner), he saw the new art not a as model but as a warehouse. Despite their archaic habitus, the Madonna panels assembled under the name of a Maestro di Varlungo, in which late Dugento features are mixed with Giottesque ones, could have been created at a similarly late date, i.e. around 1320. Hanno-Walter Kruft was right when he contradicted Giovanni Previtali: they are certainly not youthful works by our painter, but "works by a technically experienced master under the influence of Giotto"[976] – technically experienced, not concerned with new forms of representation.

A group of Florentine panels which, according to an antependium in the Uffizi from the church of Santa Cecilia, are usually labelled "Maestro della Santa Cecilia" probably dates from the same or a slightly earlier period.[977] The St. Peter panel from San Pier Maggiore, dated 1307 and responding to Giotto's Madonna for San Giorgio alla Costa, may not actually belong to this group, but is at least close to it (fig. 149). The imitation of Giotto's vocabulary gives more or less adequate results in the large figures, but the scenes look like travesties (fig. 360, 361): their very small figures bear no relation to the unreal architectural structures, in which various phases of Giotto's spatial concepts from the Assisan clerestory to Padua appear to be superimposed. These images also confirmed Giotto's leadership without providing him with competition. Our painter worked in the second decade of the century in an artistic setting shaped by hesitant imitators.

But there were also the disciples in the narrow sense. One might think of the group of panels with scenes from the New Testament, divided between Boston, Florence, London, Munich, and New York, which may have belonged to a low dossal. It is true that in terms of pictorial concept and motifs they fit best between the Arena Chapel

976 Previtali, *Giotto e la sua bottega*, pp. 36–40. H.W. Kruft, Giovanni Previtali: Giotto e la sua bottega, *Zeitschrift für Kunstgeschichte* 32, 1969, pp. 47–51, esp. 48.

977 R. Offner and K. Steinweg, *The Cecilia Master and his circle* (A Critical and Historical Corpus of Florentine Painting, sec. 3, vol. 1, ed. M. Boskovits), Florence 1986, pp. 94–113. The *terminus ante quem* 1304 according to a notice passed on in the 18th century about a fire is useless: the cult of Cecilia certainly did not cease with the fire. Rather, one should use the date as *a terminus post quem* and assign the panel to the rebuilding of the church.

and the Bardi Chapel;[978] they may therefore have been painted in the second decade. Equipped with many beautiful details and carefully executed, the narratives lag nonetheless behind the Paduan pictures in terms of thoughtfulness. The difference in quality can be objectified by looking at their framing: the surprising and varied overlapping of figures and motifs through the borders, which characterises the Paduan pictures (I recall the Christmas scene, pl. III), is contrasted here with predictability (fig. 362). If the panels are therefore not by Giotto himself, then they prove how faithfully the Paduan style could be reproduced in Giotto's environment – either in a kind of workshop or by a member of the workshop who may have been trained in Padua and had set up on his own. In this context, two copies based on Florentine pictures from Giotto's phase immediately after leaving Padua are also interesting, namely the Madonna in Castelfiorentino (Museum of San Verdiana),

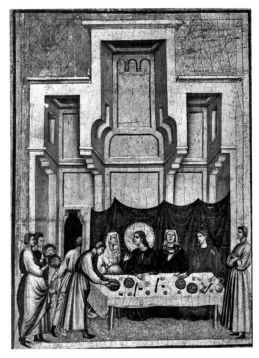

Fig. 361: Detail from fig. 360

which reproduces the Ognissanti Madonna, and the Stigmatisation panel of the Fogg Art Museum (Cambridge, Ma.), which is a well-made reduction of the Louvre panel. In both cases, the attribution to Taddeo Gaddi, Giotto's long-time pupil has been considered with good reasons.[979] He may have created the paintings in the course of Giotto's workshop production or on his own account.

The place where painters at the time were creatively implementing Giotto's lessons – rather than selectively or faithfully as in Florence – and achieved results that soon threatened the monopoly on painted alternative realities held by Giotto and his students, was Siena.[980] Although he had already been in business since the seventies of the 13th century

978 D. Gordon, A Dossal by Giotto and his Workshop: Some Problems of Attribution, Provenance, and Patronage, *The Burlington Magazine* 131, 1989, pp. 524–531.

979 A. Ladis, *Taddeo Gaddi: Critical Reappraisal and Catalogue Raisonné*, Columbia and London 1982, nos. 1, 3.

980 L. Bellosi, La lezione di Giotto, in: *Il Trecento* (Storia delle Arti in Toscana), ed. M. Seidel, Florence 2004, pp. 89–116, esp. 104–109.

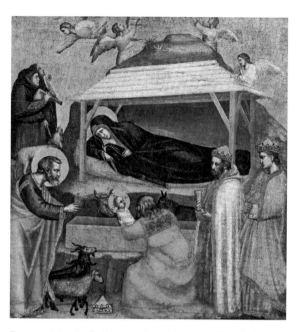

Fig. 362: New York, Metropolitan Museum: The Nativity of Christ and Adoration of the Magi (unknown painter)

and had enjoyed success not only in Siena but also in Florence, Duccio seems to have studied Giotto's inventions and benefited from them when working on the Maestà (1308–11). His painted spaces there can hardly be explained in any other way than as superimpositions of Byzantine patterns of architectural representation through various Giotto layers: one from the Roman or first Assisan period, one from the years after (Padua and the St. Francis Panel for Pisa) and one from Giotto's Assisan production of 1308 mixed with the productions of his imitators there (Mary Magdalen Chapel, St Nicholas Chapel, first phase of the St. Francis cycle). Knowledge about Giotto's Paduan revisions was certainly second-hand, but it existed: this is shown by the boxes that fill the entire width of the picture field; they are frequent in the Maestà (e.g. Washing of the Feet, Last Supper, fig. 363), but they do not occur before the Arena Chapel (e.g. Christ before Caiaphas, pl. VII), neither in Giotto's work nor in that of other painters. The central scene in the "Predella" of the Pisan St. Francis panel is a possible subcarrier (fig. 228).

Basically, the Giottesque elements are present in Duccio in a similar mixture as they are in the "Cecilia Master", but the foundation on which they are set is different; in Duccio's works, they are spread over a Byzantine foil of a high formal standard, which shines through and creates cohesion. And the elements are skilfully synthesised; this is particularly evident in the way figures and architecture merge indissolubly in the scenes of the Maestà. What Duccio also has in common with the Cecilia master is that he did not take up the closedness of Giotto's spatial configurations. The ambiguities give his spaces a fantastic touch. In this case, we are not experiencing a deficiency, but a new, we might say poetic, quality. The Sienese painters would not completely abandon it until the Quattrocento. Other qualities that Duccio passed on to his younger compatriots are the richness of the materials represented and the colourful splendour of his paintings, as well as the high intensity of the gestures and faces, sometimes leading nowhere, which he for his part had adopted from Byzantine painting. According

to Friedrich Rintelen, Sienese visual narratives were superior to Giotto's in their "frisky vividness".[981] Presumably, what Rintelen was referring to went back to Duccio and his (late) Byzantine conditioning.

The generation of Simone Martini and the Lorenzetti brothers, who began to work independently in the second half of the second decade, drew equally on Duccio and Giotto. In addition, they also opened themselves to inspiration from Gothic painting beyond the Alps.[982] This material was used to create pictures of extraordinary effect: scenes that were as real as they were lively and as magnificent as they were elegant, set in spaces that were variations of Giotto's spaces in the Arena Chapel and afterwards. The assertiveness of the Sienese fresco artists is most evident in Assisi, where Pietro Lorenzetti in the south transept of the lower church and Simone Martini in the St Martin's Chapel received commissions that a few years earlier (around 1310) would probably have gone, if possible, to Giotto or to painters trained by him. On the basis of these series of pictures – in the case of Simone as well as Pietro Lorenzetti – it can also be shown that important prerequisites for the new qualities of Sienese mural painting were indeed impulses from the works of Giotto and his pupils. In contrast, the assertiveness of the Sienese in the field of panel painting was guaranteed above all by the medium of the architectural polyptych invented by Duccio.

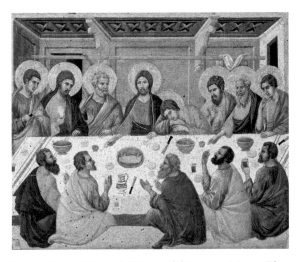

Fig. 363: Siena, Museo dell'Opera del Duomo: Maestà, The Last Supper (Duccio)

As far as the latter phenomenon is concerned, we have already gained an insight into Giotto's strategy for his response: The artist did not take up Sienese or Florentine forms for the frames of his own polyptychs (Florentine forms would have been Arnolfo di Cambio's Gothic of the cathedral façade), but developed a new system on a transalpine basis. And it was this system that prevailed in Florence – with Pacino di Buonaguida, Bernardo Daddi and others, and which was accordingly also accepted

981 F. Rintelen, *Giotto und die Giotto-Apokryphen*, Basel (2) 1923, p. 11.
982 It is doubtful whether the so-called Gothic Workshop in Assisi played the key role in the transmission of forms that Luciano Bellosi attributed to it. L. Bellosi, *Il pittore oltremontano di Assisi, il gotico a Siena e la formazione di Simone Martini*, Rome 2004. Certainly there were also other sources: book illumination, minor arts.

566 Giotto's Painting and the Visual Culture of his Time

by the Florentine clients. Even a retable executed by the Sienese painter Ambrogio Lorenzetti in 1332 for the church of San Procolo in Florence follows the system developed by Giotto.[983]

GIOTTO AND THE SIENESE OR THE TRIUMPH OF THE REAL

In fact, not only were Sienese works imported, as is true of the altarpieces by Ugolino di Nerio for Santa Maria Novella and Santa Croce, but there were also Sienese artists working in Florence – in all fields and in all techniques: art historians have not noticed it for a long time, but judging from the style, it was workmen from Siena to whom the Calimala guild entrusted the completion of the mosaic decoration of the Baptistery. This is a series of half-figure images of saints at the base of the dome and one of busts of Old Testament figures on the parapet of the gallery. In addition, there is the decoration of individual chapels of the gallery whose figures of saints are positioned to be fully visible from the main space. The *terminus ante quem* for the project is probably 1330, the year when Andrea Pisano started work on the bronze door. It would have been nonsensical to carry out two elaborate and costly artistic campaigns in parallel. The *terminus post quem* is probably given by a major work of painting in Siena: according to the inscription, Simone Martini created the Maestà of the Palazzo Pubblico in 1315.[984] The medallions of busts on the painted frame of this mural served as models for the images of the prophets and saints in the baptistery (fig. 364–367). It is possible that the team of mosaicists was a branch of the workshop that decorated the façade of Siena Cathedral from around 1310.[985] Since nothing of these façade mosaics has survived, the assumption cannot be substantiated by comparisons. What is certain, however, is that at the beginning of the 14th century there was the ability to produce mosaics in Siena. With their mosaics in the Baptistery, the Sienese offered the Florentines a gripping new image of the saint and the prophet. Ugolino di Nerio's figures on his retables, also dominated by strong and sinister affects, and the mosaics mutually confirmed their relevance in this field. Andrew Ladis pointed

983 H. Kiel, Der Altar des Ambrogio Lorenzetti aus San Procolo, Florenz, *Pantheon* 19, 1961, pp. 101–103.

984 The date of 1325, which is sometimes mentioned for these mosaics, seems irrelevant when examined more closely: Schwarz, *Die Mosaiken des Baptisteriums in Florenz*, note. 30 on p. 18. A report on the older history of scholarship and conjectures on authorship using the paradigm of connoisseurship can be found in: M. Boskovits, *The Mosaics of the Baptistery of Florence* (A Critical and Historical Corpus of Florentine Painting, sec. 1, vol. 2), Florence 2007, pp. 250–254.

985 G. Milanesi, *Documenti per la storia dell'arte senese*, 3 vols., Siena 1854, vol. 1 pp. 175–176.

Giotto and the Sienese or the Triumph of the Real 567

Fig. 364: Florence, Baptistery, parapet of the gallery, Prophet (unknown mosaicist)

Fig. 365: as fig. 364

to similar emotions in Taddeo Gaddi's figures from the twenties onwards and traced them back to the example of Ugolino di Nerio's painting.[986]

Ambrogio Lorenzetti seems to have pursued his career in both cities – Florence and Siena – in parallel from about 1320. This went so far that he became a member of the Florentine doctors' and apothecaries' guild (1.3.4).[987] The San Procolo Retable of 1332 was not his first relevant work in the Florentine milieu.[988] Before that, he had created the deathly sad Madonna of the Church of Sant'Angelo in Vico l'Abate near Florence, who fixes her gaze mercilessly on the sinful viewer; the panel bears the date 1319 and is now in the Museo Giuliano Ghelli in San Casciano (fig. 368). This spectacular picture considerably diminished the novelty value of Giotto's Ognissanti Madonna.[989] What connects the Madonna with the Sienese mosaics of the Baptistery and Nerio's saints is the directness of the dark affect. However, it is not only the mother's sadness that grips us, but also the kindness and alertness of the child who turns to the mother and will probably free her – and us – from her grief. The staging is reminiscent of the central panel of the Badia altarpiece (fig. 322). Whereas Giotto's previous Christ children were serious and dignified, on his buttressed altarpieces they show different variations of being human and correspond in this to the Christ children of the Lorenzetti. It would be daring to say that Giotto had approached the Sienese artistically – but one can certainly speak of an approximation of his spiritual offer, which was not least addressed to his patrons and their piety.

Through Ghiberti's Commentarii we know that Ambrogio executed two fresco commissions in Florence, both of which are lost: A chapel in San Procolo and the chapter

986 A. Ladis, *Taddeo Gaddi*, passim.
987 H.B.J. Maginnis, *The World of the Early Sienese Painter*, University Park 2001, p. 153.
988 G. Rowley, *Ambrogio Lorenzetti*, Princeton 1958, p. 129.
989 Ibid., pp. 27–32.

Fig. 366: Siena, Palazzo Pubblico, Maestà, moulding; Prophet (Simone Martini)

Fig. 367: as fig. 366

house of Sant'Agostino. Ghiberti described the second decoration more eloquently than any work by his official hero Giotto.[990] I quote what he communicates about two of the painted "stories":[991]

> The first is about how Saint Catherine is in a temple and how the tyrant is enthroned high above and is questioning her. It seems that on this day there is a feast in this temple and therefore there are many people painted inside and outside; there are priests at the altar making offerings. This story is very rich and excellently done. On the other side, Catherine is seen disputing with the wise men in front of the tyrant and seems to convince them; some of them seem to enter a library and look for books to convince her.

We do not know exactly when these murals were painted. Ambrogio Lorenzetti outlived Giotto by more than a decade, but from the mid-thirties onwards he was predominantly

990 G. Ercoli, Il Trecento Senese nei Commentari di Lorenzo Ghiberti, in: *Lorenzo Ghiberti nel suo Tempo. Atti del Covegno Internazionale di Studi (1978)*, Bd. 2, Florence 1980, pp. 317–341. W. Prinz, *Die Storia oder die Kunst des Erzählens in der italienischen Malerei und Plastik des späten Mittelalters und der Frührenaissance 1260–1460*, 2 vols., Mainz 2000, vol. 1 pp. 30–32.

991 Lorenzo Ghiberti, *I Commentarii*, ed. L. Bertoli, Florence 1998, pp. 88–89.: "Nella faccia maggiore sono tre istorie. La prima è come santa Katerina è in uno tempio e come el tiranno è alto e come gli domanda, pare che sia in quello dì festa in quello tempio: èvi dipinto molto popolo dentro e di fuori; sonvi e sacerdoti all'altare come essi fanno sacrificio. Questa istoria è molto copiosa e molto excellentemente fatta. Dall'altra parte come ella disputa inanzi al tiranno co' savi suoi e come e' pare ella gli conquida; èvi come parte di loro pare entrino in una biblioteca e cerchino di libri per conquiderla: nel mezo Christo crocifisso co' ladroni e con gente armata a piè della croce."

active in Siena, where he created his most important works, the allegories of the Palazzo Pubblico.[992] If the murals of Sant'Agostino were painted in the twenties or early thirties, they were serious competition for what Giotto had to offer the Florentines in terms of the variety and density of motifs. Above all, however, such works were able to provide a new impetus. Part of the Sienese inspiration evident in the Stefaneschi altar and the Peruzzi murals, which I have traced to Pietro Lorenzetti's Crucifixion in Assisi and Ambrogio Lorenzetti's frescoes for San Francesco in Siena, may also have come from the decoration of Sant'Agostino, which, according to Ghiberti, included a populous Calvary: "the crucified Christ with thieves and armed people at the foot of the cross."

It will not be possible to decide. What is clear, however, is that the Sienese painters, having adopted and further developed much of Giotto's representational and narrative techniques, had a repertoire at their disposal that was more varied than Giotto's – or at any rate more varied than Giotto's repertoire in the Arena Chapel and later in the Bardi Chapel. Giotto reacted to the

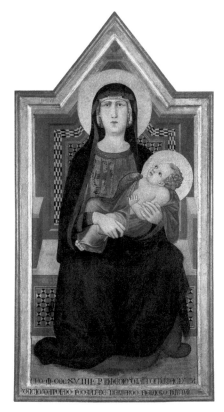

Fig. 368: San Casciano in Val di Pesa, Museo Giuliano Ghelli: Madonna (Ambrogio Lorenzetti)

competition by addressing what made his competitors' products particularly attractive. He answered with individual motifs such as the animated Christ children, but there was also a major change, a new paradigm shift comparable to that around 1303. It may be that the laboratory in which the new approach took shape was not a Florentine commission, but the huge project of the murals for the *Capella magna* in Naples. Sienese art had also arrived at the Angevin court – at the latest with Simone Martini, the panel of Saint Louis of Toulouse he painted on royal commission, and the annual pension of 50 gold ounces that the painter and newly created "miles" had been receiving from Robert the Wise since 1317 (see vol. 1 p. 60). When Giotto began to orientate himself in Naples in 1328, he may

992 DizBI s.v. Lorenzetti, Ambrogio (M. Becchis).

have learned, among other things, the prestige that Sienese painting now enjoyed even beyond central Italy.

When Giotto returned to Florence, it was probably impossible not to notice that his old pupil Taddeo Gaddi was now a major player in the art scene. The frescoes of the Baroncelli Chapel depart from Giotto's model through the use of Sienese features: the partly fantastic complexity of their architectures, the richness of their details, the often uncanny affects. In addition, there was a new way of dealing with light in the picture. Taddeo Gaddi had created a synthesis that was capable of replacing Giotto's art as a model.

The murals of the Peruzzi Chapel respond to this with fundamental innovations. This is identifiable in the Drusiana picture (pl. XX). Here, more clearly than in any of the other works, the painter developed the imagery he had worked out in the Arena Chapel away from a stage-like or box-like presentation and towards a simulated section of reality. Yet the picture with the banquet (pl. XIX) and the other Peruzzi pictures hardly lag behind it: it is significant, for example, how largely the inverted passe-partout, which had experienced a renaissance in the Bardi Chapel, has now been suppressed. The notorious brown strip abutting a blue surface is now only present in the Annunciation scene (fig. 330, the top picture). Likewise, the frame motifs that regularly appear in the most advanced pictures of the Arena Chapel are omitted: one thinks back to the ornamented architectural moulding in the picture of Christ before Caiaphas, which turns the perfectly furnished hall of the priest into a kind of peep-box (pl. VII). This extensive renunciation of an abstract definition of the image is contrasted in the Peruzzi chapel with an almost comprehensive density of visual description in which it is no longer possible to distinguish between meaning-bearing parts and the real – in other words, the accidental, in which is embedded that which is actually worthy of being represented (cf. p. 77). This extends to the affects portrayed: in their elaboration, no qualitative differentiation is made between the protagonists and the extras; the members of both groups reveal themselves to be emotionally involved, and often in surprising ways. The people, buildings and objects grow together into a uniformly rich texture of materials and motifs, some of which even claim to reach beyond the boundaries of the picture and unite with the reality beyond them. The pathos of the bodies and the projection of certain architectural features even seem to question the picture plane. These are elements that can also be read as a return to Giotto's imagery before the Arena frescoes, but which are used here in a more complex way and which particularly interested the artists of the 15th and 16th centuries in the Peruzzi murals.

THE CAMPANILE: SURVIVAL UNDER CONSTRUCTION

Our painter took part in the erection of the Florentine cathedral of Santa Maria del Fiore – especially in the erection of the Campanile – for barely three years. This began with his appointment as chief architect of the cathedral and of the municipal buildings: the council's decision is dated 12 April 1334; we do not know when it took effect. And it ended with his death on 8 January 1337 (vol. 1, pp. 62–64). The foundation stone of the tower was laid on 18 July 1334 (2.1.1). At that time, a plan of how it should look must have been ready and approved. We can assume that this plan was Giotto's. Since the mid-15th century, there has been repeated mention of a "modello", "modulus", "exemplar" or "imago" of the tower (2.7.5; 2.8.2; 2.1.6; 2.1.8–10), but it is not clear whether anyone actually saw such an object, nor whether any plan present in the 15th century was the one made by Giotto. Nevertheless, Giotto must have designed a plan, and he did not consider his task done with its completion. He let himself be seen in the building lodge – this is attested by a document dated 12 December 1335 (1.1.74). From this we may conclude: he really was in charge of the building and the office was more than a sinecure – which it could well have been according to the wording of the decision that led to the appointment. The document speaks a lot about the person and has surprisingly little to say about the office and its tasks (1.5.2).

What qualified Giotto as an architect? Whether one assumes that the Campanile was his first relevant work or presupposes that he had already gained experience elsewhere (there has been much speculation about this, but the sources do not give any clues)[993]: he was surely not hired as a building practitioner. As a *designer*, by contrast, he was distinguished, namely when it concerned objects of a small scale or two-dimensional structures. This refers firstly to his polyptychs with their extremely well thought-out Gothic frame systems, and secondly to the painted interior façades of his chapels. Among what has been preserved, the most similar to a building in terms of scale and complexity is the painted structure on the altar wall of the Bardi chapel (pl. XVI). More or less at the same time as the tower, the altar wall of the Peruzzi Chapel was designed, of which unfortunately little remains.

This means that the Florentines entrusted the construction of the tower to someone who was at home in the medium of virtual architecture. As soon as it came to practical matters, he should and probably could fall back on the expertise available in the cath-

993 Cf. D. Gioseffi, *Giotto architetto*, Milan 1963 and A.M. Romanini, Giotto e l'architettura gotica in alt'Italia, *Bollettino d'arte* 50, 1965, pp. 160–180. A. Tomei, Giotto: L'architettura, *Art e Dossier*, 1998, no. 140. G.M. Radke, Giotto and Architecture, in: *The Cambridge Companion to Giotto*, ed. A. Derbes und M. Sandona, Cambrigde 2004, pp. 76–102.

The Campanile: Survival under Construction

edral's lodge. It had existed for about 40 years – at times probably with a reduced staff, but from 1331 on it was again solidly funded and active. Some progress had already been made on the new construction of the cathedral (previously Santa Reparata, now Santa Maria del Fiore).[994] However, building a tower was a particularly demanding technical task and the lodge lacked experience in this field.

Why precisely did the tower fall to Giotto? Probably this has less to do with the artist's ambition (as is sometimes assumed in Giotto literature) than with the situation on the building site: when Giotto took up his post, the new building planned and begun by Arnolfo di Cambio consisted of the lower part of the façade and short sections of the side walls.[995] They surrounded the eastern part of the previous building, which was still used for worship, like a bracket from the west. If one wanted to work towards an operational new building from this situation, the next steps could only be the following: the side walls had to be driven further to the east in order to form a spatial unit that roughly covered the area of the old church. Then the old building could be taken down. Where it had stood, the pillars for the central nave of the new church were to be erected and the space could then be provisionally roofed over. In the months or years between the removal of what was left of the old cathedral and the roofing over of the new building, the baptistery would function as a cathedral.

However, the old bell tower stood in the way of continuing the north wall to the east.[996] Demolishing it would have meant depriving the cathedral and the baptistery of

994 A. Grote, *Das Dombauamt in Florenz 1285–1370: Studien zur Geschichte der Opera di Santa Reparata*, Munich 1959.

995 Cf. G. Kreytenberg, *Der Dom zu Florenz: Untersuchungen zu Baugeschichte im 14. Jahrhundert*, Berlin 1974, F. Toker, Florence Cathedral: The Design Stage, *The Art Bulletin* 60, 1978, pp. 213–230 and F. Toker, Arnolfo's S. Maria del Fiore: A Working Hypothesis, *Journal of the Society of Architectural Historians* 42, 1983, pp. 101–120. G. Kreytenberg, La decorazione del duomo nel trecento e la genesi della scultura fiorentina, in: *Santa Maria del Fiore: The Cathedral and Its Sculpture*, ed. M. Haines, Fiesole 2001, pp. 47–58. F. Toker, Arnolfo di Cambio a Santa Maria del Fiore: Un trionfo di forma e di significato, in: *La cattedrale e la città: Saggi sul duomo di Firenze: atti del convegno di studi (1997)*, ed. T. Verdon and A. Innocenti, Florence 2001, pp. 227–241. F. Pomarici, *La prima facciata di Santa Maria del Fiore: Storia e interpretazione*, Rome 2004. An important indication of the progress of construction is an inscription from 1310 on the base of the cathedral next to the campanile.

996 The location of the tower is documented firstly by Giovanni Villani's report of a fire near the "campanile vecchio di Santa Reparata" in 1331 (X, ccix). The place name "via di Balla" points to the north side of the church, where there is a "canto di Balla" to this day. The street and canto are named after a gate in the second ring of walls that ran north along the church: R. Ciabani, *I canti: Storia di Firenze attraverso i suoi Angoli*, Florence 1984, pp. 165–166. Secondly, the location of the tower is attested by the fresco of the Madonna

The Building 573

their voices – and that for many decades, namely as long as it would take to first make the body of the new church usable and then to erect the new tower up to the height of the belfry. So there was a lot to be said for the path that was taken when Giotto became director of construction and which was actually followed until the end of the fifties: first the new tower had to be built, then the old one could be demolished and the bells transferred to its replacement, and after that it was possible to proceed with the construction of the church itself.[997] This sounds complicated – but it was not a situation that distinguished the Florentine cathedral building from others. Anyone who examines construction sequences on large churches will find that the construction of the bell tower often determined the work schedule.[998]

THE BUILDING

Given his short period of office, not much of the tower as it stands today next to the cathedral (fig. 369) can have been built under Giotto, especially since sources inform us that the foundation work was of enormous scope; it certainly took several months.[999] Another question is how long the building lodge and the patrons felt committed to the original plan, Giotto's plan. After Giotto's death, did his successor Andrea Pisano continue to use the first design or did he submit a new one? The exterior of the tower reveals at least one caesura. It separates the storey above the base, which is decorated with niches and statues, from the first storey with windows, and is easily recognisable by the pilaster strips, which sit just below the windows and thus in the most aesthetically and statically senseless place. Whoever planned the first window storey, we may conclude, could not do anything with the architectural features on the statue storey and was therefore certainly not responsible for their existence. Was Giotto's design therefore carried out up to the statue storey?[1000]

della Misericordia in the Bigallo from the mid-14th century (M. Trachtenberg, The *Campanile of Florence Cathedral: "Giotto's Tower"*, New York 1971, fig. 285). It probably rose above the left transept arm of the old cathedral. In any case, because of the old city wall there was no room for an independent building comparable to the new campanile. That there was also a tower above or next to the right transept arm is sometimes assumed, but cannot be substantiated from the Bigallo fresco.

997 Trachtenberg, *The Campanile of Florence Cathedral*, pp. 122–123.

998 For Prague see: M.V.Schwarz, Kathedralen verstehen (St. Veit in Prag als räumlich organisiertes Medienensemble), in: *Virtuelle Räume: Raumwahrnehmung und Raumvorstellung im Mittelalter*, ed. E. Vavra, Berlin 2004, pp. 47–68.

999 Trachtenberg, *The Campanile of Florence Cathedral*, S. 22.

1000 This is Kreytenberg's conclusion: G. Kreytenberg, Der Campanile von Giotto, *Mitteilungen des kunsthistorischen Institutes in Florenz* 22, 1978, pp. 147–184.

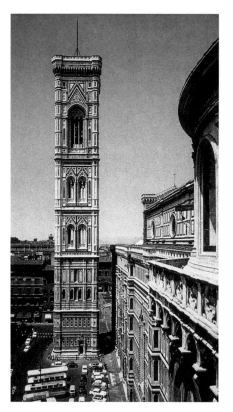

Fig. 369: Florence, Campanile

There is also a caesura inside the tower. It lies between the actual basement storey and its repetition. In the interior of the "lower" basement, the walls are formed with a broad pillar in the middle and niches beside it. Basically, this is the substructure for a tower shaft which consists of eight pillars – four octagonal pillars placed on the outside in front of the corners with reinforcements on the inside as well as four pillars on the inside in the middle of each side: a skeleton construction which one has to imagine reinforced by vaults and blind arches.[1001] It is a sophisticated system that strives for strength with the most minimal use of materials and could be called typically Gothic. However, this construction method is already abandoned in the storey above, in the "upper" basement. Here, the walls are solid and all around as thick as the pillars.[1002] This means that a heavy solid building, which consumed a lot of material, was put on top of a technically sophisticated skeleton construction, which had saved up to a quarter of the material.

Equally striking is the doubling of the basement storey on the exterior (fig. 370). This strange motif also points to a discontinuity. The "lower" basement with the seven upright panels per side is a variation of the incrusted pedestal zone of the side wall of the new Duomo, which in turn continues motifs from Arnolfo's cathedral façade. The basement storey ties the campanile aesthetically to the cathedral. This corresponds to the position of the tower in the line of the façade. In contrast, the repetition of the basement is unintelligible from the point of view of the cathedral's architecture, and obscures the connection that had been created between them. Along with the change of technical concept, the artistic concept was changed and the Campanile was treated as an autonomous building.

1001 Ibid. pp. 156–162. Kreytenberg's examination of the masonry refutes the old assumption, also held and further supported by Trachtenberg (*The Campanile of Florence Cathedral*, pp. 24–25), that the pillars were reinforcements installed by Andrea Pisano

1002 *S. Maria del Fiore: Rilievi, documenti, indagini strumentali, interpretazioni*, ed. G. Rocchi Coopsmans de Yoldi, Florence 1996, fig. p. 138 (Rocchi Coopsmans de Yoldi).

All in all, there is much to be said for attributing the upper caesura to the change in building direction from Andrea Pisano to Francesco Talenti. This thesis, which is more or less the consensus, also takes account of the fact that the construction is uniform, starting from the observed change up to the incompletely executed spire, and that it was Talenti who the sources identify as completing the tower (2.1.2). If this assumption is correct, then the lower caesura, the one between the first and second basement storeys, can be linked to the change from Giotto to Andrea Pisano, a thesis that can be supported by two further arguments.

First, the panels on the basement not only refer to the incrustation of the cathedral, but – as Decio Gioseffi has shown – also to incrustations that Giotto simulated in painting: upright rectangular panels with hexagons in the centre are an important motif in the framing system of the Arena

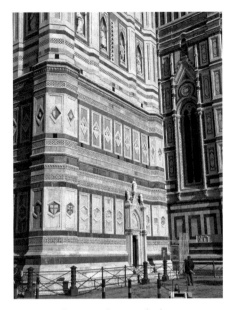

Fig. 370: Florence, Campanile, basement

Chapel. They help to organise the palace-side picture wall. With five analogous, but horizontal fields, Giotto covered the predella of the Baroncelli altar, which proves the use of the motif in the painter's late period. If the basement is designed by Giotto, then the artist has placed his own architectural preferences there as much as he has references to the cathedral and the legacy of Arnolfo di Cambio. Secondly, the basement repeats in exactly this form on the Sienese Campanile plan (fig. 371, 372). It was Aristide Nardini Despotti Mospignotti who noticed this in 1885, and it was reason enough for him to recognise Giotto's campanile project in this plan.[1003] This identification did not go unchallenged. For over a century, scholarship has been divided between authors who attribute the plan to our painter and those who attribute it to the Sienese Duomo nuovo project and its architect Lando di Pietro.[1004] One aspect remained unnoticed: the drawing is not

1003 A. Nardini Despotti Mospignotti, *Il campanile di Sagnta Maria del Fiore: Studi*, Florence 1885, pp. 11–18.

1004 History of scholarship: *Rinascimento da Brunelleschi a Michelangelo: La rappresentazione dell'architettura*. Exh. cat. ed. H.A. Millon and V. Magnago Lampugnani, Venice 1994, no. 1 (C. Ghisalberti). W. Haas und D. von Winterfeld, *Der Dom S. Maria Assunta: Architektur, Textband* (Die Kirchen von Siena 3.1.1.1), Munich 2006, pp. 515–518. Hans W. Hubert's comments on the Siena parchment as a copy are particularly helpful: H.W. Hubert, Über-

only related to the basement of the Campanile. As a whole, it is close to Giotto's architectural taste, as far as can be deduced from his other design work – much closer than it is to any other building or building plan in Italy.

Fig. 371: Siena, Museo dell'Opera del Duomo: Campanile plan, basement

THE SIENA PARCHMENT: GIOTTO'S GOTHIC ONCE AGAIN

The plan in the Opera del Duomo in Siena – 222,4 cm high and composed of three parchment skins – is a pen drawing executed with the aid of compass and ruler in brown ink over blind grooves without corrections and coloured with a brush in brown, pink and red (fig. 372). It is obviously a presentation plan and was not supposed to give instructions to builders, but to win potential patrons for a project. This is reflected not only in the colourful finish but also in the effort put into the figurative parts: a total of three angels standing on the top of the spire and the buttresses on its side are not ciphers for sculptures, but rather living beings (fig. 373). It is also obvious that they are not Giotto's works. Although we lack drawings for comparison (no drawings by Giotto have survived), the whole approach is one that stands apart from Giotto's figures: There are no such elegantly deformed bodies anywhere in our painter's oeuvre. The parchment may reflect Giotto's plan for the Florentine Campanile, but it *is* not Giotto's plan. It is probably addressed not to Florentines but to Sienese patrons, advertising the addition of a new bell tower to the Duomo Nuovo in Siena, which would have rivalled Giotto's legendary project for Florence – but would not have fit in Siena.[1005]

What connects the drawing with the planning for the Florentine Campanile is, first,

legungen zu Materialität und Medialität von Architekturzeichnungen, in: *Die Quadratur des Raumes: Bildmedien der Architektur in Neuzeit und Moderne*, ed. M. Melters and Chr. Wagner, Berlin 2017, pp. 45–61, esp. 49–52.

1005 M.V. Schwarz, Toskanische Türme. Repräsentation und Konkurrenz, in: *Information, Kommunikation und Selbstdarstellung in mittelalterlichen Gemeinden*, ed. A. Haverkamp, Munich 1998, pp. 103–124.

Fig. 373: Siena, Museo dell'Opera del Duomo: Campanile plan, angel

Fig. 372: Siena, Museo dell'Opera del Duomo: Campanile plan

the similarity of the basement storeys, which goes further than merely motifs. They also match in proportions. The plan reproduces the built basement quite accurately on a scale of 1:48.[1006] Secondly, the ground plan is the same, which can be easily deduced from the elevation in the plan. It is the rare case of a square with octagonal piers; in the plan as in the building, two half and three whole sides of the total of

1006 V. Ascani, *Il trecento disegnato: Le basi progettuali dell'architettura gotica in Italia*, Rome 1997, p. 83. It is often said that the plan and the building differ in the bench that surrounds the built campanile. But this is due to the lowering of the street level in 1339. Trachtenberg, *The Campanile of Florence Cathedral*, p. 26.

Fig. 374: Strasbourg, Musée de l'Oeuvre Notre-Dame: fragment from the rood screen of the Minster

eight sides project from the core of the tower. This disposition does not occur again in Italy and there are a few examples in Gothic tower building north of the Alps. Earlier than the Florentine case are: Notre-Dame in Paris, where the octagonal piers are only visible just below the final cornice (below this they are packed and hidden by the buttresses). Then there is the west tower of the famous pilgrimage church of Halle in Belgium. Here the octagons are visible throughout.[1007] Finally, there is a fragment from the rood screen of Strasbourg Minster that probably belonged to the micro-architecture of a figure canopy (fig. 374). It shows a square tower with corner pillars that are square at the bottom and octagonal at the top.[1008] Windows reveal them to be stair towers, a function that perhaps the Florentine piers were also to assume in sections. On the built tower, the north-east pillar contains a spiral staircase at a height that was planned by Talenti.[1009]

From these examples, it is natural to categorise the octagonal pillars as Gothic.[1010] In Florence's cathedral square, however, they not only appear as Gothic and as ambassadors of a new taste, but they also connect aesthetically with the octagonal construction of the baptistery. This suggests that we are dealing with a planning in the parchment project that combines motifs from Giotto's fundus, Gothic forms, and Florentine *genius loci*.

All the parts above the basement are different in the Siena parchment and in the Florentine building.

1007 M. Franssens, L. Walschot, and W. Everaert, Samenvattende Torenstudie Sint-Martinusbasiliek Halle 1989, *Hallensia: Trimestrieel Bulletin van de Koninklijke Geschied- en Oudheidkundige Kring van Halle* 12, 1990, pp. 35–65.

1008 H. Koepf, *Die gotischen Planrisse der Ulmer Sammlungen*, Ulm 1977, p. 16. *Les bâttiseurs des cathédrales gothiques*. Exh. cat. ed. R. Recht, Strasbourg 1989, p. 423. Kind advice from Bernd Roeder.

1009 Trachtenberg, *The Campanile of Florence Cathedral*, pl. X.

1010 Part of a Gothic system are also the octagonal pillars on the transept of Naples Cathedral, in which Decio Gioseffi wanted to recognise Giotto's models: Gioseffi, *Giotto architetto*, p. 82.

The plan shows five storeys of equal height, separated by similar cornices, each forming a square field between the octagonal pillars. The wash and the depiction of mouldings reveal that they are meant to be incrusted, with the basement providing the motif: panels with hexagons whose arrangement is subject to systematic variation.[1011] Each of these fields is more fenestrated than the one below, so that the incrustation is gradually replaced by openings. On the first floor, a tracery rosette is encountered, followed on the second floor by a round-arched window framed

Fig. 375: Siena, Museo dell'Opera del Duomo: Campanile plan, fifth storey

by vegetal ornamentation, above this appears a larger pointed-arched window; then – and here probably the belfry begins – two double-lancet tracery windows open the wall. Finally, a group of three windows with pediments and pinnacles appears on the fifth storey, the actual bell storey, which is separated from the fourth by a walkway with parapet (fig. 375). There is literally no room for incrustation on this level. The Gothic architectural motifs require even more wall surface than the square available; they stretch over the final cornice of the tower shaft.

The figuration of windows, gables, and pinnacles is particularly interesting for two reasons: firstly, we are dealing with a design that is close to the framework of the Stefaneschi and Badia altarpieces. In its perfection and inner logic, as well as in its proximity to the systems of the *Style rayonnant* and their Rhenish succession, we have arrived again at "Giotto's Gothic". If one wonders in the case of the designer of the altars whether he had been in France or another country where Gothic planning and building was the local style, then the same question also arises in the case of the designer of the tower. Secondly, a lapse is noticeable: this storey cannot be built as it was drawn. If the pinnacles and gables were really to step in front of the end cornice, their substructures would obstruct the walkway. The architecture may be aesthetically mature, but it would have had to be considerably modified in the course of construction.

The crowning of the tower is a huge yet graceful octagon with a spire surrounded by pinnacles (fig. 376). One reference of this motif is local, namely to the lantern erected in

1011 E. Mandelli, Lettura di un disegno: La pergamena di Siena, *Studi e documenti di architettura* 9, 1983, pp. 99–134.

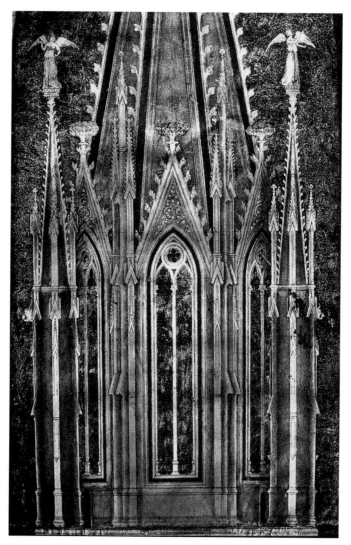

Fig. 376: Siena, Museo dell'Opera del Duomo: Campanile plan, octagon

1150 above the opeion of the baptistery: a slender octagonal monopteros with a pointed conical roof.[1012] At the same time, it is an explicitly Gothic component that is linked to

1012 M.V. Schwarz, Light and Rain: The Invention of the Dome Lantern in 12th-Century Florence, in: *Illuminations: studies presented to Lioba Theis*, ed. G. Fingarova, F. Gargova, and M. Mullett, Vienna 2022, pp. 139–146.

buildings in West and Central Europe. The way the sides are opened by windows and surmounted by gables, as well as the spire studded with ribs and crockets, point to contemporary tower buildings of the High Gothic period north of the Alps. The tower of Freiburg Minster, which was being worked on at the time, is particularly similar.[1013] A closer comparison shows that certain inventions made during the building process in Freiburg are not incorporated into the Sienese plan. In Freiburg, for example, there is a walkway that runs between the eight gables and the spire on the top of the octagon (fig. 377). In contrast to the Siena plan, the Freiburg spire thus sits on the inner edge of the wall; the thrust from the spire is discharged there into the thickness of the walls of the octagon. When elaborating the parchment plan or its Florentine model, the question of the thrust emanating from the spire, which threatens to push the cage of the octagon apart, was also considered, but not really solved: the rods that emerge from the tracery-couronnement of the diagonal sides of the

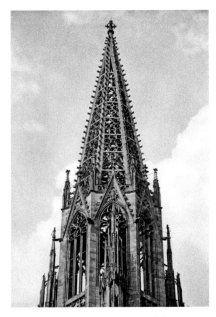

Fig. 377: Freiburg, bell tower of the Minster, octagon

octagon and lead diagonally to the corner pinnacles can have little other purpose than to divert thrust, but especially if they are made of metal (and what else could they be made of?), they would be unable to do this. The bars would bend. Used as peripheral anchorage, as on the Freiburg tower, metal elements however are helpful. A certain awareness of the problem was present and solutions were searched for, but as drawn, the Florentine Octagon would not have been stable.

These considerations lead us into the temporal forefield of the planning for the Freiburg tower. One might think of the (never executed) octagons of the façade of Strasbourg Minster, as they appear in the Strasbourg Plan B (fig. 378), or of their French antecedents.[1014] If we assume a development of the Gothic tower during the decades around 1300 – a tendency towards the light, filigree and elegant – then the octagon on the Sienese plan

1013 H. Klotz, Deutsche und italienische Baukunst im Trecento, *Mitteilungen des kunsthistorischen Institutes in Florenz* 12, 1966, pp. 171–206. M.V. Schwarz, Die Erfindung des gotischen Turms: Reims, Straßburg, Florenz, Freiburg, Köln, in: *Ecclesia docta: Společenství ducha a umění: k životnímu jubileu profesora Jiřího Kuthana*, ed. M. Nespěšná Hamsíková, J. Peroutková, and St. Scholz, Prague 2016, pp. 214–228.

1014 On plan B: *Les bâttiseurs des cathédrales gothiques*, pp. 386–388.

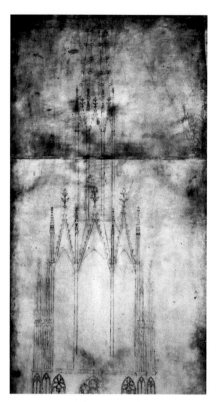

Fig. 378: Strasbourg, Musée de l'Oeuvre Notre-Dame: plan B, detail

belongs somewhere between Saint-Nicaise in Reims and the planning for Freiburg: The abbey church of Saint-Nicaise, demolished during the French Revolution, already had the wide-open polygons (not octagons, but in this case hexagons) as well as pediments in front of the spires (fig. 379). In contrast, however, comparatively massive tabernacles leaned against the diagonal sides of the polygons. These are exchanged for free-standing pinnacles in Strasbourg's Plan B, but now the shape of the spire causes problems because its thrust can no longer be directed to the tabernacles. The attempt at a two-step truncated spire with a lantern, which Plan B presents, reveals itself to be a stopgap. The difficulty is then overcome in Freiburg by making tracery indents in the spire and introducing an iron peripheral anchorage. The solution reached on the Siena parchment corresponds to Gothic building around 1300 between France and Germany, an insight that has brought us suddenly back into the sphere of the models for Giotto's architectural polyptychs: Richard Hamann has located the origins of the architectural and sculptural elements of the Marburg high altar in Strasbourg and Freiburg.[1015] It is a lucid manifestation of Gothic that can hardly be confused with what the Sienese had in mind and with Arnolfo's intricate architectural designs.

However, one might say that the tower project is additive – unlike Giotto's polyptychs. But this impression does not stand up to closer analysis. Firstly, the proportions are cleverly chosen and hold the shaft and the coronation together: Irene Hueck has observed that the walkway between the fourth and fifth floors is exactly halfway up the entire building.[1016] In this way, the fifth storey is simultaneously part of the shaft and the crowning and braces the two parts. Secondly, the square fields of the five storeys of the shaft, structured by incrustation, can certainly be read as "Gothic". The transept façades of Notre-Dame in Paris, for example, which are regarded as prime examples of the *Style rayonnant*, also appear strongly horizontal and divided

1015 R. Hamann and K. Wilhelm-Kästner, *Die Elisabethkirche zu Marburg und ihre künstlerische Nachfolge*, 2 vols., Marburg 1924, 1929, vol. 2 pp. 91–112.

1016 I. Hueck, Giotto und die Proportion, in: *Festschrift für Wolfgang Braunfels*, ed. F. Piel and J. Träger, Tübingen 1977, pp. 143–155.

into fields – among other things by the motif of the walkway with balustrade. Likewise, the miniature tower from the Strasbourg rood screen can be cited: also here we find storeys that are clearly separated horizontally and architectural motifs displayed like pictures.

It is therefore by no means the case that the tower is divided into a conventional shaft and a Gothic top (which might even have been designed by a different artist than the shaft)[1017], but the architecture as a whole is Gothic in the sense of French standards of the late 13th century – albeit in a special variant. Any deviation takes into account the *genius loci* of Florence and anchors the building in the Cathedral Square next to the church of the city's patron saint, the Baptistery. It is Florentine incrustation architecture in the modernising and noble dress of the *style rayonnant*. What began in the 11th century with the Baptistery and was continued on Arnolfo's cathedral façade in a kind of additive model-book Gothic is translated on the tower in the system of the French formal language.

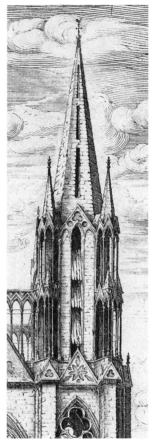

Fig. 379: Reims, Saint-Nicaise, façade, south tower (engraving by Nicolas de Son)

Fig. 380: The octagon of Giotto's Campanile (after Igino Benvenuto Supino)

It is conceivable that the project appears in the Siena parchment with modifications that were intended to make it suitable for Siena, but it is not clear from the motifs what was changed. This also applies to the striping of the octagonal pillars that begins above the basement storey. Those who wish to relate this motif to the striped incrustation of the Sienese cathedral should bear in mind that the corner pillars of the Florentine Baptistery,

1017 A. Melani, Storia d'un campanile nel Museo del Duomo di Siena, *La Lettura*, Settembre 1902, pp. 815–816. Similarly still: Trachtenberg, *The Campanile of Florence Cathedral*, p. 45.

which according to Giovanni Villani (VIII, iii) were subsequently executed in marble in 1293, are also striped. The stripes do not need to be read as a Sienese characteristic, since they can also be understood as one of many patriotic Florentine motifs. Nor can corrections in the graphic execution of the plan be detected: apparently, the pen strokes quite faithfully copy an elaborated original. To the extent that the project on the parchment appears mature and consistent, there is much to suggest that the drawing authentically reproduces Giotto's idea for the Florentine tower.

If this campanile had been built – with the technically necessary modifications (fig. 380 shows Supino's attempt to become clear about the effect of the built tower)[1018] – the cityscape of Florence would probably have developed differently. The construction of the cathedral would certainly have been continued in a more "Gothic" manner, and other explicitly Gothic towers with polygonal spires would have joined the more than 100-metre-high Campanile of Santa Maria del Fiore. Giotto's Gothic, and with it a French-oriented architectural taste, would have become the guiding model, displacing Arnolfo's Gothic. Masters such as Francesco Talenti and Orcagna would have provided simpler and more system-oriented designs. Giotto's reputation and his success in the field of painting could lead one to expect that this would have been the course that architectural history would take. Why did things turn out differently?

THE SHEPHERD'S TOWER

Two critical remarks mingle in the decades-long chorus of admiration for the deceased master. One, about Giotto's mistakes as a painter, only becomes interesting in the following volume (2.5.5). The other concerns mistakes made by the architect: A commentator on Dante's *Divine Comedy*, called the Anonimo Fiorentino, wrote around 1400 at the end of a lengthy section on the artist (2.5.7):

> *He designed and built the marble campanile of Santa Reparata in Florence, a remarkable campanile that cost a lot of money. In doing so, he made two mistakes: one was that it had no recess from the foot* (che non ebbe ceppo da piè), *the other that it was [too] narrow. This, he said, caused him such pain in his heart that he fell ill and died.*

Comparing the parchment campanile and the stone campanile (fig. 372, 369), it is noticeable that the wall of the built tower is significantly recessed above the doubled basement. What the Anonimo Fiorentino tells probably preserves a memory of how Giotto's project

1018 I.B. Supino, *Giotto*, Florence 1920, p. 286.

The Shepherd's Tower

was discussed after his death and which led to the change of plan: when Giotto could no longer argue for his project, it seemed too risky.

His successor, who had been in office since April 1340 at the latest[1019] and who either shaped the view that the plan was flawed or willingly dealt with it, was, according to all we know, no more a building practitioner than Giotto. Andrea Pisano had made an impression as the modeller of the bronze doors of the Baptistery with the images from the life of the city's patron – and also on our painter, as the pictures of the Peruzzi Chapel show. We do not have a drawing, but Andrea's project must have differed decisively from Giotto's in two points: being both heavier and lower. That the height would be reduced can be concluded from the setback above the doubled basement. The comparison of the wall structures on the first and second basement levels shows that Andrea built more massively.

However, the extent of the difference to Giotto's plan only becomes clear when we consider how the interior of the tower shaft would have been structured according to the Sienese plan: it is to be expected that the lower chamber would have integrated the base and the first storey in the interior. The lighting would have been provided by the rosettes that form the window motif of the first storey. Their position is central above the inner pillars. Under these circumstances, the wall structure in the chamber could have only looked like this: under the cross vault, the piers are connected with blind arches; in the spandrels between the arches and the vault, the rosettes pierce the wall, which is as thick as the piers in this area. The blind arches and the vault between the first and second chamber form the first stiffening ring of the skeleton construction of the tower shaft.

All this was changed by Andrea Pisano, and these interventions put him in a bind. Therefore, in the lower chamber, he had to resort to improvised lighting using slanted window channels whose openings he hid in the dark slabs of the incrustation. And he continued in the zone above with this form of lighting. Here, in the chambers of the statue storey, the slits are window-sized but lie behind tracery grids. The renunciation of using the windows to structure the building and the superfluous conflict between the articulation of the walls and the illumination are among the weaknesses of the section built by Andrea. Pucci's report that those responsible were dissatisfied and that Andrea had been dismissed seems plausible (2.1.2).

What may have initially made the concept attractive, however, is its rich decoration with figurative sculpture – reliefs and statues. It is usually assumed that Andrea's sculptural work for the Campanile began under Giotto's supervision. The execution of the hexagons on the base as reliefs and their unusual programme were therefore Giotto's responsibility:[1020] these are the 21 images depicting the creation of Adam, the creation of

1019 Trachtenberg, *The Campanile of Florence Cathedral*, p. 184 (doc. 57).
1020 Flores d'Arcais, *Giotto*, S. 366.

Eve, the labours of Adam and Eve, the biblical inventors of man's activities, the seven *artes mechanicae* and other arts, including (or rather supplemented by) architecture, sculpture and painting (fig. 370) – a programme influenced by scholasticism but open to the experience of reality in a city of trade and commerce, hereafter called the Arti cycle.[1021]

Some written sources can even be read as if the sculptures were made by Giotto's hand. Looking back after the completion of the Campanile, Antonio Pucci says about Giotto's activity (2.1.2): "[I] primi intagli fe con bello stile." However, this does not necessarily mean that the author had informed himself, but may be a conclusion he drew from the knowledge that Giotto had begun the construction. Ghiberti also maintained that the relief panels were Giotto's work. Yet this assertion is transparent in its motivation (vol. 1, pp. 28–29). And the biographer presents the facts differently a few pages later in his remarks on Andrea Pisano: here the entire earlier Campanile sculpture is claimed for Andrea (2.1.4): "The seven works of mercy, the seven virtues, the seven liberal arts, the seven planets" (so far his description of the reliefs on the upper basement; "sacraments" instead of "works of mercy" would have been correct.) "There are also four figures by the hand of Master Andrea, carved in stone, each four cubits high" (these are the sculptures on the statue storey, a series actually of eight statues, which was extended to sixteen in the 15th century.) Then Ghiberti comes to the Arti cycle and says that from Andrea originates: "a large part of the images in relief which represent the inventors of the arts. Giotto, however, chiselled, as they say, the two first stories. He was experienced in one art as well as the other." According to Andrea's *vita,* what remains for Giotto are the panels with the Creation of Adam and the Creation of Eve. But since nothing essential connects these two reliefs with Giotto's painted works and nothing separates them from the sculptures claimed for Andrea, there is no reason to take this statement more seriously than the corresponding passage in Ghiberti's Giotto *vita.*

An obvious question has been discussed surprisingly casually so far: did Andrea introduce the medium of sculpture, including the reliefs of the Arti cycle, into the project only after Giotto's death? The Sienese plan does not provide for sculptural images: the hexagons at the basement are empty and not drawn differently from those on the four storeys above, and a placement of figurative reliefs there can be ruled out, as they would not have been legible.[1022] By introducing sculptures, Andrea brought his own strengths into play

1021 J. von Schlosser, Giusto's Fresken in Padua und die Vorläufer der Stanza della Segnatura, *Jahrbuch der kunsthistorischen Sammlungen des allerhöchsten Kaiserhauses* 17, 1896, pp. 12–100. E. Simi Varanelli, *Artisti e dottori nel medioevo: Il campanile di Firenze e la rivalutazione delle "arti belle"*, Rome 1995. T. Michalsky, Der Reliefzyklus des Florentiner Domcampanile oder die Kunst der Bildhauer, sich an der Heilsgeschichte zu beteiligen, in: *Artes im Mittelalter*, ed. U. Schaefer, Berlin 1999, pp. 324–343.

1022 Cf. Trachtenberg, *The Campanile of Florence Cathedral*, p. 86.

The Shepherd's Tower 587

and compensated the public for the elimination of spectacular aspects of Giotto's plan. That it would have been possible to subsequently insert the reliefs into the incrustation of the basement is obvious. Besides, no one knows to what degree the decoration there was really irreversibly executed when Andrea took over the site.[1023] It should be noted that the reliefs were finished to varying degrees when they were installed; in very few of them is the relief's ground fully worked out.[1024] And there were only 21 slabs instead of the 28 necessary for a four-sided freestanding structure. This means that the Arti Cycle was to enclose the tower on only three sides and not, like the cycle on the upper basement level, on all four sides. The fact that it was the north side – the side facing the cathedral – that was initially disadvantaged (so that panels for this wall had to be added in the 15th century), must not have been intended when Andrea designed the cycle and the panels were produced. The space between the tower and the cathedral, which appears to us today as a narrow alley, was a particularly prestigious passageway in Florence at the time.

During Andrea's time, another change occurred that was significant for the appearance of the tower and is interlinked with the problems of furnishing it with images. Well into Andrea's tenure, if not beyond, the canonry of the cathedral to the east of the Campanile building site was still standing upright. One must imagine a cloister around which the apartment and common rooms of the canons were arranged. The decision to demolish these buildings was taken in October 1339, and was hardly prepared in advance, as it was not until the following year that any provision was made for the construction of new premises.[1025] It may have been a long time until the old *canonica* really disappeared. As long as this complex existed, anyone looking from the Baptistery did

1023 When the reliefs were removed in 1964/65, evidence was found that the hexagons on the west side were relocated together with the surrounding pieces of incrustation; but this is no proof that they belong to Giotto's planning: L. Becherucci, La bottega Pisana di Andrea da Pontedera, *Mitteilungen des kunsthistorischen Institutes in Florenz* 11, 1963–65, pp. 227–261, esp. 261.

1024 In the studies on the reliefs, little has been said so far about the degree of completion and the history of production. This is also the case, for example, in: A.F. Moskowits, *The Sculpture of Andrea and Nino Pisano*, Cambridge 1986, pp. 38–50. However, it is easy to recognise that the degree of completion varies – as can be seen, among other things, from the condition of the relief ground: Partly it is filled with a blue mass, partly it is only deepened and roughened (as in the image with the painter). Sometimes even this does not seem to have been done.

1025 Trachtenberg, *The Campanile of Florence Cathedral*, pp. 51. On the *canonica*: F. Toker, On Holy Ground: Architecture and Liturgy in the Cathedral and in the Streets of Late-Medieval Florence, in: *La cattedrale come spazio sacro: saggi sul duomo di Firenze* (Atti del VII centenario del Duomo di Firenze II, 2), ed. T. Verdon and A. Innocenti, Florence 2001, pp. 544–559, esp. 553–556.

588 The Campanile: Survival under Construction

not experience the slowly rising Campanile as free-standing, but would have assigned it to the canonry.

In the following period, two portals were planned for the tower: One led in at ground level from the east side. There is nothing to suggest that the opening itself, which corresponds to the staircase system,[1026] does not belong to Giotto's original plan. On the other hand, the elaborate framework showing the lamb of the Arte della Lana in the tympanum, built in front of the wall, spoils Giotto's system of structuring the basement (fig. 371). Stylistically, too, the framing stands out from "Giotto's Gothic" and must have been created subsequently. The other portal opens in the north wall high above the floor at the level of the second basement storey. Its existence may have to do with the change of plan after Giotto's death. It was accessed via a bridge from the cathedral – rather improvised as anyone will admit who has ever realised the sloping course of the connection between the door in the cathedral wall and that in the campanile wall.

These findings suggest the following possibility: Giotto's tower was not meant to be completely free-standing, but rather to have its eastern side connected to the canonry. One may refer to situations like that in Volterra, where the campanile is set back from the cathedral and at the same time integrated into the *canonica*.[1027] The Florentine canons would have been able to enter the Campanile more or less directly from their buildings – either across a narrow alley or through a passage. This concept probably existed until the beginning of Andrea's term of office. It was not until the demolition of the enclosure buildings in the years after 1339/40 that it became necessary to also provide the east side of the basement with a marble incrustation, which was equal in quality to those on the other sides. The portal, which until then had been a kind of internal portal, now had to be staged as a prestigious entrance. At the same time, the need arose for a separate entrance for the clergy. This is how the second portal, accessible from the cathedral via the bridge, came about. Interestingly, the entrance from the piazza leads to a staircase that provides direct access to the bell storeys and the platform, while the entrance from the cathedral

1026 Cf. Kreytenberg, Der Campanile von Giotto, p. 164: According to Kreytenberg, the staircase leading from the corridor opened by the portal was built in later. The argument for this is that the wall design of the stairwell does not correspond to that on the floors above. If, unlike Kreytenberg, one reckons with a building caesura between the first and second basement storeys, the argument no longer applies. The argument that Giotto had planned a spiral staircase in the north-east pillar, which Trachtenberg presents, is also weak: Trachtenberg, *The Campanile of Florence Cathedral*, p. 25: The tiny "window" he observes there in the incrustation, but which does not lead into the interior, is probably a graveyard light.

1027 The Campanile in Volterra is early modern, but, as a building inscription informs us, a remake of a high medieval predecessor: C. Leoncini, *Illustrazione sulla Cattedrale di Volterra*, Siena 1869, p. 121.

The Shepherd's Tower 589

primarily provides access to two chambers in the statue storey. Trachtenberg thought of
the lower chamber as a meeting place for the canons – this would have been the replace-
ment for the chapter house of the Canonica, which had been scheduled for demolition
since 1339. It is worth noting that the upper chamber was the ringing chamber. The bell
ropes were operated from here. Those who wanted to reach the belfry itself from this
room had to rely on a door that led from the ringing chamber into the main staircase and
which could be open or closed. The bells could therefore be serviced from the ringing
chamber on a case-by-case basis, but they were always accessible to those who entered
the tower from the piazza. In addition, bells may have existed that could only be set in
motion from the level above the ringing chamber and were not permanently available to
the cathedral clergy. Other cathedral towers are known to have also carried communal
bells.[1028] This is not likely in Florence, because the commune had its own bell towers at the
Bargello and at the Palazzo Vecchio. But bell ownership was not limited to diocesan and
municipal organisations. In the Florentine sources there is information about a bell that
belonged to the Fraternity of St. Zoenobius. On the orders of the city government, it was
taken down from the Campanile by the Opera del Duomo in 1448 and then recast into a
bell for the Palazzo Vecchio.[1029]

Those who had the key to the portal with the Arte della Lana coat of arms and so could
enter the tower from the newly created square on the site of the *canonica* would have had
unrestricted control over the most effective stock of acoustic media in the city. In contrast,
those who entered the tower from the cathedral via the bridge only controlled the bells to
the extent that the holders of the other keys allowed. With the transfer of the bells from
the old to the new campanile in 1357/58, the bishop and the cathedral chapter lost influ-
ence. Hand in hand with this, the new campanile – as was probably already envisaged in
Giotto's time – had changed from an audiovisual medium in the service of the bishop and
the chapter to a monument to its own supporting institutions. The latter were the Arte
della Lana, which had been in charge of the Opera since 1331, and the commune, which
financed the construction to a considerable extent and whose representatives appointed
the *capomaestro* of the building without (visibly) involving the church authorities in this
decision, as happened in April 1334. The Arti cycle harmonises with this secular patronage.
In a city governed by guilds and on a magnificent building for which the city was respon-
sible, the depiction of human abilities and inventions did not refer to the Fall of Man
(which was elegantly omitted from the cycle) and the misery of a life outside Eden, but to
the creative capacity of human beings. And although the register above with the planets,

1028 G. Bönnen, Zwischen Kirche und Stadtgemeinde: Funktionen und Kontrolle von Glocken
 in Kathedralstädten zwischen Maas und Rhein, in: *Information, Kommunikation und Selb-
 stdarstellung in mittelalterlichen Gemeinden*, ed. A. Haverkamp, Munich 1998, pp. 161–199.
1029 *Il Duomo di Firenze*, ed. G. Poggi, Florence 1988, vol. 2, p. 184 no. 2340.

the virtues, the artes liberales, and the sacraments suggests a metaphysical reading of this capacity, it remains human.[1030]

The tower, released from pastoral dominance and also physically detached from the cathedral and the *canonica*, did not only represent the commune and the guilds, however. It could also be read as a medium and monument to its first *capomaestro*. Both the tower and the architect are praised by the Florentine cleric Domenico da Corella in his book on Marian shrines of 1469, assigning the tower only marginally to the most important Marian shrine in Florence, namely its cathedral (2.7.5):

> *Giotto previously designed a magnificent picture of it,*
> *he, who earned the victory palm in painting*
> *and surpassed all masters of his time.*
> *He was not inferior to the old painter Apelles.*
> *He, who wanted to do great service to his hometown*
> *created the noble model of the tower.*
> *On earth there is no more splendid one,*
> *in colourful marble it shines far and wide.*

Additionally, one could quote Giotto's epitaph, written by Angelo Poliziano on behalf of Lorenzo il Magnifico twenty years later (2.8.2), which has Giotto speak ("Ille ego sum ...") and name just one of his works, the campanile. "You admire the eminent tower re-sounding through sacred metal? / Based on my measure, this too grew up to the stars." The inscription was compulsory reading for every visitor to Santa Maria del Fiore for centuries and one of the most effective media of Giotto's afterlife. Or one can mention the discussion of the tower in Bendetto Varchi's funeral oration for Michelangelo a century later (2.9.1): here the tower and its builder are representatives of the great change from the bad to the good in the art of building. There are few cases where architecture is so closely and stably connected with the person of the architect.

One reason for this was that Giotto died as a public figure (vol. 1, p. 64–67) and the Campanile, as his most public project, grew like a legacy – regardless whose plans were used. Another reason was that the Arti cycle referred not only to the lost paradise and the origin of the guilds, but also to artistry. The introduction to the painting treatise, which Cennino Cennini authored around 1400, starts with Adam and Eve and in a few sentences spans the arc to Giotto. One might almost think that the basement reliefs of the Campanile had provided the model: the progenitors are created and – according to Cennino – "gifted with all abilities". Chased out of God's garden, Adam rediscovers these abilities and makes inventions that keep the couple alive. That is where the *artes* come from. One

1030 Michalsky, Der Reliefzyklus des Florentiner Domcampanile.

Fig. 381: Florence, Museo dell'Opera del Duomo, relief from the Campanile: Jabal (Andrea Pisano)

Fig. 382: Florence, Museo dell'Opera del Duomo, relief from the Campanile: the painter (Andrea Pisano)

of them is the "art called painting." According to Cennino, it has to do with the divine gift of imagination and no one handled it more perfectly than the teacher of his teacher's teacher – Giotto (2.3.6). In reality, Cennino's opening echoed a pattern already known from the treatise of Theophilus Presbyter, but this observation only underlines how the Arti cycle harmonised with collective notions of artistry and how easily it could be read in the light of artists' mythology and Giotto's fame.[1031]

"The shepherd's tower" is what John Ruskin called the Campanile in the last of his *Mornings of Florence,* thus linking it to the Giotto of Memory, Ghiberti's and Vasari's sheep-drawing prodigy, who for Ruskin was the real Giotto and the quasi hero of his book.[1032] Ruskin treats the Arti cycle accordingly: a work not only by Giotto's own hand, but also a subtle message from the master, addressed to posterity, about the inner connection between Christianity and art. The author discovers special qualities in the hexagon which shows Jabal, known to be the "father of such as dwell in tents, and of such as have cattle" (Gen. 4, 20). Here, Ruskin suggests, Giotto is thinking back to his childhood (fig. 381). By "scratching" sheep into the stone (the relief around the animals is strikingly

1031 Cf. Schlosser, Giusto's Fresken in Padua und die Vorläufer der Stanza della Segnatura, pp. 67–68.
1032 J. Ruskin, *Mornings in Florence Being Simple Studies of Christian Art For English Travellers,* New York 1903, pp. 101–123. The first edition of the text (New York 1876) does not include the Florentine Morning entitled *The Shepherd's Tower*.

flat), he again becomes the herding boy over whose shoulders Cimabue peers. Also special for Ruskin is the hexagon that represents *Pictura*: a painter, balancing on a stool, bending over the easel with a picture panel (fig. 382). The author is well aware of the artistic and technical imperfections that are more evident in this relief than in others. Before I refer to Ruskin's explanation, some hints: when the hexagon of *Pictura* was to be installed, the work was obviously further behind in execution than many of the others and was completed hastily and superficially. In the process, the finishing of the plinth strip was omitted. Moreover, the relief was originally only slightly more than half the width of the others. Some scholars believe that it was intended for a position next to the door at ground level, from which it supposedly had to be moved when the door was given the existing framing.[1033] In any case, the addition was made almost amateurishly, so that the plate finally corresponded to the others in shape but not in quality.

Ruskin's explanation for the shortcomings is a semantic one: for him, behind them is the modesty of the Christian artist who renounced self-promotional brilliance so as not to overshadow the appearance of the progenitors and patriarchs. Accordingly, Ruskin did not want to speak of a self-portrait. Instead, he noticed that the painter in the relief holds and wields the brush just as he, Ruskin, holds and wields the pen. Readers of *Mornings of Florence* are spared a self-portrait of Giotto, but instead experience how the author himself tries to become one with Giotto, from whom he hopes to find standards for his own approach to the art of pre-modern Florence.

1033 Trachtenberg, *The Campanile of Florence Cathedral*, p. 74.

PHOTO CREDITS

Musei Civici di Padova: pl. I–X; SCALA Florence:, pl. XI, XII, XIV, XV, XIX, XX, fig. 217; A. Quattrone: pl. XIII; Photo Archives Kunsthistorisches Institut der Universität Wien: pl. XVI, fig. 1–6, 8, 9, 11–14, 21, 25, 26, 31–36, 38–43, 51, 53–55, 58–71, 73, 82, 93–103, 105–108, 114, 116, 123–131, 133–137, 140, 144, 147, 149, 150, 155, 169, 170, 172, 176, 181, 198. 199, 220, 224, 227, 235, 237, 243, 244, 262, 268, 269, 272. 278, 279–284, 286–289, 292–294, 295–299, 301, 303, 305, 313–16, 329, 337–340, 342–344, 348–351, 353–356, 358–, 359, 362–370, 377–379, 381, 382; Musei Vaticani (Governatorato SCV, Direzione dei Musei. Tutti i diritti riservati): pl. XVII, XVIII; after Basile, *Giotto: The Arena Chapel*: fig. 7, 18–20, 22, 23, 72, 74, 75, 119, 121, 157, 191, 193, 206, 352; after *La Cappella degli Scrovegni a Padova*, ed. Banzato et al.: fig. 10, 15, 24, 27–30, 44–50, 55–57, 76–91, 160, 271; after Il Battistero di San Giovanni a Firenze, ed. Paolucci: fig. 52; R. Hamann-MacLean: fig. 104; after *La basilica di San Francesco in Assisi*, ed. Bonsanti: fig. 109–111, 115, 117, 118, 120, 122, 153, 154, 156, 166–168, 171, 173–175, 177–180, 182–190. 192, 194–197, 200–205, 212–216, 218, 219, 221–223, 226, 229, 231–234, 252, 256, 260, 304, 306, 307, 508, 310, 312, 346; after *Giotto e compagni*, ed. Thiébaut: fig. 224, 228, 230, 236; Sopraintendenza per I beni artistici e storici di Firenze, Pistoia e Prato: fig. 239, 240, 245–251, 153, 255, 257–259, 261, 263–267, 333–336, 341; after Poeschke, *Wandmalerei der Giottozeit in Italien*: fig. 241, 242, 230, 231; Public domain: fig. 270, 272, 274, 318, 321–323, 325, 328, 345, 360, 361, 368; after Gaeta, *Giotto und die Croci dipinte des Trecento*: fig. 275, 276; after Boskovits, *Frühe italienische Malerei*: fig. 277; after Gnudi, *Giotto*: fig. 285; after *The Treasury of Saint Francis of Assisi*: fig. 300; after *Sancta Sanctorum*: fig 309, 357; after *Giotto: Il restauro del Polittico di Badia*, ed. Tartuferi, fig. 317; after Mueller von der Haegen, *Giotto di Bondone*, fig. 324, 327; after Tintori and Borsook, *Giotto: La cappella Peruzzi*, fig. 332, 347; after Trachtenberg, *The Campanile of Florence Cathedral*: fig. 371, 373–376; Lensini Foto: fig. 372; the other figures are quotations after the literature in the footnotes.